THE PAST FROM ABOVE

Georg Gerster

THE PAST FROM ABOVE

Aerial Photographs of Archaeological Sites

Edited by Charlotte Trümpler

THE J. PAUL GETTY MUSEUM, LOS ANGELES

Originally published in German under the title
Flug in die Vergangenheit
© 2003 Schirmer/Mosel, Munich

First published in the United Kingdom in 2005 by
Frances Lincoln Ltd
4 Torriano Mews, Torriano Avenue,
London NW5 2RZ
www.franceslincoln.com

Translation by Stewart Spencer
© 2005 Frances Lincoln Ltd
All rights reserved

Text and illustrations edited by Charlotte Trümpler
Layout by Karsten Moll

First published in the United States of America in 2005 by
Getty Publications
1200 Getty Center Drive, Suite 500
Los Angeles, California 90049-1682
www.getty.edu

Christopher Hudson, *Publisher*
Mark Greenberg, *Editor in Chief*

Library of Congress Control Number: 2004116643

ISBN 0-89236-817-9
ISBN 978-0-89236-817-4

Printed and bound in China by
Kwong Fat Offset Printing Co. Ltd

FOREWORD AND ACKNOWLEDGMENTS

It is perhaps no accident that the world's first exhibition of aerial photographs of archaeological sites is taking place at the Ruhrlandmuseum, Essen, for it was a former director of the museum, Walter Sölter, whose highly informative book on the subject, *Das römische Germanien aus der Luft*, played such an important role in awakening and furthering interest in the use of aerial photography in archaeology in Germany when it appeared in 1981. But it was the photographs of Georg Gerster – one of the world's finest and best-known aerial photographers – that proved decisive. My very first encounter with his breathtakingly beautiful images afforded a new insight into antiquity. In keeping with his motto that 'distance creates an overview of the subject, and an overview creates a greater understanding', archaeological sites that are generally in a ruinous state suddenly acquire an unsuspected coherency and a unified sense of structure. Thanks to his bird's-eye view, we can obtain a new and comprehensive insight into ancient cultures, including their whole way of life and architectural traditions. In short, his photographs are not just fascinating because of their artistic quality and technical perfection, they are also an invaluable source of scientific information, as many of them were taken in countries that can now be flown over only with difficulty, if at all, countries such as Iraq, Iran, Syria, Israel and Palestine. Some, moreover, show buildings that are now lost for ever or that no longer exist in the form in which they appear here as a result either of natural change or human agency.

This book bears witness to the magnificent achievements of a single artist and scientist, a man who in forty years as a photographer has flown over more than one hundred countries in every part of the world, tirelessly assembling an unrivalled collection of aerial photographs of archaeological sites in fifty-one different countries in Africa, North and South America, Asia, Australia and Europe. At the same time, this book offers a unique overview of the architectural masterpieces of bygone cultures that have been created by humankind in the course of thousands of years. The reader is thus able to compare and contrast the different sites, seeing the differences and similarities between them and gaining an astonishing understanding.

Our collaboration was harmonious, constructive and fascinating, easily surviving its single turbulent phase when we had to make a choice from thousands of aerial photographs, each more precious than the last in terms of its beauty and scientific value. If Georg Gerster's heart bled at the loss of his favourite images, so my own archaeologist's heart grieved at the loss of so many important archaeological sites.

We have to thank Georg Gerster's unbridled curiosity and uncontrollable desire for travel for the fact that we can enjoy the exceptional variety and formal range of these ancient sites in so many different parts of the world on the sofa in our own living rooms or on a leisurely stroll through the museum. For him, 'there are still, thank God, white areas on the map', places that wait to be photographed with the same perfection, the same draughtsman's rigour and matchless use of light as all the places he has already visited.

We should like to take this opportunity to thank the following sponsors, without whose generous support and trust this unique overview and insight into ancient cultures would have been much the poorer: the Alfred and Cläre Pott Foundation, Hochtief, National-Bank,

Sparkasse Essen and the Society of Friends and Supporters of the Essen Archaeological Collection.

 We are grateful to the following institutions and private lenders for their willingness to make exhibits available and for supporting the exhibition and catalogue in other ways:

Carlos Aldunate, Chile
Ashmolean Museum, Allen Air Archive, Oxford
Bavarian War Archives, Munich
Justus Cobet, Department of History, University of Duisburg-Essen
Department of Antiquities, Amman
English Heritage, Swindon
Institute of Archaeology, O.G.S. Crawford Archive, Oxford
Carolina Jiminez C., Chile
Antje Krug, Archives of the German Archaeological Institute, Berlin
Museum of Ethnology, Munich
Patrick Nagy, Cantonal Archaeology, Zurich
Lévon Nordiguian, Université Saint-Joseph, Beirut
Barbara Patzek, Department of History, University of Duisburg-Essen
Royal Jordanian Airforce, Amman
Rolf Stucky, Department of Archaeology, University of Basel

Charlotte Trümpler
Ruhrlandmuseum, Essen

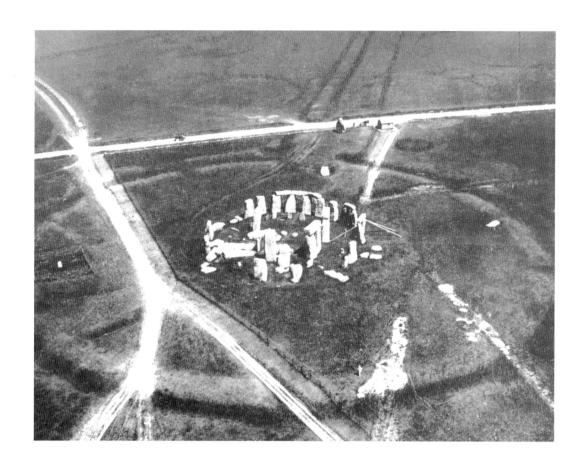

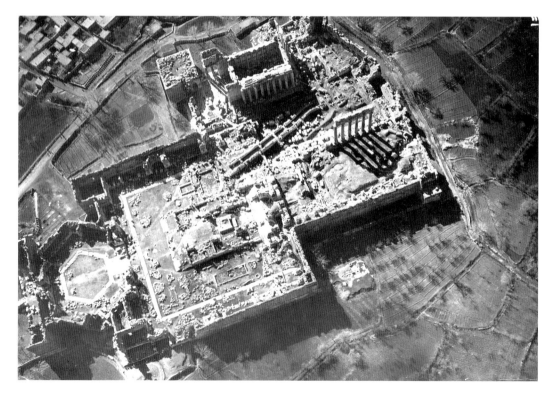

Illus. 1 | **The prehistoric ruins at Stonehenge**, England, 1906. Photo: Lieutenant P. H. Sharpe

Illus. 2 | **The ruins at Baalbek**, Lebanon, 1917/18. Photo: German Airforce Squadron 304

AERIAL PHOTOGRAPHY
IN ARCHAEOLOGY
AND ITS PIONEERS

CHARLOTTE TRÜMPLER

Submerged in water, destroyed by war, turned to lime, lost in the sand, built over by houses – what would be left of archaeological sites if images had not immortalized their beauty for at least a moment?

Photographing ancient monuments can look back on more than one hundred and fifty years of history. Photography developed around the middle of the nineteenth century and continues to play an important role in archaeology. Initially the available technology meant that photographs could be taken only from the ground, but gradually methods were developed that allowed them to be taken from the air, as well as under water and deep inside the earth. Even today aerial photography continues to enjoy a special significance in archaeology: seen from the air, details come together to form a unified whole, fragments acquire a pattern and the abstract becomes concrete. The desire on the part of archaeologists to see ancient monuments from the air is all the more justified, therefore, in that it is often difficult to see any overall design in archaeological sites, many of which survive in only a ruinous state. Moreover, only images taken from above give an overview of the site as a whole and show how it is part of its natural environment. They show the landscape, the geographical context and the area covered by a settlement, together with its natural resources and the factors that lend it protection. Occasionally an aerial view also allows us to discover previously unknown monuments that are invisible from the ground. In short, archaeology is more

dependent than other sciences on its ability to examine its objects from a distance, so that it is not surprising that aerial research and documentation have had such an important impact.

As far as we know, the first photographs relating to aerial archaeology were taken in 1906 when Lieutenant P. H. Sharpe photographed the prehistoric ruins at Stonehenge (Illus. 1). Although the photographs were taken more or less by accident during an exercise flight in a war balloon, they were so impressive in terms of their quality that they were published in the journal *Archaeologia* in 1907.[1] Whether this really was the first aerial photograph of an archaeological monument seems doubtful, in fact, given the large number of unpublished and uncatalogued early aerial photographs that are known to have been taken from balloons, kites and Zeppelins. After all, nearly fifty years had passed between the very first aerial photograph and Sharpe's archaeological pictures: as early as December 1858 the famous Paris portrait photographer Gaspard Félix Tournachon – more familiar by the name of Nadar – had taken the world's first aerial photograph of the Val de Bièvre near Paris. Unfortunately the photograph, which was taken from a balloon, was of such poor quality that it could not be reproduced.[2] The first genuinely beautiful and sharply focused aerial photograph to be published was taken at a height of 400 metres above Boston on 13 October 1860.[3]

It is almost impossible for today's readers to imagine the sort of difficulties with which the pioneers of early aerial photography had to contend. Not only were the climatic conditions a problem (navigation was hampered, not least, by fluctuating aerial conditions), so too was the equipment needed for a balloon flight. The large, heavy cameras were unwieldy, and their negatives consisted of glass plates which, following their exposure, had to be developed within twenty minutes as they were still coated in collodium and silver nitrate. As a result, the balloon had to have its own darkroom and all the necessary materials that would allow the photographer to develop his pictures during the flight. Not until the physicist Richard Leach Maddox invented lightweight gelatine negative plates in 1871 was it possible to replace the earlier system, which was as expensive as it was complicated. The principal advance here consisted in the fact that the plates required a much shorter exposure time and did not have to be coated with emulsion in the balloon but could be processed after the flight.

Subsequent developments were to render superfluous the air-borne photographer. By 1869 the American scientist John A. Scott had patented a system under the name 'Ophthalmos' whereby a camera was sent up in an unmanned balloon attached to the end of a rope. Its lens would open automatically at a particular moment.[4] Scott's successful experiments persuaded the French photographer Arthur Batut to use a kite as a camera stand. He decided to build his own kite, as a dirigible balloon was beyond his means. His book *La photographie aérienne par cerf-volant*, published in Paris in 1890, includes detailed instructions on how to build both the kite and the camera and describes the importance that kite

photography could have for research into a country, including its archaeology and agriculture. Kites were first used in archaeology in the Sudan, where Sir Henry Wellcome deployed several of them in 1913 in order to document his excavations in the country. All the kites had a delayed-action shutter release. Unfortunately the outbreak of the First World War put an end to his promising experiments.

Since then, kites and balloons have largely been replaced by aeroplanes as camera supports, yet they still retain their importance in archaeological field research. Many excavations are photographed from unmanned balloons or kites as photographs from aircraft are often too expensive to produce or are simply not allowed. These photographs are priceless documents, with both overviews and individual details providing insights that are often not apparent on the ground.

In around 1903 Julius Neubronner devised a further system for taking aerial photographs: the carrier pigeon. A lightweight miniature camera was attached to the bird, with the shutter timed to fire once every sixty seconds. It was Neubronner's father who gave him the idea of using pigeons in this way as he himself already employed them to transport medicines from his apothecary in Kronberg in the Taunus Mountains to a hospital some distance away. The disadvantage of this system is that pigeons can only fly back to their starting point, not the other way round. In spite of this, photographs taken by carrier pigeons acquired considerable importance, especially in the army. As far as I am aware, they were not used to photograph archaeological sites, but it may be interesting to search through photographs taken by carrier pigeons for military purposes to see whether in the course of time archaeological objects also happen to have been photographed in this way.[5]

All the foregoing techniques, however, are no more than precursors of a proper, comprehensive documentation using aerial photography. Only with the invention of the aeroplane were the conditions established for a systematic investigation of archaeological sites from the air, for only now did precision navigation make it possible to aim the camera directly at the object. These new possibilities were immediately exploited, with the earliest sets of aerial photographs of archaeological sites dating from the time of the First World War. It is the German archaeologist Theodor Wiegand (1864–1936) whom we must thank for realizing how important aerial photographs could be for archaeology as a science. It was his idea to ask pilots to photograph archaeological sites during reconnaissance flights. Best known for his excavations at Miletus, Wiegand became general inspector of monuments in Syria and Palestine under the supreme command of the commander of the Turkish Army, Ahmed Djemal Pasha. In this capacity Wiegand photographed the principal Turkish and older Islamic buildings.[6] His letter of 10 September 1917 to the Army Division of the Prussian Ministry of War is worth quoting at length:

The archaeological photographs that I was allowed to take in the Sinai Desert with the permission of the Ministry of War have revealed the exceptional value of

aircraft photography for archaeology and historical geography. [...] These interesting findings persuade me to ask the Ministry of War to draw the attention of all the airforce squadrons active in the Orient to the scientific value of such photographs and to express the idea that such photographs should be taken wherever the war situation allows it – and not only where there are substantial ruins but also in the case of larger modern towns with a historical past.

Wiegand's far-sighted and systematic approach is clear from the paragraph that followed: 'All the photographs must be provided with precise details about the place, date and the direction in which the aircraft was flying, including details concerning the altitude from which the photograph was taken, the name of the

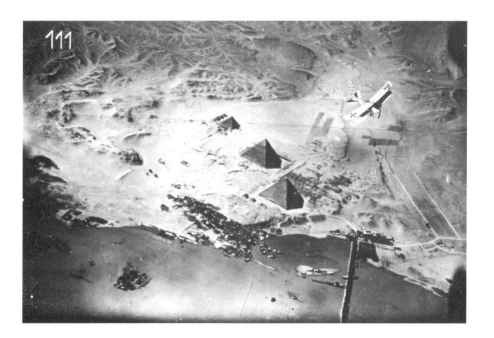

Illus. 3 | **The pyramids at Giza**, Egypt, 1916/17. Photo: German Airforce Squadron 304

observer and his squadron. The Department of Antiquities at the Royal Museums in Berlin might be considered a suitable place to house the complete collection of photographs.'[7]

The aerial photographs taken on Wiegand's initiative constitute a priceless source of information for archaeologists in general. Most are of an extraordinarily high quality and precision and are irreplaceable as documentary records. In addition to the published photographs of the Sinai and Palestine, the German Archaeological Institute in Berlin also houses aerial photographs of the Dardanelles, Russia, Romania, the Caucasus, Syria, Jordan, the Lebanon, Iraq, Turkey, Macedonia, Greece and Egypt (Illus. 3). All of them date from between 1916 and 1918, and all of them show these ruins in a state in which they no longer exist. Environmental destruction, later excavations, the removal of material for other purposes and reconstruction work have all had a profound impact on these sites. Take the example of the theatre at Bosra, which was photographed at nine o'clock in the morning on 21 March 1918 from a height of 2000 metres by Airforce

Squadron 305 (Illus. 4). This is no longer a citadel, the original buildings having been removed from within the site, thereby revealing the old theatre that can be seen in Georg Gerster's 1996 photograph of the same site (no. 72). Illus. 5 dates from 1918 and shows an interesting view of the Abu Dulaf Mosque at Samarra that includes houses from the ninth century AD. Here the mosque can be seen in its original state. Since this picture was taken, the mosque has been restored and the wall completed.

Although Wiegand's exemplary work in the field of aerial photographic archaeology initially found no imitators in Germany, it none the less made a decisive contribution to the subject. Until Wiegand's day aerial photographs had played no part in research into archaeological monuments. Individual aerial photographs of

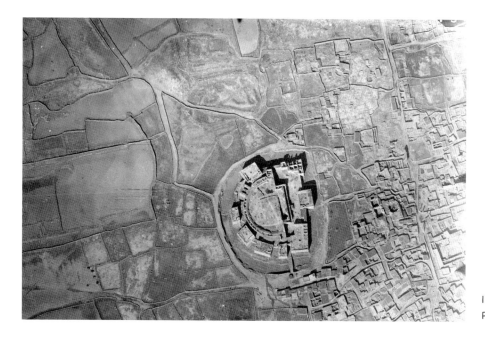

Illus. 4 | **The theatre at Bosra**, Syria, 1918.
Photo: German Airforce Squadron 305

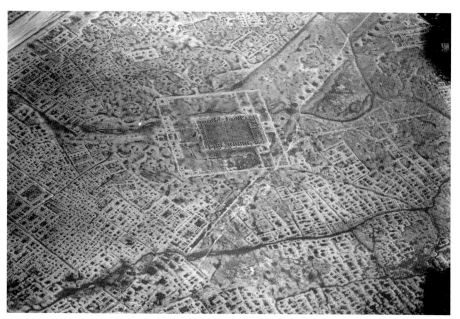

Illus. 5 | **The town and mosque at Samarra**, Iraq, 1918. Photo: German Airforce Squadron 2

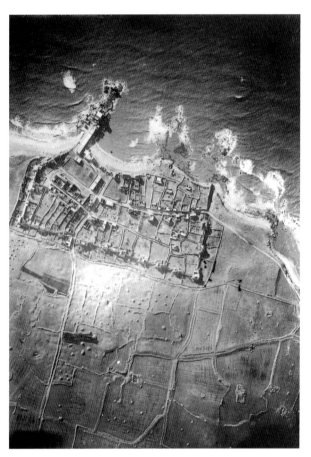

ancient monuments had been taken more or less at random and had no influence on archaeology as a science. It was left to Wiegand to realize that aerial photography could be important for investigating and understanding ancient sites. His main concern was to document archaeological monuments as comprehensively as possible, not least in order to be able to plan his future activities more efficiently. His goal was not the aerial prospecting pioneered by the English but aerial photography as a form of documentation.

Some of the photographs commissioned by Wiegand have already been published. He himself included the photographs of Sinai in a volume published in 1920 by the Turko-German Command for the Protection of Ancient Monuments,[8] while the ones of Palestine appeared in 1925 in Gustaf Dalman's *Hundert deutsche Fliegerbilder aus Palästina*.[9] All of these photographs were taken by Airforce Squadron 304. The negative glass plates are now in the Bavarian War Archives in Munich (Illus. 6). Ahmed Djemal Pasha used both ground photographs and aerial photographs in his 1918 monograph on ancient monuments in Syria, Palestine and Western Arabia, and Carl Schumacher likewise availed himself of aerial photographs taken by the German airforce in his 1918 study of his excavations at the Roman *limes* – the frontier zone of the Roman Empire – at Dobrudja in Romania, although these photographs had to wait until 1954 to be published in England by O. G. S. Crawford.

It is no accident that the first serial photographs to be taken from the air date from wartime, with the armed forces playing a decisive role during the First World War, much as they had done in the case of earlier photographs of archaeological sites. Without the vast sums of money expended on advances in aircraft design, on techniques of air reconnaissance and on photographic equipment in general, the use of aerial photography in archaeology would have taken far longer to develop. Numerous archaeologists and other individuals who later specialized in aerial photography were active in airforce squadrons during the war and in that way learnt the importance of aerial photographs. One such pioneer was G. A. Beazeley, a lieutenant-colonel in the Royal Air Force, who photographed the ninth-century city of Samarra and its ancient irrigation systems that could be identified only from the air. So detailed were his photographs that he was later able to establish the size of the city and the location of the houses. These important findings were made public in two lectures that he published with illustrations in the *Geographical Journal* in 1919 and 1920 and in which he stressed the importance of aerial photography in archaeology.[10]

For the armed forces, aerial photographs were chiefly important in producing maps, with the result that they supported the efforts of archaeologists in documenting sites. In 1938, the English archaeologist Osbert Guy Crawford (1886 –1957) described aerial photographs as 'a unique combination of a cartographical photograph of the object in question and its actual appearance in every detail, such as the surveyor's plan on its own is incapable of providing. Vertical photographs are the best, because they offer us a plan that is true to

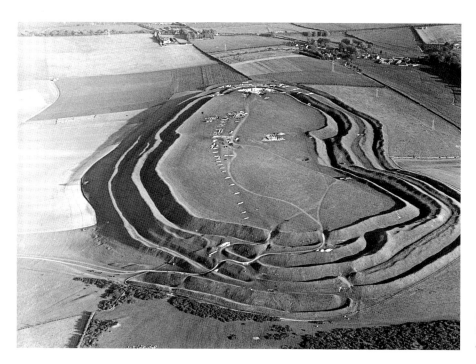

Illus. 7 | **Maiden Castle**, Dorset, England, 1937. Photo: Major George W. G. Allen

scale.' Crawford is generally described as the inventor of aerial photography in archaeology, even though the above-mentioned individuals had successfully pioneered the subject before him. But Crawford's great merit was to develop systematic methods of producing and analysing aerial photographs of archaeological sites and successfully to apply his findings in England above all.

Crawford was born in 1886 and studied philology and, later, geography in Oxford, a subject that was to be of use in his subsequent activities. Fired by his interest in archaeology, he took part in Sir Henry Wellcome's excavations in the Sudan in 1913. Wellcome's attempts to produce aerial photographs using kites had a profound influence on Crawford, who served in the infantry during the First World War and was initially engaged in producing maps. He later became an observer with the Royal Flying Corps on the western front. It was here that he realized the incalculable potential of aerial photography in archaeological research, but it was only later, when he became Archaeological Officer of the Ordnance Survey (a post created specially for him), that he was able to see the numerous photographs taken during the war, as they were regarded as military documents and kept firmly under lock and key.

In 1922 Air Commodore (later Air Vice-Marshal) Sir Robert Hamilton Clark-Hall showed Crawford some aerial photographs of Wiltshire on which Crawford was able to identify the patterns created by the darker and lighter growths of corn. He immediately saw that these were caused by lynchets – Celtic fields – that had left traces in the landscape and that he had been trying for some time to investigate. These prehistoric fields and strips of land remained untouched in the soil and were so clearly visible in the aerial photographs that the Royal Air Force had happened to take during the war that not only was it possible to reconstruct the agricultural and farming systems, Crawford was also able to establish the relation-

ship between the various prehistoric sites. It was then that he realized the tremendous importance that aerial photographs had in investigating ancient monuments that are invisible from the ground. In a lecture that he gave in Berlin in 1938, Crawford explained that 'since 1922, when, if I may say so, I invented it, aerial photography has provided archaeology with a research tool that is as valuable to it as the telescope was for astrology'.[11]

After examining the army's comprehensive collection of photographs, Crawford realized that archaeologists would have to undertake organized photographic campaigns aimed solely at documenting archaeological sites. Together with the airforce veteran Alexander Keiller and the pilot Captain Caskell he began in May 1924 to photograph Wessex, an area of southern England particularly rich in prehistoric sites.

By chance, the log of these first three flights has survived in a 'cavalry mapping board' now in the Ashmolean Museum in Oxford. The log begins on 28 May 1924 and reports that the first flight began at 4.19 and lasted twenty minutes. Four photographs were taken from a height of between 350 and 700 metres.[12] In the course of the total operation, three hundred photographs were produced. Excavations and soundings were then undertaken in order to verify these findings, and the results were published in 1928 in *Wessex from the Air*, in which Crawford laid the foundations for a new method of producing aerial photographs of archaeological sites. This was the first time that the texture and nature of the ground had been analysed in order to provide information about archaeological monuments. At the same time, methods were developed that allowed these monuments to be more clearly identified from aerial photographs. Observations had revealed the existence of shadow sites, earth monuments that emerge far enough from the ground to cast shadows when lit by the oblique rays of the sun. One such example is Maiden Castle in Dorset (Illus. 7). Such sites are most clearly identifiable when photographed from the air in the right light and at the right time of the year. Other sites are known as crop sites on account of differences in their vegetation type. Examples include the ring ditches and burial mounds at Eynsham (Illus. 8). These monuments can no longer be seen from the ground but are identifiable by the cereal crops that grow over them to various heights and in various colours. With aerial photographs the corn appears darker over ditches as the soil is deeper and more fertile than over walls. As a result, the crops grow taller and acquire a more intense colour as they do not dry out as quickly. In this way it is possible to posit the existence of structures beneath the ground that can then be investigated by means of specific excavations. In order to be able to provide a proper assessment of the different types of plant growth, it is often necessary to take a series of aerial photographs at different times of the year, sometimes over a period of several years.

Crawford's method would not have been so successful if he had not received help from Major George W. G. Allen (1891–1940). Allen was an engineer and the director of a family business in Oxford. In 1930 he came across one of Crawford's articles and was fired with enthusiasm for his new ideas. As an engineer he

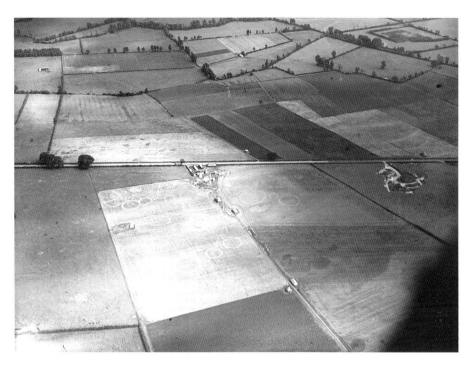

Illus. 8 | **Unexcavated graves at Eynsham**, Oxfordshire, England, 1933. Photo: Major George W. G. Allen

recognized the potential of aerial photography for archaeology, and a fortunate combination of circumstances – independent means, sufficient free time and a private aeroplane – enabled him to throw himself uninhibitedly into his new interest. Not only did he produce a large number of outstanding and, in some cases, uniquely beautiful aerial photographs, he also developed cameras that seemed to him ideally suited to their purpose. The two thousand or so aerial photographs that are now housed in the Ashmolean Museum in Oxford were all taken over a ten-year period within a radius of 40 kilometres of Oxford. In this way Allen put Crawford's theories into practice, repeatedly photographing archaeologi-cally relevant sites at different times of the year. By a terrible irony, Allen died in 1940 in a motorcycle accident. He was only forty-nine. Following his sudden death, his fantastic photographs and drawings remained unpublished, plans to issue them being additionally frustrated by the deaths of their two editors, Crawford himself and John Bradford. Not until 1984 did they appear under the title *Discovery from the Air*.[13]

Meanwhile – and independently of developments in England – advances were being made in aerial archaeology in the Middle East, advances associated above all with the French Jesuit missionary Antoine Poidebard (1878–1955). Poidebard was almost exactly the same age as Crawford and, like his English contemporary, was not an archaeologist by training but had spent a number of years working as a missionary in Armenia, where he learnt to speak not only Armenian but also Turkish and Tartar. During the First World War he flew over Persia and in that way discovered the potential of aerial photography for archaeology. Between 1924 and his death in 1955 he lived in Beirut, caring for Armenian refugees on behalf of the

Armenian Mission. But at the same time he was commissioned by the French Geographical Society in the Upper Jezira to produce maps of ancient roads and thoroughfares and also to discover sources of water. Poidebard began his researches in 1925 by using an aircraft to investigate the Roman *limes* on the Turkish border. France had mandatory power over Syria at this period and was therefore the only country with the right to fly over Syria. The French wanted information on the Romans' road network and defence system as they hoped it would be useful in organizing and administering Syria. Poidebard was able to discover a vast defence system that was based on fortifications and that revealed how the Romans defended themselves against the powerful Persian army and Bedouin tribesmen. He also reconstructed an extensive and complex Roman irrigation system. As an officer, Poidebard had the great advantage of being able to use all the resources of the armed forces: an aircraft and photographers were always available for aerial documentation (Illus. 9); there was an army to protect him and soldiers to help with excavations that in turn enabled him to verify his findings on the ground. 'In the case of our investigations on the ground,' he wrote to the English archaeologist Aurel Stein in 1937, 'we had a car and an escort of dromedary riders at our disposal. The dromedary riders advanced their encampment by around fifty kilometres a day. With the car we were able to visit ruins in the vicinity. Water and petrol were obtained for us by the dromedary riders, and up to two camels carried our provisions.'[14]

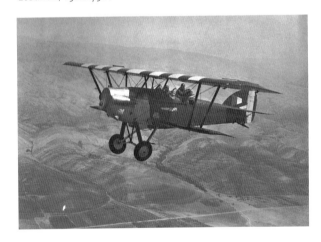

Illus. 9 | **Antoine Poidebard in a Potez 25 TOE**, Lebanon, 1920s/30s

Above all, however, it was the photographers of the Thirty-Ninth Regiment of the German Airforce whose work has proved the most invaluable for later generations. Together with Poidebard, they developed methods particularly well suited to the aerial documentation of sites in these tropical and subtropical zones, which entailed completely different problems from those that obtained in a country as wet and fertile as England. They built their own cameras and lenses with the right sort of filters for aerial photography in this region, even using infrared filters in some cases. Poidebard did not initially take his own photographs, a decision he justified as follows: 'On my first flights I simply acted as an observer. My pilot then took off again with just the photographer, and together they formed a team. They flew to places over which I would like to have had objective control through the photographic apparatus. Only when the method was well established and people could no longer say that I had added the colours I wanted to my negatives did I take my own photographs.'[15]

Poidebard published his findings in two books, *La trace de Rome dans le désert de Syrie* (1932) and *Le limes de Chalkis* (1945). The photographs they contain have never been equalled and were taken, almost without exception, by the Thirty-Ninth Regiment. Even today, they remain an invaluable record of these sites. This regiment seems to have specialized in taking vertical photographs from a low angle, rather than at an oblique angle, which is generally still the case today. Although very difficult to take, vertical photographs can be viewed like plans and as a result serve as correctives for sketches and drawings produced on the ground. Yet although he developed this method, Poidebard evidently did not always make

use of the information contained in the aerial photographs. In the case of a photograph of Khan i-Hallabat in Syria, for example (Illus. 10), one of the towers is larger than the others, but Poidebard ignored this and drew four towers of equal size. It is this, more than anything else, that shows most clearly that although he may have been a pioneer of aerial photography in archaeology, he was not an archaeologist. His archaeological activities were only one part of his life, which also included religious, humanitarian and military pursuits.

For all that they may have been better equipped and able to conduct their investigations on the basis of maps, many later scholars have none the less been able to pursue their research thanks to Poidebard's findings in North Africa and the Middle East. One such scholar was Colonel Jean Baradez, who excavated the Roman *limes* in Morocco and Tunis after the Second World War. Here he succeeded in uncovering vast irrigation systems that the Romans had used to reclaim the desert. Another was Erich Friedrich Schmidt, who led a research team to Iran between 1935 and 1937, undertaking numerous flights and taking many aerial photographs. Schmidt was able to trace Alexander's Wall over several kilometres and to discover many cities, including the Sassanian city of Gur (no. 13). His impressive photographs were published in 1940 in *Flights over Ancient Cities of Iran*.

At more or less the same time that Poidebard and Crawford were taking aerial photographs of the Middle East and Wessex, the world-famous American aviator Charles Lindbergh, who shortly before had made the first non-stop solo transatlantic flight from New York to Paris, began to examine ruined pueblos and Maya sites in Central America. The problem here was that the sites of Maya culture lay in dark and humid rainforests and could be reached by foot only with difficulty. As a result, aircraft offered enormous help, even if the ruins were often difficult to identify from the air. Lindbergh first began to document pueblo settlements in 1929 with Alfred Kidder (1885–1963), the head of the Division of Historical Research at the Carnegie Institution at Washington. He went on to fly over the area once inhabited by the Maya, flying the aircraft himself and keeping an eye on the maps, while his wife Anne took the photographs. Although they were able to discover and document a number of hidden sites, their research differed from that of their European colleagues in being unsystematic and lacking in any true understanding of the local geography. They were convinced that by flying as low as possible they would see more of the sites, but this was in fact rarely the case. Nor did they take any account of the incidence of the light, the time of day, the altitude of the aircraft or the particular type of filter or lens. In spite of all this, their photographs are an important source for archaeologists as they are among the earliest aerial photographs of this region.[16]

Probably the largest collection of aerial photographs at this time was taken in Peru between 1928 and 1930. Most were taken by a gifted young officer, George R. Johnson, in the airborne division of the Peruvian navy – once again it was the armed forces that showed the way. Among the sites that Johnson discovered was not only that of Chan Chan, the pre-Columbian capital of the Chimú in the Moche

Illus. 10 | **The Roman fort at Khan i-Hallabat**, Syria, 1930. Photo: Sergeant Savidan

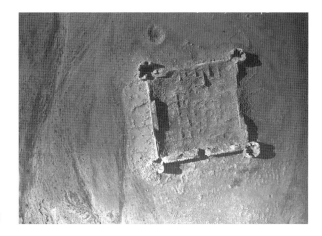

Valley on the north coast of Peru, but also the Great Wall of Peru. The Servicio Aerofotografico in Lima continued Johnson's work in various parts of Peru both during the Second World War and afterwards. These photographs served as a source of information for Paul Kosok of the University of Long Island. Kosok, who was interested in cultural geography in general and in irrigation systems in particular, flew over the area in 1940 and 1941 and took around twenty thousand photographs of his own, all of which were of considerable use to him in his research. In his 1965 book *Life, Land and Water* he adopts the best scientific manner in describing how he and a colleague worked for seven days a week over a three-month period, generally until ten in the evening, evaluating these photographs in Lima: 'There was always tremendous satisfaction in discovering new pyramids, settlements, fortifications, walls, roads and canals on a photograph. Indeed, it was even exciting to find such ruins on photographs after we had not seen them in the field. For here they looked quite different! We would often exclaim: Why didn't we see that there was another ruin right nearby when we were in the field? Why didn't we see that this wall extended all the way up the hill?'[17]

Kosok's greatest contribution to archaeology lay in his interest in the monumental images on the desert plain in the Nasca region of southern Peru. Together with the German archaeologist Maria Reiche, who continued his research after his death in 1959, he studied the large number of mysterious lines that are often more than 140 metres in length (nos. 212 and 215). These shapes were very much predestined to be examined from the air as they emerge as 'total artworks' only from a certain height. In order to be able to obtain better photographs of the figures, Maria Reiche even strapped herself to the outside of a helicopter, an unusual method that set her apart from her male colleagues, whose photographs were always taken from inside aircraft. The meaning of these monumental geoglyphs, which consist of geometric designs and representational figures such as animals, gods and demons, remains contested. Their size has inspired the most fantastical suggestions, although they are undoubtedly associated with the religious and daily rituals of the Nasca cultures between 200 BC and AD 600. Thanks to her intense commitment and her attempts to make these geoglyphs better known, Maria Reiche succeeded in saving many of them.

It is thanks to the initiative of Count Wulf Diether zu Castell (1905–80) that we possess a veritable treasury of early aerial photographs of another country: China. These photographs are wonderful because they are not only unique records of this period but also because for a long time they were the only aerial photographs of China in existence. The director of the Munich Airport, Count Wulf Diether zu Castell flew as a pilot for Eurasia between 1933 and 1936. This company was set up by the Chinese national government and Lufthansa to open up air routes between cities and regions in China that had previously had no permanent connections. Castell was fascinated by the country: 'Even after my first flights I was so overwhelmed by the uniqueness of the Chinese landscape that I decided to capture its particular structure in the form of photographs. At the same time I was concerned not just to produce beautiful pictures but to choose examples of

documentary value, examples that really show the characteristic aspects of the landscape, its geology, its ground monuments, the way in which it has been settled, and its historical monuments.' Castell was being unduly modest when he spoke of his intention of producing not just beautiful images, for he succeeded in fact in combining the two: his black-and-white photographs are all unbelievably beautiful as well as being of considerable documentary value. Although his photographs were not taken out of any archaeological interest, they include images of ancient monuments, some of which no longer exist in that particular form. Among such monuments are the pagodas and temple ruins at Qingtongxia (Illus. 11). Even at that date the ruins of the predecessor to the present temple could be detected only beneath the surface, whereas they have now disappeared completely as the result of flooding. No less fascinating is the photograph of a prehistoric hillfort whose exact whereabouts are unknown but which was evidently still being

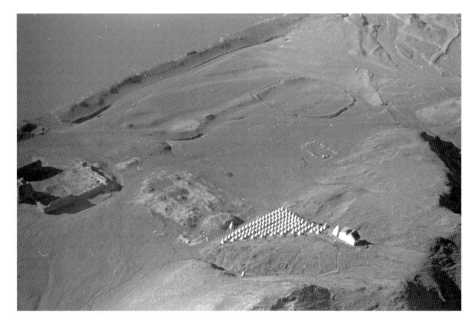

Illus. 11 | **Pagodas and temple ruins near Qingtongxia**, China, 1933–6. Photo: Count Wulf Diether zu Castell

used as a settlement, with solid walls built round it to keep out bandits (Illus. 12). That Castell's work in the field was both demanding and exhausting is clear from his book *Chinaflug*, which reveals a genuine sense of humour.[18] He also deserves our respect not least for the fact that he took these beautiful photographs while flying himself. In this he differed from other pioneers of his period. Some of his photographs were reproduced in his book and are of outstanding quality. All are now in the Museum of Ethnology in Munich and are currently being analysed as part of a research project into the use of aerial photography in Chinese archaeology that is being undertaken at the Institute of Prehistory and Early History at the University of Bochum.

It is thanks to Castell and the other pioneers of documentary aerial photography that new generations of scholars and photographers, inspired by these early

images, can pursue their own research on the basis of their predecessors' experiences. Developments are advancing rapidly as technology becomes more sophisticated and methods more complex – but the foundations that were laid by these pioneers remain the same. Today's photographers have to confront problems that are no longer the ones faced by their predecessors. Demands increase, as do expectations, and difficulties arise, especially when the field of activity expands to embrace the whole globe. Georg Gerster has succeeded in achieving the almost impossible feat of taking aerial photographs of archaeological sites in fifty countries across five continents. The difficulties that he had to face – and not just from the weather – are impressively clear from his own account of the background to his photographs.

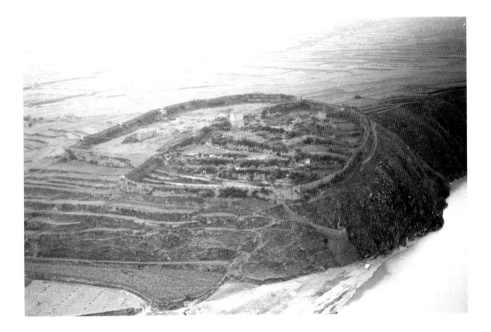

Illus. 12 | **Prehistoric hillfort with later settlement**, China, 1933–6. Photo: Count Wulf Diether zu Castell

1 Leo Deuel, *Flights into Yesterday: The Story of Aerial Archaeology* (Harmondsworth 1973), 32.
2 Beaumont Newhall, *Airborne Camera: The World from the Air and Outer Space* (London and New York 1969), 21–2.
3 Newhall, *Airborne Camera* (note 2), 23–4.
4 Daniel Gethmann, 'Unbemannte Kamera: Zur Geschichte der automatischen Fotografie aus der Luft', *Fotogeschichte: Beiträge zur Geschichte und Ästhetik der Fotografie*, 73 (1999), 17–27.
5 Gethmann, 'Unbemannte Kamera' (note 4), 20–22.
6 Gerhard Wiegand (ed.), *Theodor Wiegand: Halbmond im letzten Viertel* (Munich 1970), 198.
7 From the correspondence in Wiegand's papers, now in the Archives of the German Archaeological Institute in Berlin.
8 Theodor Wiegand, *Sinai* (Berlin 1920) (Veröffentlichungen des Deutsch-Türkischen Denkmalschutzkommandos 1).
9 Gustaf Dalman, *Hundert deutsche Fliegerbilder aus Palästina* (Gütersloh 1925) (Schriften des Deutschen Palästina-Instituts 2).
10 G. A. Beazeley, 'Air Photography in Archaeology', *The Geographical Journal* (May 1919), 331–5; and 'Surveys in Mesopotamia during the War', *The Geographical Journal* (Feb. 1920), 109–27.
11 Osbert G. S. Crawford, 'Luftbildaufnahmen von archäologischen Bodendenkmälern in England', *Luftbild und Vorgeschichte* (Berlin 1938), 20.
12 Arthur MacGregor, 'An Aerial Relic of O. G. S. Crawford', *Antiquity*, 74 (2000), 87–100.
13 George W. G. Allen, *Discovery from the Air* (East Dereham 1984) (Aerial Archaeology 10).
14 Lévon Nordiguian and Jean-François Salles, *Aux origines de l'archéologie aérienne: Antoine Poidebard (1878–1955)* (Beirut 2000), 44.
15 Nordiguian and Salles, *Aux origines de l'archéologie aérienne* (note 14), 42.
16 Deuel, *Flights into Yesterday* (note 1), 207–9.
17 Paul Kosok, *Life, Land and Water in Ancient Peru* (New York 1965), 40–42.
18 Wulf Diether Graf zu Castell, *Chinaflug* (Berlin 1938).

Photo acknowledgements:
Ashmolean Museum, Allen Air Archive, Oxford: Illus. 7, 8
Bayerisches Hauptstaatsarchiv, Munich: Illus. 6
Bibliothèque Orientale, Université Saint-Joseph, Beirut: Illus. 9, 10
Deutsches Archäologisches Institut, Berlin, Archiv. Nachlaß Theodor Wiegand: Illus. 2, 3, 4, 5
English Heritage, Swindon: Illus. 1
Museum für Völkerkunde, Munich: Illus. 11, 12

FROM THE PRIVATE LOG OF
AN AERIAL PHOTOGRAPHER

GEORG GERSTER

Archaeological sites located beneath the ground are revealed by vegetation and contrasting tonal patterns caused, for example, by different degrees of moisture: this has been part of the catechism of every aerial archaeologist since O. G. S. Crawford first adopted a systematic approach to the subject in the 1920s. These tell-tale signs are either there or they are not, which means that the aerial photographer must rely on serendipity – the happy art of finding things for which one is not in fact looking. There is no point in trying to force the issue or manipulate events. This is not the case with remains above the ground, which are revealed by the play of light. William M. Sumner, who excavated the Elamite capital at Anshan (Tal-i Malyan) in south-western Iran, wrote to tell me that when he saw an aerial photograph of the site that I had taken when the sun was low in the sky, he saw and understood more in ten minutes than he had done in ten years of regular work on the ground. The ideal incidence of light works wonders, and it is no accident that a belief in the sun's power to shape objects is part of the basic creed of all aerial photographers. But it always requires an effort to live one's life according to this creed, and sometimes it is simply impossible.

I remember ...
A series of flights over Syria is planned for May 1997. The first of them is scheduled to set out from Palmyra, and we are hoping to take off with the first rays of

the sun in an Mi-8, a helicopter with a five-blade main rotor. The machine is duly given the all-clear shortly before sunrise, but some of the team accompanying us are late, and so, to the dismay of all concerned, I call off the flight: I refuse to accept a delay of even a few minutes. I imagine that the abandonment of the flight rankles with me more than it does with my companions. For who knows what tomorrow may bring? But disciplining them produces results, and for none of the following flights do the crew or hangers-on – minders, translators and archaeologists – keep me waiting. A flight to the theatre at Bosra in Hauran in the south of the country is intended to bring our Syrian project to an end. I set the start for 10.30. The crew is shocked. Their spokesman asks me, reproachfully: 'And the light, Monsieur?' A dozen flights have sufficed for the crew to live with the light as I do. But the reason for the indecorously late hour finally dawns on them: if the sun's rays strike the site at too low an angle, the auditorium will be in darkness. (As it turned out, we still reached Bosra too soon.)

A low angle of light when the sun is low in the sky – although this basic prescription promises success, it can easily develop into an obsession. It is this that drives on the aerial photographer of archaeological sites, occasionally testing his patience to its limits. And this does not even begin to take account of climatic injustices and unfavourable weather conditions. But in other ways too, compromise means stumbling blocks and potholes on the path of photographic virtue, paved, though it may be, with good intentions. Many small airfields do not man their control towers until the sun is already high in the sky, or else they go home just as the evening sun is starting to gild the countryside. Or the crew that you are using simply cannot wait for their supper – especially if a banquet is planned.

I remember ...
Xinjiang, China, 4 and 5 September 1987. I have been waiting for several days for a spare part to reach me in Ürümqi, the capital of the Autonomous Region of Xinjiang, and have used the time to prepare every last detail of what to me is the most important of all my Chinese flights to the Turfan Depression. I have discussed every last detail of every last flight with the crew. The helicopter, a Sikorsky UH-60 Black Hawk, is finally airworthy again, and we take off exactly on time. It becomes clear very quickly that my intense preparations have not been a waste of time. But my elation does not last long, for I soon notice that the crew is arbitrarily changing the agreed flight route. My objections die away unheard, drowned out by the sound of the engine. We land only ninety minutes later at the military airfield at Shanshan – at the very time that the light in the desert is at its most propitious. My first thought is that this is simply a refuelling stop, but it turns out that we are to spend the night at Shanshan. It is dinner time. The mess tables have already been laid for me and my crew, and they are almost literally groaning beneath the weight of the grapes and melons for which the region is famous. I simply have to put a brave face on it. After all, I am the first foreigner to be allowed to take aerial photographs in Xinjiang. The Chinese government has used a ruse to get round its ban by making me the 'teacher' of the official flight

photographer. But I feel that I have been tricked and make a scene, my anger more than just play-acting. I sulk and refuse the grapes and melons. My translator, Wang Juan Juan, who has already complained of feeling unwell while we were taking off, now starts to sob uncontrollably, so great is the additional stress. Outbursts of anger and sulking, whether feigned or genuine, are my tried and tested secret weapons: admittedly, the 'long-nose' loses face, but my companions lose theirs too, because at the end of the day they have to tell Beijing that their 'foreign friend' is unhappy. Once again my loss of face produces the desired results, and the little Machiavelli in me chalks up another triumph: by sunrise the next day we are back in the air. Wang remains behind in the sickbay, under sedation. I direct the helicopter using hand movements. Jiahoe, Gaochang, Astana, the Flaming Mountains, towns and sites on the Silk Road. The flight goes smoothly. Wang's breakdown turns out to be an unexpected bonus: we fly back to Shanshan to collect her. (Two days later, when we return to Beijing on a scheduled flight, we shall abduct her from the hospital in Ürümqi, where she has been interned for dereliction of duty.)

After more than 3500 hours taking aerial photographs in small aeroplanes, some of them unimaginably small, I remain a mere passenger, as I have never bothered with a pilot's licence. Not even I myself can understand this, but there is no doubt that it works to the advantage of my fellow human beings on the ground. Every flight excites me. After forty years I have still not managed to curb my enthusiasm each time we soar and the earth changes dramatically. And so I depend on pilots who keep their eyes on the flight controls, rather than looking round them all the time. Of course, their circumspection and their ability to follow my own train of thought, even when it has nothing to do with flying, is always extremely welcome. Always?

I remember ...

Khorasan, Iran, 25 May 1978. Captain Ibrahim Rabii lands his Britten-Norman BN 2 Islander on the busy highway between Teheran and Mashhad, skilfully bringing the twin-engine plane down between two lorries, before taxiing off the road.
An emergency landing? The young man reassures me. He just wants to do me a favour. On today's programme is Shahr-i Qumis. Close by is the Parthian city that the Greeks knew as Hecatompylos – the hundred-gated city – but a cloud has momentarily cast an unwanted shadow over the site. Captain Ibrahim says that he prefers to wait on the ground as there is not enough fuel for us to circle the site in the air. Of course, I mistrust his attempt to explain away our illegal and dangerous unscheduled landing: Ibrahim has picked up a young woman, who is sitting with him in the cockpit and whom he clearly wants to impress. Taking off is more complicated than landing. We collar two passing motorists and persuade them to block off the road for several kilometres, giving us room to take off again. Meanwhile the old Parthian city is bathed in radiant sunlight.

Captain Ibrahim was a delightful man, but he could not refrain from playing the occasional joke on me. I used to work at the back of the Britten-Norman Islander,

lying, rather than sitting, beside the freight door opening. The noise of the plane made it difficult to communicate with the cockpit or with my archaeological adviser and guide, Dietrich Huff, who was sitting at the front of the plane. There was no two-way intercom on board, so the pilot just turned off the engines, and the plane glided silently over the mountain wilderness of Iran. I hardly need add that I have never spoken so quickly in all my life. But these glider flights, with their attendant conversations, were not enough for Captain Ibrahim. In order to terrify me, he would switch off the engines on other occasions too, just like that. Map-reading was not one of his strong points. In order to be sure that we were still in Iran, he flew so low over a small town with his twin-engine plane that he was able to read a sign for Coca-Cola. (At that date the Soviets drank only Pepsi-Cola.) Twice we flew deep into the Soviet Union. On the first occasion I was surprised to see Azerbaijani kolkhozy beneath me, while on the second I could make out the Cyrillic lettering on Turkmenian derricks. The Soviet Union was not pleased and protested to Teheran about these violations of its airspace, shooting down an Iranian helicopter that had strayed over the border in the fog. Captain Ibrahim was summoned to appear before a military tribunal, but he killed himself by colliding with another plane at an air show, a victim of his fatal fondness for fooling around. His death saved me from having to appear as a witness at an Iranian court martial.

God knows, I have no wish to speak ill of pilots – mine or others. All told, I regard them as examples of a type of person with a well-developed sense of responsibility. But they are human beings, with the result that, as with the rest of us, their sense of responsibility and duty is always under siege. There is temptation, thirst ...

I remember ...

Sudan, 29 January 1963. My first photographic flight. I have hired a Cessna 172, together with a Swedish pilot, in Khartoum. I want to document the temples, pyramids and fortresses of ancient Nubia between the Fourth and Second Nile Cataracts above Wadi Halfa. At Soleb, close to the Third Cataract, a team under Michela Schiff Giorgini is examining and restoring the great sanctuary of Amenophis III. As an archaeologist, Signora Schiff Giorgini fully deserves her reputation: as a hostess in a desert camp she has no equal. For her, a Martini without an olive is unthinkable. The first pilot to land in her camp will find a bottle of whisky waiting in the fridge. As we are approaching Soleb, I uncautiously tell my pilot about this oasis of creature comforts and the prize awaiting whoever lands there first. Now there is no holding him back. The archaeologists on the ground use sheets to indicate the wind direction on the bumpy runway, but the thirsty man finds the fridge and bottle without any further assistance. We are hailed like Lindbergh after his Atlantic crossing. The inhabitants of the surrounding villages flock to see their first light aircraft. An hour later, the Cessna, now long overdue, takes off and staggers – there is no other word for it – the last 200 kilometres to its destination. In Wadi Halfa the police arrest the drunken pilot and impound his plane.

But enough of these tales of mischief among pilots. The success or failure of a photographic flight depends equally on the photographer's other colleagues. Every patch of earth has long been exposed to inquisitive eyes in orbit, but in spite of this the authorities in many countries remain paranoid and assume that every aerial photographer is a spy. He can count himself lucky if he is allowed to fly at all. And he generally has to deal with a security officer who does everything in his power to make life difficult for him. But there are, of course, tried and tested ways of dealing with bullies.

I remember ...

Israel, 20 December 1971. We are flying over the occupied West Bank in a Cessna 172. I want to photograph Tell es-Sultan, the biblical Jericho, but the young female lieutenant, still very new to her job, prevents me from going about *my* job because she cannot find out what I am not allowed to photograph (not that I have any wish to photograph it either). Finally I show her the secret radar station on the hill. Now she at least allows me to photograph Jericho, but on the rest of the flight she is determined to make the male chauvinist pig pay for making her look so foolish. She now insists on saying no to everything. No, no, no. The time finally comes for counterreprisals if I am to salvage anything from the flight. I ask the pilot to circle over a harmless site. Tighter and tighter, steeper and steeper, circle upon circle. In my experience, passengers in the back seat cannot handle this, and sooner or later their faces will become the colour of an avocado. And, sure enough, on the rest of the flight over the occupied Sinai Peninsula my lieutenant is so ill that she can only nod in apathetic agreement to all my requests. Involuntarily I now become a spy, mixing up the Israeli positions and the abandoned Egyptian defences on the Straits of Tiran – and my now almost lifeless minder gives her blessing to this disastrous mistake. Only let's get it over with ... All she can think about is landing. (For my own safety I later destroy the highly compromising photographs.)

I have nothing against onboard soldiers. Their presence may save my life. But it should then be a general.

I remember ...

Iquique, Chile, 3 September 1978. General Eduardo Franke Iensen arrives late for supper. He is clearly in a state of shock. 'We were almost shot down.' We had flown together in a Cessna 337 Push-Pull over the Cerro Unita, on the slopes of which is a gigantic geoglyph that is one of the more mystifying images in the western foothills of the Andes. It is said to be the largest prehistoric representation of a human figure in either North or South America. General Iensen wanted to show me his discovery while the giant still exists. The Cerro Unita is part of a practice firing range for the Chilean airforce, with the combat pilots using the geoglyph as a larger-than-life human target. As a result the giant, which has been here for hundreds if not thousands of years, has only a slim chance of survival. But General Iensen has omitted to inform the authorities that the flight is to go ahead, as the regulations require him to do, so that the unnotified Cessna, which

normally patrols the coastline, keeping watch over the fishing fleet and locating shoals of fish, attracts unwelcome attention over the Atacama Desert and especially in a prohibited area. Permission has clearly already been given to shoot us down when news of the identity of the aircraft's passengers spreads. The former supreme commander of the Chilean airforce is not the sort of person you shoot down without further ado.

The aerial photographer's colleagues include not only the pilot and minder but possibly also the air-traffic controller on the ground. In countries where aerial photography is banned – and it is banned virtually everywhere – the photographer is dependent on others looking the other way if he leaves the aircraft door on the ground or tapes the window to the underside of the wing before take-off. Benevolent credulity is also welcome. The air-traffic controller noticed the missing door from the opposite side of the runway at Trujillo in Peru and demanded an explanation, only to accept the excuse that I whispered in my pilot's ear: the pilot was carrying an eccentric passenger who suffered from claustrophobia. Air-traffic controllers are entirely open to special requests as long as they are well founded. Sometimes an appeal to the fatherland is enough to get special permission, on other occasions an appeal to particular proprietary articles will suffice. When I photographed the keyhole tombs of the early emperors of Japan under the approach path to the main airport at Osaka, I asked for a flight path several hundred metres higher. Initially the controller refused. Only when I repeated my suggestion, adding that although I was Swiss, I worked exclusively with Japanese Nikon cameras, did he relent. Thank God he was not an aggrieved fan of Canon, Pentax or Olympus cameras.

It is illegal to play cat and mouse with an air-traffic controller. Above all, it is not without its dangers, especially if the game takes place over the endless Amazon jungle. In these circumstances a cellphone is advisable. Or at least a fishing rod.

I remember ...

Near Manaus, 3 March 1979. We are flying over the green sea of Amazonia in a Cessna 182 fitted with floats. Earlier in the day I photographed the confluence of the Rio Negro and the Amazon for an Air France advertising campaign. The four of us – me, the pilot, who is a Canadian missionary, and, in the rear seats, a French couple, Marc and Chloé – are now on an ethno-archaeological reconnaissance flight over the areas inhabited by the Waimairi and Akroairi Indians. In its policy towards the native Indians, the Brazilian government has never cared to show its hand, particularly to airborne travellers, and so our missionary-cum-pilot has preferred not to notify the authorities about our flight but to slip away beneath the radar of the airport of Manaus. We are forced to be entirely self-reliant. No one knows where we are. Suddenly Marc taps my shoulder and asks me to inform the pilot in English that Chloé has been taken short. It is urgent. 'Chloé has to pee.' The man of God at the controls takes it all in his stride, selects an atmospheric tributary, lands on the water, brings the Cessna to a rest on a sandbank and

releases his fishing rod from its mounting, intending to take advantage of our unplanned pit stop to do a spot of fishing. Discreetly we men turn our backs on Chloé and the Cessna while she does what she has to do. The Cessna unfortunately takes this opportunity to do something it is not supposed to do, breaking free from the sandbank and drifting slowly into the river. Stranded on a sandbank in the middle of a river almost certainly teeming with peckish piranhas, with no links to the outside world and not even missed by our fellow human beings: our situation could hardly be more unpleasant. But our fisherman-pilot keeps his head and, casting his line with well-aimed accuracy, catches the aircraft as it drifts away, then slowly, ever so slowly, draws in his catch. Never before has the tensile strength of fishing lines given me such pause for thought.

I find myself putting the cart before the horse in this account of my activities. After all, my experiences of pilots, security officers and air-traffic controllers all presuppose that I have at my disposal a vehicle suitable for photographic flights, be it a helicopter, a fixed-wing aircraft or a balloon. Nowadays I generally hire a plane, but I recall with some nostalgia the good old days when, with a little luck, you could use regular commercial aircraft for aerial photographs – admittedly not always to the universal delight of your fellow passengers. Sometimes the blood would drain from their faces or they would suffer from butterflies at such photographic escapades. I should like to apologize belatedly for all such unpleasantnesses.

I remember ...

Luxor – Wadi Halfa, 15 January 1964. We are planning to use a Fokker F27 Friendship. This is my chance to take an aerial photograph of the two rock-temples at Abu Simbel before they are removed to a new site where they will be safe from the rising water. The cockpit in a Fokker Friendship has a sliding window that can be opened. Moreover, the co-pilot on this flight is from Poland and I am accompanying the archaeologist Kazimierz Michalowski. Everyone is talking about his discovery of the cathedral at Faras near Wadi Halfa, quite apart from which he is also chairman of the academic council that is advising on the relocation of Abu Simbel. In short, he is a real heavyweight. And Polish. Michalowski offers to intercede on my behalf and before we take off speaks to the co-pilot as one Pole to another. As we begin to approach Abu Simbel, I am called to the cockpit. I come, I see, and I conquer. The captain pushes open the sliding window and, without warning his passengers, suddenly drops some two thousand metres from cruising height to the Nile in order to take me as close as possible to the two temples. Before we land I return from the cockpit to my seat in the cabin. My fellow passengers would gladly have lynched me if they had been capable of lifting their heads from their sickbags. Only the distinguished, white-haired professor from Warsaw has retained his healthy complexion. But he was the only passenger to know that we had not really been about to plunge to our deaths.

Never before or since has obtaining a suitable aircraft proved as expensive or

as adventurous as it did in Iraq. In 1972 I discovered a Cessna 182 quietly rusting away at the Iraqi Flying Association's airfield in Baghdad. The plane was in a wretched state. I profited from several visits to Iraq to find the right parts and bring them with me. For a journalist, it was impossible at this time to obtain a visa for Iraq, but if you entered the country 'with the spare parts needed to undertake emergency repairs on an ailing machine in the south that is indispensable in the search for oil', the border officials would turn a blind eye and stamp your passport with an emergency visa. The machine that was 'indispensable in the search for oil' was gradually restored to health and following a test flight was certified as airworthy. Grateful for my services, the aeroclub arranged for me to spend three days on an aerial exploration of the 'cradle of civilization', from Ur to Nineveh and from Basra to Mosul – admittedly with a minder on board, but even so ...

I remember ...
Mosul, 29 April 1973. The cloudless sky is broken only by the vapour trails of the MiG patrols. On the ground the mood is one of nervous tension. The witches' cauldron of the Middle East is seething once again. But I can hardly believe my own luck: three days taking photographs over the Tigris and the Euphrates without breaking down. Not even the security agent fancied himself as a spoilsport. We are in the plane, ready to fly back to Baghdad and are waiting for clearance for take-off. But instead of giving us permission to leave, the tower suddenly orders us to wait. A jeep races towards us over the airfield. I feel uneasy – will they ruin all my efforts at the last minute and take away my films? I hurriedly number some unexposed films. If the worst comes to the worst I shall allow them to confiscate these ones, adding as a precaution that they are special films and that if they are wrongly developed they will turn out transparent. But my fears are unjustified. The adjutant of the commanding general leaps out of the jeep with a bouquet of red roses. 'With the compliments of the base commander.' The roses are from the garden of the commander of the military airfield.

Chartered aircraft that you haven't assembled yourself are best examined very closely. There are no roses without thorns. The discontinued model of a canvas plane that was to take me and my friend Ernst Scheidegger from Algiers over the Atlas Mountains in search of a lost city in the Sahara was rejected without our even bothering to inspect it, a peremptory dismissal on our part that later proved providential as the owner had been hoping that it would crash in order to pay off his debts with the hoped-for indemnity from the insurance. However reasonable it may be to mistrust old machines, this sentiment is not always universally shared.

I remember ...
Nanjing, mid-June 1987. I have been asked to photograph China from the air for an Australian publisher working in collaboration with one of China's state-owned publishing houses. I have to rely on the machine placed at my disposal by the armed forces. There are no chartered planes in the Middle Kingdom. I first see the machine at a military airfield in Nanjing, a Soviet Antonov AN-2 from the 1940s

that was rebuilt in China. A double-decker with a radial engine, it was the largest single-motor double-decker in the history of aeronautics and looks for all the world like a gigantic crop-spraying plane. It is certainly an old-timer. It is no wonder that my heart sinks and my voice rises in pitch. 'This thing must be thirty years old.' 'No, no,' my companions reassure me. 'More ... older.' Their answer reflects the Chinese respect for great age, which apparently guarantees increased reliability even in airplanes.

In other ways, too, I have problems with the veteran AN-2. The armed forces' ideas on safety are very lax. They expect me to stand in the open doorway during the flight, leaning slightly forward in order to be able to see out of the plane, but without an adequate safety belt. Suddenly I remember a clause in my contract: 'Life must always remain subordinate to the best photograph.' Until now I had assumed that it was the translation that had turned the Chinese original's well-meaning concern for the photographer's life and limb into an expression of ominous nonchalance, but in spite of this I risk standing during a brief flight over the mausoleum of Sun Yat-sen. Safely back on the ground, I insist on a seat for all future flights. My wish is my companions' command, and I am duly given a seat for the next flight – a kindergarten stool perched perilously close to the gaping door of the plane. It is badly anchored to the ground, and in the foetal position that I am forced to adopt, I can scarcely see further than my knees. On landing, I therefore express an urgent request for a more solidly built chair for an adult, a chair more appropriate to the task in hand, more resilient, more welcoming, more comfortable and, finally, conducive to a relaxed posture. My translator, never at a loss for a flowery expression, evidently does an excellent job when passing on my catalogue of demands, for on the next flight I find that the kindergarten stool has been replaced in the open doorway by a feudal and formidable club armchair, almost certainly a solution unique in the annals of flying. But I refuse, of course, to be a pioneer: the heavy chair is so badly lashed down that if the plane were suddenly to change direction both the chair and its occupant would slide into space.

My employers finally saw sense and placed a large helicopter at my disposal, so that the armchair did not fly after all. But turbulence is a recurrent nightmare of mine, with the armchair from the Chinese officers' mess alternating in my dreams with three jeroboams of Burgundy.

I remember ...
5 July 1998, a flight from the Auvergne to the valley of the Rhône. Within minutes of taking off from Clermont-Ferrand I have photographed the remains of the Roman Temple of Mercury on the Puy de Dôme. In place of the image of the god that Pliny the Elder numbered among the wonders of the ancient world, a television tower now raises its ugly head. Over the Cevennes we end up in heavy turbulence. The broad-winged Britten-Norman Islander is ill designed to cope and begins to lurch. A few days earlier a hotelier in Burgundy had given me three jeroboams of Auxey-Duresses Côte de Beaune AC 1994 for an aerial photograph of

his hostelry. The little crates containing the three-litre bottles break free from their moorings and fly around the cabin like bombs. Even during a calm flight it is no fun to crouch at the back of an Islander, beside the opening, without a safety belt, but now – for what seems like an eternity – I feel that my final hour has struck. Even so, the jeroboam bombs miss me, and only a camera, lens and case, together with their exposed film, end up overboard.

I foresee ...

A news item in the miscellaneous column on 26 September 2003 AGD: 'We earlier reported a find that experts initially thought was the fossil of a goggle-eyed frog (*Rana bolbophthalma*). An institute specializing in the archaeology of the BGD period has now succeeded in identifying it as an artefact. This remarkably complex object of metal and glass must be one of those delightful pieces of apparatus with which people went hunting for images in the period before the Great Disaster. The word "Nikon" on one of its metal parts may indicate the tribe from which it came. There is no doubt that it was used in a cultic context. Research funds from the department of "Cultic Elements in Prehistoric Photography" have enabled expensive work to be undertaken on the artefact and to reveal the last image that was captured on it. It almost certainly shows a tribal sanctuary: an unequivocal object rises vertically upwards from the foundation walls of a temple. It appears from the image that the Nikonites adhered to a phallic cult.'

It is nice to know that an incorrigible wanderer can still provide the material for future dissertations, even if it is to the dismay of his insurers.

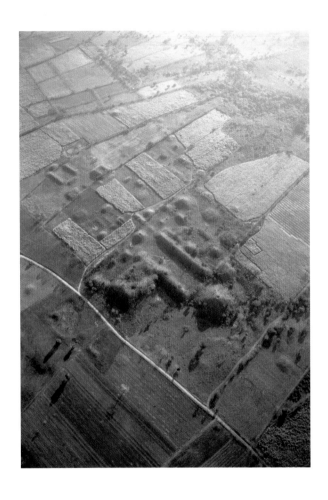
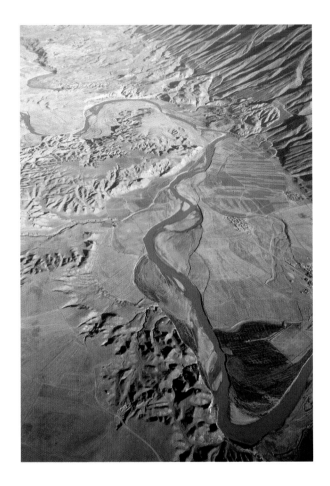

1 | **Laguna de los Cerros, Veracruz**, Olmec culture, 1500 BC–2nd century AD, Mexico, 1997

2 | **Open countryside in Luristan**, Iran, 1976

I. CULTURE AND NATURE –

ARCHAEOLOGICAL SITES

IN THE LANDSCAPE

The eagle took him upwards for a mile.
 'My friend, look at the country! How does it seem?'
 'The affairs of the country buzz like flies
 And the wide sea is no bigger than a sheepfold!'
The eagle took him up a second mile.
 'My friend, look at the country! How does it seem?'
 'The country has turned into a garden
 And the wide sea is no bigger than a bucket!'
It took him up a third mile.
 'My friend, look at the country! How does it seem?'
 'I am looking for the country, but I can't see it!
 And my eyes cannot even pick out the wide sea!'

Myth of Etana, Tablet III, ll. 55–66 (early 2nd millennium BC)

3 | **Hominid site on the River Omo**, 3.6 million BC–130,000 BC, Ethiopia, 1972. World Heritage Site

4 | **The Thingvellir Parliament**, AD 930, Iceland, 1981

5 | **Rock tombs at the Jebel Al-Khubtha in Petra**, Nabataean, 1st–2nd century AD, Jordan, 2003. World Heritage Site

6 | **Dogon settlements at Bandiagara**, AD 1100 to present, Mali, 1973. World Heritage Site

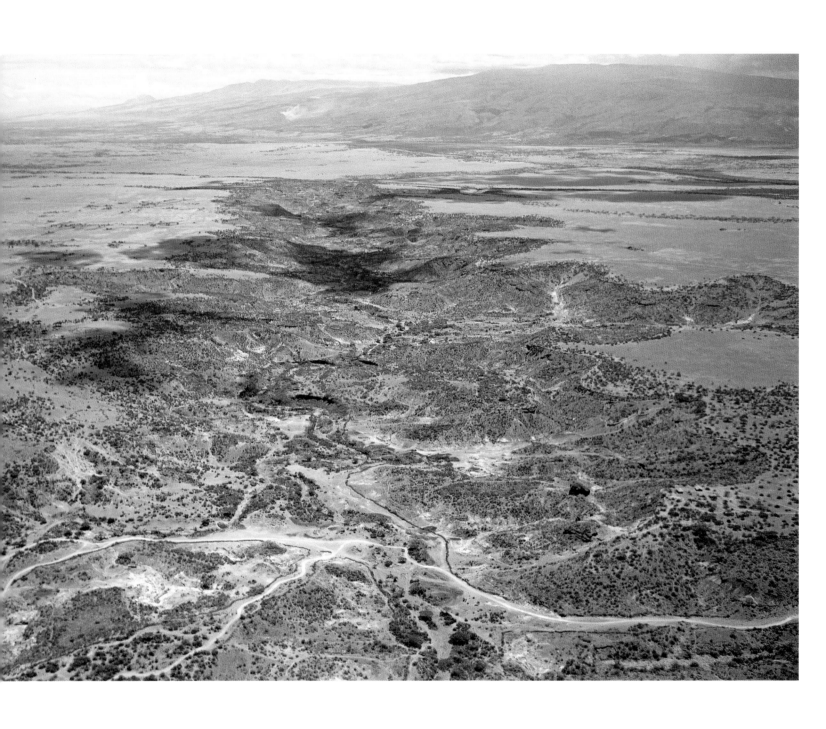

7 | **The Olduvai Gorge**, 2.5–1.5 million years BC, Tanzania, 1970

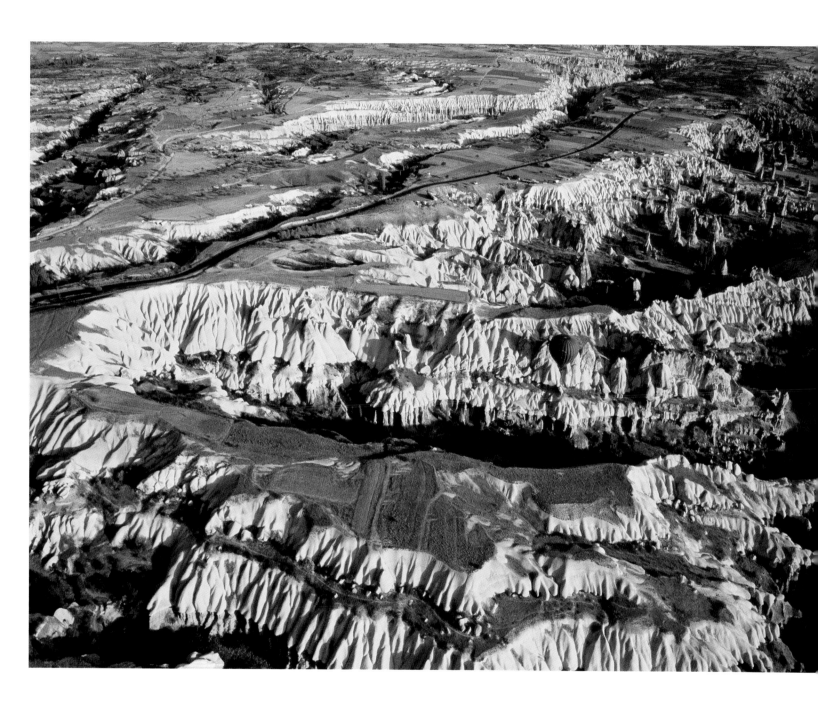

8 | **The landscape at Cappadocia**, Turkey, 2002. World Heritage Site

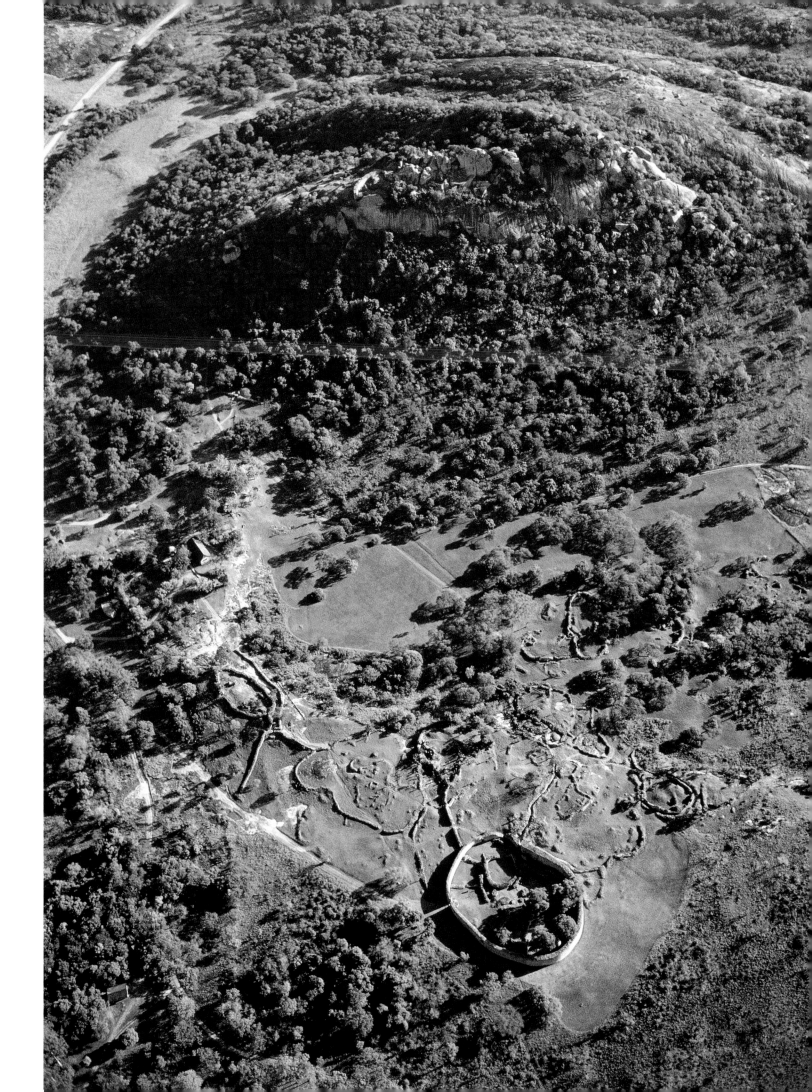

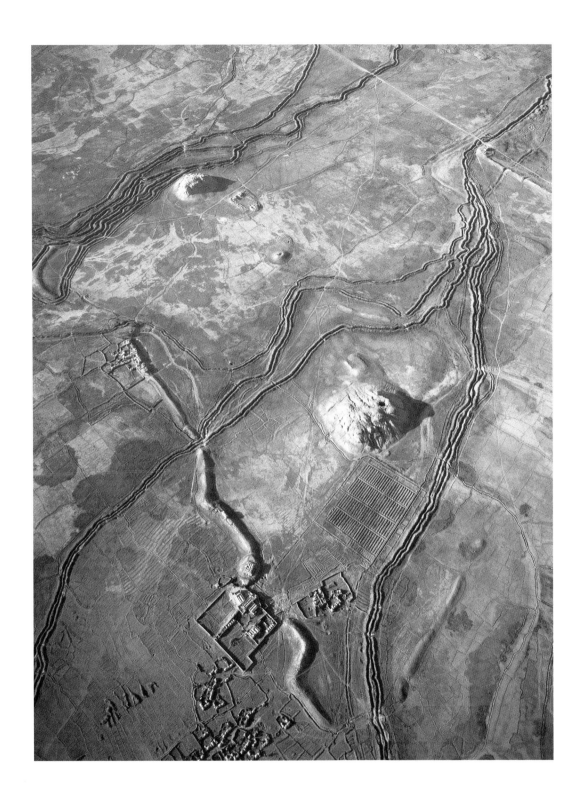

9 | **Ruins at Great Zimbabwe**, AD 1000–1500, Zimbabwe, 1983. World Heritage Site

10 | **The ruins at Nad-i Ali**, 8th century BC–6th/7th century AD, Afghanistan, 1977

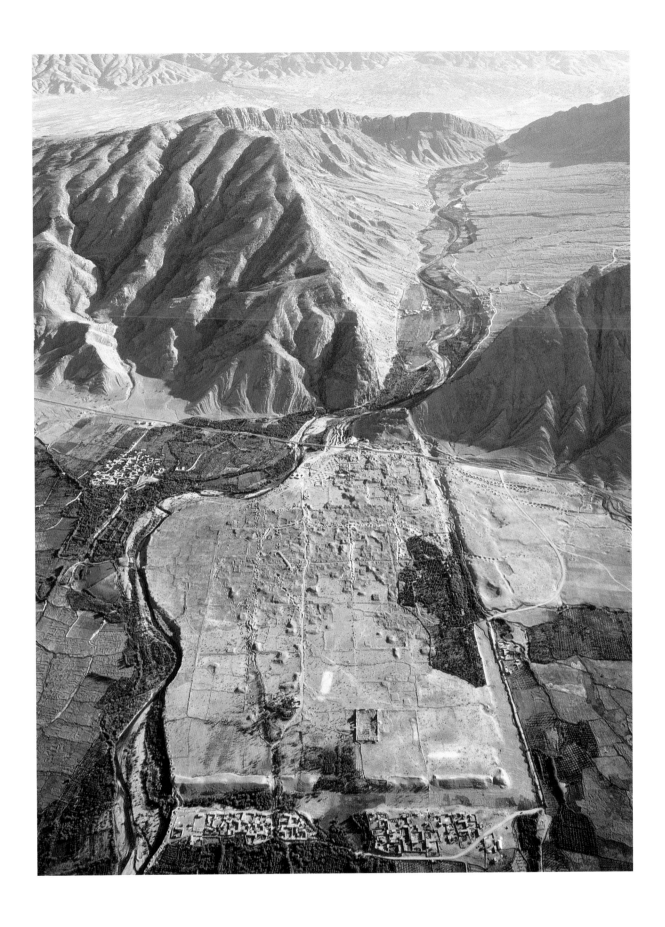

11 | **The Sassanian city of Bishapur,** founded AD 266, Iran, 1976

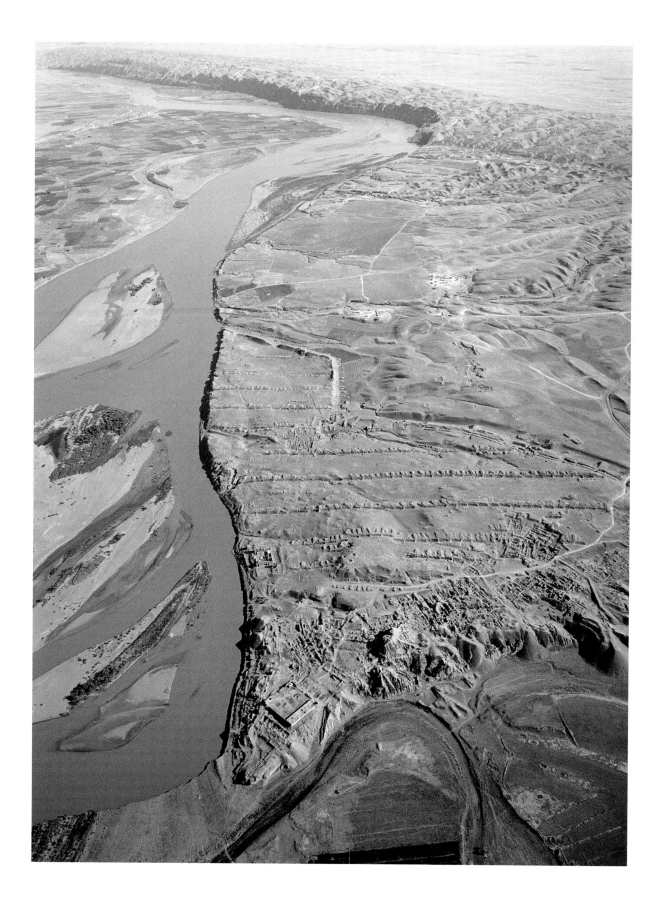

12 | **The old Assyrian capital of Ashur**, 3rd millennium BC–early 1st millennium BC, Iraq, 1973. World Heritage Site

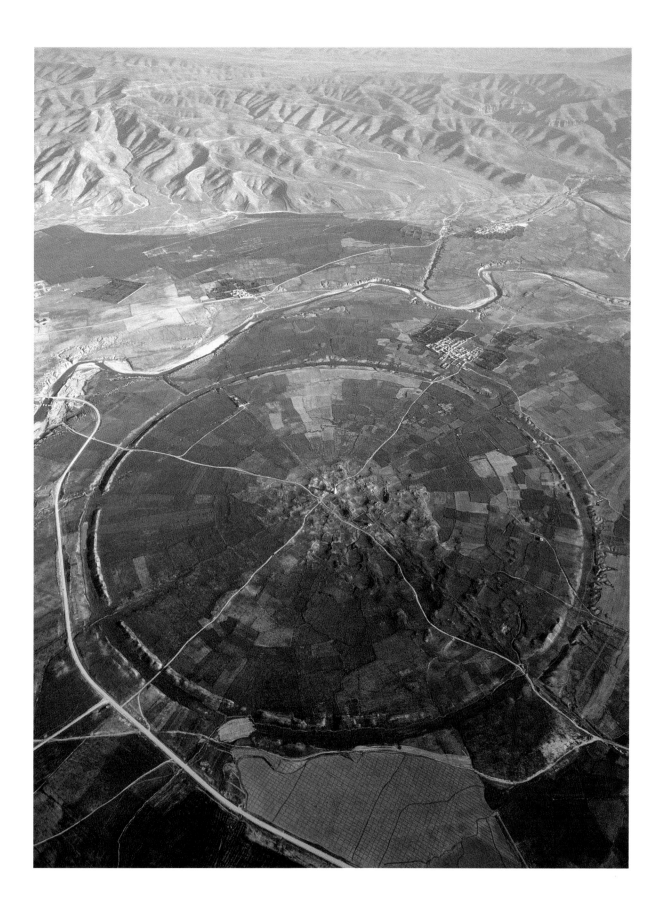

13 | **The Sassanian city of Gur/Firuzabad**, 3rd century AD, Iran, 1976

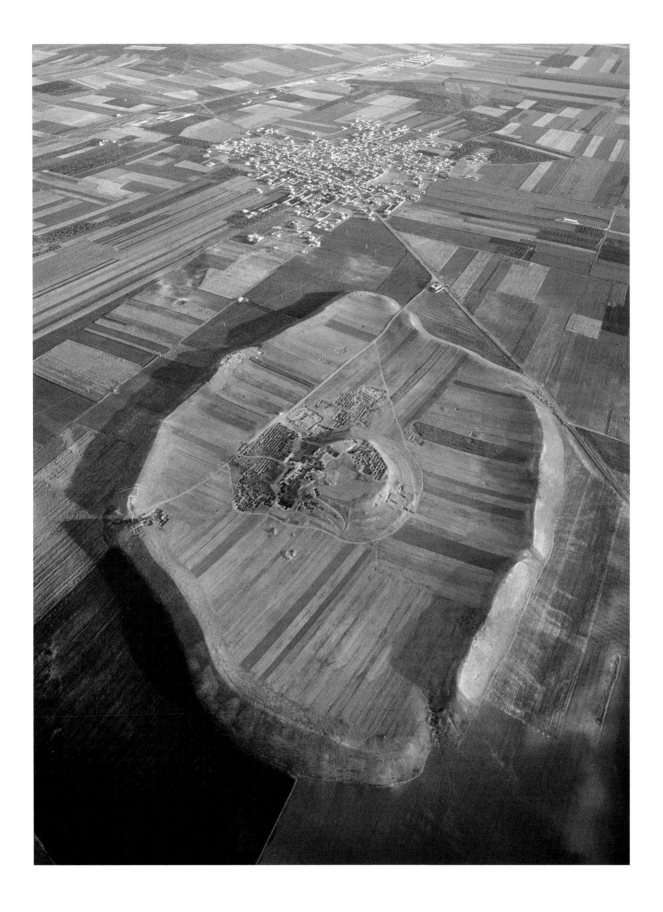

14 | **The city of Ebla**, *c*2370–*c*1600 BC, Syria, 1997

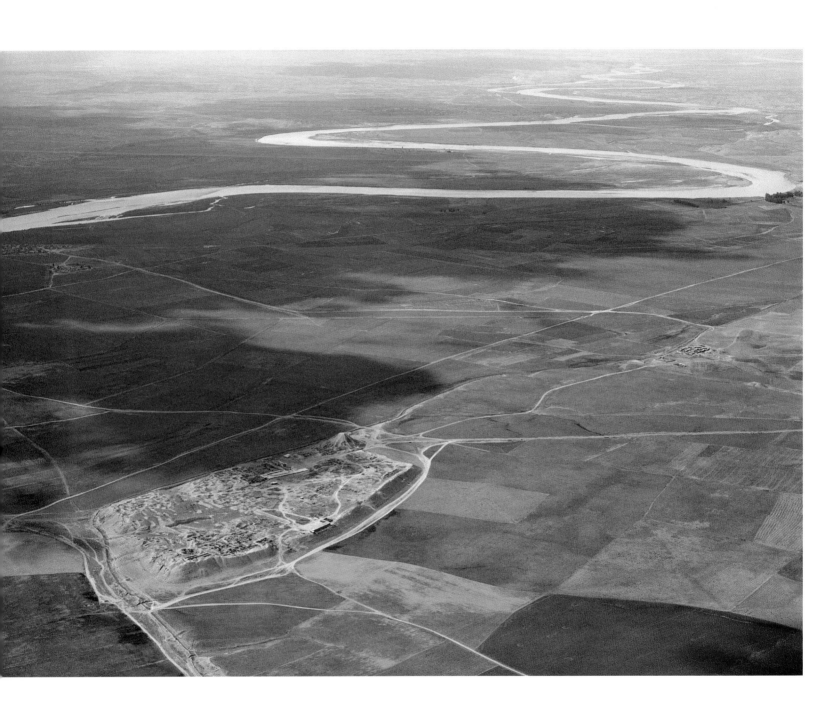

15 | **The new Assyrian capital of Nimrud**, 9th–8th century BC, Iraq, 1973

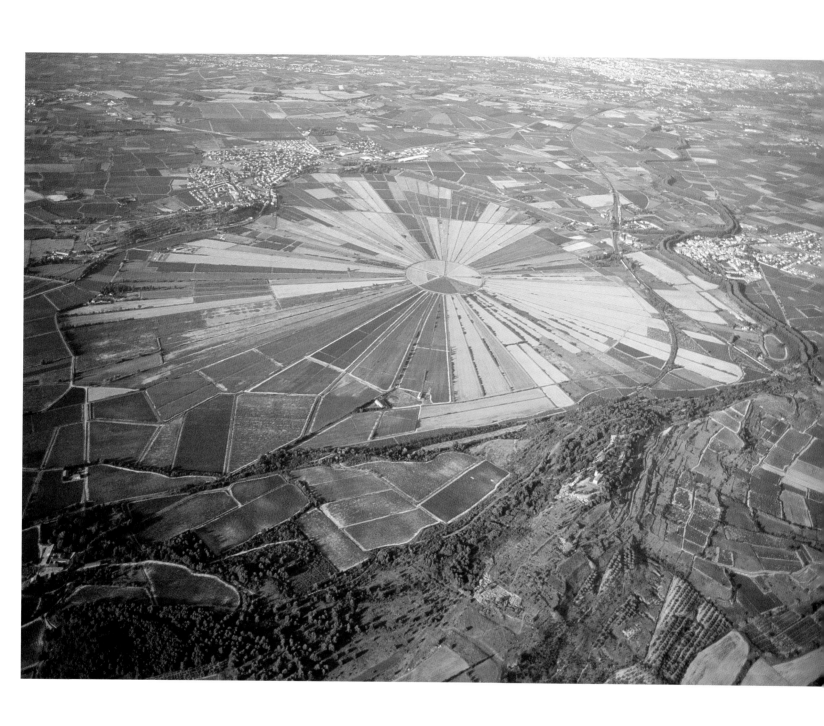

16 | **The oppidum at Ensérune**, 6th century BC–1st century AD, France, 1998

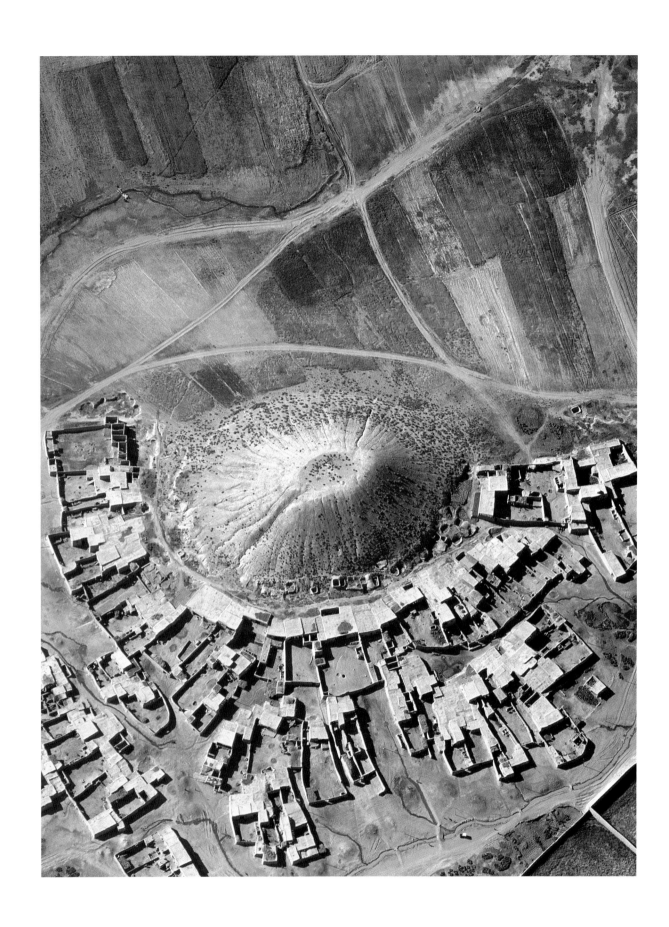

17 | Tepe (settlement mound) at Cheqa Narges, Mahidasht, Iran, 1976

18 | The Sassanian imperial sanctuary at Takht-i Suleiman, 5th–7th century AD, Iran, 1976. World Heritage Site

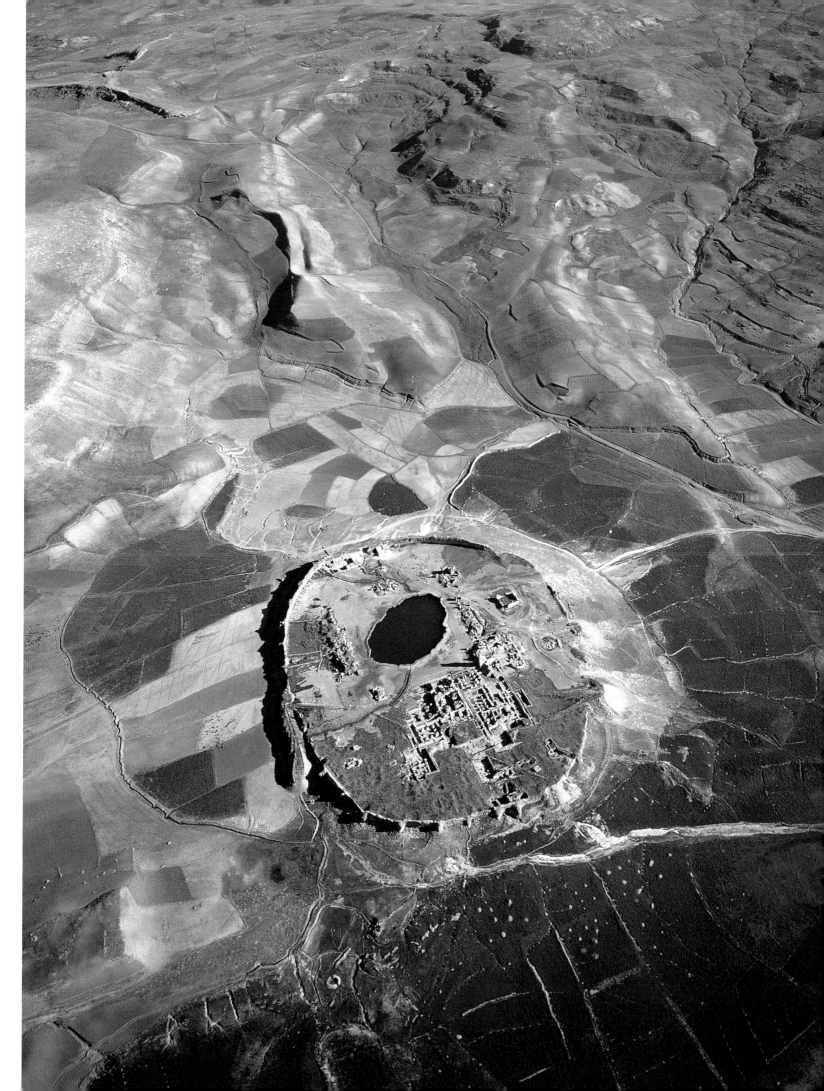

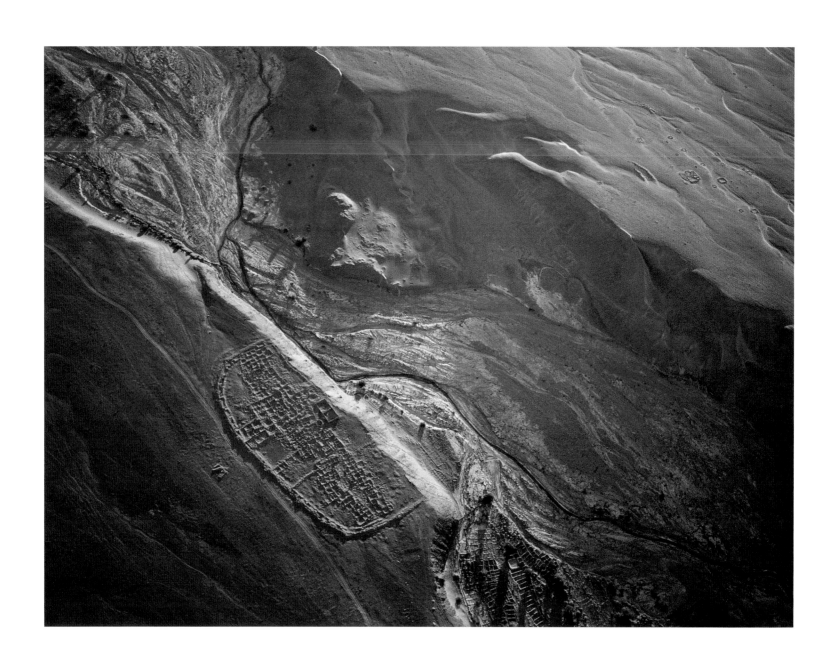

19 | **Caserones in the Quebrada de Tarapacá**, 3rd–16th century AD (several building phases), Chile, 1978

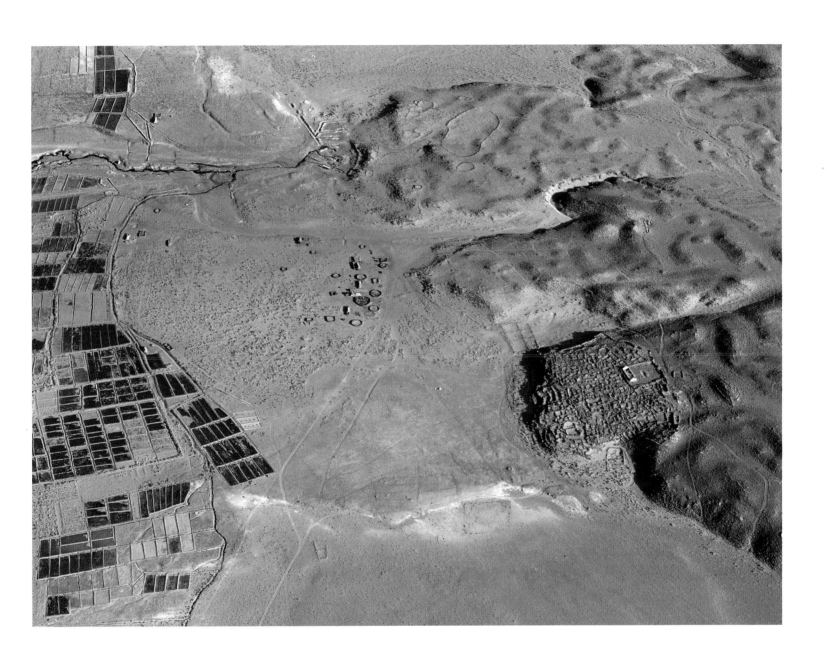

20 | **The Pukara de Turi in the Loa Valley**, 10th–16th century AD, Chile, 1966

21 | *56–7:* **The Temple of Apollo on Delos**, 7th–1st century BC, Greece, 2002. World Heritage Site

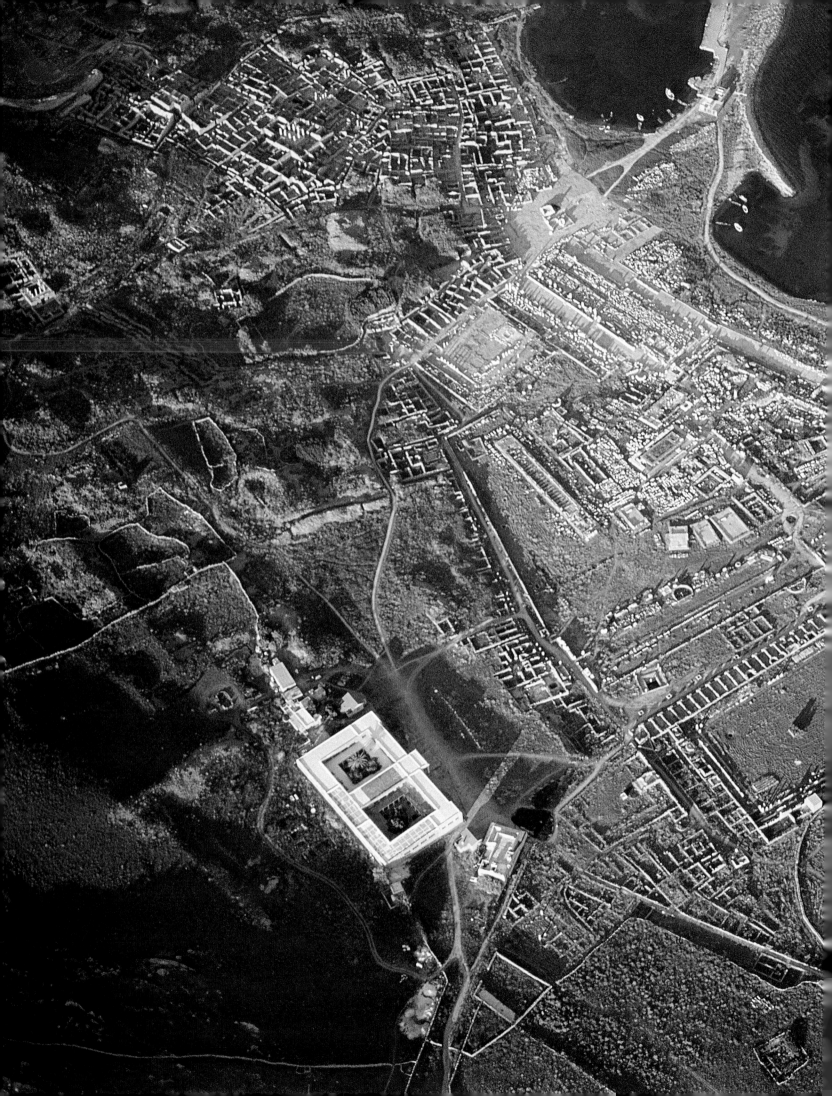

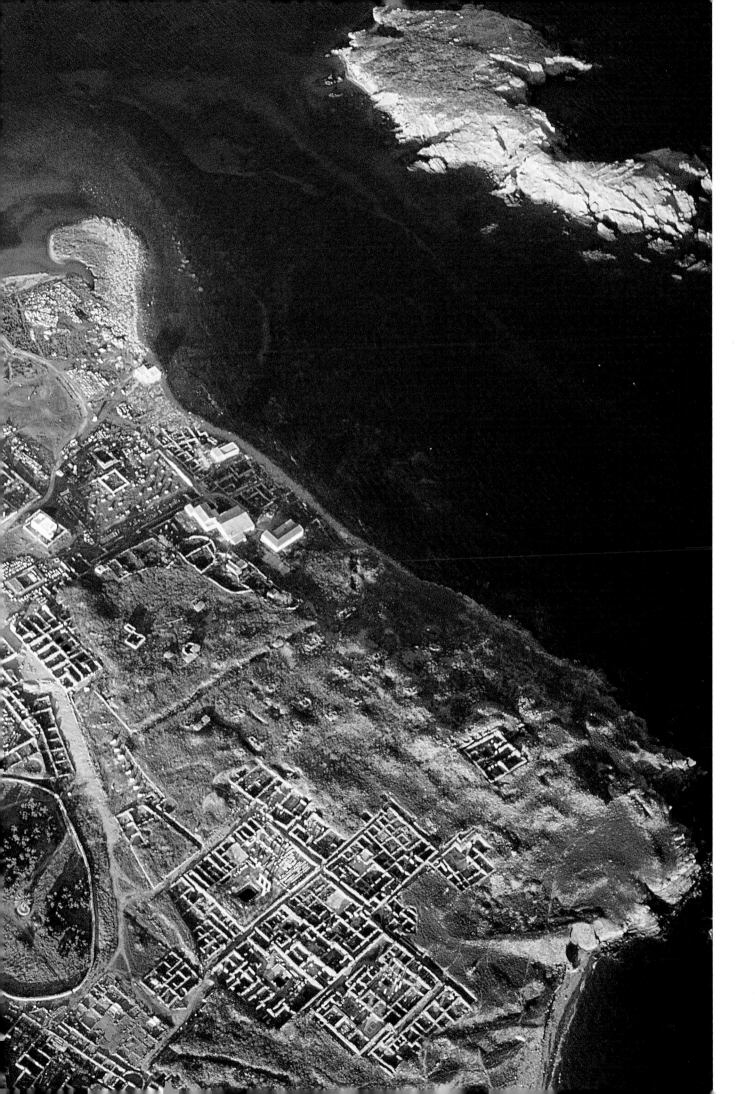

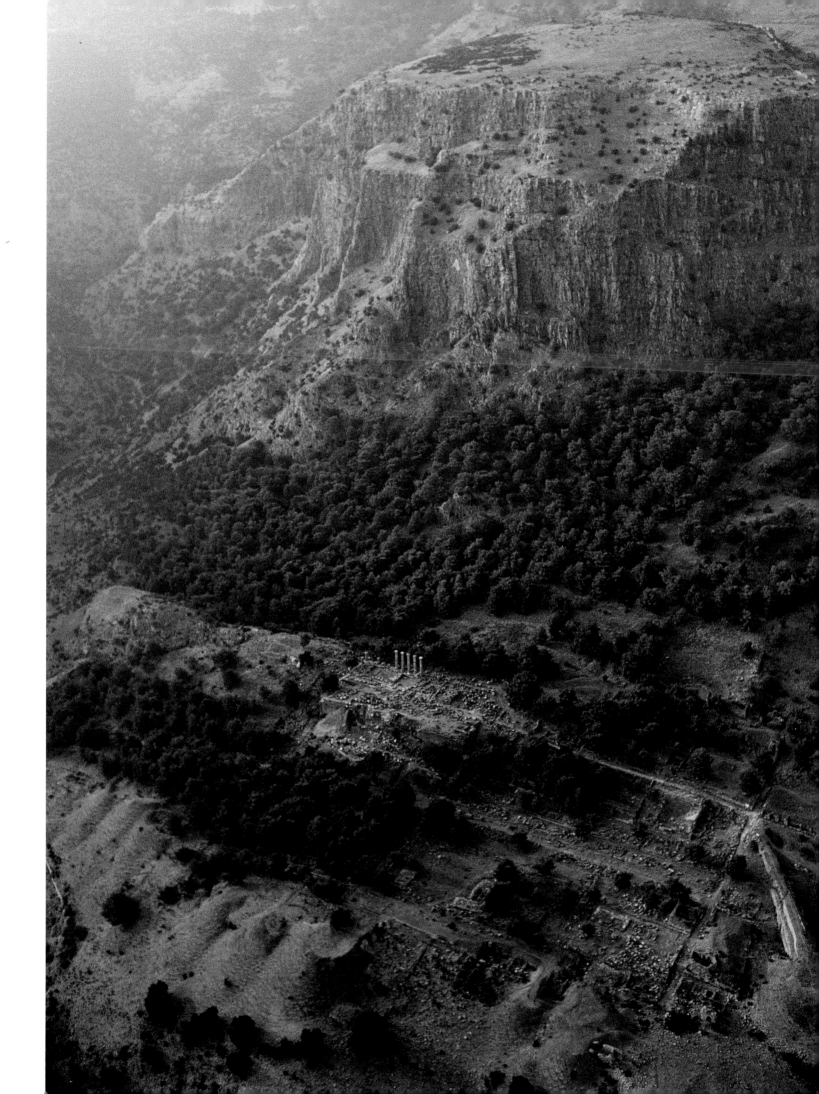

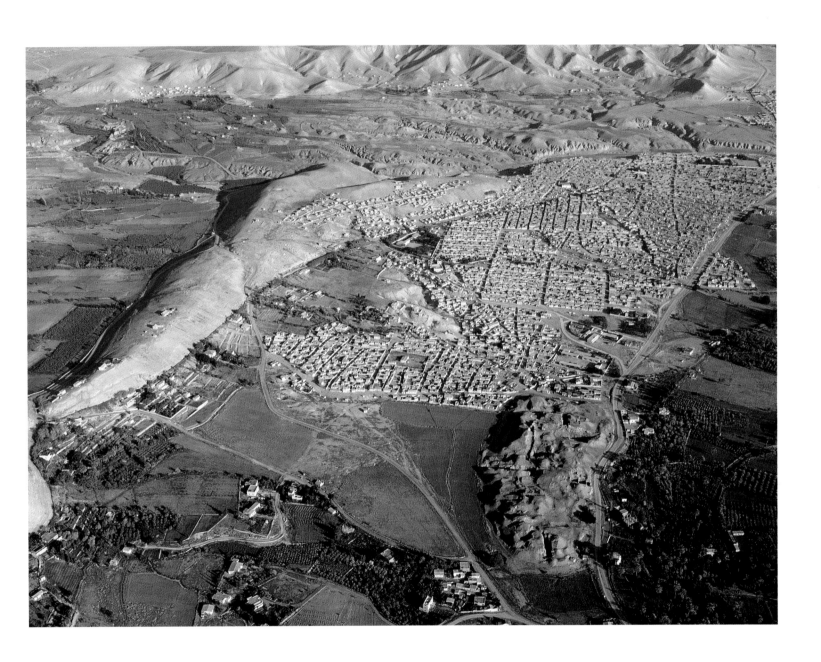

22 | **The city and acropolis of Priene**, 4th century BC, Turkey, 2002

23 | **Tell es-Sultan/Jericho**, settled since the 9th millennium BC, Palestine, 1971

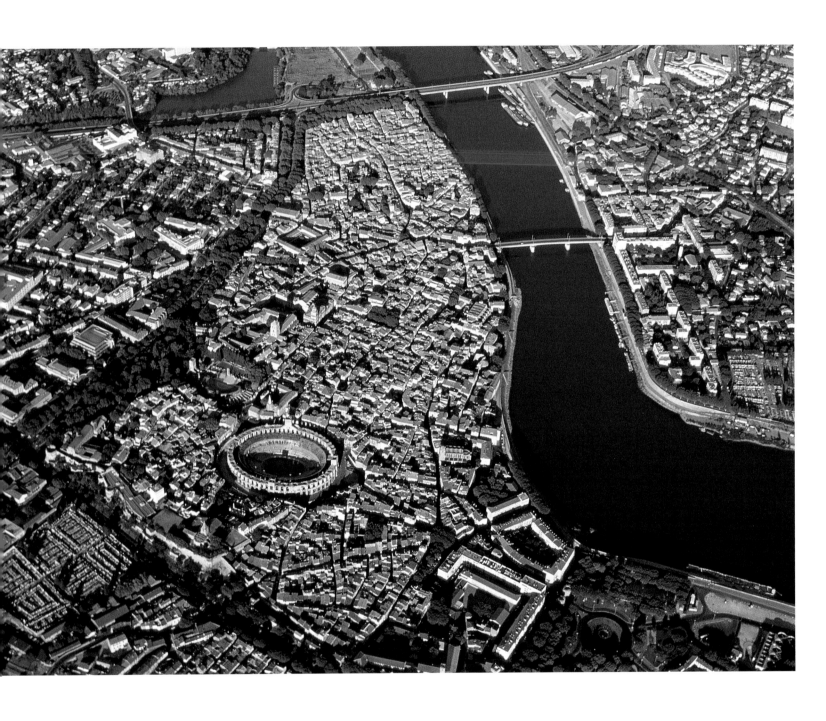

24 | **The Roman city of Arles**, France, 1998. World Heritage Site

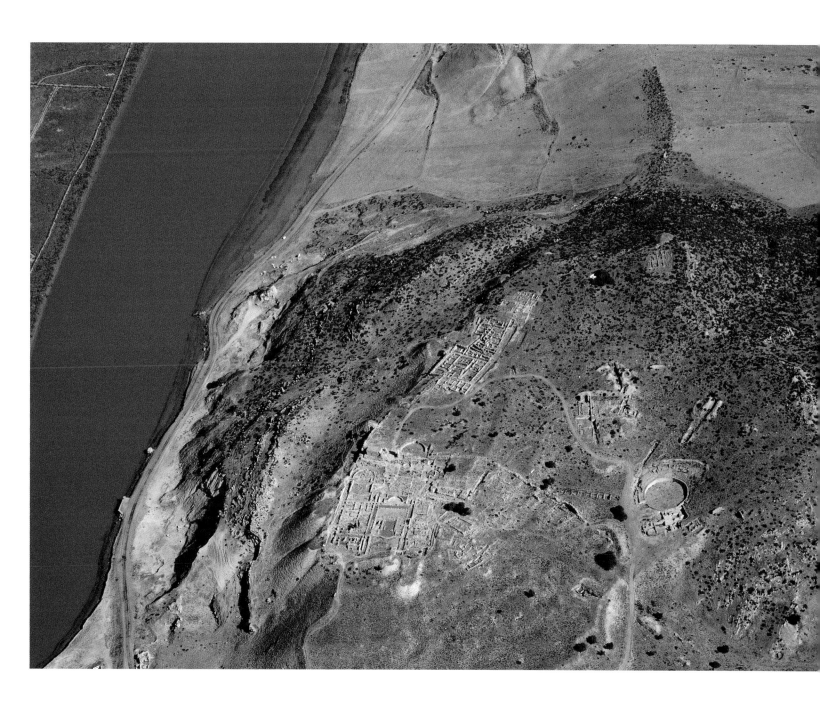

25 | **Ruins at Lixus**, Phoenician settlement from 8th century BC, Morocco, 1982

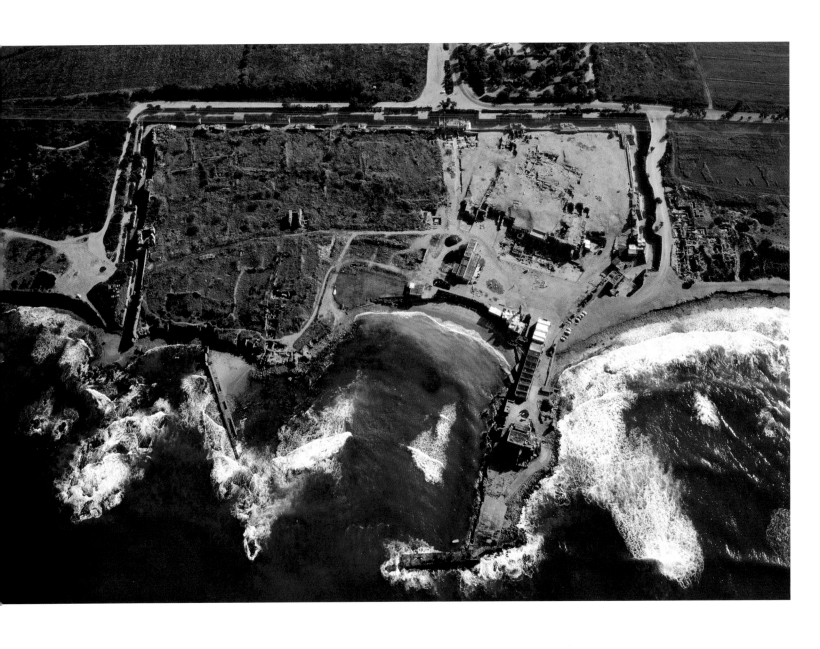

26 | **The port at Caesarea**, 22 BC–13th century AD, Israel, 1981

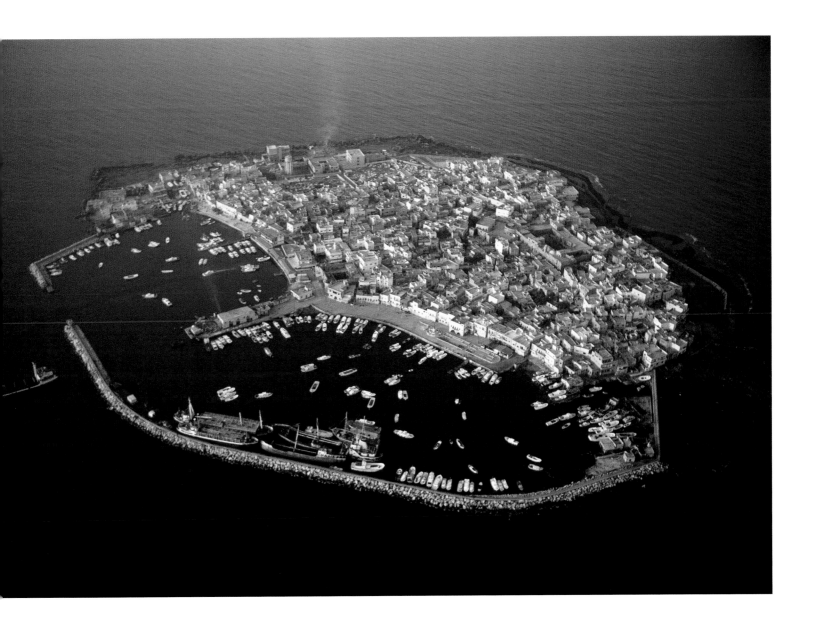

27 | **The island of Arwad/Ruad**, flourished in 1st millennium BC, Syria, 1997

28 | **The port at Siraf/Bandar Taheri**, Iran, 1976

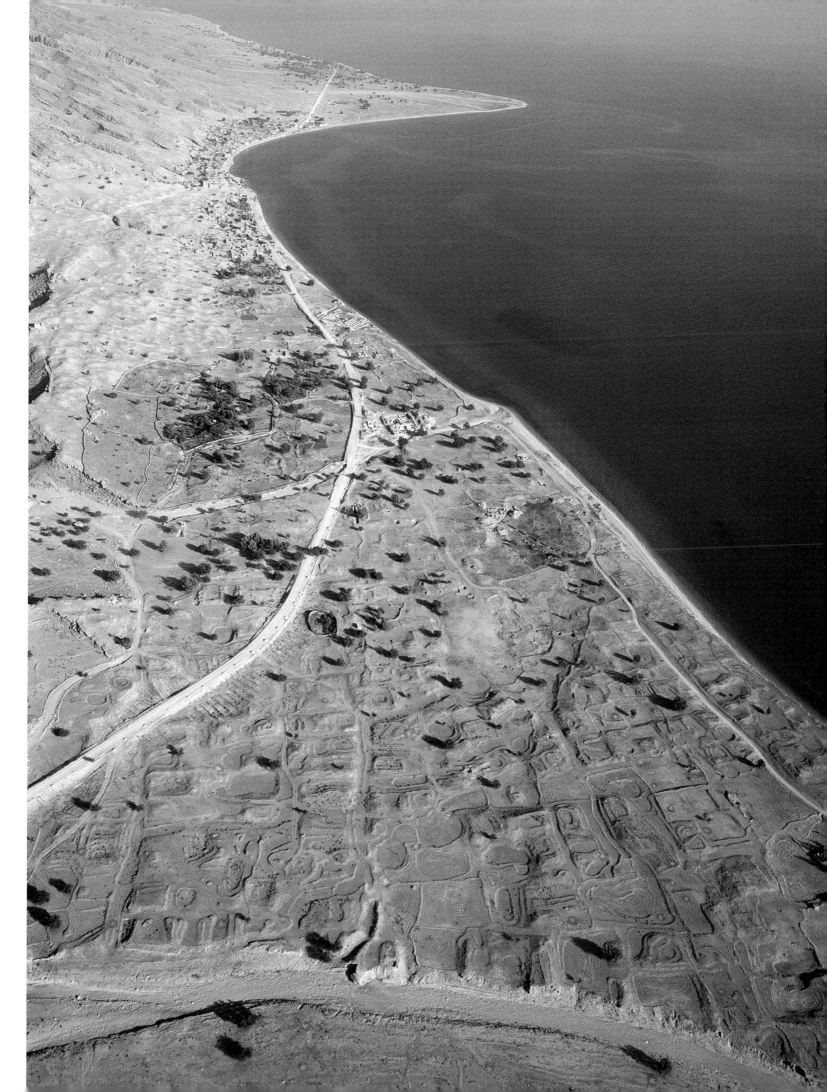

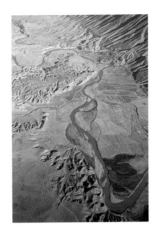

1 | Laguna de los Cerros, Veracruz, Mexico

Still largely unexamined by archaeologists, Laguna de los Cerros lies on the alluvial plain in the southern part of Veracruz, one of the member states of Mexico, some 110km west of the port of Coatzalcoalcos. It was here that Olmec culture emerged c1500 BC. In turn, this culture was to leave its mark on later Mesoamerican cultures. At Laguna de los Cerros we already find the essential elements of later Mesoamerican ceremonial centres. The pyramid at one end of a rectangular plaza framed by parallel platforms, with a smaller structure at the other end, became a model for many later variants. The Olmecs also achieved a remarkable mastery in carving stone monuments. From Laguna de los Cerros come some of the smaller giant stone heads that are so typical of Olmec culture. The source of the volcanic material used for the giant heads at other, larger sites was long a mystery but has now been partially explained: only 7km from Laguna de los Cerros is the quarry of Llano del Jicaro, where a number of unfinished, typical Olmec stone monuments have been found. Whereas the majority of the major Olmec sites such as La Venta had been abandoned by 500 BC at the latest, Laguna de los Cerros survived until the early centuries of the Christian era.
H. J. P.

F. J. Bove, 'Laguna de los Cerros: An Olmec Central Place', *Journal of New World Archaeology*, 2 (1978), 1–56; D. C. Grove and others, 'Five Olmec Monuments from the Laguna de los Cerros Hinterland', *Mexicon*, 15 (1993), 91–5

2 | Open countryside in Luristan, Iran

The western periphery of the Iranian Plateau is inhabited by Kurds in the north, Lurs in the centre and by the Bakhtiyari tribal confederacy in the south. All of them speak related Iranian dialects but regard themselves as independent tribal groupings. In Luristan in particular, it was for the most part nomadic economies that survived away from the region's few cities, at least until the nineteenth century: the boulder-strewn mountain valleys, largely lacking in water, were best suited to keeping sheep and goats. There were small settlements from a very early period – the Elamite city of Madaktu is believed to have been located in the Saimareh Valley, while the impressive ruins of Derreshahr and Shirvan date from Sassanian and early Islamic times. But the most important archaeological sites are the large and often richly furnished graveyards that go back to the 5th millennium BC. The famous Luristan bronzes come for the most part from graves of the 2nd and 1st millennia BC. The casting technique of these bronzes is highly developed and their formal repertory exceptionally imaginative. The Assyrian rock relief of Shikaft-i Gulgul near Ilam is an example of the cultural interrelation with neighbouring Mesopotamia. Numerous ruins of Sassanian fire temples, some of them remote pilgrims' shrines commanding magnificent views of the western lowlands, suggest that the ancient Persian Zoroastrian religion withdrew to this region and that it continued to flourish here long after the Arab conquest.
D. H.

L. Vanden Berghe, 'Die Bronzen der Hirten und Reiter aus Luristan', *Teheran: Das Museum Iran Bastan* (Paris 1968), 102–23 (Archaeologia viva 1/1); C. Goff, 'Luristan in the First Millennium BC', *Iran*, 6 (1968), 105–34; P. Callmeyer, 'Luristan – Luristan Bronzen', *Reallexikon der Assyriologie* (Berlin and New York 1987–90), 6.174–99

3 | Hominid site on the River Omo, Ethiopia

The present picture shows the erosion gulleys on a plateau in the Omo Valley. (The green and white tents of the international research camp in the middle of the picture can be identified with some difficulty.) The Omo rises in southern Ethiopia and flows into Lake Rudolf in Kenya. It is part of the East African Rift Valley, which stretches from the valley of the Jordan River via the Red Sea and East Africa to Malawi in the south and which arose 15–20 million years ago when the African Plate broke up, accompanied by extensive vulcanism. As a result of erosion and sedimentation, this geological activity has left layers of the earth that are millions of years old on the surface. The palaeoanthropological layers above the camp provide insights into the earliest history of mankind. Early expeditions took place in the 1920s and 1940s but it was not until 1960 that the first systematic excavations were carried out. The hominid finds from the Shungura formation date from between 3.6 and 1 million years ago and proved a sensation when discovered by Coppens, Howell and Leakey in 1967. The lower jaw of Omo L-18 was evidence of a new species, *Australopithecus aethiopicus*, that lived 2.5 million years ago. The subsequent discovery of a lower jaw provided evidence of the earliest appearance of *Australopithecus boisei* 2.3 million years ago. Remains of *Australopithecus boisei* at Olduvai in northern Tanzania suggest that this species still flourished as recently as 1.2 million years ago. Two skull fragments discovered in a more recent layer, the Kibish formation of 200,000 to 100,000 years ago, are thought to be 130,000 years old, making them the oldest known remains of *Homo sapiens*, the species to which we ourselves belong.
T. St.

C. Arembourg, J. Chavaillion, Y. Coppens, *Premiers résultats de la nouvelle mission de l'Omo* (Paris 1967) (Compte Rendu d'Académie Scientifique de Paris); R. E. Leakey and R. Lewin, *Origins Reconsidered* (New York 1992); D. Johanson and B. Edgar, *From Lucy to Language* (New York 1996)

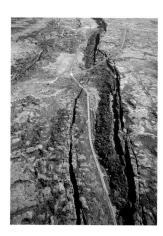

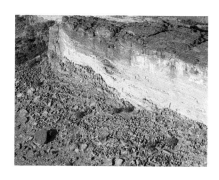

4 | The Thingvellir Parliament, Iceland

Some 50km to the east of Reykjavik, on the northern shores of the island's biggest lake, Lake Thingvallatan, lies the Thingvellir (Parliament Plain). Now covered with lava, this rift valley was created when the North Atlantic and Eurasian Plates drifted apart. In AD 930 it was chosen as the site of the world's first parliament, Iceland's legislative and judicial body, the Althing, which met here every year. All freemen were entitled to attend, making it the most important social event of the year. The national assembly met in the open air at the Lögberg (Law Rock), a natural assembly point within the valley. But the Althing had no executive powers, a vacuum that allowed internal power struggles to develop and that provided the basis of the Icelandic sagas that first found written form in the 13th century. In the year 1000 the Althing provided for a peaceful transition to Christianity, although pagan customs continued to be practised. Iceland lost its independence in 1262, when it swore allegiance to its new feudal overlord, the king of Norway. In 1380 Denmark assumed this role. In spite of this, the Thingvellir continued to be used for meetings until the Althing was disbanded in 1800. By 1845 it had been reconvened as an advisory body and still gives its name to the Icelandic parliament. Thingvellir, the birthplace of the nation, became Iceland's first national park in 1928, ten years after the island achieved independence.
T. St.

B. Radice, *Njals Saga* (London 1960); J. L. Byock, *Medieval Iceland: Society, Sagas and Power* (Berkeley 1988); T. M. Anderssen and W. Miller, *Law and Literature in Medieval Iceland* (Stanford 1989)

5 | Rock tombs at the Jebel Al-Khubtha in Petra, Jordan

The inhabitants of Petra, the capital of the Nabataean kingdom in the south of what is now Jordan, could rely on the defences of the fissured sandstone massifs that surround the town. A long, narrow, winding ravine known as the Siq is the only sizeable access to the town from the west. It leads through the rocky massif of the Jebel Al-Khubtha into the broad valley occupied by the town centre. Here lie the remains of houses and public buildings surrounded by the impressive tombs that are hewn into the walls of rock rising vertically upwards. These tombs were already much admired by 19th-century travellers. Particularly magnificent is the row of tombs in the 'King's Wall' on the western side of the Jebel Al-Khubtha, which creates the impression of a stage set. The lack of funerary inscriptions means that few of the occupants of these graves can be identified, but, to judge by the multi-storey façades modelled on hellenistic palaces like the one in the bottom centre of the picture, they must have been members of the aristocracy. Close by is a broad ceremonial stairway, cut into the rock and leading up to a small plateau with the ruins of a sacred site. Beside it lie the remains of a large cistern to collect rainwater, an important part of the city's water supply as the valley had few sources of fresh water. One of a small number of aqueducts ends in a cistern immediately next to the multi-storey Palace Tomb.
R. S.

G. Dalman, *Petra und seine Felsheiligtümer* (Leipzig 1908); I. Browning, *Petra* (London 1973); T. Weber and R. Wenning (eds.), *Petra: Antike Felsstadt zwischen arabischer Tradition und griechischer Norm* (Mainz 1997)

6 | Dogon settlements at Bandiagara, Mali

The heartlands of the Dogon are a plateau 200km long, 40km wide and up to 790m high in the south-eastern corner of Mali, near the border with Burkina Faso. Traditionally built in mud, their settlements are found both on the high plateau and on the surrounding escarpments. Captured by the French in 1893, Bandiagara now numbers 12,000 inhabitants and is the largest town on the plateau. The Dogon occupied their present settlement area in two migratory waves in the 11th and 15th centuries, an upheaval caused in part by the Arab-Muslim conquest of Ghana. An outstanding feature of Dogon architecture is the way in which it harmonizes with its environment on the strength of common social, religious and aesthetic ideas. This mimicry reflects the strategic aspect of the villages as defensive positions or 'camouflaged' settlements. The peasant population withdrew into inhospitable regions in order to protect itself and its faith from the onslaught of the Islamic equestrian nations. With its clearly differentiated types of building, ranging from the ancestors' house and men's quarters to the menstruation building, granary, smithy and so on, the Dogon village reveals a multifaceted social structure in a traditional settlement area that is now, however, under threat. A drought that has lasted since 1973 is forcing the Dogon into conurbations, and the resultant sale of valuable family implements and religious artefacts, together with tourism, is leading to the disappearance of an independent culture that has existed since AD 1100.
T. St.

L. Desplanges, *Le plateau central nigérien: Une mission archéologique et ethnographique au Soudan français* (Paris 1907); M. Griaule, *Dieu d'eau: Entretiens avec Ogotemmêli* (Paris 1948); W. Lauber (ed.), *Architektur der Dogon: Traditioneller Lehmbau und Kunst in Mali* (Munich and New York 1998) (exhibition catalogue)

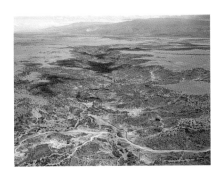

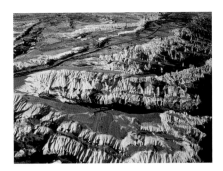

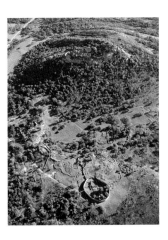

7 | The Olduvai Gorge, Tanzania

The Olduvai Gorge in northern Tanzania is 50km long and up to 90m deep. Part of the East African Rift Valley, it cuts across the Serengeti with its often sheer walls. Its palaeoanthropological importance was first noted by Kattenwinkel in 1911: nine geological layers record the last two million years in the earth's history and evolution. Stone tools were discovered in the 1930s, encouraging Louis Leakey to hope that hominid finds would also be made there. Some 28 years later, Leakey's wife, Mary, made the decisive discovery in the form of an almost complete skull 1.75 million years old and unlike any other hominid fossil known at that time. Described by Leakey as *Zinjanthropus boisei*, it is now generally known as *Australopithecus boisei*. Scarcely less sensational was the discovery in 1960 of the finger bones, teeth and jawbone of a 10- or 12-year-old youth some 1.75 million years old. The reconstructed cranial capacity and form of the teeth set him far apart not only from the australopithecines but also from *Homo erectus*, some 1.2 million years old and also found in Olduvai. Leakey's definition of the finds as *Homo habilis* was initially contested and not recognized until 1970. More recently it has again been called into question. Not only fossilized hominids have been found in the Olduvai Gorge, so too have their earliest classified stone tools. This stage in human development is known as Oldowan and dates from 2.5 to 1.5 million years ago.
T. St.

M. D. Leakey, *My Search for Early Man* (London 1979);
V. Morrell, *Ancestral Passions: The Leakey Family and the Quest for Humankind's Beginnings* (New York 1995);
B. A. Wood and M. Collard, 'The genus Homo', *Science*, 284 (1999), 65–71

8 | The landscape at Cappadocia, Turkey

The curious rock formations of Cappadocia in central Anatolia owe their origins to volcanic activity several million years ago. Chief among these now extinct volcanoes are Mount Argaeus (Erciyes Dagi) and Hasan Dagi. The resultant layers of tuff, basalt and andesite have been eroded and weathered by heavy rainfall and the extreme temperatures of Anatolia's hot summers and cold winters, producing the bizarre rocky landscapes familiar to us today. The curious pyramids and peaks result when the remains of a harder layer of rock protect the tuff beneath it, allowing erosion to take place only at the sides. In the course of time individual groups of peaks emerge from the solid layers of rock, the most resistant of which last the longest, until they too finally disintegrate as part of a never-ending process. This area has been settled since prehistoric times, the fertile volcanic soil being ideal for viniculture and citrus fruits. The Romans established the province of Cappadocia here in AD 17. During the unstable centuries of late antiquity, and especially from the time of the Arab invasions of the 7th century AD, these valleys became a place of refuge for thousands of Christians who built not only their homes in the soft tuff but also entire monasteries, chapels and churches, the murals of which are among the earliest examples of Byzantine religious art.
R. S.

J. Wagner, *Göreme* (Stuttgart 1979); B. Radt, *Anatolien 1* (Munich 1993)

9 | Ruins at Great Zimbabwe, Zimbabwe

Lying between granite mountains and the savannah, the ruins of Great Zimbabwe cover an area of some 40 ha in the south-eastern corner of Zimbabwe, approximately 300km east of Bulawayo. Stone walls transect the fertile site in an apparently random fashion between the 'Great Enclosure' in the south and 'Hill Complex' on the 90m high granite ridge in the background. The walls are made from flaked granite blocks piled up without the use of mortar to a height of almost 10m and a width of 5.2m and roughcast with daga, a mud-based building material common in Africa. These walls evidently served as courtyard boundaries, doorways and enclosures for round daga houses whose existence can be inferred archaeologically. The largest of the site's three main areas is the Great Enclosure whose outer wall was 244m in circumference. Three entrances gave access to an inner area subdivided into further enclosures of various shapes, at the southern end of which a massive, conical tower, 9m high, rises up among the trees. Great Zimbabwe was no doubt a seat of religious and political power and was laid out around AD 1000, later developing into a trade centre between the heart of Africa and the outside world. Imported finds from Indonesia, India, Persia and China confirm its international importance. A decline in trade led to the abandonment of the settlement in AD c1500. Archaeological excavations reveal that Great Zimbabwe was home to an autochthonous late Iron Age, south central African culture, thereby refuting the racial and biblical hypotheses that arose in the wake of its discovery by the geologist Georg Mauch in 1871.
T. St.

J. T. Bent, *The Ruined City of Mashonaland* (London 1892); P. S. Garlake, *Great Zimbabwe* (London 1974); R. J. McIntosh, 'Riddle of Great Zimbabwe', *Archaeology*, 51 (1998), 44–9, 72

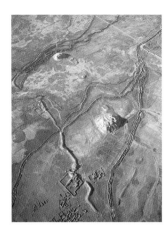

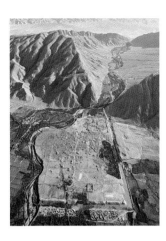

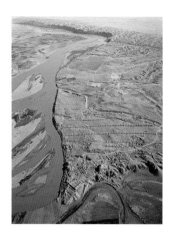

10 | The ruins at Nad-i Ali, Afghanistan

Some 6km north of Zaranj, the capital of the province of Nimruz, on the banks of the River Helmand that forms the border with Iran, lies the site of Nad-i Ali. Situated at the centre of an extensive, agriculturally fertile area, Nad-i Ali is a collective term for several ruins, the two most important of which may be seen between the fields and channels in the middle of the photograph. The larger of the two tells is called Sorkh Dagh (Red Hill), the smaller one Sefid Dagh (White Hill). All that remains of the large medieval settlement of Nad-i Ali is the eastern corner of the surrounding perimeter wall in the top right-hand corner of the picture. Officers from the British Border Commission report that according to legend the palaces of the two founders of the Saffarid dynasty (9th century AD) once stood here. According to a different tradition, the three tells were repeatedly raised as part of a competition to find the best position during a siege. Excavations undertaken in Sorkh Damb in 1936 and 1968 revealed that the 39m high Sorkh Dagh consists in essence of a platform of unfired mud bricks. The two major phases in the site's settlement history have been dated by ceramics and bronze artefacts such as arrowheads to the time of the Medes and Sassanians in the 8th century BC and the 6th/7th centuries AD. But scattered finds indicate that there were settlers here as early as the late 3rd millennium BC. The major sites on the Iranian side of the border show that the region played an important role in cultural developments, first as a centre for autochthonous cultures, later as a frontier post of the western empires on their journey east.
U. F.-V.

G. F. Dales, *New Excavations at Nad-e Ali (Sorkh Dagh), Afghanistan* (Berkeley 1977) (Research Monograph Series: Center for South and South-East Asia Studies. University of California 16); R. Ghirshman, 'Fouilles de Nad-i Ali dans le Seistan Afghan', *Revue des arts asiatiques*, 13/1 (1942), 10–22

11 | The Sassanian city of Bishapur, Iran

Politically, economically and culturally, the Sassanian kingdom enjoyed a golden age under Ardashir's son Shapur I (AD 240–72). The remote settlement of Ardashir Khurreh was soon overshadowed in importance by the kingdom's new centre at Ctesiphon in Mesopotamia. As his official seat of power, Shapur built a new city, Bishapur, on the plains of Kazarun. In the gorge behind the city Shapur proclaimed his victories over the Romans in a series of rock reliefs. Roman prisoners of war helped to build the palaces and temples, with the whole city designed along Hippodamian lines. The ruins of Shapur's fortified palace lie on a rocky spur above the present highway. Within the city itself, French and Iranian excavations in 1933–40 and since 1998 have revealed a magnificent complex of buildings that was initially believed to be a palace but which is in fact the largest Sassanian fire temple that we know. At the intersection of the two main streets is a column in honour of Shapur, its inscription giving AD 266 as the year in which the city was founded. The north-western side of the city is protected by the river that the cardo maximus crossed on a bridge. The moat on the south-eastern and south-western sides was fed by the river by means of a tunnel dug beneath the rock on which the palace was situated. At the entrance to an enormous dripstone cave in the rocky ridge above the broad river valley behind the city stands an 8m statue of Shapur hewn from a single stalactite. The cave may have been his funeral chamber.
D. H.

R. Ghirshman, *Bichapour*, 2 vols. (Paris 1956–71); R. Ghirshman, *Iran: Parthians and Sassanians* (London 1962), 137–68; D. Huff, 'Sassanidische architektuur', *Hofkunst van de Sassanieden/Splendeur des Sasanides* (Brussels 1993), 45–61 (exhibition catalogue)

12 | The city of Ashur, Iraq

The ancient capital of the Assyrian Empire stands on a natural elevation high above the west bank of the Tigris. Not far from the confluence of the Tigris and its tributary, the Lower Zab, some 100km south of Mosul, near the modern village Qala'at Shergat, a first urban settlement developed during the 3rd millennium BC. By the 2nd millennium BC it had become a magnificent royal residence. Temples and palaces occupied the whole of the northern side of the city (visible at the lower edge of the photograph). Here the escarpment falls away steeply towards a branch of the Tigris that nowadays normally dries up completely. The temple of the local deity, Ashur, stood on the spur overlooking the Tigris. To its right is the ziggurat dedicated to the god Enlil. Its shadow can be made out in the present photograph, which was taken in the early morning sun. The city was protected on two sides by the raging floodwaters of the Tigris and required additional defences only on its landward side. The city walls still survive as a steep embankment and describe a wide arch from the northern front (beyond the right-hand edge of the photograph) to the banks of the Tigris in the south. Excavations undertaken by Walter Andrae on behalf of the German Orient Society between 1903 and 1914 are still regarded as models of their kind. The residential quarters were examined in long, exploratory trenches dug at regular intervals. These clearly mark out the area of the city in the photograph above. In the distance, at the point where the Tigris breaks through the Maqhul Mountains, a dam was under construction when Saddam was overthrown. This megalomaniac project, which would have resulted in a gigantic lake, drowning large parts of Assyria, including its capital, was stopped. Virtually at the last moment Ashur was saved from being swept away by the current. Recently Ashur was added to the United Nations' list of World Heritage Sites.
M. M.-K.

W. Andrae, *Das wiedererstandene Assur* (Leipzig 1938), 2nd edn ed. W. Hrouda (Munich 1977); P. O. Harper and others (eds.), *Discoveries at Ashur on the Tigris: Assyrian Origins. Antiquities in the Vorderasiatisches Museum, Berlin* (New York 1995)

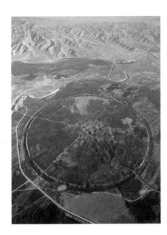

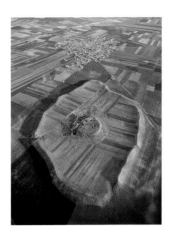

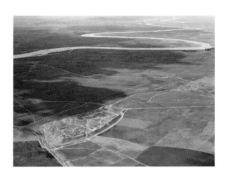

13 | **The Sassanian city of Gur/Firuzabad, Iran**
'And he, Ardashir, laid his city's foundations in the shape of a circle, as though drawn with a pair of compasses.' Thus Ibn al-Balkhi, writing in the 12th century, described the first Sassanian city, Ardashir Khurreh (or 'Gur'), which was renamed Firuzabad in the 10th century. The usurper Ardashir Papakan ('Artaxerxes') seized control of the whole of southern Iran in the early 3rd century AD, draining the marshy plain and building a city some 2km across. The Parthian king Artabanus V (AD 213–24) initially tolerated his rebellious subject's crimes, but the foundation of a city that the latter called Ardashir Khurreh – the 'Light of Ardashir's Good Fortune or Victory' – was one step too many. Only kings were allowed to found cities – the Persian word for city, 'Shahr', contains within it the title 'king': Shahristan, for example, means 'the king's place'. In the decisive encounter between the two men, Ardashir single-handedly killed his overlord and had himself appointed 'king of kings of Iran'. Archaeological excavations confirm reports that the area around Gur was drained and turned into farmland. The city is divided into 20 parts, radially structured and extending over the entire plain, which is crossed by pathways, drainage ditches and irrigation channels. Even the legendary tunnelling of a mountain is true: it enabled an arid valley to be irrigated. The tower at the heart of the city was essential for measuring the radial lines, but it no doubt also had a symbolic significance, as did the circular shape of the city: Ardashir wanted to create a reflection of his notion of a world order that he felt God had called on him to realize. The tower is the symbol of the king as the regent of God, ordering, tending and protecting the world.
D. H.

D. Huff, 'Zur Rekonstruktion des Turmes von Firuzabad', *Istanbuler Mitteilungen*, 19/20 (1969/70), 319–38; D. Huff, 'Firuzabad', *Encyclopaedia Iranica* (London 1999), 9.633–6

14 | **The city of Ebla, Syria**
The ruins at Tell Mardikh, some 65km south-west of Aleppo, were identifed as Ebla in 1968 following the discovery of a basalt torso with a cuneiform inscription naming one of its kings. It was not until 1964 that archaeologists from Rome's 'La Sapienza' University discovered this site and started to excavate it. Six major periods have been discovered, beginning in the Early Bronze Age (c2375–2250 BC). Particularly important is an archive of more than 17,000 cuneiform texts found in one of the palace complexes from this period. Ebla once again enjoyed the status of a major power in the 18th century BC, before being sacked by the Hittites around 1600 BC and sinking into obscurity. The ruins lie in the middle of a fertile plain in northern Syria and are an example of a typical ringed hill in which a central elevation – the acropolis – is surrounded by massive, if irregular, ramparts some 3km long. The area within these ramparts covers an area of around 700 x 900m and is now used as farmland by the inhabitants of Mardikh. Only small parts of it have so far been excavated, but these include the acropolis, areas at the foot of the central elevation within the ruins and two of the town gates (the south-west gate to the left of the picture and the south-east gate towards the lower right-hand corner). In the western section of the area under excavation (marked out with a grid) the remains of a building (Palace Q) have been discovered that was destroyed by fire but which contains an undam-aged necropolis.
R. W.

P. Matthiae, *Ebla: An Empire Rediscovered* (London 1977); G. Pettinato, *The Archives of Ebla: An Empire Inscribed in Clay* (New York 1979); P. Matthiae and others (eds.), *Ebla: Alle origini della civiltà urbana. Trent'anni di scavi in Siria dell'Università di Roma 'La Sapienza'* (Milan 1995) (exhibition catalogue)

15 | **The new Assyrian capital of Nimrud, Iraq**
Forming a series of wide horseshoe bends, the Tigris now flows several kilometres to the west of the ruined city of Nimrud. When King Ashurnasirpal II (883–859 BC) chose Kalkhu as the new capital of his Assyrian Empire, its western side was protected by the river. Ashurnasirpal, like his predecessors, had previously ruled the kingdom from Ashur, 70km downstream. The new royal residence was surrounded by a massive city wall 8km long. The palace itself – the North-West Palace, on the left of the photograph – was built on the site of an older settlement. Here archaeologists working for the Iraqi Department of Antiquities recently found the intact graves of three Assyrian queens, including that of the wife of Ashurnasirpal himself. The brick vaults were beneath the floor of the rooms that were apparently occupied by the queens during their lifetimes. The breathtaking splendour of the grave goods allowed us our first insight into the lavish magnificence that was typical of an Assyrian court. Alongside the North-West Palace, a whole series of other public buildings and temples was discovered on the citadel, including the ziggurat dedicated to Ninurta. The city wall connects the citadel in the south-west corner of the capital with the north-west corner (near the excavated area on the right of the photograph). The photograph shows around a fifth of the city, the greater part of which extends to the right of the picture. Kalhu was the centre of the Assyrian Empire for some 150 years, until Sargon II moved the capital to Dur Sharrukin (now Khorsabad) to the north of Mosul in 717 BC. The once magnificent city fell into obscurity following the decline of the Assyrian Empire.
M. M.-K.

A. H. Layard, *Nineveh and its Remains* (London 1849); M. S. B. Damerji, *Gräber Assyrischer Königinnen aus Nimrud* (Mainz 1999), 1–84 (Jahrbuch des Römisch-Germanischen Zentralmuseums 45); J. and D. Oates, *Nimrud: An Assyrian Imperial City Revealed* (London 2001)

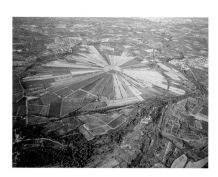

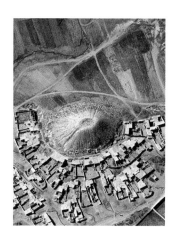

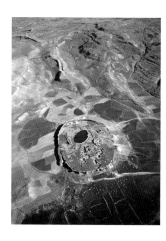

16 | The oppidum at Ensérune, France
The wooded hill at Ensérune rises to a height of
more than 100m above the surrounding plain and
forms a plateau pointing eastwards. First excavated
in the early years of the 20th century, the remains of
the oppidum extend over 600m to either side of the
museum. The hill's natural height allowed it to
dominate an area much changed since antiquity.
The lake at Montady was not drained until the 13th
century and can easily be identified by the radiating
ditches that allowed the water to drain away
towards the centre before it was channelled away
through a tunnel dug at the furthest edge of the hill.
The oppidum was founded in the middle of the 6th
century BC and from around 425 BC was rebuilt as a
carefully ordered town enclosed by a rampart. In
spite of this it remained open to Mediterranean
influences. Its cemetery, with its rich find of inurned
burials, occupied the western part of the plateau.
The town was again rebuilt around 225 BC, when it
was extended in both a westerly and a southerly
direction. It enjoyed a certain renaissance following
the Roman conquest, when large cisterns and
Italianate houses were built and the Latin alphabet
was adopted to the detriment of Iberian. At this
date in its history the town dominated the Domitian
Way, the straight line of which still cuts through
the countryside today (top right; see also no. 54).
The town then went into rapid decline and was
abandoned during the second half of the 1st
century AD.
J.-L. F.

J. Jannoray, *Ensérune: Contribution à l'étude des civilisations
préromaines de la Gaule méridionale*, 2 vols. (Paris 1955);
M. Schwaller, *Ensérune: Carrefour des civilisations protohis-
toriques* (Paris 1994), 107 (Guides archéologiques de la
France 28)

**17 | Tepe (settlement mound) at Cheqa Narges,
Mahidasht, Iran** Ancient settlements form settle-
ment mounds, and old settlement mounds form
new settlements. The tepe at Cheqa Narges, some
10km north-west of the town of Mahidasht near
Kermanshah, has an almost classical frustum
shape. The aerial photograph shows that its fairly
steep contours are probably due to a fortification
subsequently placed on its summit. Its oval ring-
wall is still clearly identifiable. It has formed a
depression in which rainwater collects. This water
then drains away through what is presumably the
former gateway, leaving a deep gully in the hillside.
For today's Kurdish village, the mound provides a
protective rear wall. The area at its feet is used to
collect clay for house building and to dig pits for
cowsheds, storerooms and kennels. The region of
Mahidasht, literally 'fish plain', is largely unexcavat-
ed. It has less water and is less fertile than the
neighbouring region around Kermanshah, the politi-
cal and cult-ural centre of north-west Iran in ancient
and early medieval times, where archaeological
finds from every period have been discovered in
large quantities. None the less, ceramics found in
the Mahidasht region indicate that there were
human settlements here as early as the 5th millenni-
um BC.
D. H.

E. Henrikson, 'An Updated Chronology of the Early and
Middle Chalcolithic of the Central Zagros Highlands, West-
ern Iran', *Iran*, 23 (1985), 63–108; I. A. Brookes, *The Physical
Geography, Geomorphology and Late Quaternary History of
the Mahidasht Project Area, Qara Su Basin, Central West Iran*
(Toronto 1989), 35–8

**18 | The Sassanian imperial sanctuary at Takht-i
Suleiman, Iran** During the late Sassanian period,
the most venerated of all Iran's Bahram fires, the
Atur Gushnasp (the 'Fire of the Stallion'), burned
on the banks of a lake situated in a mountain valley
2000m high between Bidjar and Miandoab. The
lake was approximately 70m deep and had a water
temperature of 21°C. The sanctuary was described
by Sir Robert Ker Porter, Sir Henry Rawlinson and
others in the 19th century, but it was left to Pope's
American expedition to examine the ruins in 1937.
German and Swedish archaeologists excavated the
site between 1960 and 1978 and confirmed the tra-
ditional association of the Sassanian royal house
with the Atur Gushnasp, which is described in early
chronicles as the fire of warriors and horsemen and
the most favoured place of pilgrimage by the late
Sassanian kings. The sanctuary lies between two
temple areas, a smaller one for ordinary pilgrims,
and a larger one for the king and his courtiers. This
larger area included not only the lake but also a
palace with an audience chamber, a raised throne
in front of the Gushnasp Temple and a second fire
temple evidently reserved for the king and his ret-
inue. The buildings were originally made of mud
bricks, but following the suppression of the socio-
religious Mazdakite uprising by Khosro I (AD
531–79), these were gradually replaced by stone.
The Byzantine emperor Heraclius captured and
destroyed the fortified temple in around 626.
According to Heraclius' own report on his cam-
paign, the then Sassanian king Khosro II, who had
sought refuge there, escaped, 'taking with him the
magic fire and the national exchequer'. In 1265 the
Mongol ruler Abaqa Khan drove the now Islamic
population from the town and erected on the
Sassanian ruins what is now Iran's best-preserved
medieval palace.
D. H.

R. Naumann, *Die Ruinen von Tacht-e Suleiman und Zendan-
e Suleiman* (Berlin 1977); D. Huff, 'Takht-i Suleiman: Tem-
pel des sassanidischen Reichsfeuers Atur Gushnasp',
*Archäologische Entdeckungen: Die Forschungen des Deutschen
Archäologischen Instituts im 20. Jahrhundert*, 1 (2000), 103–9

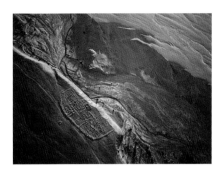 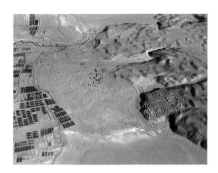 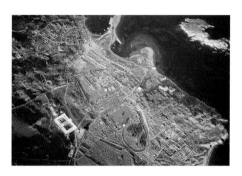

19 | **Caserones in the Quebrada de Tarapacá, Chile**

The evening sun catches the 'big houses' at Caserones above the Tarapacá Gorge, which starts on the western slopes of the cordilleras and fades away in the coastal plateau to the north-east of Iquique. This desert region has the least precipitation of any part of the world, and at 1300m above sea level human life can survive in only a handful of oases. To judge by their woven fabrics made out of camelid wool, geometrically decorated baskets and, at a later date, their simple ceramics, the settlers belonged to the Faldas del Morro culture first found 200km away on the slopes of the famous hill at Arica. They collected the fruit of the algaroba tree but also grew maize, which they traded for fish. During the pre-Christian era there was enough wood for post-built houses, but after that the only building materials were sods of nitreous earth and pebbles set in mud. This community flourished between the 2nd and 6th centuries AD. To the north of the site (on the right of the picture) were two parallel rows of buildings, while in the south something similar can be made out in the pattern of the approximately rectangular rooms, perhaps indicating a dualistic trend in the inhabitants' social structure. Only two round buildings are visible. The erection of two parallel defensive walls, with bastions, in the 7th/8th centuries may relate to the expansion of Tiahuanaco on the Bolivian Altiplano. These walls are still 1.2m high. Measuring 312 x 122m, they also offered ample and secure space for llama pens. The settlement appears to have died out around AD 1100, perhaps at a time of exceptional drought. The separate area close to the escarpment, with its gable house measuring 15 x 15m and forecourt, dates to the Inca or Spanish colonial period as the plaster coating contains sheep droppings, which are found throughout the settlement – the ruins continued to be used as a shelter by shepherds until very recently.
H. B.

L. A. Nuñez, 'Caserones-1: Una aldea prehispánica del norte de Chile', *Estudios Arqueológicos*, 2 (1966), 25–9; D. L. True, 'Archaeological Investigations in Northern Chile: Caserones', *Prehistoric Trails of Atacama: Achaeology of Northern Chile*, ed. C. W. Meighan and D. L. True (Los Angeles 1980), 139–78

20 | **The Pukara de Turi in the Loa Valley, Chile**

Situated on the western slopes of the cordillera 3000m above sea level, the walled settlement (pukara) at Turi dominates an oasis created by a spring near the the upper Loa, the only river to flow through the Atacama Desert. Traces of earlier fields and llama pens can be seen at the foot of the hill. Leading off from the oasis, at least two alleys give access to the confused mass of more than 600 courtyards and rooms built in an irregular cell-like formation over an area of 215 x 180m. The settlement was founded in the 10th century by shepherds and farmers of the Atacama culture. Unidentifiable in the photograph are the small towers from the second building phase around 1300 in the upper part of the settlement (on the right), which attest to immigration or increased influence from the neighbouring uplands and which have been interpreted as sacrificial sites dedicated to the mountain gods. Many towers were destroyed when a rectangular area was levelled off under Inca domination in the 15th/16th centuries: the Inca preferred to offer their sacrifices on the mountain peaks themselves. The towers were replaced by a large three-door building made from mud bricks, rather than the rubble walls usual in Turi. Covering an area of 26.4 x 8.9m, it had gables rising to over 5m and was one of the largest Inca buildings in Chile. Its orientation suggests some relation with the sun cult, although such halls are normally assumed to have been multipurpose and to have been used for drinking sessions, too. Like a neighbouring complex that dates to the same period, the courtyard is completely cut off from the settlement and accessible only from the Inca road to the east. On the other side of the road, which is 5m wide at this point, a walled hill may have formed part of the same complex.
H. B.

G. Mostny, 'Ciudades atacameñas', *Boletin del Museo Nacional de Historia Natural*, 24 (1949), 125–212; F. I. Gallardo and others, 'Arquitectura Inka y poder en el Pukara de Turi, norte de Chile', *Gaceta Arqueológica Andina*, 24 (1995), 151–71; C. Aldunate del Solar, 'Tawantinsuyu Dominion Over Turi', *In the Footsteps of the Inka in Chile*, ed. C. Aldunate and L. E. Cornejo (Santiago de Chile 2001), 38–43

21 | **The Temple of Apollo on Delos, Greece**

Situated at the centre of the ring of islands known as the Cyclades, Delos was regarded by the ancients as the birthplace of Apollo and Artemis and by the 7th century BC was one of the god's most important sanctuaries. Between 478 and 454 BC Athens entrusted the exchequer of the Delian League to his protection. French archaeologists first excavated the site in 1873. The Sacred Harbour provided the only access to the precinct, with its Temples of Apollo, Artemis and their mother Leto, together with the halls and treasuries in the centre of the picture. Beside it lies a second, commercial harbour, from which a residential quarter full of winding streets leads to the theatre on the left of the picture. Around the centre are grouped sanctuaries to other gods, sportsgrounds for the competitions held on the occasion of the festivals that took place on a regular basis in classical times, residential dwellings, large villas of the kind visible in the lower right-hand corner of the picture, and also market-places, where members of the most varied mercantile associations met. The island owed its great wealth to its favourable situation but above all to the fact that in 166 BC it was made a free port by the Roman Senate, thereby overturning the hegemony of Rhodes as a trade centre. The Roman merchants who used it had their own large agora, identifiable at the foot of the photograph as a self-contained area beside the Sacred Lake, which has now been cordoned off. In the 2nd century BC Delos was the centre of the Greek slave trade and up to 10,000 individuals are said to have been sold here every day. Delos was sacked by Mithridates VI in 88 BC. Pirates wrought further devastation in 69 BC, and from this the island never recovered.
R. S.

L'exploration archéologique de Délos (Paris 1909—); H. Gallet de Santerre, *Délos primitive et archaïque* (Paris 1958); P. Bruneau and J. Ducat, *Guide de Délos* (Paris 3/1983)

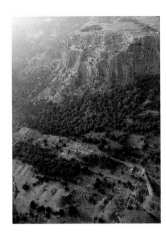

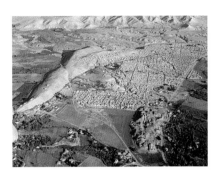

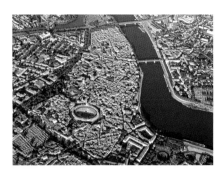

22 | The city and acropolis of Priene, Turkey

Priene had to be refounded on the northern edge of
the Latmic Gulf in the middle of the 4th century BC
after the River Meander flooded the harbour of the
earlier city to the east. In keeping with the rules of
classical urban architecture, the houses and public
buildings of the new city were laid out in a Hippo-
damian grid pattern, involving rectangular blocks
of houses that were all of equal size. The main
municipal buildings lined the three roads running
from east to west that are still clearly visible. The
theatre is situated at the point where the escarp-
ment starts to rise sharply. The nearest of the
parallel streets to the south leads past the bouleu-
terion (town hall), with its rectangular groundplan,
to the Temple of Athena, which lies on its own
terrace within a sacred precinct towards the centre
of the picture. It was planned by the famous archi-
tect Pytheos and was still unfinished when
Alexander the Great visited the city in 334 BC. He
contributed to its building costs in return for
permission to quote his name in a dedicatory
inscription on the temple wall. It was here, in 1765,
that Richard Chandler began his excavations for the
Society of Dilettanti. A further English team visited
the site in 1868/9, followed between 1894 and 1899
by Carl Humann and Theodor Wiegand. The broad
thoroughfare further south leads past the agora, the
main square, which contained numerous
monuments and, at its eastern extremity, a Temple
of Zeus. The whole city was encircled by a wall that
also included the fortress of Teloneia on the summit
of the rock. The fortress can still be reached from
the city today by a steep and winding stairway cut
into the sheer rock wall.
R. S.

T. Wiegand and H. Schrader, *Priene* (Berlin 1904); M.
Schede and others, *Die Ruinen von Priene* (Berlin 2/1964);
F. Rumscheid, *Priene: A Guide to the 'Pompeii of Asia Minor'*
(Istanbul 1998)

23 | Tell es-Sultan/Jericho, Palestine

Close to the modern city of Jericho in the Jordan
Valley and at the edge of the Judaean Desert lies the
Tell es-Sultan (visible in the lower right-hand corner
of the photograph), the site of what is arguably the
oldest city in the world and certainly the oldest
proto-urban large-scale settlement known to us.
The earliest settlement, including houses, a fortified
wall and a large tower, dates back to the Pre-pottery
Neolithic period in the late 9th millennium BC. This
marks the beginning of one of the great upheavals
in human history, the Neolithic Revolution, when
man settled down and began to till the land. The tell
– an artificial mound created by rebuilding human
settlements that have been destroyed on the same
site – lies just next to a spring that continues to this
day to ensure that the site is a fertile oasis. It was
presumably the optimal conditions of a warm
climate, a spring and the fertility of the land that
made the site suitable as a place for a settlement
based on agriculture. Settlements can be identified
on the tell more or less continuously until Persian
times. One gap in our knowledge is the period
when the Israelites came into possession of the
land. At the time when Joshua marched round the
city with trumpets, it had already lain in ruins for
several centuries. The biblical story is evidently a
historical construct, but it meant that interest in the
ruined mound continued throughout the Judaeo-
Christian tradition, even after the settlement had
been rebuilt in the region of the modern town
during the hellenistic period.
A. L.

E. Sellin and C. Watzinger, *Jericho* (Leipzig 1913); K. M.
Kenyon, *Digging up Jericho* (London 1957); I. Finkelstein
and N. A. Silberman, *The Bible Unearthed: Archaeology's
New Vision of Ancient Israel and the Origin of Its Sacred Texts*
(New York 2002)

24 | The Roman city of Arles, France

Situated at the foot of the Rhône delta, Arles enjoys
a particularly advantageous geographical position.
In classical times it was the first port encountered
by sailors coming from the Mediterranean. By the
middle of the 6th century BC it had become a
trading centre for Greeks and locals. The hellenistic
settlement, of which little is known, became a
colony of the 6th Roman Legion in 46 BC (Colonia
Julia Paterna Arelate Sextanorum). The main build-
ings – the forum, theatre and city wall – and the
chequerboard layout of the town seem to date from
between 50 and 30 BC. The amphitheatre (in the
middle of the photograph) dates from a second
building phase around 80 AD, while the circus to
the south-west of the centre (in the top centre of
the photograph) was not started until 149 AD. On
the western bank of the river lay the suburbs, whose
luxury villas were decorated with rich mosaics.
Warehouses now line the banks of the Rhône. The
city was pillaged in the 3rd century but restored by
Constantine, who made it his principal residence.
Its bishopric dates from the 1st century, its elevation
to the seat of the prefecture of the Gauls from the
end of the 4th. Arles also had its own mint. At this
period, too, its ring-wall was rebuilt on a smaller
scale. The best known and best preserved buildings
are now the cryptoporticus beneath the forum; the
Augustan theatre that could seat 10,000 spectators
on a cavea 102m in diameter; and the amphitheatre
measuring 136 x 107m and based on the original
plans for the Colosseum in Rome: capable of
seating 20,000 spectators, it is still two storeys
(21m) high. The cemetery at Alyscamps recalls
ruined Romantic landscapes.
M. R.

P. Gros, 'Un programme augustéen: Le centre monumen-
tal de la colonie d'Arles', *Jahrbuch des Deutschen Archäolo-
gischen Instituts*, 102 (1987), 339–63; C. Sintès (ed.), *Musée
de l'Arles antique* (Arles 1996); M. Heijmans, 'La topogra-
phie de la ville d'Arles durant l'antiquité tardive', *Journal of
Roman Studies*, 12 (1999), 142–67

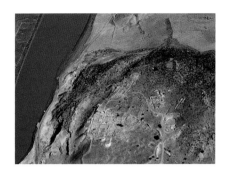

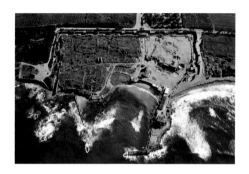

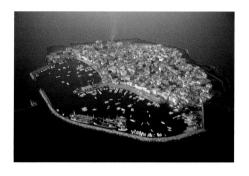

25 | Ruins at Lixus, Morocco

The ancient site of Lix or Lixus lies c80km south-west of Tangiers close to the modern town of Larache on the River Lixus, only 4km from the Atlantic Ocean. Lixus was one of several classical sites associated with the mythical Garden of the Hesperides and with Hercules's battle with the giant Antaeus. According to ancient tradition, Lixus and Gades (modern Cadiz) were two of the oldest Phoenician settlements in the west, although the given date of c1100 BC has not been archaeologically verified. Traces of human habitation have been dated to the 8th century BC. Lixus was famous for its sanctuary to Melqart Hercules. After belonging to the kingdom of Mauretania and suffering devastation at the time of the late republic and early principiate, Lixus enjoyed its period of greatest prosperity under provincial Roman rule in the 2nd and 3rd centuries AD. Like many ancient towns and cities along the Atlantic coast to the north and south of the Pillars of Hercules (now Gibraltar), Lixus was an important fish-processing centre and especially associated with the production of garum, a basic spice of Roman cooking produced from salted sun-dried fish. During the 3rd and 4th centuries the population declined dramatically, although the town could still boast the oldest mosque yet to have been identified in western North Africa. In the 19th century the ruins of Lixus were often mentioned in travellers' tales, although archaeological excavations have suffered many delays and interruptions.
S. A.

M. Tarradell, *Lixus: Historia de la ciudad. Guía de las ruinas y de la seccion de Lixus del Museo arqueológico de Tetuán* (Tetuán 1959); *Lixus: Actes du colloque organisé par l'Institut des Sciences de l'Archéologie et du Patrimoine de Rabat* (Larache 1989 and Rome 1992)

26 | The port at Caesarea, Israel

The town of Caesarea was founded in 22 BC by Rome's Jewish client king, Herod the Great. Its foundation was an urgently needed step in the direction of binding his kingdom to the Roman Empire and proved highly successful, the quay walls of the vast artificial harbour projecting at least twice as far into the sea as the medieval walls seen in the present photograph and helping to transform Caesarea into the most important Roman harbour in the Levant. Additionally, Herod erected numerous public buildings, together with a palace for his own use. The town was dominated by a temple to Emperor Augustus on a terrace overlooking the port. It prospered until the Byzantine period, and only in the wake of the Persian conquest in AD 614 did its population leave. By the 10th century the town's fortunes had revived, and it regained some of its old importance following its capture by the Crusaders in 1101. To this period dates the impressive town wall identifiable in the photograph. By now, however, the town was much smaller than it had been in Roman and Byzantine times. The Temple of Augustus had been built over by an octagonal church during the Byzantine period, only for the Crusaders to replace it in turn with a three-aisled cathedral, its eastward-pointing apses still recognizable in the picture in the southern part of the town. The Crusaders were driven out in 1265, and the town then sank into total obscurity.
A. L.

J. Ringel, *Césarée de Palestine: Étude historique et archéologique* (Paris 1975), 165–74; A. Raban and K. G. Holum (eds.), *Caesarea Maritima: A Retrospective after Two Millennia* (Leiden 1996)

27 | The island of Arwad/Ruad, Syria

Some 800m in length, the island of Arwad lies barely 3km offshore from the port of Tartus. First mentioned as Aruada in cuneiform texts of the 2nd millennium BC, the island has always been closely bound up with the political history of the coastal towns and their empires. The heyday of this small island state is to be found in the early 1st millennium BC, when the Phoenician Arwad became one of the main ports on the Syrian coast and an important maritime power. Among the many trading outposts that Arwad founded on the mainland were Antarados (Tartus), Paltos, Amrit, Gabala and Balanaia, their principal aim being to supply the island with food and water. History also recounts that sailors from Arwad fought under Xerxes in the Battle of Salamis against the Greeks in 480 BC and that from 1291 to 1302 the island was the last bastion of the Crusaders. Until now the modern buildings and medieval fortifications have largely prevented the island from being excavated. At the edge of the confused mass of houses, close to the port, is a small Arab fort. The larger fortress from the 12th or 13th century can be identified in the middle of the picture as a clearly structured recti-linear building with an inner courtyard and corner bastions. Walls designed to protect the island from the power of the sea probably date back to Phoeni-cian times, and remains of these can be made out on the shoreline and in the water, especially on the western side of the island facing the open sea.
R. W.

H. Frost, 'Ruad, ses récifs et mouillages: Prospection sous-marine', *Les annales archéologiques de Syrie*, 14 (1964), 67–74; J.-P. Rey-Coquais, *Arados et sa Pérée aux époques grecque, romaine et byzantine* (Paris 1974)

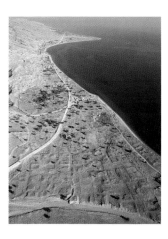

28 | **The port at Siraf/Bandar Taheri, Iran**

The coast of the Persian Gulf has generally been avoided by the Iranians as a settlement area on account of its hot and humid climate but has always played an important role in Iran's maritime trade and in the country's defences. The ports founded here by the Sassanian kings between the 3rd and 7th centuries AD also served as a base from which to launch their punitive expeditions against pirates and to subject the Arab principalities on the opposite shore. One such Sassanian maritime base came to light when an English team excavated the medieval Siraf, some 200km south-east of Bushir, between 1966 and 1973: it was a castle defended by round bastions with a fortified settlement.

According to legend, the name Siraf derives from the mythical king Kaikaus who, following his failed attempt to use eagles to help him to fly, begged here for milk and water – 'shir' and 'ab'. During the early Middle Ages, maritime trade with India, Ceylon, China and East Africa turned Siraf into the leading trade centre for the whole of Iran. Chronicles of the time describe it as the wealthiest city in the country. The urban area from the riverbank in the foreground of the photograph to the point at which the shoreline starts to curve was densely built with mosques, warehouses and multi-storey houses made of wood imported from Africa. Vast necropolises of rock-cut tombs continue to this day to cover the mountain slopes. But the city's wealth also meant that its inhabitants' morals and lifestyle were held in low esteem far beyond the country's frontiers, and the earthquakes that devastated the area in the late 10th century and from which the city never fully recovered were regarded as a divine punishment.

D. H.

P. Schwarz, *Iran im Mittelalter nach den arabischen Geographen* (Leipzig 1896, repr. Hildesheim and New York 1969), 59–64; A. Stein, *Archaeological Reconnaissances in North-Western India and South-Eastern Iran* (London 1937), 202–12; D. Whitehouse, 'Excavations at Siraf: Sixth Interim Report', *Iran*, 12 (1974), 1–30

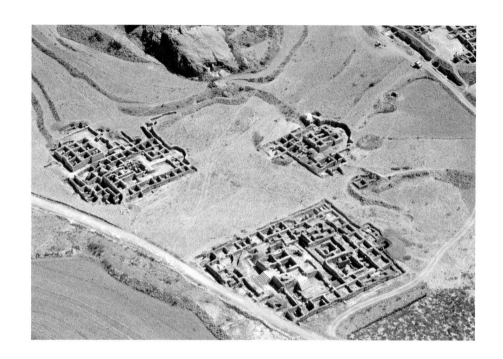

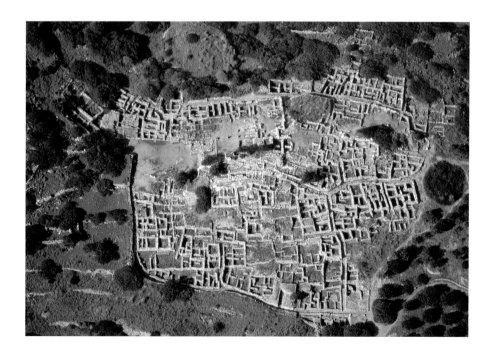

29 | **The town of Matara, Eritrea**, from the 6th century AD, Ethiopia, 1965

30 | **The Minoan town of Gournia on Crete**, 17th–15th century BC, Greece, 2000

2. VILLAGES AND TOWNS –

SETTLEMENT TYPES

Saith the Lord:

'And shall not I spare Ninive, that great city, in which there are more than a hundred and twenty thousand persons that know not how to distinguish between their right hand and their left, and many beasts?'

The Prophecy of Jonas 4:11 (5th century BC)

Most people here in Rome perish for want of sleep, the illness itself having been produced by food lying undigested on a fevered stomach. For what sleep is possible in such a lodging? Who but the wealthy get sleep in Rome? There lies the root of the disorder. The crossing of wagons in the narrow winding streets, the slanging of drovers when brought to a stand, would make sleep impossible for a Drusus – or a sea-calf.

Juvenal (AD 67–138), 'Unbearable Rome', *Satires*

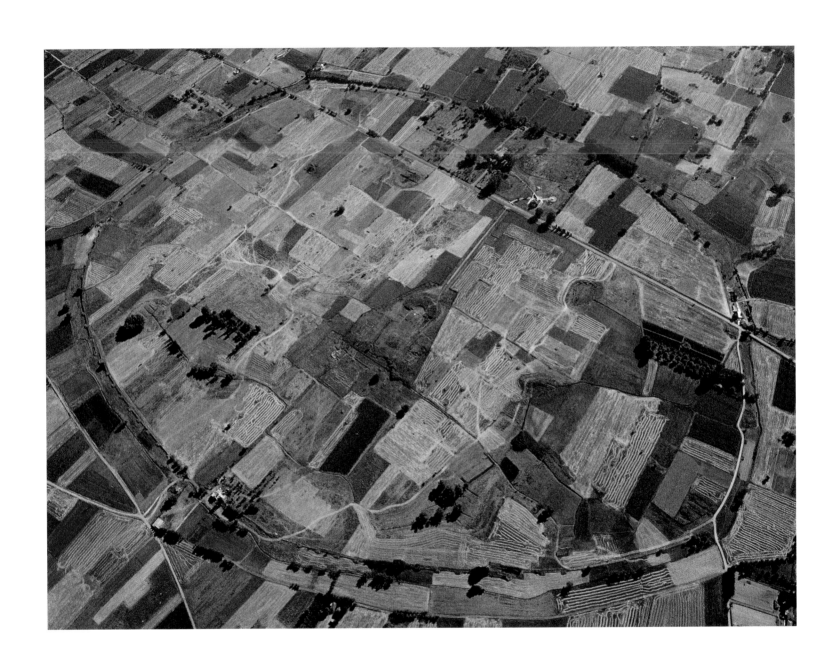

31 | **The town of Mantineia in Arcadia**, 5th–4th century BC, Greece, 2001

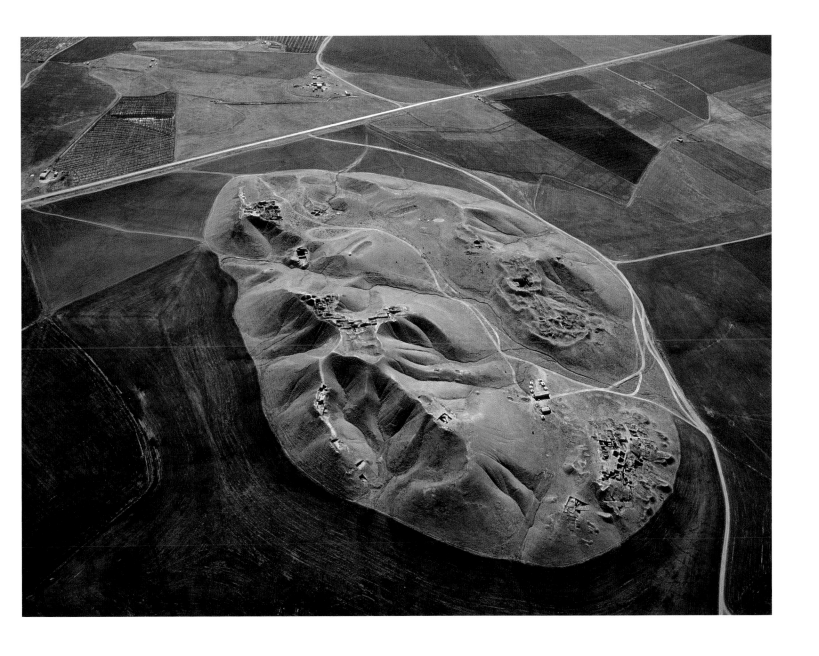

32 | **The settlement mound at Tell Brak**, from second half of 4th millennium BC, Syria, 1997

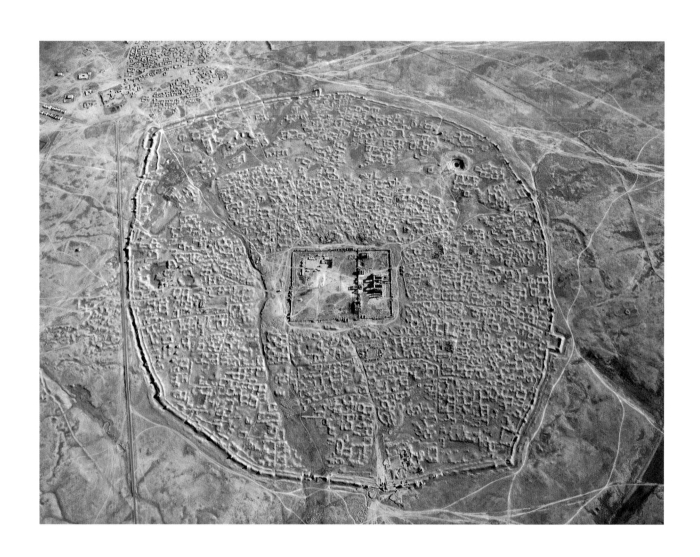

33 | **The city of Hatra**, 2nd–3rd century AD, Iraq, 1973. World Heritage Site

34 | **The Median capital at Hamadan**, from 7th century BC, Iran, 1976

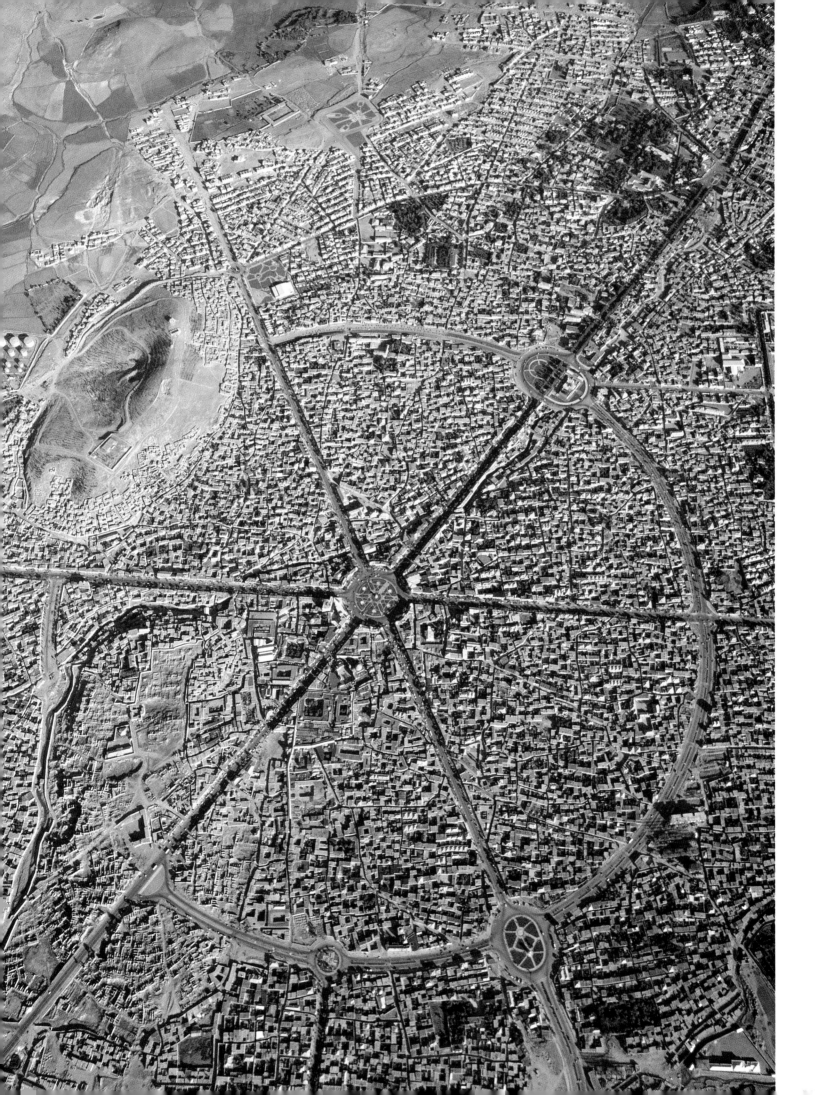

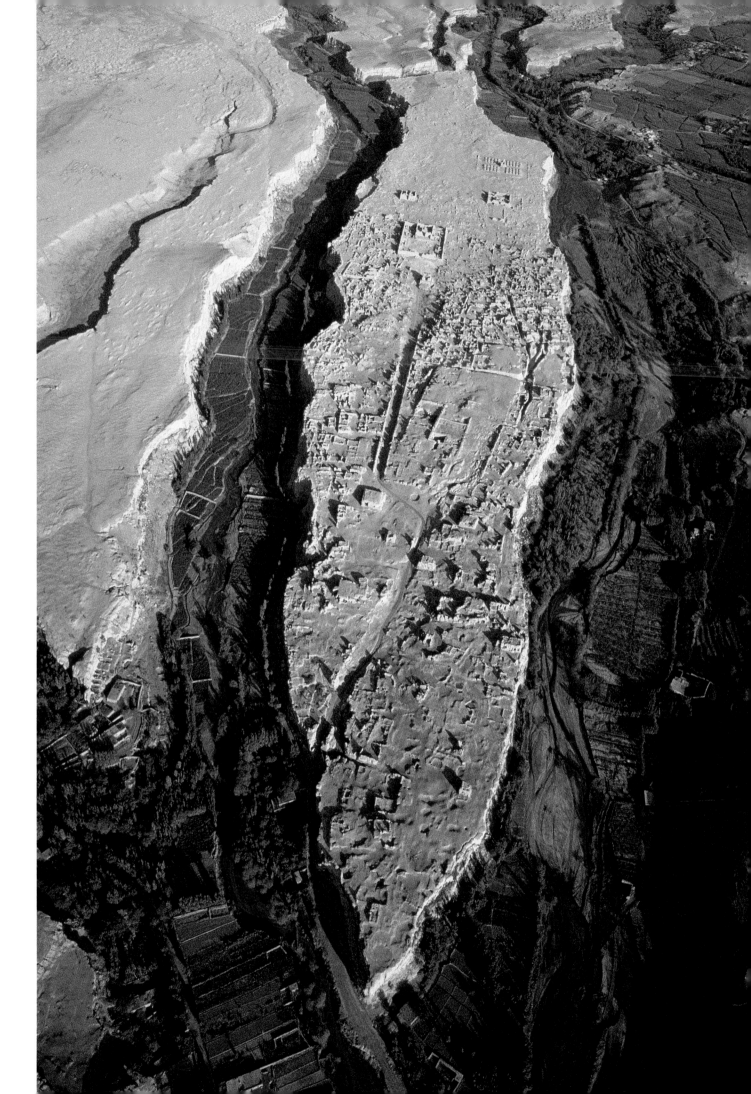

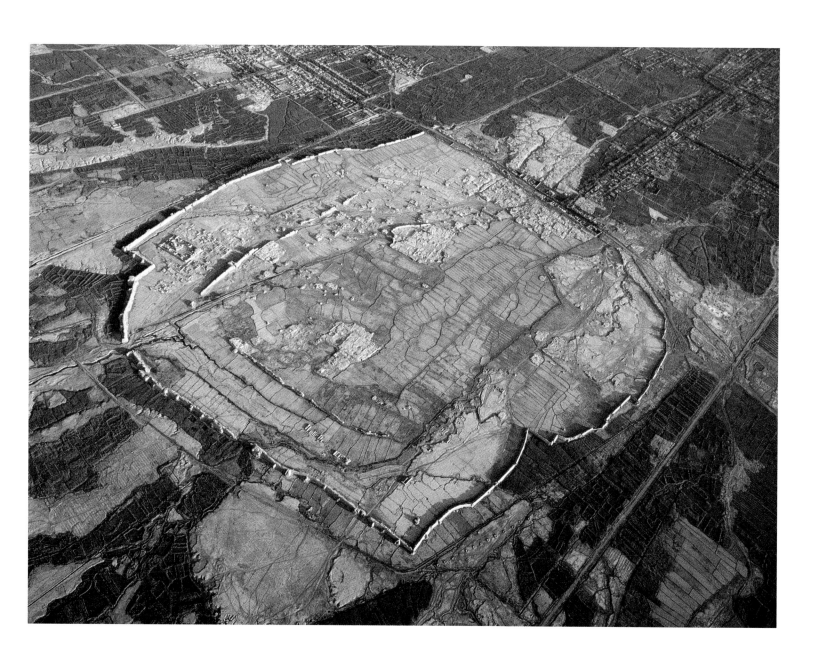

35 | **Jiaohe in Xinjiang**, 2nd century BC–13th century AD, China, 1987

36 | **The town of Gaochang**, 2nd century BC–14th century AD, China, 1987

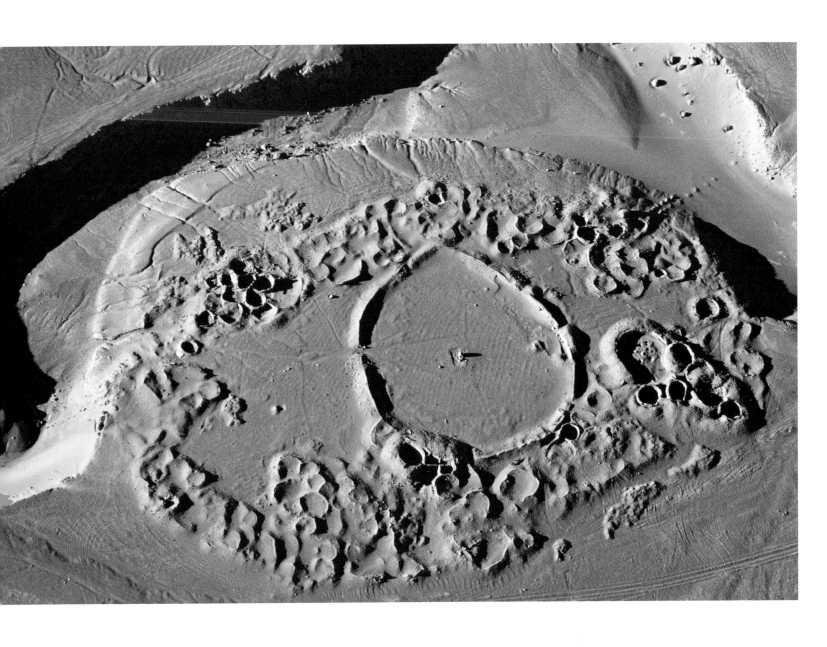

37 | **Guatacondo in the Atacama Desert**, 2nd–5th century AD, Chile, 1978

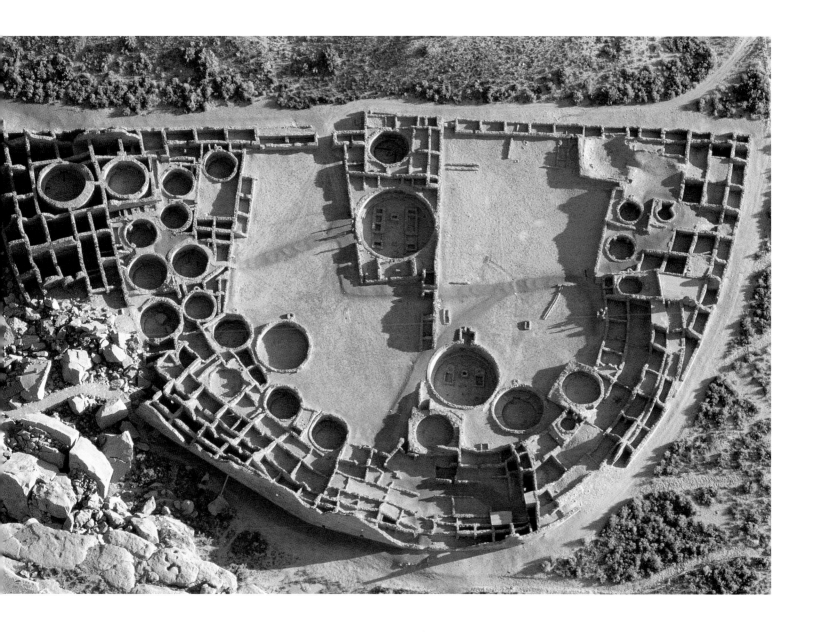

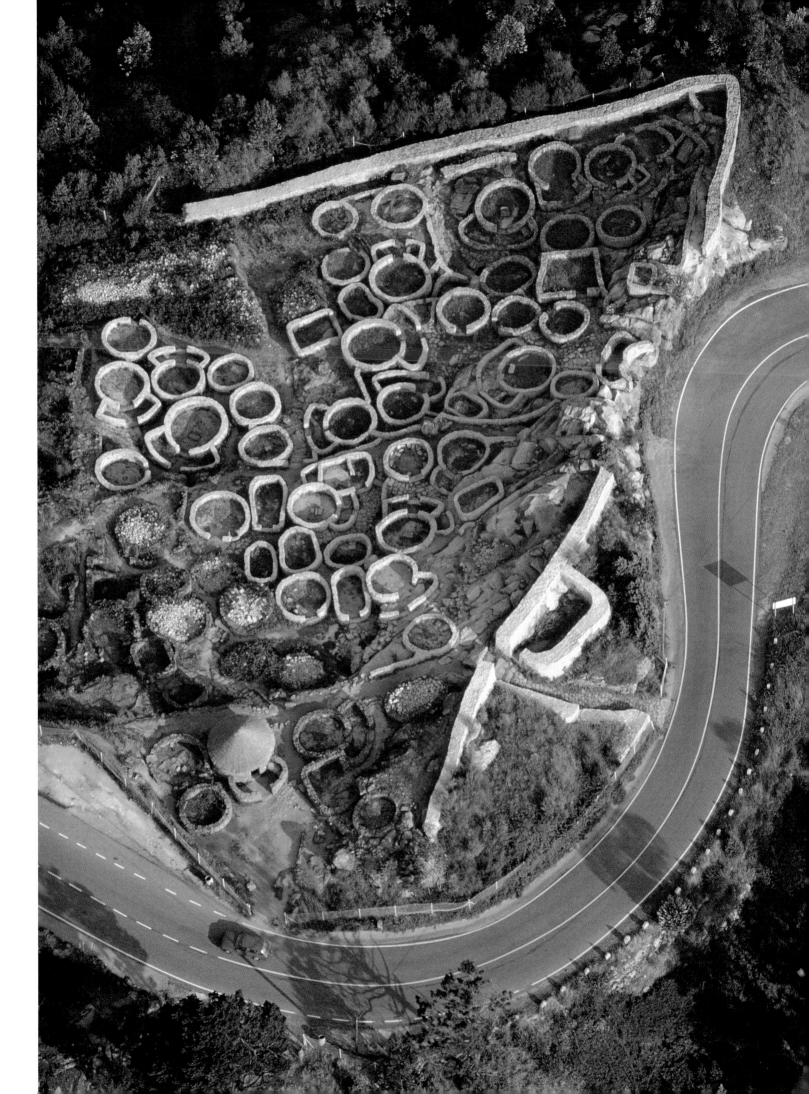

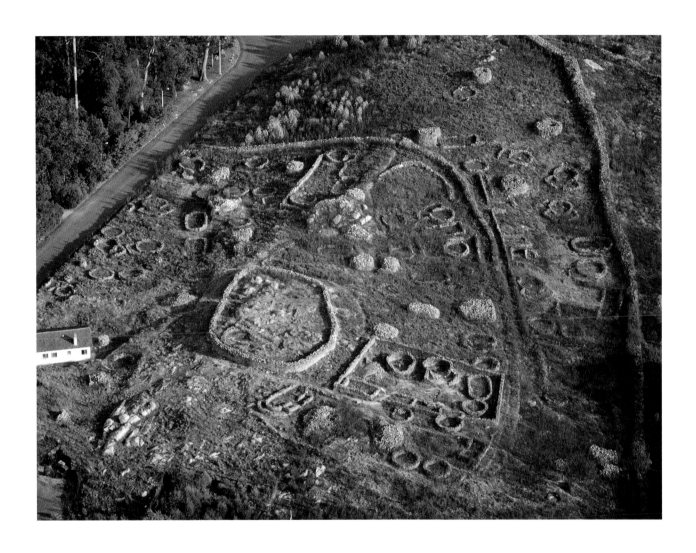

39 | **The hilltop settlement at Santa Tecla**, second half of 1st millennium BC–Roman period, Spain, 1990

40 | **The hilltop settlement at Santa Luzia**, second half of 1st millennium BC–Roman period, Portugal, 1990

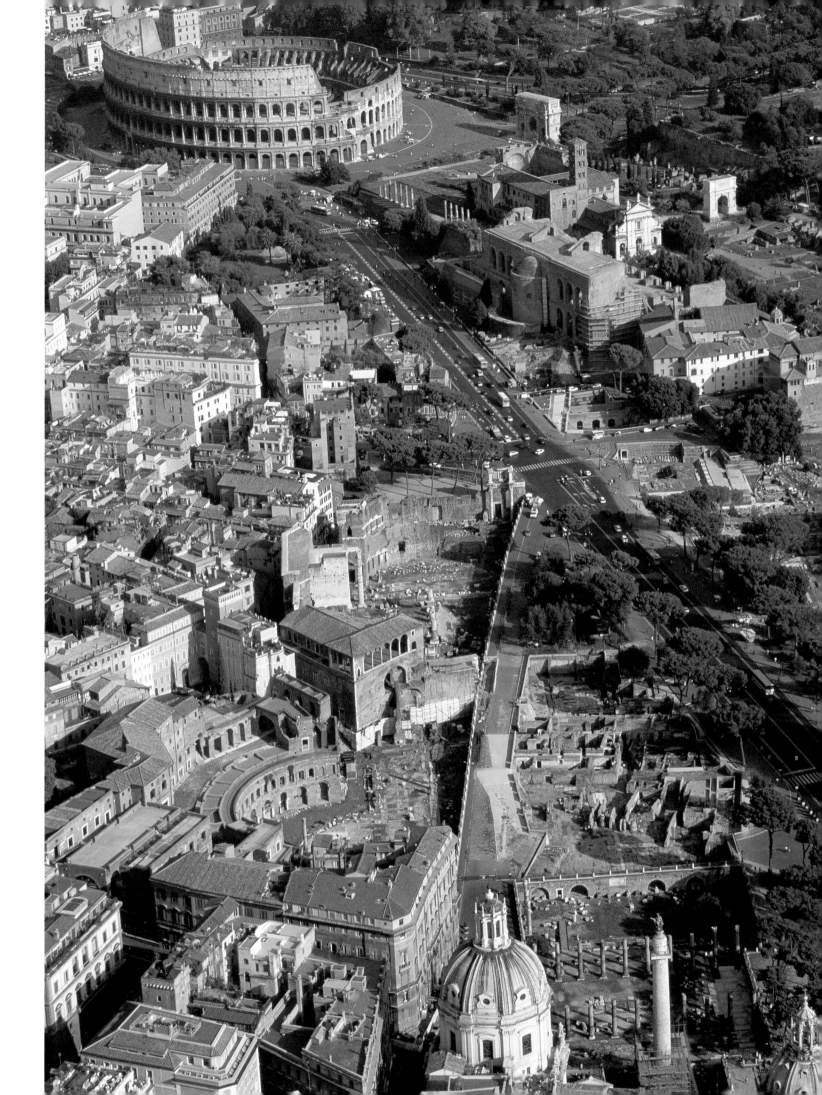

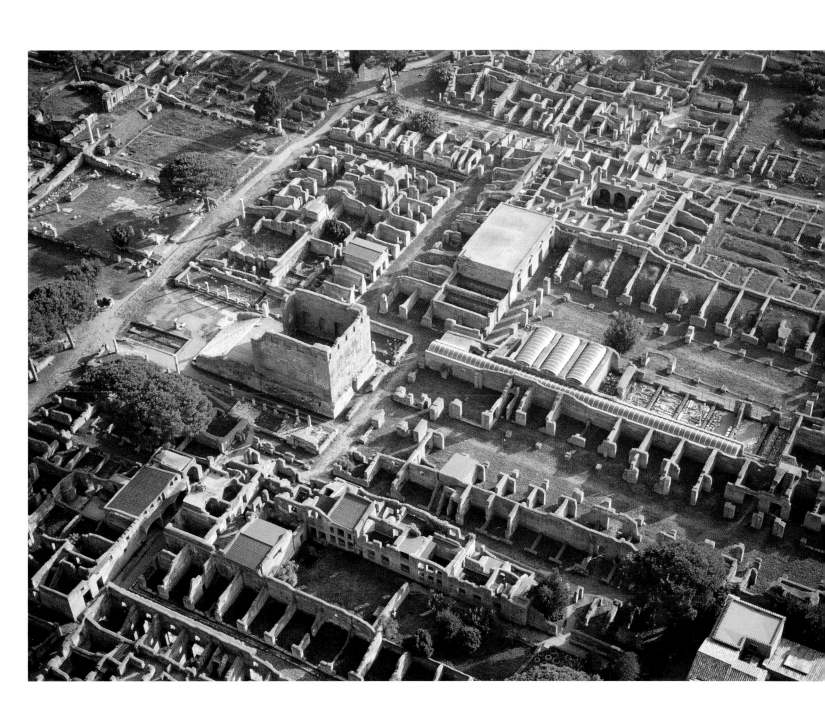

41 | **The Imperial Forums in Rome**, middle of 1st century BC–early 2nd century AD, Italy, 2002. World Heritage Site

42 | **Ostia, the port of ancient Rome**, fl. 2nd century AD, Italy, 2002

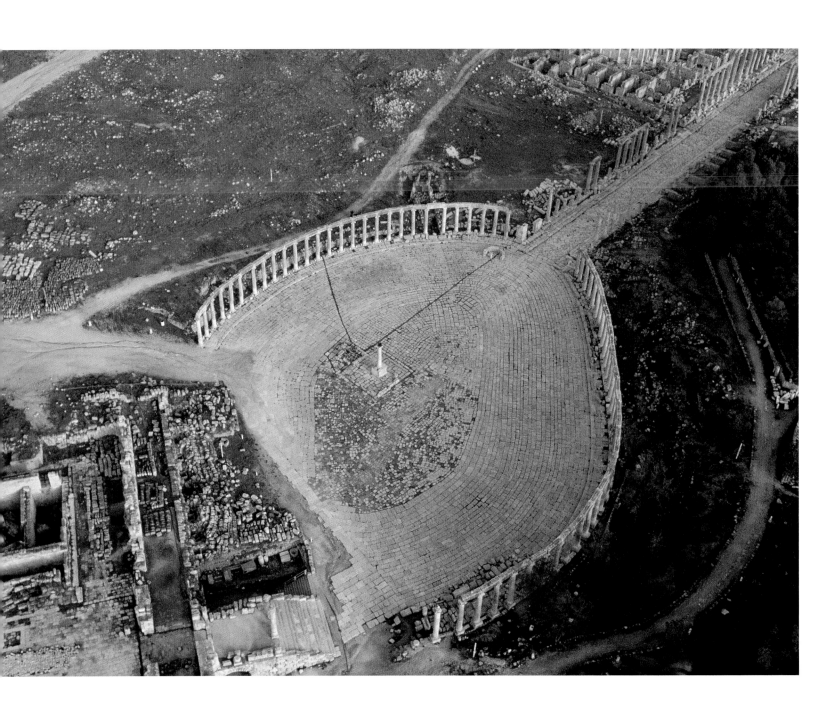

43 | **The Oval Plaza at Jerash**, c300 AD, Jordan, 2003

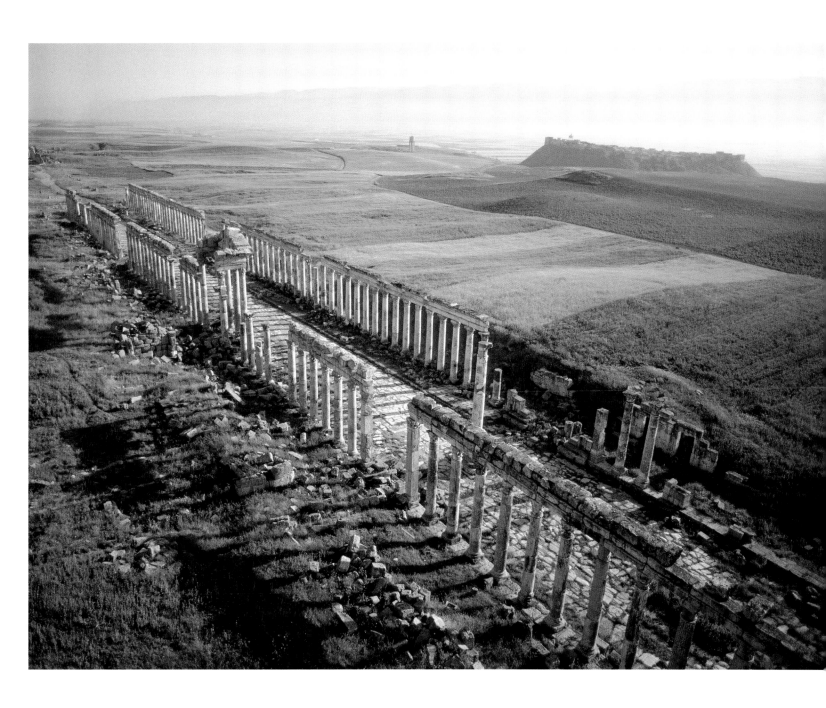

44 | **The Colonnaded Street at Apamea**, 2nd century AD, Syria, 1997

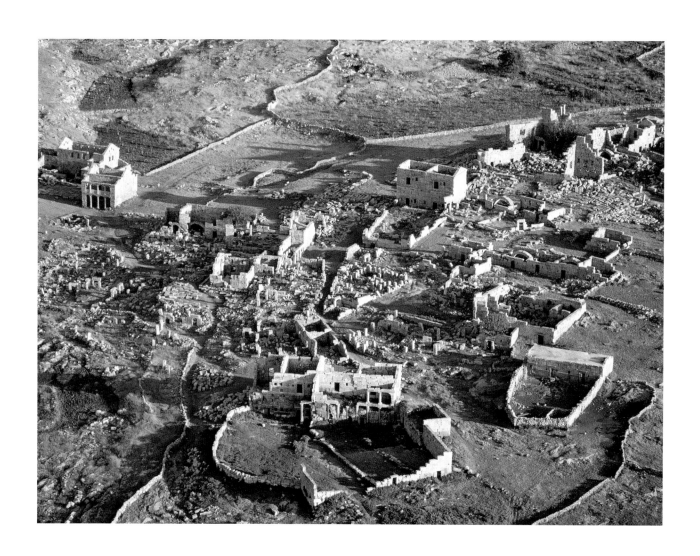

45 | The 'Dead City' of Serjilla, 2nd–6th century AD, Syria, 1997

46 | Remains of the city of Ugarit, early 2nd millennium–c1200 BC, Syria, 1997

47 | 94–5: The capital of the Chimú polity at Chan Chan, 12th–15th century AD, Peru, 1995. World Heritage Site

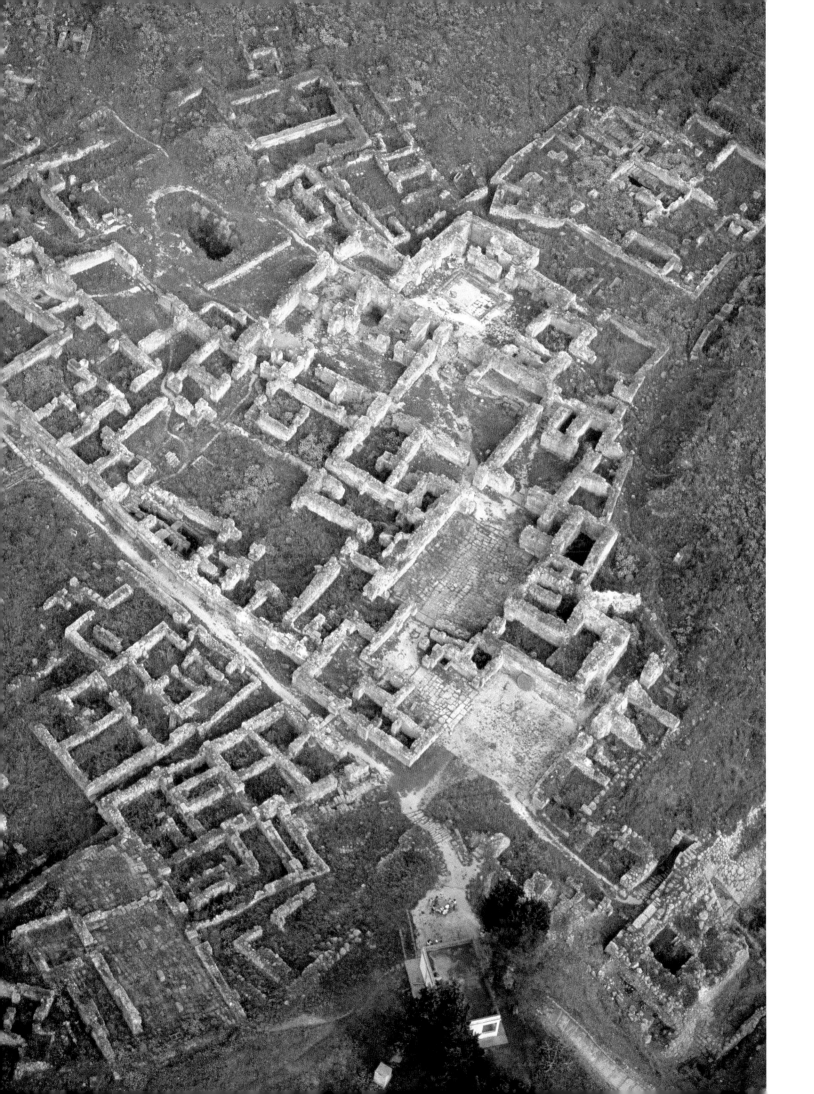

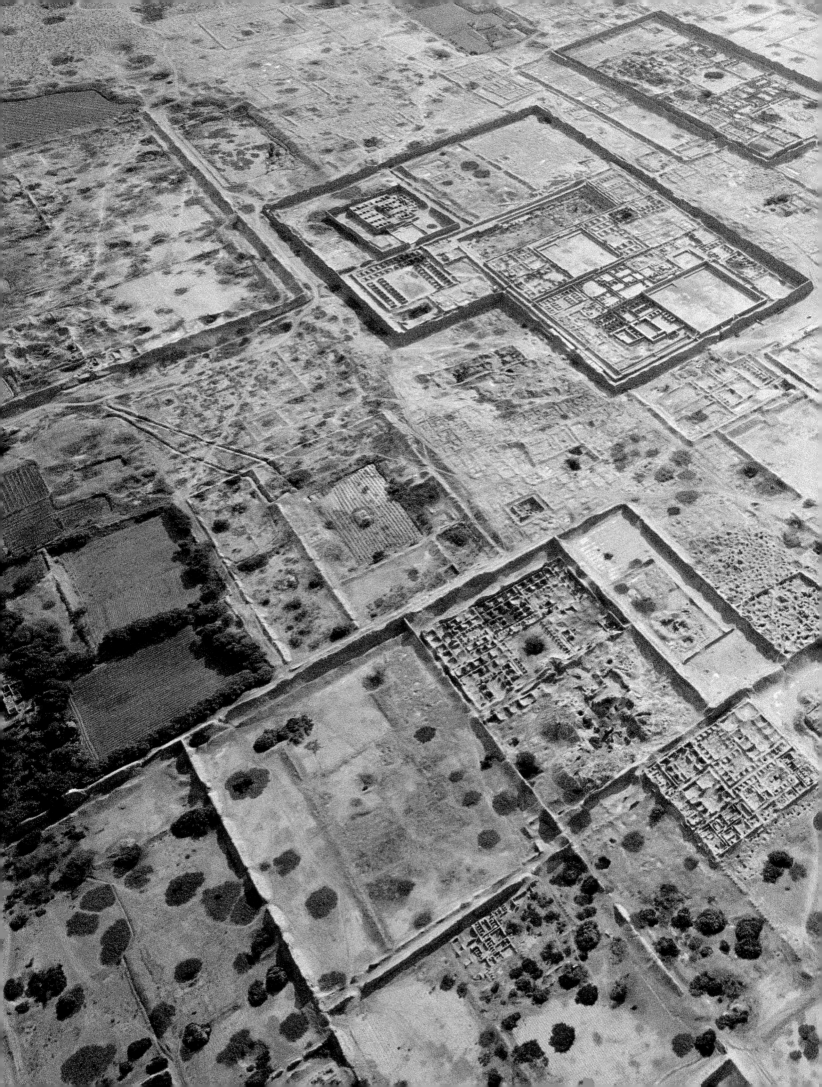

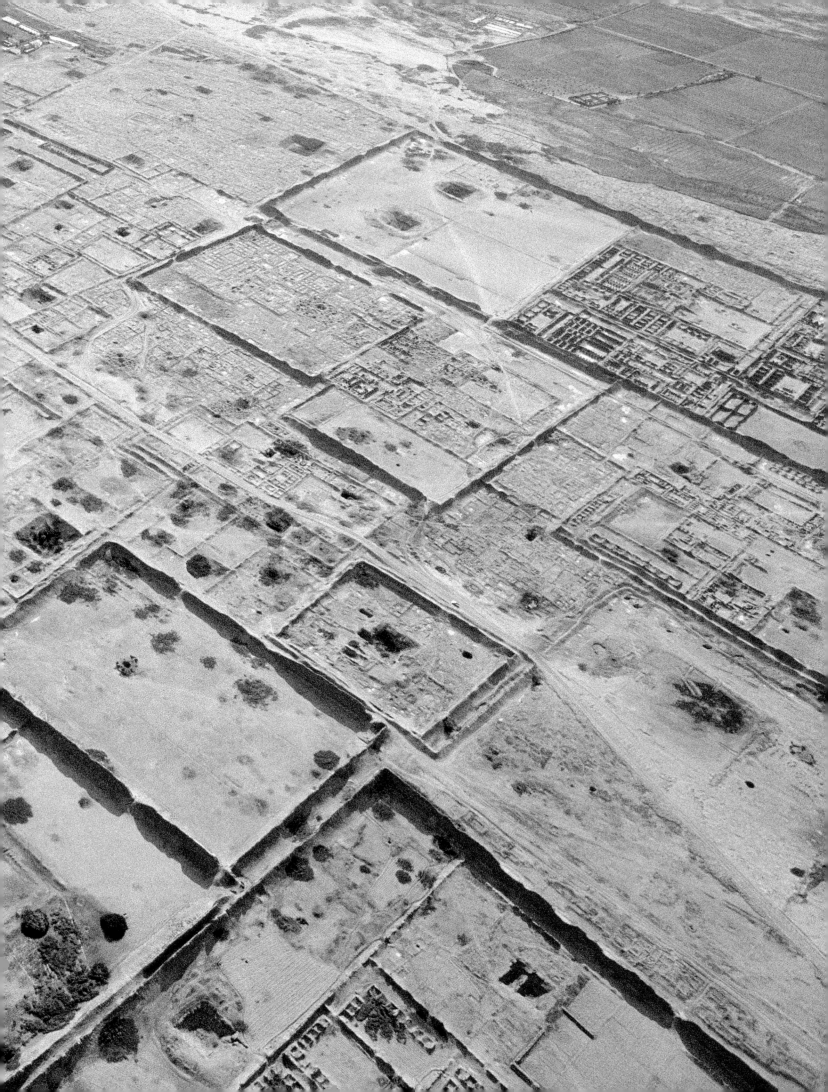

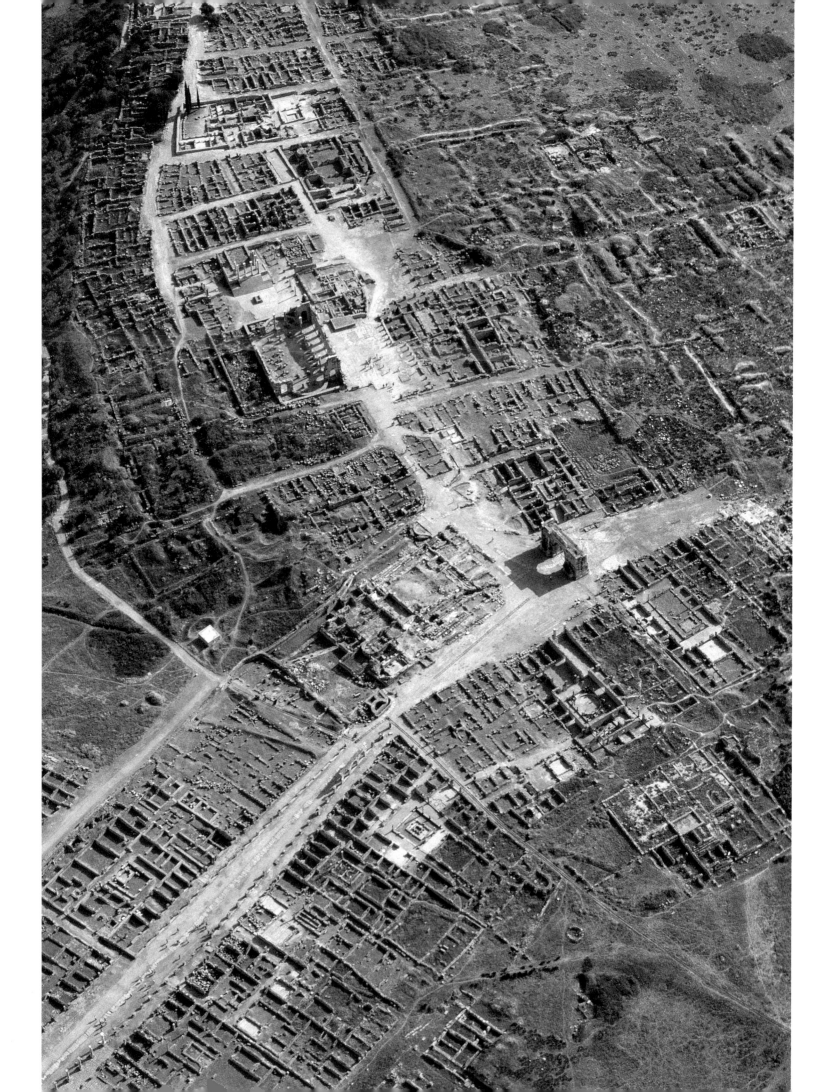

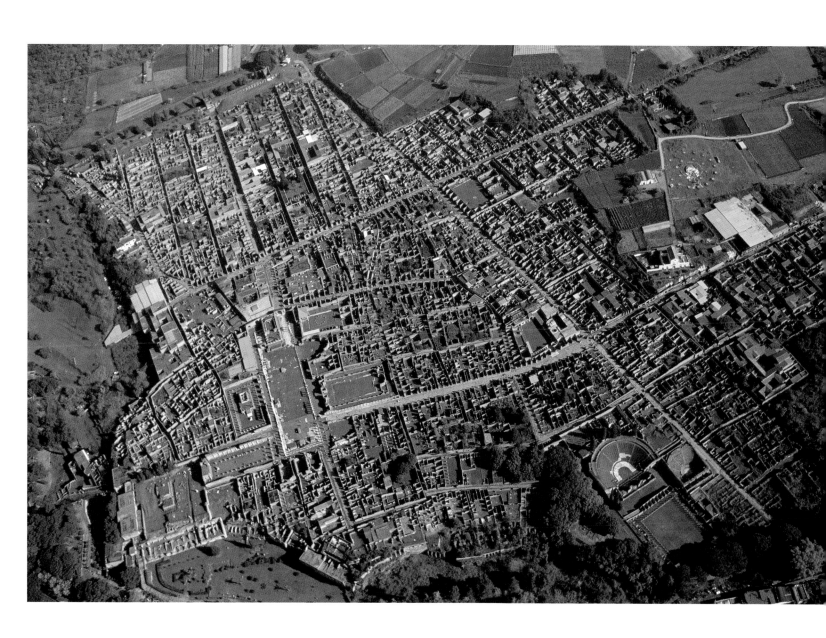

48 | **Ruins at Volubilis**, fl. 2nd–3rd century AD, Morocco, 1982. World Heritage Site

49 | **The Roman city of Pompeii**, destroyed AD 79, Italy, 2001. World Heritage Site

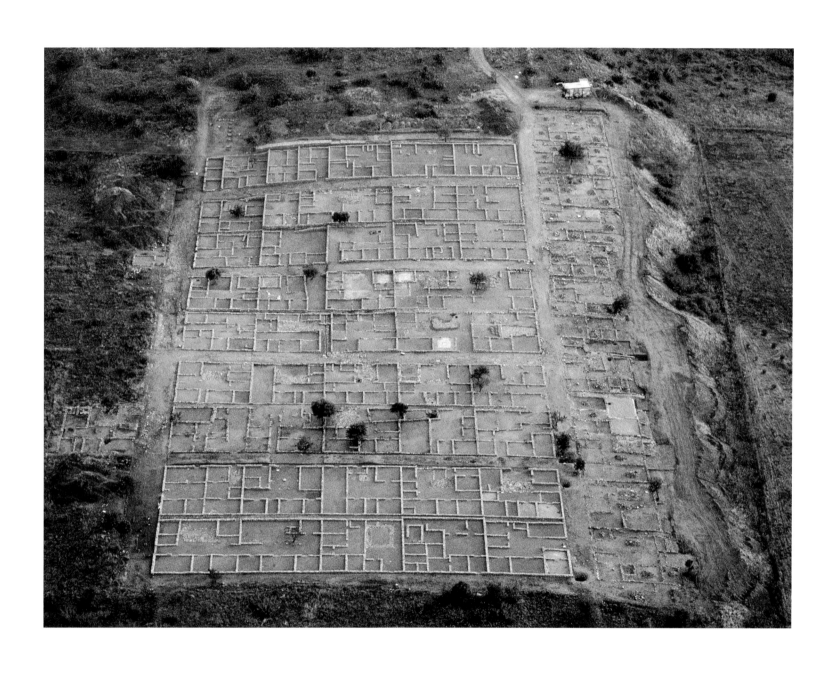

50 | **Houses in the New Town of Olynthus**, late 5th–4th century BC, Greece, 1996

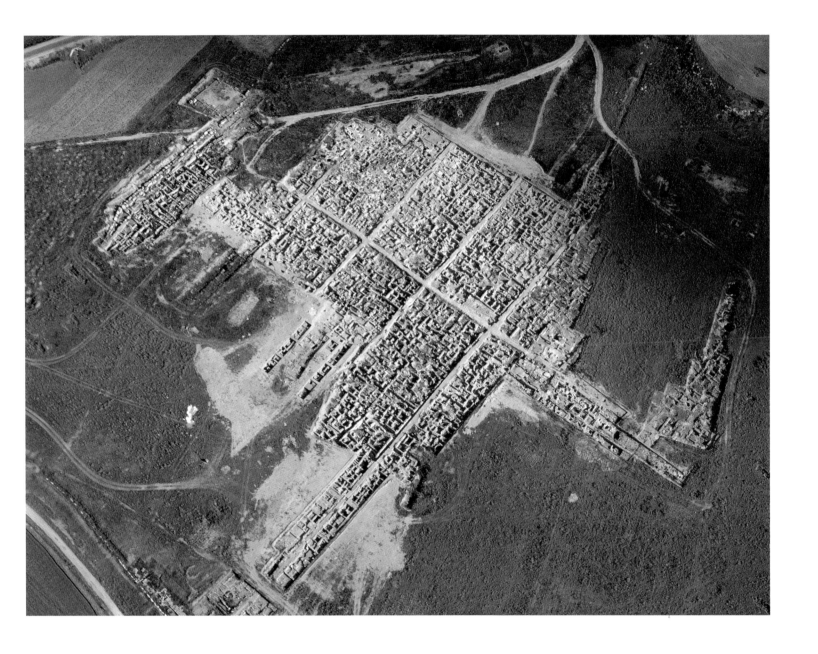

51 | **The Late Bronze Age town of Enkomi/Alashiya**, 13th–12th century BC, Cyprus, 1971

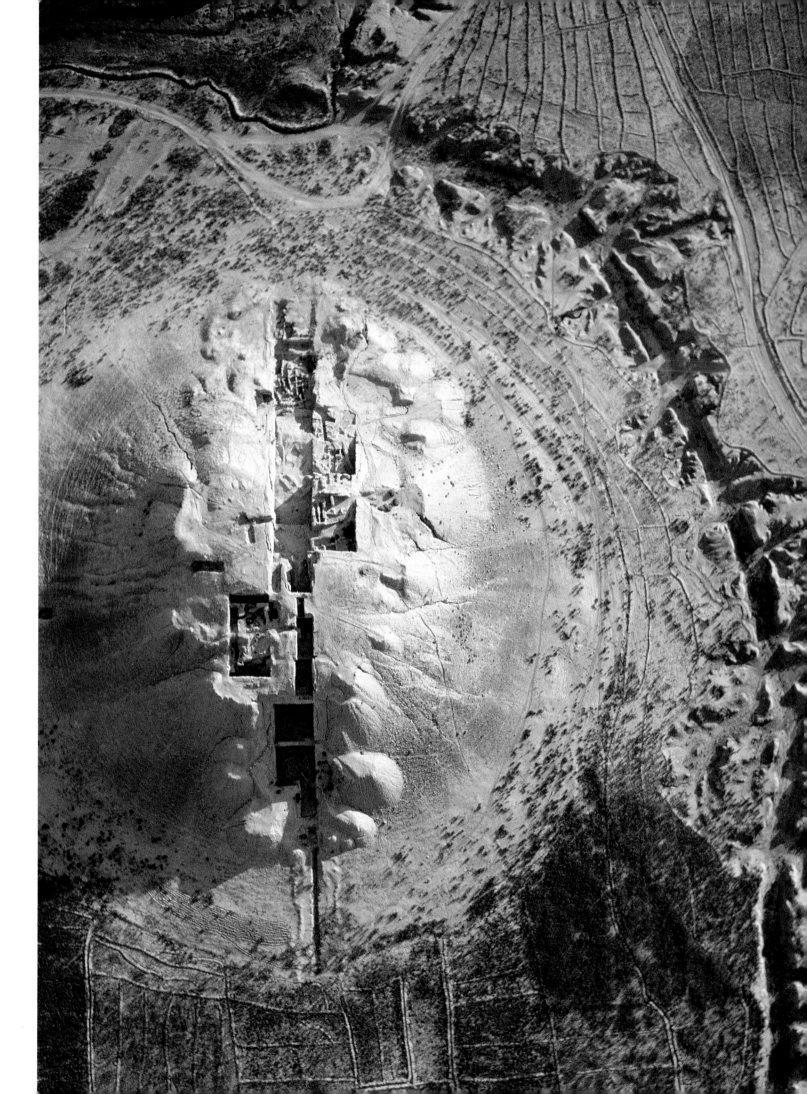

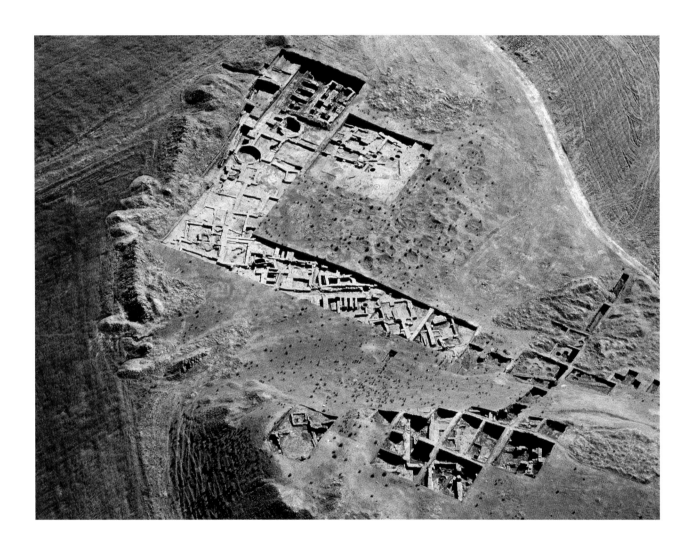

52 | **The settlement mound of Tepe Yahya**, from 4th millennium BC, Iran, 1976

53 | **The settlement mound of Tell Knedig**, from first half of 3rd millennium BC, Syria, 1997

54 | **The Via Domitia near Montpellier**, 118/117 BC, France, 1998

55 | **The legionary camp at Carnuntum**, from AD 50, Austria, 1974

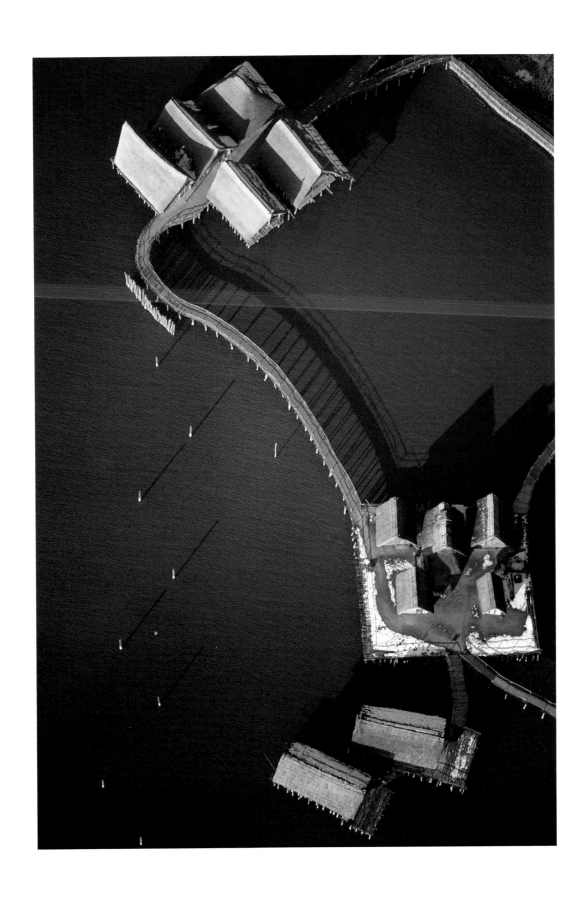

56 | **Reconstructed pile dwellings at Unteruhldingen**, 1922–2002, Germany, 2003

57 | **Pile structures at Constance**, Middle Ages/early modern period, Germany, 2003

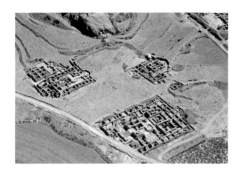 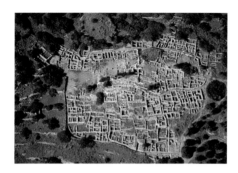 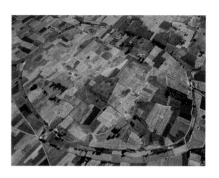

29 | **The town of Matara, Eritrea**

Known to archaeologists for over a century, the town of Matara – its ancient name is not known – lies 140km south of Asmara in what is now the United Nations' buffer zone between Eritrea and Ethiopia. One of the most important sites in Eritrea, it was first examined by several Italian teams of explorers before being more fully excavated by Enno Littmann in 1906. But it was not until the ten expeditions led by the French archaeologist Francis Anfray during the 1960s and early 1970s that we gained a clearer picture of the history of the settlement between the 1st century BC and the 8th century AD. The remains of the buildings on the topmost level date from the Axumite period (4th–8th century AD). Visible in the foreground is the vast palace measuring some 160 x 120m, with its encircling wall, courtyards and main building reached by exterior flights of steps. The other building complexes are 7th-century churches that are also surrounded by ring-walls and that reflect the architectural influence of early Christian Syrian churches. The buildings that have been found beneath their foundations attest to a cultic tradition dating to the pre-Christian period. The most important find from the Sabaean, pre-Axumite period is a 5m high monolith with a carved representation of the disc and crescent of the moon, together with a four-line Semitic inscription. The disc and crescent are symbols of Ilumquh, the moon god of southern Arabia, while the inscription itself is the oldest known example of Ge'ez, the old Ethiopic script. The wealth and importance of Matara derived from its position on the trade route between the capital Axum and Adulis on the Red Sea.
T. St.

E. Littmann, *Die Deutsche Aksum Expedition* (Berlin 1913); F. Anfray, 'Mission de l'Institut d'Archéologie du Service des Antiquités d'Éthiopie, en mai et juin, dans le Soddo', *Nyame Akuma: Bulletin of the Society of the Africanist Archaeologists*, 5 (1974), 6–8; D. Phillipson, *Ancient Ethiopia* (London 1998)

30 | **The Minoan town of Gournia on Crete, Greece**

The small rural town of Gournia in eastern Crete is the only Minoan settlement of any size in which simple dwellings and artisanal buildings cover a greater area than the palaces. Its position at the narrowest point of the island on the Gulf of Mirabello was no doubt chosen because goods could easily be transported overland here, avoiding the long and dangerous detour around the island's eastern cape. The visible remains date almost exclusively to the period between the 17th and 15th centuries BC. The site was excavated by a team of American archaeologists under Harriet Boyd-Hawes between 1901 and 1904. The town lies on a flat hill and is traversed by two main roads that run virtually parallel to each other in a north-south direction. Narrow, winding streets, sometimes with steps, branch off from them. At the highest point, in the middle of the town, is the religious and administrative centre, a small complex whose inner courtyard, theatre-like structure, storerooms and cultic shrine lend it the features of a Minoan palace. Neither here nor in any of the larger palaces is there a fortification wall: clearly it was sufficient for the place to be protected by the Minoan fleet. To judge by the finds from the houses, Gournia was mainly inhabited by fishermen, traders, farmers and artisans; numerous objects were left lying around after the earthquake in the 15th century BC that also destroyed Santorin, and these convey a lively impression of life at that time.
R. S.

H. B. Boyd-Hawes and others, *Gournia, Vasiliki, and other Prehistoric Sites on the Isthmos of Hierapetra, Crete* (Philadelphia 1908); R. W. Hutchinson, 'Prehistoric Town Planning in Crete', *Town Planning Review*, 21 (1950), 199–220; J. W. Graham, *The Palaces of Crete* (Princeton 1962), 47–9

31 | **The town of Mantineia in Arcadia, Greece**

Mantineia owes its existence to the amalgamation of five surrounding villages in the middle of a plateau in eastern Arcadia in the Peloponnese. From the 5th century BC the town was in constant dispute with its more powerful neighbours. Originally it had only a single mud-brick wall that the Spartans easily toppled by damming the River Ophis when they laid siege to the town in 385 BC. The clearly identifiable fortification and other buildings date to the period after 371 BC, when the town was rebuilt after the Spartans had been defeated in the Battle of Leuctra by the Theban general Epaminondas. But Theban rule ended in 362 BC when Epaminondas fell in the decisive Battle of Mantineia. The new enclosing wall of almost 4km in diameter has a solid stone base, 10 gates and more than 100 square towers that project outwards. As an additional defence, the river was rerouted around the town. Little is known about the town's private and public buildings. Between 1867 and 1898 French archaeologists excavated the columned agora and theatre at its centre. The town's position on a plateau allowed it to be structured along regular, symmetrical lines, albeit with the disadvantage that the seating in the theatre could not exploit a natural mountain slope, requiring, instead, an artificial bank of earth.
R. S.

G. Fougères, *Mantinée et l'Arcadie Orientale* (Paris 1898); F. Winter, *Greek Fortifications* (Toronto 1971), 216–18, 272–4; S. and H. Hodkinson, 'Mantineia and the Mantinike: Settlement and Society in a Greek Polis', *The Annual of the British School of Athens*, 76 (1981), 239–96

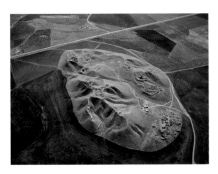

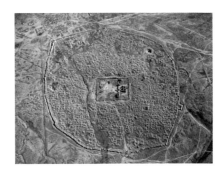

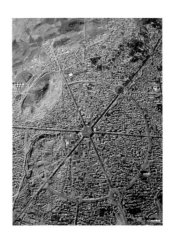

32 | The settlement mound at Tell Brak, Syria

The ancient settlement mound at Tell Brak lies in the extreme north-eastern corner of Syria, some 50km south of the border with Turkey. Measuring some 400 x 600m, the ruined site is impressive in size and, at a height of 45m, towers imposingly over the surrounding area. The erosion caused above all by heavy rainfall has produced several deep gullies and hollows, resulting in the loss of a number of historic buildings. Thanks to its position on the overland route from the Tigris Valley through the fertile Khabur triangle to the Euphrates and ultimately the Mediterranean, Tell Brak was one of the largest and politically most important towns in northern Mesopotamia. It first came to prominence in the Akkadian and neo-Sumerian period in the late 3rd millennium BC, when it was known as Nagar/Nawar. The town was resettled at the beginning of the 2nd millennium BC, and as Taidu it became the centre of the Hurrian kingdom of Mitanni until the early 13th century BC. The earliest systematic excavations were undertaken by Agatha Christie's husband, Max Mallowan, in 1937/8. They were resumed in 1976 and are still in progress. Among the major finds are a vast terrace temple ('Eye Temple') and palace. Early scholars described the region as inhospitable steppe with few inhabitants, but following the systematic reopening of north-east Syria in the 1960s, the area is again one of the country's major agricultural regions, just as it was in the 3rd and 2nd millennia BC.
R. W.

M. E. Mallowan, 'Excavations at Brak and Chagar Bazar', *Iraq*, 9 (1947), 1–259; D. and J. Oates and others, *Excavations at Tell Brak*, vols. 1 and 2 (Cambridge 1997 and 2001); C. Trümpler (ed.), *Agatha Christie und der Orient: Kriminalistik und Archäologie* (Bern 1999), 121–36 (Essen exhibition catalogue)

33 | A city in the desert: Hatra, Iraq

The oasis town of Hatra lies in the middle of the desert, a day's journey (50km) from the Tigris. A stone wall with 163 towers and four gates facing the four points of the compass once surrounded the circular site, which was 2km in diameter. In front of the wall were a broad ditch and a bank of earth 9km long. The rectangular temple precinct can be identified in the middle of the picture. It, too, was surrounded by a high wall. The town itself was a confusion of houses, streets and alleys. Numerous springs, fountains and cisterns provided Hatra with water and made life possible in so inhospitable a region. The city was founded in the 3rd century BC as a staging post on an important caravan route linking Persia with the Mediterranean and flourished under Parthian rule. Kings resided here from the middle of the 2nd century AD, calling themselves the 'glorious kings of the Arabs' and lording it over an empire stretching from the Tigris in the east to the Euphrates in the west, and from the Taurus in the north almost as far as Ctesiphon (near Baghdad) – the winter residence of the Parthian kings, among whose vassals Hatra was numbered – in the south. The Romans besieged Hatra on several occasions, but always without success. In AD 241 the city was captured and sacked by the Sassanian king Shapur I. The first systematic research was undertaken by the Deutsche Orient-Gesellschaft in the early 20th century. An extensive rebuilding programme began in 1989. Since 1985 Hatra has been on the United Nations list of World Heritage Sites, until recently the only place so designated in Iraq.
M. M.-K.

W. Andrae, *Hatra: Nach Aufnahmen von Mitgliedern der Assur-Expedition der Deutschen Orient-Gesellschaft* (Leipzig 1908); J. Tubach, *Im Schatten des Sonnengottes* (Wiesbaden 1986); H. Stierlin, *Städte in der Wüste* (Stuttgart 1987); M. Sommer, *Hatra: Geschichte und Kultur einer Karawanenstadt im römisch-parthischen Mesopotamien* (Mainz 2003)

34 | The Median capital, Hamadan, Iran

According to Herodotus, Hamadan – the ancient Persian Hagmatana, Greek Ecbatana – was built by the first king of the Medes, Deioces, as a residence and as the first city of the Medes. Herodotus's description of seven concentric walls, each a different colour and slightly higher than its neighbour, is entirely fanciful. Situated on the main road to Mesopotamia at a height of almost 2000m, with a good climate, plentiful supply of water and on a large fertile plain, this was the most important city on the plateau during the Achaemenid period. Alexander the Great hoped to turn it into the capital of the eastern empire. A lion torso, now a fertility fetish, may have been the memorial that he erected to his dead friend Hephaestion. In the 11th century, the most famous physician and scholar of his day, Ibn Abu Sina (Avicenna), taught and died here. French archaeologists excavated the site in the 19th and 20th centuries but found very little. Instead, it was left to looting and illicit excavations in the houses and courtyards to bring to light some sensational finds. Beginning in 1983, Iranian excavations have uncovered a solid city wall with mud-brick rectangular bastions in the lower left-hand sector of the modern street network on the bank overlooking a stream. Behind the wall are insulae in an orthogonal network of streets, with four or eight identical houses in each insula. The Hippodamian system, Achaemenid spoliae and Parthian and Sassanian finds and ceramics suggest that the city was founded in hellenistic or Parthian times, rather than during the Median period, and that it continued to be used until the Sassanian period.
D. H.

P. Schwarz, *Iran im Mittelalter nach den arabischen Geographen* (Leipzig 1925, repr. Hildesheim and New York 1969), 513–30; M. Sarraf, 'Neue architektonische und städtebauliche Funde von Ekbatana-Tepe (Hamadan)', *Archäologische Mitteilungen aus Iran und Turan*, 29 (1997), 321–39; Herodotus, *Histories*, Book 1, 98–9

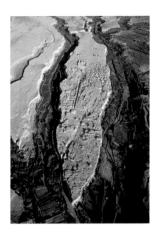

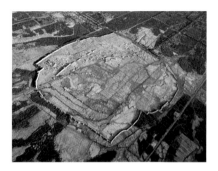

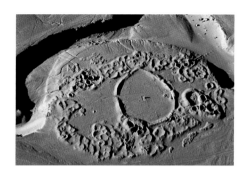

35 | Jiaohe in Xinjiang, China

Flanked by two rivers, the town of Jiaohe (also known as Yarkhoto) lies on a 30m high, spur-like plateau c1650m long and 300m wide. Its striking position gave the town its present name: in Chinese, 'Jiaohe' means 'Place of Confluence'. It lies some 10km west of Turfan in Xinjiang province. Jiaohe bi (Jiaohe Citadel) was built here at the time of the Western Han Dynasty (206 BC to AD 24) as a military base designed to defend the Chinese border. From the time of the Sixteen States (AD 304–439) to the Tang period (AD 618–907) Jiaohe was a prefecture and as such one of the most important trading posts and centres of Buddhism on the Silk Road. Jiaohe was finally destroyed by the Mongols in the 13th century, but thanks to the region's dry climate the ruins have been preserved. Streets and alleys are clearly visible, as are numerous Buddhist temples, workshops and dwellings, some of which have survived intact. The slope falls away abruptly on all sides, making a city wall superfluous. On the east, south and west are steep pathways leading down to the river valley. The town is divided into an eastern and a western half by a street 350m long and 10m wide. The temple buildings are concentrated in the western and northern parts of the town and are largely symmetrical in design. The residential quarters of the simple townspeople probably lay in the eastern half, while the south-east corner was occupied by large buildings that probably served as administrative buildings and accommodation. Jiaohe has been classified as a historical monument since 1981.
B. S.

Xinjiang gudai minzu wenwu (Cultural Assets of Ancient Peoples in Xinjiang) (Beijing 1985), 12–14; *Zhongguo dabaikequanshu, kaoguxue* (Chinese Encyclopedia: Archaeology) (Beijing and Shanghai 1986), 232; *Over China* (Sydney and Beijing 1988), 252–3

36 | The town of Gaochang, China

The ruined site of Gaochang (also known as Kharakhoja or Chotsho) lies some 40km to the south-east of Turfan in the Turfan Depression in Xinjiang Province. It was built by Chinese border guards as a garrison town at the time of the Han emperor Wudi (140–87 BC). The 'Flaming Mountains' provide a natural defence to the north. But Gaochang was not only important from a military standpoint, it also became a leading political and cultural centre and a major trading post on the northern Silk Road. Numerous monasteries and temples attest to a flourishing Buddhism before and during the Tang period (AD 618–907). The city was burnt down in the 14th century. Early in the 20th century three German teams excavated the site. Two of the German scholars who took part, Albert Grünwedel and Albert LeCoq, discovered not only Buddhist texts, together with paintings and sculptures, but also traces of the Nestorian and Manichaean communities of the 8th and 9th centuries. In a letter Grünwedel described Gaochang as 'a forgotten Asiatic city of extraordinary interest. Even its size is impressive; the inner sacred city, which consisted only of temples and palaces extends over 7400 English feet at the widest point of the city wall, which is still standing. Hundreds of terrace temples and magnificent vaulted buildings cover a vast area of land through which the present-day inhabitants run their irrigation canals.' The ruins have been a protected monument since 1961.
B. S.

Xinjiang gudai minzu wenwu (Cultural Assets of Ancient Peoples in Xinjiang) (Beijing 1985), 12–14; *Zhongguo dabaikequanshu, kaoguxue* (Chinese Encyclopedia: Archaeology) (Beijing and Shanghai 1986), 232; H. Härtel and M. Yaldiz, *Die Seidenstraße: Malereien und Plastiken aus buddhistischen Höhlentempeln* (Berlin 1987) (artefacts from the collection of the Museum for Indian Art in Berlin)

37 | Guatacondo in the Atacama Desert, Chile

Around the middle of the 1st millennium AD, a streamlet on the northern edge of the Atacama Desert changed its course, with the result that the surrounding area dried up and the inhabitants of Guatacondo had to leave. The ruins of their village were preserved beneath sand dunes until rediscovered in 1963 1500m above sea level some 80km north-east of Quillagua, a small town on the Río Loa. Radiocarbon measurements indicate that the architecture goes back to the early centuries of the Christian era. The buildings here look different from those at Caserones 110km to the north, although they too are attributed to the Faldas del Morro culture group that was the first in the region to cultivate maize, pumpkins, bottle gourds and Lima beans in artificially irrigated fields. Their diet was supplemented by the fruit of the algaroba tree (*Prosopis glandulosa*), which then grew in huge numbers, together with fish traded over 90km from fishermen from the coast and meat from domesticated llamas and the guanaco that they hunted. In addition to woollen goods, basketry and simple ceramics we also find copper and gold jewellery. The village covers an area of 120 x 95m, its bipartite division into a northern (upper) and southern (lower) section indicating a social structure similar to that found at Caserones. The 183 round buildings of 3–4m in diameter often have slightly excavated floors and represent a building type that was found in previous millennia on the west coast of South America in Preceramic Peru and that was used among Fireland Indians until recently. The mud-brick construction of the walls, supported by posts, suggests that the inhabitants of Guatacondo were relatively sedentary. A block of stone 1.5m in height stands in a large walled plaza in the centre of the village. As elsewhere in the Andes, the villagers may have seen in it a protecting ancestor turned to stone.
H. B.

E. De Bruyne, *Informe sobre el descubrimiento de un área arqueológica* (Santiago de Chile 1963) (Museo Nacional de Historia Natural: Publicación Ocasional 2); C. W. Meighan, 'Archaeology of Guatacondo, Chile', *Prehistoric Trails of Atacama*, ed. C. W. Meighan and D. L. True (Los Angeles 1980), 99–126

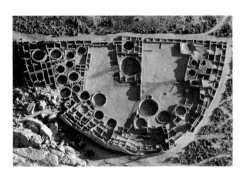

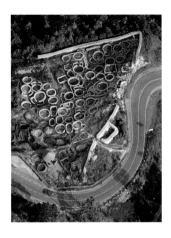

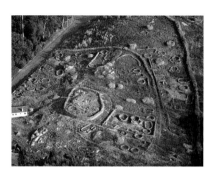

38 | Pueblo Bonito in Chaco Canyon, USA

In north-western New Mexico, in the middle of the steppe-like landscape of a sandstone plateau rising to 2000m, lies Chaco Canyon. Situated beneath the northern edge of the canyon, Pueblo Bonito (literally 'Beautiful Village') is a ruined village of the Anasazi culture that was first discovered and described in the course of a military expedition in 1849. Construction of the site began in 819 and proceeded in several, centrally planned phases, so that the present ruin reflects the final phase of the building work, which took place between AD 1030 and 1079. In spite of the 18 entrances, the crescent-shaped design reveals a single, self-contained structure whose 600 or so rooms were grouped around a central courtyard, rising to five storeys along the outer walls. In addition to the rectilinear living quarters and working areas, the site also contains 40 circular structures, the largest of which is in the middle of the courtyard. These subterranean 'kivas' were originally covered over and were cultic in function. The latest research suggests that the village had a permanent population of around 1000, their wealth based on their control, through exploitation and trade, of the turquoise mines c150km away at Cerrillos. Their abandonment of the settlement around AD 1250 has been ascribed to the Toltecs' gaining control of the turquoise market, the discovery of new turquoise mines in Arizona and Nevada and a period of drought. The rockfall visible in the lower left-hand corner of the photograph dates from 1941, when part of the canyon wall fell on the site, destroying some 30 buildings. Pueblo Bonito was also important in the history of science in that dendrochronology – dating based on tree-ring sequences – was first used here in the 1920s.
T. St.

N. M. Judd, *The Architecture of Pueblo Bonito* (Washington 1964) (Smithsonian Miscellaneous Collections 147/1); B. J. Mills, 'Recent Research on Chaco', *Views on Economy, Ritual and Society: Journal of Archaeological Research*, 10 (2001), 65–117

39 | The hilltop settlement at Santa Tecla, Spain

Perched on the top of a hill 343m in height, directly to the south of A Guarda near the point where the Río Miño flows into the Atlantic lies the fortified 'castro' of Citaña de Santa Tecla (Galician Santa Trega), together with the pilgrimage church that gives the town its name. The picture shows an uncovered section of the largest of these sites in the north-west of the Iberian peninsula. An area of some 700 x 300m has been excavated, and part of this can be seen in the present picture. The settlement area is surrounded by a huge dry-stone wall, parts of which have been much restored and which includes a section of cliff on its north-eastern side (to the right of the picture). Other striking features are access ramps or steps on both the inside and the outside and a prominently positioned rectilinear bastion with rounded corners. The remains inside are mainly dry-stone foundations of circular houses, some of which are more than 5m in diameter, with an antechamber or vestibule often built at an angle to the entrance. Occasionally we also find oval or rectangular groundplans of similar size and structure. Some houses are joined together by sections of wall, but there is no sense of any underlying structure in the form of open spaces, paths and so on. In the lower left-hand corner a round building has been reconstructed with a conical roof that originally was probably thatched; traces of supporting posts in the middle of the building have also been found. The site was discovered in 1913 and not only excavated but also much restored. Some of the finds date back to the later Iron Age 'castro' culture of the second half of the last millennium BC, while others date to Roman times. Some may be seen as part of a small onsite exhibition.
V. P.

F. Lopez Cuevillas, *La civilización céltica de Galicia* (Santiago de Chile 1953; repr. Madrid 1988), 87–9; M. Höck, *Denkmäler der Frühzeit: Hispania Antiqua*, ed. M. Blech and others (Mainz 2001), 377–9, 587–8

40 | The hilltop settlement at Santa Luzia, Portugal

Together with the pilgrimage church that gives the site its name, the Cidade Velha (Old Town) of Santa Luzia lies at a height of c550m on a mountain spur situated between the valley of the Rio Lima and the Atlantic some 7.5km to the north of Viana do Castelo. The photograph shows a section of the settlement surrounded by three concentric ring-walls, their outline clearly visible to the west and north. To the south they extend into the forest beyond the road, while to the east they extend beyond the foot of the picture. The innermost wall is around 30m in diameter and as such is strikingly small. Within all three defensive circuits are typical round houses, their walls built on polygonal foundations and assembled without mortar. Some of these walls still survive to a height of more than 50cm. At their entrances most of the houses have an anteroom set at an angle to it. Round buildings predominate, but there are also oval and rectilinear groundplans of similar size and design. Larger rectilinear enclosures containing several floor plans of houses can be seen principally in the area enclosed by the central wall. These evidently formed 'farmsteads' cut off from the rest of the settlement. In places they intersect with other floor plans, indicating different building phases. It is unclear how these building phases and especially the three ring-walls are related chronologically. Various finds, including those on display in the Viana do Castelo Municipal Museum, date to the Iron Age 'castro' culture of the last centuries BC and extend into Roman times. The site has been known at least since the end of the 19th century and, following restoration work and the provision of certain safety measures, is now open to the general public.
V. P.

J. L. de Vasconcelos, *Religiões da Lusitania na parte que principalmente se refere a Portugal*, vol. 1 (Lisbon 1897); F. Lopez Cuevillas, *La civilización céltica de Galicia* (Santiago de Chile 1953; repr. Madrid 1988), 87–9; M. Höck, *Archäologischer Wegweiser durch Portugal*, ed. T. G. Schattner (Mainz 1998), 25–7, 59.

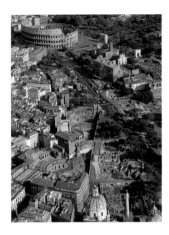

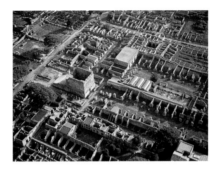

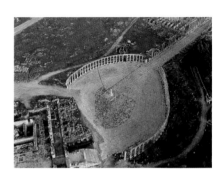

41 | The Imperial Forums in Rome, Italy
Now classified as a World Heritage Site, the
Imperial Forums are situated beneath and along-
side the Via dei Fori Imperiali that Mussolini built
in 1932/3. Still only partially excavated, they were the
work of the emperors Augustus, Vespasian, Nerva
and Trajan and attest to the imperial power of Rome
and its emperors. The site has been reexcavated in
recent years. The picture shows, from the bottom
upwards, the Forum Traiani (AD 107–13) with its
famous column, the Basilica Ulpia and, to the left,
Trajan's Markets with the Via Biberatica and the
House of the Knights of Rhodes built upon it.
Beyond it lies the Forum Augustum with the Temple
of Mars the Avenger, begun in 42 BC and completed
in 2 BC. Further away and dominated by the Temple
of Minerva is the narrow Forum Transitorium that
was built by Domitian but dedicated by Nerva in AD
97. And finally there is the Forum or Templum Pacis
with its libraries and gardens built by Vespasian
between AD 71 and 75. In the distance can be seen
the Basilica of Maxentius, the Temple of Venus and
Roma, the Arches of Titus and Constantine, the
Colosseum and the green Mons Caelius or Caelian
Hill. In the lower right-hand corner it is just
possible to make out traces of the Forum Caesaris,
the first imperial forum, which was built between 54
and 46 BC. Little remains of the Temple of Venus
Genetrix. The Forum Augustum was surrounded
by a high firewall separating it off from the lower-
class quarter of Subura and was notable for its
particularly impressive statuary. But the largest and
most magnificent of the Roman forums was
Trajan's Forum, said to have been designed by the
architect Apollodorus of Damascus and still much
admired in the 4th century AD. Trajan found his final
resting place in the base of the column that bears
his name, the relievo carvings of which attest to his
victory in his wars against the Dacians.
S. St.

P. Zanker, *Forum Augustum* (Tübingen 1968); P. Zanker,
'Das Trajansforum als Monument imperialer Selbstdarstel-
lung', *Archäologischer Anzeiger* (1970), 499–544; F. Coarelli,
Rom: Ein archäologischer Führer (Mainz 2000), 109–47

42 | Ostia, the port of ancient Rome, Italy
Ostia Antica lies some 25km south-west of Rome,
close to the mouth of the Tiber, and is one of the
most excavated and best preserved of all Roman
towns, providing us with a great deal of information
about Roman town planning, as well as about the
architecture, economy, religion and daily life of
Roman towns and cities. It was founded as a
castrum in around 325 BC and retained its impor-
tance until late antiquity. But from around 400
onwards it went into decline and was finally
abandoned in the 9th century. In its heyday in the
2nd century AD it must have numbered 50,000
inhabitants. Excavations began at the end of the 19th
century and are still continuing. To date some two
thirds of the town have been uncovered. In the
centre of the town the large rectangular castrum
from the 4th century BC stands out clearly with its
solid tuff walls. It covers an area of *c*2 ha. Ostia also
had a forum with a Capitolium, a basilica, a theatre
seating some 3000 spectators, several baths and
many shops and latrines. Characteristic above all are
the many horrea (granaries) and the large multi-
storey apartment blocks with balconies built around
courtyards. These 2nd-century functional buildings
were built in opus caementicium and clad in tiles,
continuing to this day to leave their mark on our
image of the town. Ostia was international in
character and noted for its many religious cults,
including those of oriental origin. The rich mosaics,
mainly in black and white, date for the most part to
the first half of the 2nd century. On the left of the
aerial photograph may be seen parts of the forum
with the Capitolium, where the cardo and
decumanus maximus intersect. Top right are the
Horrea Epagathiana and Epaphroditiana, while the
House of Diana and other town houses can be
identified in the foreground.
S. St.

Scavi di Ostia I–X (Rome 1953–79); C. Pavolini, *La vita quo-
tidiana a Ostia* (Bari 1986); R. Chevallier, *Ostie antique: Ville
et port* (Paris 1986)

43 | The Oval Plaza at Jerash, Jordan
The irregularly shaped Oval Plaza at the southern
edge of the ancient city of Gerasa in Jordan
measures 66 x 99m and connects two different
orientational systems in the city's buildings and
streets. The older system dates back to the time
when one of the Seleucid kings (Antiochus III or IV)
founded the city, which was probably then called
Antiocheia, on the Chrysorhoas. This older city
included the important Sanctuary of Zeus in the
lower left-hand corner of the picture. According to
inscriptions, it was still being built in the 1st century
AD. At that period it consisted of a rectangular court-
yard surrounded by covered chambers, with a large
altar at its centre. Not until the 2nd century was a
temple built on the western side of the courtyard. It
was placed on a large podium and surrounded by
columns. The city was almost completely rebuilt in
early Roman imperial times. The system of streets
was now rectilinear and aligned along a different
axis, so that the main road, running from west to
east, now passed straight through the centre of the
city, where it intersected with two broad axes at right
angles to it. The eastern axis ended in a triple arch in
the Oval Plaza. Very little of this arch survives. In
order to connect the older Temple of Zeus to the
new street system, the Plaza was surrounded with
Ionic columns skilfully leading from the gate to the
main steps to the sanctuary, thereby creating the
impression of an impressive forecourt.
R. S.

C. H. Kraeling (ed.), *Gerasa: City of the Decapolis* (New
Haven 1938); I. Browning, *Jerash and the Decapolis* (London
1982); J. Seigne, 'Jerash romaine et byzantine: Développe-
ment urbain d'une ville provinciale orientale', *Studies in the
History and Archaeology of Jordan*, 4 (1992), 331–41

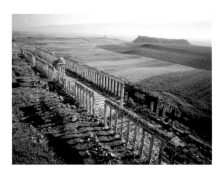

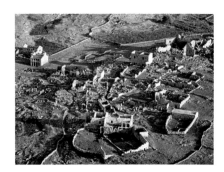

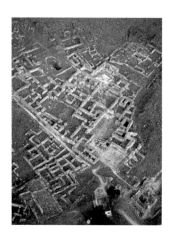

44 | The Colonnaded Street at Apamea, Syria

In the central Orontes Valley at the foot of a large
tell built over by an Arab fort and inhabited to this
day (now called Qalat al-Mudiq, this tell is visible in
the upper right-hand corner of the photograph) lies
an extensive field of ruins: the architectural remains
of the town of Apamea (in Greek Apameia). At the
time of its capture by Alexander the Great, it was
called Pharnake, and following the Battle of Issus
in 333 BC it was renamed Pella by the Macedonian
ruler. Not until it was refounded by Seleucus I
Nicator around 300 BC did it become Apamea. As a
member of the Tetrapolis of Syria (League of Four
Cities), Apamea was one of the main bases of
Seleucid power in the country and at the same time
a military headquarters. Strabo reports that the
cavalry horses and Indian war elephants were
stationed near the town and that there were 30,000
mares and 300 stallions. By the early 5th century AD
Apamea had become the capital of the Eastern
Roman province of Syria Secunda. With an overall
circumference of more than 6km, the polygonal city
wall encloses an area of some 250 ha. The surviving
Roman architecture shows a system of streets that
cross at right angles and that may date back to the
city's hellenistic origins. The main street – the
cardo maximus – was paved. It is 1774m long and
37.5m wide, including the lateral gates. The
columns have been replaced over a length of more
than 600m. Some of the site is used for agriculture.
Since 1930 it has been excavated, chiefly by Belgian
and Syrian archaeologists.
R. W.

J. C. Balty, *Guide d'Apamée* (Brussels 1981); H. Klengel,
*Syrien zwischen Alexander und Mohammed: Denkmale aus
Antike und frühem Christentum* (Leipzig 1986), 164–8; A. R.
Zakzouk, 'Apamée', *Syrie: Mémoire et Civilisation* (Paris
1993), 280–83

45 | The 'Dead City' of Serjilla, Syria

There are more than 800 ancient ruined sites within
an area of 150 x 40km on the limestone massif of
northern Syria. The 'Dead Cities' are among the
most important archaeological sites in the Middle
East. Serjilla is only one example among many of
the countless larger and smaller towns built from
local limestone in this densely settled region. It lies
in the middle of the southern mountain chain of the
Jebel Zawiye (Jebel Riha) some 100km south-west
of Aleppo. The well-to-do population lived in villas,
villages and towns, its wealth based on the cultiva-
tion of grapes and olives, the proceeds of which
went hand in hand with intensive building activity
that found expression in particular in important
sacred buildings, many of which have survived.
The houses built in the eastern part of the town
during the early settlement phase in the 2nd and
3rd centuries are still relatively modest in compar-
ison to the early Byzantine buildings of the 4th to
6th centuries. The centre of the village community
was formed by the meeting hall with its two-storey
antechamber (the 6th-century andron in the top
left-hand corner was described as a café by Butler)
and the relatively plain thermae at right angles to it.
Built in 473, this complex had a saddleback roof, a
mosaic floor in its main room and an external
cistern. The ruins of the three-aisled basilica can be
made out in the middle of the picture.
R. W.

G. Charpentier, 'Les bains de Sergillan', *Syria*, 71/1–2 (1994),
113–42; C. Strube, 'Baudekorationen im Nordsyrischen
Kalksteinmassiv I: Kapitell-, Tür- und Gesimsformen der
Kirchen des 4. und 5. Jahrhunderts n. Chr.', *Damaszener
Forschungen*, 5 (1993), 154–9

46 | Remains of the city of Ugarit, Syria

The ruins of the ancient city of Ugarit lie on an
overgrown hill, Ras Shamra ('Fennel Headland')
approximately 11km north of Latakia. The site was
examined by French archaeologists between 1929
and 1939 and again from 1948, but its size – it
measures some 600 x 500m – means that only a
small part of it has been properly excavated. The
site is easily reached and is particularly attractive to
visitors not only because of the extent of its
surviving structures but because of the fascinating
contrast that it provides between excavated areas,
others that have not yet been examined and that are
still covered in dense vegetation and, finally, those
areas that are already grown over again. Ugarit was
the capital of a small Syrian kingdom with contacts
far beyond the Mediterranean. It flourished during
the Middle and Late Bronze Age (c2000 to the early
12th century BC), but the period about which we
know the most is the one from the early 14th
century BC to the sudden demise of Ugarit's urban
civilization. The picture shows the western part of
the residential quarter with the entrance for visitors
to the town in the lower right-hand corner. The
irregularly enclosed building is the royal palace with
its six courtyards and numerous rooms bounded by
the ancient road that dominates the area (the Rue
du Palais). To the south is a smaller palace, where a
clay tablet was found containing the 'Ugarit
alphabet', a consonantal script only superficially
similar to the cuneiform that was normally used.
R. W.

G. Sa'adé, 'Ougarit', *Métropole Cananéenne* (Beirut 1979);
G. D. Young (ed.), *Ugarit in Retrospect: 50 Years of Ugarit
and Ugaritic* (Winona Lake, Ind., 1981); M. Yon, *La cité
d'Ougarit sur le tell Ras Shamra* (Paris 1998)

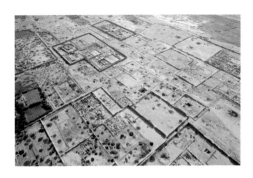

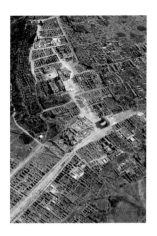

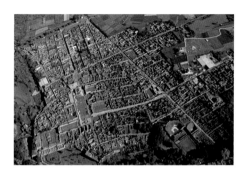

47 | **The capital of the Chimú polity at Chan Chan, Peru** Chan Chan was the largest city in pre-hispanic Peru. Situated on the Pacific coast north of Trujillo, its centre alone covered an area of more than 6 sq km and is believed to have had a resident population as high as 20,000. By the 12th century AD the Chimú polity had begun to expand from the Moche Valley along the coast until it encountered the equally expansionist Inca empire in the 15th century. Around AD 1470 Chan Chan was overrun by the Inca and the Chimú polity was incorporated into the Inca state. The centre of Chan Chan contained few open spaces or streets but was dominated by ciudadelas, or citadels. These were compounds surrounded by adobe walls up to 10m high and served as living quarters, administrative centres, storehouses and burial sites for the rulers of Chan Chan, who presumably erected these buildings one after the other according to a uniform model. Between the citadels were smaller buildings of a similar design in which the local élite lived. The living quarters and workshops of the ordinary people were erected outside the walled compounds and can barely be seen today. They are known chiefly from excavations. During the Chimú period the desertlike area surrounding Chan Chan was opened up by a dense network of settlements, roads, irrigation canals and fields. During the early colonial period the Spanish systematically searched the city for gold. In 1986 the precarious state of the mud-brick buildings encouraged Unesco to declare Chan Chan a World Heritage Site and to include it in its list of endangered heritage sites.
K. L.

E. F. Mayer, *Chanchán: Vorspanische Stadt in Nordperu* (Munich 1982) (Materialien zur Allgemeinen und Vergleichenden Archäologie 6); M. E. Moseley and K. C. Day (eds.), *Chanchan: Andean Desert City* (Albuquerque 1982) (School of American Research: Advanced Seminar Series); M. E. Moseley and A. Cordy-Collins (eds.), *The Northern Dynasties: Kingship and Statecraft in Chimor* (Washington 1990)

48 | **Ruins at Volubilis, Morocco**
The largest Roman city in what is now Morocco, Volubilis lies c120km east of Rabat and c55km west of Fez. The settlement is probably Berber in origin but later fell under Punic influence. With the end of the Carthaginian Empire in 146 BC, Volubilis became one of the urban centres and residences of the Berber kingdom of Mauretania, which was largely inhabited by nomads. With the establishment in AD 40 of the Roman province of Mauretania Tingitana – the most westerly province in the Roman Empire – Volubilis served as the provincial capital alongside Tingis (now Tangier). Situated deep inland, it functioned not only as an administrative and religious centre but also as the economic nub of a region noted above all for the cultivation of olive trees. Its heyday as a city came in the 2nd and 3rd centuries AD. The monuments dating from Roman imperial times continue to leave their mark on the ruined townscape, although there are also visible remains of the Punic and Mauretanian phases, including a lengthy section of fortification. Following the founding of Fez by the first Muslim dynasty to rule over the new kingdom of Morocco at the end of the 8th century, Volubilis was gradually abandoned. The ruins are first mentioned in a European document in 1721, but it was not until 150 years later that they were identified as the ancient city of Volubilis. The earliest archaeological excavations began in 1887 and were intensified after part of Morocco was made a French protectorate in 1912. They are still continuing.
S. A.

L. Chatelain, *Le Maroc des Romains* (Paris 1944), 139–315; R. Thouvenot, *Volubilis* (Paris 1949); M. Riße (ed.), *Volubilis: Eine römische Stadt in Marokko von der Frühzeit bis in die islamische Epoche* (Mainz 2001); J.-L. Panetier, *Volubilis, une cité du Maroc antique* (Paris 2002)

49 | **The Roman city of Pompeii, Italy**
One of the most famous and most visited archaeological sites in the world, Pompeii is protected as a World Heritage Site. The first recorded excavations took place in 1748, although it was not until 1860 that it was excavated in any systematic way. This work continues to the present day. Situated on the Gulf of Naples close to the mouth of the Sarno in an extremely fertile volcanic zone, the city was occupied between the 6th century BC and the 1st century AD by various ethnic groups including Oscans, Etruscans, Samnites and Romans before a serious earthquake struck in AD 62. Seventeen years later, on 24 August 79, the city was completely buried and destroyed when Vesuvius erupted, an event recounted by Pliny. Pompeii is divided into nine regions, the oldest part of the city, with its triangular forum and Doric temple, being located in regions 7 and 8. The aerial photograph shows large sections of the city with its generally regular layout divided by decumani and cardines into numerous insulae. On the left-hand side may be seen the elongated forum with the Capitolium, the Temple of Apollo, the Basilica and other public buildings, while to its right and towards the foot of the photograph are the theatre, the Odeon and the small sports field. The city also had an amphitheatre, three thermae and numerous shops, businesses, workshops and brothels. The houses vary in size and status, but are often decorated with frescoes categorized into four different styles. Pompeii is unique among Roman cities in providing us with a great deal of unrivalled information about the manifold aspects of everyday life in the Empire.
S. St.

T. Kraus, *Lebendiges Pompeji: Pompeji und Herculaneum. Antlitz und Schicksal zweier antiker Städte* (Cologne 1977); P. Zanker, *Pompeji: Stadtbild und Wohngeschmack* (Mainz 1995); P. G. Guzzo and A. d'Ambrosio, *Pompei* (Naples 1998)

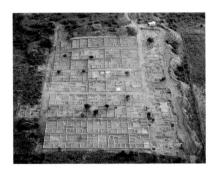

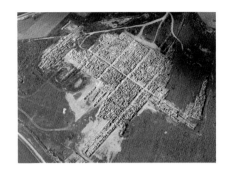

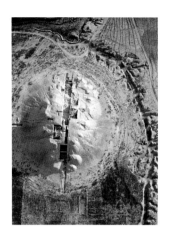

50 | **Houses in the New Town of Olynthus, Greece**
The regular layout of the houses in the New Town of Olynthus on Chalcidice is one of the best examples of the rational planning of Greek towns and cities in the classical period. Following the arrival of settlers in 432 BC, the city had to be much extended. A section of this new quarter may be seen in the present photograph of the north hill: here ten similarly sized houses with an almost square floor plan were built in an elongated block that was divided into two strips by a narrow channel. The squares and public buildings were likewise incorporated into this grid. At the top of the picture can be seen the remains of the columns of a hall. Access to the houses was gained from the adjoining streets, in each case in the centre of the property, with the living accommodation and workrooms grouped around the central courtyard. All that remains of the walls are the gravel bases, whereas the baked mud-brick walls and wooden ceilings and roofs have disappeared. The remains of interior decorations that were lavish by the standards of the time and that included elaborate mosaic floors attest to the wealth of the inhabitants, a wealth based on trade and on the cultivation of the extremely fertile alluvial land around the city. But all this came to an end in 348 BC, when Philip II of Macedonia, the father of Alexander the Great, conquered the city and completely destroyed it. Between 1928 and 1934 part of the site was excavated by American archaeologists.
R. S.

D. M. Robinson and others, *Olynthus I–XIV* (Baltimore 1929–52); W. Hoepfner and E. L. Schwandner, *Haus und Stadt im klassischen Griechenland* (Munich 2/1994), 68–113; N. Cahill, *Household and City Organization at Olynthus* (New Haven and London 2002)

51 | **The Late Bronze Age town of Enkomi/Alashiya, Cyprus** The ruins near the village of Enkomi to the north of Famagusta are the most extensive remains of a Bronze Age settlement on Cyprus. The earliest excavations were undertaken by the British Museum in 1889, followed by French and Cypriot teams, all of whom uncovered large parts of the area. Almost all of the remains of the buildings that are visible today date from the 13th and 12th centuries BC, after the city's streets were redesigned by refugees from Mycenaean Greece using the then unique rectangular grid system. At the same time, the city was fortified with a solid wall. Around 1200 and again in the following century the city was destroyed by catastrophic fires but on each occasion it was rebuilt in the same basic form. As a result of the numerous additions and alterations, the original floor plans are often unclear, but it is evident that the houses were rectilinear in shape. There is a narrow public square at the intersection of the main street, which runs along a north-south axis, and the fifth street at right angles to it. The large building with the carefully assembled ashlar walls in the middle of the adjacent block of houses is an administrative centre or residence. There are two smaller sanctuaries in the adjacent blocks to the north and east. The size of the city and its public buildings suggests that it may have been the ancient capital Alashiya that is mentioned in Egyptian texts. The Egyptians imported copper from here – always one of Cyprus's chief exports – and several bronze workshops indicate that copper was also processed in Enkomi.
R. S.

A. S. Murray and others, *Excavations in Cyprus* (London 1900), 1–54; C. F. A. Schaeffer and others, *Alasia I* (Leiden and Paris 1971); J. C. Courtois, 'Enkomi und das Ras Schamra: Zwei Aussenposten der mykenischen Kultur', *Ägäische Bronzezeit*, ed. H. G. Buchholz (Darmstadt 1987), 182–217

52 | **The settlement mound of Tepe Yahya, Iran**
Tepe Yahya lies approximately 225km south of Kirman. Some 20m in height and 190m in diameter, it is the largest settlement mound in Kirman Province in southern Iran. It owes its characteristic frustum shape to the solid mud-brick walls of a citadel that is no longer visible but which stood on the summit of the tell during its final settlement period in Parthian or Sassanian times. But it was during the earlier periods that the settlement acquired its greatest importance, a history that has been traced back to the 5th millennium BC by American excavations. There are few other places in Iran that can boast such a long and continuous history. The rich Achaemenid settlement beneath the citadel may be the Carmania familiar from Greek sources as the place Alexander passed through with the remnants of his army on his way back to Greece from India. Even more important for Iran's early and prehistoric past are the Bronze Age and Neolithic levels that have revealed not only richly painted ceramics, decorated stone vessels and bronze tools but also seals and clay sealings known as bullae, together with proto-Elamite clay tablets from the 4th and 3rd millennium BC. In the Middle Ages the region became a refuge for Zoroastrian communities; numerous *chahartaqs* are presumably the ruins of fire temples that survived the Islamic conquest longer than elsewhere.
D. H.

C. C. Lamberg-Karlovsky, 'The Proto-Elamite Settlement at Tepe Yahya', *Iran*, 9 (1971), 87–96; C. C. Lamberg-Karlovsky and M. Tosi, 'Shahr-i Sokhta and Tepe Yahya: Tracks on the Earliest History of the Iranian Plateau', *East and West* (New Series), 23 (1973), 21–74

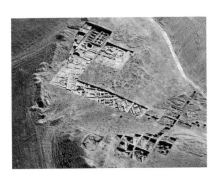

53 | **The settlement mound of Tell Knedig, Syria**
Tell Knedig lies some 20km south of Hassakeh, the administrative centre of the province of the same name, on the west bank of the Khabur River. The ancient settlement site is morphologically integrated into the oval tell in the foreground, which is some 15m high, and also into a flat settlement to the north-east of the hill. Together, the tell and the flat settlement cover an area of 200 sq m or nearly 3 ha. Tell Knedig attracted the attention of researchers when Syria began to plan a regional irrigation system on the Lower Khabur and more than 30 historic settlement sites were threatened with flooding by a dam that was completed in 1997. Between 1993 and 1997 researchers from the Museum of the Near East in Berlin were allowed to examine the site under the terms of a rescue excavation. These excavations concentrated on a large area of the flat settlement and also on the tell plateau. Whereas the uncovered settlement structures in the 'lower town' belong to the Early Bronze Age (first half of the 3rd millennium BC) with their private houses, large rectangular storage building (close to the upper edge of the picture), fountain (the round structure to the right) and round storage building (the round structure to the left), the remains of the walls on the plateau date to the Neo-Assyrian period (early 1st millennium BC). Also discovered were traces of settlements from the Parthian and Roman period (1st–2nd century AD) and from the Abbasid and Ayyubid period (9th–12th century AD). The round hollows in the area that was not excavated are modern remains of round earth silos in which the semi-nomadic population kept its agricultural produce until the middle of the 20th century.
R. W.

Preliminary reports: E. Klengel and others, *Mitteilungen der Deutschen Orient-Gesellschaft*, 128 (1996), 33–67; 129 (1997), 39–87; 130 (1998), 73–82

54 | **The Via Domitia near Montpellier, France**
The oldest Roman road in Gaul links the Rhône and the Pyrenees and owes its name to the proconsul Domitius Ahenobarbus. A military milestone in the museum at Narbonne attests to the fact that he built it in 118/117 BC. Its course followed an earlier road, the Via Herculanea, so called because according to legend it was the one taken by Hercules when he returned home with the cattle that he had stolen from Geryon on the island of Erythia. The source of this attribution is the Greek historian known only as Pseudo-Aristotle, who also reports that before the Roman conquest the local chiefs were required to guarantee the safety of tradesmen and travellers. It is not surprising, therefore, to find that this road links important pre-Roman settlements such as Nîmes and Béziers. Long sections of the road have been preserved in the vicinity of Montpellier by a country lane known locally as the 'Chemin de la Monnaie', a term derived from the Latin *via munita* ('paved way') but changed under the influence of the Occitan word *moneda* ('coin'). This region also included the waystations Forum Domitii (Montbazin), Sextantio (Castelnau-le-Lez) and Ambrussum (Villetelle). Important excavations are currently in progress close to the Roman bridge over the Vidourle at Villetelle.
J.-L. F.

P. A. Clément and A. Peyre, *La voie Domitienne: De la via Domitia aux routes de l'an 2000* (Montpellier 1991), 190; G. Castellvi and others, *Voies romaines du Rhône à l'Èbre: Via Domitia et via Augusta* (Paris 1997), 304 (Documents d'Archéologie Française 61)

55 | **The legionary camp at Carnuntum, Austria**
Originally an oppidum of the Celtic Boians, Carnuntum developed as a bridgehead across the Danube on the Amber Route at the Porta Hungarica between Bratislava and Hainburg. First mentioned in AD 6 as a winter camp for Roman troops a few kilometres upstream from the sulphur springs at Bad Deutsch-Altenburg in eastern Lower Austria, it became the permanent quarters of the Fourteenth Legion and supreme command of the province of Pannonia from AD 50. From AD 170 Marcus Aurelius used it as his base of operations in his campaign against the Marcomanni. A civilian settlement of the same name, 2.5km to the west, was later created a municipium by Hadrian (AD 117–38). Septimius Severus was proclaimed emperor here by his soldiers in 193 and bestowed on the town the title of colonia. Carnuntum flourished in the decades that followed. The site is now an archaeological park, its main attractions the Pagan Gate (a triumphal arch erected by Constantine in around AD 350), two amphitheatres, ruined gardens and a museum. But the greater part of these settlements – like the camp, which was again covered over in the Second World War – lies unexcavated in fertile areas of arable land. In the present photograph the unexcavated settlement around the camp – the *canabae legionis* – can be identified by the vegetation. This settlement was expanded along urban lines in the 2nd century and a regular system of streets introduced. Most of the houses and working areas are grouped round a large central courtyard. To the left of the picture is the approach to the camp on which no building work is permitted.
P. S.

W. Jobst, *Provinzhauptstadt Carnuntum: Österreichs größte archäologische Landschaft* (Vienna 1983); M. Doneus and others, 'Archäologische Prospektion der Landschaft von Carnuntum: Möglichkeiten der Luftbildarchäologie', *Carnuntum Jahrbuch* (2000), 53–72; M. Kandler, 'Carnuntum', *The Autonomous Towns of Noricum and Pannonia/Die autonomen Städte in Noricum und Pannonien: Pannonia*, ed. M. Sasel and P. Scherrer (Ljubljana 2003) (Situla 41)

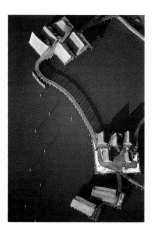

56 | **Reconstructed pile dwellings at Unteruhldingen, Germany** Situated in an idyllic bay on the northern shore of Lake Constance near Überlingen, the reconstructed pile dwellings at Unteruhldingen (1922–2002) are a unique blend of research, imagination and the ideology associated with archaeological studies on such dwellings. The findings of the excavations undertaken by Schmidt and Reinerth of the Tübingen Research Institute on the Federsee in the early 1920s exploded the theory propounded by Keller in 1854, whereby pile dwellings were settlements built in water. But their new interpretation of these dwellings as lake-shore settlements was ignored when both scholars, working in cooperation with the newly founded Society for Pile Dwellings and Local History, built the first two houses – at the lower edge of the photograph – in 1922. The Bronze Age reconstructions in the middle of the photograph were opened in May 1931 and again reflected Keller's outdated theory, whereas the interior and interpretation of these dwellings – modelled on the findings of the excavations at the Buchau Water Castle – were influenced by National Socialist ideas on Germanic culture. With its six pile dwellings and palisade (off the edge of the top right-hand corner of the photograph), the Neolithic village erected between 1938 and 1940 was finally reconstructed as a lake-side settlement, but the defensive character of the site continued to reflect National Socialist ideology. The final part of the building programme (in the top left-hand corner) dates from 2002 and shows a Late Bronze Age reconstruction of the findings from Unteruhldingen-Stollenwiesen (973–966 BC).
T. St.

F. Keller, 'Die keltischen Pfahlbauten in den Schweizer Seen', *Mitteilungen der Antiquarischen Gesellschaft Zürich*, 9/2 (1854), 66–8; R. Bollmus, *Das Amt Rosenberg und seine Gegner: Studien zum Machtkampf im nationalsozialistischen Herrschaftssystem* (Stuttgart 1970); Pfahlbaumuseum Unteruhldingen (ed.), *Plattform 1–3* (1992–3)

57 | **Pile structures at Constance, Germany**
The site illustrated here lies to the east of the Municipal Gardens in Constance, at the point where Lake Constance flows into the Rhine. The wooden posts are best seen in winter, when the water is not clouded by algae. Three parallel lines of posts may be identified. These are believed to represent the groundplan of a house, whereas the single row of posts has no known function. Both structures have yet to be dendrochronologically dated, but unlike a neighbouring pile structure that dates from the Urnfield period (*c*1060–850 BC), they are thought to date from the Middle Ages or early modern period. The chalk banks at the edges of Lake Constance have been used for lake settlements from the Neolithic period around 4100 BC. By building these dwellings on posts or stilts, the local inhabitants were able to counter changes in the lake's water level caused by melting snow in the Alps. Underwater explorations undertaken by the Baden-Württemberg Department of Historical Monuments have shown that the shores of Lake Constance were settled, with interruptions, for 3250 years, from Neolithic times to the end of the Bronze Age. The phenomenon of using lakesides for settlements is not confined to Lake Constance – in south-west Germany alone there are one hundred or so lakeside or peat-moor settlements – but embraces the whole area covered by the foothills of the Alps, from the former Yugoslavia to Austria, Switzerland, Italy, France and as far away as northern Spain.
T. St.

H. Schlichtherle and B. Wahlster, *Archäologie in Seen und Mooren: Den Pfahlbauten auf der Spur* (Stuttgart 1986); H. Schlichtherle, 'Siedlungsarchäologie im Alpenvorland', *Forschungen und Berichte zur Vor- und Frühgeschichte in Baden-Württemberg*, 36/37 (Stuttgart 1990); M. Höneisen (ed.), *Die ersten Bauern: Pfahlbaufunde Europas*, 2 vols. (Zurich 1990) (exhibition catalogue)

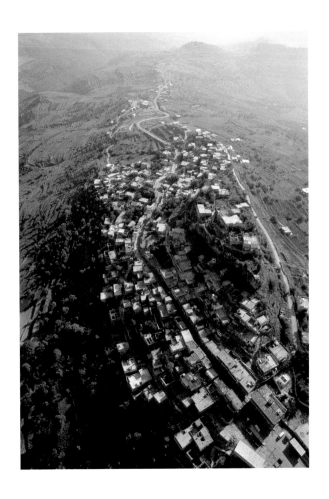

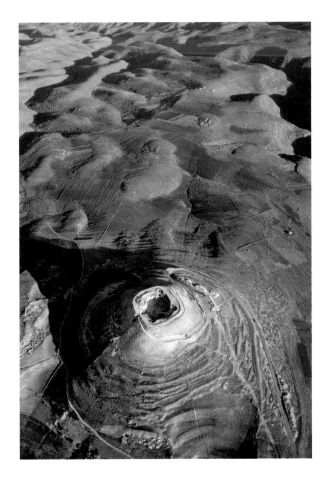

58 | **The royal residence at Qadmus**, 12th century AD, Syria, 1977

59 | **The palace complex at Herodium**, 1st century AD, Palestine, 1972

3. LIVING IN THE LAP OF LUXURY – PALACES AND ROYAL RESIDENCES

How long will it be before there is no longer a lake into which the gables of a villa do not stare! There will be no river whose banks are not crowned by your country seats! Wherever the sealine forms a bay you will lay the foundations for another palace!

Seneca, *Epistulae morales* 89:21 (1st century AD)

The days and the months flow by,
But the palace on Mount Mimoro lasts for ever.

Sei Shonagon, lady in waiting at the court of the empress Sadako in Kyoto (AD *c*1000)

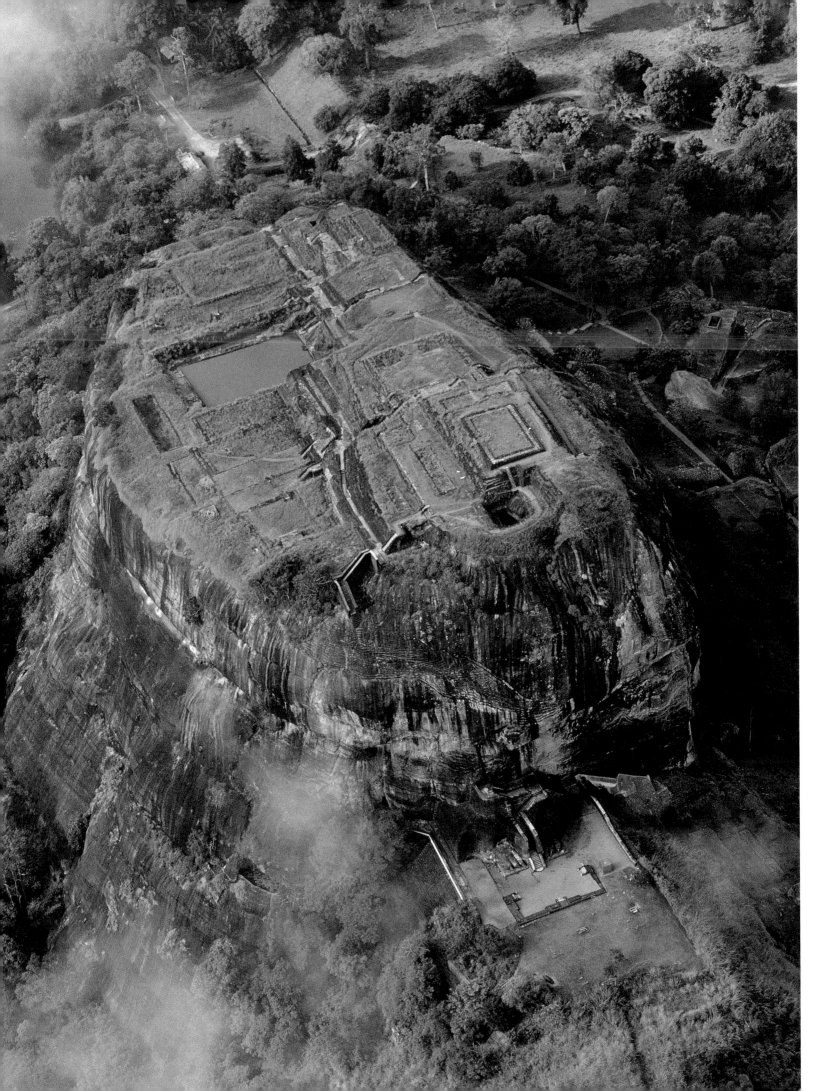

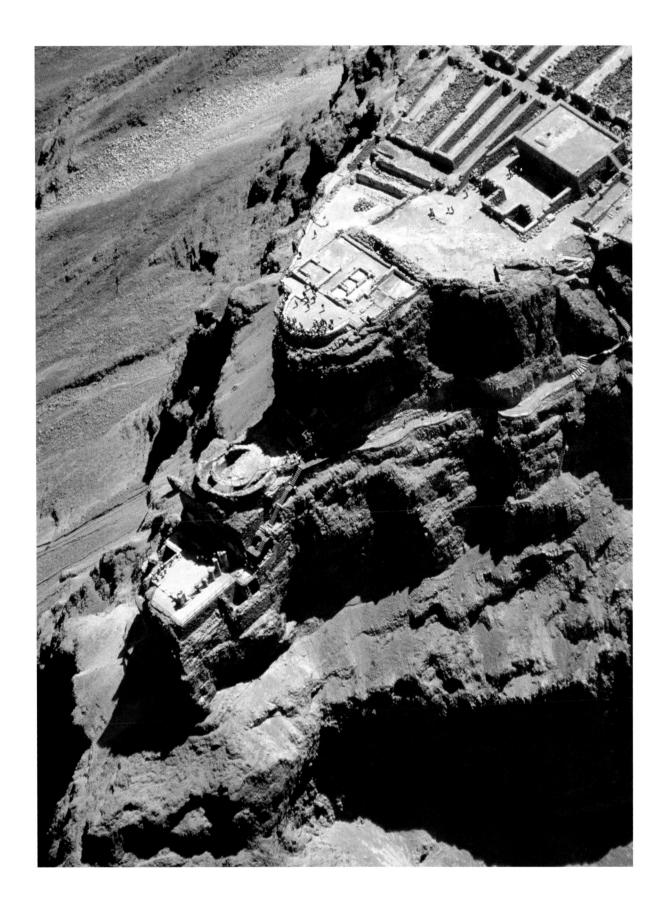

60 | **The royal residence at Sigiriya**, 5th century AD, Sri Lanka, 1969. World Heritage Site

61 | **The fortress-palace at Masada**, 1st century BC, Israel, 1972. World Heritage Site

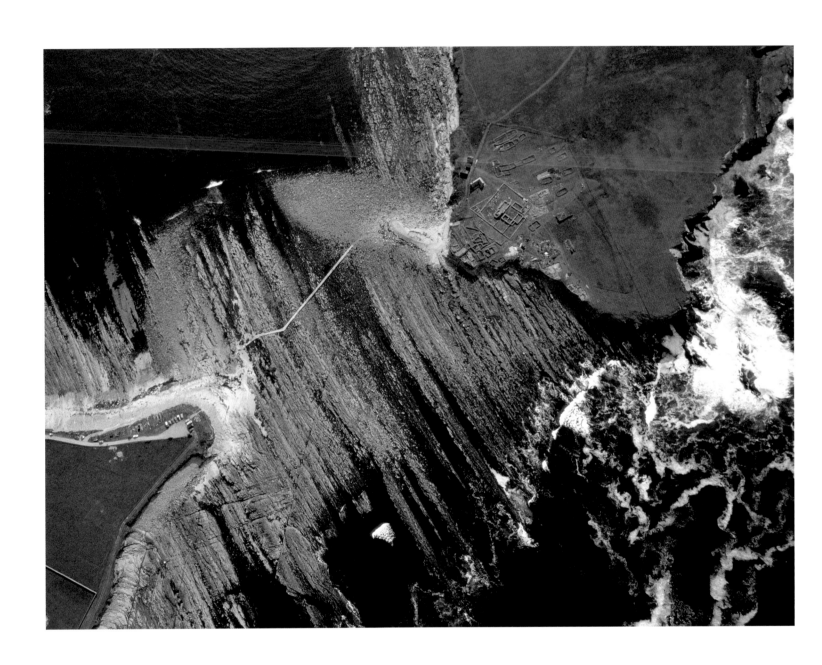

62 | **The Brough of Birsay on Mainland, Orkney Islands**, from 9th century AD, Scotland, 1976

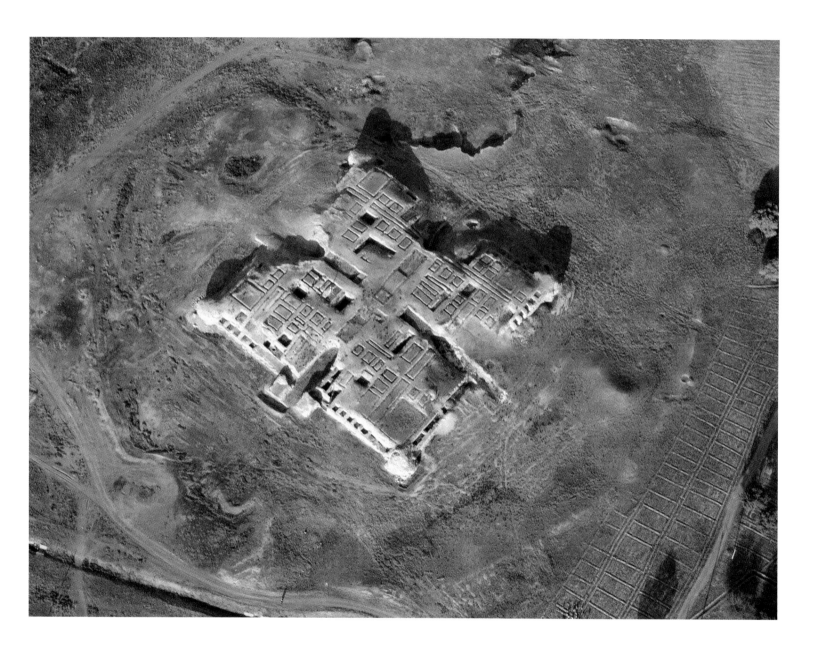

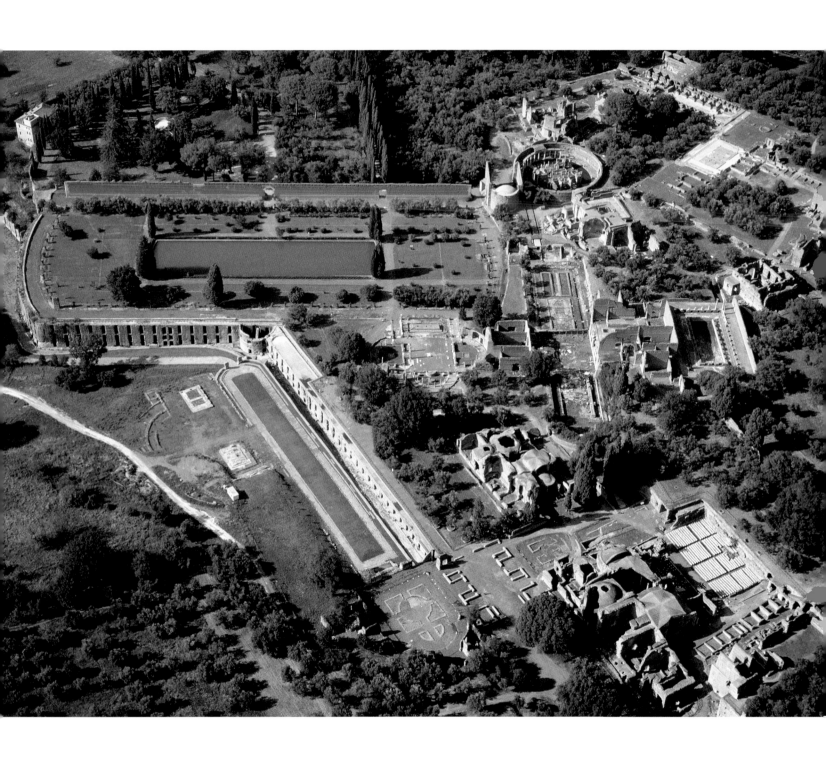

64 | **The Villa Adriana at Tivoli**, AD 118–34, Italy, 2002. World Heritage Site

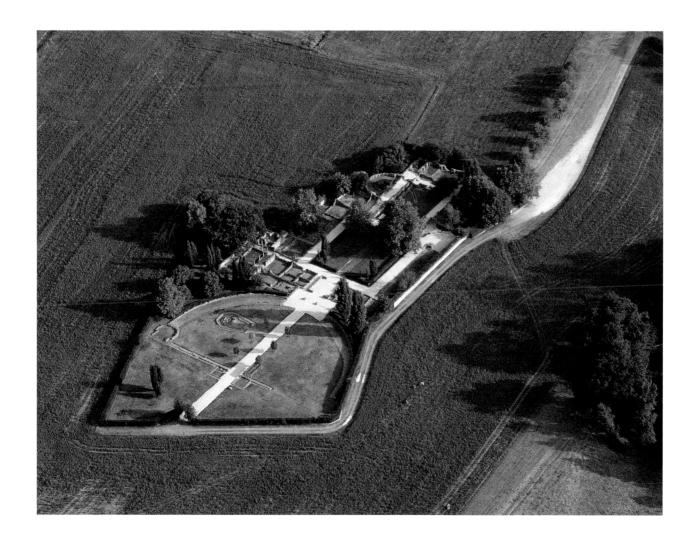

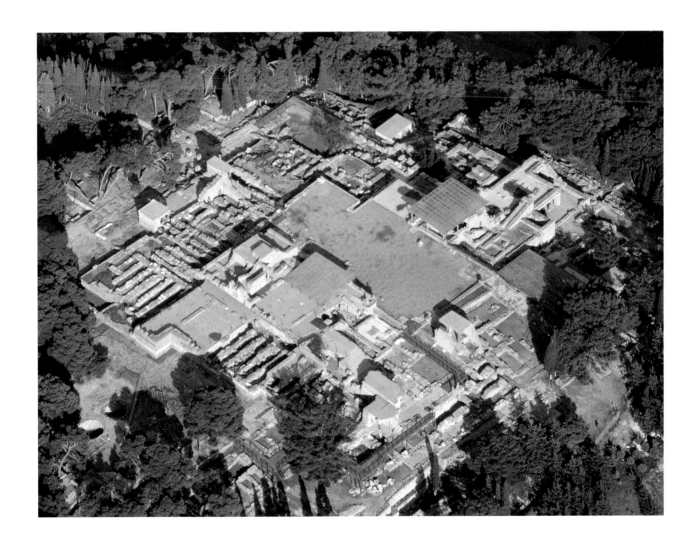

66 | **The Minoan palace of Knossos on Crete**, c2000–1400 BC, Greece, 2000

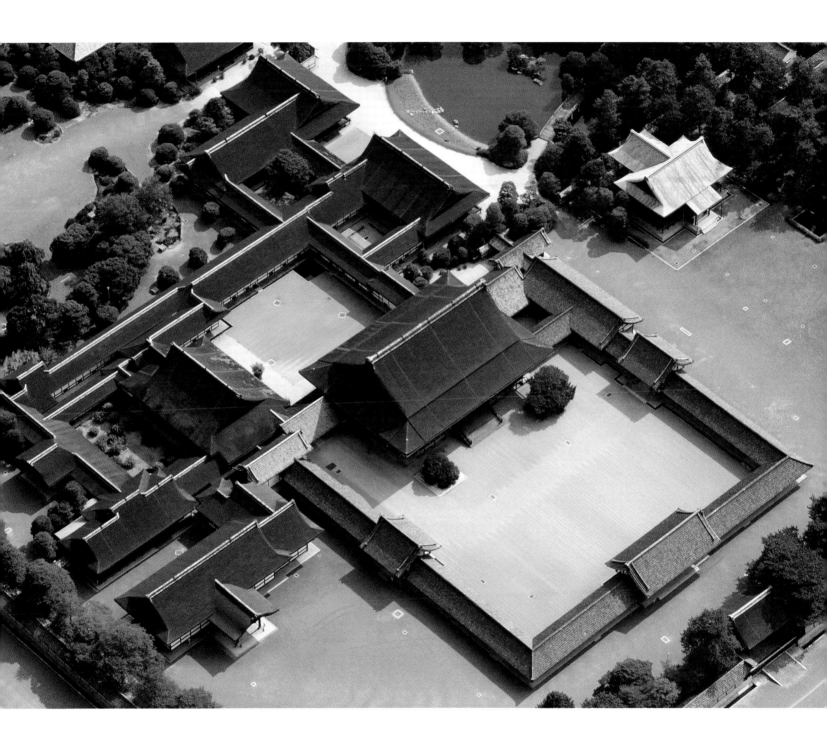

67 | **The Imperial Palace at Kyoto**, founded AD 794, Japan, 1987. World Heritage Site

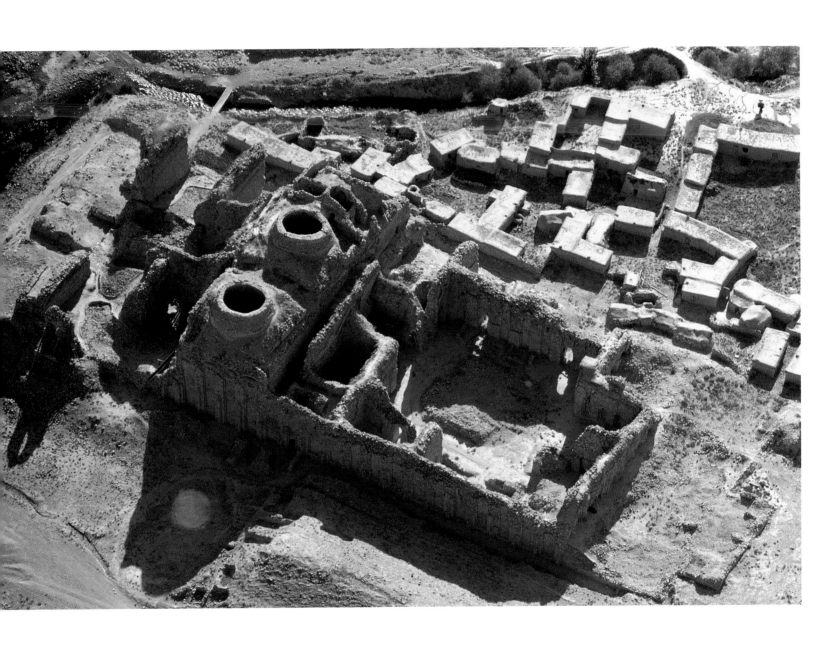

68 | **The Sassanian palace of Ardashir I near Gur/Firuzabad**, early 3rd century AD, Iran, 1976

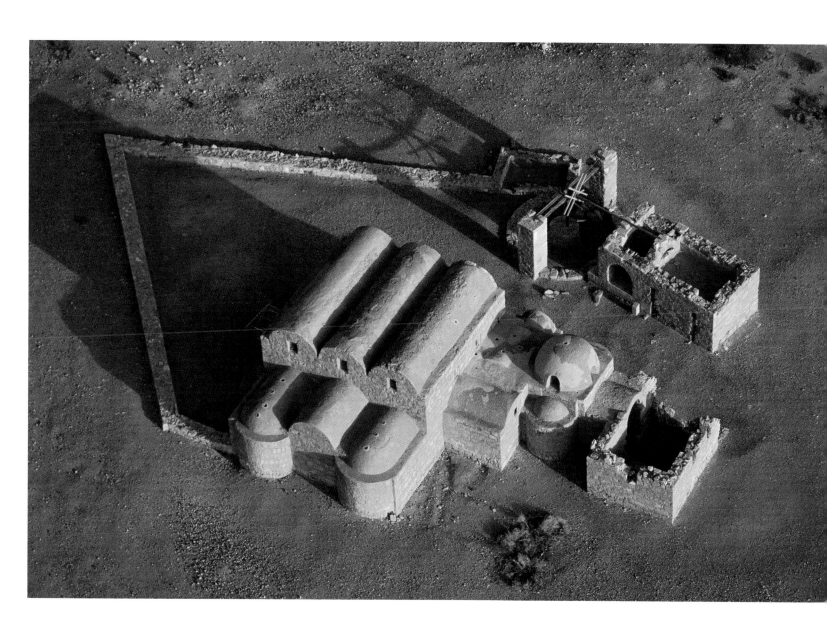

70 | **The palace at Persepolis**, 520/519 BC–4th century BC, Iran, 1976. World Heritage Site

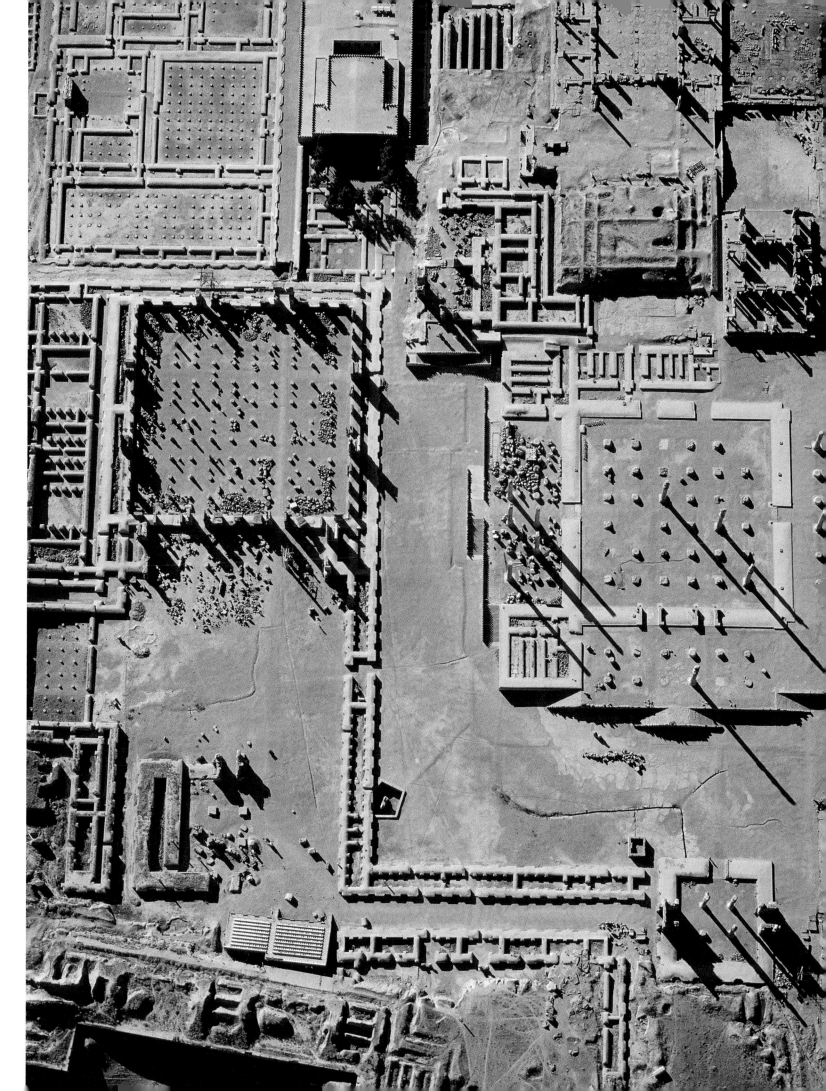

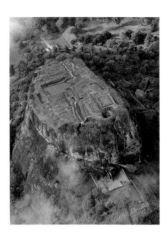

58 | **The royal residence at Qadmus, Syria**

In the 12th century the central belt of the Jebel Ansariye – the mountain chain that runs parallel to the Syrian coast – was controlled by the Shiite Ismailites from a series of remote and often inaccessible castles, chief of which were Qalat al-Kahf, Masyaf, Qalat Olleiqa, Qalat Maniqa and Qadmus itself. Qadmus lies in the western foothills of the coastal mountains some 27km from Baniyas on the Mediterranean and can be reached by the road that runs from Baniyas via Masyaf to Hama. It was one of the headquarters and safe retreats of Sinan ibn Salman, also known as Rashid ad-Din (1163–93). Described by the Crusaders as the charismatic and legendary 'Old Man of the Mountains', he became the Syrian representative of the political and militant secret society of the Assassins and for decades was a much-feared local ruler. The politically motivated actions of this fanatico-religious sect of Neo-Ismailites, which broke away from the Shiites and fought against their Christian and Sunni Muslim enemies, were proverbial and have given us the term 'assassin', meaning a particularly radical and spectacular murderer. (The word is derived from the word 'hashish' and refers to the assassins' rapt, opiate-induced state.) The castle was destroyed by Ibrahim Pasha in 1838 and the historic remains removed.

R. W.

P. Deschamps, *Les châteaux des Croisés en Terre Sainte: Le Crac des Chevaliers*, vol. 1 (Paris 1934) (Étude historique et archéologique 2); B. Lewis, *The Assassins: A Radical Sect in Islam* (London 1985)

59 | **The palace complex at Herodium, Palestine**

According to the Jewish historian Josephus, the artificial mound to the south of Bethlehem on which Herod the Great built the palace that he named after him resembled a woman's breast. The site lies in the middle of the Judaean Desert and commemorated a battle fought here. Hard pressed in his flight from Jerusalem, Herod defeated the supporters of the Hasmonaeans who had reigned before him as priest-kings. Herod built a circular four-towered fortified palace on top of the hill, furnishing it with every royal luxury, including banqueting halls and swimming pools in palatial rooms further down the hill. Such remote desert palaces were not unknown to the Hasmonaeans, and some of them even bore dynastic names, but Herodium out-Heroded all its predecessors. The fortified palace was excavated during the 1960s and can be seen as such in the present aerial photograph, whereas examination of the buildings lower down the hill did not begin until 1972, the year in which the photograph was taken. The overall design, which took account of sight lines and other architectural reference points, was a dynastic monument to Herod, as is clear from the fact that he not only named it after himself (thereby implicitly picking up a Hasmonaean tradition) but also had himself buried there. His grave has yet to be discovered but has been the object of much speculation.

A. L.

E. Netzer, *Greater Herodium* (Jerusalem 1981); V. Corbo, *Herodion I: Gli edifici della Reggia-Fortezza* (Jerusalem 1989); A. Lichtenberger, *Die Baupolitik Herodes des Großen* (Wiesbaden 1999), 99–112

60 | **The royal residence at Sigiriya, Sri Lanka**

In the centre of Sri Lanka, some 200km north-east of the capital Colombo, the 170m high rocky massif of Sigiriya towers over the surrounding jungle. Covering an area of some 12,000 sq m, the massif reveals traces of walls that are believed to be the remains of a palace. Access to the site is thought to have been afforded by a flight of steps hewn into the rock on the western side of the hill and by a monumental entrance in the shape of a lion on the northern side (towards the bottom of the photograph). There were originally 500 frescoes of women on the western side, but of these only 19 'cloud maidens' remain, albeit still sufficient to give an idea of the magnificence of the site. The fortress-like residence formed the centre of a lower city 3km wide and 1km long that was secured by three ramparts and two moats. The buildings inside it included pavilions, terraces, ponds, fountains, swimming pools and gardens, all of which took account of the ambient topography. Fed by an artificial lake with a 12km long dam, a sophisticated hydrotechnical system of streams and canals regulated the supply of water within the fortified complex. The overall area of Sigiriya gives us an insight into the complexity of urban planning in the 5th century AD. The city is believed to have been built by the Sinhalese king Kassapa I (AD 477–95), who usurped the throne and moved the seat of power from Anuradhapura to Sigiriya. It was abandoned 18 years later, following Kassapa's death, but continued to be used as a monastery until the 14th century.

T. St.

R. H. De Silva, *Sigiriya* (Colombo 1971); S. Bandaranayake, *The Rock and Wall Paintings of Sri Lanka* (Colombo 1986); S. Bandaranayake, *Sigiriya: City, Palace, and Royal Gardens* (Colombo 1999)

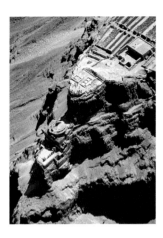

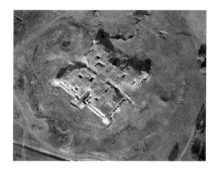

61 | **The fortress-palace at Masada, Israel**
The desert fortress of Masada lies on a pointed, sheer rocky plateau on the west side of the Dead Sea. Here the Jewish king Herod the Great (40–4 BC) built several magnificent palaces, including bathing complexes, which he surrounded with a wall. The fortification and the natural topography made the fortress virtually impregnable. Large cisterns and numerous storerooms whose tubular outlines can be seen from the air ensured that the palace was well supplied even during lengthy sieges. The most lavish and sophisticated of the palaces was the North Palace seen here. It extended over three terraces, each of which exploited a different geometric form: on the lowest terrace was a rectangular dining hall, with a round pavilion above it and, on the topmost terrace, a semicircular observation platform. Such openness towards the surrounding countryside is an example of hellenistic architecture taken to its furthest extreme and is otherwise found only in contemporary Roman villas. The fortress-palace at Masada acquired further notoriety at the time of the Jewish revolt, for it was here that the last rebels sought refuge following the fall and destruction of Jerusalem in AD 70. The fortifications withstood Rome's military machine for two long years. Only with the help of a vast ramp of rubble were the Romans finally able to take the fortress. According to Josephus the final Jewish defenders took their own lives on the eve of the city's capture. These events have now entered the collective consciousness, and recruits in the Israeli army are required to swear on oath here that Masada will never again be allowed to fall.
A. L.

Y. Yadin, *Masada: Der letzte Kampf um die Festung des Herodes* (Hamburg 1967); E. Netzer, *Masada III: The Yigael Yadin Excavations 1963–1965. Final Reports. The Buildings: Stratigraphy and Architecture* (Jerusalem 1991)

62 | **The Brough of Birsay on Mainland, Orkney Islands, Scotland** The Brough of Birsay is separated from the mainland only at low tide. The first settlement on this island was a Celtic monastic chapel and graveyard beneath the later Norse farmsteads which began in the 9th century AD and developed into a substantial settlement established in the 11th century AD, visible here as stone and earthwork long houses (to the right of the cathedral). The main building on the promontory is the church built by Earl Thorfinn the Mighty in the 11th century AD, the first Norse Christian church to be built in Orkney. In the 12th century a cathedral was established here but this was replaced by the cathedral of St Magnus in Kirkwall. After winter storms in January 1993 erosion of the cliff face revealed eleven periods of occupation and three levels of earlier walls beneath the existing consolidated walls.
R. B.

J. R. Hunter, *Rescue Excavations on the Brough of Birsay 1974–82* (Edinburgh 1986); C. D. Morris, *Sites in Birsay Village and on the Brough of Birsay, Orkney* (Durham 1996) (Birsay Bay Project 2)

63 | **The memorial at Haraqlah, Syria**
The mysterious ruins at Haraqlah lie some 3km north of the Euphrates and 8km from the town of Raqqa. Whereas the square design convinced early researchers that it was a Roman castle, Syrian excavations beginning in 1976 have shown the structure to be an Arab complex without precedent in Islamic architecture. Archaeological studies and a long-standing written tradition indicate that it is a military memorial built in the early 9th century by the Abbasid caliph Harun ar-Rashid to commemorate his victory over the Byzantine emperor Nicephorus I at the Battle of Heraclea (now in Turkey). The massive structure is enclosed within an encircling wall incorporating small towers, with gates leading to the central building from all four points of the compass. A second inner encircling wall stands out faintly in the photograph. The central building is some 100m long and takes the form of a vast terrace made from square hewn stones and reaching a height of 10m. It is entered from outside steps. In the middle of each side a lofty hall opens outwards. The cells are filled with earth and river gravel, suggesting that they were false rooms with no doors or windows. The complex presumably remained unfinished.
R. W.

K. Toueir, 'Syria Islamica aus archäologischer Sicht', *Das Altertum*, 25/2 (1979), 94–6; K. Toueir, 'Haraqlah: A Unique Victory Monument of Harun ar-Rashid', *World Archaeology*, 14/3 (1983), 296–304; A. and U. Becker, 'Hiraqla erschien uns zunächst als eine rätselhafte Ruine', *Damaszener Mitteilungen*, 11 (1999), 37–48

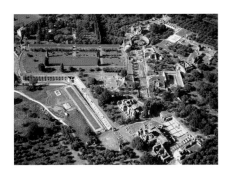

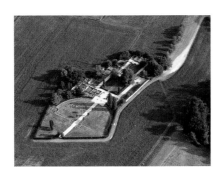

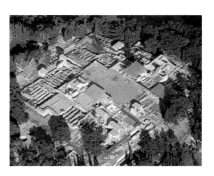

64 | The Villa Adriana at Tivoli, Italy

Situated on a plateau at the foot of the Sabine Hills below Tivoli, the Villa Adriana has a surface area of 120 ha, making it the largest of all Italian villas. A World Heritage Site, it was built between AD 118 and 134 as a summer residence for the emperor Hadrian and embodies a superb blend of nature, architecture and art, its various complexes reflecting the emperor's manifold cultural interests and extended journeys to diverse parts of his empire. The Poikile, Lyceum, Academia and Terrace of Tempe recall Greece, while the Canopus and Temple of Serapis are reminders of Egypt. The complex also included a palace, baths of various sizes, a stadium, a small island villa known as the Teatro Marittimo and the circular Temple of Venus. Incorporating an older late republic villa, the complex is divided into six main areas arranged around different axes. A number of complexes such as the domed hall on the Piazza del'Oro are notable for their unusual, almost eccentric, Baroque-like architecture. The Villa Adriana was once richly decorated with sculptures and mosaics that are now held by a large number of European museums. Following the end of the Roman Empire, the villa was used as a quarry for more than a thousand years until first being mentioned again in 1461. Renaissance artists such as Giuliano Sangallo, Bramante, Raphael, Palladio and Pirro Ligorio visited and drew the villa, while Baroque architects such as Borromini and Rainaldi were inspired by it. The same is true of 20th-century architects. The present aerial photograph shows – at the top and from the left – the Poikile, Nymphaeum, Teatro Marittimo and Piazza d'Oro, while at the bottom are the Vestibule and the great bath complexes.
S. St.

H. Kähler, *Hadrian und seine Villa bei Tivoli* (Berlin 1950); W. L. MacDonald and J. A. Pinto, *Hadrian's Villa and Its Legacy* (New Haven and London 1995); E. Salza Prina Ricotti, *Villa Adriana: Il sogno di un imperatore* (Rome 2001)

65 | The Roman villa at Montmaurin, France

In late antiquity the large Gallo-Roman villa at Montmaurin in the north-west of Saint-Gaudens in the *département* of Haute-Garonne was one of the wealthiest aristocratic residences in the province of Novempopulana. It was rediscovered in 1879 and excavated between 1947 and 1960. The complex includes a residential building (seen in the photograph) and various operational buildings spread over an area of some 18 ha and enclosed within an encircling wall. An earlier phase dating to the 1st century AD is barely visible any longer. The later villa, which can now be visited, is notable for its axial structure and symmetry. The visitor enters through a large semicircular peristyle court containing a small hexagonal shrine (at the foot of the photograph). Next comes a vast rectangular courtyard bordered by porticos that give access to rooms that served various purposes as well as to a small thermal complex in the north-west corner and to gardens outside the villa to the north. This central courtyard leads in turn to a raised section of the building with reception rooms designed on a clover-leaf plan and richly decorated with stucco, marble and mosaics: typical of many luxury villas of late antiquity, these were the main rooms of the house. The villa at Montmaurin was initially believed to date from 350 but is now thought to be later (*c*400). It attests to the wealth of the region at the time of the Visigoth invasions.
M. R.

G. Fouet, *La villa gallo-romaine de Montmaurin (Haute-Garonne)* (Paris 1969) (Gallia: Supplementary Volume 20); C. Balmelle, *Les demeures aristocratiques d'Aquitaine: Société et culture de l'antiquité tardive dans le sud-ouest de la Gaule* (Paris 2001)

66 | The Minoan palace of Knossos on Crete, Greece

Said to have been built by Daedalus for the legendary king Minos, the great palace at Knossos on the island of Crete was believed by the later Greeks to have been the labyrinth that housed the half-human Minotaur, a maze in which the unwary traveller would lose his way without a red thread to guide him. As the aerial photograph shows, the building is structured around a number of superimposed axes, but this plan was obscured by the addition of rooms around a central courtyard, a change partly due to the constant extension and rebuilding of the palace since it was founded in the early 2nd millennium BC. Sir Arthur Evans began to excavate the site in 1900 and by means of extensive restoration of the walls and frescoes attempted to convey an idea of what had once been its magnificent decorations, most of which were part of the more recent palace dating to 1700 BC. The main approach road ends in a flight of steps to the left of centre. The most important state rooms and cult rooms surrounded the paved courtyard on the western, northern and eastern sides, and it may have been in this courtyard that the acrobatic bullfights depicted in the frescoes took place. To the east, where the ground falls away, the palace was five storeys high. Somewhat further away were the workshops and working areas. Enormous clay storage vessels, especially those found in the long, narrow chambers in the west wing, give an idea of the Bronze Age palace economy. The palace was abandoned in *c*1400 BC after it had burnt down, probably in the wake of a severe earthquake.
R. S.

J. D. S. Pendlebury, *A Handbook to the Palace of Minos, Knossos* (London 2/1954); L. R. Palmer, *A New Guide to the Palace of Knossos* (London 1969); S. Hood and W. Taylor, *The Bronze Age Palace at Knossos* (London 1981)

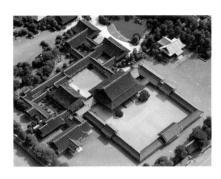

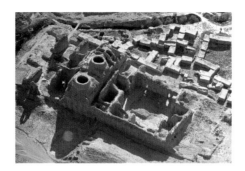

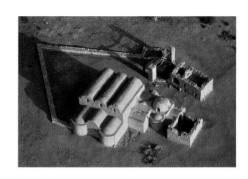

67 | **The Imperial Palace at Kyoto, Japan**
Covering an area of 84 ha, the rectangular Imperial
Park with the Old Imperial Palace (Kyoto-gosho)
lies in the Kamigyo-ku district of Kyoto and is now a
World Heritage Site. The original palace (Daidairi)
was established in the north-western part of the city
at the time that Kyoto was founded by the emperor
Kammu (737–806) in AD 794, marking the start of
the Heian period (794–1185). It was repeatedly
destroyed or damaged by fire, before being rebuilt
in its present position and original form in 1790.
This building too burnt down and was rebuilt in
1855 in the Shinden style. The rectangular area
measuring 1.4 x 1.1km is surrounded by a wall of
earth. Accessed by six gates, it houses eighteen
buildings that were used both for official and private
purposes and that were linked to each other by
galleries, their symmetry broken up by courtyards
and delightful gardens and ponds. The present
aerial photograph shows the most important
complex in the south of the palace grounds, namely,
the large Shishinden (33 x 22m), a vast hall used for
state occasions and other ceremonies and
containing the imperial throne. In front of the
southern façade may be seen an orange tree (ukon-
no-tachibana) and a cherry tree (sakon-no-sakura).
To the left of the Shishinden are the former imperial
living quarters, or Seiryoden, and to the right of that
is the Shunkoden with its curved roofs. Above it is
the small palace of Kogosho and the study hall or
Kogakumon-ju. The Imperial Palace is, as it were,
the conceptual and geographical centre of Kyoto,
which was Japan's capital from 794 to 1868 and
where even today there are more than 1500
Buddhist temples and 200 Shinto shrines (no. 193)
both within the city itself and in the surrounding
area.
S. St.

M. Fujioka, *Kyoto gosho* (The Kyoto Imperial Palace) (Tokyo
1956); K. Kamei (ed.), *Heijokyu (Heijo Palace)* (Tokyo 1963);
S. Ota, *Shinden-zukuri no kenkyu* (Research on the Shinden
Style) (Tokyo 1987)

68 | **The Sassanian palace of Ardashir I near Gur/
Firuzabad, Iran** Istakhri reports that in the 12th
century AD one of the most famous of all Iran's fire
temples stood near a pool at Firuzabad and that
according to a Pahlavi inscription it cost 30,000
dirhem. The inaccurate report brought about the
misleading name of Atashkadeh (Fire Temple). For
all its fame, the ruin is not in fact that of a fire
temple but is a second palace of the founder of the
Sassanian state, Ardashir I (AD 224–41). It was
essentially planned along identical lines to the first
palace, Qal'a-ye Dukhtar, which Ardashir, while still
an ambitious rebel, had built inside his fortress
overlooking the approach gully to his new capital
Ardashir Khurreh. Situated at the very edge of the
plain, this second palace was unfortified, demon-
strating beyond doubt that the rebellion had been
brought to a victorious conclusion. The state rooms
had been so luxurious in the first palace that the
Great Parthian King had felt provoked into under-
taking a punitive but unsuccessful expedition
against Ardashir, yet such pomp was even greater in
the later palace, which had a vast reception ivan and
three domed halls, rather than just the one. Here
the new king of Iran held audience from his throne
situated in a niche high above the ground. Demon-
strating state-of-the-art vaulting techniques,
Ardashir consciously perpetuated the older style of
Achaemenid architecture that was designed to
impress, an aim clear from his use of ornamental
elements from Persepolis. The buildings associated
with Ardashir are exceptionally well preserved,
making them outstanding examples not only of
Sassanian palace architecture but of Iranian palace
architecture in general.
D. H.

P. Schwarz, *Iran im Mittelalter nach den arabischen
Geographen* (Leipzig 1896, repr. Hildesheim and New York
1969), 56–9; D. Huff, 'Qal'a-ye Dukhtar bei Firuzabad',
Archäologische Mitteilungen aus Iran (New Series), 4 (1971)
127–71; D. Huff, 'Sassanidische architektuur', *Hofkunst van
de Sassanieden/Splendeur des Sassanides* (Brussels 1993),
45–61 (exhibition catalogue)

69 | **Omayyad palace at Qasr Amra, Jordan**
The palace at Qasr Amra in what is now Jordan is
one of a group of small palaces that the Omayyads
built around their new capital following the
conquest of Damascus. The builder may have been
Prince Walid II, who lived in the first half of the 8th
century and who was regarded as a great lover of
wine, banquets, music and female dancers, all
subjects reflected in the palace's interior decora-
tions. The palace was discovered by Alois Musil
during his study trips to the Arabian Desert. A
Spanish team undertook a thorough restoration of
the site between 1971 and 1975. The largest building
in the walled complex is an audience chamber
surmounted by three barrel vaults, with a throne
room flanked by two restrooms to the south. The
baths to the east have an anteroom, tepidarium and
domed steam bath designed along the lines of
Roman thermae. The final room is a storeroom.
Opposite this building is a sophisticated water
supply system. Harnessed to a large wheel, an
animal walking in a circle within the round enclo-
sure drew water from a 40m deep walled well,
emptying it into the cistern beside it. Hunting for
wild animals in the surrounding area is depicted in
the frescoes in the hall and was undoubtedly one of
the reasons for building the complex. The depiction
of episodes from ancient myth, enthroned rulers
and extensive building operations show that the
builders appropriated ancient traditions and sought
to portray themselves as the equals of the Byzantine
rulers. The religious ban on images meant that such
scenes are missing from later Islamic art.
R. S.

A. Musil, *Kusejr Amra* (Vienna 1907); M. Almegro and
others, *Qusayr Amra: Residencia y banos Omeyed en el
Desierto de Jordania* (Madrid 1975); L. Winkler-Horacek,
'Dionysos in Qusayr Amra: Ein hellenistisches Bildmotiv
im Frühislam', *Damaszener Mitteilungen*, 10 (1998), 261–90

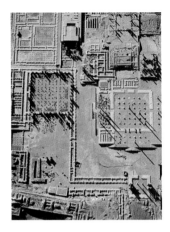

70 | **The palace at Persepolis, Iran**

Situated on a wide plain in south-western Iran,
some 60km north of Shiraz, the palace at Perse-
polis first attracted the attention of European
travellers in the 17th century, but it was not until the
20th century that excavations allowed us to recon-
struct its history with any certainty. It was the centre
of government of the Persian Empire for almost
200 years. Building work was begun by Darius I in
520/519 BC and continued by his successors. The
present photograph shows the bulk of the buildings
that make up the palace complex. All lie on a vast
platform 15m high and 450 x 300m in extent. In the
middle of the picture two buildings stand out: the
Apadana or throne room, the columns of which
were more than 19m high (some are still standing),
and the Hall of the Hundred Columns, where the
court officials worked. A broad flight of steps gave
access to the palace from the fertile plain below it
and led via the Gate of All Peoples to a courtyard
and thence over a further ceremonial staircase
decorated with reliefs to the throne room. A large
gate between the two halls led to the private living
quarters, including the palaces of Darius and Xerxes
and the apartments of their officials. Divided into
several smaller sections, the large complex to the
south-east is the treasury. Following his conquest of
Persepolis in 330 BC, Alexander the Great set fire to
the state rooms in order to avenge the destruction
wrought by the Persians in Greece. Few of the
residential tracts remained undamaged, but they
continued to provide accommodation for the
Seleucid kings who succeeded Alexander in the
Middle East.
R. S.

E. F. Schmidt, *Persepolis*, 3 vols. (Chicago 1953–70);
F. Krefter, *Persepolis: Rekonstruktionen* (Berlin 1971)
(Teheraner Forschungen 3); L. Trümpelmann and others,
Ein Weltwunder der Antike: Persepolis (Mainz 1988)

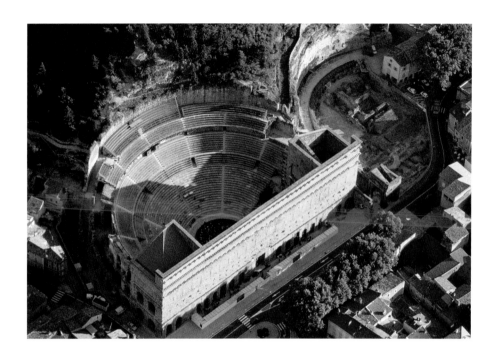

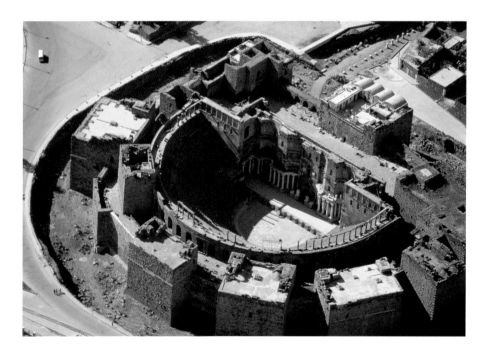

71 | **The Roman Theatre at Orange**, 1st century BC, France, 1998. World Heritage Site

72 | **The theatre at Bosra**, built AD c300, Syria, 1997. World Heritage Site

4. SEEING AND BEING SEEN – FESTIVAL SITES AND PLACES OF ASSEMBLY

The play-element in the Roman State is nowhere more clearly expressed than in the cry for *panem et circenses*. A modern ear is inclined to detect in this cry little more than the demand of the unemployed proletariat for the dole and free cinema tickets. But it had a deeper significance. Roman society could not live without games. They were as necessary to its existence as bread – for they were holy games and the people's right to them was a holy right.

Johan Huizinga, *Homo Ludens: A Study of the Play Element in Culture* (1938)

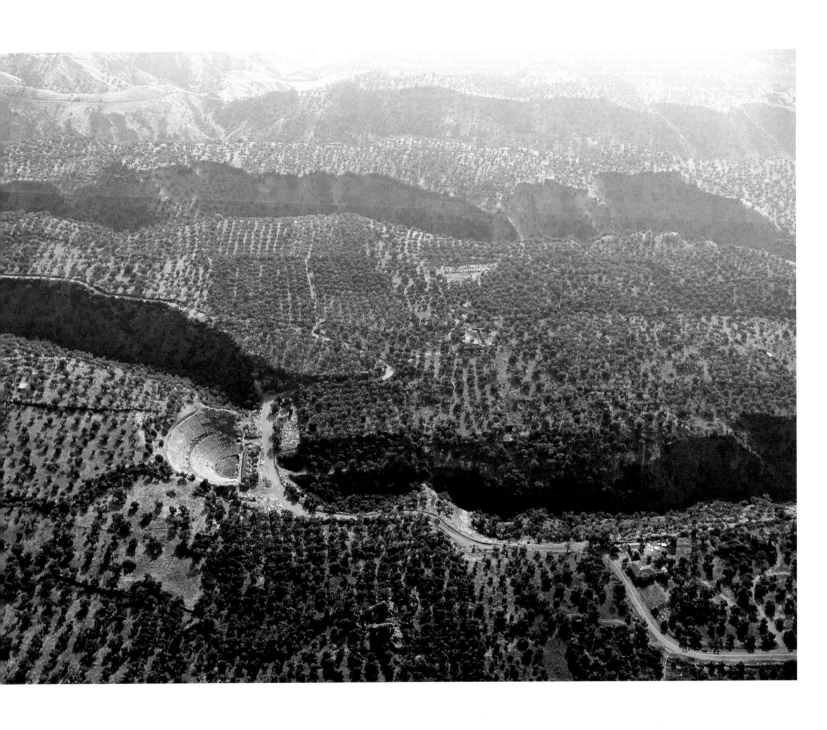

73 | **Theatre and stadium at Nysa in Caria**, 1st–2nd century AD, Turkey, 2002

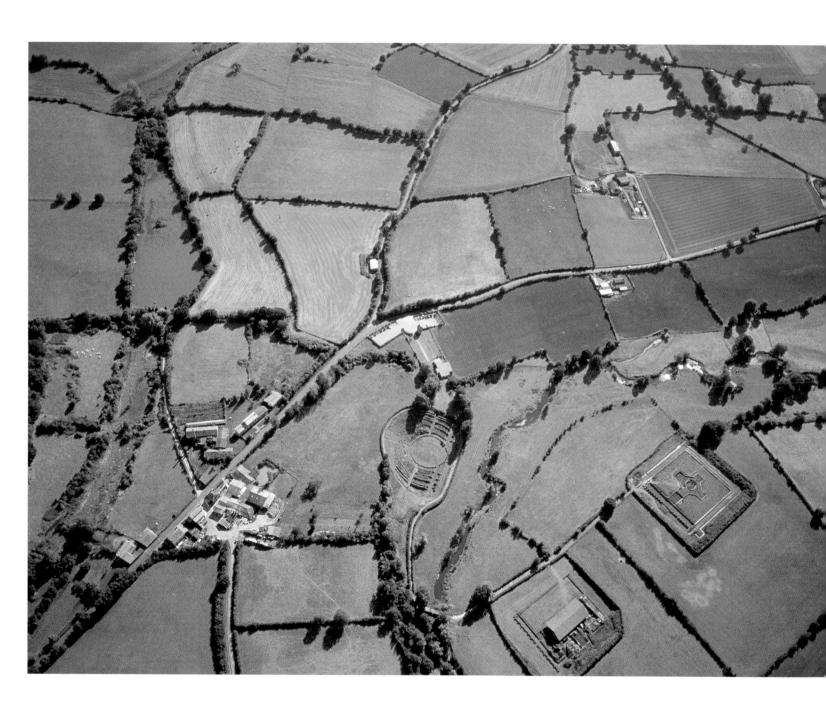

74 | **The Gallo-Roman sanctuary at Sanxay**, 1st–2nd century AD, France, 1998

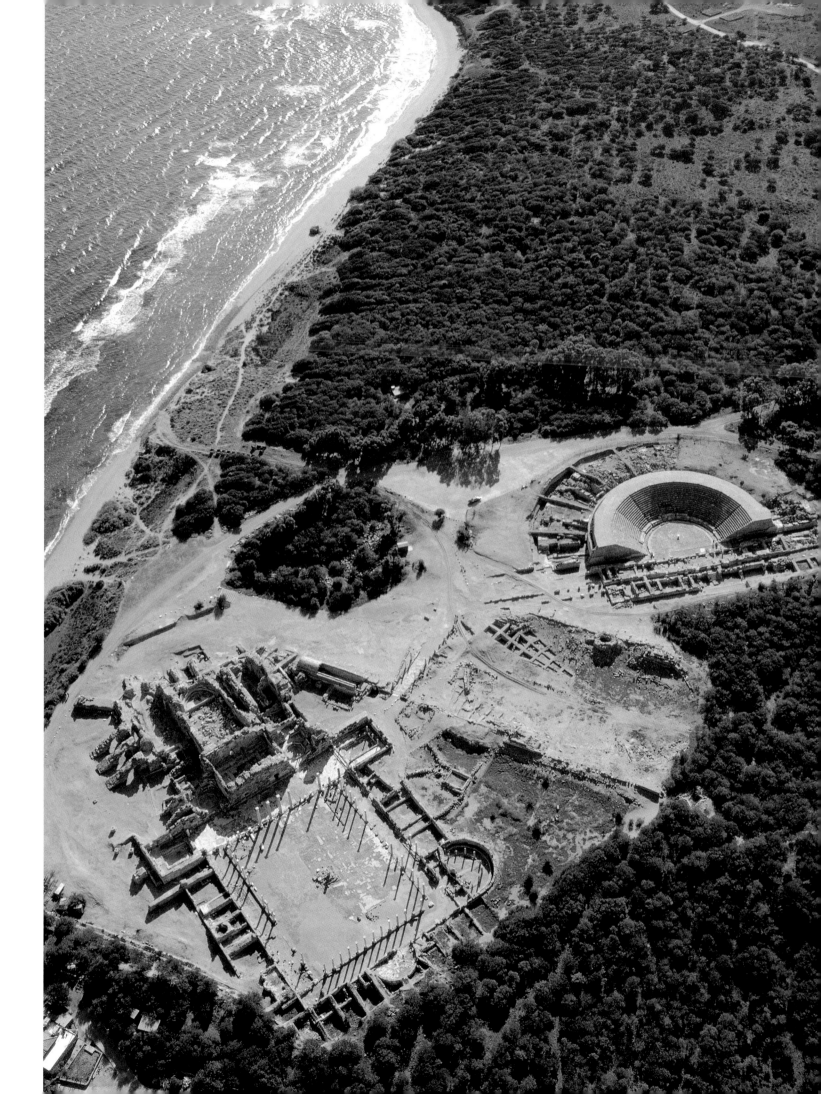

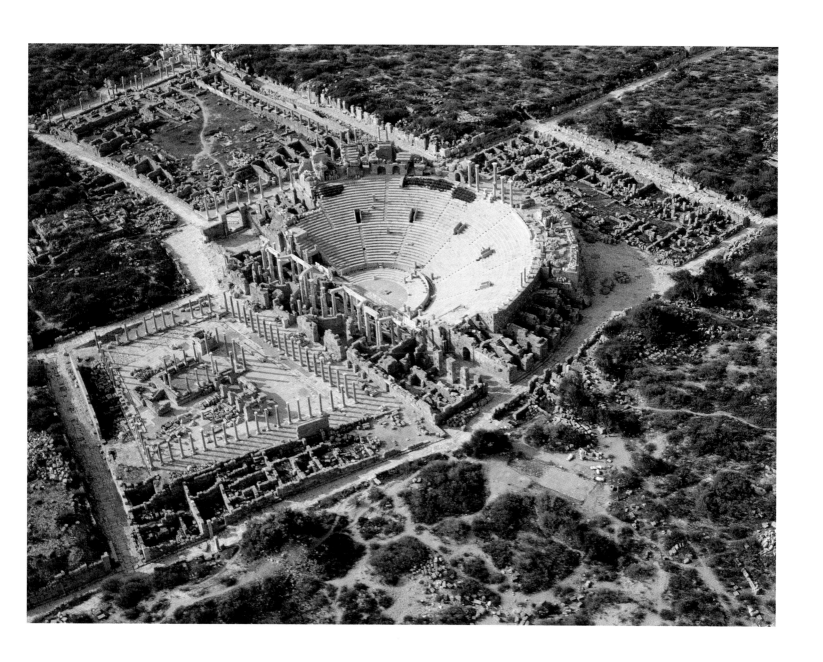

75 | **Sports grounds and playing fields at Salamis**, 1st–4th century AD, Cyprus, 1971

76 | **The Roman theatre at Leptis Magna**, 2nd century AD, Libya, 1965. World Heritage Site

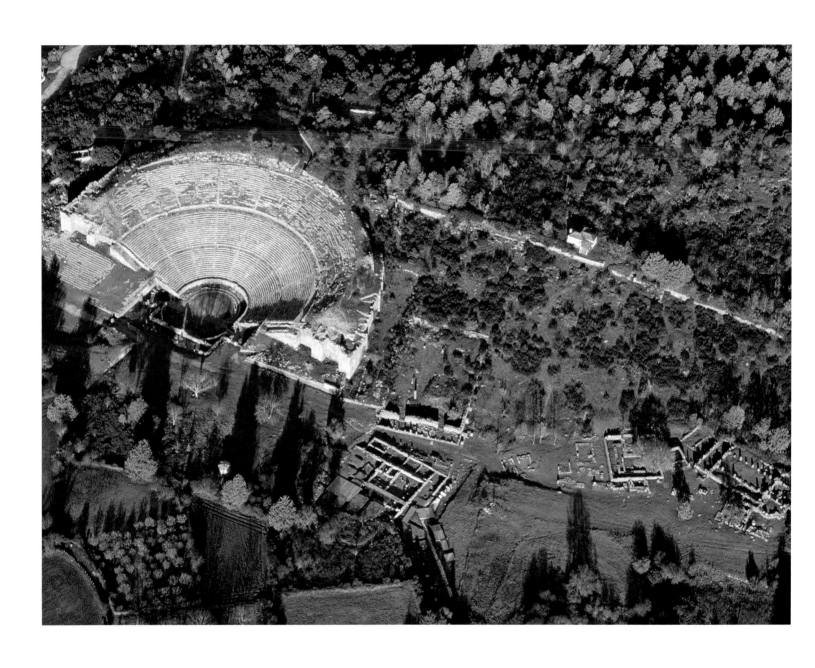

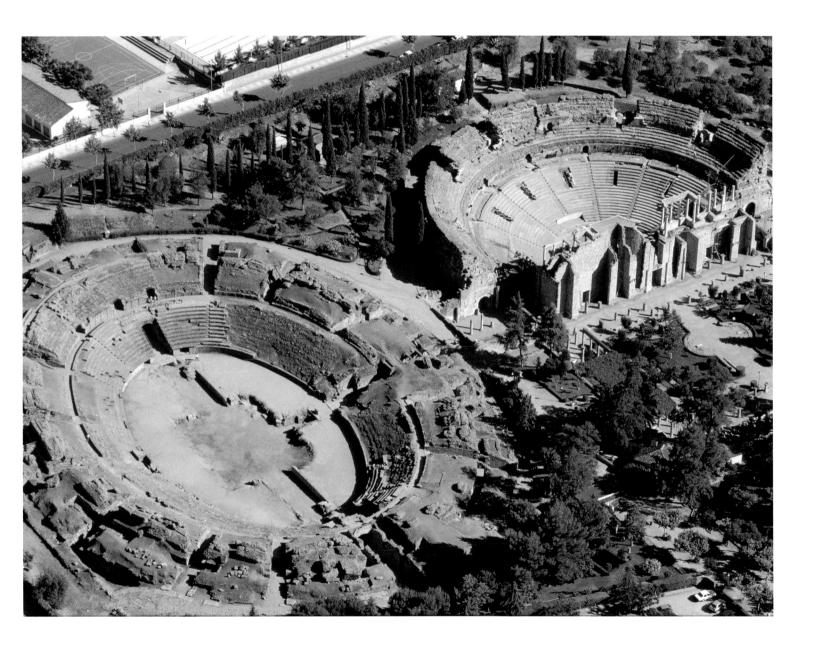

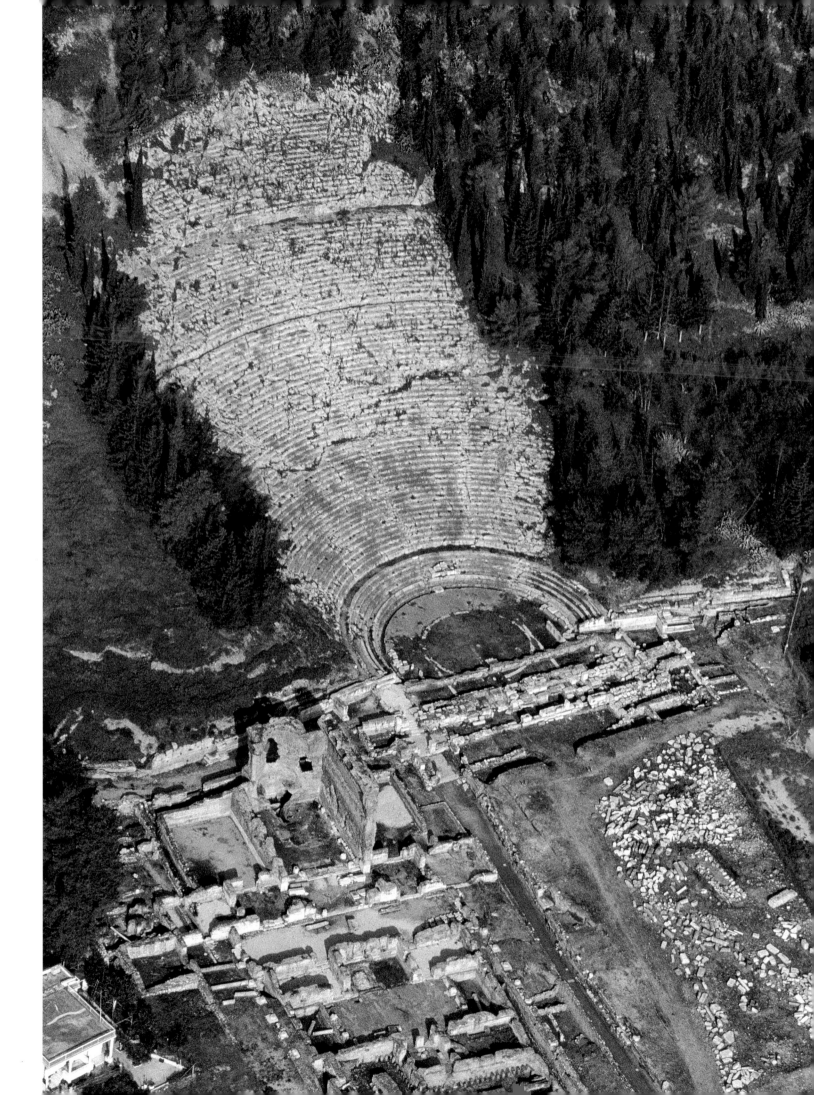

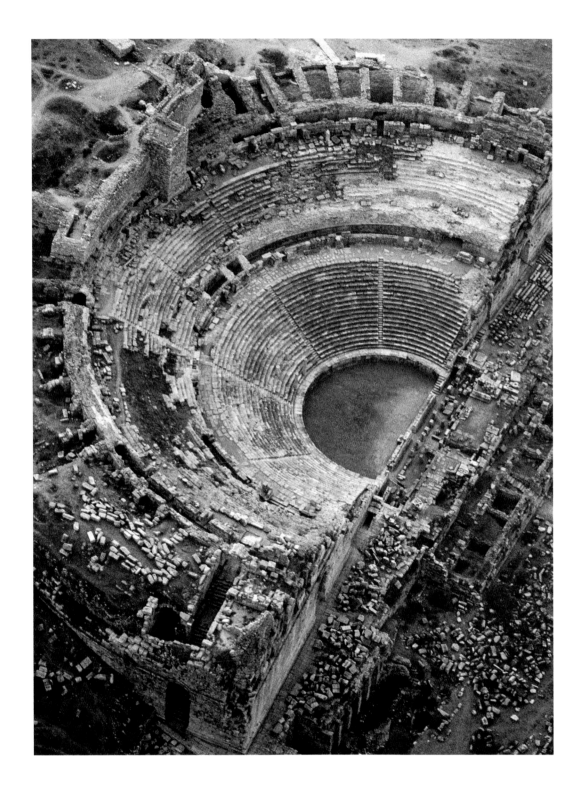

79 | **The theatre at Argos**, 4th century BC, Greece, 2001

80 | **The theatre at Miletus**, 2nd century AD, Turkey, 2002

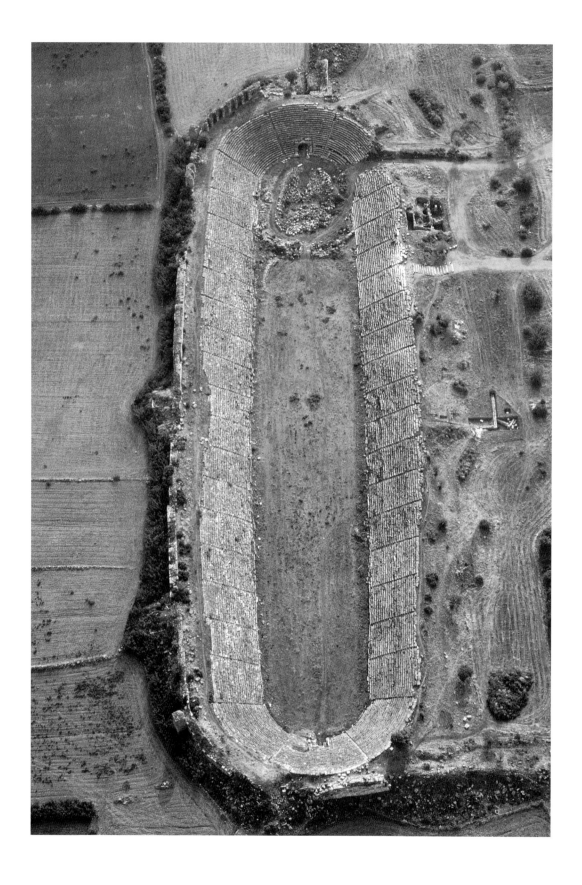

81 | **The theatre and stadium at Nicopolis**, late 1st century BC, Greece, 2000

82 | **The stadium at Aphrodisias in Caria**, 1st–4th century AD, Turkey, 2002

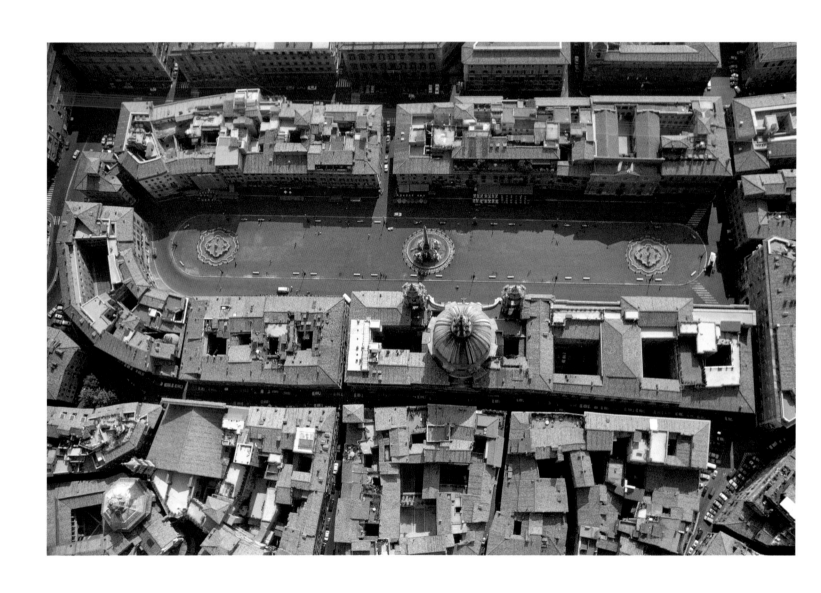

83 | **The Piazza Navona in Rome**, from AD 86, Italy, 1974. World Heritage Site

84 | **The ball court in the Wupatki Pueblo in Arizona**, AD c1065–1212, USA, 1970

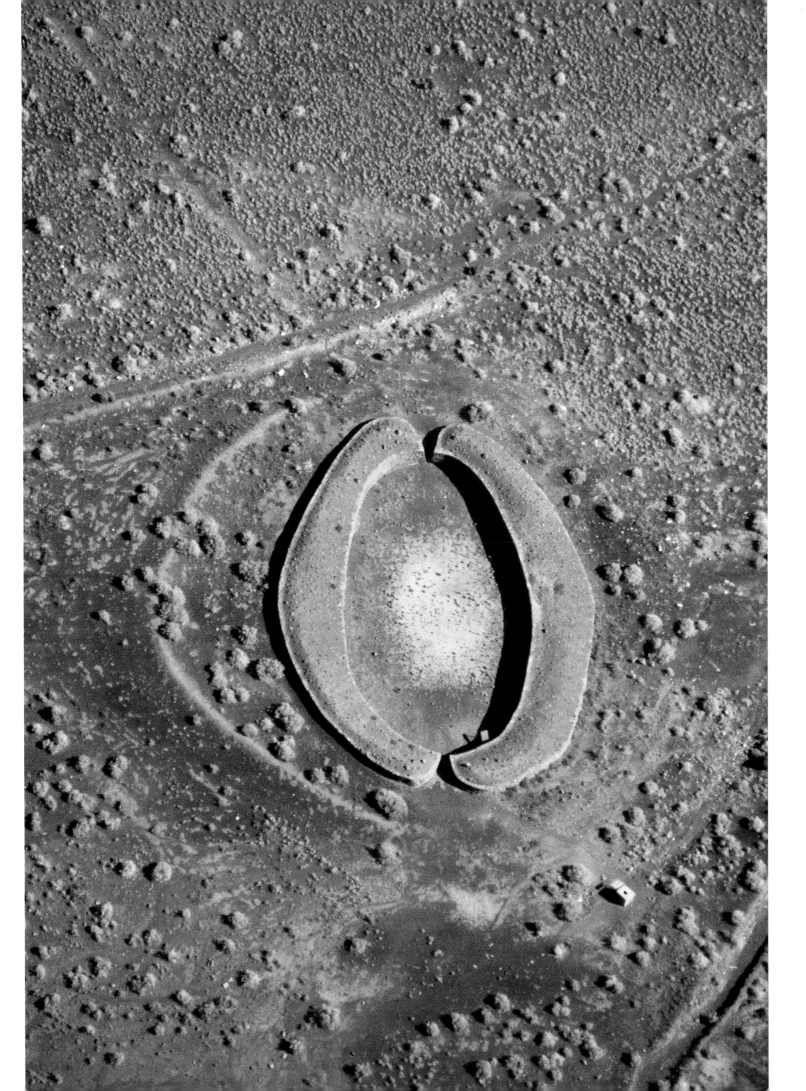

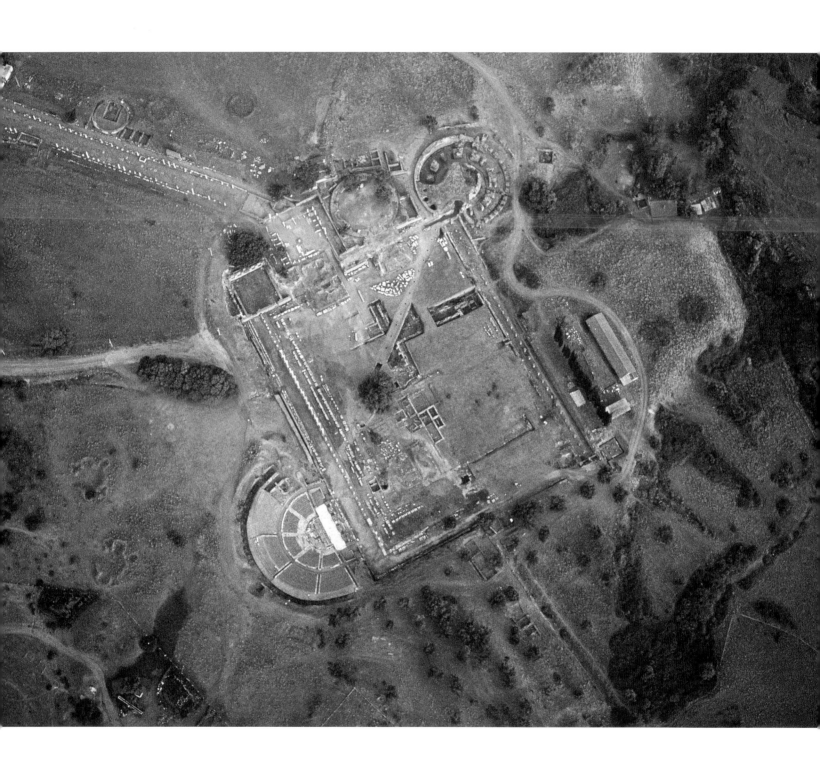

85 | **The Asclepion at Pergamon**, 4th century BC–2nd century AD, Turkey, 2002

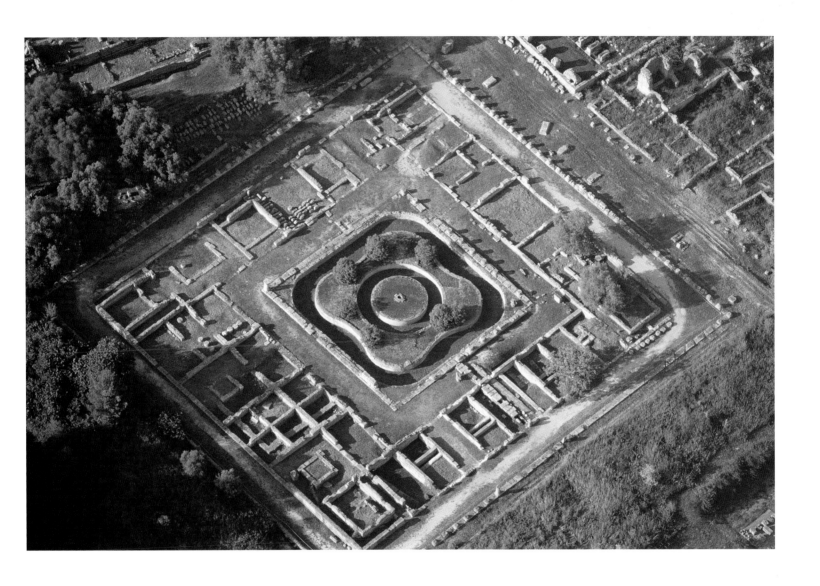

86 | **The Leonidion at Olympia**, second half of 4th century BC, Greece, 1998. World Heritage Site

87 | *152–3:* **Hierapolis/Pamukkale in Phrygia**, 3rd century BC–5th century AD, Turkey, 2002. World Heritage Site

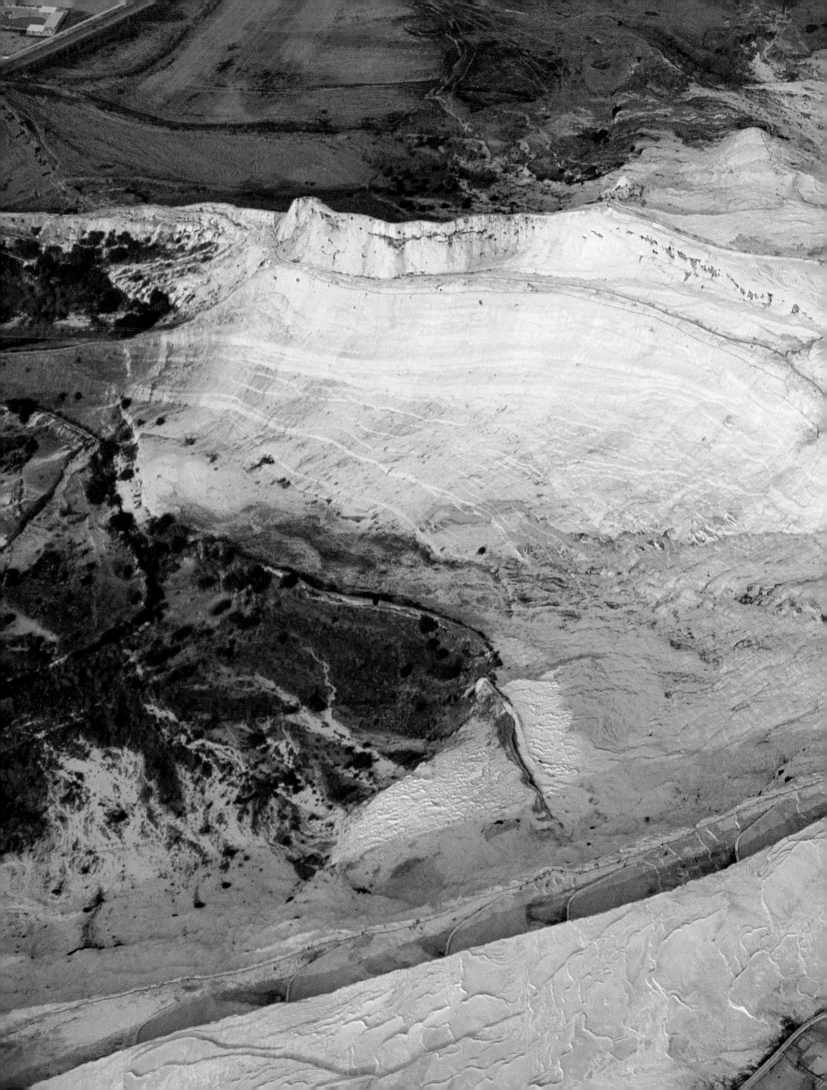

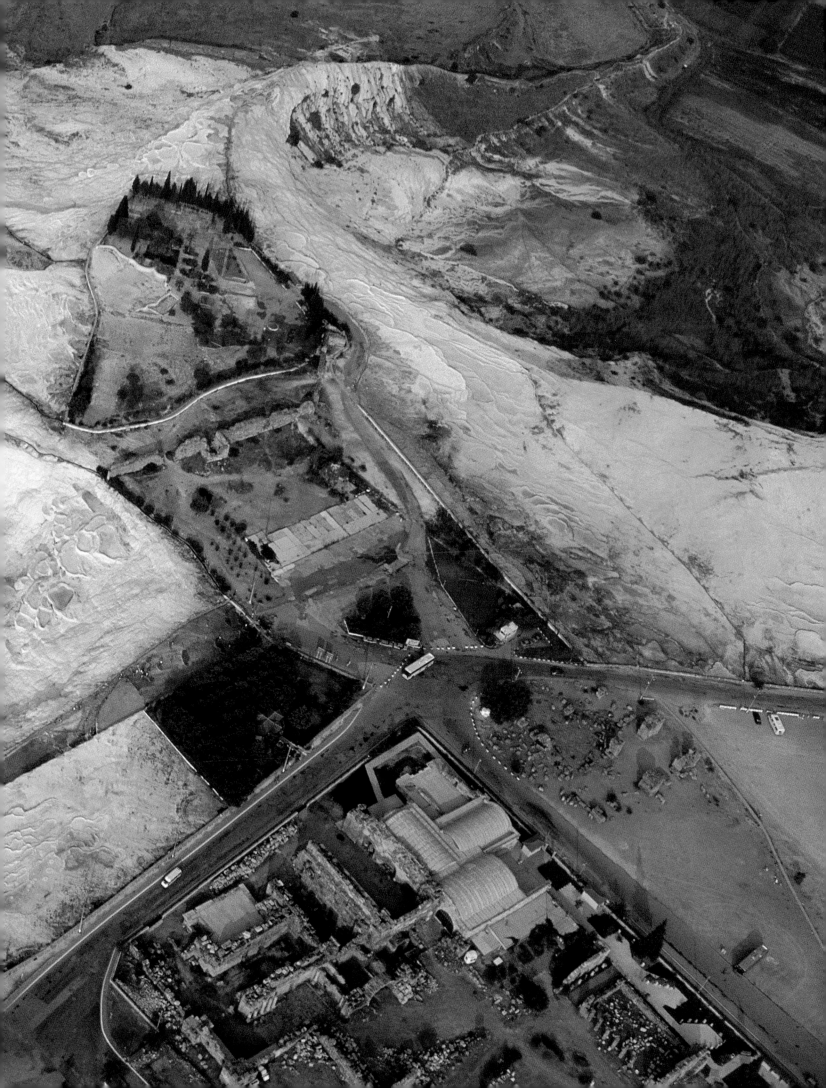

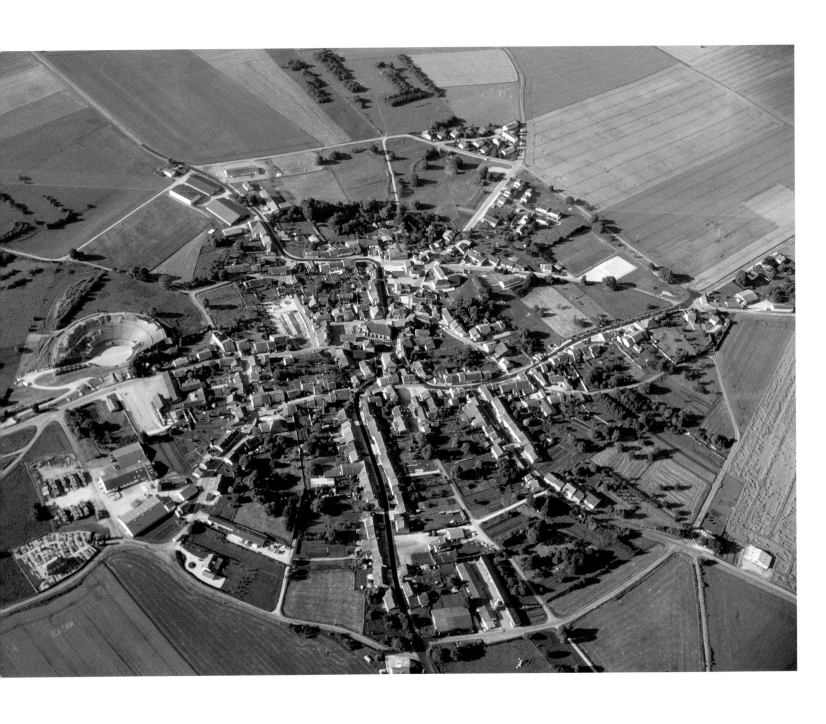

88 | **The water sanctuary at Grand**, 1st century AD, France, 1998

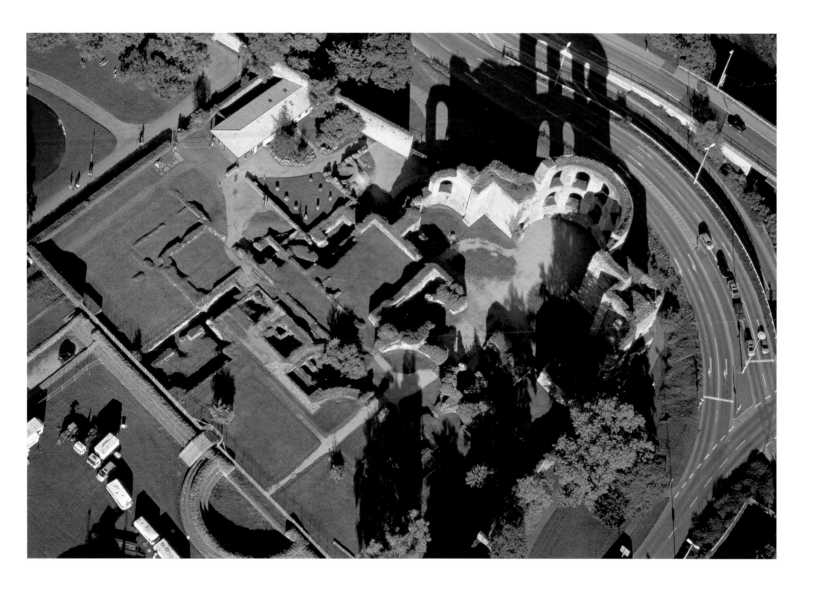

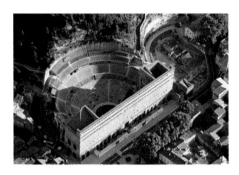 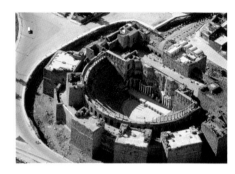

71 | The Roman Theatre at Orange, France

Intended for the veterans of the Second Gallic Legion who had fought in the civil wars, the Roman colony of Orange (Colonia Firma Iulia Secundanorum Arausio) was established in the territorium of the Cavares in the lower Rhône valley in 35 BC. Surrounded by a ring-wall, the town was designed to a cadastral plan and covered an area of 70 ha. A monumental, triple-arched triumphal arch erected outside the city limits during the reign of Tiberius leads to the cardo. It is decorated with trophies that recall the Romans' victory over Gaul. Orange is also famous for the marble cadastral plans that were discovered here in 1949 and that show public and private land allotments. These inscriptions are displayed in the Municipal Museum alongside elements of architectural decor from the Roman town. But the most impressive monument is undoubtedly the Roman theatre, which is uniquely well preserved in comparison to other examples from the Roman world. It was intended from the outset to be part of the cadastral plan and takes up the width of one insula (103m). The rows of seats are divided into three tiers and provide space for 7000 spectators. The knightly classes sat in the front tier, their seats still marked by inscriptions. The stage wall survives virtually intact: with its columned niches over three storeys, it formed a spectacular 36m high backdrop for the performances on stage. Its rusticated outside face was described by Louis XIV as the finest wall in his kingdom. The velum that protected the spectators from the sun was attached to its upper section. Classified as a World Heritage Site, the theatre is still used for performances every year. To the right of the theatre can be seen the remains of an anonymous temple with a hemicycle partially cut into the hillside.
M. R.

M. E. Bellet, *Orange antique: Monuments et musée* (Paris 1991) (Guides archéologiques de la France 23)

72 | The theatre at Bosra, Syria

The Romans annexed the kingdom of the Nabataeans in AD 106, turning Bosra, which for a time had been the second city of the Nabataean kingdom, into a Roman outpost with an occupying army. A period of peace followed, lasting until the middle of the 3rd century AD and bringing great wealth to many cities. During this time Bosra was able to profit not only from its fertile hinterland but above all from its favourable position on one of the most important caravan routes in the Near East. Under the emperor Septimius Severus the town rose to the rank of a colonia and later still became the main centre of the province of Arabia. A visible sign of its increasing affluence were the public buildings with which its well-to-do citizens adorned their town in the course of time. In addition to the magnificent colonnaded roads, these buildings were mainly given over to entertainment and leisure and included thermae and the large theatre that is one of the best preserved of all Roman theatres. The decorative forms of its structural elements suggest that it dates from the late 2nd or early 3rd century AD. The principal building material was the dark basalt typical of southern Hauran, although white limestone and even imported marble were also used for the architectural sections of the frons scenae. The excessive use of cement during modern restoration work has unfortunately obscured the conscious contrast between the different materials. The city was taken by the Arabs in AD 634, and by the 11th century the theatre had been turned into a fortress, but the structural alterations dating from this period have now been removed.
R. S.

B. M. Sartre, *Bosra des origines à l'Islam* (Paris 1985); H. Finsen, *Opmalingen af det Romerske Theater in Bosra, Syrien* (Rome 1972) (Analecta Romana Instituti Danici: Supplement 6); K. S. Freyberger, 'Zur Datierung des Theaters von Bosra', *Damaszener Mitteilungen*, 3 (1988), 17–26

73 | Theatre and stadium at Nysa in Caria, Turkey

The extensive ruins of the ancient city of Nysa lie at the edge of the upper valley of the Meander in western Asia Minor, some 2km upstream from the modern town of Sultanhisar. The ancient remains were first examined by Walther von Diest in 1907 and 1909, but it is only recently that Turkish archaeologists have excavated the site, especially the theatre and large marketplace. Nysa owed its affluence to the fertile alluvial plain of the Meander and the lucrative cultivation of olive trees and vines on the surrounding hillsides. But it was also an important cultural centre. It was here, for example, that the well-known Stoic philosopher Apollonius taught; here, too, that the leading geographer Strabo was brought up. (He died here in 21 BC.) The remains of several buildings, including even a multi-storey library, attest to the city's cultural life. These buildings are concentrated on the side of the low-lying valley that cuts through the town in the middle of our photograph. The steep slopes were ideal for the theatre's tiered seating and also for the stadium below it, large sections of which are still buried and overgrown. The centre of the stadium had to be built on a substructure over the bed of the stream that ran through it, but this expensive expedient did at least have the advantage that the water could be dammed for the naval battles that were a popular spectacle in Roman times. A large public square below the theatre was similarly built over the gully. In ancient times this part of the city, with its public buildings and private houses on the terraced hillside, must have presented a magnificent sight.
R. S.

W. von Diest and others, *Nysa ad Maeandrum* (Berlin 1913) (Jahrbuch des Kaiserlich Deutschen Archäologischen Instituts, Supplementary Volume 10); K. Grewe and others, 'Antike Welt der Technik. 7: Die antiken Flußüberbauungen von Pergamon und Nysa (Türkei)', *Antike Welt*, 25 (1994), 348–52

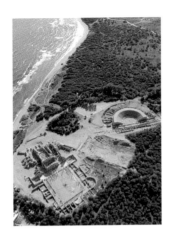

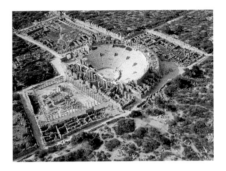

74 | **The Gallo-Roman sanctuary at Sanxay, France**
The Gallo-Roman sanctuary at Sanxay (Vienne) is
set within a loop of the River Vonne some 30km
south-west of Poitiers and belonged to the Picts. Its
ancient name is not known. It seems that there was
no previous occupation of this site and that it was
not until the middle of the 1st century AD that the
first religious buildings appeared. It is not known
to which deities they were dedicated. The complex
is made up of a considerable number of buildings,
of which only three are visible today. To the north
(the covered building towards the foot of the photo-
graph) is a water sanctuary that has undergone a
series of adaptations and which probably sheltered
two deities before being turned into a bath suite,
no doubt with therapeutic properties, in the 2nd
century. To the west (in the lower right-hand corner
of the photograph) is a further temple with an
octagonal cella containing a spring. Surrounded by
a cruciform ambulatory and with a vast courtyard
framed by a quadriporticus, this groundplan is
unique in the ancient world. In front of this
building, facing the baths, was a vast esplanade
with a central tholos that can no longer be seen.
The complex was surrounded by other buildings
that have been revealed by subsequent excavations
and that may have included accommodation for
pilgrims and perhaps also pools and living quarters
for the local clergy. On the other side of the river
can be seen a theatre-amphitheatre of a type
unusual in Roman Gaul, with a circular orchestra,
frons scenae and seating for 6500. This kind of rural
cult centre, combining a temple, bath suite and a
building suitable for sacred spectacles and assem-
blies, is common in Roman Gaul. The one at Sanxay
is among the most famous and best preserved.
M. R.

P. Aupert and others, *Sanxay: Un grand sanctuaire rural
gallo-romain* (Paris 1992) (Guides archéologiques de la
France 25)

75 | **Sports grounds and playing fields at Salamis,
Cyprus** According to Greek tradition, Salamis on
the island of Cyprus was founded in the 11th century
BC by Prince Teucer from the Attic island of Salamis.
It thus replaced the nearby Bronze Age city of
Enkomi/Alashiya as the capital and during the
following centuries developed into the island's chief
town. It suffered serious damage in an earthquake
in AD 342 but was rebuilt by the emperor Constan-
tius II and under the name of Constantia became
the island's administrative capital. At its heart lies a
cultural complex with buildings from the early to the
middle imperial age. The theatre dates from
Augustan times and with its 15,000 seats is one of
the largest in the Mediterranean. The seats closest
to the stage are a modern restoration. The stage
building was removed in late antiquity, its columns
used to restore the large square palaestra. The
entrance to this exercise area was to the north,
through a propylon built by Ptolemy V in the early
2nd century BC. Beside it lies a large semicircular
latrine with 44 seats. On the western side of the
courtyard is the entrance to a bath complex dating
from late antiquity. The walls of the central rooms
and two adjoining halls to the north and south can
still be seen. All that remains of the stadium are a
few steps for seating to the north, buttressing a
barrel-vaulted corridor leading to the amphitheatre
that stands out as an elongated depression between
the sports ground and the theatre.
R. S.

V. Karageorghis, *Salamis: Die zyprische Metropole des Alter-
tums* (Bergisch Gladbach 1970); *Salamine de Chypre:
Histoire et archéologie. État des recherches* (Paris 1980)
(Actes du colloque Lyon 13–17 mars 1978); V. Karageorghis
and others, *Excavating at Salamis in Cyprus 1952–1974*
(Athens 1999)

76 | **The Roman theatre at Leptis Magna, Libya**
Situated some 120km east of Tripoli, Leptis Magna
was the largest town in ancient Tripolitania (now
north-west Libya). Founded by the Phoenicians,
probably in the late 7th century BC, the city soon fell
under Carthaginian ('Punic') control. Following the
overthrow of the Carthaginian Empire by Rome in
146 BC, the city fell nominally under Numidian rule
but was effectively independent. By the time of
Augustus it was a Roman province. The upper
classes enjoyed a considerable degree of affluence
through the cultivation of olives and trade in goods
from the surrounding region and central Africa
(gold, ivory, slaves and animals). Even the late
Punic city, which was largely cut off at the time of
the Roman occupation, covered a wide area, and
this was further expanded under imperial rule. By
the 2nd century AD, imported materials such as
marble were being used. Leptis Magna was the
birthplace of the Roman emperor Septimius
Severus (193–211). The city centre and its popula-
tion began to shrink in size in late antiquity, when
Leptis Magna fell successively under Vandal and
Byzantine rule. By perhaps the 13th century the
settlement had been abandoned and its ruins were
covered in sand. In the first half of the 16th century
numerous pillars were taken from the site for the
great mosque at Tajura, and in the 17th and 19th
centuries structural elements from state buildings
were transported to Europe (they may now be seen
at Versailles, Windsor and elsewhere). Leptis was
often mentioned by travellers in the 19th and early
20th centuries and parts of it were sketchily
mapped, but it was only in 1920 that ongoing
archaeological excavations began.
S. A.

P. Romanelli, *Leptis Magna* (Rome 1925); D. J. Mattingly,
Tripolitania (London 1995), 116–22; L. Musso, 'Leptis
Magna', *Enciclopedia dell'Arte Antica*, 2nd Supplement
(1995), 3.333–47

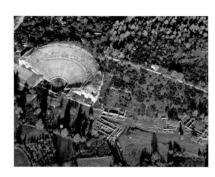

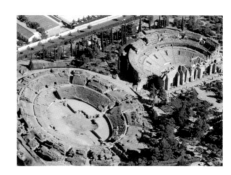

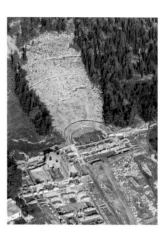

77 | The theatre and oracle at Dodona, Greece

Dodona in Epirus was the site of one of the oldest and most important sanctuaries of the supreme Greek god Zeus. Its famous oracle was said to speak through the rustling of a sacred oak, but auguries were also taken from the flight and call of doves. Homer mentions it, and other writers claim that the goddess Athena included a piece of the tree in the ship used by Jason and the Argonauts. Among prominent rulers who consulted the oracle were Croesus, Pyrrhus of Epirus and the Roman emperor Julian the Apostate. Pyrrhus in particular did much to promote the sanctuary and in 297 BC built the theatre for the use of cultic performances. With its 18,000 seats, it was one of the largest in Greece. A stadium was added in the 3rd century BC. The cult buildings for Zeus, his consort Dione and their daughter Aphrodite are visible on the right-hand side of the picture and are relatively small in comparison. An oak once again flourishes in the almost square area sacred to Zeus, its predecessor having been torn down in AD 391, when Christianity was introduced and a three-aisled basilica built next to it. The sanctuary also had an important political function as an assembly place for the Epirotic League, which met in the rectangular assembly hall next to the theatre. In spite of its former importance, the site fell into total neglect, and only the chance discovery of ancient votive offerings in 1873 led to a renewed interest in it.
R. S.

C. Carapanos, *Dodona et ses ruines* (Paris 1878); H. W. Parke, *The Oracles of Zeus: Dodona – Olympia – Ammon* (Oxford 1967), 1–163, 259–86; S. I. Dakaris, *Archaeological Guide to Dodona* (Athens 1994)

78 | The theatre and amphitheatre at Mérida, Spain

Our view of Mérida continues to this day to be marked by the Roman street grid and its ancient buildings, some of which are remarkably well preserved. The town was founded by Augustus in 25 BC, following the successful conclusion of his war with the Cantabri, and was designed as a settlement for veterans of the Fifth and Tenth Legions. Covering an exceptionally large area, Augusta Emerita developed into one of the most important Roman cities on the Iberian peninsula. The public buildings attest not only to the city's affluence but also to the imperial house's particular interest in Mérida. Augustus's son-in-law, Marcus Vipsanius Agrippa, paid for the theatre, which was inaugurated in 16/15 BC, while the emperor himself footed the bill for the amphitheatre, which was officially opened in 8/7 BC. These donations were not entirely philanthropic, as the buildings in question were not just places of leisure and education but also had a political function. In keeping with Augustus's wish that the 'Golden Age' that his reign had ushered in should be exemplified by magnificent buildings, large quantities of marble were used in these buildings. The columned hall at the end of the gardens opposite the stage house contains a room in which the statues of the imperial family could be venerated, but their portraits were also exhibited in the stage house. The emperor Trajan later erected a sanctuary to the imperial cult between the rows of seats, so that visitors were everywhere confronted by the old and new representatives of state order.
R. S.

W. Trillmich and others, *Hispania Antiqua: Denkmäler der Römerzeit* (Mainz 1993), 239–40, 273–85; J. Alvarez Sáenz de Buruaga, 'Observaciones sobre el teatro romano de Mérida', *El teatro en la Hispania romana* (Badajoz 1982), 303–11 (Actas del Simposio, Mérida 13–15 de noviembre de 1980)

79 | The theatre at Argos, Greece

Argos at the heart of the Argolid is one of the oldest towns in Greece and even in Homer's day was famous for breeding horses. Its mythical king Adrastus led the army known as the 'Seven against Thebes', and Diomedes was one of the bravest Greek heroes in the siege of Troy. The history of Argos is the history of a constant struggle with Sparta for supremacy over the eastern Peloponnese. Following the Argives' heavy defeat at Sepeia in 494 BC, even the womenfolk took up arms under the leadership of the poetess Telesilla in order to defend the city. Telesilla was later honoured with a statue above the theatre that was built in the 4th century BC on the south-eastern slope of the Larissa, the higher of the two acropolis hills. It towers over the agora and a Roman bath complex from the 2nd century AD. Seating some 20,000 spectators, it is the second-largest theatre in the Peloponnese, smaller only than the theatre at Epidaurus. Of the seats, only the 81 middle rows cut into the cliff face have survived. The ones at the sides were made of masonry and have disappeared, the area that they covered now being overgrown. The theatre was last rebuilt in the 4th century AD, when the orchestra was turned into a watertight basin used to stage sea battles. The theatre again had an important political role to play during the Greek Wars of Independence in the early 19th century, when two national assemblies met here.
R. S.

R. A. Tomlinson, *Argos and the Argolid* (London 1972); M. Piérart and G. Touchais, *Argos: Une ville grecque de 6000 ans* (Paris 1996)

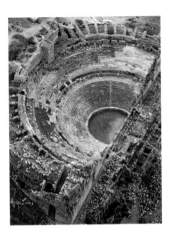

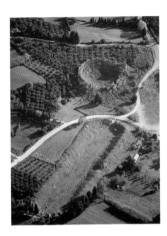

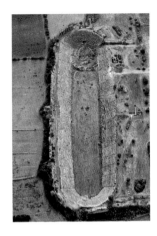

80 | **The theatre at Miletus, Turkey**

Seating some 20,000 spectators, the theatre at Miletus is the largest Roman theatre in Asia Minor, even though it dates from a time when the city had long since lost its cultural influence and could only dream of its former glories as a commercial metropolis and the founder of dependent cities. Yet even at this date there were still annual festivals for the local deity, Apollo, when the theatre may also have had a role to play. It lies on one of the hills within the city, a hill now called Kaletepe, the southern slope of which could be used for the tiers of seats. At the foot of the hill was an inlet of the Latmic Gulf, with the result that the stage house had to be built on stable substructures on the beach itself. The entrances at the sides were designed as terraces and at the same time formed part of the city's fortifications at this point. The spectators could also enter the theatre through two large vaulted passages that emerged into the auditorium in the aisle between the first and second tiers. Alternatively, there was an exterior flight of stairs where it was even possible to dock in the inlet. The oldest remains date back to the hellenistic period, whereas the parts that are visible today date for the most part to the middle of the imperial age. In late antiquity, when a new fortified wall was built around the immediate centre of the city, a castle was erected on the highest point, with the theatre incorporated into it.
T. St.

W. Müller-Wiener, 'Das Theaterkastell von Milet', *Mitteilungen des Deutschen Archäologischen Instituts: Abteilung Istanbul*, 19 (1967), 279–90; G. Kleiner, *Die Ruinen von Milet* (Wiesbaden 1968); F. Krauss, *Das Theater von Milet: 1. Das hellenistische Theater* (Berlin 1973)

81 | **The theatre and stadium at Nicopolis, Greece**

Today the once extensive Roman city of Nicopolis in Epirus is partially covered with vegetation, but the theatre and stadium at the foot of the Michalitzi Hill that rises up towards the left of the photograph and that is situated in the town's northern suburb are still clearly visible. It was on this hill that Caesar's nephew Octavian – later to become the emperor Augustus – pitched his tent in 31 BC prior to the decisive sea battle of Actium in which he defeated Antony and Cleopatra. Following his victory he erected a sanctuary to Neptune, Mars and his own protective deity Apollo and founded the city of Nicopolis, whose population, forcibly resettled, was made up of the inhabitants of the neighbouring towns and villages. The theatre and stadium were built for the 'Actian Games', festivals that took place here every five years. Both buildings are still largely unexamined. It is striking that the two shorter sides of the stadium are curved, a feature that is found only in those rare cases where the stadium assumes the functions of an amphitheatre, as was also the case with the slightly later stadium at Aphrodisias in Caria (no. 82).
R. S.

A. Philadelpheus, *Nicopolis: Les fouilles 1913–1926* (Athens 1933); E. Chrysos (ed.), *Nicopolis I: Proceedings of the First International Symposium on Nicopolis, Preveza 23–29 September 1984* (Preveza 1987); P. Büscher, 'Das Siegesmonument von Nikopolis', *Akarnanien: Eine Landschaft im antiken Griechenland*, ed. P. Berktold and others (Munich and Würzburg 1996)

82 | **The stadium at Aphrodisias in Caria, Turkey**

The city of Aphrodisias in western Asia Minor was named after its protective deity Aphrodite. Her great temple attracted vast numbers of pilgrims from the 1st century BC. It was to her cult that the city owed its patronage by the Romans, especially the emperors of the Julian and Claudian dynasties, who traced their ancestry back to Aphrodite herself. Most of the public buildings date from the 1st century AD or later and include the large stadium on the northern edge of the city. It is undoubtedly the best preserved structure of its kind. Even without the excavations that began only recently, it is still possible to identify its principal features. The stadium is about 270m long and 59m wide at its central point. The tribunes were arranged in 30 rows and 40 sections and provided seating for around 30,000 spectators. The lower third was dug out of the ground, while the rest was built on the earth and stones that were removed in this way. Unlike most stadiums, the two shorter sides are rounded as in an amphitheatre. This form made it possible to stage other events here, including the horse racing, animal fights and gladiatorial games popular in Roman times, but processions, too, could enter through the large gates in the shorter sides of the stadium and parade in front of the spectators during religious festivals. In the middle of the 4th century AD the stadium was incorporated into the city wall, and it seems that the athletic games stopped soon after this, for a small amphitheatre was built into the eastern part of the stadium, with a columned hall on the upper tiers. The rooms at the back of this hall have survived.
R. S.

C. Roueché, *Performers and Partisans at Aphrodisias* (London 1993); K. Welch, 'The Stadium at Aphrodisias', *American Journal of Archaeology*, 102 (1998), 547–69

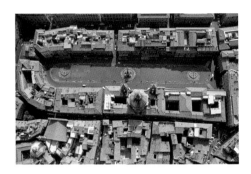

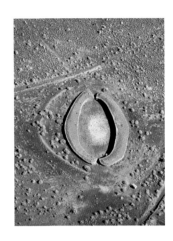

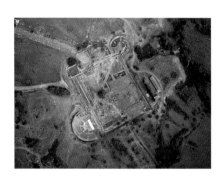

83 | The Piazza Navona in Rome, Italy

With its characteristic shape of an elongated
rectangle with a semicircular northern end, the
Piazza Navona – one of the most famous squares
not just in Rome but the whole of Europe – mirrors
that of the stadium built by the emperor Domitian
on this site in AD 86. Situated at the very heart of the
Campus Martius, it lay near the theatre of Balbus
and Pompey and the Thermae Neronianae or
Alexandrinae. It could accommodate around 30,000
spectators and was 275m long and 106m wide. The
stadium was originally used chiefly for Greek types
of sport and was restored under the emperor
Alexander Severus (222–35). Remains of the
substructure can still be seen on the north side
beneath the palazzo in the Piazza di Tor Sanguigna
and beneath the Church of Sant'Agnese in Agone.
Houses and defensive structures were built here
from the 13th century, churches and palaces from
the Renaissance onwards. A market was first held
here in 1477 but survives only in the form of the
Christmas market held each December. It was
above all during the Baroque age that the Piazza
Navona assumed its present guise, largely thanks to
the two famous rival architects Gian Lorenzo
Bernini and Francesco Borromini. Bernini designed
the Fontana dei Quattro Fiumi in the middle of the
piazza, topping it off with an Egyptian obelisk, while
Borromini was responsible for the domed Church of
Sant'Agnese in Agone on the western side, next to
Girolamo Rainaldi's Palazzo Pamphili – now the
Brazilian Embassy – on the south side of the
square. The two smaller fountains are the work of
Bernini (Fontana del Moro) and Giacomo della
Porta (Fontana del Nettuno). The Piazza Navona is
a superb example of the continuity of Rome's urban
architecture from antiquity to the present day.
S. St.

A. M. Colini, *Stadium Domitiani* (Rome 1943); H. V.
Morton, *The Fountains of Rome* (London 1970); F. Coarelli,
Rom: Ein archäologischer Führer (Mainz 2000), 289–90

84 | The ball court in the Wupatki Pueblo in Arizona, USA

Built of local sandstone, the Wupatki Pueblo
lies on a high plateau in northern Arizona to the
north-east of Sunset Crater, a volcano that rises
1000ft above the surrounding area. The three-storey
complex comprises more than 100 rooms and
housed up to 300 individuals between AD c1065 and
1212. It was discovered in the course of a military
expedition in 1851 but first mapped in 1900. Some
200m away, but still within view of the pueblo, lies
an oval ball court on a north-south axis measuring
27m in length and 14m at its greatest width. Two
convex shell walls approx. 2.4m high form the outer
limit of the playing area. Narrow entrances are
provided at either end of the oval. In the middle of
the site and just 4m from each of the entrances,
playing-field markings have been found in the flat
clay surface. In addition to the ball court, other
settlement finds point to contact with the civiliza-
tions of Mexico and Honduras, where a ball game
known as ulama was played on similar playing
fields. Here individuals and teams competed,
scoring points in the opposing half by means of a
rubber ball. The players could use only their hips,
buttocks or knees. Ulama players had a character-
istic kind of sportswear consisting of helmet,
loincloth, gloves and knee and arm protectors.
Ulama was a leisure activity for the upper class but
was also cultic in character. The settlement and the
ball court were abandoned in the early 13th century
when a period of drought made agriculture impos-
sible.
T. St.

L. Sitgreaves, *Report of an Expedition down the Zuni and
Colorado Rivers* (Washington 1853) (Executive Document.
Senate and Congress of the United States, Congress 32nd
Session, no. 2, 59); D. G. Noble (ed.), *Wupatki and Walnut
Canyon: New Perspectives on History, Prehistory and Rock Art*
(Santa Fe 1993)

85 | The Asclepion at Pergamon, Turkey

By the 4th century BC the Asclepion in the hellenistic
city of Pergamon in western Asia Minor was one of
the most important sanctuaries of Asclepius in the
ancient world. A magnificent colonnaded avenue
lined with shops, memorials and lavish grave
monuments led to the sanctuary from the city. An
elaborate gateway gave access to the wide court-
yard, it too surrounded by columns. In its western
half lay the oldest temple, where Asclepius was
venerated as 'Soter' ('Saviour'). It was presumably
the sacred springs nearby that inspired the cult.
Baths were as much a part of the curative process
as psychosomatic remedies such as healing sleep
and oneiromancy. That the treatment could be
lengthy we know from the orator Aelius Aristides,
who spent 13 years here. To accommodate the
growing number of visitors, the centre of the
sanctuary was extended and living quarters
provided in the immediate vicinity. The site was
comprehensively rebuilt under the emperor Hadrian
(AD 117–38). During this period wealthy local
patrons added the 3500-seat theatre, the North
Hall, a library, the above-mentioned entrance gate
and, above all, the circular temple to Zeus Ascle-
pius, a miniature version of the famous Pantheon in
Rome. The round two-storey baths complex in the
south-east is of a somewhat later date. These
impressive buildings turned the sanctuary into one
of the most popular social meeting places in the
Roman Empire, comparable to the famous 19th-
century spa resorts in central Europe.
R. S.

O. Ziegenaus and G. de Luca, *Das Asklepieion* (Berlin
1968–84) (Altertümer von Pergamon XI/1–4, ed. German
Archaeological Institute); W. Radt, *Pergamon: Geschichte
und Bauten, Funde und Erforschung einer antiken Metropole*
(Darmstadt 1999), 220–42

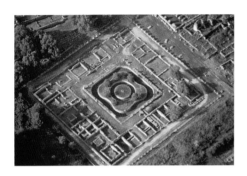 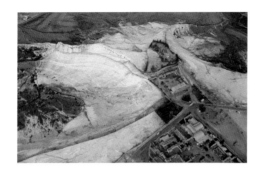 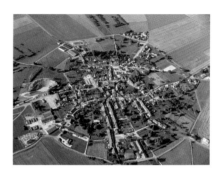

86 | The Leonidion at Olympia, Greece

Competitions were held every four years in the sanctuary to Zeus in Olympia. Intended to honour the father of the Greek gods, the festival drew athletes from the whole Greek world. Visitors initially lived in temporary accommodation, and it was not until the 2nd half of the 4th century BC that a wealthy patron from Naxos paid for permanent lodgings to be built, the Leonidion which, as we know from an inscription on the building, takes its name from its benefactor, Leonides, the son of Leotes. It lies to the south of the Temple of Zeus on the Via Sacra, rather than in the Altis, or Sacred Grove. This was not, however, a hotel open to every passing visitor, but was evidently reserved for special guests or ambassadors. The Roman travel writer Pausanias, for example, reports that in his own day, the 2nd century AD, the Roman officials were accommodated here. Covering an area of 74.8 x 81.08m, this is the largest building in Olympia. Only its substructure was made of limestone, the walls being made of mud bricks. The oldest building had six equally large rooms in its west wing and twelve in its east wing. A porter's lodge was situated next to the main entrance to the north. A serious fire meant that the Leonidion had to be rebuilt, resulting in the present layout of the rooms. During Roman times, when water features similar to those found at the Villa Adriana at Tivoli (no. 64) became fashionable, the well in the middle of the courtyard, which had originally been used to supply water, was turned into a complex, symmetrically curved, brick-built pool.
R. S.

R. Bormann, 'Das Leonidaion', *Olympia 2*, ed. E. Curtius and F. Adler (Berlin 1892), 83–93; A. Mallwitz, *Olympia und seine Bauten* (Munich 1972), 246–54; V. Heermann, 'Bankettträume im Leonidaion', *Mitteilungen des Deutschen Archäologischen Instituts Athen*, 99 (1984), 243–50

87 | Hierapolis/Pamukkale in Phrygia, Turkey

The city of Hierapolis was founded by the Seleucid kings at the edge of the Lycus Valley in the 3rd century BC. The remains were properly examined for the first time at the end of the 19th century, largely thanks to the efforts of the German archaeologist Carl Humann. The name means 'Holy City' and refers to the large number of cult sites. As we know, there were numerous festivals held in Hierapolis throughout the year, devoted either to the arts or athletics. The present name, Pamukkale, means 'Cotton Castle' and refers to the sinter terraces formed by the calcareous thermal springs at the western edge of the city and now one of Turkey's main tourist attractions. They are not mentioned in antiquity, when the principal sight was the Pluto-nium, a deep grotto inside which poisonous gases arose from an underground stream. This site lies next to a much frequented oracle, the Temple of Apollo Careius, who was the local deity. The wealth of Hierapolis was based on its flourishing workshops but above all on cotton-growing and dying. With the help of the warm spring water it was possible to produce a red dye using vegetable matter that was just as good as the crimson dye obtained by an expensive and laborious process from snails. The large thermal complex at the foot of the photograph was erected in the early 2nd century AD as part of a rebuilding programme that followed the destruction of much of the city in an earthquake in AD 60. Some of the rooms that have been restored and roofed in the meantime are now used as a museum.
R. S.

C. Humann and others, *Altertümer von Hierapolis* (Berlin 1898) (Jahrbuch des Kaiserlich Deutschen Archäologischen Instituts, Supplementary Volume 4); P. Verzone, *L'urbanis-tica di Hierapolis di Frigia* (Turin 1972); D. De Bernardi Ferrero, 'Hierapolis', *Arslantepe, Hierapolis, Iasos, Kyme: Scavi archeologici Italiani in Turchia* (Venice 1993), 104–87

88 | The water sanctuary at Grand, France

Situated in the foothills of the Vosges some 30km north-west of Contrexéville lies Grand, a former water sanctuary dedicated to Apollo Grannus and possibly the site referred to in Latin sources as Andesina. The modern cadastral plan still shows the rounded outlines of the ancient pomerium, or religious district, at the centre of which was the sacred spring. Karstic in origin, this natural spring draws water from the whole of the surrounding area, with the result that at certain times of the year – notably following heavy rain or snowmelt – there is severe flooding around the spring, accompanied by a powerful telluric rumbling. There is no doubt that it was this natural phenomenon that led to the creation of a sanctuary here by Roman times at the latest. It may well have included incubation rites. An extensive artificial network of underground drainage channels more than 15km in length must have allowed this 'sacred' phenomenon to be regulated and even artificially produced. The sanctuary was protected by a ring-wall built around the end of the 1st century AD that enclosed all the cult buildings: the actual spring, a basilica containing a large mosaic measuring 224 sq m and dating to the first half of the 3rd century, a richly decorated temple and various public baths. Outside the protecting wall, a theatre-amphitheatre was built for pilgrims. Early written sources suggest that Caracalla and, later, Constantine visited this exceptional sanctuary. The water cult was Christianized at a relatively early date, a development confirmed by the martyrdom of Saint Lib. She was beheaded on Julian's instructions for refusing to worship the gilt statue of Apollo, whereupon she washed her severed head in the fountain which thereafter acquired healing powers. The site was destroyed at around this time.
M. R.

Grand: Prestigieux sanctuaire de la Gaule (Paris 1991) (Les dossiers de l'archéologie 162)

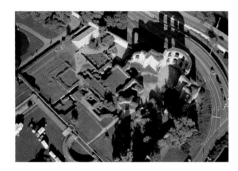

89 | **The Imperial Thermal Baths at Trier, Germany**
Unfinished buildings are not a modern invention
but existed in antiquity. This was the fate of the
Imperial Baths at Trier, the eastern section of which
is among the best-preserved Roman ruins in
Germany. Trier's elevation to the status of an
imperial residence at the end of the 3rd century AD
resulted in a tremendous building boom designed
to bring a suitable imperial grandeur to the town.
Among the buildings that date from this period are
some of the largest bath complexes in the whole of
the Roman Empire. But when the emperor Constan-
tine I moved his residence to Constantinople on the
Bosporus, the thermae in Trier remained unfin-
ished: together with its immense apses, the
caldarium (the hottest room in the complex) was
never used for its original purpose. When Trier
again became a residence in the second half of the
4th century AD, no attempt was made to complete
the thermae. Instead, its eastern section was
converted into a palace, with the unfinished
caldarium turned into a prestigious reception room.
By the middle of the 5th century at the latest the
unfinished bathhouse had fallen into disrepair. It
owes its preservation to an act of recycling, whereby
the old wall was incorporated first into the Bishop's
Palace and later into the town's medieval fortifica-
tions. It is clear from this that post-classical Trier
covered only a fraction of the Roman city. The ruins
have been successfully restored and now form part
of an archaeological park near the Rheinisches
Landesmuseum. Even modern observers for whom
large-scale complex buildings are self-evident are
bound to be impressed by this example of Roman
architecture.
T. F.

D. Krenker and E. Krüger, *Die Trierer Kaiserthermen* (Trier
1929) (Trierer Grabungen und Forschungen 1/1); H.
Cüppers, 'Kaiserthermen', *Die Römer in Rheinland-Pfalz*, ed.
H. Cüppers (Stuttgart 1990), 620–23

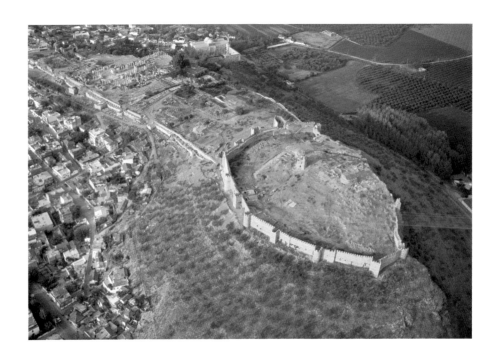

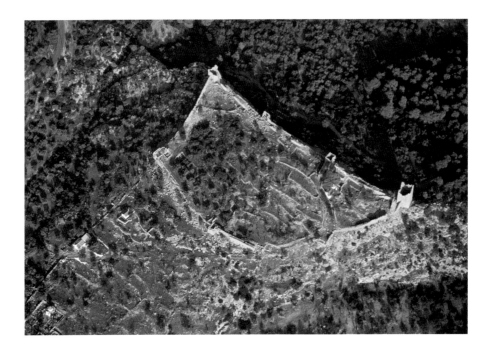

90 | **The medieval citadel at Ephesus**, Turkey, 2002

91 | **The town and acropolis at Aegosthena**, 5th–4th century BC, Greece, 2000

5. FOR SAFETY'S SAKE — FORTRESSES AND BULWARKS

Only the trees which thou knowest that they be not trees for meat, thou shalt destroy and cut them down; and thou shalt build bulwarks against the city that maketh war with thee, until it be subdued.

Deuteronomy 20:20 (5th century BC)

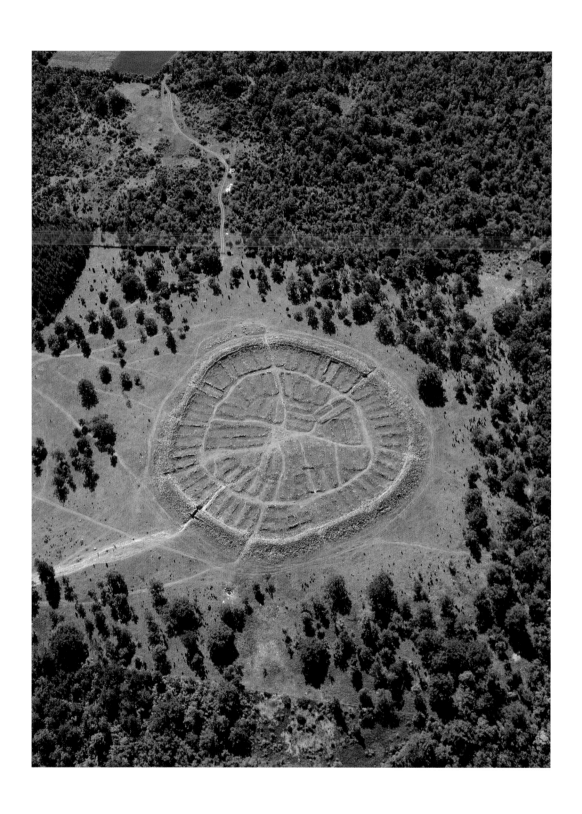

92 | **The ring-fort at Ismantorp**, 3rd–7th century AD, Sweden, 1977

93 | **The Dún Eochla fort on the Isle of Aran, Inishmore**, Ireland, 1989

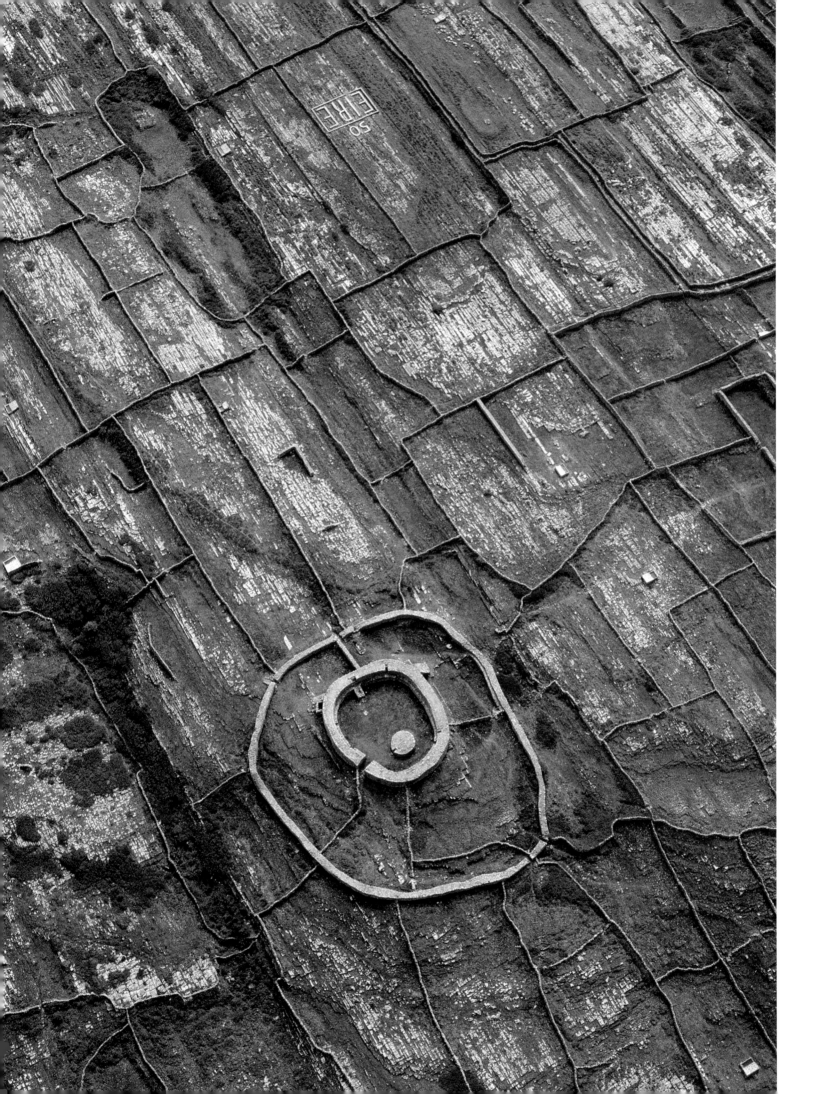

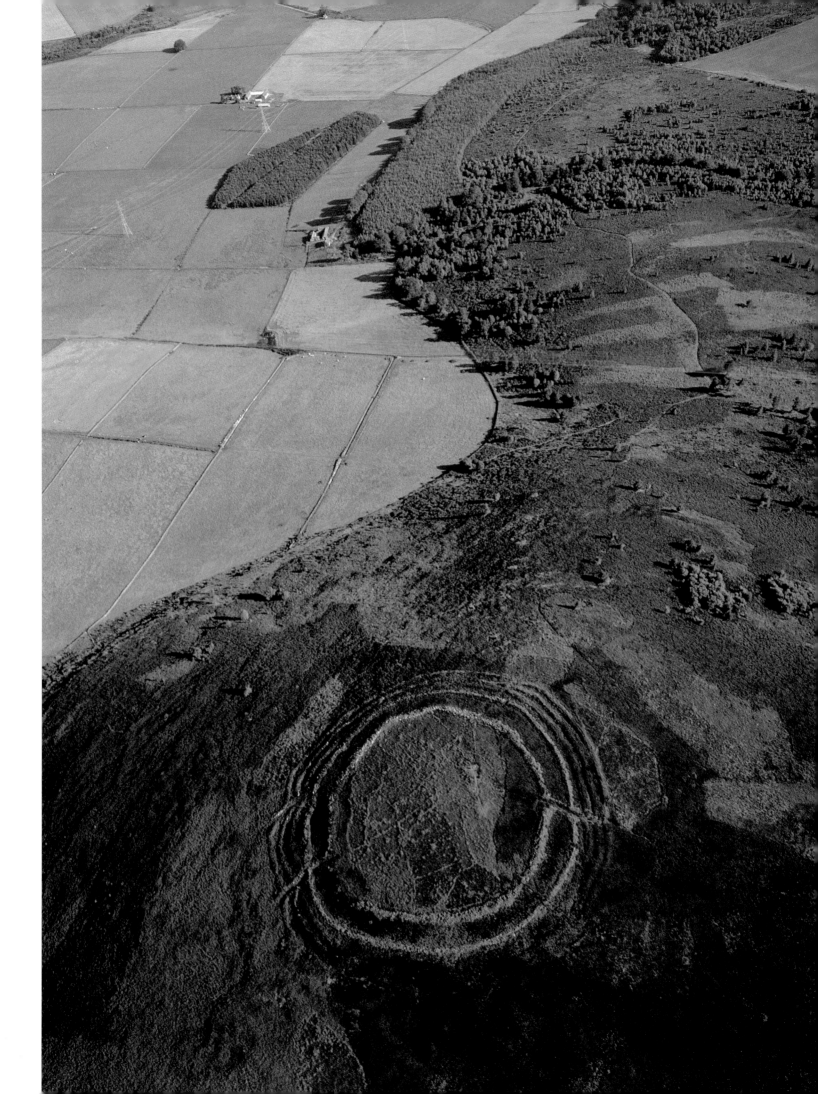

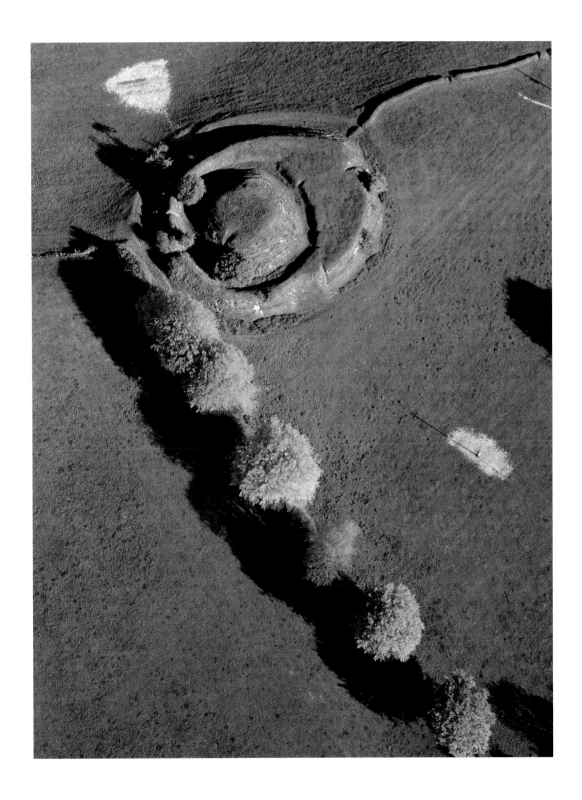

94 | **Barmkin hillfort at Echt**, 1000–700 BC, Scotland, 1976

95 | **The earthwork at Crooked Wood**, 12th century AD, Ireland, 1991

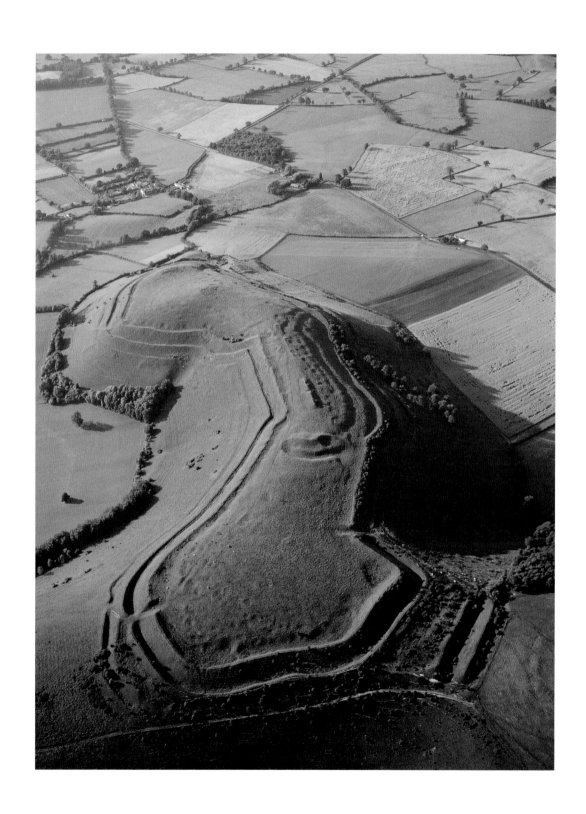

96 | **Hambledon Hill, Dorset**, 3000–600 BC, England, 1971

97 | **The hillfort at Maiden Castle, Dorset**, from 3500 BC, England, 1971

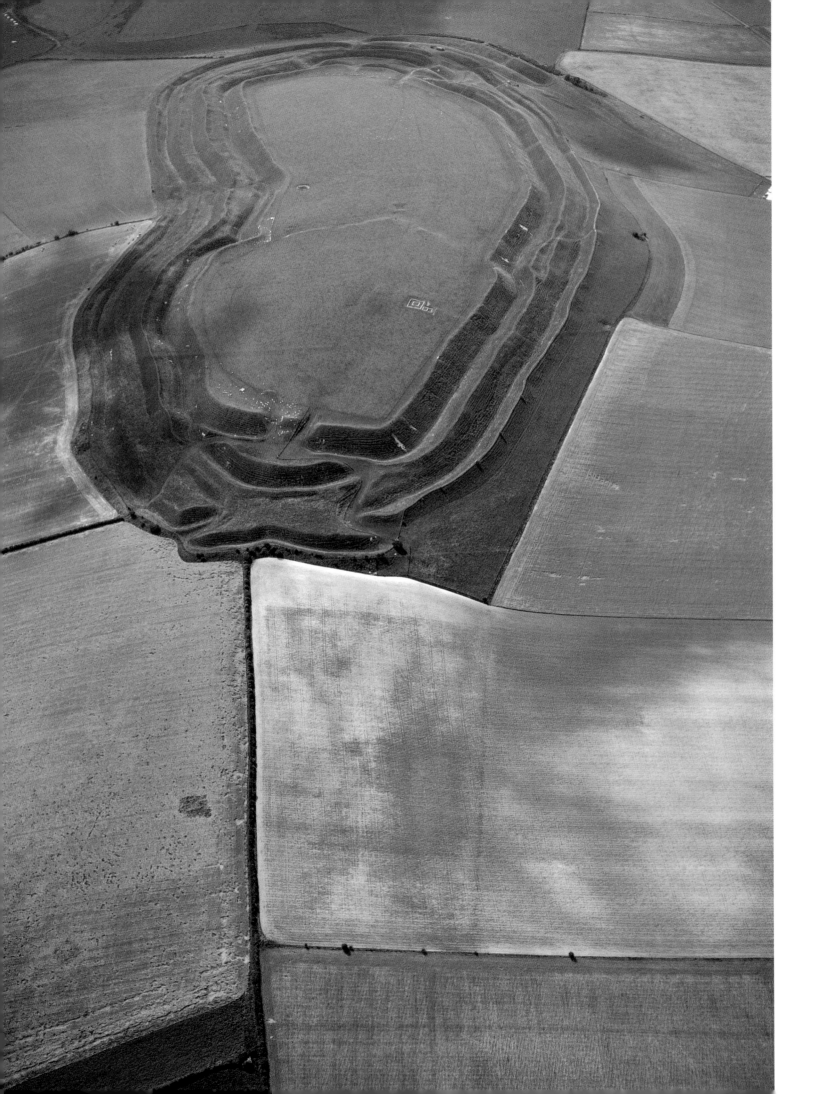

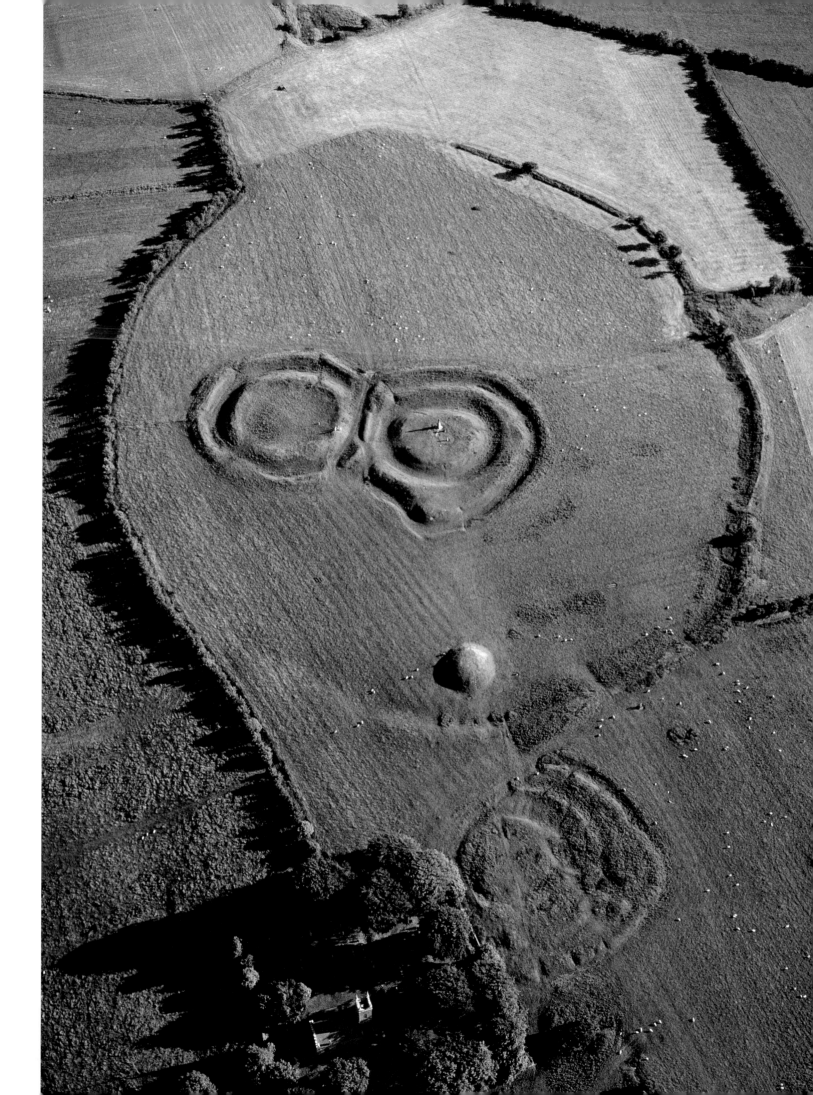

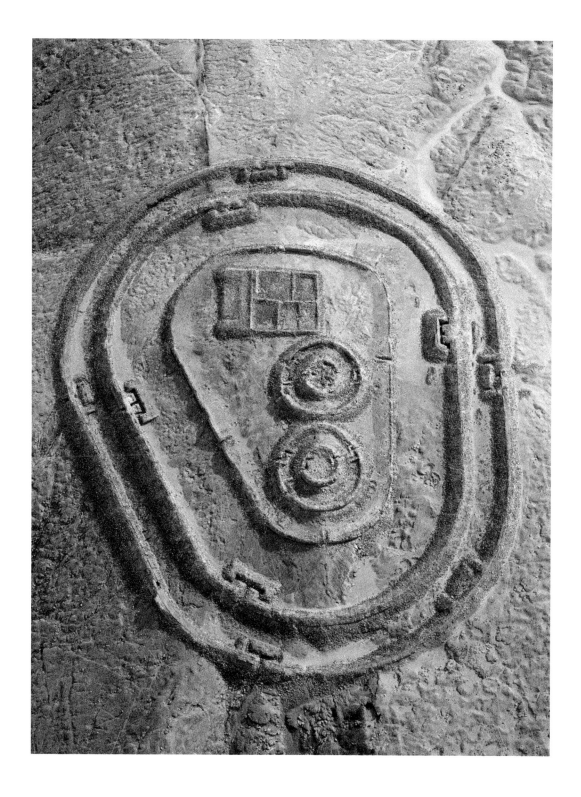

98 | **The Hill of Tara**, last decades BC, Ireland, 1989

99 | **The fortress at Chanquillo**, 400–100 BC, Peru, 1995

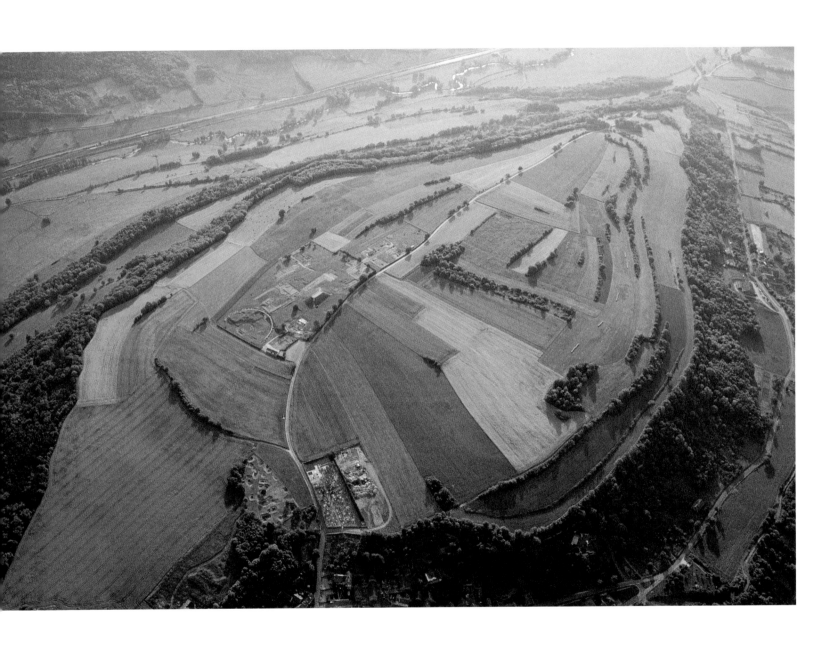

100 | **The Gallic oppidum at Alesia**, from 1st century BC, France, 1998

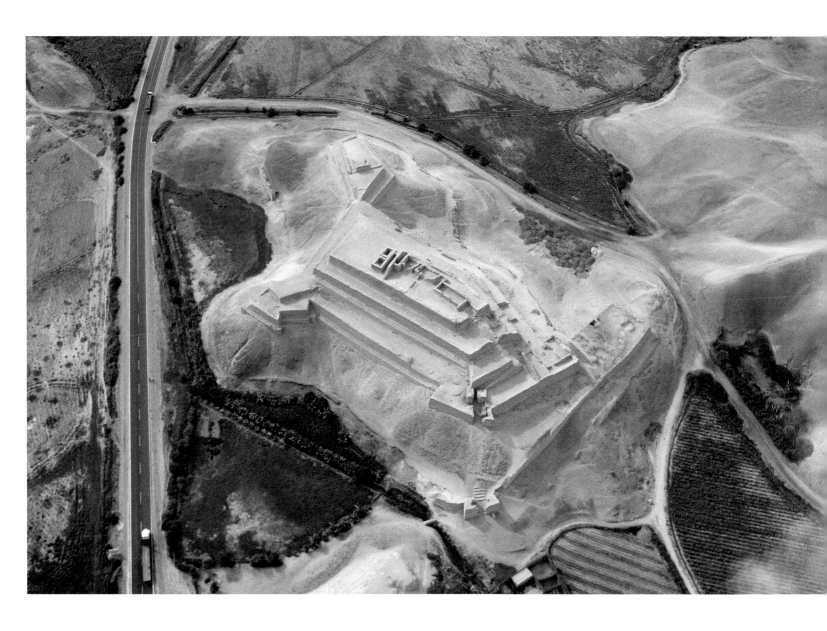

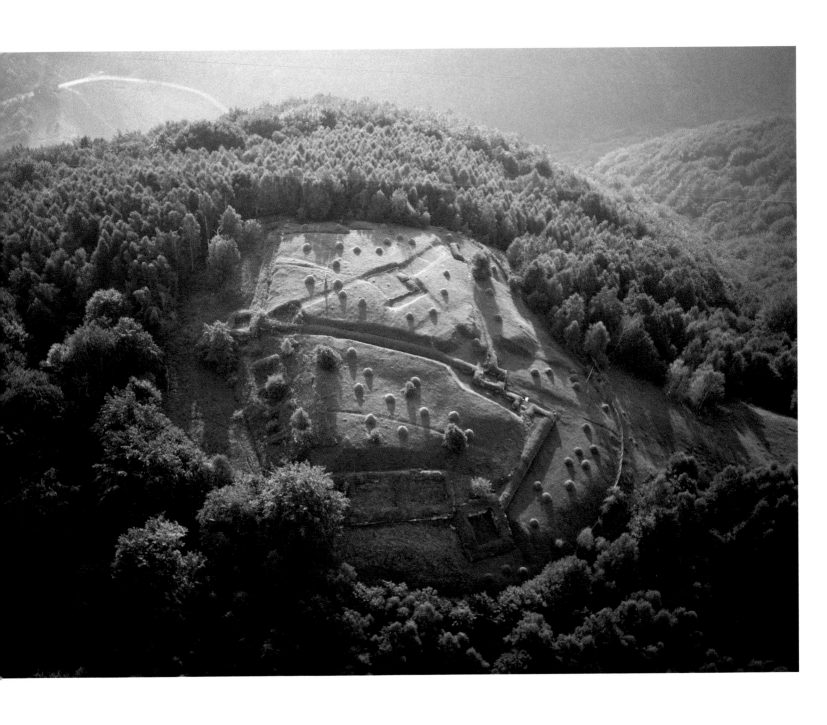

102 | **The fortress at Blidaru**, 1st century BC, Romania, 1991. World Heritage Site

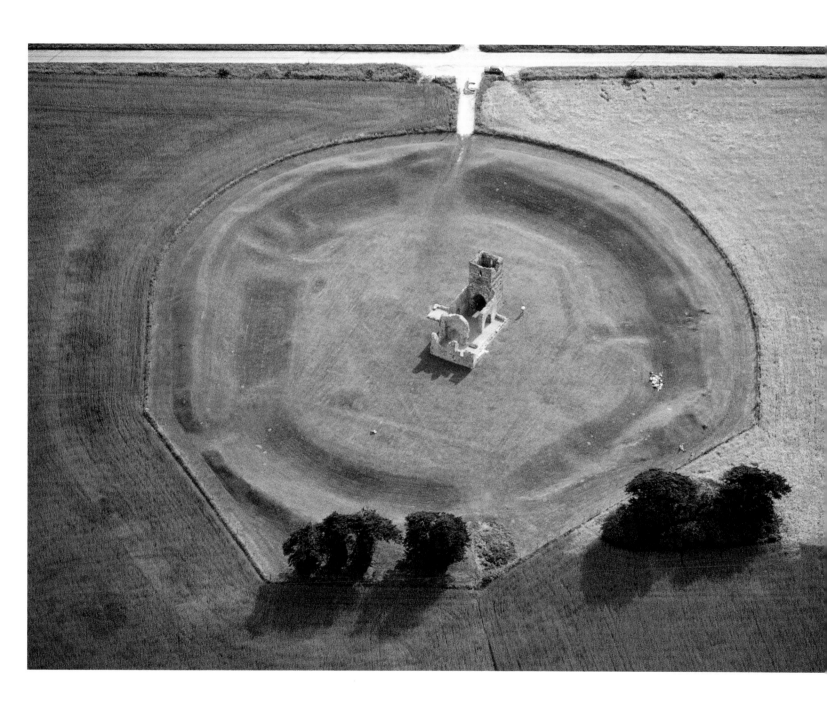

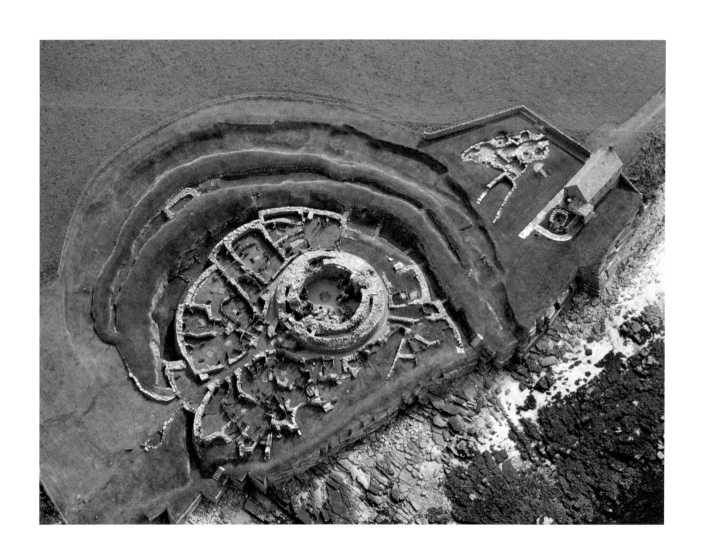

104 | **The Broch of Gurness**, 2nd–3rd century AD, Scotland, 1976

105 | **The citadel at Mycenae**, fl. 14th–13th century BC, Greece, 2001. World Heritage Site

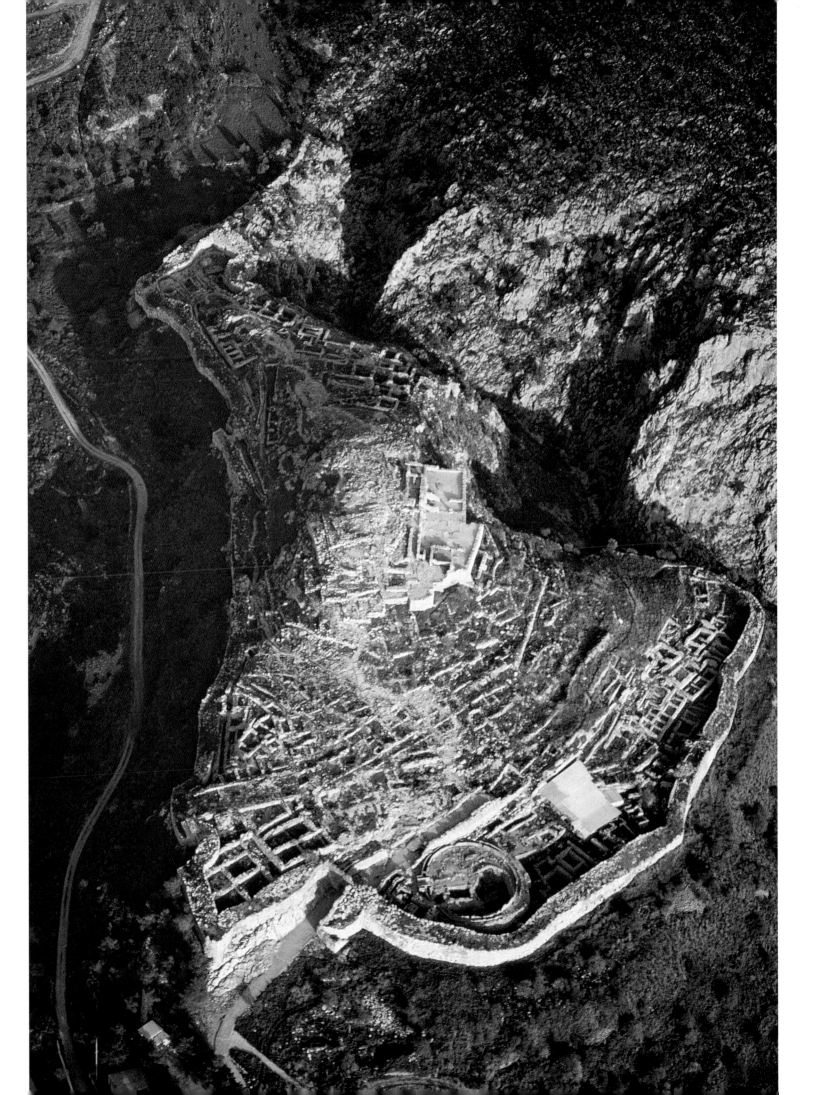

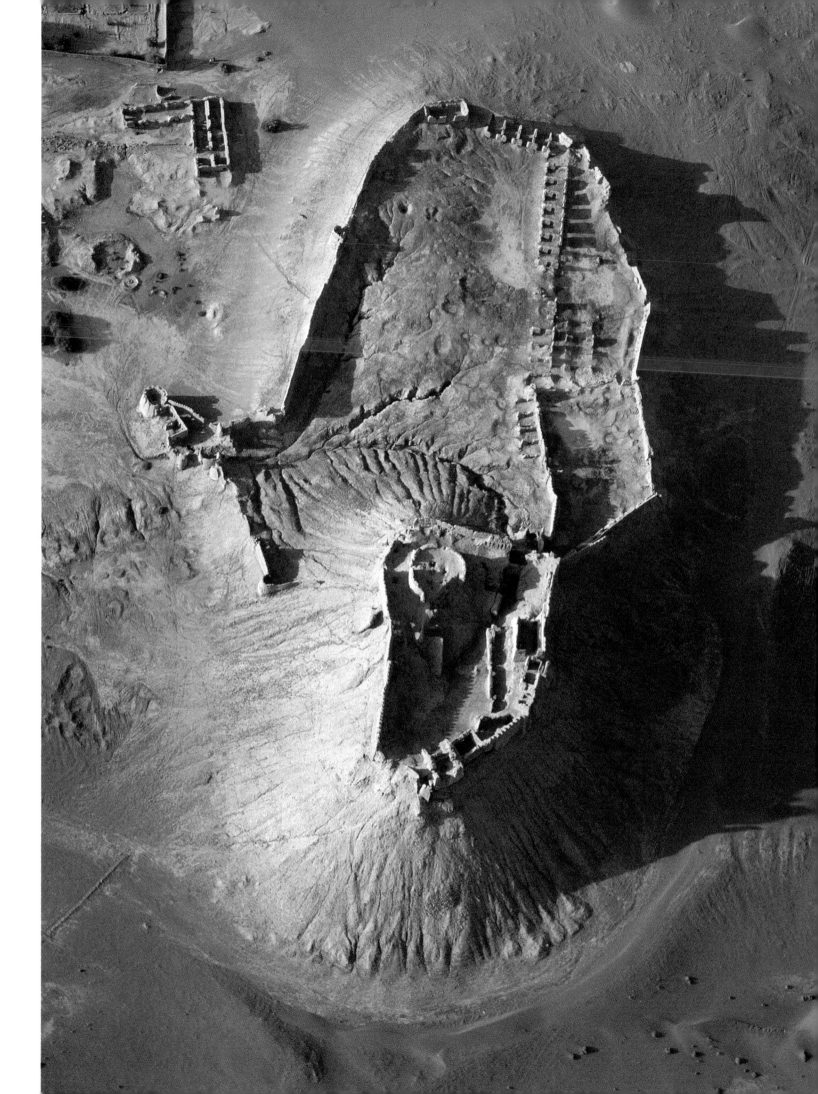

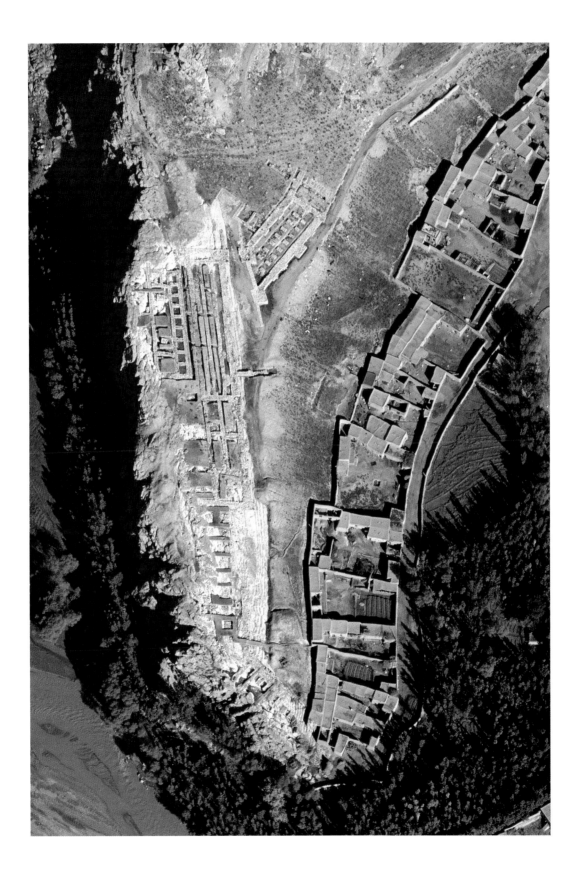

106 | **The Islamic fortress at Bampur**, Iran, 1977

107 | **The Urartian citadel at Bastam**, 7th century BC, Azerbaijan, Iran, 1976

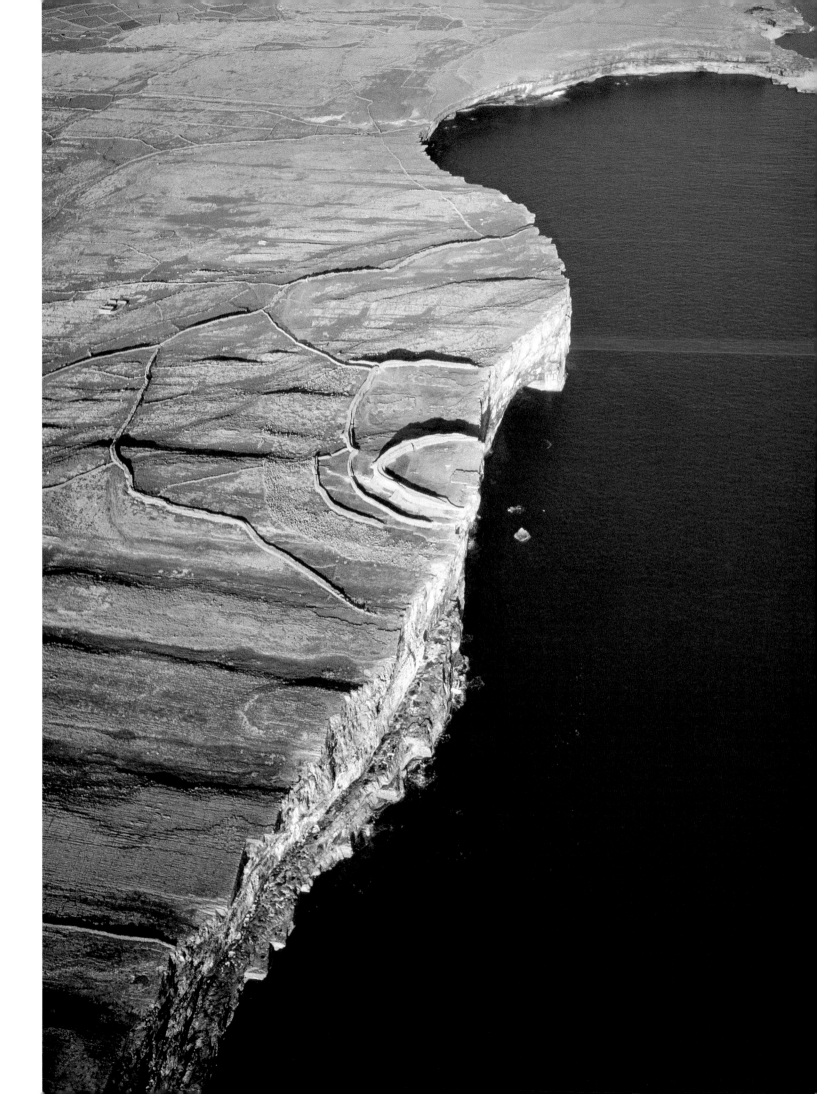

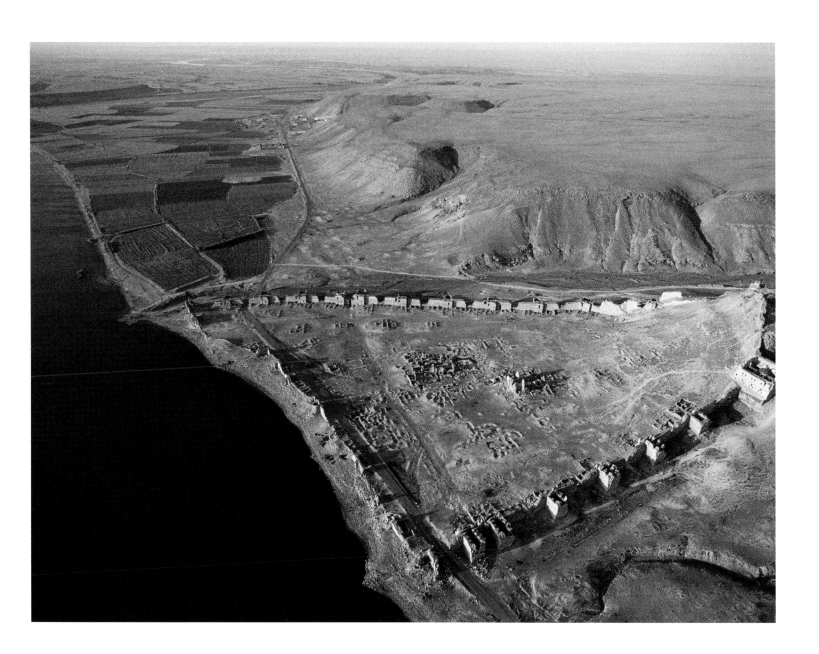

108 | **Dún Aengus on Inishmore**, Late Bronze Age 1300–800 BC, Ireland, 1989

109 | **Zenobia on the Euphrates**, AD 266–early 7th century AD, Syria, 1997

110 | *184–5:* **Uyghur island fortress in Lake Tere-Khol**, 10th–13th century AD, Tuva Republic, Russian Federation, 1994 183

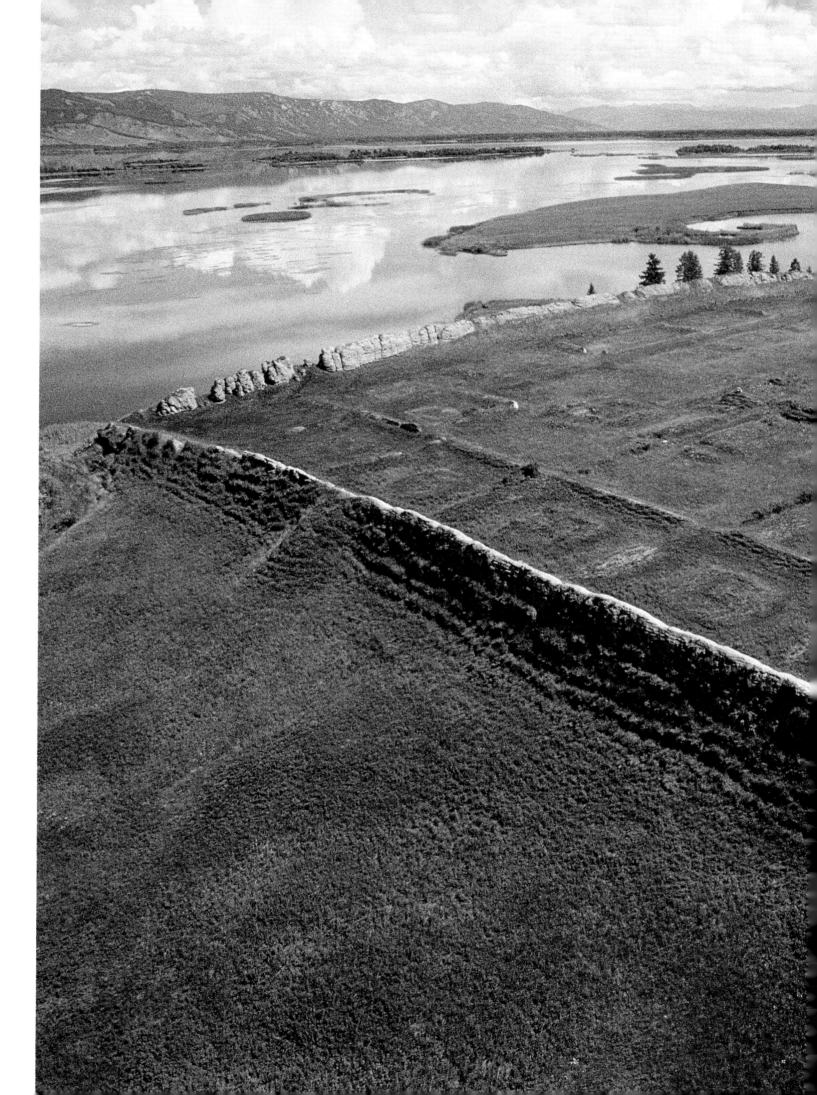

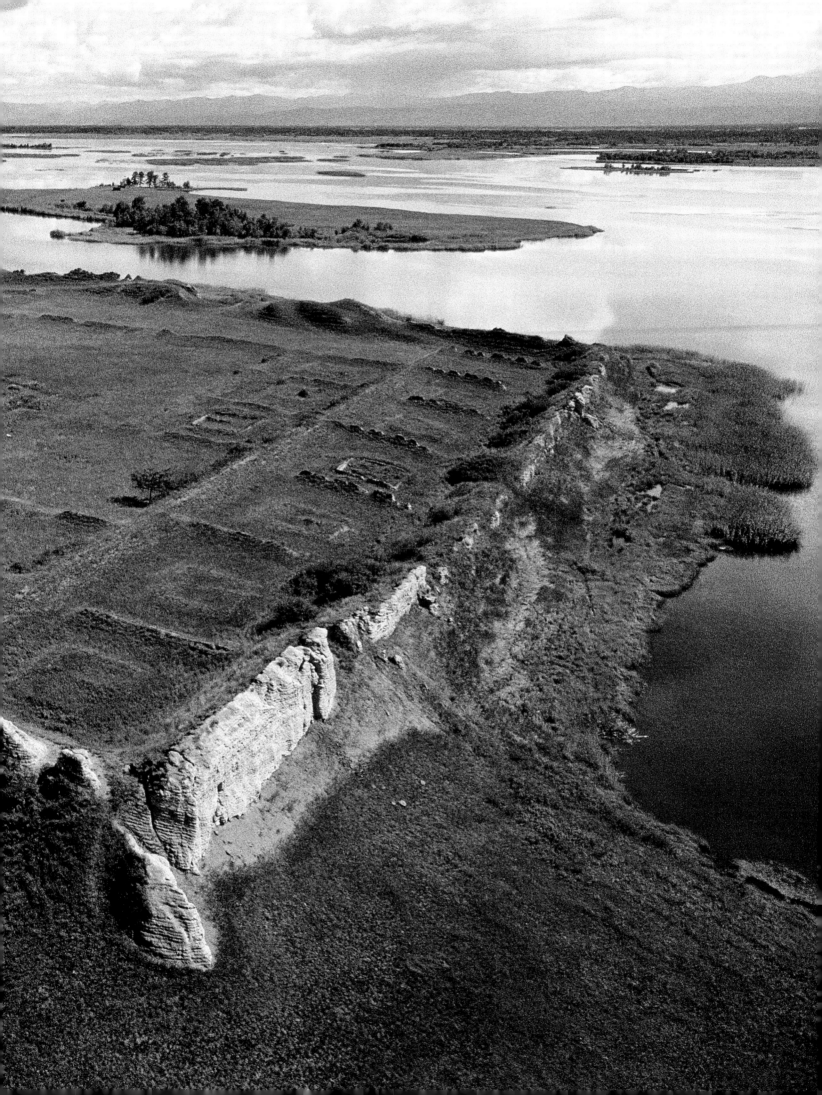

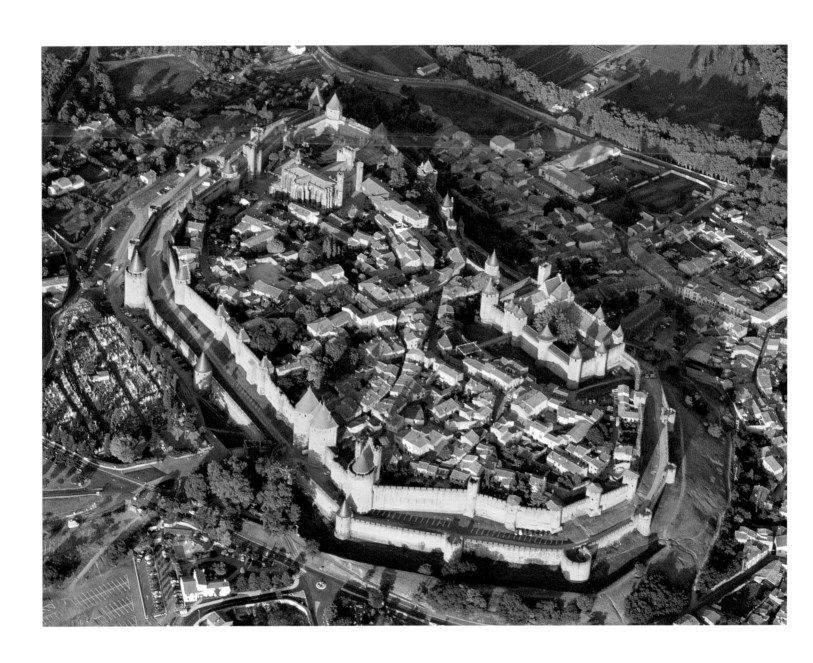

111 | **The fortified town of Carcassonne**, 13th century AD, France, 1998. World Heritage Site

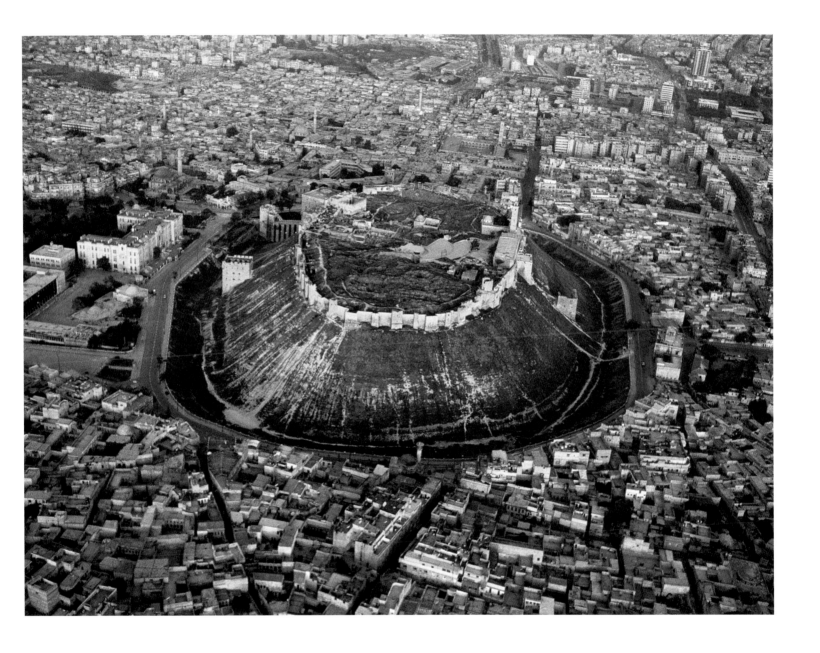

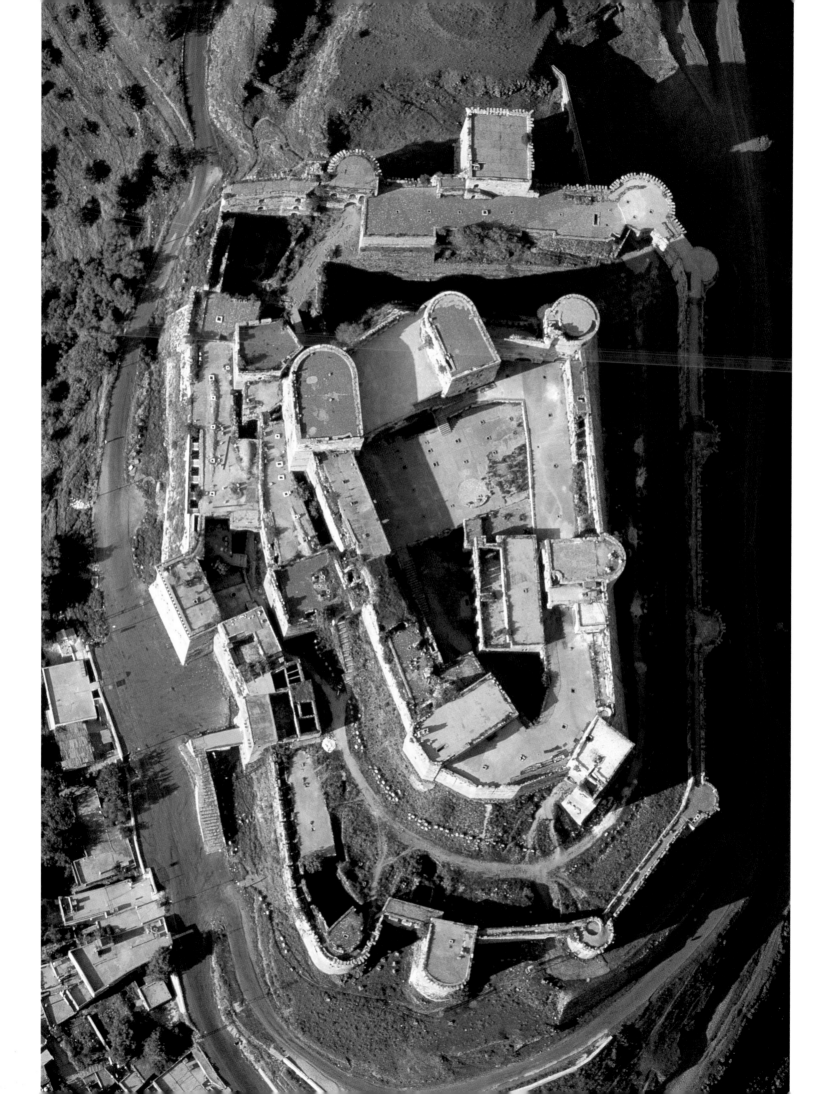

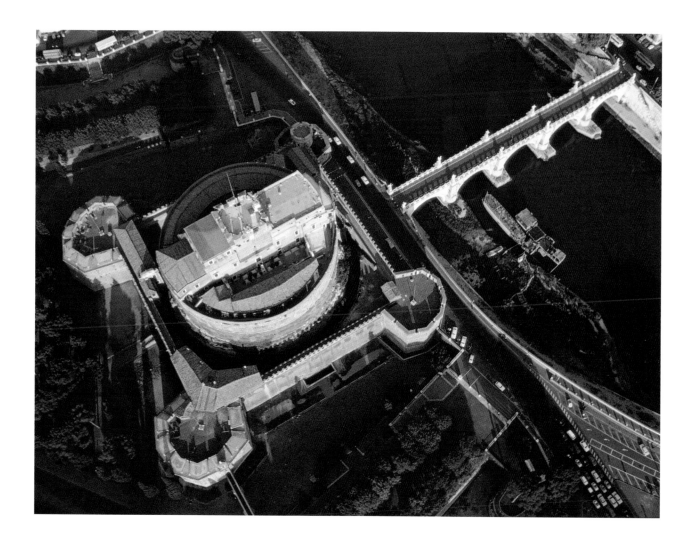

113 | **The Krak des Chevaliers**, *c*1150–second half of 13th century AD, Syria, 1997

114 | **The Castel Sant'Angelo in Rome**, AD 130–39, Italy, 1974. World Heritage Site

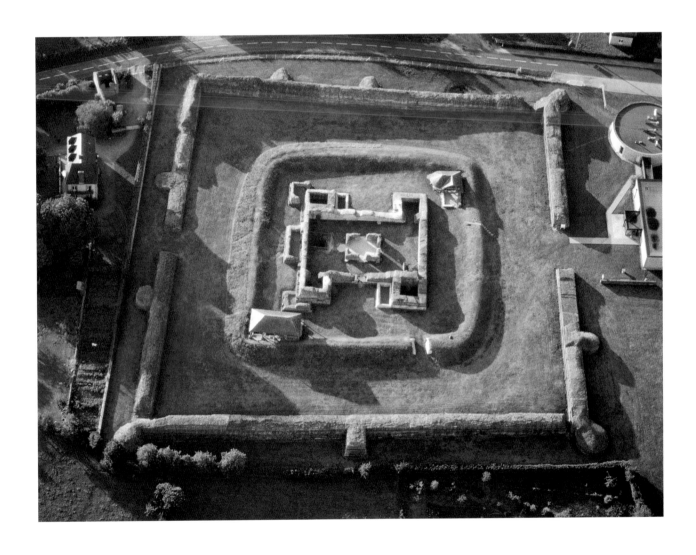

115 | **The fortress at Jublains**, 3rd century AD, France, 1998

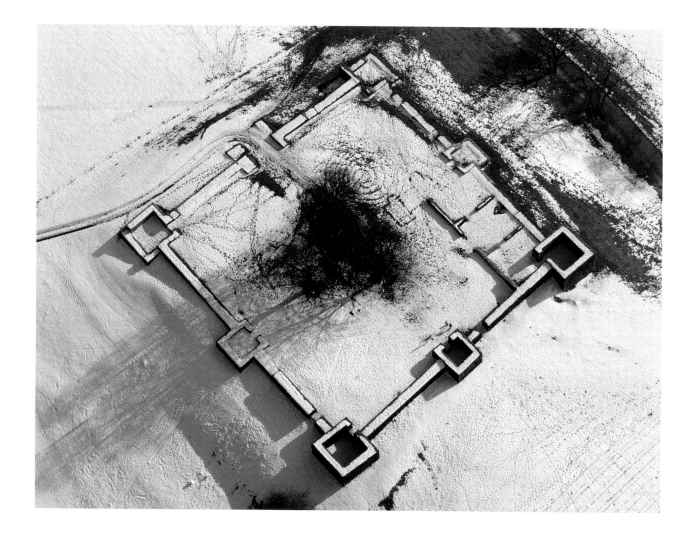

116 | **The late Roman castellum at Irgenhausen**, 4th century AD, Switzerland, 2003

117 | **The Viking fortress at Trelleborg**, AD c980, Denmark, 1971

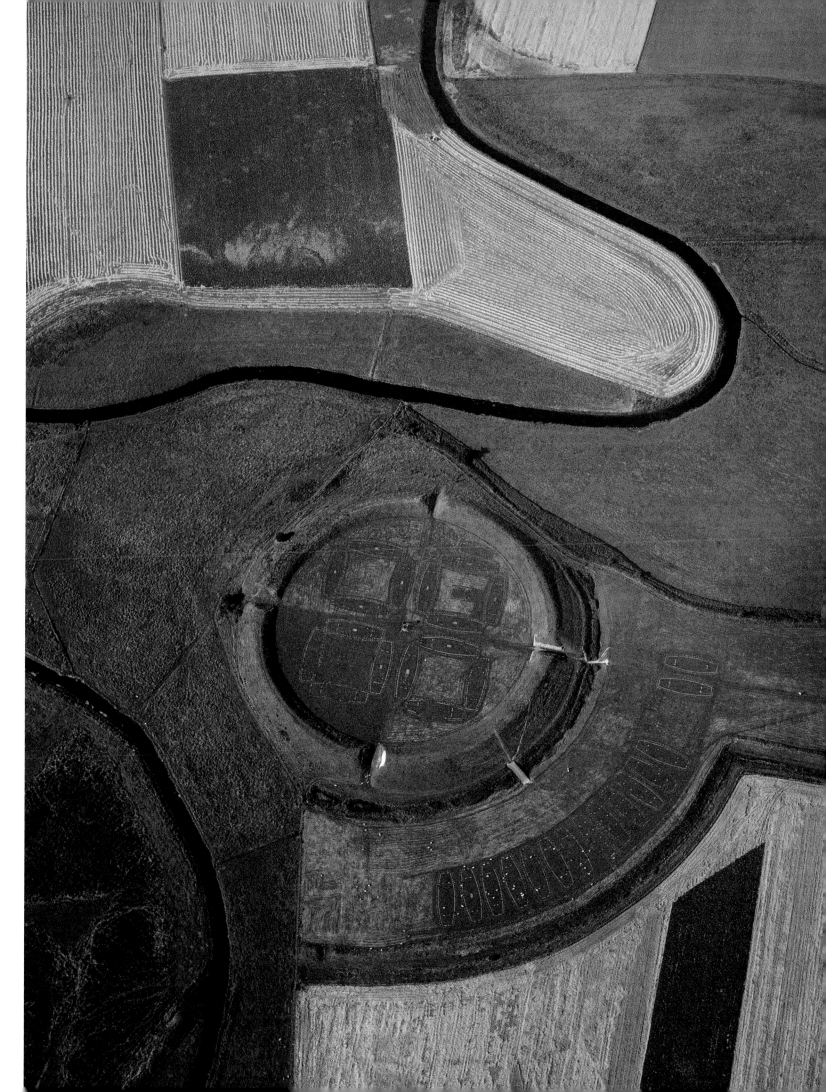

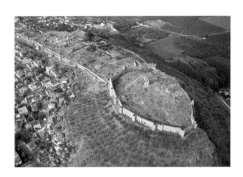 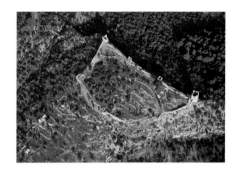 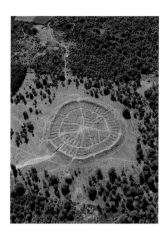

90 | The medieval citadel at Ephesus, Turkey

The remains of the medieval town of Ephesus lie on top of a hill now known as Ayasoluk Hill. This hill originally overlooked a great inlet on the coast, but over the centuries this was silted up by the River Caÿster. It was occupied even in Mycenaean times, but the hellenistic and Roman city extended over flatter terrain some 3km away. Settlers returned here only when the burial site of St John the Evangelist became a centre for pilgrims (no. 204) and the 7th-century castle offered protection from the Arab attacks that were beginning at this time. The early Byzantine defences were admirably suited to the terrain. The lower part was carefully built from solid walls and projecting rectangular towers made from material taken from older buildings. Visitors entered through the monumental and still well-preserved 'Gate of Persecution'. The hilltop is additionally fortified by a castle. The original layout is largely preserved, although the buildings have several times had to be repaired and reinforced following earthquakes, with several of the towers being enlarged. Apart from a brief period between 1190 and 1197 when the Seljuks occupied the town, Ephesus remained under Byzantine rule until the Turks captured it in 1304. The Ottomans used the citadel as a garrison until the early 19th century, building a mosque and converting the small church on the summit into a reservoir.
R. S.

F. Miltner, *Ephesos: Stadt der Artemis und des Johannes* (Vienna 1958); W. Müller-Wiener, 'Mittelalterliche Befesti-gungen im südlichen Ionien', *Istanbuler Mitteilungen*, 11 (1961), 5–122, esp. 85–112; C. Foss, *Ephesus after Antiquity: A Late Antique, Byzantine and Turkish City* (Cambridge 1979)

91 | The town and acropolis at Aegosthena, Greece

The ruins of Aegosthena lie amid extensive olive groves on the southern slopes of Mount Cithaeron. Situated at the north-east corner of the Gulf of Corinth, the town controlled access to the ancient country of Megaris and as a result was strongly fortified. It is one of the best-preserved classical Greek fortresses. One of the battles in the Archi-damian War was fought near here in 378 BC, and in 371 BC the Spartans withdrew to the town after suffering an annihilating defeat at the hands of the Theban general Epaminondas at Leuctra. Large sections of the walls and towers of the lower and upper towns can still be seen, admirably constructed from large polygonal and square blocks of limestone. The acropolis lies on a steep slope in the eastern part of the town and is additionally forti-fied by a transverse wall. Eight towers with a square groundplan strengthen the fortification. The south-eastern tower to the right of the photograph still rises more than 10m above the surrounding walls. No excavations have taken place here, and so virtu-ally no remains of private or public buildings are known. In the 12th century monks established a monastery within the stronghold and built a small church on the eastern edge of the acropolis. A further, larger Byzantine basilica, partly built over by a modern chapel, can be identified in the south-west corner of the town just below the centre of the photograph.
R. S.

E. F. Benson, 'Aegosthena', *The Journal of Hellenic Studies*, 15 (1895), 314–24; J. Ober, *Fortress Attica* (Leiden 1985); H. R. Götte, *Athen – Attika – Megaris* (Cologne 1993), 244–5

92 | The ring-fort at Ismantorp, Sweden

One of Sweden's most impressive prehistoric monuments, the ring-fort at Ismantorp lies on the island of Öland. The well-preserved ruins give the visitor a fascinating insight into the past. Eleven or twelve forts were built on Öland and were used between the 3rd and 7th centuries AD. Today the Ismantorp fort is beautifully set within a forest glade. Its ring-wall, built of limestone, is still 5m high and surrounds an area with a diameter of 125m. Nine gates give access to the interior. Communication is provided by a ring road, with four smaller roads running off from it and meeting at the centre. There are 49 houses along the ring road and another 44 in the centre. All are examples of the typical long houses of the period on Öland. In the surrounding area the ruins of several abandoned farmsteads may be seen. An unusual small semicircular building in an open space in the centre of the fort was perhaps intended for some kind of ritual celebrations. Excavations have taken place in the 19th, 20th and 21st centuries, but few finds have been made. The Öland ring-forts were built at a turbulent period in Baltic history and served primarily as strongholds for the population. Some, like the ring-fort at Eketorp, were perma-nently occupied by farming communities, while Ismantorp seems to have been in periodic use only.
U. N.

M. Sternberger, *Öland under äldre järnaldern* (Stockholm 1933), 235–43, summary p.269; E. Wegraeus, 'The Öland Ring-forts', *Eketorp: Fortification and Settlement on Öland. The Monument*, ed. K. Borg and others (Stockholm 1976), 33–44

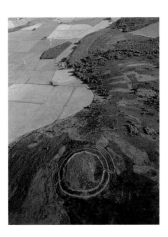

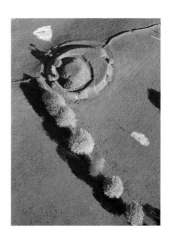

93 | The Dún Eochla fort on the Isle of Aran, Inishmore, Ireland Despite its relatively small size, Inishmore possesses no fewer than five substantially built, dry-stone forts. Dún Eochla, on the highest point of the island, is a circular fort, 27m in greatest internal diameter, enclosed by an outer rampart, oval in plan, which has internal dimensions of 78 x 60m. Internal terraces occur and there is a single narrow entrance in the east. Traces of internal huts are visible. This is a massively impressive site, enjoying wide views across the sea in all directions. Without excavation, however, its date is unknown, nor is its precise function clear. It could be contemporary with Dún Aengus (early 1st millennium BC) or it could date from the early historic period (AD 500–1000).
B. R.

B. Raftery, 'Irish Hillforts', *Council for British Archaeology: Research Report*, 9 (1972), 50–51; P. Harbison, 'Wooden and Stone Chevaux de Frise in Central and Western Europe', *Proceedings of the Prehistoric Society*, 31C (1971), 195–225

94 | Barmkin hillfort at Echt, Scotland
This large hillfort is situated on a heather-covered hill at 275m above sea level and had an unusual number of ditches and banks, five concentric rings of defence and a high number of entrances. The innermost ring has a diameter of 122m and each ring has a slightly different construction of earth or dry-stone walling up to 2.6m thick. Although unusual in the number of defensive banks, it is clearly a Late Bronze Age or Early Iron Age hillfort (1000–700 BC). The society at the time was controlled by warrior-chiefs who would need defended locations from which to launch their attacks on rival chiefs and tribes.
R. B.

A. and G. Ritchie, *Scotland: An Oxford Archaeological Guide* (Oxford 1998)

95 | The earthwork at Crooked Wood, Ireland
This is an imposing, well-preserved earthwork, situated in open pasture close to the village of Crooked Wood, to the south of which lies the early monastic site of Taughmon, called after a 6th-century saint, Monnu. It consists of a circular earthwork with external ditch enclosing an area measuring 49 x 40m. Situated eccentrically immediately inside the enclosure is a prominent, flat-topped earthen mound 3.5m high, with an external ditch. No excavation has ever taken place here nor has it ever been systematically planned. The general feeling among archaeologists, however, is that this is an Anglo-Norman motte, probably dating to the 12th century. There are, however, certain features which suggest the possibility of another interpretation. The way in which the mound is clearly surrounded by the enclosure, rather than attached to it (which is more typical of the bailey usually associated with a Norman motte) allows for the possibility that this is a two-period site. Thus it might have originally been a ring-fort that was then used by the intrusive Normans as a convenient enclosure but also as a political statement demonstrating the dominance of the invading group. The typical motte was more an outpost than a settlement, being part of the initial phase of colonization (and built in frontier zones) before more permanent castles were built. On the summit of the mound a single strong wooden building originally existed while the bailey would have been for the horses or possibly even for cattle. None of the original wooden structures have survived.
B. R.

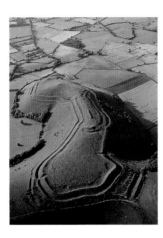

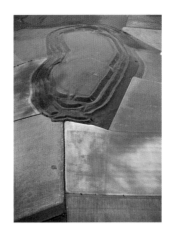

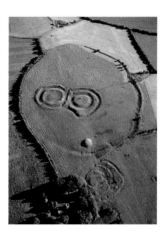

96 | Hambledon Hill, Dorset, England

The earthworks on Hambledon Hill in Dorset represent over 3000 years of occupation beginning with Neolithic (c3000 BC) causewayed enclosures (one of which is visible in the centre left) and ending with the most dominant feature on this chalk promontory, the ramparts of an Iron Age hillfort (c600 BC). Also clearly visible is a Neolithic long barrow, 73m long, 16.8m wide and 1.8m high at its centre, running along the spur, with the remains of a Bronze Age barrow next to it. The earthworks and archaeological remains continue on the hilltop (bottom left and right), but the strategic position of the site's location is clearly visible as the chalk hillside rises up sharply from the low-lying plain below. Hambledon Hill marks the western end of chalk hills and was a significant location for over 3000 years, not least as a defence against the Romans. Even in the Neolithic period there is evidence of warfare in the form of a skeleton with an arrowhead lodged in its spine. The site is in private ownership but is protected as an ancient monument.
R. B.

R. Mercer, *Hambledon Hill: A Neolithic Landscape* (London 1980)

97 | The hillfort at Maiden Castle, Dorset, England

The hillfort at Maiden Castle in Dorset is one of the largest and most imposing defended hillforts in southern England. There are over one thousand such hillforts in Britain. The defensive ditches and banks are clearly visible from the air but are impressive on the ground. In the Neolithic period (c3500 BC) this important chalk promontory to the west of Dorchester was occupied by a causewayed enclosure defined by a number of ditches; the faint remnants of this enclosure are just visible in the centre of the hillfort in a curving arc running from left to right. The purpose of these enclosures is not known, but they were probably important foci for the local community for meetings, rituals and even festivals. There is also a burial mound, a Neolithic bank burrow, running almost three-quarters the length of the interior of the hillfort (from top to bottom of the photograph, but only just visible). The main archaeological features are the remains of the Iron Age hillfort, with a complex and well-defended entrance. The hillfort was sacked by the Roman invaders under the command of Vespasian in AD 43. There is also a Roman temple, built in around AD 367, which was excavated by Sir Mortimer Wheeler in the 1930s. Recent excavations in the 1980s improved our understanding of the site, and numerous well-preserved round houses were discovered, suggesting a large population lived inside the hillfort for a number of years. The site is managed by English Heritage and is open to the public.
R. B.

A. Lawson, *Prehistoric Hinterland of Maiden Castle* (London 1992); N. Sharples, *Maiden Castle* (London 1998); R. Bewley, *Prehistoric Settlements* (Stroud 2003)

98 | The Hill of Tara, Ireland

This site, figuring prominently in early Irish literature, is probably the best known of the great royal centres of pagan Celtic Ireland. This was the site of the high king, the place where important ceremonies, including inaugurations, took place. While its ceremonial character is clear, secular occupation also took place, but its extent can be determined only by archaeological excavation. Situated on a north-south ridge, Tara today consists of a large concentration of earthen monuments of varying type, both visible and invisible, the earliest of which date to the 3rd millennium BC, but the majority probably date to the Celtic Iron Age, i.e. the last centuries BC. The visible sites all have pseudo-historical names today, but these are fanciful inventions. Most prominent are the monuments on the summit, comprising a large earthen enclosure of Iron Age date, within which is a pair of undated, conjoined earthworks and a small Neolithic passage tomb. Outside the enclosure a series of mounds of varying type occur, most probably dating to the Iron Age. A pair of parallel earthworks extending to the north are of uncertain date and purpose. Immediately outside the larger enclosure to the north are the damaged remains of a triple-ramparted enclosure. Though severely damaged in the early 20th century by a sect known as the British Israelites who were seeking the Ark of the Covenant, the site was in fact used over a lengthy period for burial, ceremonial and habitational purposes. The most important finds are the Roman remains of the 2nd or 3rd centuries AD.
B. R.

R. A. S. Macalister, *Tara: A Pagan Sanctuary of Ancient Ireland* (London 1931); S. P. ORíordáin, *Tara: The Monuments on the Hill* (Dundalk 1961); C. Newman, *Tara: An Archaeological Survey* (Dublin 1997 (Discovery Programme Monographs 2)

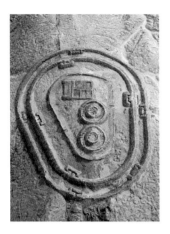

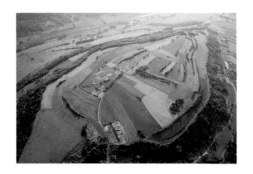

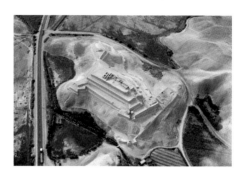

99 | **The fortress at Chanquillo, Peru**

The ruins at Chanquillo in the Casma Valley on Peru's northern coast, some 15km from the Pacific, create the impression of a solid fortress. Three concentric ring-walls up to 6m high enclose three buildings, of which two consist of ring-walls. The complex dates from the late phase of the Early Horizon period (c400–100 BC), when the Casma Valley was part of an empire extending as far as the neighbouring uplands. The ruins also include several large multi-roomed complexes on the plateau at the foot of the hill, as well as a series of 13 stone towers on a nearby ridge. It is difficult to know how to interpret the site as it had not been properly examined until 2001, when extensive excavations were undertaken. The solid walls and easily defended position make one think that the hilltop ruins were defensive in character, and yet the numerous entrances (five in the outer wall, four in the middle wall and three in the inner wall) could be locked only from the outside. The interior of the complex was evidently kept very clean, as was often the case with buildings of a cultic nature. The unpublished results of the latest research point in the same direction. According to this view, Chanquillo was a fortified ceremonial complex with a temple at its centre. The fights that took place here were generally ritual in character. The site was presumably also used for calendrical observations, with the 13 towers on the ridge of the hill beyond the plain serving as orientational points on the horizon.
K. L.

E. G. Squier, *Peru: Incidents of Travel and Exploration in the Land of the Incas* (New York 1877); R. Fung and V. Pimentel, 'Chankillo', *Revista del Museo Nacional*, 39 (1973), 71–80; S. and T. Pozorski, *Early Settlement and Subsistence in the Casma Valley, Peru* (Iowa City 1987)

100 | **The Gallic oppidum at Alesia, France**

The plateau of Mont-Auxois (407m) on which the Gallic oppidum of Alesia lies is situated at the intersection of two natural lines of communication known as the 'Gateway to Burgundy'. It covers an area of some 97 ha and is surrounded by sheer limestone cliffs that tower high above the valleys of the Oze and Ozerain. Traces of human habitation date back to the Bronze Age. The oppidum was the main centre of the local tribe of Mandubii and first enters recorded history in 52 BC, for it was here that the supreme commander of the Gallic armies, Vercingetorix, holed up with his troops when pursued by Caesar (*Bellum Gallicum* 7.68–70). A prehistoric settlement dating to the end of the second Iron Age (c80 BC) and a town wall of the murus gallicus type have been uncovered on the plateau. In order to force his enemies into submission, Caesar surrounded the oppidum with a series of camps and a double system of fortifications designed to besiege the town and at the same time to protect himself against an attack from the rear. These siegeworks were excavated for Napoléon III between 1861 and 1865 and again between 1991 and 1997, on the latter occasion by a Franco-German team. Life continued in the oppidum after the defeat of the Gauls, and Alesia became a vicus that was graced with classical monumental buildings in the course of time: a theatre, a public centre with a basilica and curia, and temples for autochthonous gods, especially Ucuetis, the protective deity of the bronze smiths who were responsible for Alesia's affluence. The settlement continues to be inhabited. 'Miracle water' from Alesia was still being sold in Paris in the early 20th century.
M. R.

M. Reddé and S. von Schnurbein (eds.), *Alésia: Fouilles et recherches franco-allemandes sur les travaux militaires romains autour du Mont-Auxois (1991–1997)*, 2 vols. (Paris 2001) (Mémoires de l'Académie des Inscriptions et Belles-Lettres 22); M. Reddé, *Alésia: L'archéologie face à l'imaginaire* (Paris 2003)

101 | **The fortress at Paramonga, Peru**

After taking the Inca ruler Atahualpa hostage in Cajamarca in 1532, the Spanish conquistador Francisco Pizarro sent his brother Hernando to the sanctuary at Pachacamac to demand a part of the ransom. In the course of this initial foray along the Peruvian coast, Hernando and his soldiers went past Paramonga, which, no doubt because of its similarity to Spanish castles, they took to be a fortress. They reported on its superb wall paintings depicting birds and big cats. Very little of these paintings survives. Paramonga lies on a rocky spur in the foothills of the Andes overlooking the Río Pativilca some 210km north of Lima. Several terraced ring-walls adapted to the natural form of the hill provide the base for a platform on which a whole series of buildings once stood. The whole complex is built from adobe (unfired mud bricks) and has only a single entrance. Together with the protruding sections of the walls, which create the impression of bastions, this suggests a military function, and historical accounts do indeed indicate that this site may have been a stronghold on the southern border of the Chimú empire, which is known to have fought several battles with the Inca in the 15th century. But in its architecture and overall design, Paramonga is very similar to the sanctuary at Pachacamac, Hernando Pizarro's destination in 1532, so that it may also have been an Inca temple accessible only to priests and other dignitaries. Only an archaeological examination will be able to resolve this question.
K. L.

G. R. Johnson, *Peru from the Air* (New York 1930) (Special Publication 12); L. M. Langlois, *Paramonga* (Lima 1938); P. Kosok, *Life, Land and Water in Ancient Peru* (New York 1965)

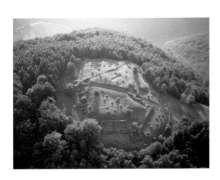

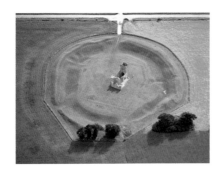

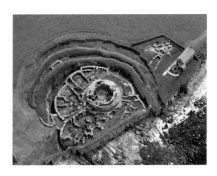

102 | The fortress at Blidaru, Romania

The Dacian fortress of Blidaru lies on an elevation rising to a height of 705m above the Gradiste Valley in the Orastie Mountains that are part of the southern Carpatians. It secured access to the Dacian capital of Sarmizegetusa Regia from the north and consists of two adjacent castles with a trapezoid groundplan and four corner towers. The defensive walls are built of stone and covered in square blocks held together by diagonal wooden beams. The core is made of clay mixed with unworked stones. The road to the fortress at Blidaru was additionally protected by 18 towers. The oldest part of the castle is the courtyard with the four corner towers, a residential tower and a free-standing residential tower in the middle that dates from the 1st century BC. During a second phase the first ring of walls on the western side was doubled and a third belt added in order to provide a better defence of the saddle. Inside the wall there were storerooms at ground level. During the excavations enormous storage vessels were uncovered. The site was discovered by chance in 1923 and was declared a World Heritage Site in 1999.
I. G.

C. Daicoviciu and A. Ferenczi, *Asezarile* (Bucharest 1951); C. Daicoviciu and H. Daicoviciu, *Cetatile* (Bucharest 1960); I. Glodariu and F. Stanescu, *Sarmizegetusa Regia* (Deva 1996)

103 | The Church Henge, Knowlton, England

The Church Henge at Knowlton, Dorset, is the only remaining earthwork henge in this area, known as the Knowlton Circles. The others have been levelled by the plough in this chalk downland landscape. The ditch is visible on the inside of the bank, a defining feature of Neolithic henges and clearly a non-defensive construction. Henges derive their name from the 'hanging stones' at Stonehenge and their function is not fully understood. They are thought to have been meeting places for festivals, rituals, even markets, and many of them have more than one entrance. This large earthwork, with an internal diameter of 100m and an external diameter of 150m, was clearly a significant landmark when the Normans arrived after AD 1066. They erected a church in its centre, thus continuing a spiritual and ritual purpose. Surrounding this site are numerous other archaeological sites, such as the largest Bronze Age round barrow in Dorset, but only the henge is protected by law: the fence defines the protected area. The henge is open to the public and is in the care of English Heritage.
R. B.

M. Pitts, *Hengeworld* (London 2000)

104 | The Broch of Gurness, Scotland

The Broch of Gurness, situated on the northern coast of the Mainland of Orkney, has one of the most dramatic locations of a broch (defended tower) anywhere in Scotland. It was discovered when the sketching stool of the poet Robert Rendall slipped into the ground, revealing the stairs inside the tower. Brochs are defended settlements and are found only in Scotland and date from the Iron Age. Artefacts from excavations at the Broch of Gurness have been dated to the 2nd and 3rd centuries AD. This broch is now only 3.2m high but would have been much higher, and is 20m in diameter, with walls 4–5m thick. The cliff provides an excellent defence on the seaward side, and three deep, rock-cut ditches provide a defence from a land attack. Later Viking buildings occupied part of the site, and a Viking woman's grave was inserted into the wall of the outer courtyard. She was buried with a shell necklace, an iron sickle, a knife and two oval bronze brooches. There is a small museum on the site, which is managed by Historic Scotland.
R. B.

J. W. Hedges, *Bu, Gurness and the Brochs of Orkney* (Oxford 1987); A. Ritchie, *Orkney* (Edinburgh 1996)

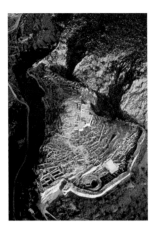

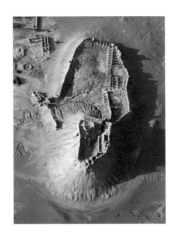

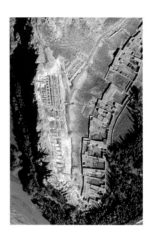

105 | **The citadel at Mycenae, Greece**

Mycenae, the impressive citadel site in the eastern Peloponnese, gave its name to the final period of Bronze Age Greece. According to legend, it was founded by Perseus, the son of Zeus and Danae, later passing into the hands of the Atrides, whose sombre fate provided the subject matter for many famous tragedies. It was from here that Agamemnon set out for Troy as the leader of the Greek army. And it was the fame enjoyed by Mycenae in Greek verse that persuaded Heinrich Schliemann to begin his excavations here in 1874. Solid 'Cyclopean' walls up to 6m thick and dating from the 14th century BC encircle the rulers' residence, outside which lies a residential area. The palace is situated on virtually the highest point of the acropolis, its central courtyard and large megaron surrounded by smaller state rooms and residential accommodation. This complex stands at the end of the main thoroughfare that begins at the Lion Gate, the tower-defended entrance in the lower left-hand corner of the photograph. Immediately behind the gate lies the royal cemetery surrounded by two stone circles. Inside the shaft graves, Schliemann found undisturbed burials with spectacular grave goods that amply confirmed Homer's description of 'Mycenae, rich in gold'. Yet it was not Agamemnon and his family who were buried here, but an older dynasty from the 16th century BC. Improvements to the defences and extensive measures to ensure a steady water supply in the late 13th century BC were unable to prevent the citadel from being captured and destroyed shortly afterwards. The few remains of the archaic and hellenistic periods show that the place never regained its former importance.
R. S.

H. Schliemann, *Mycenae* (London 1878); G. E. Mylonas, *Ancient Mycenae: Capital City of Agamemnon* (London 1957); A. J. B. Wace, *Mycenae: An Archaeological History and Guide* (New York 1964)

106 | **The Islamic fortress at Bampur, Iran**

In the overwhelmingly inhospitable mountains of south-eastern Iran the citadel at Bampur is the most striking sign of human habitation. It stands on a steep hill at the eastern edge of the vast and deep Bampur Basin above the bed of the Bampur river, which at least during the rainy season contains enough water to irrigate fields, gardens and palm groves. Although the town consisted only of mud and reed huts until recently, the citadel was for a long time the administrative centre of the province of Baluchistan. As late as 1932, when Aurel Stein undertook the first archaeological investigations here, there was a small garrison in the part of the citadel that projects in the shape of a triangle from the main building and that includes the gate and cistern. The fortress itself had already fallen into disrepair. Situated at the highest point of the plateau, the main castle contained a round donjon and the palace building, all of which served as an ultimate refuge. They could be reached only through a steep, narrow gatehouse, accessible from the castle courtyard beneath them. Here and in the large lower castle were barracks and stables. To judge by the Islamic ceramics, the citadel must have been surrounded by a prosperous settlement in the Middle Ages, although it has not been possible to identify the place in medieval chronicles. The region of Bampur flourished during the Bronze Age. Stein's excavations, together with those undertaken by the British Archaeological Institute in 1966, found high-quality ceramics, stone vessels and arrowheads in the 7m deep settlement layers beside the fortress. Richly furnished graveyards were discovered in the surrounding area.
D. H.

A. Stein, *Archaeological Reconnaissances in North-Western India and South-Eastern Iran* (London 1940), 104–10; B. de Cardi, 'Bampur', *Teheran: Das Museum Iran Bastan* (Paris 1968), 151–3 (Archaeologia Viva 1/1); B. de Cardi, 'The Bampur Sequence in the 3rd Millennium B.C.', *Antiquity*, 41 (1967), 33–41

107 | **The Urartian citadel at Bastam, Azerbaijan, Iran**

'Rusa the son of Argisti built this house for Haldi, the lord. I erected the building and decided on its name: Rusai URU.TUR. I am Rusa, the mighty king of the Biai lands, king of kings, lord of the city of Tuspa.' In a long cuneiform inscription found in the early 19th century in the village of Bastam, 54km north-east of Khoy, King Rusa II (685–645 BC) boasted of having founded one of the greatest Urartian citadels, which he modestly named the 'Little Town of Rusa'. During the first half of the 1st millennium BC Urartu was a well-organized, federal empire, with its royal seat at Tuspa near what is now Van, the rugged mountain terrain of which was ruled by vassal kings and governors from their powerful mountain fortresses. Rusai URU.TUR was evidently a new power base and administrative centre for the empire following its expansion in the direction of Lake Urmia to the south-east. The present aerial photograph shows the lower citadel on a rocky spur between the village farmsteads and the bed of the River Aqcay. It constitutes only a very small part of the citadel, which is some 800m long and 400m wide. Between the substructures of the long halls and a three-nave colonnaded hall, the entrance leads through the south gate to the upper citadel, which was extensively excavated by a German team between 1968 and 1978. As in all these citadels, there was a temple to Haldi, the god of the weather and the sun. Clay tablets and seals – bullae – monitoring the storage and flow of goods point to the citadel's administrative functions.
D. H.

W. Kleiss, *Bastam/Rusa-i URU.TUR* (Berlin 1977); W. Kleiss, *Bastam*, 2 vols. (Berlin 1977–88)

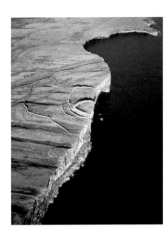

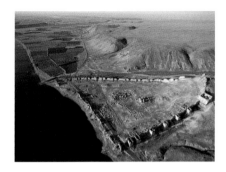

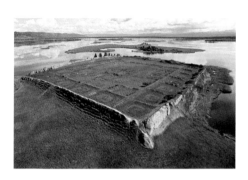

108 | **Dún Aengus on Inishmore, Ireland**

The site, situated on Inishmore, one of the three Aran Islands in County Galway, consists of three walls of dry-stone masonry, with the remains of a fourth, built up against the edge of a vertical cliff 87m above sea level. The total area of the site is 5.7 ha. The innermost of the three principal ramparts is the most substantial, being 5.8m in maximum thickness and 4.9m high, with two internal terraces and a narrow, lintelled entrance in the north-east. The second enclosure is similarly constructed, the outer, however, is ruinous. Between the second and third ramparts is a broad band of closely spaced stone spikes, some more than 1m in height (a *chevaux de frise*), with a narrow diagonal passage through them in the north-east. The presence of such an impressive defence on such a small island in the Atlantic has puzzled scholars, and some have wondered whether Dún Aengus might, at least at some time in its period of use, have served a ceremonial or ritualistic purpose. Traditionally this site has been regarded as a last refuge of westward-retreating peoples some time in the last centuries before Christ. Excavation, however, has shown that occupation occurred there as early as the later Bronze Age (between 1300 and 800 BC). A number of small circular huts of this period were found, some pottery, bronzes and also evidence for bronze working. The precise relationship between this material and the stone enclosures is not absolutely certain, but the earliest phase of defence at the site dates, in all probability, to the Bronze Age.
B. R.

T. J. Westropp, 'A Study of the Fort of Dun Aengusa, in Inishmore, Aran Isles, Galway Bay: Its Plan, Growth and Records', *Proceedings of the Royal Irish Academy*, 28C (1910), 1–46; C. Cotter, 'Western Stone Fort Project: Interim Report', *Discovery Programme Reports* (1992), 1–19 and (1995), 1–11

109 | **Zenobia on the Euphrates, Syria**

The ruins at what is now Halabiye lie on the right bank of the Euphrates, some 100km south-east of Raqqa. The ancient city controlled the river at the point where the valley of the Euphrates narrows, a point known as al-Chanuka ('The Strangler'). The city was founded as a fortified settlement to control the river traffic through the desert oasis of Palmyra (no. 170) and was named after the Palmyrean queen Zenobia (AD 266–72). In Roman and Byzantine times, Zenobia functioned as a bulwark against pressure from its Persian neighbours to the east, until it was destroyed in AD 610 and lost its function as a frontier fortress. The layout of the ancient citadel town, with its forum, thermae, basilicas, colonnaded streets and palaces, as well as its external features, including numerous grave towers, has become increasingly known since 1944 as a result of French excavations. With its more or less triangular groundplan, the city impresses above all by dint of its situation on a rugged plateau bounded on two sides by wadis and on its third side by the Euphrates. The fortifications consist of more than 30 surviving bastions, with six gates let into the wall. The ruins of the citadel lie on the highest point of the site, on a steep rocky peak at the apex of the triangle formed by the wall. The town's governor probably resided in the building by the north wall (to the right of the photograph), a building that looks like an enormous tower.
R. W.

J. Lauffray, *Halabiyya-Zenobia: Place forte du limes oriental et la Haute-Mésopotamie au VIe siècle* (Paris 1983); F. R. Scheck and J. Odenthal, *Syrien: Hochkulturen zwischen Mittelmeer und Arabischer Wüste* (Cologne 1998), 338–40

110 | **Uyghur island fortress in Lake Tere-Khol, Tuva Republic, Russian Federation** Many puzzles continue to surround the medieval history of the region now occupied by the Republic of Tuva. The Scythians were followed by bands of Huns, who were gradually replaced by Turkic tribes. During the centuries before the Mongol ruler Genghis Khan established his Eurasian empire in the 13th century and incorporated Tuva into it, the region was ruled by the Uyghurs, a Turkic people that established its rule in western Mongolia in the 8th/9th century, extending its territory to large tracts of Central Asia and especially Turkestan between the 10th and 13th centuries, before Genghis Khan put an end to its aspirations. Excavations of Uyghur sites in Turkestan above all have revealed carefully planned towns and monasteries with frescoes, statues, cult objects, manuscripts and the like. The religious evidence indicates a blend of Buddhist, Nestorian and Manichaean elements. In Tuva itself the culture of the Uyghurs is little known, even though the whole region is dotted with fortresses with walls of clay or stone that are pre-Mongol and likely, therefore, to be Uyghur. One such site is the fortress-palace on an island in Lake Tere-Khol seen in the present photograph. Clearly identifiable are the regular outlines of the buildings within the site, the solid mud walls with corner towers recalling caravanserais. According to oral tradition, the island once housed one of Genghis Khan's harems, in which he kept his most beautiful women. But the complex almost certainly belongs to an earlier Uyghur period, even though the site – like virtually all others of the same type – has yet to be systematically excavated.
H. P.

R. Kenk, *Frühmittelalterliche Gräber aus West-Tuva* (Munich 1982) (Materialien zur Allgemeinen und Vergleichenden Archäologie 4)

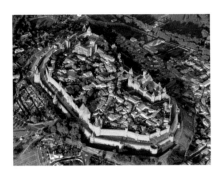

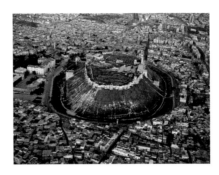

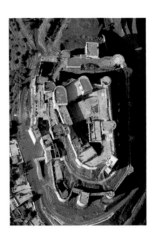

111 | The fortified town of Carcassonne, France

Carcassonne lies on a hill several hundred metres from the right bank of the Aude. The prehistoric settlement was an oppidum of the Volcae Tectosagi on the road from Aquitaine. The town was occupied by the Romans and was granted the status of a colony, perhaps from the time of Augustus. Little is left from this period. During the later Roman Empire it became a bishopric. The town's most distinctive feature is its fortified wall, the oldest parts of which date to the late 4th or early 5th century. Significant elements of this first defence system have survived: curtain walls made from small pieces of masonry, some 20 semicircular towers originally between 13 and 14m high, and postern gates. This wall was still standing in 1209, at the time of the Albigensian Crusade. In the 13th century the Roman wall was incorporated into the inner medieval wall, which was built in three stages and is now the largest and most complete fortification complex to have survived from this period. Two concentric curtains, essentially flanked by round towers, defend not only the town but also the cathedral, which dates from the 11th to 14th centuries, and the citadel of the count's castle. In 1262 a section of the population was forced from the town in order to allow a glacis, or buffer zone, to be built at the foot of the ramparts. These former inhabitants founded their own settlement on the opposite bank of the Aude. After a period of rapid development, this second settlement was destroyed in 1355 during the Hundred Years War. Thanks to the strength of its defence system, Carcassonne itself was not besieged. By the 19th century the town walls were close to collapse and were extensively restored by the French architect Eugène-Emmanuel Viollet-le-Duc and his successors.

M. R.

J. Guilaine and D. Fabre (eds.), *Histoire de Carcassonne* (privately published 1984); P. A. Février, *Topographie chrétienne des cités de la Gaule 7* (Paris 1989), 65–8; F. Letterlé (ed.), *Carcassonne: Études archéologiques* (Carcassonne 2001)

112 | The town of Aleppo, Syria

Aleppo can look back on more than 5000 years of history and as such is one of the oldest continuously inhabited cities in the world. Its position between the Mediterranean and the Euphrates on the one hand and between Asia Minor, Syria and Mesopotamia on the other established its importance as a trading centre at a very early date. At certain times Aleppo was a road-station and trading centre on the Silk Road from the south of the Arabian Peninsula to China. The city dominated a wide area, especially in the 18th century BC, when it was known as Haleb and, as the residential capital of the Yamkhad empire, became involved in the power struggles of the superpowers around it. With its monumental Islamic ruins, the citadel, almost 50m high, dominates the present city. It was built by the Ayyubid sultan Malik al-Zahir Ghazi (AD 1186–1216), a son of Salah ad-Din (Saladin). Using older structures, he built a defended palace city with a glacis and moat. The two free-standing bastions date from the 14th century. A team of French archaeologists began the task of uncovering the medieval buildings on the plateau in 1923, and since then extensive restoration work has taken place. According to the latest excavations, it is now beyond doubt that the ancient city was at the centre of the medieval and Islamic town. A large temple to the weather god was discovered close to the small mosque and open-air theatre. It was found beneath several metres of rubble and belongs in its oldest phase to the Middle Bronze Age (first half of 2nd millennium BC).

R. W.

H. Gaube and E. Wirth, *Aleppo: Historische und geographische Beiträge zur baulichen Gestaltung, zur sozialen Organisation und zur wirtschaftlichen Dynamik einer vorderasiatischen Fernhandelsmetropole*, 2 vols. (Wiesbaden 1984); M. Fansa and others (eds.), *Damaskus – Aleppo: 5000 Jahre Stadtentwicklung in Syrien* (Mainz 2000) (Oldenburg exhibition catalogue)

113 | The Krak des Chevaliers, Syria

A little to the north of the border with Lebanon and situated at a height of more than 700m in the western foothills of the Jebel Ansariye, the Krak des Chevaliers (Qalat al-Hosn) remains a superb example of Crusader architecture in the Near East, an accolade that it owes not least to its excellent state of preservation. The citadel had an important function within the security system of the Crusader castles: it was within sight of Safita 15km to the west, which lay in Christian hands and which had links with Tartus on the Mediterranean, while to the east lay the Orontes Valley and enemy Homs. Krak des Chevaliers was in the hands of the Crusaders from 1109, when it was taken by Tancred of Antioch, to 1271, when it was captured by the Mameluke sultan Baibars. As such it was an island of Christianity within a country ruled by Muslims. The citadel could accommodate around 1500 foot soldiers and 400 horsemen, together with their horses. The architecture of the site is characterized by two concentric defensive walls, the outer one of which is strengthened by semicircular bastions. The impressive upper castle was the centre of the fortifications and as such had its own bastion, with donjon, courtyard, pillared hall, great hall, long hall and castle chapel, the last named building clearly showing Romanesque influence. The main fortifications are on the south side, where an aqueduct leads over the moat and steeply sloping glacis. It was not until three years after Syria became independent of the French Mandate in 1941 that Krak des Chevaliers came into Syrian possession. Until then it had been classified as a French monument.

R. W.

W. Müller-Wiener, *Burgen der Kreuzritter im Heiligen Land, auf Zypern und in der Ägäis* (Munich and Berlin 1966), 61–3; A. Rihaoui, *The Krak of the Knights* (Damascus 1982)

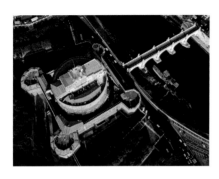

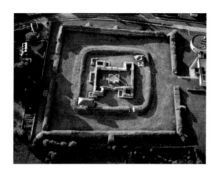

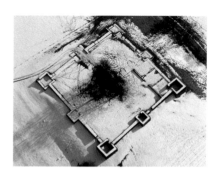

114 | **The Castel Sant'Angelo in Rome, Italy**
Situated close to St Peter's and the Vatican and
overlooking the Tiber, the Castel Sant'Angelo incor-
porates one of the most famous and monumental
of Roman funerary monuments, the mausoleum of
the emperor Hadrian (AD 117–38). Begun in around
130, it was not completed until 139, a year after the
emperor's death, and was then used as a tomb for
the imperial family until the time of the emperor
Severus. The mausoleum consisted of a square,
brick-built substructure measuring 89 x 89 x 15m
high, a cylindrical superstructure 64m in diameter
and 21m in height, and a grassy mound crowned
with a bronze imperial quadriga. The grave chamber
inside it measured 8 x 8m and included niches that
were used for both cremations and ordinary burials.
The mausoleum was later incorporated into an
outwork of the Aurelian city wall and rebuilt as a
citadel, probably in the 10th century. From the air
one can see clearly the cylindrical Roman nucleus
with the Renaissance additions for the papal
chambers, surrounded by the square defensive wall,
with its four polygonal corner towers dating from
the time of Nicholas V and Alexander VI. Also
visible is the Ponte Sant'Angelo flanked by statues
and built on the Roman Pons Aelius of 134, which
connected the mausoleum to the Campus Martius
opposite. The Castel Sant'Angelo is one of Rome's
most famous landmarks and a potent symbol of the
continuity of the power of the secular Roman
emperors and Christian popes. It now houses a
state museum in addition to the papal apartments,
some of which are decorated with well-known
grotesques.
S. St.

S. Rowland Pierce, 'The Mausoleum of Hadrian and the
Pons Aelius', *Journal of Roman Studies*, 15 (1925), 73–103; C.
D'Onofrio, *Castel S. Angelo* (Rome 1972); F. Coarelli, *Rom:
Ein archäologischer Führer* (Mainz 2000), 346–9

115 | **The fortress at Jublains, France**
Noviodunum, the ancient capital of the Aulerci
Diablintes, lay 12km south-east of Mayenne. At its
edge was a fortified complex whose walls are
remarkably well preserved. The site, which was first
excavated in 1839 and again in 1867–8, comprises
three large sections: a main building measuring
34 x 37m, with four corner pavilions and a central
tank for collecting rainwater (impluvium); a vallum
some 60m in length; and a large trapezoid wall,
105 x 117m, made from rubble and bricks and encir-
cling the whole site. In addition to these three main
elements there are thermae at the northern and
southern corners of the vallum, which was
protected by a ditch and a wooden palisade. The
outer wall was built on recycled blocks of stone and
is made of small, regular stones levelled off with
bricks. It is flanked on the north, south and west by
a series of semicircular towers, with round towers at
the corners and a rectangular tower by the eastern
wall. The relative chronology of the site has been
established with some accuracy, although precise
details, including the function of the complex, have
yet to be resolved. The ditch and vallum contained
a scattering of coins from the time of the emperor
Tetricus (271–4), a discovery which, taken together
with an archaeomagnetic analysis of bricks from the
outer wall, suggests that the building dates from
around AD 285. It probably served as a refuge for the
inhabitants. The central building may have been a
public granary from the first half of the 3rd century.
The history of the ancient settlement is traced in a
small modern museum.
M. R.

R. Rebuffat, 'Le complex fortifié de Jublains', *Recherches sur
Jublains (Mayenne) et la cité des Diablintes*, ed. J. Naveau
(Rennes 1997), 271–89 (Documents archéologiques de
l'Ouest)

116 | **The late Roman castellum at Irgenhausen,
Switzerland** The restored walls of the late Roman
castellum at Irgenhausen in the parish of Pfäffikon
in the canton of Zurich look strangely disconcerting
in the present photograph, which was taken in
winter. By the late 19th century the castellum ran
the risk of being destroyed, and so it was acquired
by the Antiquarian Society of Zurich between 1898
and 1908 and excavated and restored in stages.
Measuring 61 x 61m, the small, powerfully fortified
castellum was built on the foundations (not visible
in the present photograph) of an estate that was
swept away in the Alamannic invasions of the 3rd
century AD. It is not clear whether this happened at
the time of the emperors Diocletian and Constan-
tine in AD c300 or not until the time of Valentinian I
around AD c370. In keeping with the usual practices
at this time, the complex was surrounded by a wall
1.9m thick and had four corner towers and two
intermediary towers, one of which, to the south-
east, was turned into a gate tower. The foundations
of a three-room stone structure may be seen
against the wall in the south-west corner. They
include an open courtyard. A small bath building
was added in the eastern corner, with the typical
apses for the basins. Additional traces of buildings
inside the complex using a half-timber technique
were not discovered during the earlier excavations,
but may still lie beneath the ground. The castellum
at Irgenhausen secured an important link from Lake
Zurich in the direction of Winterthur and beyond
that to the *limes* of the Rhine, replacing an unforti-
fied village, the vicus of Cambiodunum/Kempten in
the parish of Pfäffikon, some 2.5km away. It too fell
victim to the incursions of the Alamanni in the 3rd
century AD.
T. F.

E. Meyer, *Das römische Kastell Irgenhausen* (Basel 1969)
(Archäologischer Führer der Schweiz 2); W. Drack and R.
Fellmann, *Die Römer in der Schweiz* (Stuttgart 1988),
468–70; W. Drack and R. Fellmann, *Die Schweiz zur
Römerzeit: Führer zu den Denkmälern* (Zurich and Munich
1991), 206–7

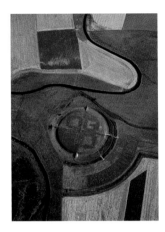

117 | **The Viking fortress at Trelleborg, Denmark**

Trelleborg is situated at the confluence of two rivers near the town of Slagelse on the island of Sjælland. It is one of four geometrically planned Viking fortresses in Denmark. All were built around AD 980 during the reign of King Harald Bluetooth and were in use for very few years. The other fortresses are Nonnebakken on Fyn, and Fyrkat and Aggersborg in eastern and northern Jutland respectively. They differ in size, but all were built according to the same overall plan, with a circular rampart, gates at the four points of the compass joined by streets which crossed at the centre of the fortress, and large, uniform, bow-sided houses arranged in quadrangles. The houses and streets were built of timber, the ramparts constructed of turf, earth and timber. Excavated between 1934 and 1942, Trelleborg contained 16 houses (each about 30m long) within a rampart, the internal diameter of which is 136m. Another 15 houses were placed in an outer ward, which also enclosed a cemetery. A full-scale reconstruction of a house and a museum have been built on the site. The four fortresses are not mentioned in any written source, and their function has been much discussed. Their main purpose was probably to control Denmark at a time of growing unrest. Harald Bluetooth died in c987 in a revolt successfully led by his son Sven Forkbeard. This may well have signalled the end of Trelleborg and the other fortresses.

E. R.

P. Nørlund, *Trelleborg* (Copenhagen 1948) (with Engl. summary) (Nordiske Fortidsminder 4/1); T. E. Christiansen, 'Trelleborgs alder: Arkæologisk datering', *Aarbøger for Nordisk Oldkyndighed og Historie* (1982), 84–110 (with Engl. trans.); E. Roesdahl, 'The Danish Geometrical Viking Fortresses and their Context', *Anglo-Norman Studies*, 9 (1987), 108–26

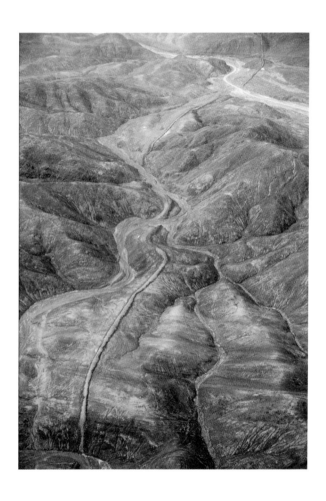

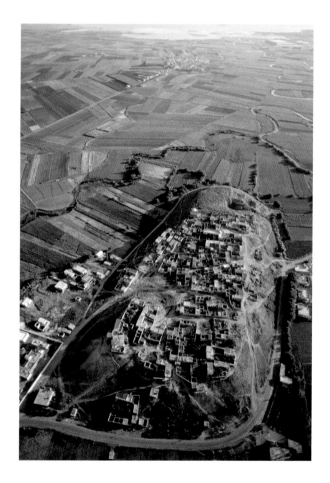

118 | **The great wall of Santa**, AD 600–900, Peru, 1995

119 | **Kadesh on the Orontes**, second half of 2nd millennium BC, Syria, 1997

6. FRONTIER WALLS TO KEEP PEOPLE OUT (AND IN) – LIMES PURSUING POLITICS BY OTHER MEANS – BATTLEFIELDS

Conceived as a protection against the barbarian nations of the steppes, the Great Wall of China is one of those attempts, perpetually repeated, to arrest the course of time. As we know, it has proved ineffectual. Time cannot be stopped in its tracks.

Max Frisch, *The Great Wall of China* (1947)

Peace is the time when sons bury their fathers. War is the time when fathers bury their sons.

Herodotus (*c*485–*c*425 BC)

A war leaves behind it three armies in a country: an army of cripples, an army of mourners and an army of thieves.

Anon.

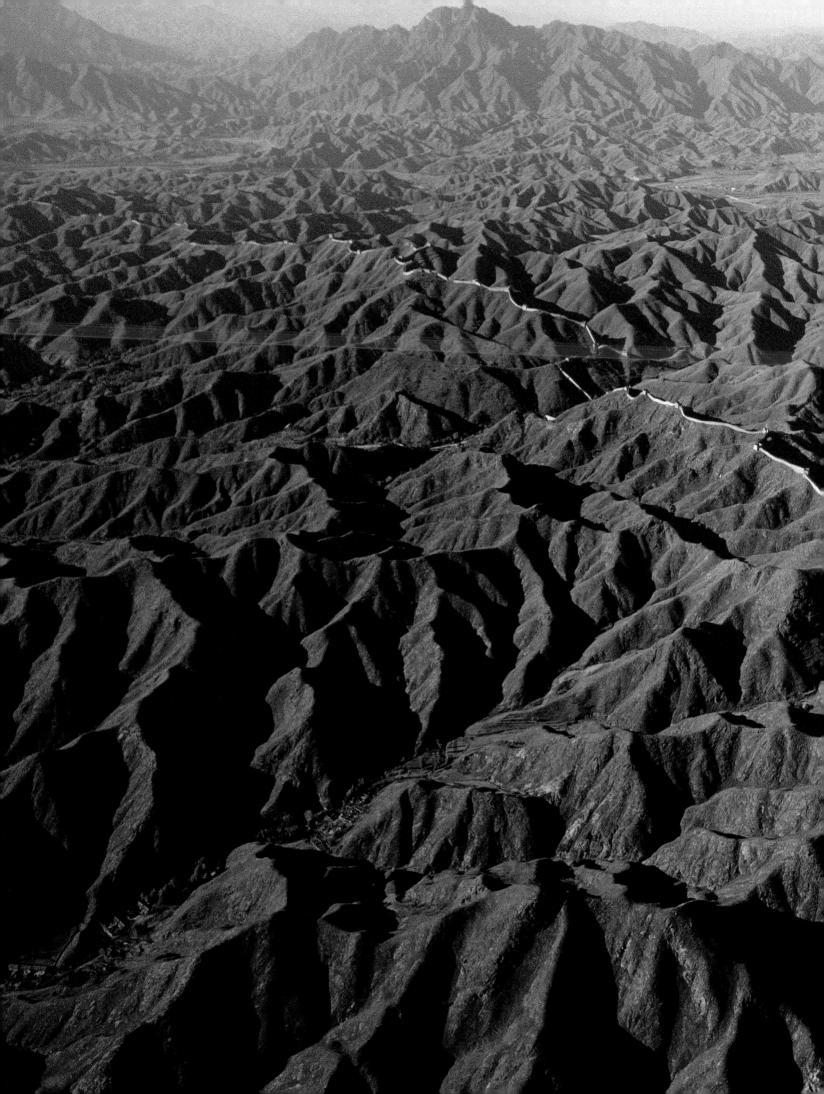

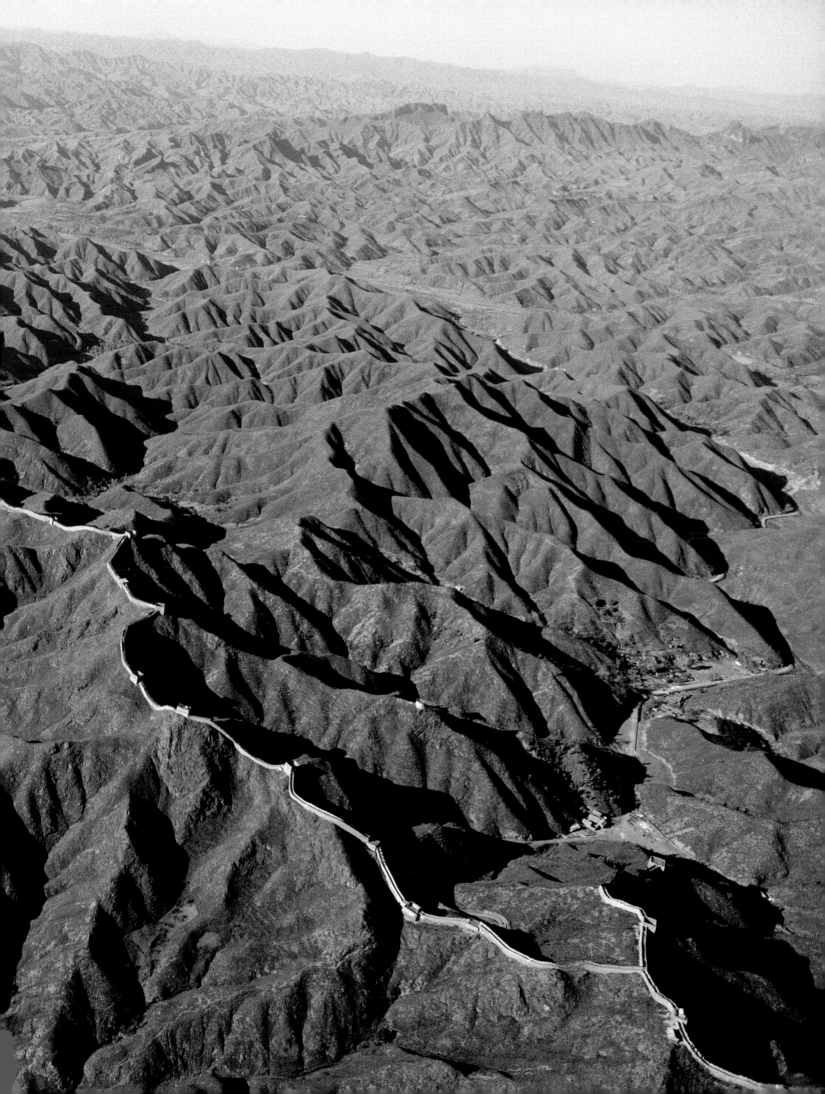

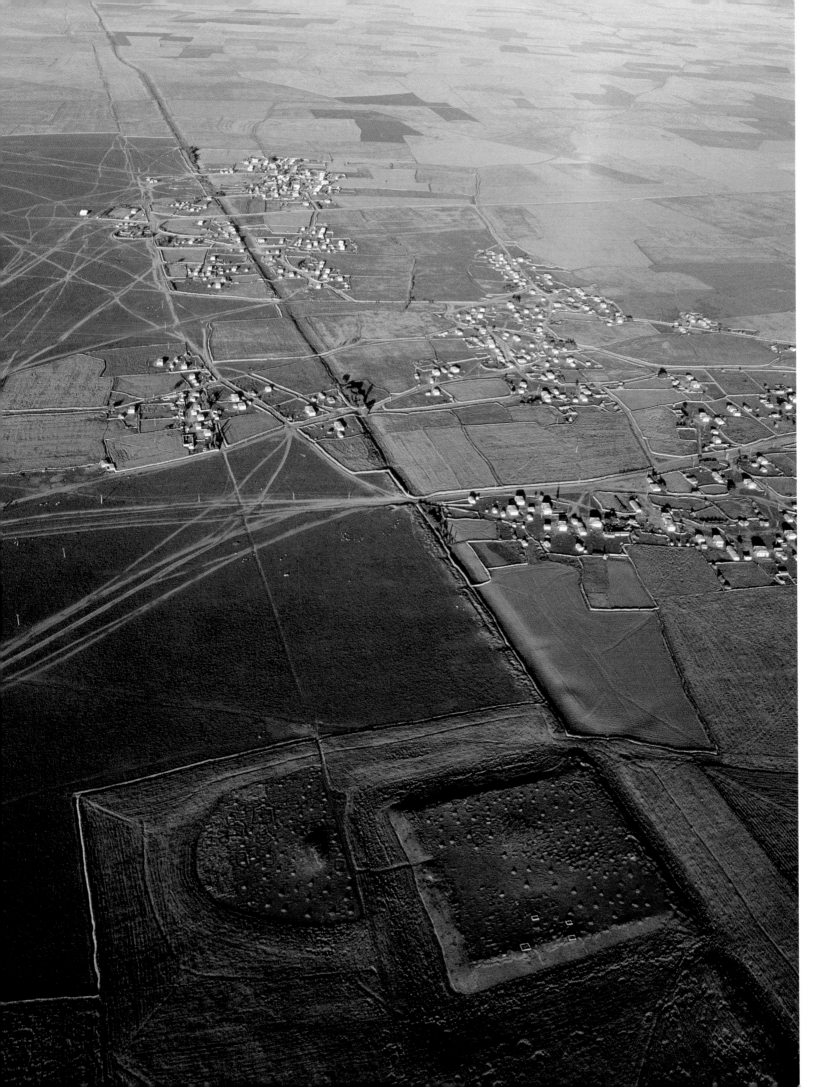

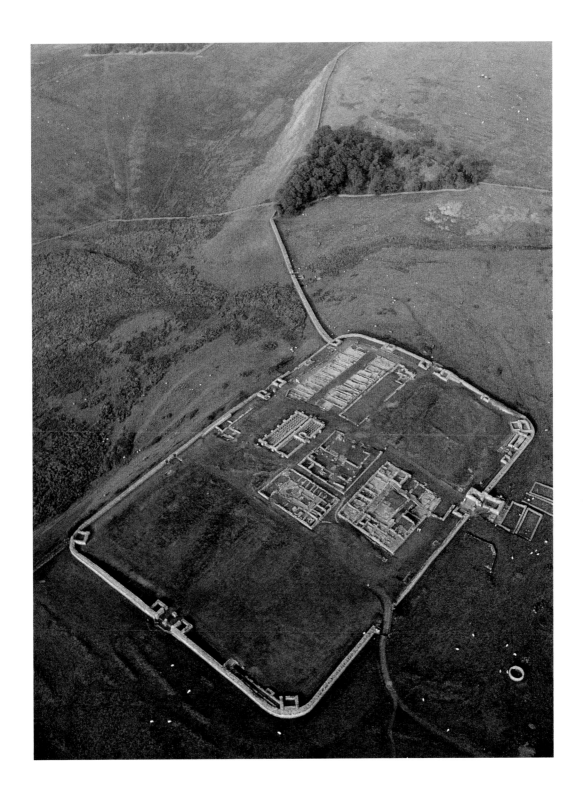

120 | *206–7:* **The Great Wall of China**, 3rd century BC–17th century AD, China, 1987. World Heritage Site

121 | **Alexander's Wall**, 2nd/1st century BC, Iran, 1978

122 | **Hadrian's Wall and Housesteads Roman Fort**, AD 122, England, 1999. World Heritage Site

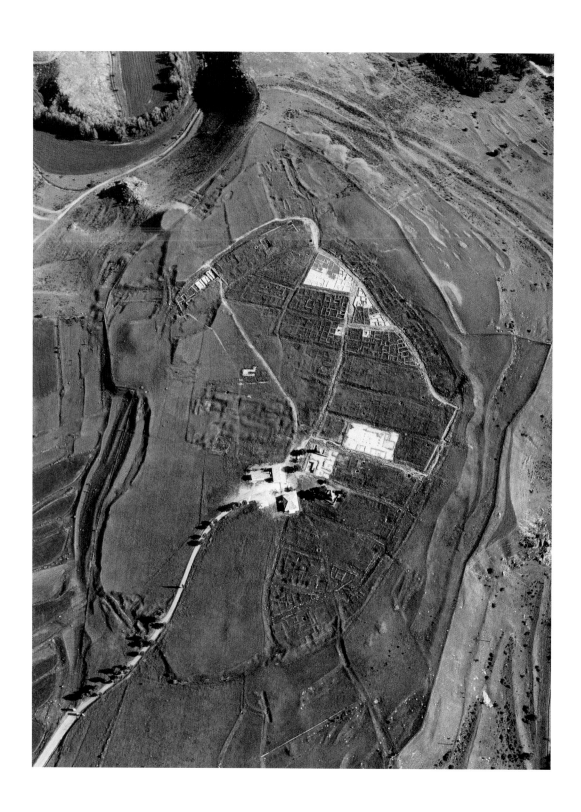

123 | **The Celtiberian settlement at Numantia**, Spain, 1995

124 | **The Plain of Marathon**, battlefield of 490 BC, Greece, 2000

125 | *212–13:* **The Flaming Mountains in Xinjiang**, China, 1987

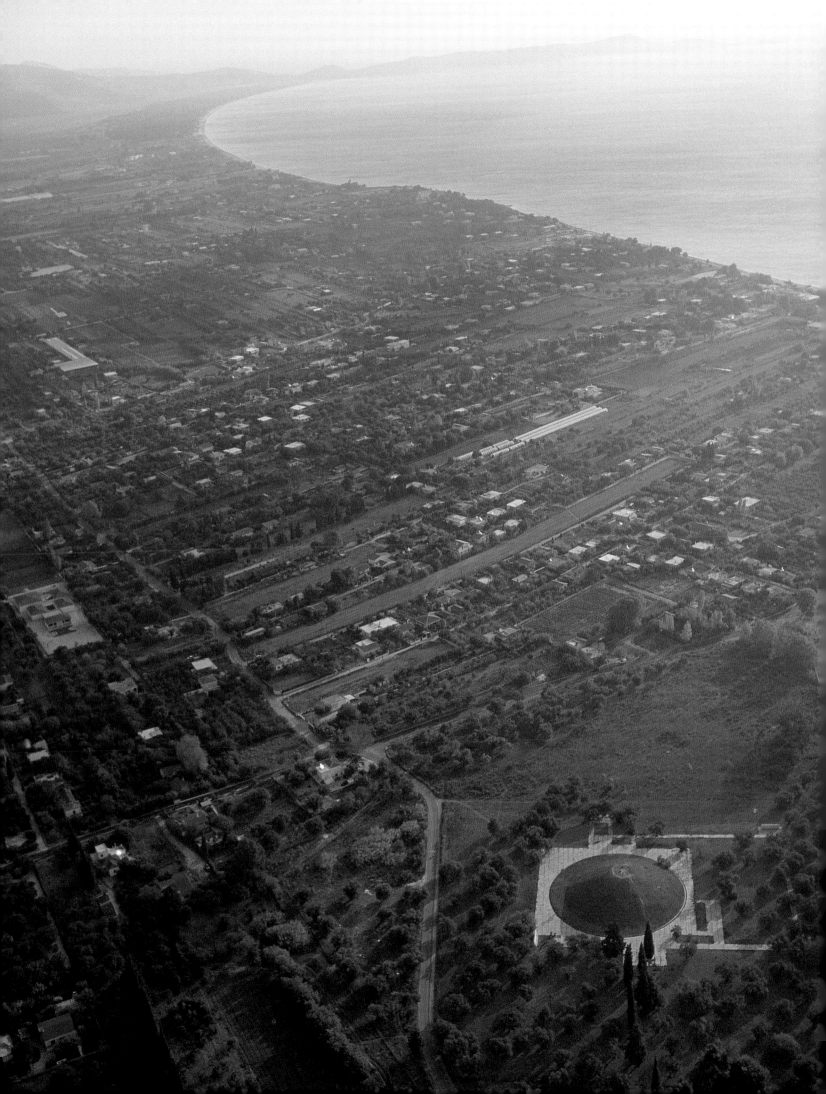

126 | **Aulis, Chalkis and the Euripus**, Greece, 2000

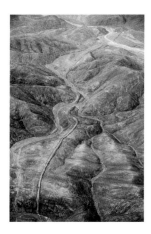

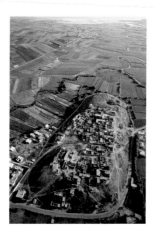

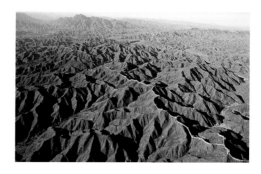

118 | **The great wall of Santa, Peru**

The coast of Peru was first systematically explored from the air and photographed by the military in the early 1930s, bringing a large number of prehispanic ruins to public attention. Among them was the great wall in the Santa Valley on the north coast of Peru. It runs for more than 50km over hills, plains and mountains on the northern side of the Río Santa. Built of rubble and mud bricks, it is up to 2.5m high and, like the Great Wall of China, was initially assumed to have been erected for defensive purposes, but later investigations have shown that it dates to the time of the early Middle Horizon (AD 600–900), when the Santa Valley belonged to one of the successor states of the Moche polity and had a denser population than at any other date in its prehispanic history. At that date the wall was not on the frontier but in the middle of a densely populated area that was part of a network of settlements and roads connecting the Santa Valley with neighbouring valleys. The points at which the roads passed through the wall were designed not as gates but as gaps in the wall up to 2km wide. These gaps reveal no trace of any former wall, so that the wall itself cannot have been used for defensive purposes. Rather, it presumably served as an internal but open border between various ethnic groups within the polity, which extended over several valleys. The wall was built by these groups working together but using different building techniques.
K. L.

R. Shippee, 'The "Great Wall of Peru" and Other Aerial Photographic Studies by the Shippee-Johnson Peruvian Expedition', *Geographical Review*, 22 (1932), 1–29; V. von Hagen, *Capac Ñan: Die Schicksalsstraße der Inka* (Reinbek 1978); D. Wilson, *Prehispanic Settlement Patterns in the Lower Santa Valley Peru* (Washington 1988) (Smithsonian Series in Archaeological Inquiry)

119 | **Kadesh on the Orontes, Syria**

The historic site of Kadesh lies on the west bank of the Orontes, some 25km south-west of Homs. The modern settlement of Tell Nebi Mend has been built over it. Situated in the border area between the great powers of Egypt and Hatti, Kadesh was drawn into their military confrontations, especially during the 2nd half of the second millennium BC. These confrontations culminated in the battle between Ramesses II and Muwatallis in 1275 BC in the immediate vicinity of Kadesh. Forced to withdraw, the Egyptians were clearly unable to expand their sphere of influence in Syria. The peace treaty concluded between Ramesses II and the Hittites under Hattusilis III in 1259 BC is regarded as the first state treaty to be based on parity between its signatories. An enlarged copy of the Hittite version of the text in the UN building in New York provides the modern world with graphic evidence of the need for peaceful coexistence. The Orontes Valley was presumably as extensively farmed in antiquity as it is today. The settlement mound is surrounded by the winding Orontes and its tributary the Mukadiyah. The section of the plain to the east/right of the river was part of the deployment zone of the Hittite troops and their chariots. For all its historical importance, the site has been inadequately explored. Excavations begun by a French team in 1921/2 were not resumed until the mid-1970s under a team from London University.
R. W.

W. Mayer, 'Eine Schlacht zwischen Ägyptern und Hethitern bei der syrischen Stadt Qadesh im Jahre 1285 v.Chr.' *Land des Baal: Syrien – Forum der Völker und Kulturen* (Mainz 1982), 342–5 (Berlin exhibition catalogue); H. Klengel, *Hattuschili und Ramses: Hethiter und Ägypter – ihr langer Weg zum Frieden* (Mainz 2000), 55–70

120 | **The Great Wall of China, China**

The Great Wall of China is an engineering feat that verges on the miraculous, the largest building project ever completed by man. This bulwark against invaders from the north is estimated to be 5000km long and was built in stages between the 3rd century BC and the 17th century AD. In the course of these twenty centuries several million individuals – peasants and soldiers – worked on the wall, mostly against their will. Its average height is 6–9m. It is 7.5m wide at its base and 6m wide at the top. It extends from the Pacific to the Gobi Desert, winding its way over plains and through valleys. Every 200m a vast defensive tower soars heavenwards. It was here that the soldiers took cover and weapons were stored. One's initial impression is that the wall meanders in a random way, but this is misleading. In fact, there is no point on its entire length where it deviates unnecessarily from its course, nor is any section strategically isolated: the wall constitutes a supremely meaningful and functional whole. Not only did every section offer the troops stationed on it an adequate basis on which to defend it, it was also in permanent contact with neighbouring sections and, thanks to comprehensive military and logistical provisions, with central government. The present photograph shows the section at Gubeikou, a gate on the road to Beijing in the north-east of the country. During the Ming Dynasty troops were stationed here with the task of guarding around a dozen similar passes.
B. S.

Over China (Sydney and Beijing 1988), 254–5; *Die Große Mauer: Geschichte, Kultur- und Sozialgeschichte Chinas* (Lucerne 1991)

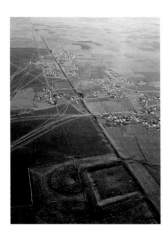

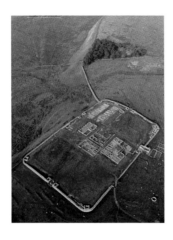

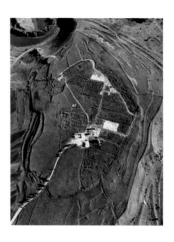

121 | **Alexander's Wall, Iran**

In the East, Alexander the Great has become a legendary figure, Iskender Dhulkarnain (the Two-Horned Alexander), whose heroic feats included resisting the nations of Gog and Magog that are mentioned in the Old Testament and that invaded the civilized world from the steppes of Asia. He is said to have put an end to their atrocities by building an immense wall. As a result, the Persians chose the term Sadd-i Iskender (Alexander's Wall) to describe the old border fortification some 150km in length that protected the fertile southern section of the Gurgan Plain. In front of the wall was a broad ditch and behind it, on the southern side, square or rectangular castles. Its date is contested, but it is generally ascribed to the Sassanian period, when the wall at Derbent on the opposite side of the Caspian Sea is known to have been built. But this last-named wall extends far into the sea and was built, therefore, at a time when the sea level, always variable, was much lower. Alexander's Wall, by contrast, ends several kilometres short of the coast and must have been built at a time when the sea level was relatively high. In short, the two walls cannot have been built at the same time. Research into variations in the level of the Caspian Sea has shown that it was very low during the Sassanian period but much higher at the time of Alexander and during the later Parthian period. For historical reasons the wall cannot be ascribed to Alexander himself, whereas it is not unlikely that it was built at the time of the great Parthian kings such as Mithridates II (123–87 BC), not least because there was contact at this time with the Han emperors and we may assume that the Parthians were familiar with the Great Wall of China.
D. H.

E. F. Schmidt, *Flights Over Ancient Cities of Iran* (Chicago 1940), 59–61; D. Huff, 'Zur Datierung des Alexanderwalls', *Iranica Antiqua*, 16 (1981), 125–39; Y. Kiani, *Parthian Sites in Hyrcania* (Berlin 1982)

122 | **Hadrian's Wall and Housesteads Roman Fort, England** Hadrian's Wall takes its name from the Roman emperor who in AD 122 ordered the building of a wall as the north-western limit of the Roman Empire. As the empire expanded, the Romans had to establish frontiers, either as ditches (as in Africa) or as a series of forts or roads (as in Arabia), or they used rivers (such as the Danube). To keep the Roman province of Britannia peaceful, the Romans built a wall (in parts made of turf and in the central section built with stone) to keep the conquered English people separate from the yet-to-be conquered Picts and Scots. The wall is some 117km long and runs from Bowness-on-Solway on the north Cumbrian coast to Wallsend in Newcastle to the east. Housesteads is one of the most impressive and well-preserved forts in Britain and controlled the central section of the wall. The barrack buildings, commandant's house, granaries and other buildings, including the latrines, are visible inside the fort. These buildings have been exposed as a result of hundreds of years of excavations but there are many more to be revealed. Housesteads is a very popular location for visitors. Managed by English Heritage, it has a museum and is an excellent starting point for exploring other parts of the wall, including its numerous turrets, milecastles and intermediary forts.
R. B.

R. Woodside and J. Croft, *Hadrian's Wall: An Historic Landscape* (London 1999); D. J. Breeze and B. Dobson, *Hadrian's Wall* (London 2000)

123 | **The Celtiberian settlement at Numantia, Spain**
Numantia was the last great independent settlement of the Celtiberians on the Iberian peninsula to be captured by the Romans. The town was the centre of the Arevaci and was favourably situated on a plateau at the confluence of three rivers on the Castilian high plateau north-east of Madrid. Traces of human habitation have been found to go back to the Iron Age (c850 BC), while the town is known to have been fortified since the 4th/3rd century BC. The simple houses with mud walls on stone foundations were divided into vast blocks by means of rectangular streets. The local population came into conflict with the Romans when the latter, following their victory over the Carthaginians in the Second Punic War, extended their influence into the interior of the Iberian peninsula, resulting in an uprising in 154 BC that left the Roman troops in some difficulty before Scipio finally took over their command in 134 BC. This military hardliner surrounded the town in a wall 2.4m wide, 3m high and 9km long, with towers at regular intervals. Even the rivers were made impassable by means of barriers. 60,000 soldiers in 9 camps faced 8000 defenders. Numantia fell after a nine-month siege, and those who did not take their own lives were sold into slavery and the town was completely destroyed. From then on Scipio was known as Numantinus. A generation later a new settlement was started here, although it was never more than a village in Roman times. Appian's account of events was confirmed by Adolf Schulten's excavations of the town and Roman camps between 1905 and 1912.
R. S.

A. Schulten, *Numantia: Die Ergebnisse der Ausgrabungen*, 4 vols. (Munich 1914–29); A. Schulten, *Geschichte von Numantia* (Munich 1933); H. J. Hildebrand, 'Die Römerlager von Numantia', *Madrider Mitteilungen*, 20 (1979), 238–71

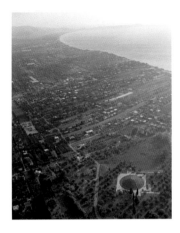

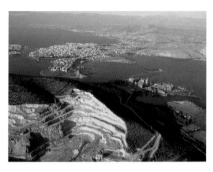

124 | **The Plain of Marathon, Greece**
The Plain of Marathon now presents a peaceful agricultural scene, but during the late summer of 490 BC it was the site of a decisive battle during the first Persian invasion of Greece. The Persian fleet had anchored in the bay, and it was here that the Persian army suffered its first major defeat in spite of its far greater numbers. The speed of the heavily armed Greeks and no doubt also their new tactics whereby the wings of the battleline were specially deep, allowing them to attack the centre of the opposing army from the sides, proved decisive. The Athenians and Plataeans having carried the day, the Spartans whose help they had expected arrived only when the fighting was over. The fallen Greeks were buried in two burial mounds that can still be seen today. The 'Soros' for the 192 Athenians (in the foreground of the photograph) is almost 10m high and lies in the middle of the plain, while the mound for the Plataeans lies at its edge, some 3km further west. Excavations have revealed that the dead were buried not only with their weapons but also with numerous painted clay vessels. The battle is now associated above all with the story of the messenger who is said to have run to Athens with news of the victory and to have collapsed exhausted in the marketplace. The marathon was accepted as an Olympic sport in 1908, its length fixed at 42.195km.
R. S.

E. Vanderpool, 'A Monument to the Battle of Marathon', *Hesperia*, 35 (1966), 93–106; N. G. Hammond, 'The Campaign and the Battle of Marathon', *The Journal of Hellenic Studies*, 88 (1968), 13–57; H. R. Götte, *Athen, Attika, Megaris* (Cologne 1993), 193–4

125 | **The Flaming Mountains in Xinjiang, China**
The Huoyan Shan, as the Flaming Mountains are known in China, rise up from the lowlands on the northern edge of the Turfan Depression in Xinjiang, reaching a maximum height of 831.7m. They form a dazzling signpost on the Silk Road, directing travellers to the cool oases of Turfan, where dates, grapes and melons await them. The Turfan Depression is China's hottest place, a veritable furnace in summer, while the cutting wind has dramatically increased the weathering and erosion of the red sandstone. The hot wind blowing over the rocks is like a fiery breath on travellers' faces, and when the sun shines straight down on the mountains at midday, the red rocks seem to be on fire. The unfavourable climatic conditions mean that most of Xinjiang resembles a desolate lunar landscape and cannot be farmed, although geologists believe that there are rare and valuable mineral resources here. According to tradition, a Tang monk by the name of Xuanzang (AD 602–64) passed this way when bringing the Buddhist writings from India to China. His difficult and unbelievably strenuous journey forms the basis of the famous novel *Journey to the West* by the 16th-century Chinese writer Wu Cheng'en, a fantastical and often comic tale that describes how Xuanzang's travelling companion, the Monkey King Sun Wukong, overcomes the heat of the Flaming Mountains by taking away the fans of the Iron Fan Princess, the wife of the Bull Demon King, and making the flames die down.
B. S.

Over China (Sydney and Beijing 1988), 34–5, 64, 65

126 | **Aulis, Chalkis and the Euripus, Greece**
In Aulis on the east coast of the ancient country of Boeotia, modern technology and industry consort with the oldest Greek legends. Today a suspension bridge carries a motorway over the Euripus, the straits between Boeotia and the island of Euboea. As early as 410 BC a bridge connected the island to the mainland. On the promontory at the bottom of the photograph lies Chalcis, one of the first Greek cities to send out colonists to the western Mediterranean and to establish trade links with the Orient. It is now an industrial centre with important shipyards. At the foot of the Megalo Vouno that overlooks the north bay at Aulis and that is slowly being eaten away by a quarry lies a cement factory instead of the Mycenaean cemetery of antiquity. It was here that the Greek army gathered before setting out for Troy. For a whole winter their ships were becalmed here. The seer Calchas finally decreed that in order to end the period of calm, the Greek leader, Agamemnon, would have to sacrifice his own daughter, Iphigenia, to the gods. Once she had been killed on the Altar of Artemis, the Greeks were able to set sail for Troy. In the less gruesome version by the Attic dramatist Euripides, the goddess substituted a hind for Iphigenia, whom she spirited away to the remote land of Tauris. A temple to Artemis Aulideia was discovered while a road was being built here in 1941. Its history can be traced back to the 8th century BC.
R. S.

S. C. Bakhuizen, *Salganeus and the Fortification on its Mountains* (Groningen 1970), 96–100, 152–6; J. M. Fossey, *Topography and Population of Ancient Boiotia* (Chicago 1988), 68–74

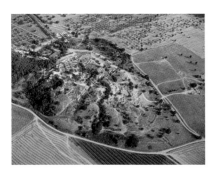

127 | Troy/Ilium, Turkey

Arguably the most famous archaeological site in the whole of the Mediterranean is the mound at Hisarlik on the Dardanelles in Turkey, where the ruins of Homer's Troy or Ilium are believed to lie. Excavations were started here by Frank Calvert in 1865 and were continued between 1871 and 1890 by Heinrich Schliemann, who was convinced that he had found the site of the ten-year Trojan War. He was rewarded by the discovery of valuable grave goods, which he imaginatively labelled the 'treasure of Priam'. Between 1932 and 1938 the excavations were led by Carl William Blegen and since 1988 by Manfred Korfmann. Until now the excavations have been concentrated on the citadel visible in the present photograph. A whole series of settlements, each superimposed on the last and often involving substantial rebuilding, has left a complicated picture that can now be traced from the Early Bronze Age to the Byzantine period and that includes more than 50 building phases in ten main layers. The town was repeatedly destroyed by fire in the 2nd millennium BC but was always rebuilt. The ruins of the solid fortifications from the Late Bronze Age may have encouraged Homer to locate his tale of Achilles, Odysseus, Hector, Priam and other heroes here. The Persian king Xerxes visited the famous ruins, as did Alexander the Great, who saw himself as a latter-day Achilles. His plans to rebuild the town were implemented by his former general Lysimachus. The Romans, too, especially Augustus, who traced his family back to Aeneas, poured money into Troy and built temples here. In AD 324 it almost became the new capital of the Eastern Empire, but in the end it was Constantinople that was chosen.
R. S.

H. Schliemann, *Troy and Its Remains: A Narrative of Researches and Discoveries Made on the Site of Ilium* (London 1875); *Studia Troica* (1991—); D. Hertel, *Troia* (Munich 2/2000); *Troia: Traum und Wirklichkeit* (Stuttgart 2001) (exhibition catalogue)

128 | **Harvesting the wheat around a Bronze Age round barrow in Wiltshire**, England, 1977

129 | **Barrows on Jutland**, Denmark, 1975

7. BUILDING FOR ETERNITY
— GRAVES AND CEMETERIES

There is a stern round tower of other days,
Firm as a fortress, with its fence of stone,
Such as an army's baffled strength delays,
Standing with half its battlements alone,
And with two thousand years of ivy grown,
The garland of eternity, where wave
The green leaves over all by time o'erthrown; –
What was this tower of strength? within its cave
What treasure lay so lock'd, so hid? – A woman's grave.

But who was she, the lady of the dead,
Tombed in a palace? Was she chaste and fair?
Worthy a king's – or more – a Roman's bed?
What race of chiefs and heroes did she bear?
What daughter of her beauties was the heir?
How lived – how loved – how died she? Was she not
So honoured – and conspicuously there,
Where meaner relics must not dare to rot,
Placed to commemorate a more than mortal lot?

Lord Byron, *Childe Harold's Pilgrimage* (1812)
(the tomb of Caecilia Metella on the Appian Way)

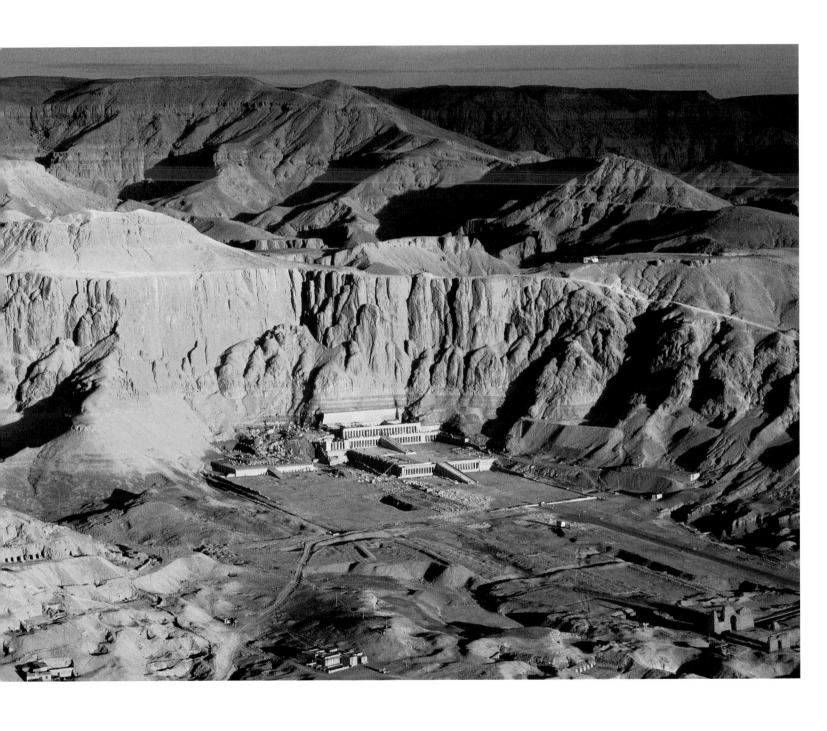

130 | **The temples at Deir el-Bahri in Thebes**, 2030–1430 BC, Egypt, 2000. World Heritage Site

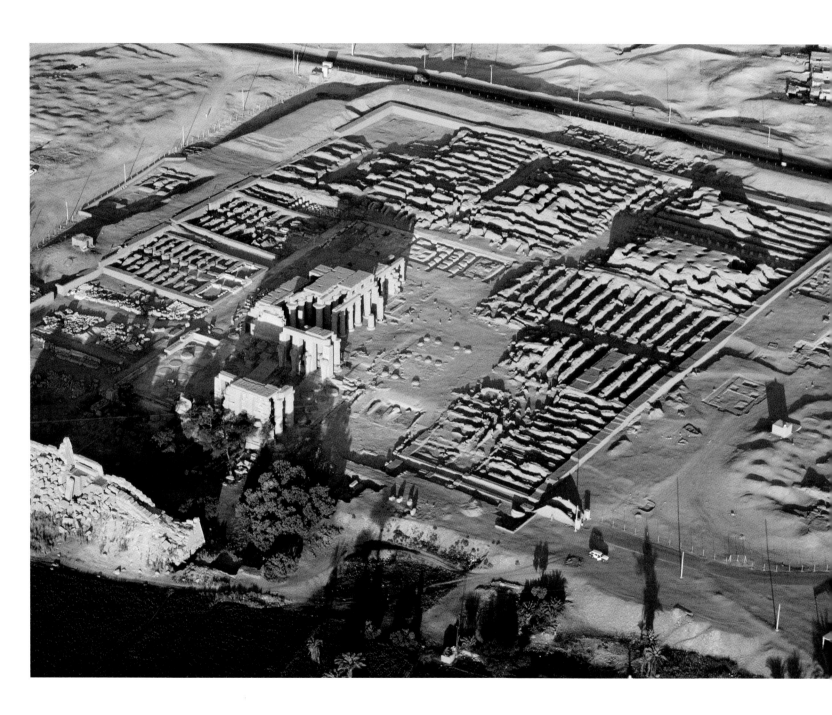

131 | **The Ramesseum at Thebes**, c1250 BC, Egypt, 2000. World Heritage Site

132 | *224–5:* **The pyramids in the Northern Cemetery at Meroe**, 270 BC–AD 350, Sudan, 1963

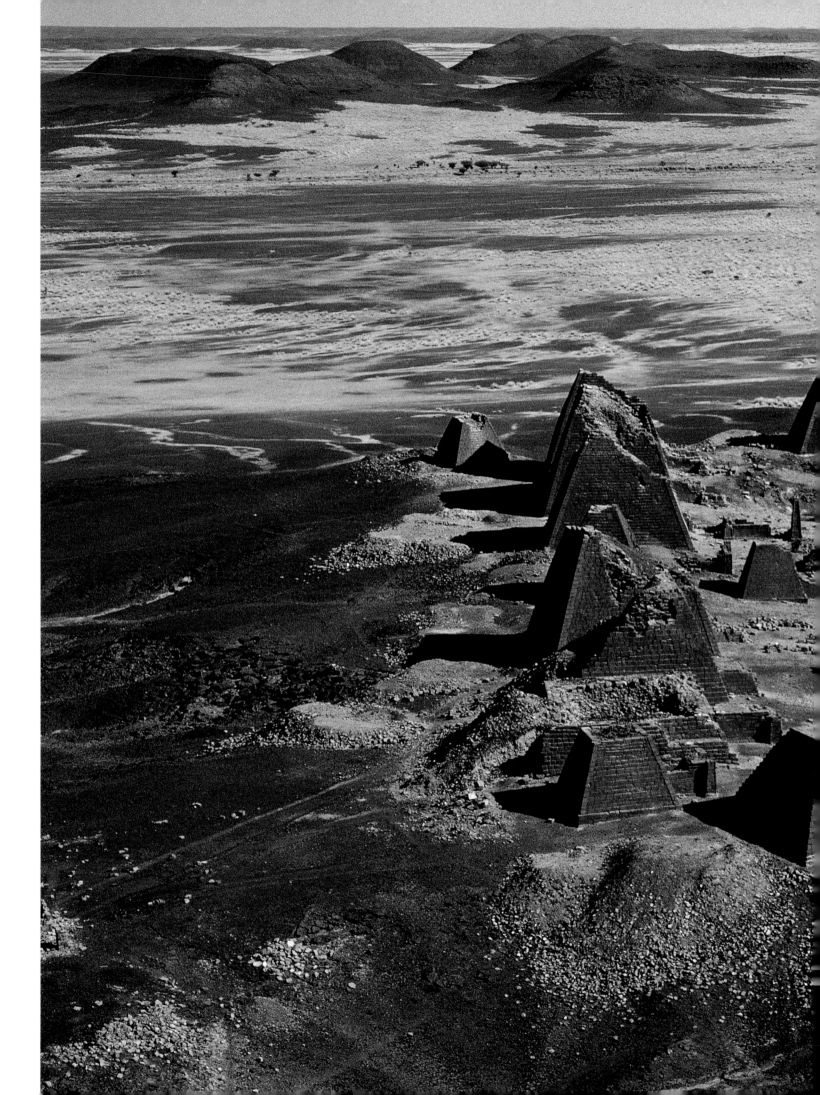

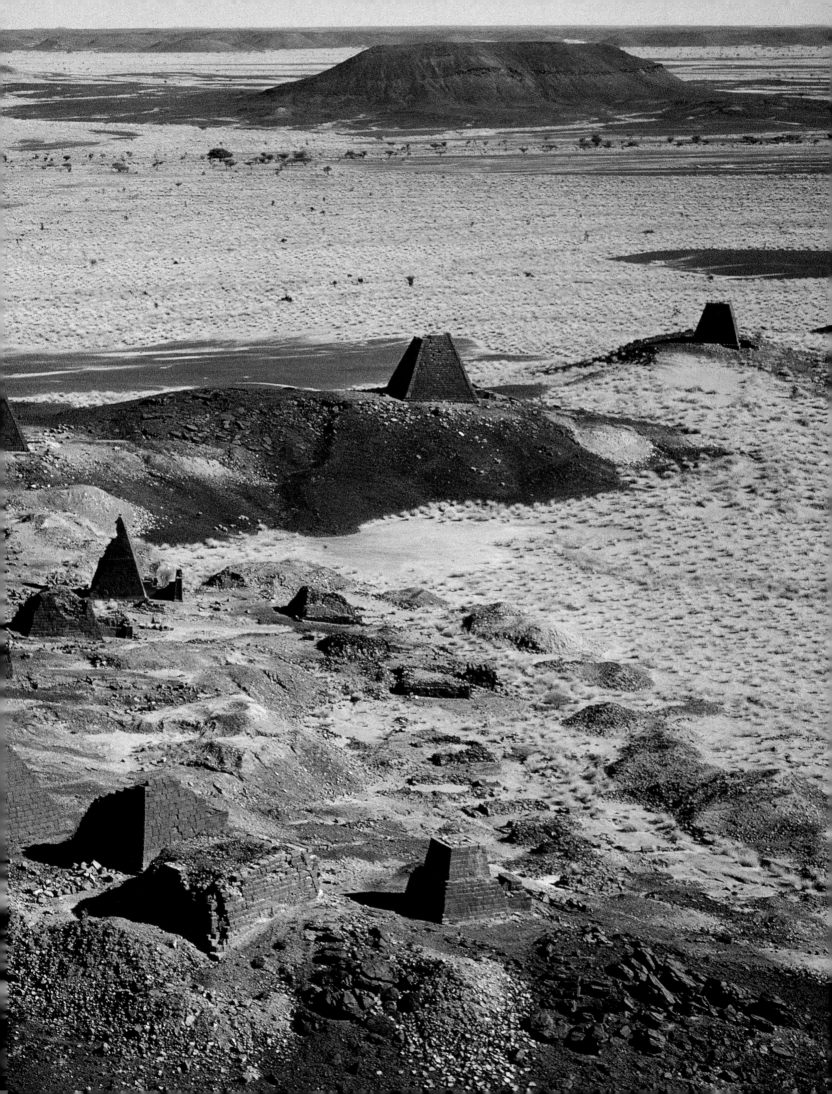

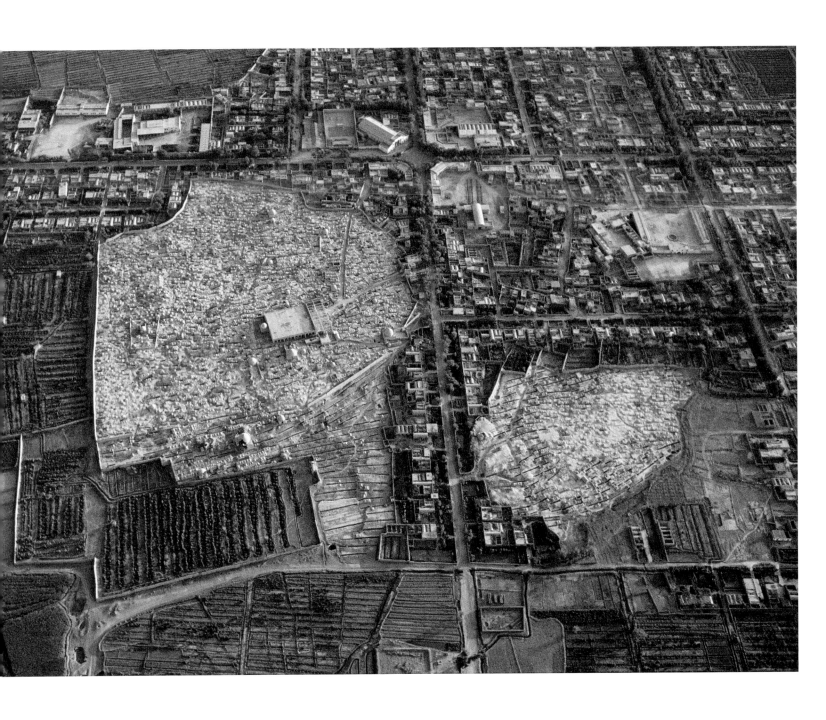

133 | **The necropolis at Astana**, 3rd–8th century AD, China, 1987

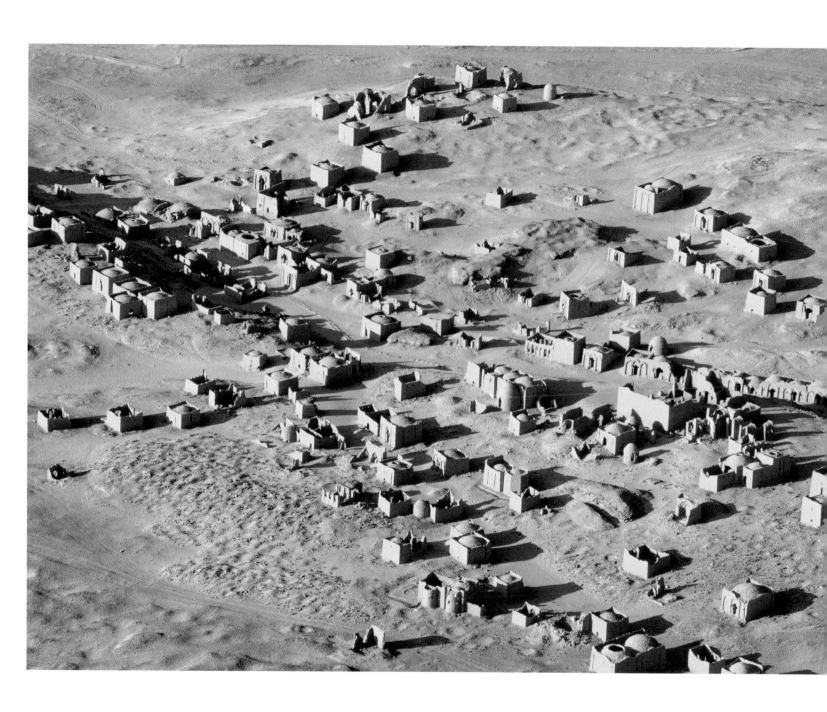

134 | The Christian necropolis at al-Bagawat in the Kharga Oasis, 4th–7th century AD, Egypt, 1978

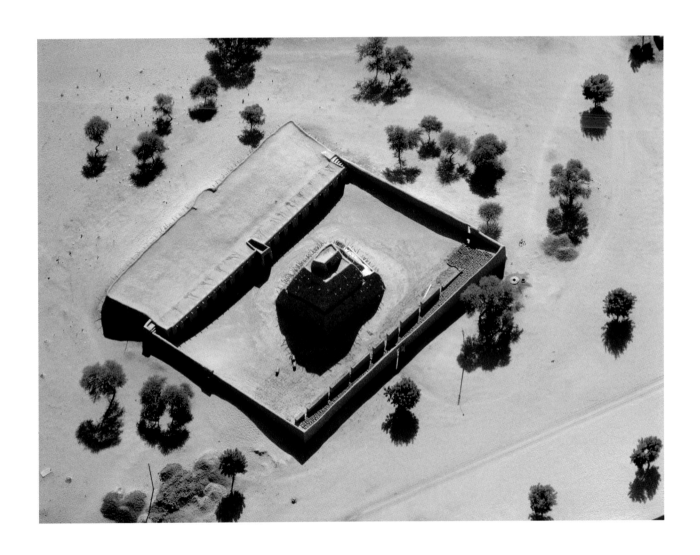

135 | **The Askia Mausoleum at Gao**, AD 1538, Mali, 1973

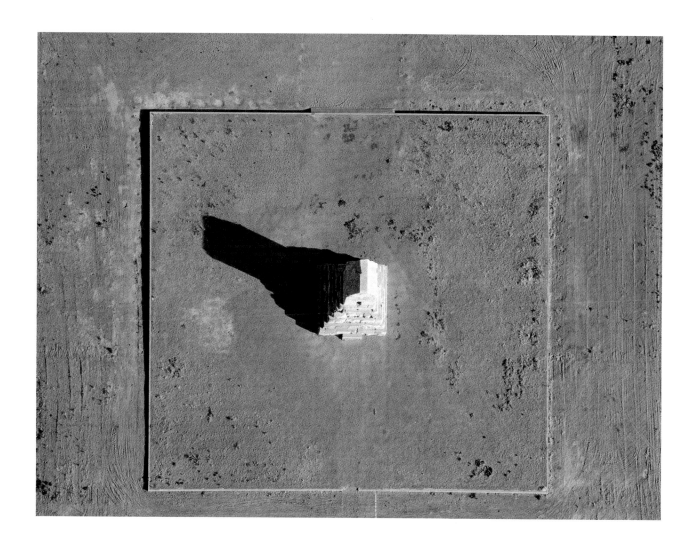

136 | **The tomb of Cyrus the Great at Pasargadae**, 530 BC, Iran, 1976

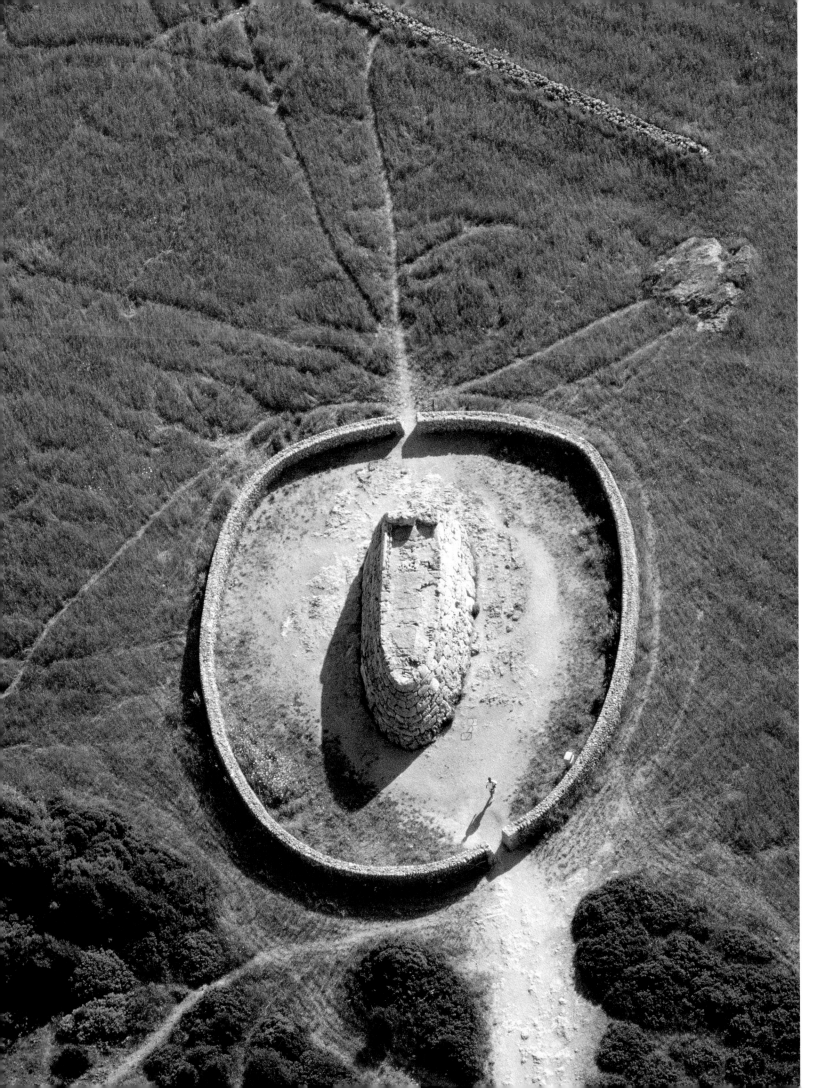

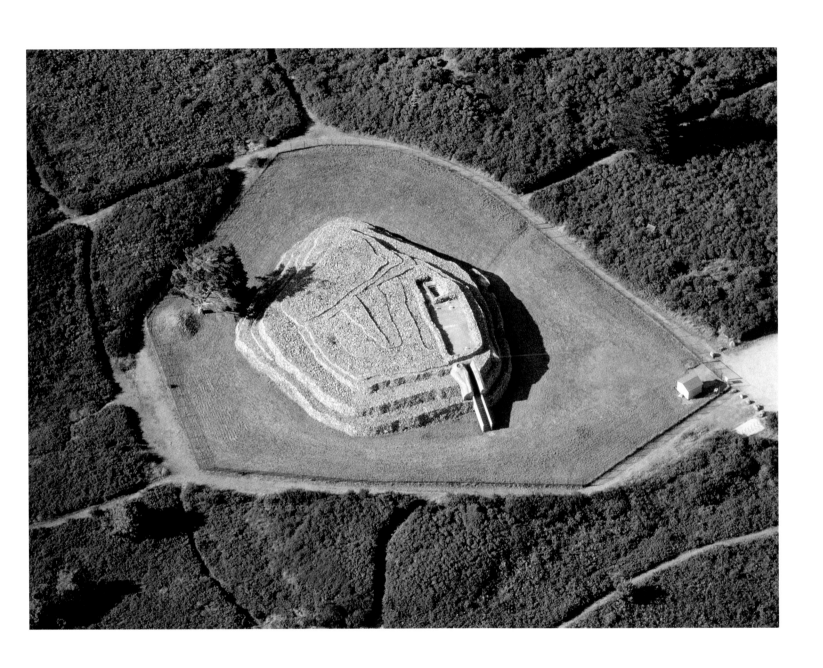

137 | **Es Tudons on Minorca**, *c*1000 BC, Spain, 1991

138 | **The megalithic site at Petit-Mont, Arzon**, 4500–3000 BC, France, 2002

139 | *232:* **Tomb of a Ming emperor**, 17th century AD, China, 1987. World Heritage Site

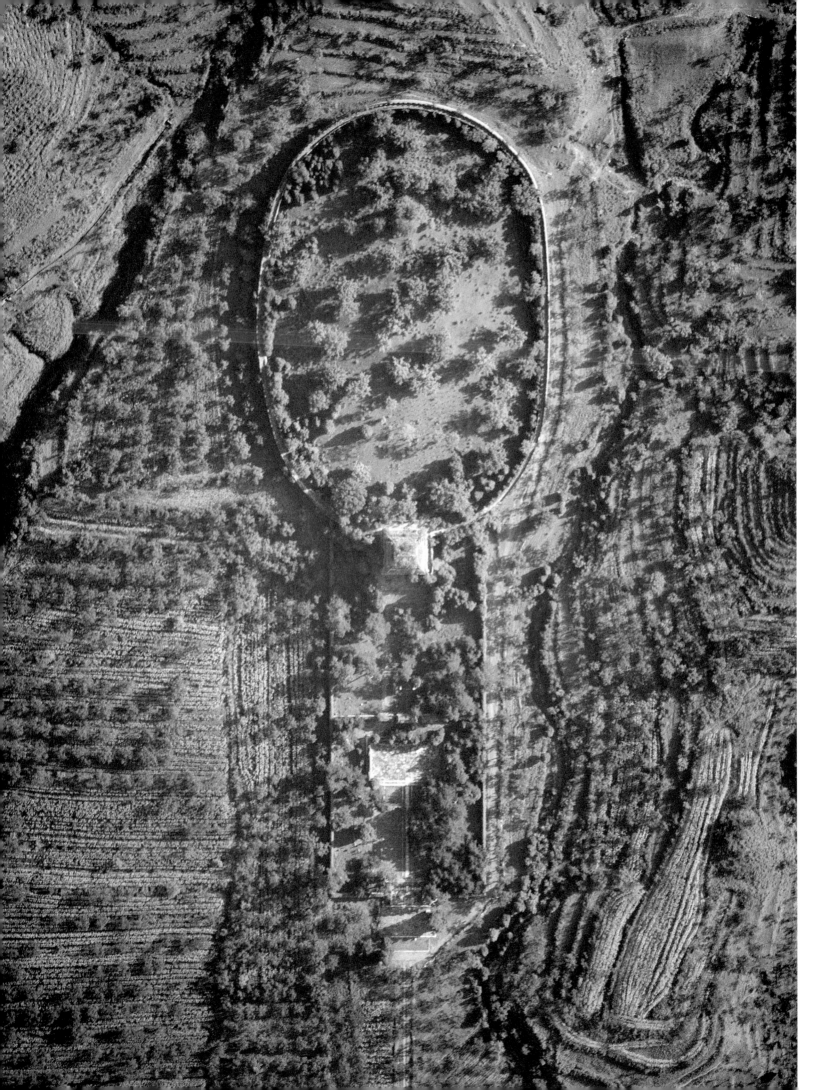

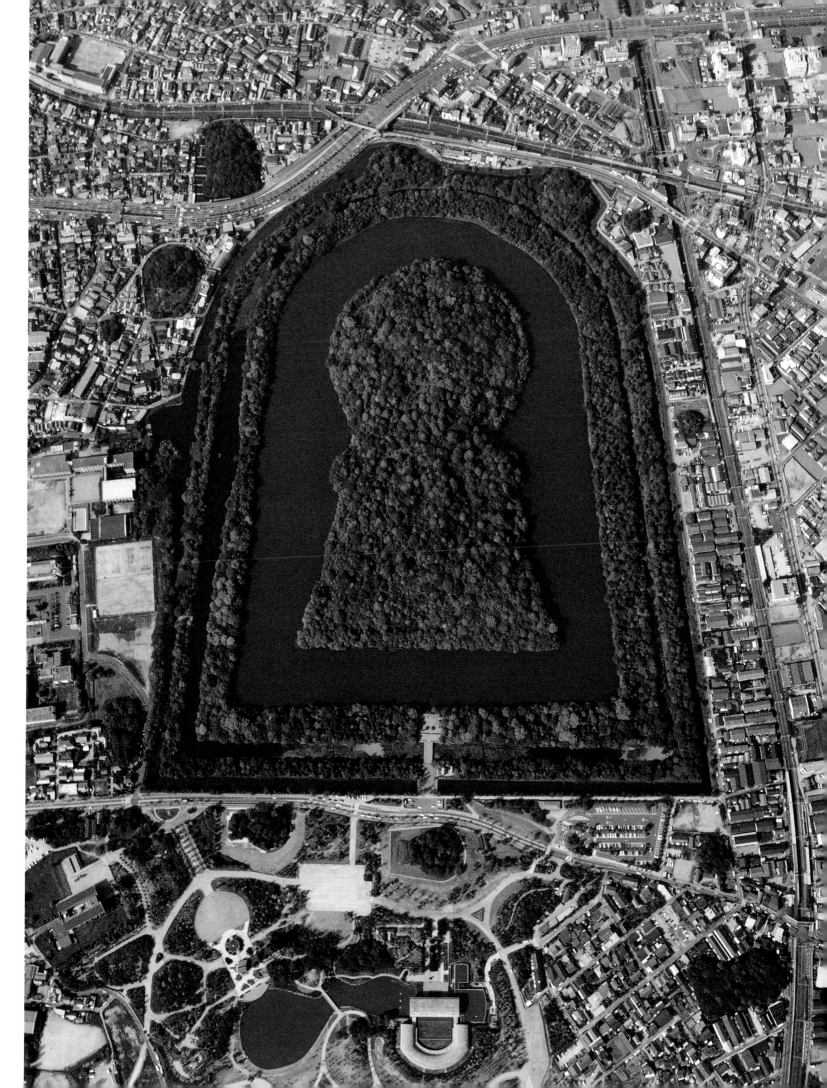

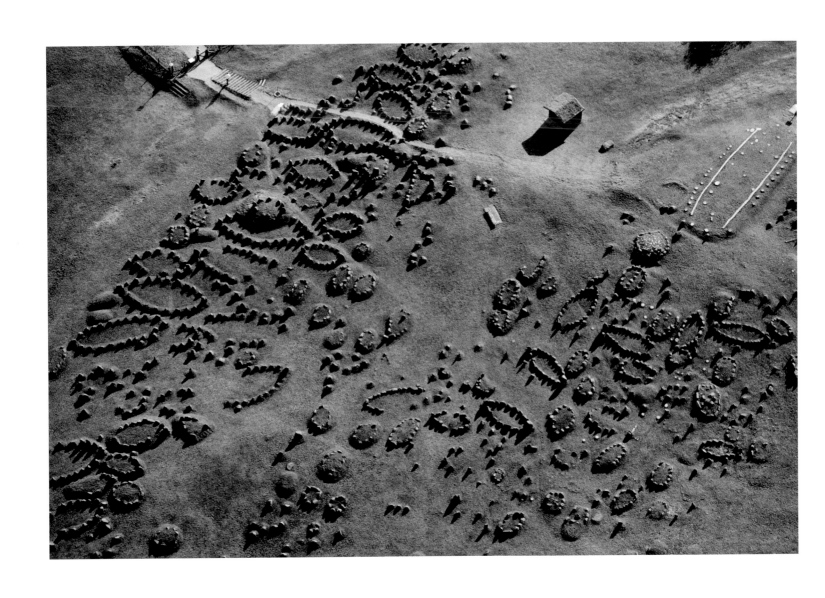

140 | *233:* **Kofun of the emperor Nintoku in Sakai**, Osaka, early 5th century AD, Japan, 1985

141 | **The Lindholm Høje cemetery at Ålborg**, 5th–11th century AD, Denmark, 1975

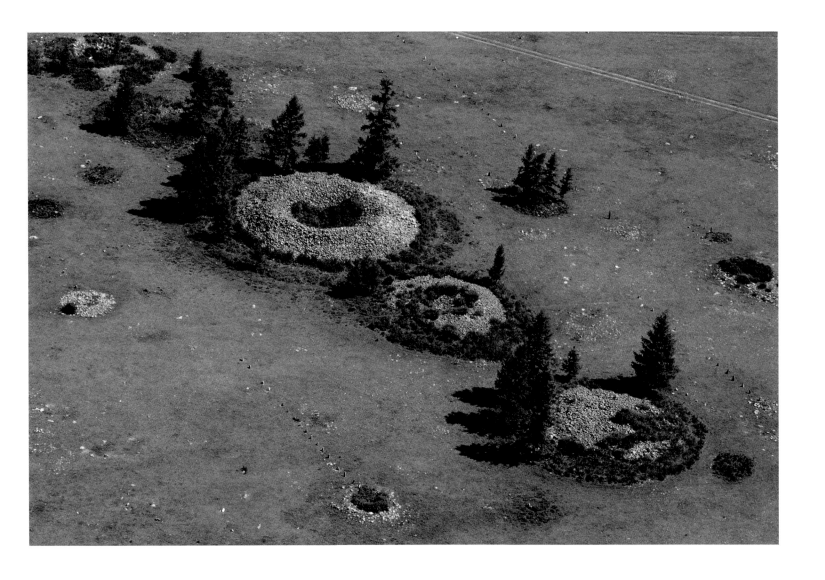

142 | **Scythian kurgans in the Sooru Valley**, 9th/8th–3rd century BC, Altai Republic, Russian Federation, 1993

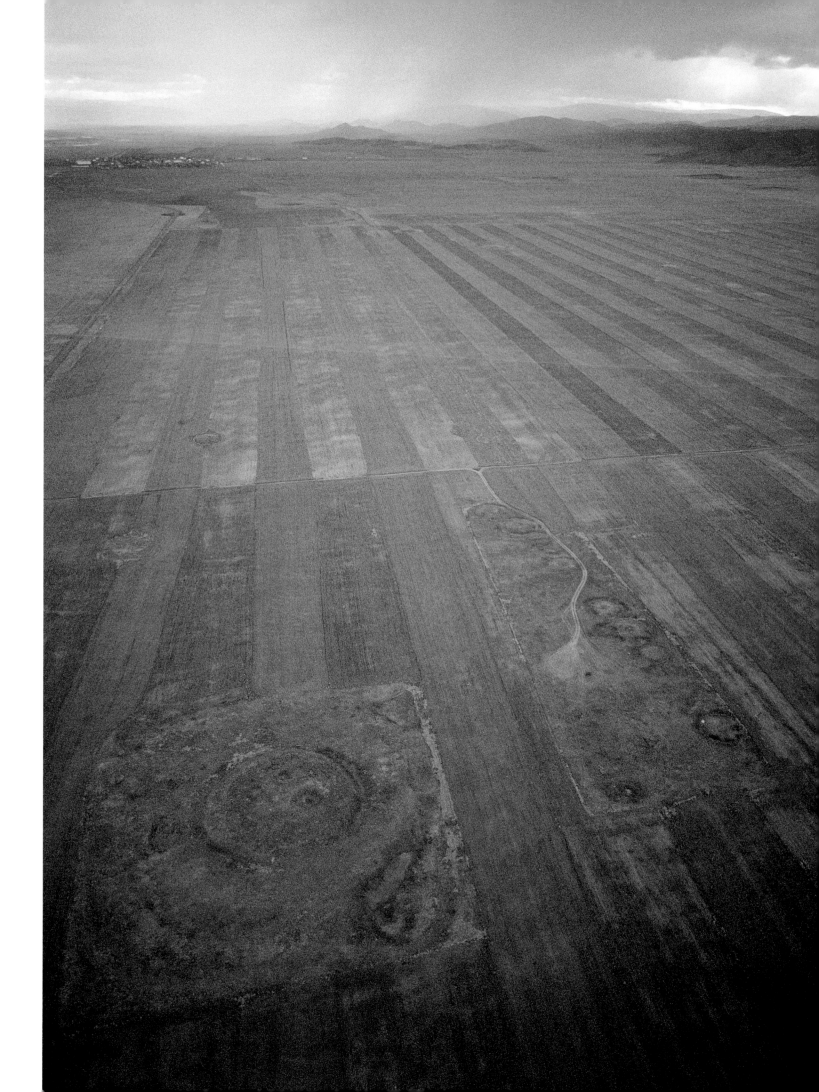

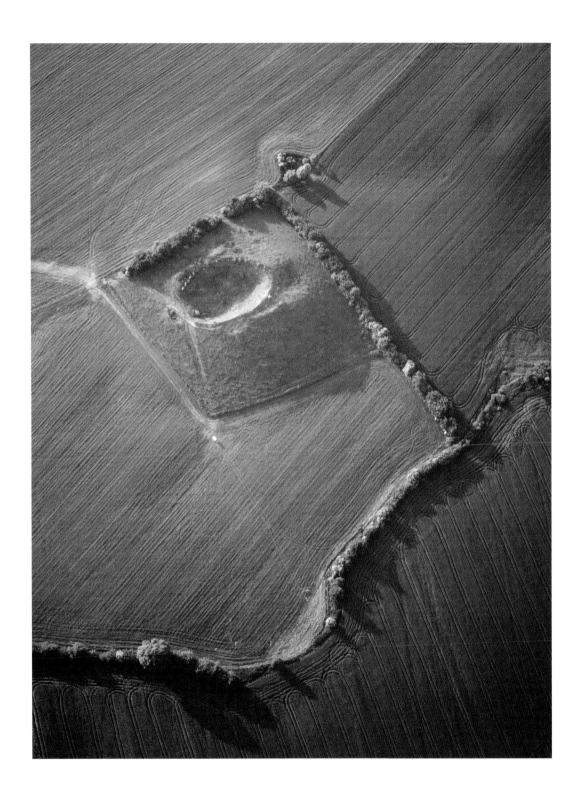

143 | **Scythian kurgans at Arzhan**, 9th/8th–3rd century BC, Tuva Republic, Russian Federation, 1994

144 | **Burial mound in Schleswig-Holstein**, 2nd millennium BC, Germany, 1983

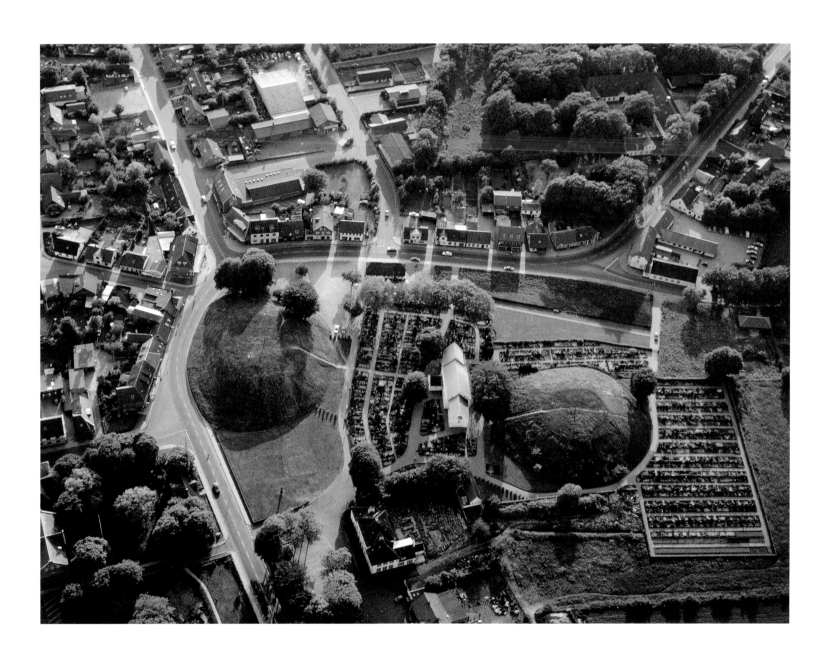

145 | **The royal memorials at Jelling**, AD 940–70, Denmark, 1975. World Heritage Site

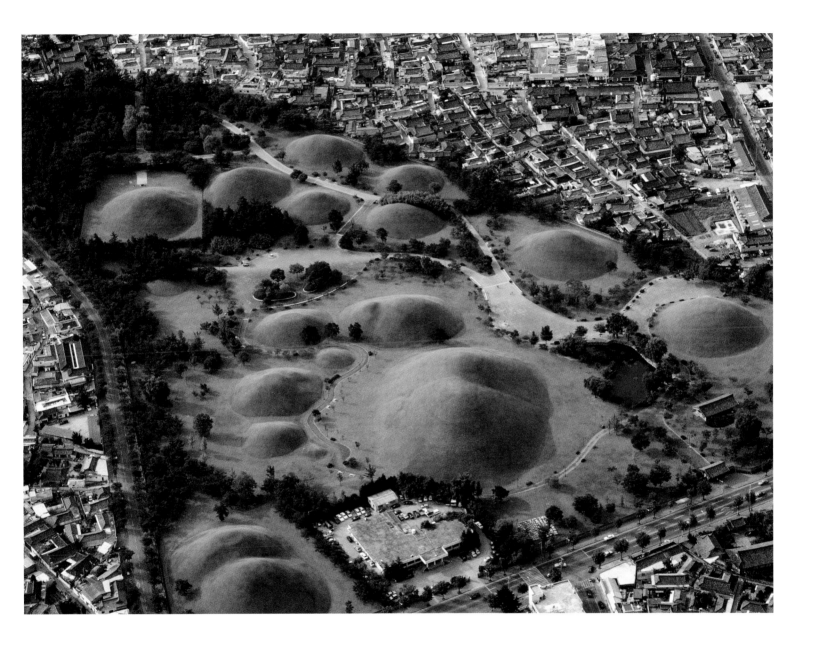

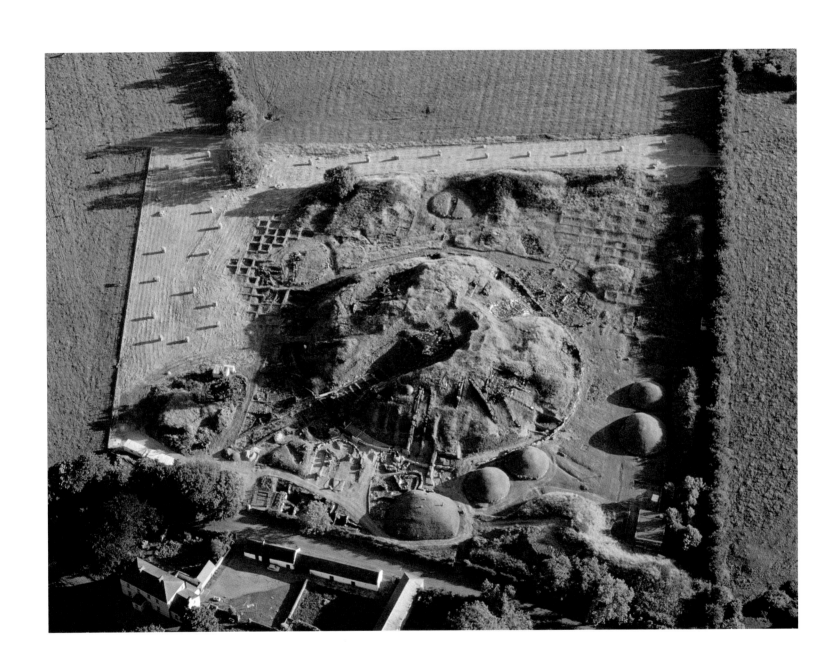

147 | **The passage tomb at Knowth**, Ireland, 1989. World Heritage Site

148 | **Yoshinogari on the Saga Plain on Kyushu**, 3rd century BC–3rd century AD, Japan, 1992

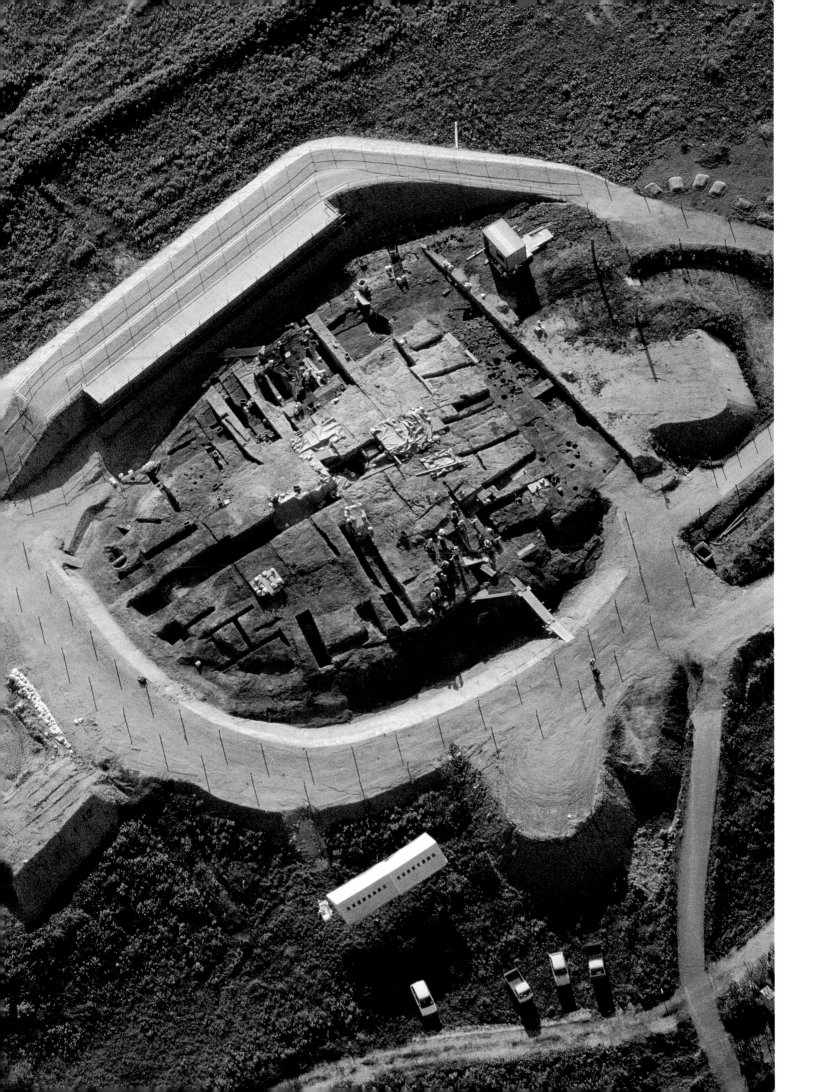

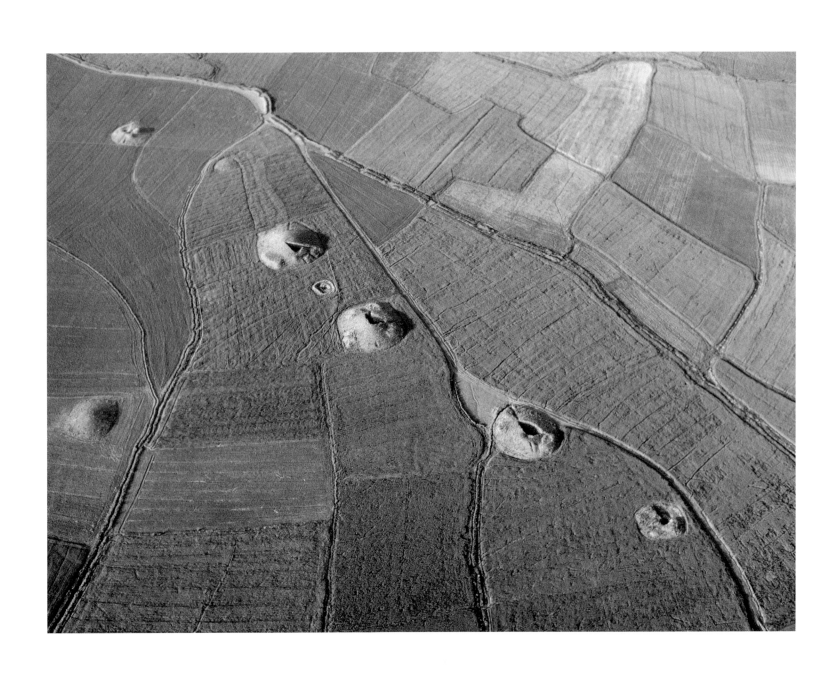

149 | **Burial mounds at Se Girdan, Azerbaijan**, Iran, 1976

150 | **The Etruscan Banditaccia cemetery at Cerveteri**, 9th–2nd century BC, Italy, 2002

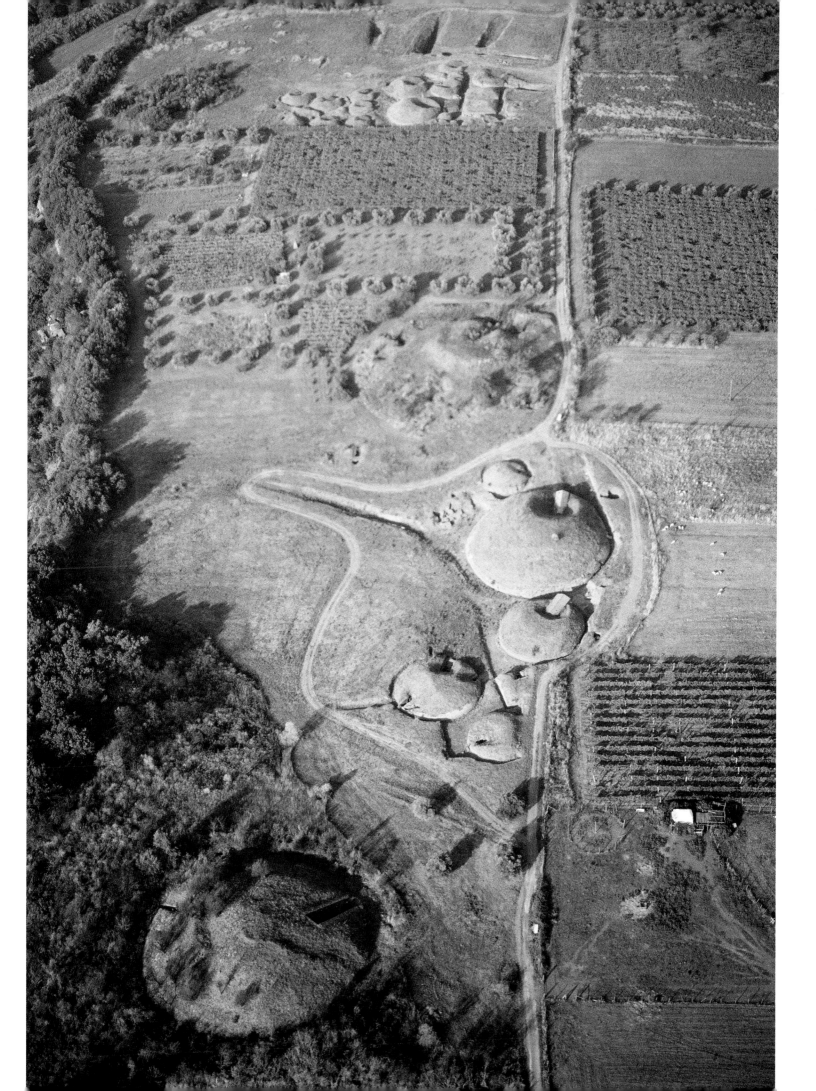

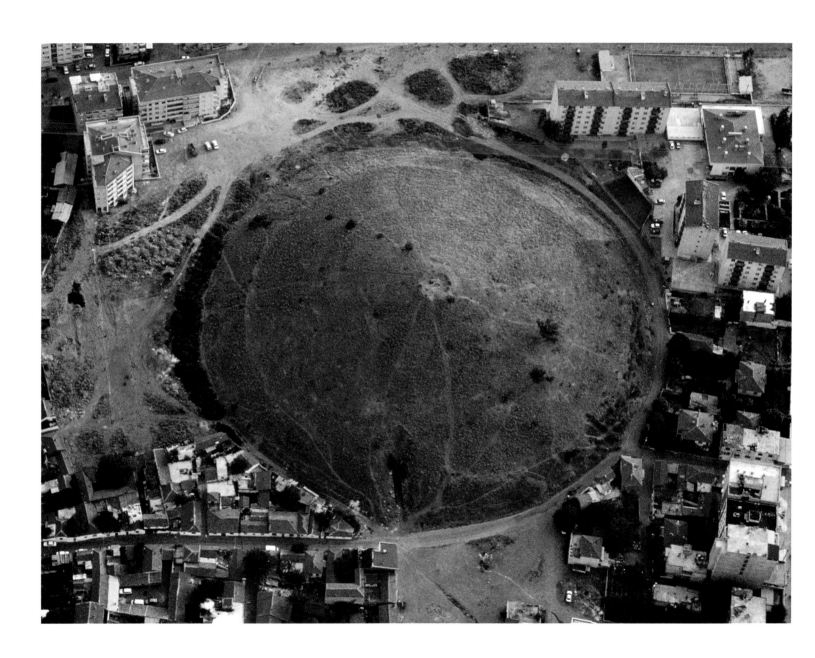

151 | **The Maltepe tumulus at Pergamon**, 1st–2nd century AD, Turkey, 2002

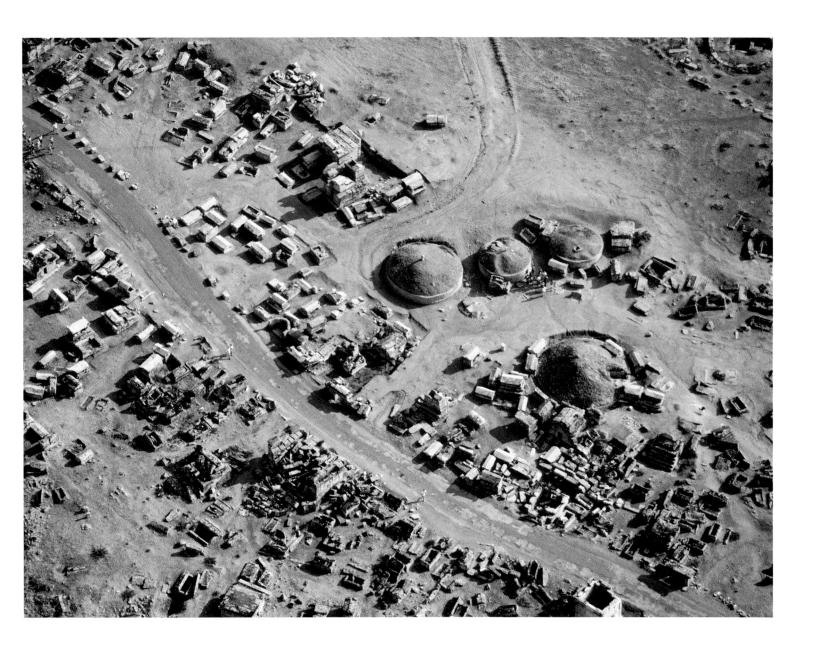

152 | **The northern cemetery at Hierapolis/Pamukkale**, 3rd century BC–3rd century AD, Turkey, 2002. World Heritage Site

245

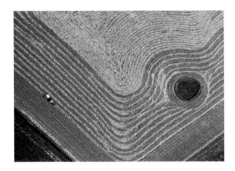

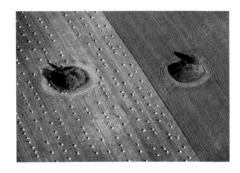

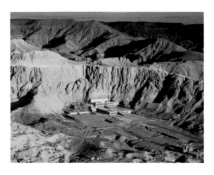

128 | **Harvesting the wheat around a Bronze Age round barrow in Wiltshire, England** There are tens of thousands of Bronze Age round barrows in England. The majority are in the south, especially in Wiltshire and Dorset. Most have been ploughed away completely, and only a few survive as upstanding earthworks. Many thousands have been recorded from the air as cropmarks or soilmarks, but it has been the intensification of farming over the past 50 years which has destroyed the vast majority of these sites, and many others, too. A recent survey funded by English Heritage concluded that on average one archaeological site has been destroyed every day since 1945 and that ploughing is the most significant agent of this destruction. The barrows were used for burials, and underneath the mound there would have been a burial or cremation pit containing grave goods (pottery, metalwork, flint and in some cases gold objects) to accompany the dead person on his or her journey into the afterlife. This barrow is protected from ploughing or damage by law, but the field surrounding it can be ploughed.
R. B.

A. Woodward, *British Barrows: A Matter of Life and Death* (Stroud 2002)

129 | **Barrows on Jutland, Denmark**
Denmark has been called the land of barrows. In the fully cultivated open countryside it is often possible to gain an idea of the original appearance of a ritual Bronze Age landscape, a landscape of memorials. Many barrows may be seen on the ancient heathlands at the Limfjord in north-west Jutland. Archaeological records of Denmark currently number more than 85,000 mounds, of which more than 20,000 are barrows more than 2m high. Most of these are believed to date from the Bronze Age. It is reckoned that originally there were more than 40,000 Bronze Age barrows. The earliest burial mounds date from the Late Stone Age, but it is the Early Bronze Age that was the main period of barrow building in Denmark. Some barrows are later and date from the Iron Age, while the most recent monumental mounds, the royal barrows at Jelling, date from the Viking period. The Bronze Age mounds are built of grass sods pared away from old pastureland. A stone kerb often surrounded the foot of the barrow. Excavated barrows often reveal a complicated history, with several phases covering hundreds of years and many generations. In some of the barrows the burials have been well preserved in their oak trunk coffins. Some of these trunks contained the remains of fully dressed Bronze Age men and women that are now the pride of the Danish National Museum in Copenhagen.
U. N.

P. V. Glob, *Højfolket* (Copenhagen 1970); J. Jensen, *Danmarks oldtid: Bronzealder 2000–500 f.Kr.* (Copenhagen 2000)

130 | **The temples at Deir el-Bahri in Thebes, Egypt**
The rocky 'bay' of Deir el-Bahri in Thebes West Bank offered a spectacular backdrop for a staged ritual of the first order. Around 2030 BC Monthuhotep II was the first pharaoh to be buried in a terrace temple here, an architectural form hitherto unknown in Egypt. In order to be buried in his homeland in Upper Egypt, he forsook the pharaohs' traditional burial ground, the great pyramid fields at Memphis in Lower Egypt, a decision that had far-reaching consequences. It even required a new god to be created, one equal to the Lower Egyptian sun god Re, Amun(-Re), whose temple was built in the extended axis of the Temple of Monthuhotep on the East Bank, eventually becoming one of the biggest temple complexes in the world: Karnak, Amun's residence. On the occasion of important festivities, Amun was transported in a barque by priests and taken to the West Bank, where his destination was Deir el-Bahri. Here Queen Hatchepsut of the 18th Dynasty had taken up Monthuhotep's idea and in c1470 BC built her own mortuary temple beside his. The most venerable lodging for Amun's visit to the Theban necropolis, it consisted of three pillar-lined terraces and has recently been impressively restored by Polish experts. Hatchepsut chose a new royal burial ground, the Valley of the Kings behind Deir el-Bahri. As recently as 1962 a third temple was discovered by Polish Egyptologists between the other two. It is the work of Thutmosis III, who later tried to erase all memory of Hatchepsut. Ironically every visitor to Egypt now knows her temple, whereas few know about his.
Ch. L.

E. Naville, *The Temple of Deir el-Bahari*, 7 vols. (London 1894–1908); D. Arnold, 'Deir el-Bahari', *Lexikon der Ägyptologie* (Wiesbaden 1975), I, cols. 1006–25; D. Arnold, *Die Tempel Ägyptens: Götterwohnungen – Baudenkmäler – Kultstätten* (Zurich 1992), 134–41

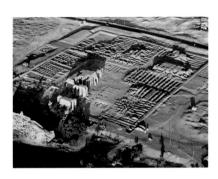

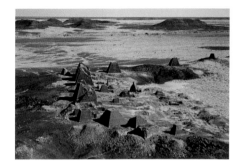

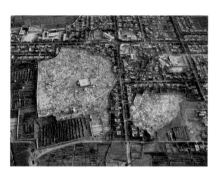

131 | **The Ramesseum at Thebes, Egypt**
Graced with the modern cognomen of 'the Great',
Ramesses II (1279–1213 BC) reigned for 67 years and
was one of Egypt's most important rulers. No other
pharaoh built as many enormous temples as he did.
The most important of them in terms of his own
continuing existence in the afterlife was his tomb,
which is the largest complex in the Valley of the
Kings, albeit poorly preserved. Although several
kilometres away, the so-called Temple of the Dead
establishes a direct link with the pharaoh's tomb,
the cult of the dead pharaoh being celebrated every
day in the easily accessible temple at the point
where the land ceases to be arable in Thebes West
Bank. The Egyptian term for these temples was
'million-year complexes', indicating that they were
intended to guarantee the pharaoh's afterlife for at
least this period. And so they were correspondingly
magnificent. One of the most impressive complexes
of this kind is the mortuary temple of Ramesses II
known as the Ramesseum. A pylon situated so
close to the point at which the land ceased to be
cultivated that its base was washed away by the
floodwaters of the Nile, causing it to collapse, was
followed by two courtyards. In the first was a seated
statue of a king. The largest ever made in Egypt, it
was hewn from a single piece of Aswan granite and
some 19m in height. It weighed over 1000 tons. The
temple interior includes three hypostyle halls and
the sanctuaries that housed the barques on which
the gods Amun, Mut and Khon were brought to the
West Bank from Karnak. A depiction of the heavens
can still be admired on the ceiling of one of the
halls, but there are unfortunately no longer any
traces of the famous temple library that was highly
praised by ancient writers.
Ch. L.

J. E. Quibell and others, *The Ramesseum* (London 1898); D.
Arnold, *Die Tempel Ägyptens: Götterwohnungen –
Baudenkmäler – Kultstätten* (Zurich 1992), 142–3;
Memnonia, vols. 1–12 (1990–2000)

132 | **The pyramids in the Northern Cemetery at
Meroe, Sudan** Some 120km north of the Sudanese
capital of Khartoum and not far from the modern
town of Shendi on the Butana plateau lies the
ancient city of Meroe, the legendary capital of the
Meroitic empire to which it gave its name. It seems
to have emerged in the 7th century BC as a Napatan
settlement, replacing Napata as the capital of the
Kush empire in c300 BC. To the east of Meroe lie
three royal cemeteries referred to as 'Beg N[orth]',
'Beg W[est]' and 'Beg S[outh]' after the modern
town of Begrawiya. Beg S is the oldest of them, Beg
W the most recent, while the Northern Cemetery is
the most impressive of the three. Of the 41 royal
tombs that were built here between 270 BC and AD
350, Beg N contains 38 generally well-preserved
pyramids. The pyramid may be regarded as the
typical grave form of Nubia. Certainly, there are now
more pyramids to admire in Sudan than in Egypt.
The three cemeteries at Meroe form a veritable
conglomerate of pyramids: of the 303 identifiable
royal burials, 144 are in the form of pyramids. The
most famous one in Beg N is that of the Kandake
(Queen Mother) Amanishaketo (Beg N 6). Unfortu-
nately, it is now in a ruinous state, having been
systematically dismantled in 1834 during a search
for gold grave goods in the course of which the
Italian physician Giuseppe Ferlini discovered
various artefacts here. When he tried to sell them,
his unusual treasure was dismissed as a forgery,
and it was only when the Berlin Egyptologist Karl
Richard Lepsius confirmed the circumstances of
Ferlini's find during his own expedition in 1844 that
the jewellery could be sold. It can now be seen in
the Museums of Egyptology in Berlin and Munich.
Ch. L.

D. Dunham, *Royal Cemeteries of Kush IV: Royal Tombs at
Meroe and Barkal* (Boston 1957); F. W. Hinkel, 'Meroitische
Architektur: 300 v.Chr.–350 n.Chr.', *Sudan: Antike König-
reiche am Nil* (Tübingen 1996), 391–415 (catalogue for
exhibition seen in Munich and elsewhere)

133 | **The necropolis at Astana, China**
Astana lies c40km south-east of the city of Turfan,
Xinjiang, and for more than 500 years – from the
Western Chin Dynasty (AD 265–316) to the Tang
Dynasty (618–907) – was the necropolis of the city
of Gaochang. It has become known throughout the
world as the 'Underground Museum' on account
of the thousands of grave finds dating from the 3rd
to the 8th centuries. Among the European archaeol-
ogists who came to Astana in the early 20th century
were Sir Aurel Stein from England, Dimitri Klementz
from Russia and Albert von LeCoq from Germany,
all of whom opened graves and took away large
quantities of grave goods. Not until 1959 were
official excavations undertaken by Chinese archaeol-
ogists. Since then more than 460 graves have been
excavated and examined. Some grave chambers
have been found to contain wall paintings with
scenes of hunting, farming and everyday life.
Thanks to the region's dry climate the bodies of the
dead, including their wooden coffins and grave
goods made from organic materials, are generally
well preserved. Chief among these grave goods are
textiles, wood carvings and public and private
documents written in Chinese on paper. The
excavated material has allowed Chinese archaeolo-
gists to divide the graves into three phases. It
seems that most of the individuals buried here were
Han Chinese and that only a few belonged to the
national minorities under Han influence. Since 1961
the gravefield at Astana has been a protected
monument in China.
B. S.

Xinjiang gudai minzu wenwu (Cultural Assets of Ancient
Peoples in Xinjiang) (Beijing 1985), 12–14; *Zhongguo
dabaikequanshu, koaguxue* (Chinese Encyclopaedia: Archae-
ology) (Beijing 1986), 7

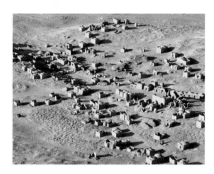

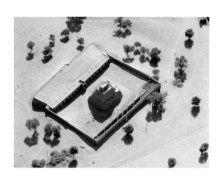

134 | **The Christian necropolis at al-Bagawat in the Kharga Oasis, Egypt** The closest oasis to the Nile is at Kharga and is some 100km from its northern extremity to its southern tip, making it the largest oasis in Egypt's Libyan Desert (no. 245). Through it runs the Darb el-Arba'in ('Forty-Day Road'), a notorious caravan route that begins in Western Sudan and ends at Asyut in the Nile Valley in Middle Egypt. In Roman times, control over this important trade route turned Kharga into an important and wealthy oasis, as is clear from its many temples and municipal complexes. Early Christianity soon spread here, and by the 4th century Kharga was the seat of the bishops appointed by the patriarch of Alexandria. It was presumably at this period that the oldest known churches in Egypt were built. Immediately to the north of the ancient town of Hibis, the capital of Kharga, lies the Christian necropolis of al-Bagawat, covering an area of some 500m. Dating from the 4th to the 7th centuries, it is one of the oldest and best-preserved early Christian necropolises anywhere in the world. What is probably the oldest building in the cemetery, a three-aisled church, stands on a hill in the centre of the site. Around it are grouped 263 mortuary chapels made from sun-dried mud bricks, most of which consist of a single square room with either a flat or a domed roof. More lavish chapels may have more than one room and arcaded façades. Cut into the rock, the actual grave was beneath the chapel. Two of the chapels still contain painted domes. The Exodus Chapel (so called from the subject matter of the painting) dates from the 4th century and is thus one of the oldest Christian paintings in the world.
Ch. L.

A. Fakhry, *The Necropolis of El Bagawat in Kharga Oasis* (Cairo 1951); P. Grossmann, 'Some Observations on the Late Roman Necropolis of al-Bagawat', *The Necropolis of El Bagawat in Kharga Oasis*, ed. A. Fakhry (Cairo 1989), 429–414 [*sic*] (= Third Appendix)

135 | **The Askia Mausoleum at Gao, Mali**
The Songhay state flourished between the 10th and the 16th century. At the time of its final dynasty (1464–1591), its capital was Gao on the Niger in the Sahal zone in south-east Mali. The Great Mosque of Gao lies in the centre of a cemetery precinct whose earliest funerary inscriptions date to the 8th century. It is a flat-roofed, four-aisled structure of mud bricks built on an east-west axis, with a courtyard to the south measuring 45 x 50m. At the centre of this courtyard is a massive mud building measuring 14 x 18m at its base and 10m high. This two-step pyramidal structure is the mausoleum of the most important Songhay ruler, Askia Mohammed Toure (1443?–1538). When the mosque's minaret collapsed, a ramp was built on its eastern side in order to provide a raised platform on which the muezzin could pray. The architecture of the memorial reflects not only Islamic influences from centres north of the Sahara but also pre-Islamic Songhay elements. These include the acacia trunks that protrude from the side walls and the conception of the site as a tumulus. Askia, who usurped power in 1492 and who was replaced by his son in 1528, secured the conquests of his predecessor in Timbuktu and Djenne and made Islam the state religion. The wealth of the Songhay state was based on goldmining and trade. It flourished by dint of a highly efficient central administration and the introduction of uniform weights and measures and a currency system but it fell into decline following the victory of the Moroccans in 1591 and their capture of the country's goldmines.
T. St.

P. and F. McKissack, *The Royal Kingdoms of Ghana, Mali, and Songhay: Life in Medieval Africa* (New York 1994); T. A. Hale, *The Epic of Askia Mohammed* (Indiana 1996); T. Insol, 'Looting the Antiquities of Mali: The Story Continued at Gao', *Antiquity*, 67 (1993), 628–32

136 | **The tomb of Cyrus the Great at Pasargadae, Iran** 'Mortal! I am Cyrus ... who founded the Persian empire, and was King at Asia. Grudge me not then my monument.' Greek historians who accompanied Alexander the Great's campaign to Asia 200 years after Cyrus's death in 530 BC recorded this and similar inscriptions on Cyrus's tomb in Pasargadae. They report that the evidently mummified body of the king was found lying in a gold sarcophagus, with a table beside it, together with a bench with gold feet on which lay a sleeved coat, Median riding breeches, clothes of every hue, weapons and trinkets. Even during Alexander's campaign the tomb was plundered, although not by Greeks, and only the sarcophagus, from which the body was wrenched, was left behind as it was too large to fit through the doorway to the tomb. Today even the inscriptions have vanished. The simple but impressive tomb chamber stands on a monumental six-stepped substructure that may have fulfilled a ritual prescription of the ancient Iranian religion, preventing the earth from being polluted by coming into contact with dead matter. The tomb stands on the southern edge of the extensive first Achaemenid residence with gardens and palaces on the 1900m high Murgab Plain, 80km north of the later residence at Persepolis (no. 70). In the 13th century it was believed to be the tomb of Solomon's mother and became the centre of a court mosque. A richly decorated prayer niche, or mihrab, was chiselled into the wall of the tomb chamber at this time.
D. H.

Arrian, *Anabasis Alexandri* vol. 2, trans. P. A. Brunt (Cambridge, Mass., 1983), 193–7; C. Nylander, *Jonians in Pasargadae* (Uppsala 1970), 91–102; D. Stronach, *Pasargadae* (Oxford 1978), 24–43

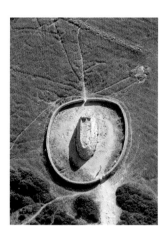

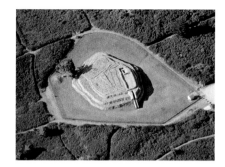

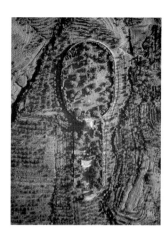

137 | Es Tudons on Minorca, Spain

Es Tudons lies in the western half of Minorca, some 4km east of Ciudadela and 200m south of the main road to Mahon. Looking like an upturned boat (naveta), it is made of regularly worked stone blocks laid together without the use of mortar. It is 13.6m long and a maximum of 6.4m wide. Its groundplan is an elongated semicircle, its longer sides slightly curved, while one of its short sides is straight, the other one rounded. Inside are two superimposed storeys with semicircular chambers approx. 7.25m long, separated by a ceiling made of stone slabs. In the side towards the top of the picture is a narrow entrance giving access to an almost square antechamber only 1.3m long. From here a second door leads to the lower chamber. The second chamber is accessible from the upper part of this antechamber. Following recent restorations, the whole complex is now 4.25m high. There is no doubt that it is a two-storey structure. Arguably the most remarkable building of its kind in the whole of the Balearics, it was evidently used as a tomb and on the strength of the many grave goods found here has been dated to the Bronze Age Talayot Culture (c1000 BC). The complex was described in the early 19th century but not excavated until the 20th, notably during the 1960s and 1970s. It has frequently been restored, especially the upper section and modern field wall. On Minorca and Majorca there are several dozen naveta complexes, some of which similarly comprise two storeys. Others lie together in groups or rest against one another. Occasionally they were used as homes. Along with the talayots and taulas (no. 157) they are a distinctive feature of the Balearic Islands.
V. P.

J. Ramis y Ramis, *Antigüedades célticas de la isla de Menorca desde los tiempos más remotos hasta el siglo IV de la Era Cristiana* (Mahón 1818); L. Plantalamor Massanet, *L'arquitectura prehistórica i protohistórica de Menorca i el seu marc cultural* (Maó 1991), 210–17; H. Schubart, *Denkmäler der Frühzeit: Hispania Antiqua*, ed. M. Blech and others (Mainz 2001), 147–9, 555

138 | The megalithic site at Petit-Mont, Arzon, France

At the far end of the Rhuys peninsula on the Gulf of Morbihan in southern France lies the monumental complex of Petit-Mont, apparently guarding its entrance. As an obvious landmark, the site has long been known, the first written references and descriptions of it dating to the 15th century. It was excavated by Cussée in 1865 and Rouzic in 1906. Rouzic also restored the site in 1936, only for it to be damaged by the construction of a bunker during the Second World War. The excavations undertaken by Lecornec between 1979 and 1989 threw light on the site's complex history. Seen from the air, the restorations reveal a veritable labyrinth of straight or concentric blind walls that are like wrinkles attesting to its lengthy history. An initial earthen burial mound dating from 4500 BC was covered with an impressive stone cone more than 50m in diameter and made up of several sections. This was a burial mound of unworked stone that had no burial structure and that replaced the original tumulus. A second burial mound dating from c4000 BC rested against the first and contained a Stone Age passage grave. Incised marks on the walls indicate that the decorated stone slabs employed here had been used previously. The monument was enlarged around 3000 BC and now included two megalithic graves, one of which was made of decorated stone blocks similarly taken from a previous structure. The history of the mound ends with the erection of a double fortification around the whole site, preventing all further access to it.
C. B.

J. Lecornec, *Le Petit-Mont, Arzon, Morbihan* (Rennes 1994), 109 (Documents archéologiques de l'Ouest)

139 | Tomb of a Ming emperor, China

In a wide depression barely 50km north of the centre of Beijing lie the mausoleums of 13 of the 16 Ming emperors. The whole valley used to be closed off by a high red wall, and only the soldiers on guard duty and a handful of peasants lived within its confines. Together with a vast retinue the emperor would visit the tombs of his ancestors several times a year. All were built along the same lines. Each is made up of two sections, three rectilinear inner courtyards surrounded by a wall, with sacrificial halls, preparation rooms at the sides, and a round tumulus, deep beneath which lay the grave chamber. A pavilion containing the stela commemorating the late emperor stood in the passage between the rectangular form, symbolizing the earth, and the round burial mound, symbolizing the heavens. Only one of these chambers has been excavated, that of the emperor Wanli (1572–1620), but it gives a good idea of what all these tomb must look like. It was examined in the 1950s, when the archaeologists were fortunate enough to find the entrance to the chamber. This led to two antechambers separated from each other by heavy stone doors. Both were found to be empty. Behind the next stone door was a further, larger hall with three marble thrones, before each of which stood a stone altar bearing five ceremonial objects. The actual burial chamber lay at an angle to the main axis, with a platform in front of the rear wall. On it rested three coffins, the emperor's in the middle, flanked by those of his wives. To the side, parallel with the main axis, two further burial chambers were discovered. No doubt intended for concubines, they were found to be empty.
B. S.

Over China (Sydney and Beijing 1988), 270–71; Z. Luo, *Zhongguo lidai huangdi lingmu* (The Imperial Grave Complexes of Successive Dynasties in China) (Beijing 1993), 126–51

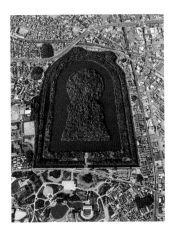

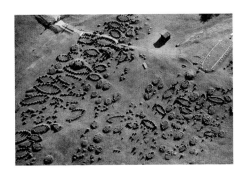

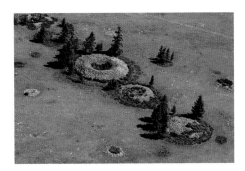

140 | **Kofun of the emperor Nintoku in Sakai, Japan**
The present photograph shows the Yamato Plain near Osaka on the main Japanese island of Honshu, one of many sites notable for burial mounds (in Japanese 'Kofun') of often immense size that gave their name to an entire period, the Kofun period (AD 300–710). Only a few of these mounds, which were reserved for emperors, princes and warriors, have been systematically excavated. Often decorated on the outside with clay figures known as haniwa, they are frequently keyhole-shaped (zenpokoen) and surrounded by moats. The burials generally took place in stone chambers (sometimes also in sarcophaguses). Some of these chambers were painted and often contained very rich grave goods, including weapons, armour, horse equipment and mirrors, some of which were imported from Korea and China. Only later sources such as Kojiki (c712) and Nihon Shoki (c720) contain legendary accounts of this protohistoric period in Japanese history. The introduction of Buddhism and other cultural and spiritual ideas from Korea and China mainly in the 7th century put an end to these monumental burial mounds and brought with them completely new burial customs. Seen here is one of the largest of these Japanese tumuli, that of the semi-legendary 16th emperor Nintoku. Dating from the early 5th century, it is situated at Sakai to the south of Osaka and is surrounded by several moats, its keyhole shape clearly visible. The site is now landscaped. This Kofun is some 35m high, around 480m long and covers a surface area of 21 ha. Its construction required an enormous amount of labour and may have involved up to 800,000 workmen.
S. St.

J. E. Kidder, *Early Japanese Art: The Great Tombs and Treasures* (Princeton 1964); M. Suenaga, *Kofun to koku kaikan* (Grand View of Old Mounds from the Air), 2 vols. (Tokyo 1975); R. J. Pearson and others, 'Windows on the Japanese Past', *Studies in Archaeology and Prehistory* (Ann Arbor 1986)

141 | **The Lindholm Høje cemetery at Ålborg, Denmark** Very few cemeteries from the late prehistoric period in Denmark give today's observer any real idea of their original appearance. The stone markers were generally reused as building material and the cemeteries themselves were ploughed over. But the large cemetery at Lindholm Høje was covered over by shifting sand at an early date and thus protected. It was discovered in the late 19th century, and excavations in the 20th century removed up to 4m of sand, uncovering numerous graves of various shapes. The cemetery is beautifully situated on high ground sloping towards the distant Limfjord. The earliest graves are inhumations dating to the Age of Migrations (5th century AD) and were found on its highest point. Further down the slope variously shaped stone settings were found: round, triangular, oval, ship-shaped. All of these were cremation graves. The last group of graves were again used for inhumations and date to the 11th century, the period when the Danes were Christianized. Contemporary settlement remains have also been uncovered on the site. Wall ditches and postholes of long houses are now filled with white concrete and thus visible to the visitor. One remarkable find was the remains of a Viking Age ploughed field, which was preserved because it was covered by a thick layer of shifting sand. The site at Lindholm Høje demonstrates how the people of the period cared for their loved ones by means of funerary rituals. A museum on the site tells this story with the help of reconstructions and original small finds.
U. N.

T. Ramskou, *Lindholm Høje: Gravpladsen* (Copenhagen 1976); E. Johansen and A. Lerche Trolle (eds.), *Lindholm Høje: Gravplads og landsby* (Ålborg 1994)

142 | **Scythian kurgans in the Sooru Valley, Altai Republic, Russian Federation** The kurgans (burial mounds) in the Sooru Valley in the Altai Mountains are among the funerary monuments left in large numbers throughout southern Siberia and in the Altai region bordering Kazakhstan, China and Mongolia by the early horse-riding nomads of the older Iron Age whom we often describe as Scythians. The oldest date to the turn of the 9th/8th century BC, the most recent to the period before 200 BC, before the Hunnish tribes seized control of this region. The kurgans of the Altai Mountains consist of piles of stones – as shown in the present photograph – that cover the grave shaft leading to the burial chamber, which is lined with larch beams. They are always in rows or grouped together and are often accompanied by stones arranged either in circles or straight lines, the precise function of which is unclear but which may have had a cultic significance. The first burial mounds in the Altai Republic were examined by the German archaeologist Wilhelm Radlov or Radloff in the late 19th century, when he was working for the St Petersburg Academy of Sciences. His sensational discoveries were repeated by Mikhail Petrovich Gryaznov and Sergei Ivanovich Rudenko at Pazyryk between the 1920s and 1940s and by Vyacheslav Ivanovich Molodin and Natalia Polosmak on the high plateau at Ukok in the early 1990s. Water seeping into the tombs left the contents encased in ice, mummifying the bodies and preserving their clothing and all those of their grave goods that were made of organic material. These unique conditions have given us extraordinary insights into the rites, lives and world of intellectual ideas of the Scythians, insights that would have been lost to us forever had it not been for these burial mounds in the Altai Mountains.
H. P.

S. I. Rudenko, *Der zweite Kurgan von Pasyryk* (Berlin 1951); N. V. Polosmak and M. Seifert, 'Menschen aus dem Eis Sibiriens: Neuentdeckte Hügelgräber (Kurgane) im Permafrost des Altai', *Antike Welt*, 27 (1996), 87–108; N. V. Polosmak, *Vsadniki Ukoka* (Novosibirsk 2001)

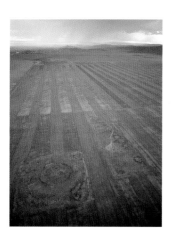

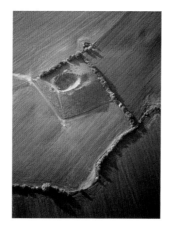

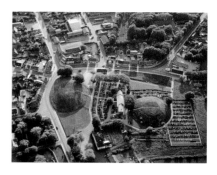

143 | Scythian kurgans at Arzhan, Tuva Republic, Russian Federation Situated at the source of the Yenisey in southern Siberia, the autonomous Republic of Tuva occupies a central position in the links between, on the one hand, the prehistoric and proto-historic cultural developments that took place in the Altai region and the Minusinsk Basin to the west and north and, on the other, Outer Mongolia and northern China to the south and south-east. Close to the town of Arzhan in the valley of the River Uyuk, a tributary of the Yenisey in northern Tuva, lies one of the biggest and most monumental of Scythian gravefields on the whole of the Eurasian steppes. It is known locally at the *dolina carej* (Valley of the Kings). Hundreds of large kurgans (burial mounds) dating to the period between the late 9th and late 3rd centuries BC cover the area, arranged in rows several kilometres long. The earliest excavations were undertaken before the First World War, but it was not until the 1970s that they were carried out on a scientific basis by the Leningrad archaeologist Mikhail Petrovich Gryaznov, who examined Mound Arzhan 1. Here he found a unique wheel-shaped wooden structure beneath a stone cairn, in the centre of which was a looted prince's grave. These remain the oldest Scythian finds from the Eurasian steppes from the late 9th and early 8th centuries BC. Arzhan thus plays a key role in our understanding of the beginnings of Scythian culture and way of life and of the Scythian-Siberian Animal Style. The excavations at Arzhan were resumed in the late 1990s by Konstantin Chugunov, Hermann Parzinger and Anatoli Nagler. In 2001/2 they discovered in Kurgan Arzhan 2 a ceremonial grave from the 7th century BC filled with more than 6000 gold objects, making it the richest Scythian grave so far discovered and the most outstanding complex of finds from this period in Siberia.
H. P.

M. Kilunovskaya and V. Semenov, *The Land in the Heart of Asia* (St Petersburg 1995); K. Chugunov and others, 'Der Fürst von Arzan: Ausgrabungen im skythischen Fürsten-grabhügel Arzan 2 in der südsibirischen Republik Tuva', *Antike Welt*, 32 (2001), 607–14

144 | Burial mound in Schleswig-Holstein, Germany The vast burial mounds of the Nordic Bronze Age (approx. 2nd millennium BC) have been called the 'pyramids of the north'. They continue to characterize the countryside in many parts of Denmark and Schleswig-Holstein. Not always, however, have they survived in a sufficiently well-preserved state to deserve their name. The present photograph of a burial mound in Schleswig-Holstein is an example of the carelessness with which modern man can sometimes treat the evidence of his own past. Its exact position can unfortunately no longer be determined. Straightforward theft is in part responsible for this state of affairs: these mounds contained the remains of wooden burial chambers and tree coffins in which the dead were buried with weapons such as swords, daggers and axes or else with bronze jewellery. The looters wanted these objects and were none too fussy about careful documentation and suitable methods of excavation of the kind that any responsible scholar would show when excavating a site of this nature. Instead, the looters simply bored several holes in the centre of the mound, an older, smaller one on its right-hand side, and a more recent and larger one that partly overlay the older hole. To this has been added the problem of the expansionist aspirations of local farmers who have increasingly ploughed up and levelled the edge of the once round hill, until its basic form resembles that of a pyramid, no more than a pitiful caricature of its original appearance as a funerary monument characteristic of the local landscape.
T. F.

E. Probst, *Deutschland in der Bronzezeit* (Gütersloh 1996); K. Rassmann, 'Bronzezeit', *Spuren der Jahrtausende: Archäologie und Geschichte in Deutschland*, ed. U. von Freeden and S. von Schnurbein (Stuttgart 2002), 156–89

145 | The royal memorials at Jelling, Denmark The small town of Jelling in central Jutland is still dominated by the royal memorials built by the pagan king Gorm ('the Old') and his son Harald Bluetooth, who made Christianity the official religion in c965. They were probably erected between the 940s and 970s and represent both paganism and Christianity. Today one can see two huge mounds and two rune-stones, together with the church that was built between the mounds in c1100 – the third successor to the church from the Conversion period. The earliest monuments were a rune-stone raised by Gorm in memory of his queen, Thyre, and a series of stones forming a boat-shaped outline, little of which is preserved. Next came the North Mound, built in the late 950s for the pagan burial of Gorm. After the Conversion his remains were transferred to a new wooden church. A magnificent rune-stone was raised outside this by King Harald. It is decorated with a rampant lion-like animal and a representation of Christ, together with an inscription commemorating Harald's parents and his own great deeds: his acquisition of power throughout Denmark and in Norway and his conversion of the Danes. The most recent monument is the South Mound, which held no grave. These monuments belong to a series of great engineering works commissioned by Harald, including a 760m long bridge at nearby Ravning Enge, the four Trelleborg fortresses (no. 117) and extensions to the Danevirke (the wall that formed the frontier with Germany). They signalled a new era, with a new religion, a new focus on royal power and much economic, political and cultural change. Jelling is a World Heritage site. There is a museum next to the church.
E. R.

K. J. Krogh, 'The Royal Viking-Age Monuments in Jelling in the Light of Recent Archaeological Excavations', *Acta Archaeologica*, 53 (1982), 183–216; K. J. Krogh and O. Olsen, 'From Paganism to Christianity: Digging into the Past', *25 Years of Archaeology in Denmark*, ed. S. Hvass and B. Storgaard (Copenhagen and Højberg 1993), 233–6

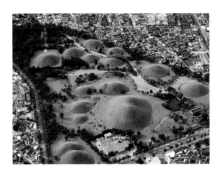

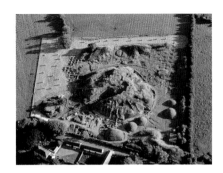

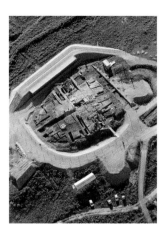

146 | Tumuli of the Silla rulers at Kyongju, South Korea Kyongju lies in the south-eastern corner of the Korean peninsula, north of Pusan and east of Taegu. Famous above all for its burial mounds of the Silla rulers (3rd–10th century AD), it is now a World Heritage Site. Kyongju was once the heart of the powerful Silla kingdom, which covered the whole of the peninsula, a magnificent cultural centre modelled on the Chinese Tang capital of Chang'an and breathing a cosmopolitan spirit. Its golden age was in the 7th and 8th centuries during the Great Silla period (668–918). At that time the Buddhist-influenced city boasted more than one million inhabitants, making it almost ten times larger than the modern town of Kyongju slightly to the north. Apart from the remains of palaces and temples, the chief objects of interest are the numerous tumuli of various sizes dating in the main to the 5th–7th century. First opened and excavated in 1921, the grass-covered mounds reach a height of 25m and were reserved for the kings and aristocrats of the Silla kingdom. Their interiors are notable for their wooden chambers with stone superstructures and sometimes also paintings. Most contained magnificent grave goods, some of them made of gold and including crowns. Also found were imported goods from Syria, Persia and the Roman Empire brought to Korea along the Silk Road. These finds, which attest to a shamanistic world view, can now be seen in the National Museum of Kyongju. The present photograph was taken in 1975 and shows the tumuli park, which was opened to the public after extensive excavations and which includes some 20 burial mounds of varying sizes.
S. St.

A. Eckart, *Korea* (Nuremberg 1972); E. B. Adams, *Kyongju Guide* (Seoul 1979); R. Whitfield (ed.), *Treasures from Korea* (London 1984) 34–9, 72–127 (exhibition catalogue)

147 | The passage tomb at Knowth, Ireland Among the many prehistoric monuments enclosed within a bend of the River Boyne in County Meath, the biggest and most impressive are the circular passage tombs at Newgrange and Knowth. These have diameters ranging from 80 to 103m and heights of up to 13m. Around the perimeter of Knowth, 17 smaller satellite tombs of the same type occur. At Newgrange a single passage leads to the interior; at Knowth there are two passages leading inwards towards each other from different sides of the tomb. The chambers, which contain carved stone basins, are roofed by overlapping stones in the so-called corbel technique. Most typically, the chambers are in cruciform arrangement. Over the entrance at Newgrange is an opening which allows the sun to shine down the passage into the back-chamber on the day of the winter solstice. Along the passages, in the chambers and also on the kerbstones outside, engraved abstract art occurs, consisting of spirals, circles, curves, lozenges, zigzags and many other motifs in varying combinations. Despite the almost breathtaking quality of the architecture, it is surprising to note the simplicity of the grave goods. These comprised little more than a selection of bone pins, stone beads, flints and, occasionally, pottery. Knowth, however, yielded a perforated flint mace-head with unique curvilinear decoration of very exceptional quality. At both sites there was sporadic, later occupation. Especially important are the extensive Roman finds, including coins and personal ornaments of gold, which were found around the immediate perimeter of Newgrange.
B. R.

R. A. S. Macalister, 'A Preliminary Report on the Excavations of Knowth', *Proceedings of the Royal Irish Academy*, 49C (1943), 131–66; M. J. O'Kelly, *Newgrange: Archaeology, Art and Legend* (London 1982); G. Eogan, *Knowth and the Passage-Tombs of Ireland* (London 1986)

148 | Yoshinogari on the Saga Plain on Kyushu, Japan Unexcavated until the 1980s and 1990s, the prehistoric settlement of Yoshinogari lies on a low hill overlooking the Saga Plain in the north of the southern Japanese island of Kyushu. To date, it is the largest circular double-moated settlement from the Yayoi period (*c*300 BC–AD 300) to be discovered in Japan and may have been the capital of the prehistoric kingdom known as Yamataikoku dating from the Yayoi period and mentioned in a late 3rd-century Chinese chronicle, *Wei zhi*. Named after a site in Tokyo, Yayoi culture was initially widespread, especially in the north of Kyushu and notable for the introduction of rice growing and the potter's wheel, for the use of metals, fixed settlements with domesticated animals, social differentiation, often more monumental funerary architecture, characteristic ceramics and the earliest Chinese imports, including bronze mirrors. The present photograph shows the Yoshinogari Historical Park with the remains of a large burial mound some 2000 years old that contained many large clay vessels. Also visible are a number of reconstructed houses of a sizeable settlement dating to the Yayoi period but known to have survived until the 4th or 5th century, in other words, to the Kofun period. It included round and oval pit-houses of wood and straw with a surface area of 5–6 x 3–4m, together with large rectangular storage rooms, wells and wooden watchtowers that are the oldest yet discovered in Japan.
S. St.

M. Hudson and G. L. Barnes, 'Yoshinogari: A Settlement in Northern Kyushu', *Monumenta Nipponica*, 46/2 (1991), 211–35; H. Otsuka (ed.), *Yoshinogari iseki wa kateru* (The Remains at Yoshinogari) (Tokyo 1992)

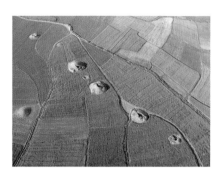

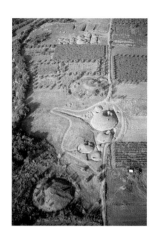

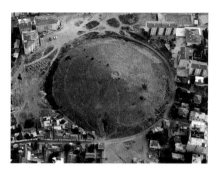

149 | **Burial mounds at Se Girdan, Azerbaijan, Iran**
Few sites carry as many hopes in archaeology as
burial mounds, for there is scarcely any other
discovery that offers so vivid a picture of a bygone
culture as a richly furnished prince's grave.
Unfortunately the hopes of rich pickings, rather
than scientific yields, have also fired whole genera-
tions of looters, so that the discovery of an intact
grave is a very rare stroke of good fortune. Generally
the archaeologist has to be content if the looters
have overlooked a few objects or thought that they
were not worth taking away. Regardless of the
outcome, the examination of a burial mound is
always expensive and time-consuming as the struc-
ture and design of the mound and chamber also
have to be researched. The American excavations of
the necropolis at Se Girdan near Oshnaviyeh to the
south-west of Lake Urmia that were undertaken
between 1968 and 1970 are a classic example of this
difficulty. Here there are 11 burial mounds of various
sizes in close proximity. Six were examined. All of
them had already been looted, the looters having
gained access to them by means of tunnels and
shafts. Some of the graves were lined with stone,
others mere pits in the earth. All were generally
completely empty. Only in one had a layer of mud
on the floor prevented the looters from discovering
numerous gold and stone beads and four bronze
axes. It was clear from the few surviving bone
remains that ochre had been used as a body
pigment. These and the few finds in the other
mounds are so uncharacteristic that the necropolis
has been variously dated to the 3rd millennium BC
and the 7th/6th centuries BC.
D. H.

O. W. Muscarella, 'The Tumuli at Se Girdan: Second
Report', *Metropolitan Museum Journal*, 4 (1971), 5–28; O. W.
Muscarella, 'The Date of the Tumuli at Se Girdan', *Iran*, 11
(1973), 178–80; S. Matheson, *Persia: An Archaeological
Guide* (London 1972)

150 | **The Etruscan Banditaccia cemetery at Cerveteri,
Italy** The famous Etruscan city of Cerveteri
(Etruscan Cisra; Greek Agylla; Latin Caere) lies on
a largely naturally protected high plateau near the
Tyrrhenian coast some 45km north-west of Rome.
Politically, economically and culturally, it flourished
above all in the 7th and 6th centuries BC, a golden
age in its past evident not least from the extensive
cemeteries around the town, with often
monumental tumuli and underground graves, of
which the cemetery at Banditaccia – now an archae-
ological park – is the best preserved and examined.
Systematic excavations and restorations have been
going on here since 1911. The large 7th-century
tumuli often contain several chamber tombs,
whereas the smaller tumuli from the late 7th and
early 6th centuries include only a single chamber
tomb and – like the later underground graves of the
6th century – are arranged in street-like rows. The
chamber graves are dug into the tuff and contain
elements of interior design and furnishings
designed to make them look like the houses of the
living. Those graves that have not been looted have
been found to contain often rich goods in gold,
bronze and ceramics. The cemetery at Banditaccia
includes graves ranging in date from the Villanovan
period (9th–8th century BC) to the hellenistic age
(3rd–2nd century BC). On the left of the photograph
is the Fosso Manganello, now much overgrown,
while to the right of it, on the plateau, are a number
of monumental burial mounds and groups of
smaller tumuli surrounded by vineyards. From the
bottom of the picture upwards we can identify the
Tumulo degli Animali Dipinti, the group
surrounding the Tumulo Giuseppe Moretti, the
Tumulo della Nave and the group around the
Tomba del Tablino.
S. St.

F. Prayon, *Frühetruskische Grab- und Hausarchitektur*
(Heidelberg 1975); G. Proietti, *Cerveteri* (Rome 1986); M.
Cristofani, *Cerveteri: Tre itinerari archeologici* (Rome 1991)

151 | **The Maltepe tumulus at Pergamon, Turkey**
Burial mounds were an opportunity for the Mediter-
ranean aristocracy to indulge in a display of ostenta-
tion not only in prehistory but later, too. To judge
from their size, the two large tumuli now known as
Maltepe and Yigma Tepe close to the hellenistic
royal residence at Pergamon in western Asia Minor
must have been the graves of members of the
Pergamon royal family or high-ranking Roman
officials. Neither has been properly excavated and
examined. In around 1908 a stone pedestal was
uncovered at the foot of Yigma Tepe, where it had
been covered by several rows of large limestone
blocks lying on top of each other. It reveals the great
expenditure that was lavished on these
monuments. The present photograph shows
Maltepe, inside which lies a three-part stone burial
chamber that was looted long ago. The use of
mortar and its alignment with the Roman street
system suggest that it dates from Roman times.
R. S.

A. Conze and others, *Stadt und Landschaft* (Berlin 1912–13),
239–45 (Altertümer von Pergamon, ed. Deutsches Archäol-
ogisches Institut 1/2); W. Radt, *Pergamon: Geschichte und
Bauten, Funde und Erforschung einer antiken Metropole*
(Darmstadt 1999), 267–70

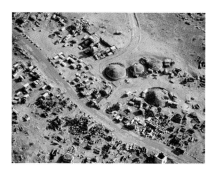

152 | **The northern cemetery at Hierapolis/ Pamukkale, Turkey** The best advertisement of every ancient city was its cemeteries, which tended to be located along its main arterial roads in front of its gates. Here the number and size of the tombs was an indication of the city's economic importance and of the hierarchical status of its individual families. Few cities in Asia Minor had as many lavish funerary buildings as Hierapolis in Phrygia. Especially impressive is the cemetery by the north gate, which marks the end of the city's broad main street, an impressiveness due not least to the great variety of different types of tomb. Among the oldest are those that date from the hellenistic period when the city was founded and which include simple underground chamber tombs for the less wealthy and round tumuli for well-to-do families. The brick base houses an underground chamber over which a conical burial mound has been raised. Typical of the Roman period are the 2000 or so limestone sarcophaguses on differently designed stone bases and mausoleums in the form of miniature temples or entire houses on some of which a sarcophagus additionally stands as if on a platform. Many graves bore inscriptions giving information about their occupants or about commemorations held in the small gardens beside them. But they also document the size of the area covered by individual graves and threaten punishment for illegal building. This was no doubt necessary because, as our photograph shows, the cemetery became increasingly crowded with the passage of time, especially in the first row of graves along the street and in the immediate vicinity of the city gates.
R. S.

C. Humann and others, *Altertümer von Hierapolis* (Berlin 1898) (Jahrbuch des Kaiserlich Deutschen Archäologischen Instituts, Supplement 4); E. Schneider Equini, *La necropoli di Hierapolis di Frigia: Contributi allo studio dell'architettura funeraria di età romana in Asia Minore* (Rome 1972) (Accademia Nazionale dei Lincei: Monumenti Antichi Serie Miscellanea 1–2)

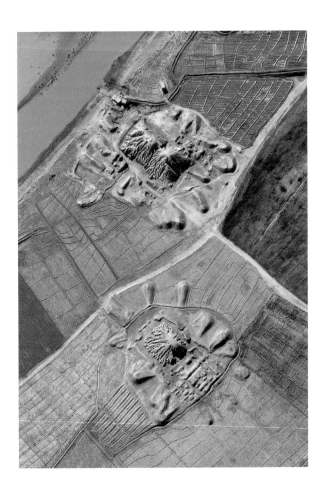 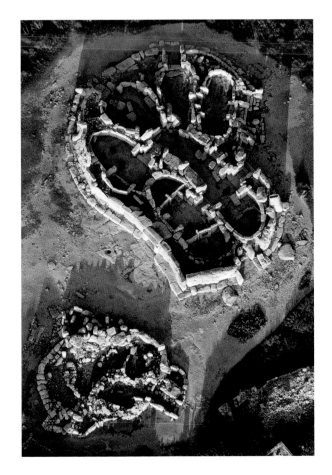

153 | **Kar-Tukulti-Ninurta**, first half of 13th century BC, Iraq, 1973

154 | **The megalithic temple at Hagar Qim**, 3rd millennium BC, Malta, 1996. World Heritage Site

8. THE SEAT OF THE GODS –

SACRED SITES

Whenever you come up from the Apsu for an assembly,
Your night's resting place shall live in it, receiving you all.
I hereby name it Babylon, home of the great gods.
We shall make it the centre of religion.

Enuma Elish, Book 5, ll.126–9 (12th/11th century BC)

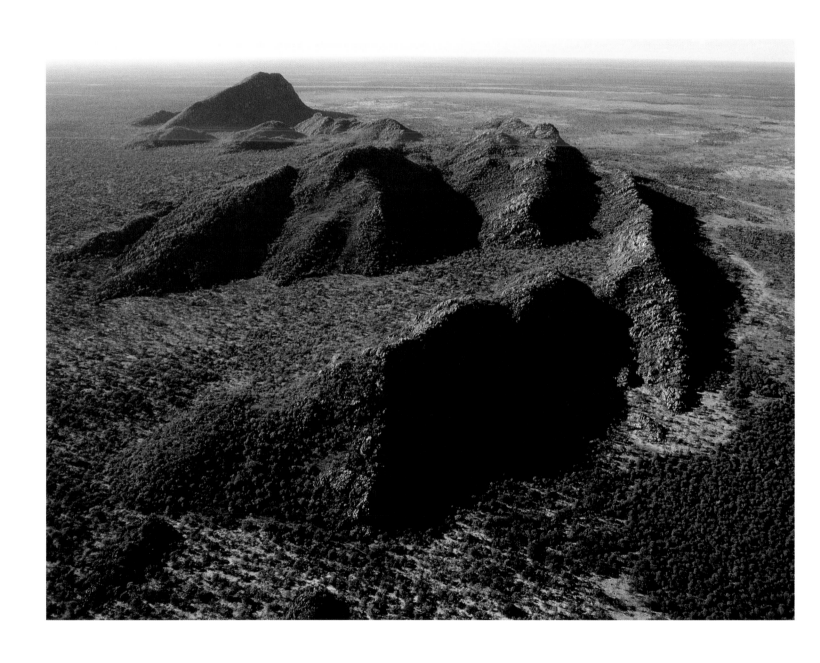

155 | **The Tsodilo Hills**, from 35,000 BC, Botswana, 1980. World Heritage Site

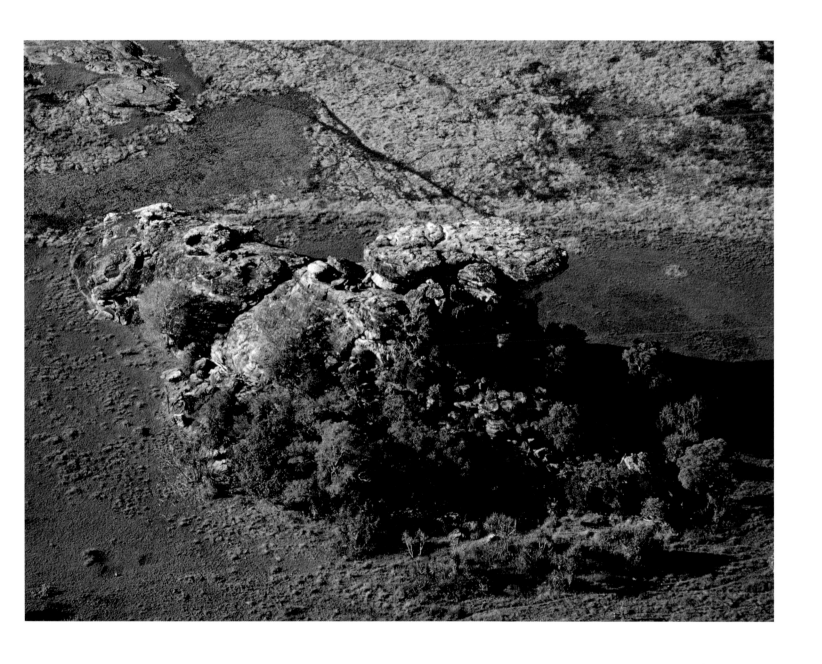

156 | **Ubirr Rock, Arnhem Land**, Australia, 1974. World Heritage Site

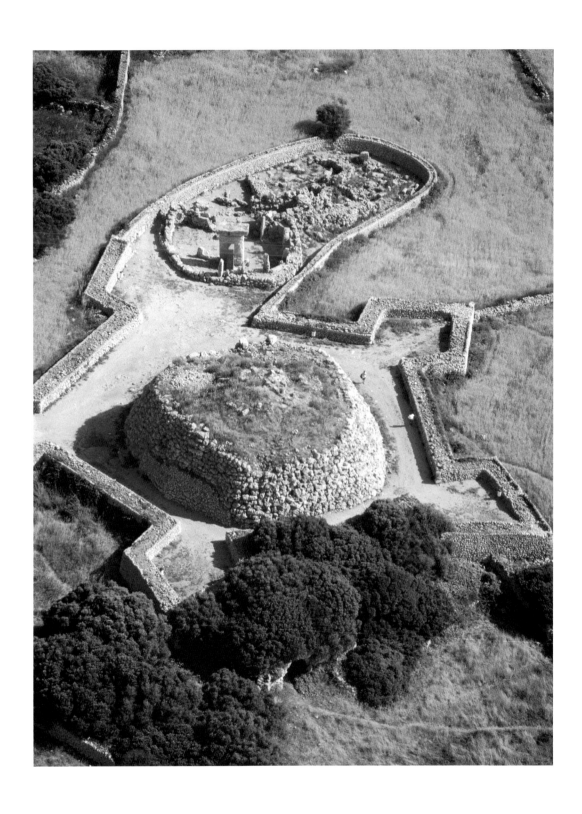

157 | **Trepucó on Minorca**, early 1st century BC, Spain, 1991

158 | **Uluru, the 'Great Pebble'**, Australia, 1974. World Heritage Site

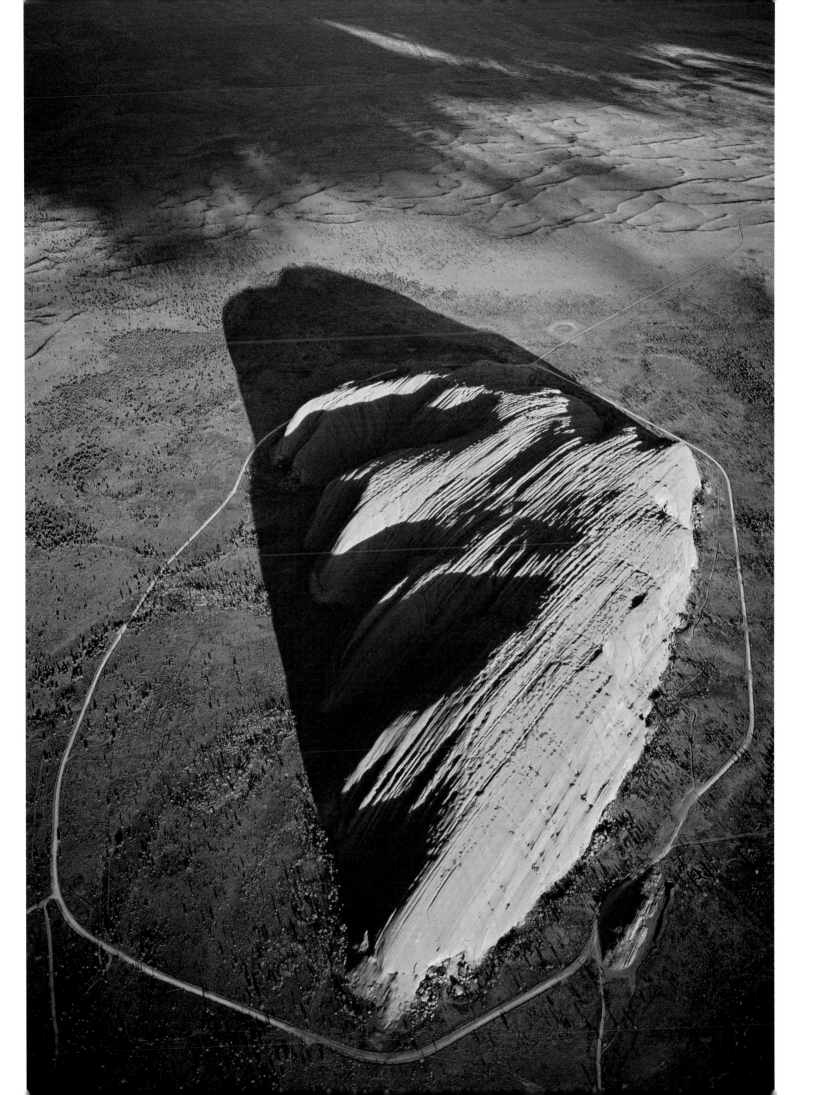

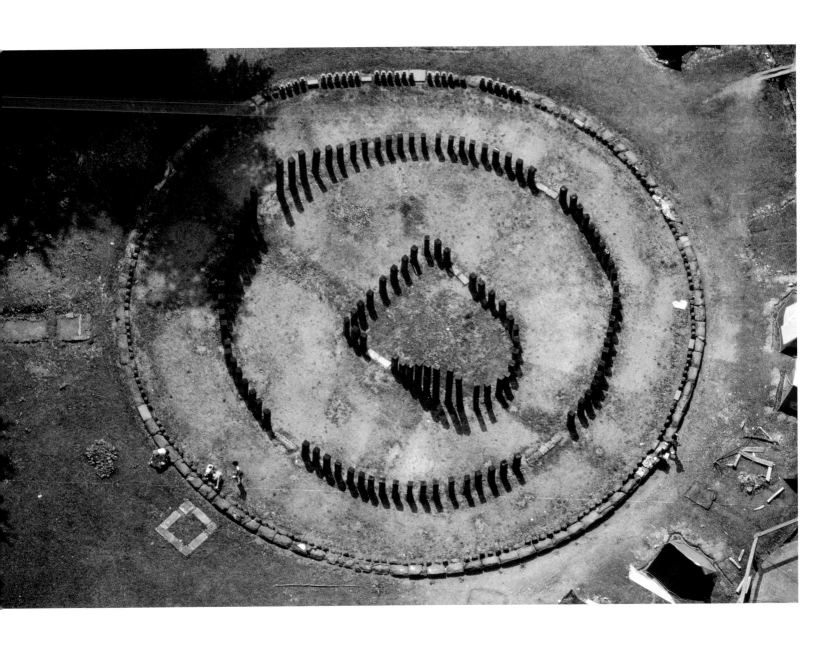

159 | **The sanctuary at Sarmizegetusa Regia**, 1st century BC, Romania, 1991. World Heritage Site

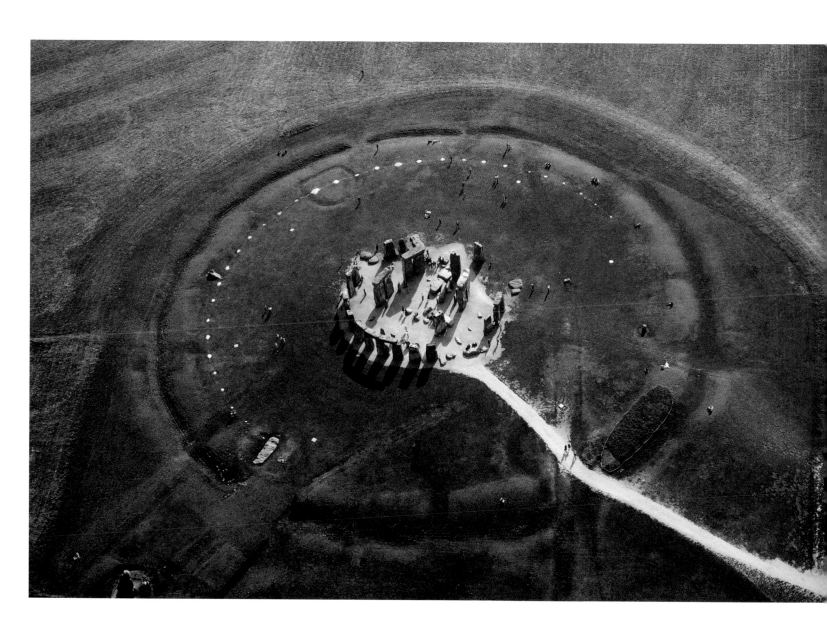

160 | **Stonehenge, Wiltshire**, 2600–1800 BC, England, 1970. World Heritage Site

161 | **The Loanhead of Daviot stone circle**, c2000 BC, Scotland, 1976

162 | **Avebury, Wiltshire**, 2600 BC, England, 1971. World Heritage Site

163 | **The Le Ménec alignment at Carnac**, 4th millennium BC, France, 2000. World Heritage Site

164 | **The Moose Mountain medicine wheel**, AD c300, Canada, 1976

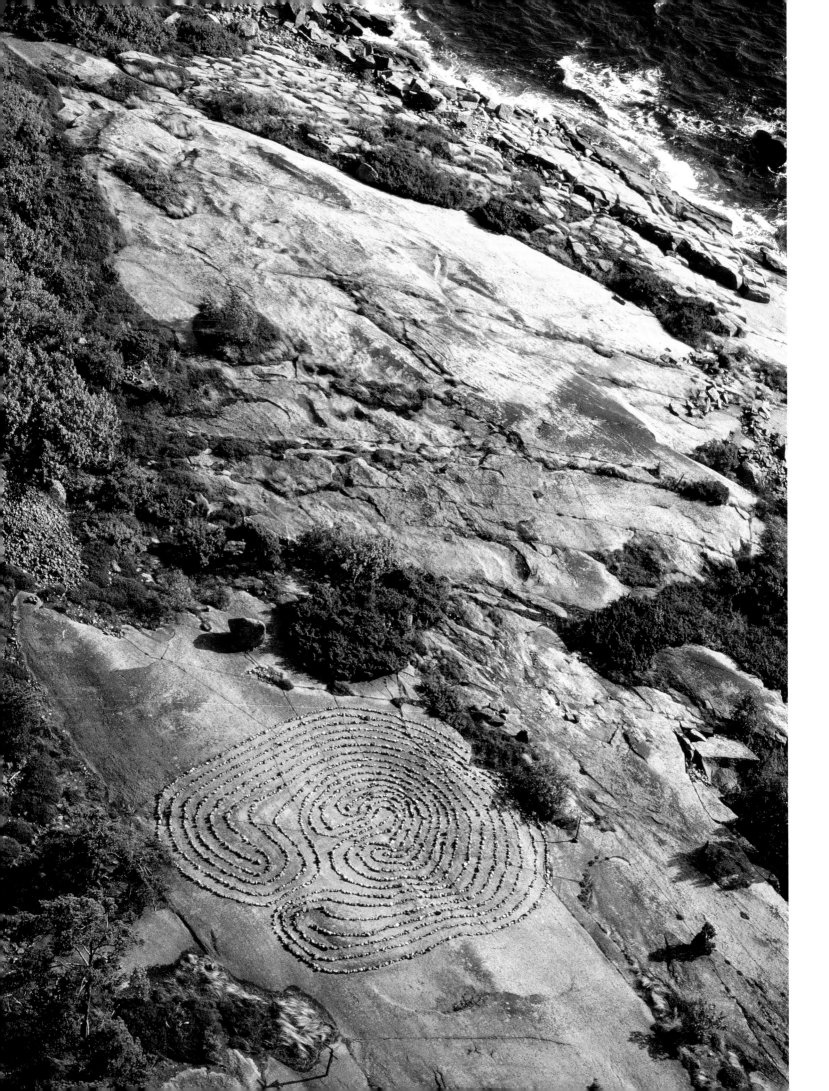

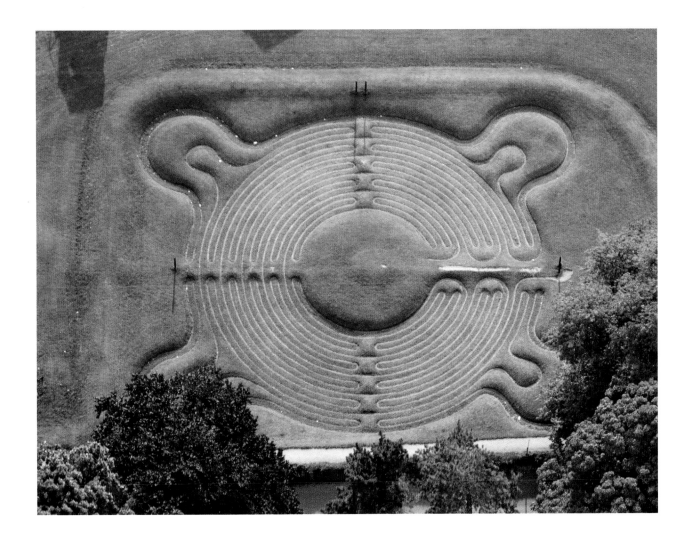

165 | **Labyrinth on Blå Jungfrun in the Kalmarsund**, Sweden, 1988

166 | **The grass labyrinth at Saffron Walden, Essex**, 17th century AD, England, 1986

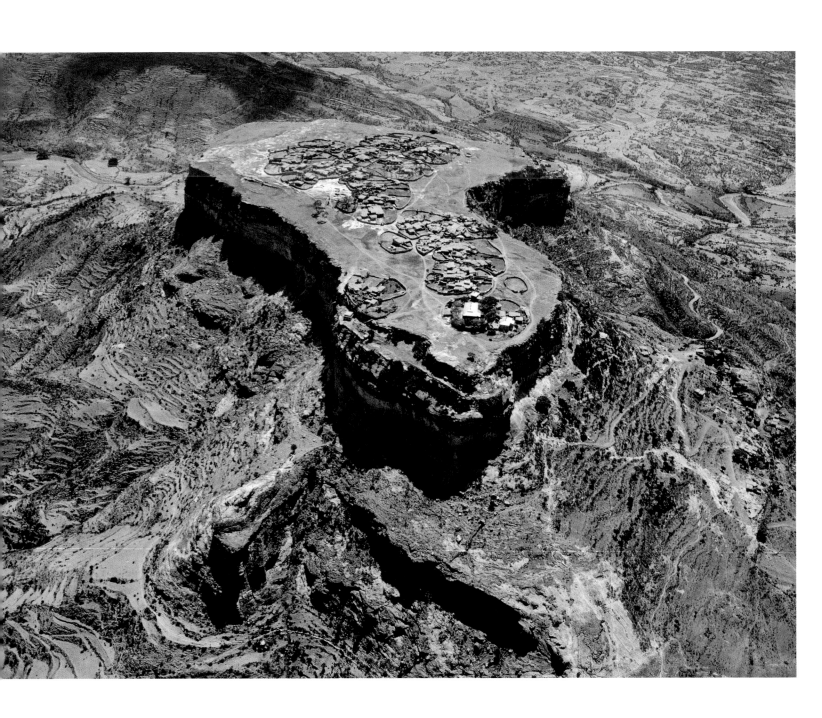

167 | **The mountain monastery of Dabra Damo**, 7th–11th century AD, Ethiopia, 1965

168 | **The temples and pyramids at Gebel Barkal**, 750–250 BC, Sudan, 1963. World Heritage Site

169 | *272:* **The Acropolis at Athens**, fl. 6th–5th century BC, Greece, 2000. World Heritage Site

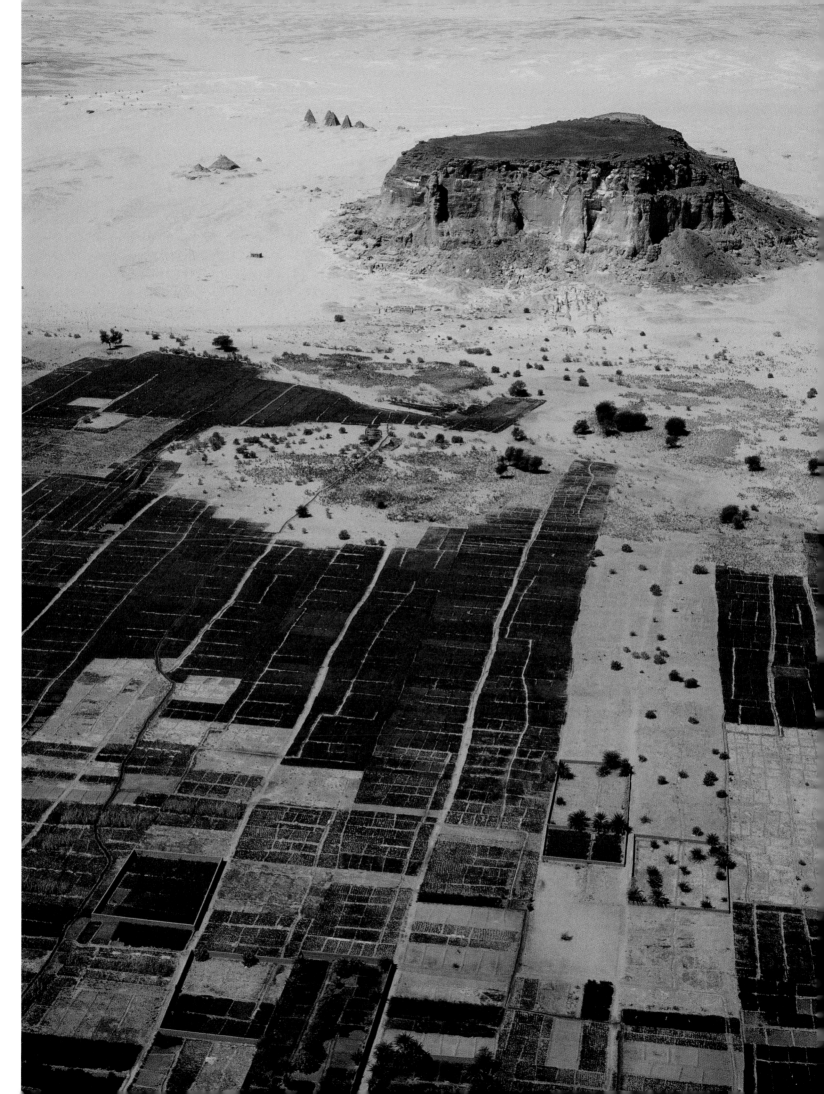

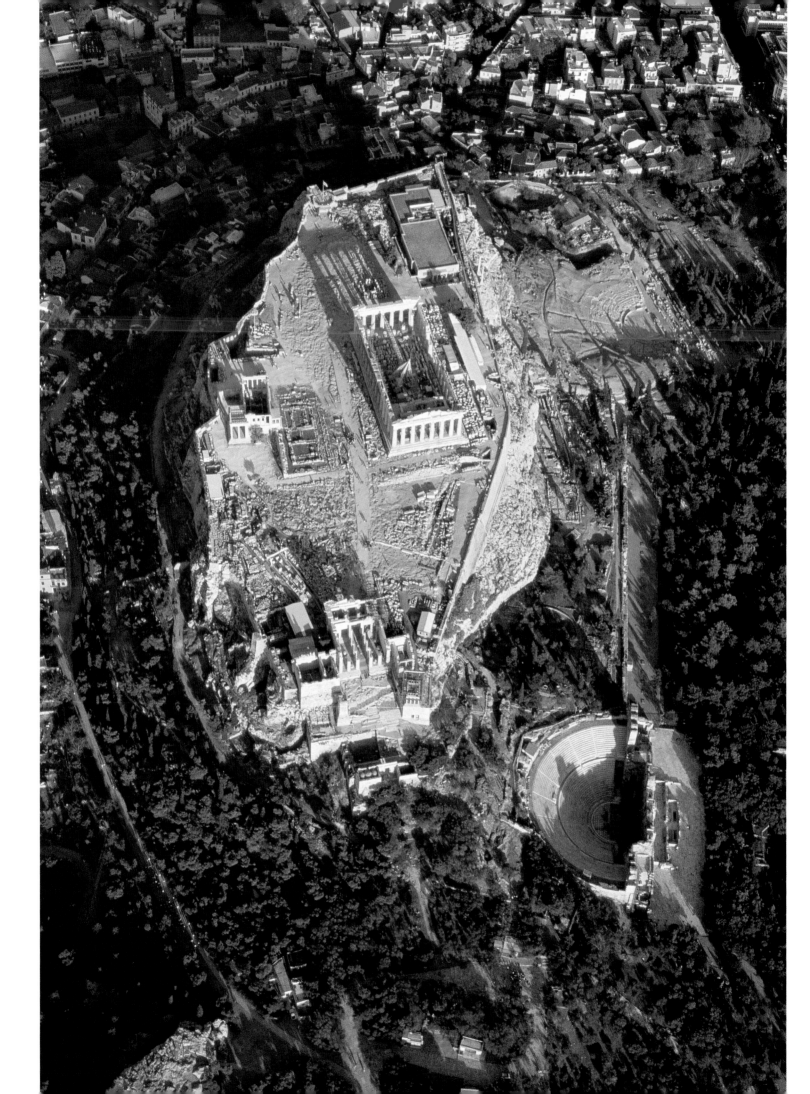

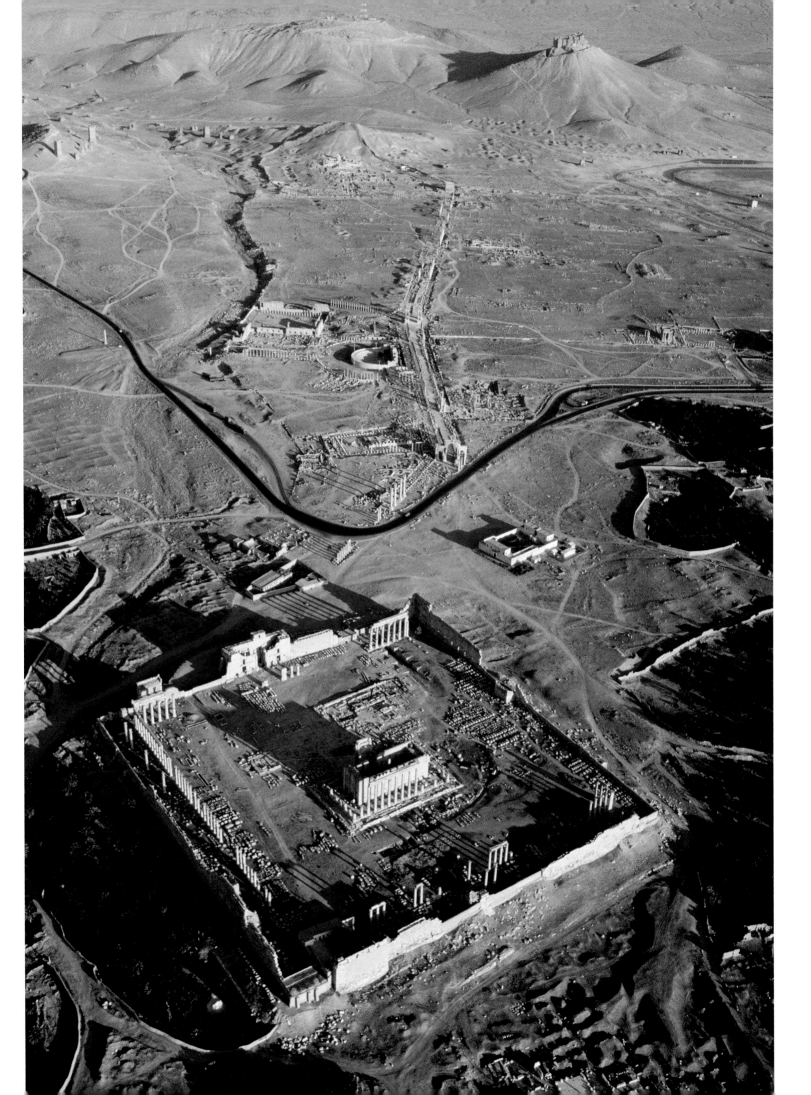

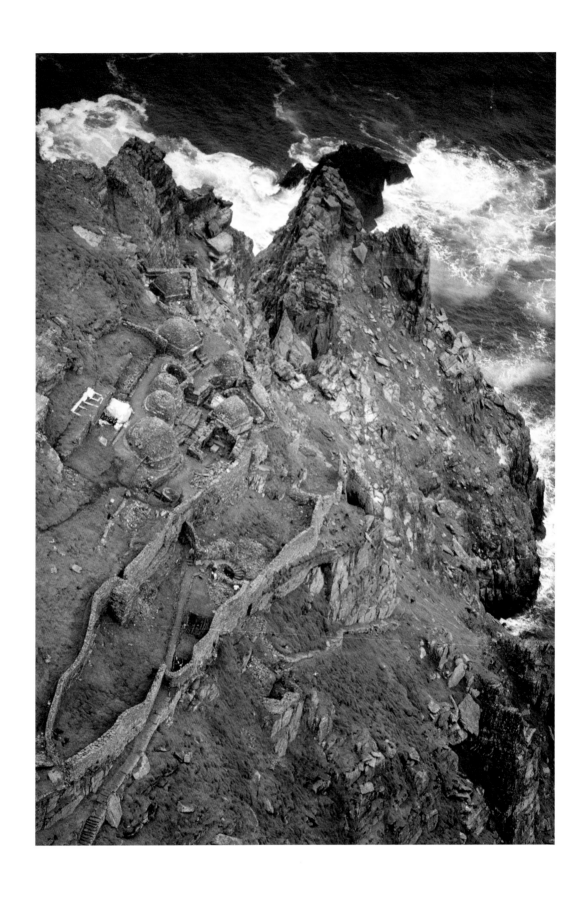

273: **The caravan city of Palmyra**, fl. 1st century BC–3rd century AD, Syria, 1997. World Heritage Site

171 | **The island of Skellig Michael**, 12th century AD, Ireland, 1989. World Heritage Site

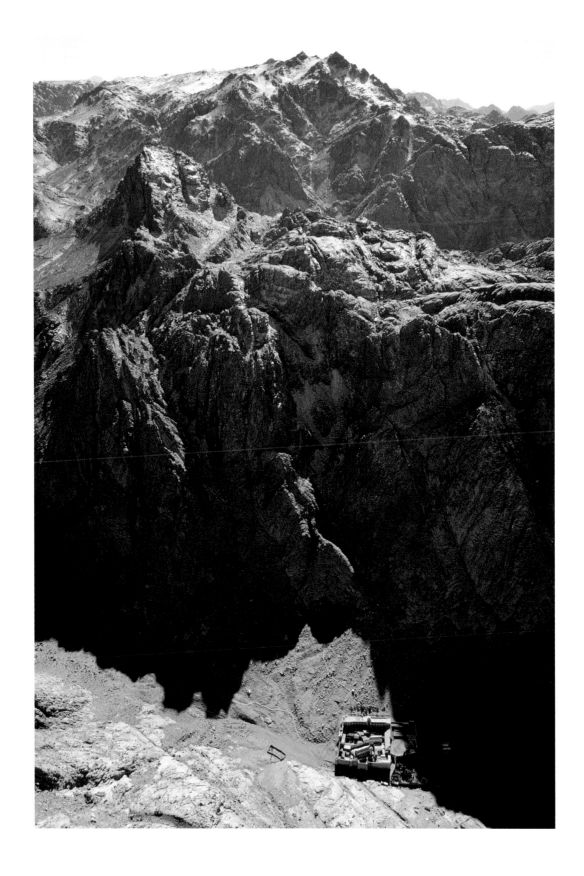

172 | **St Catherine's Monastery on the Sinai Peninsula**, from AD 562, Egypt, 1971. World Heritage Site

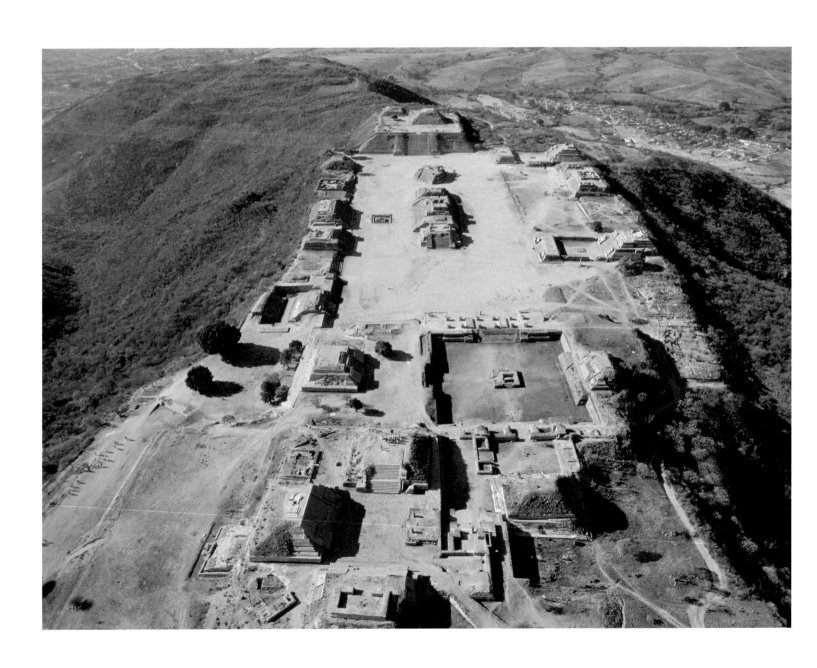

173 | **Monte Albán, the Zapotec capital**, fl. 3rd–7th century AD, Mexico, 1997. World Heritage Site

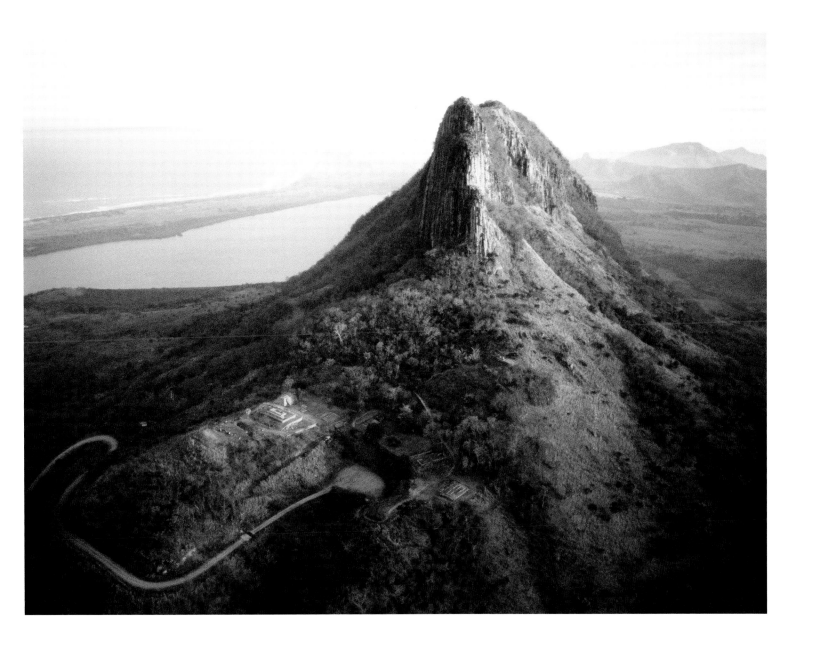

174 | **The temples at Quiahuiztlan**, Totonac culture, 15th century AD, Mexico, 1997

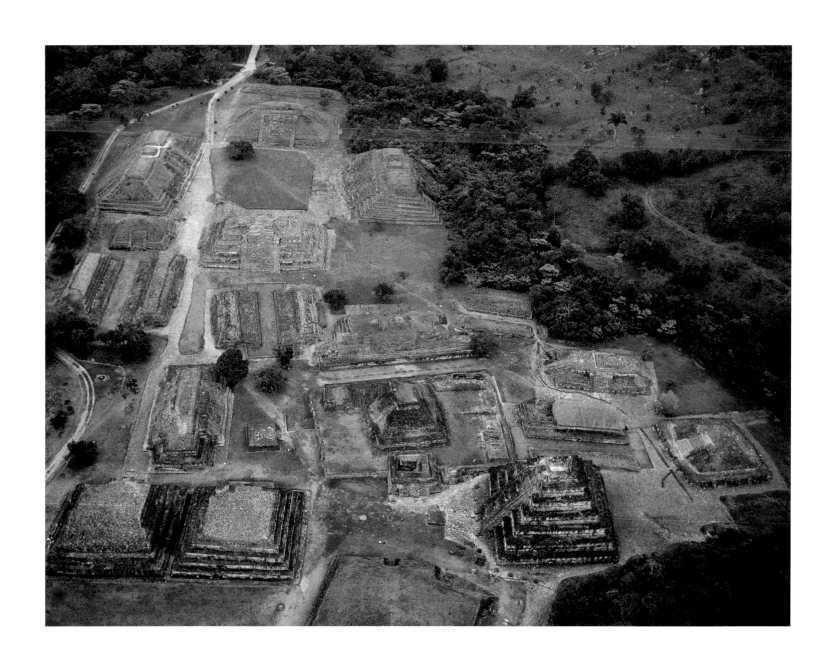

175 | **El Tajín, Veracruz**, 9th–12th century AD, Mexico, 1997. World Heritage Site

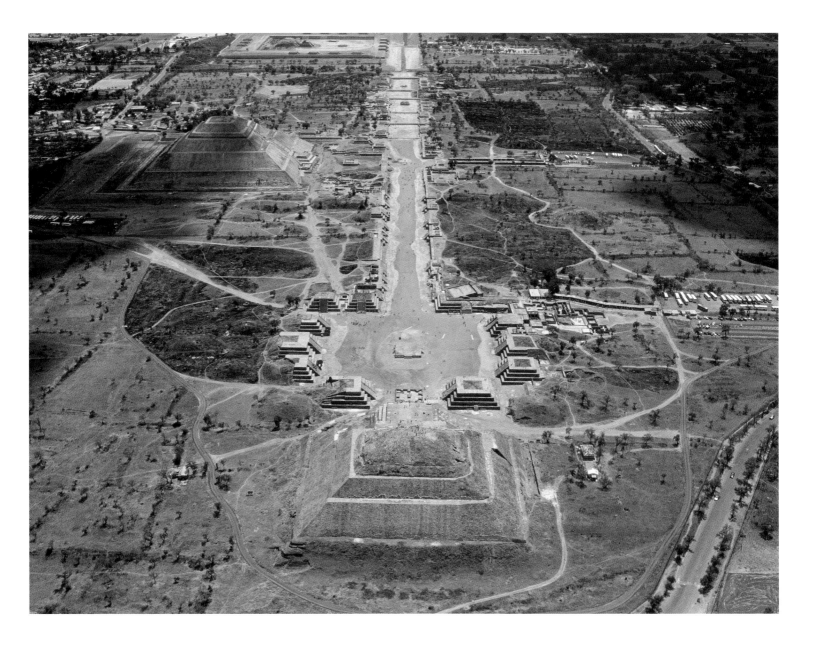

176 | **The pyramids at Teotihuacan**, 1st–5th century AD, Mexico, 1997. World Heritage Site

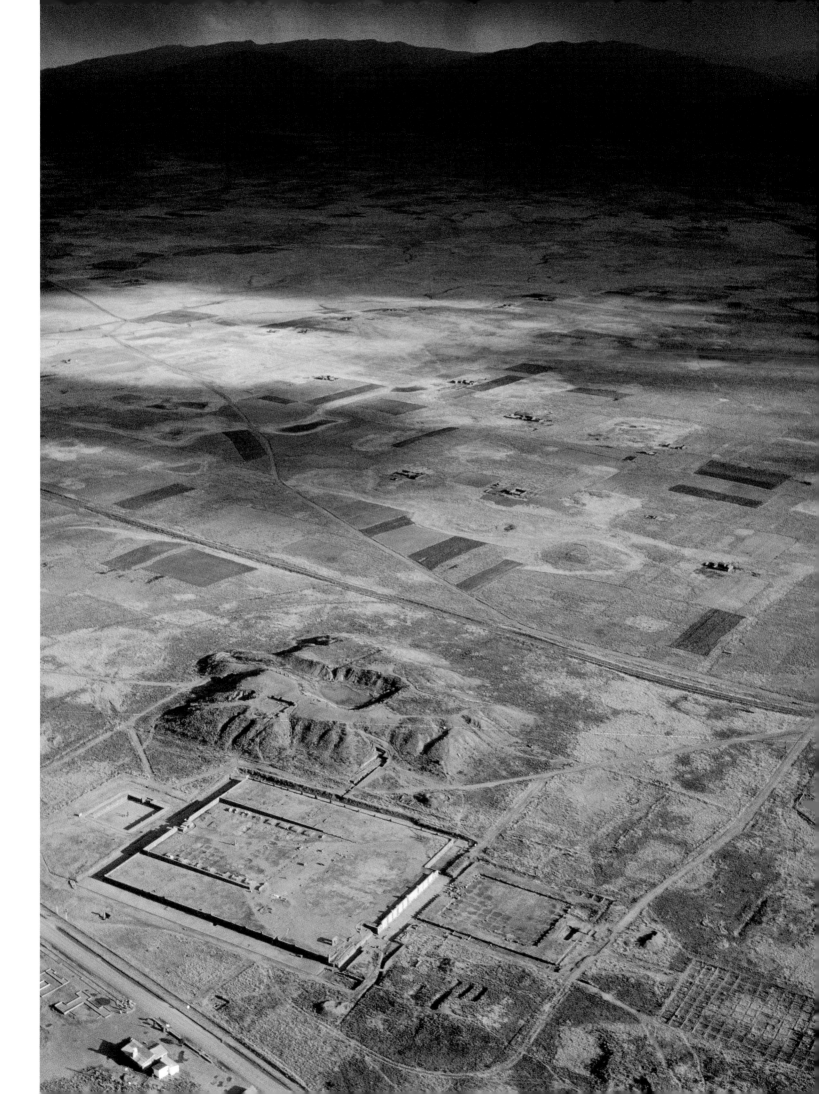

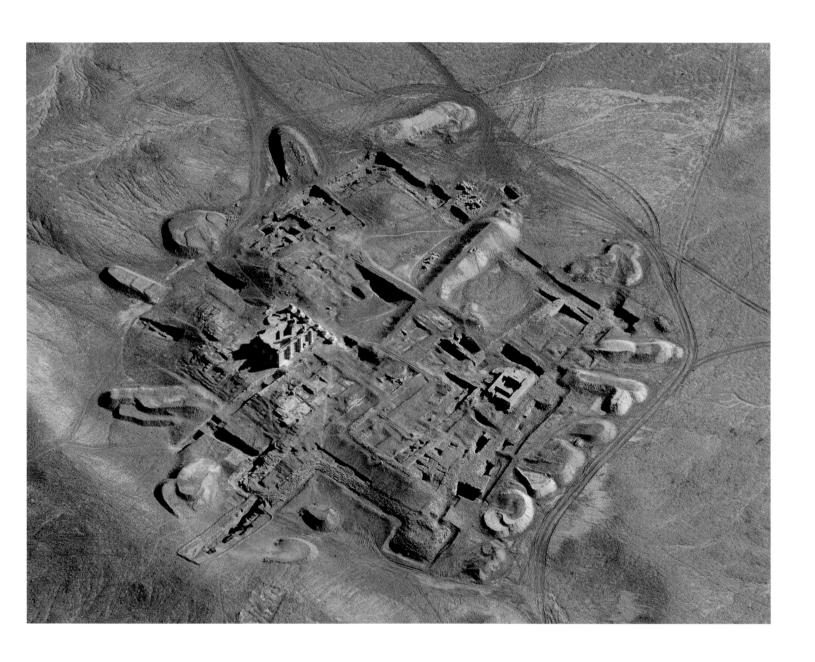

177 | **The ruins at Tiahuanaco**, fl. AD 300–900, Bolivia, 1994. World Heritage Site

178 | **The Temple of Gareus, Uruk**, 2nd century AD, Iraq, 1973

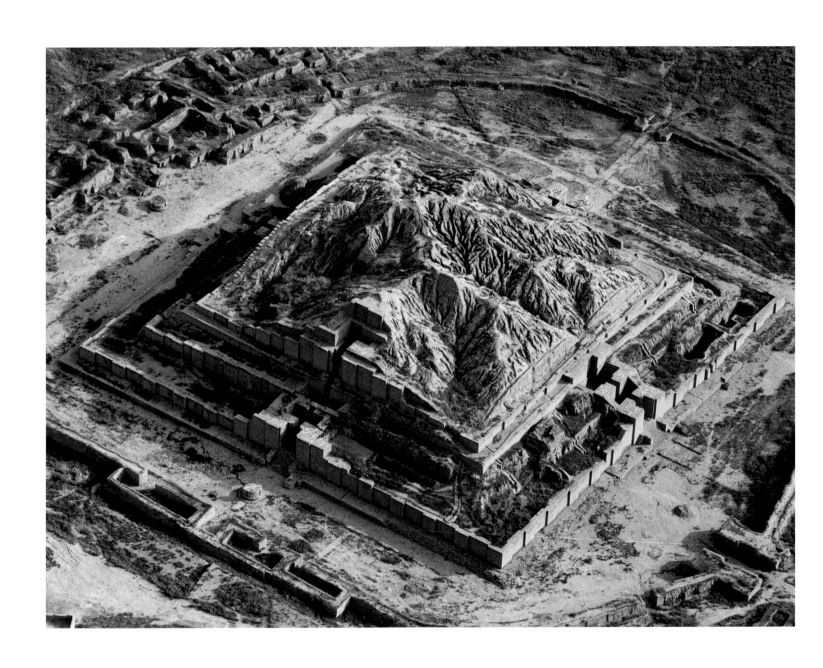

179 | **The ziggurat at Choga Zanbil**, mid-13th century BC, Iran, 1976. World Heritage Site

180 | **The Tower of Babel**, 6th century BC, Iraq, 1973

181 | *284–5:* **The zigurrat at Ur**, 21st century BC, Iraq, 1973

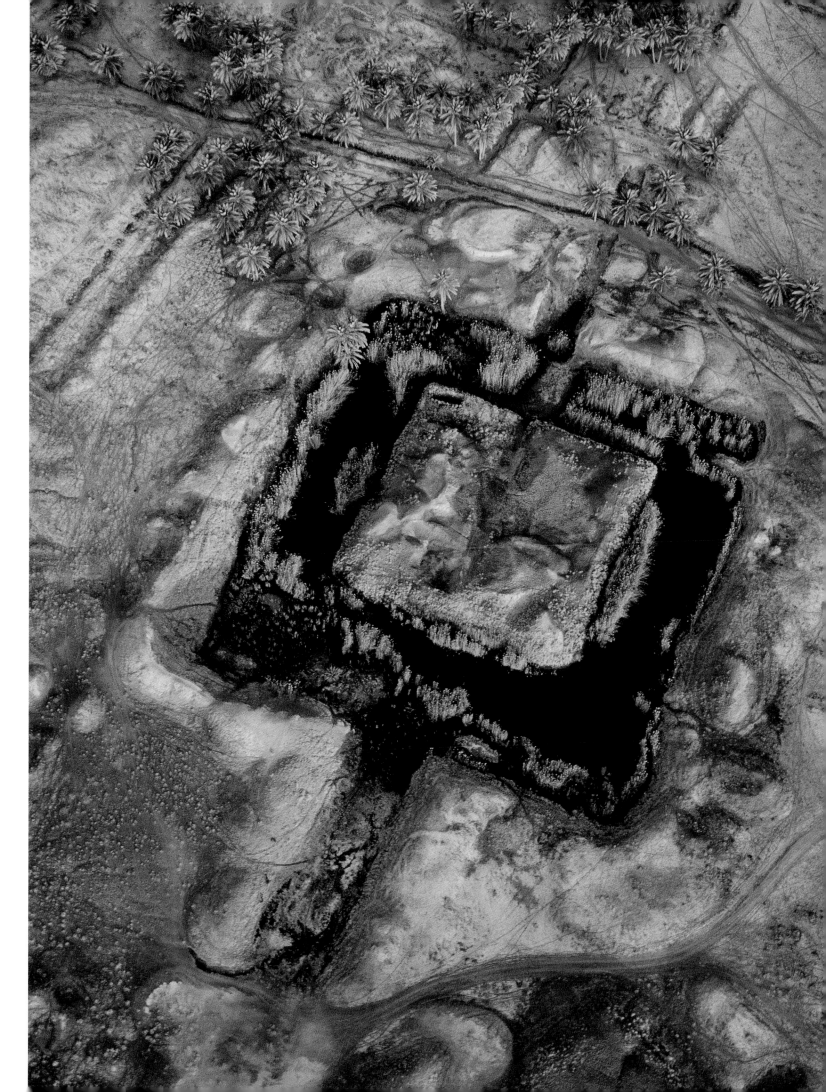

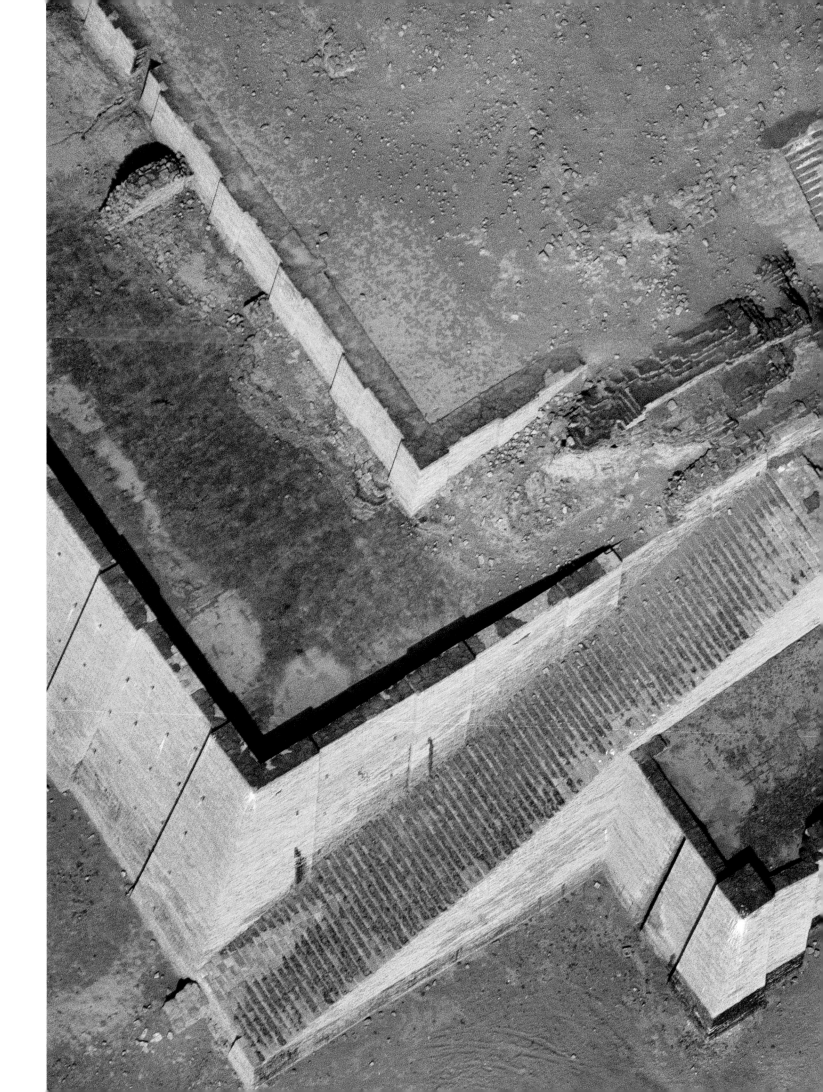

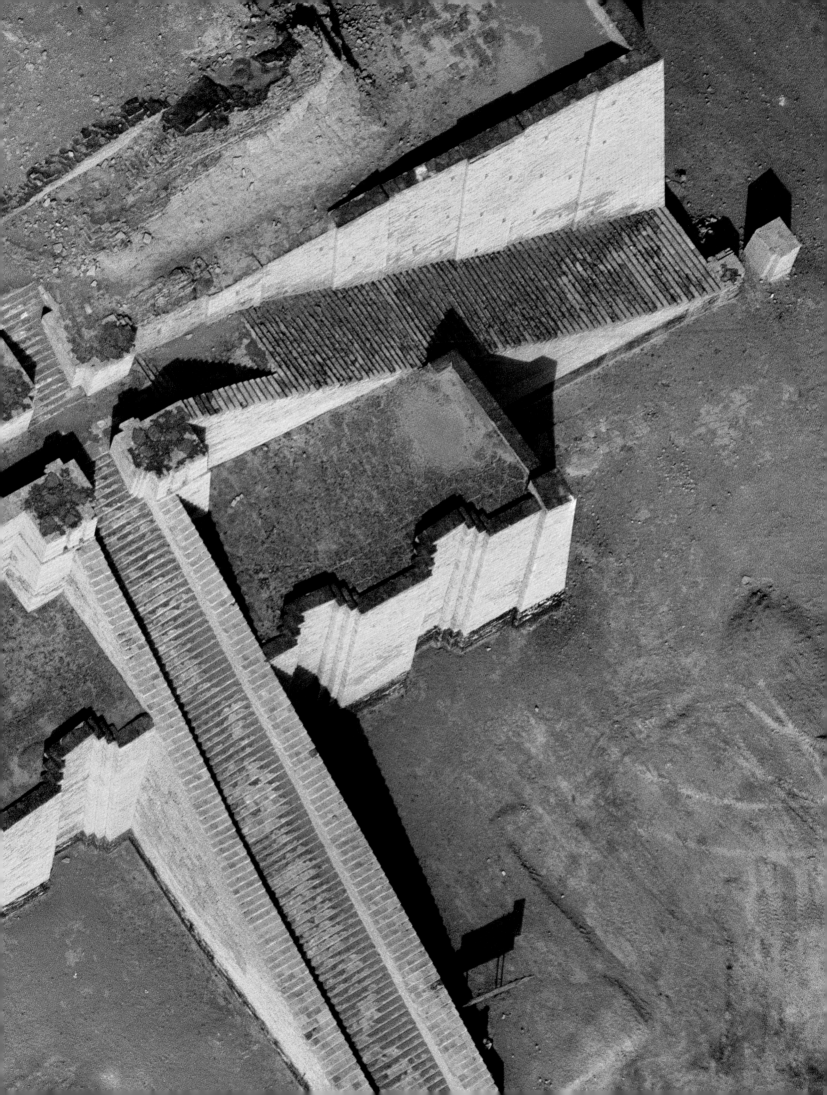

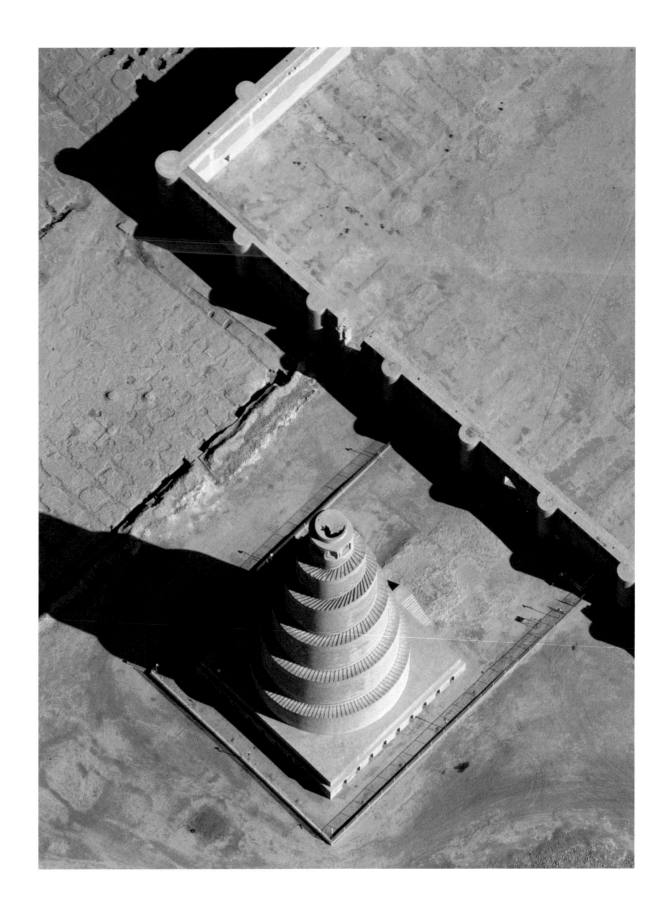

182 | **The Great Mosque at Samarra**, 9th century AD, Iraq, 1973

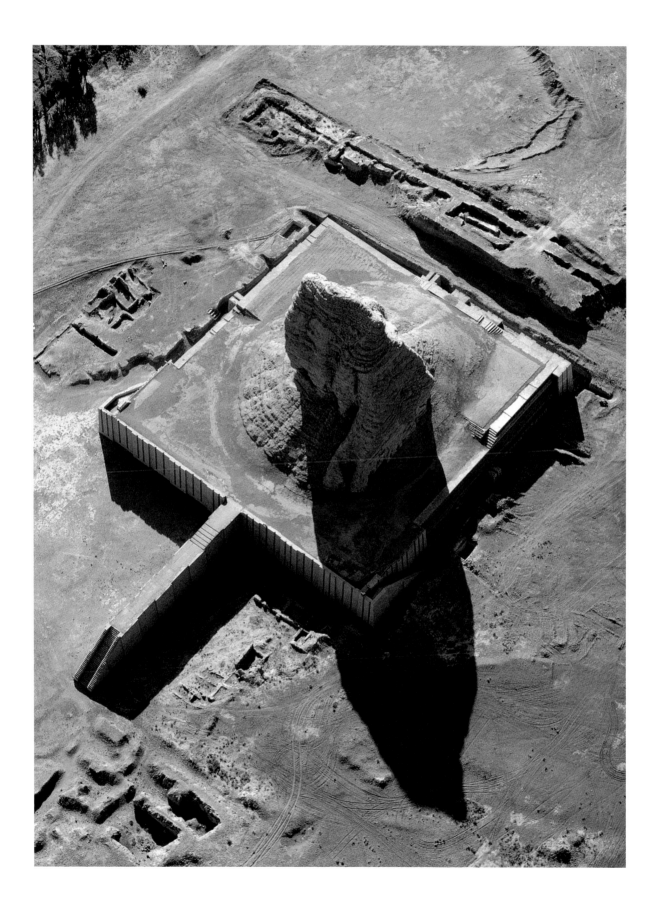

183 | **The ziggurat at Aqar Quf**, 14th century BC, Iraq, 1973

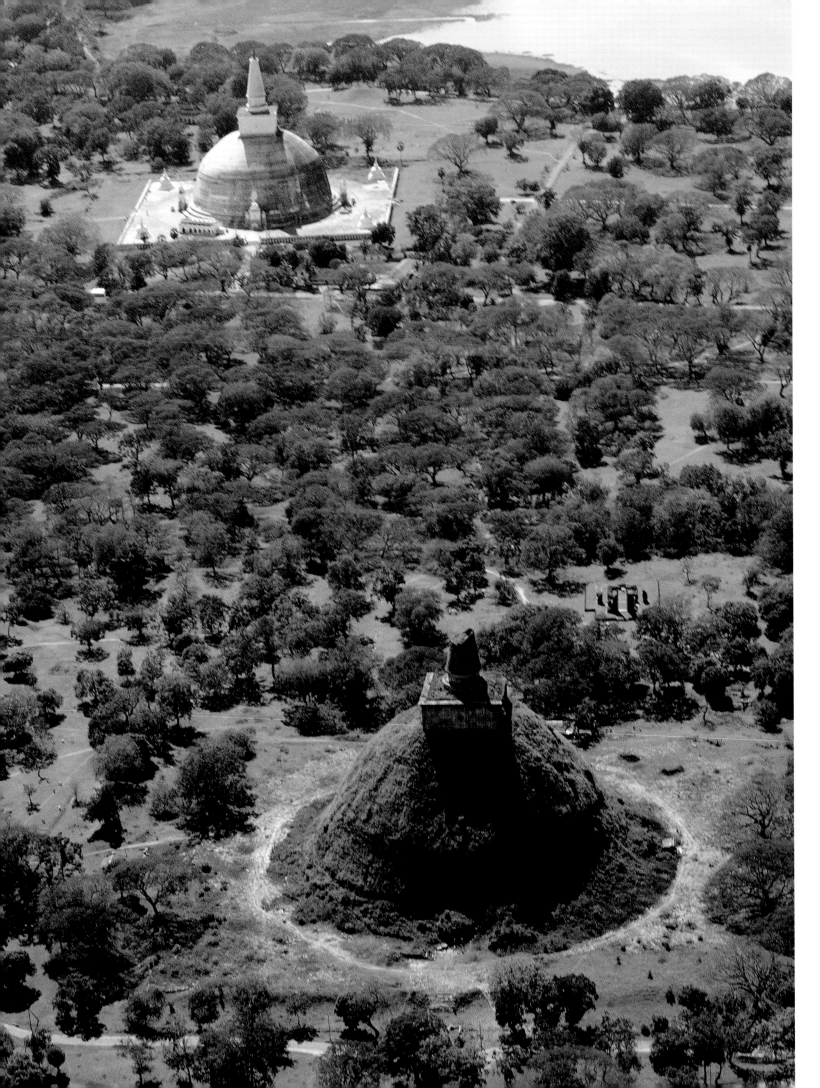

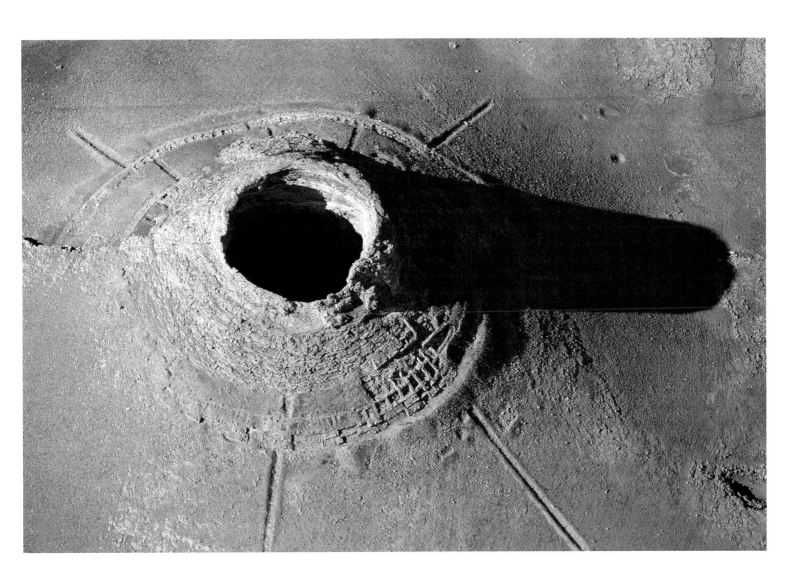

184 | **The Buddhist centre at Anuradhapura**, 3rd century BC–AD 1017, Sri Lanka, 1969. World Heritage Site

185 | **The spring cone at Zendan-i Suleiman**, early 1st millennium BC, Iran, 1976. World Heritage Site

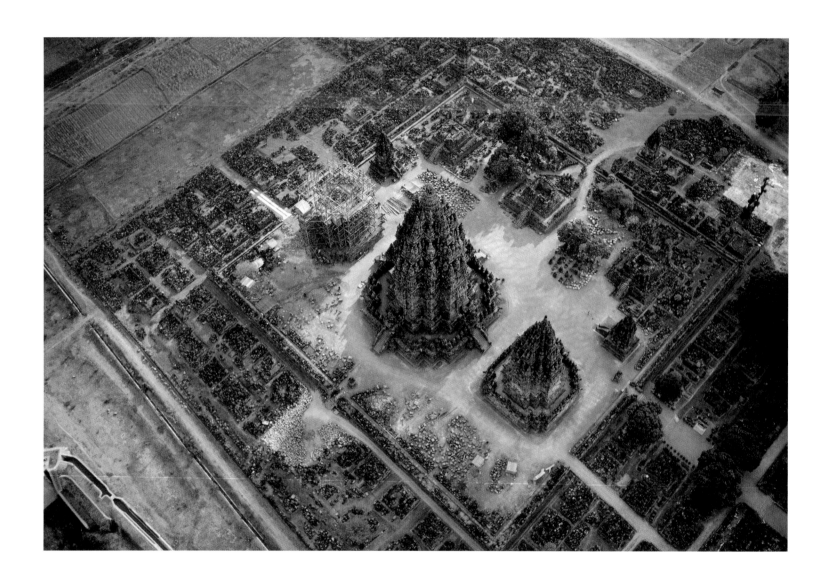

186 | **The temple complex at Prambanan on Java**, mid-9th century AD, Indonesia, 1989. World Heritage Site

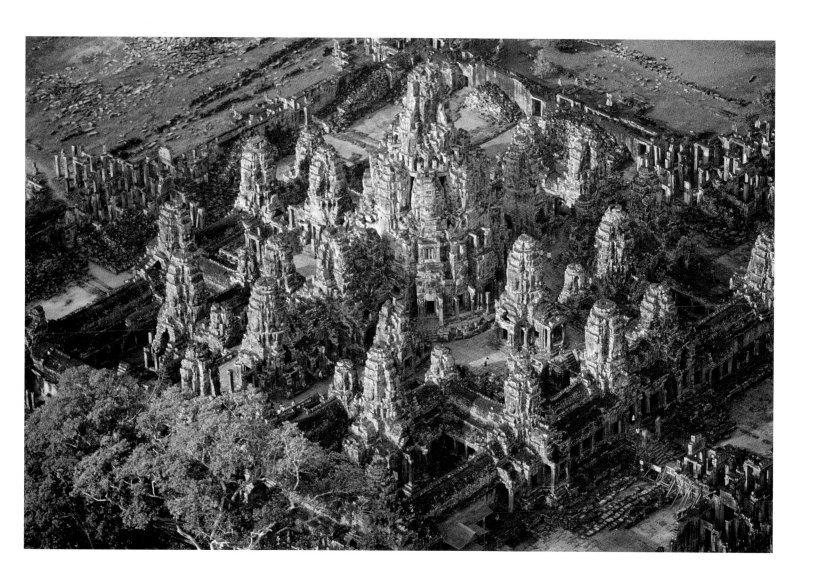

187 | **The Bayon at Angkor Thom**, late 12th/early 13th century AD, Cambodia, 1997. World Heritage Site

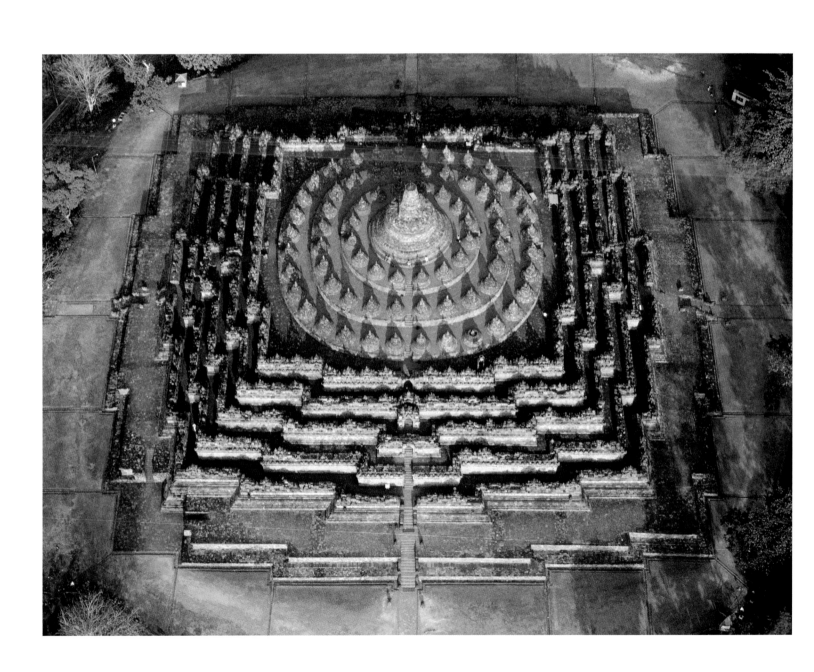

188 | **Borobudur on Java**, AD 780–930, Indonesia, 1989. World Heritage Site

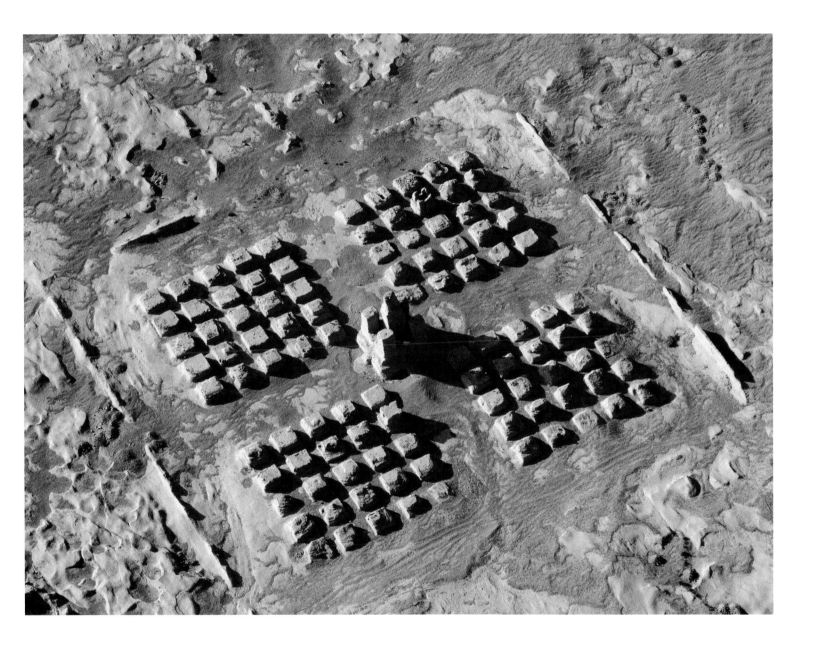

189 | **The Temple of a Hundred Stupas in Jiaohe**, 5th–6th century AD, China, 1987

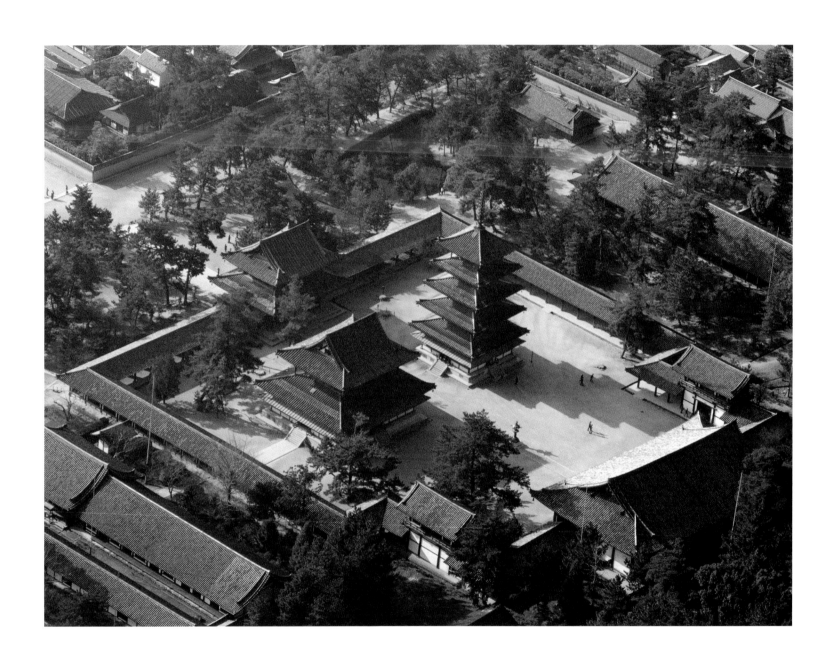

190 | **The Horyu-ji Temple at Nara**, founded AD 607, Japan, 1998. World Heritage Site

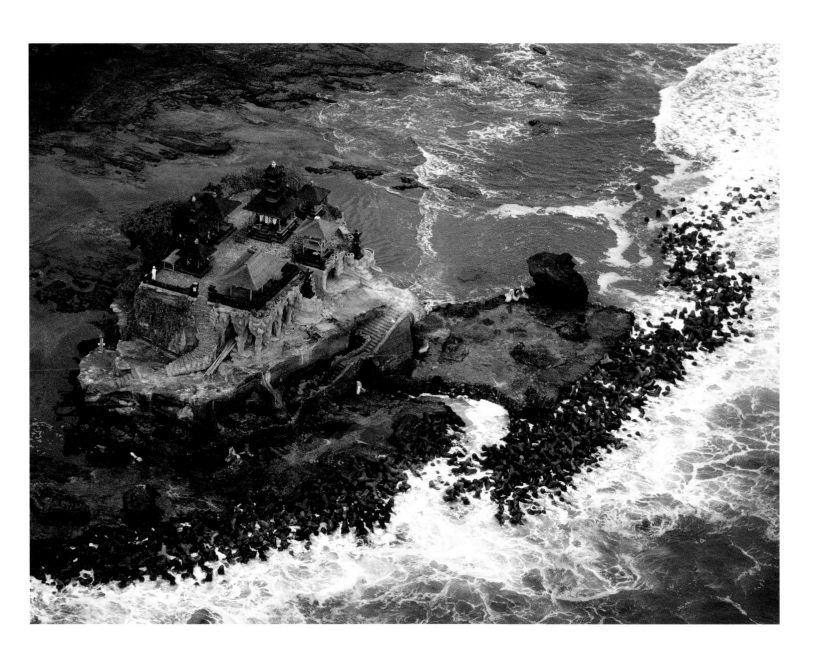

191 | **The Temple at Tanah Lot on Bali**, 18th century AD, Indonesia, 1989

192 | *296–7:* **The Inner Shrine at Ise on Honshu**, from 5th century AD, Japan, 1993

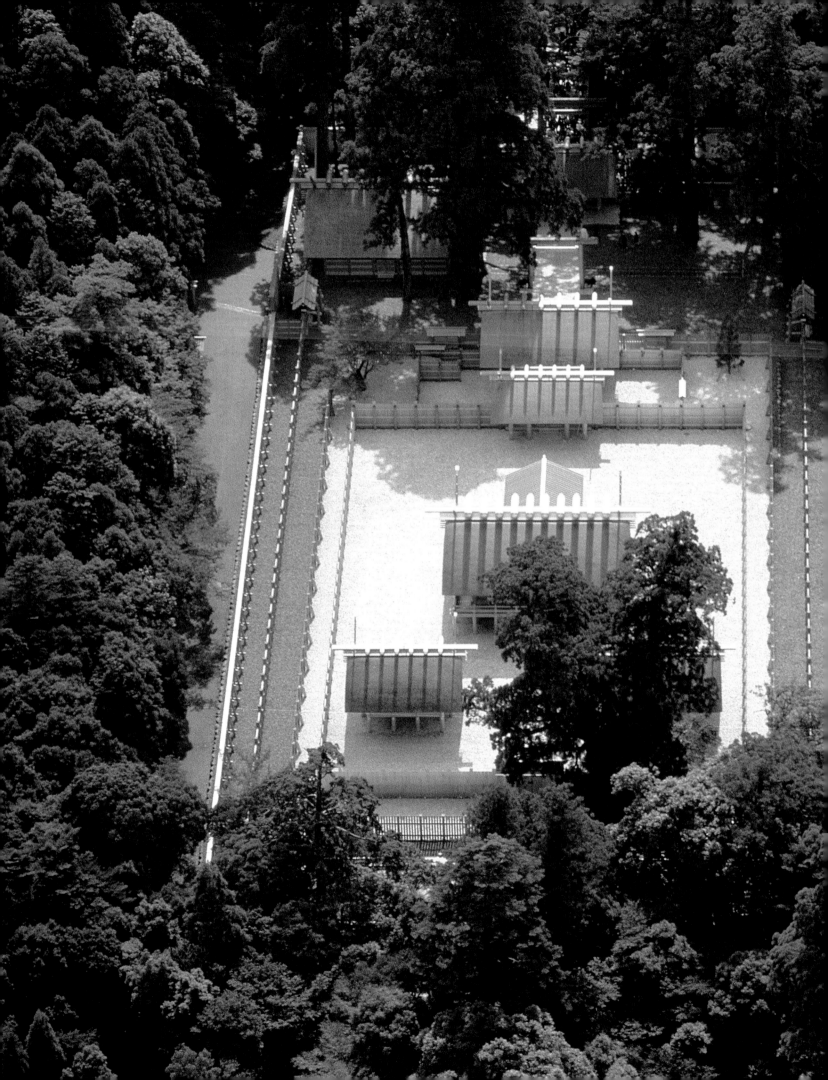

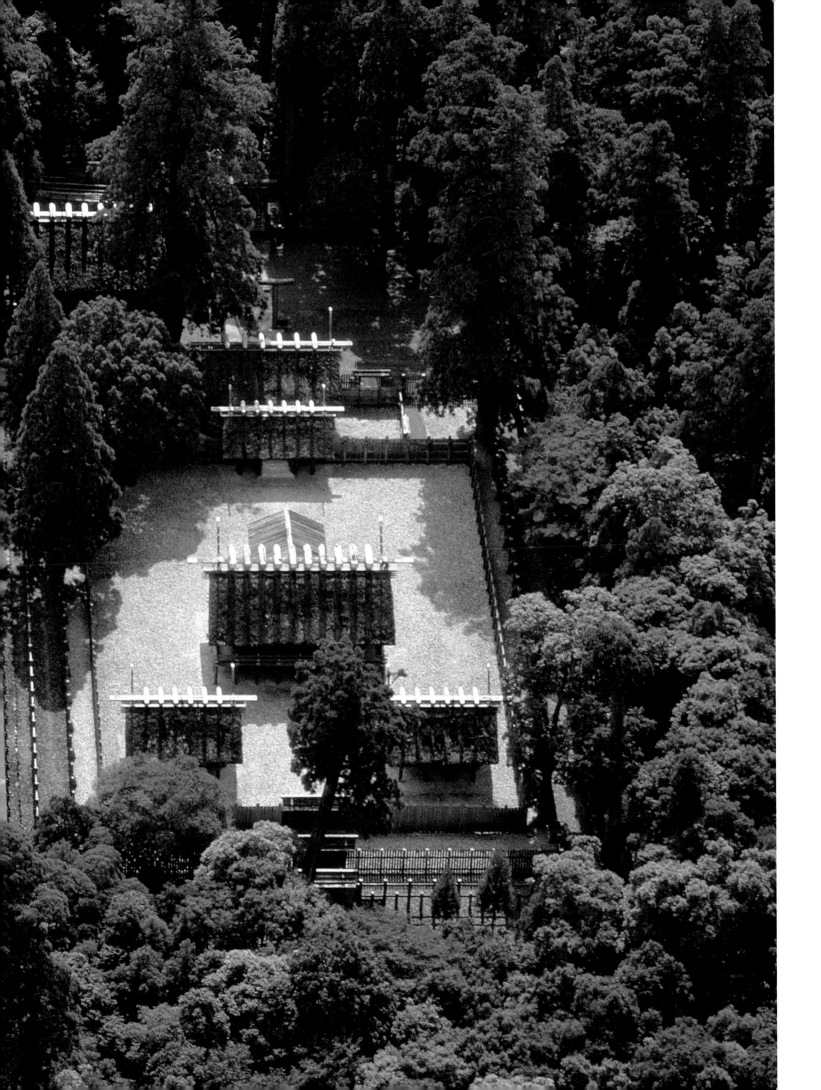

193 | **The Fushimi-Inari Shrine in Kyoto**, founded AD 711, Japan, 1992

194 | **The monolith church of Beta Giyorgis in Lalibela**, AD c1200, Ethiopia, 1968. World Heritage Site

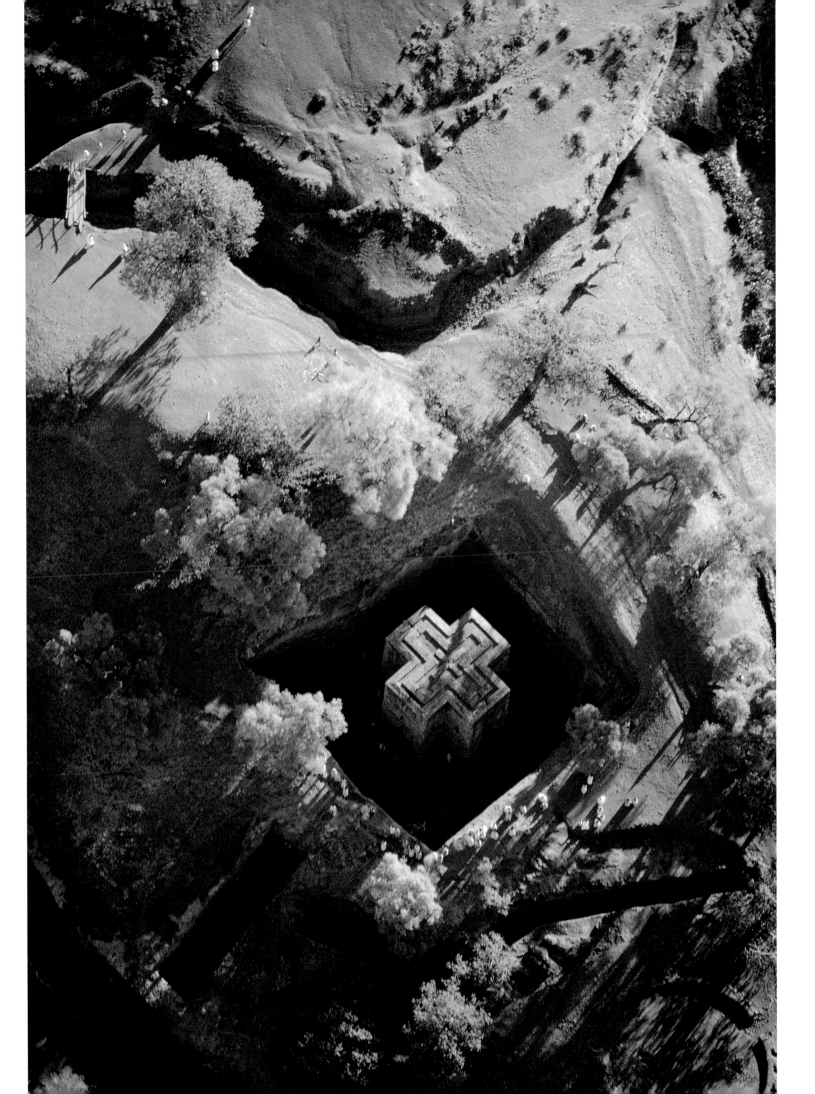

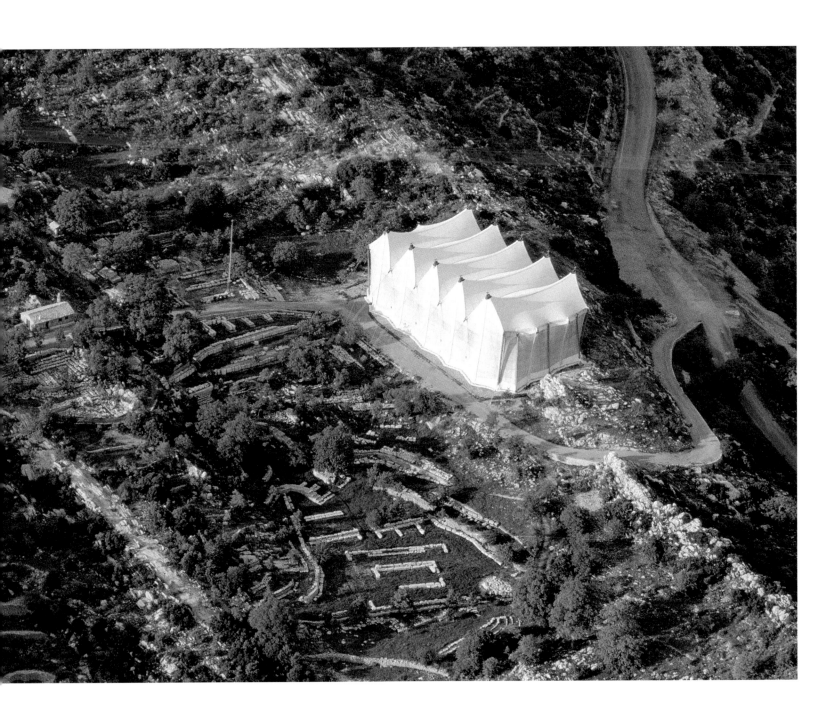

195 | **The Temple at Bassae in the Peloponnese**, *c*420 BC, Greece, 1998. World Heritage Site

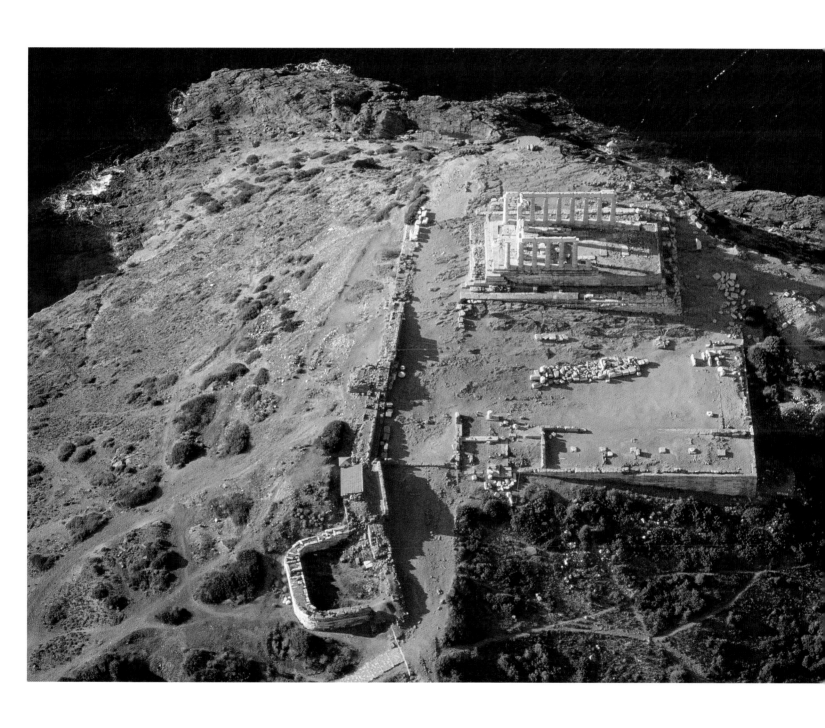

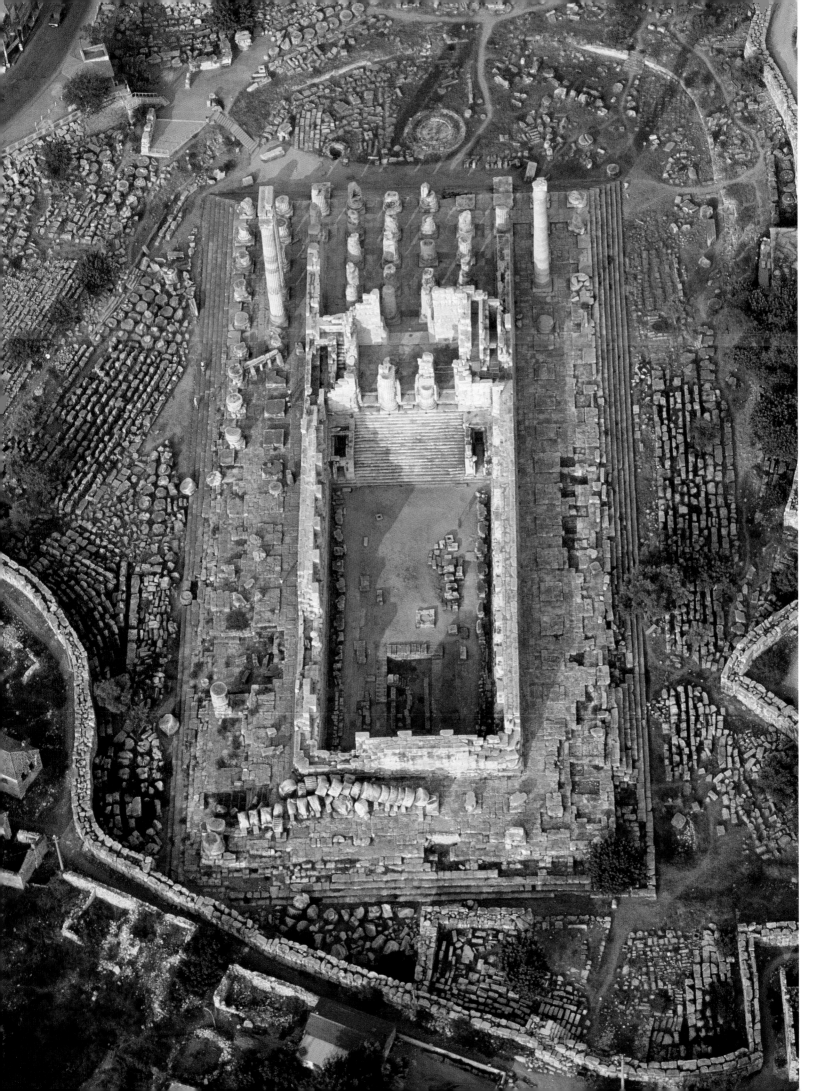

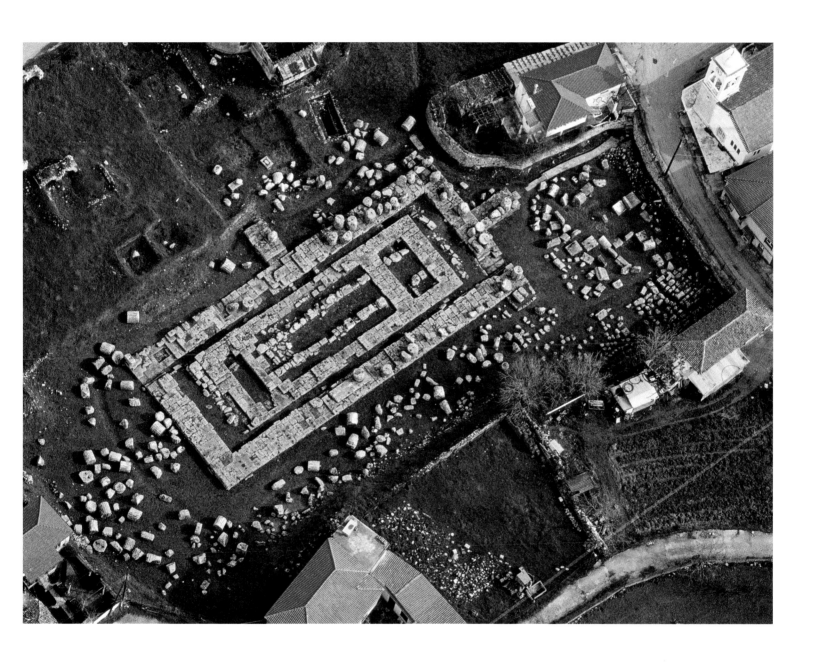

197 | **The Temple of Apollo at Didyma**, late 4th century BC, Turkey, 2002

198 | **The Temple of Athena at Tegea in the Peloponnes**, 4th century BC, Greece, 2001

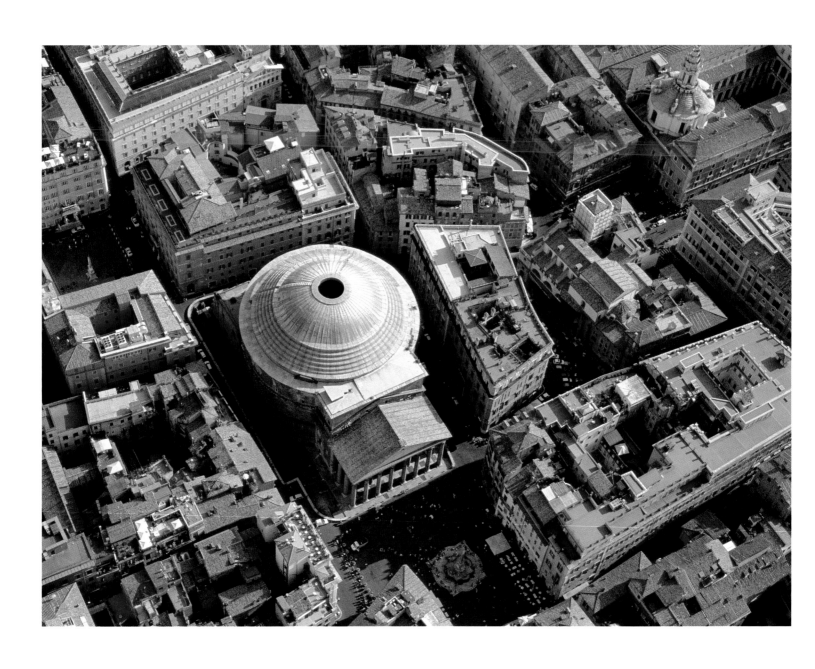

199 | **The Pantheon in Rome**, 27–25 BC and AD 118–25, Italy, 2002. World Heritage Site

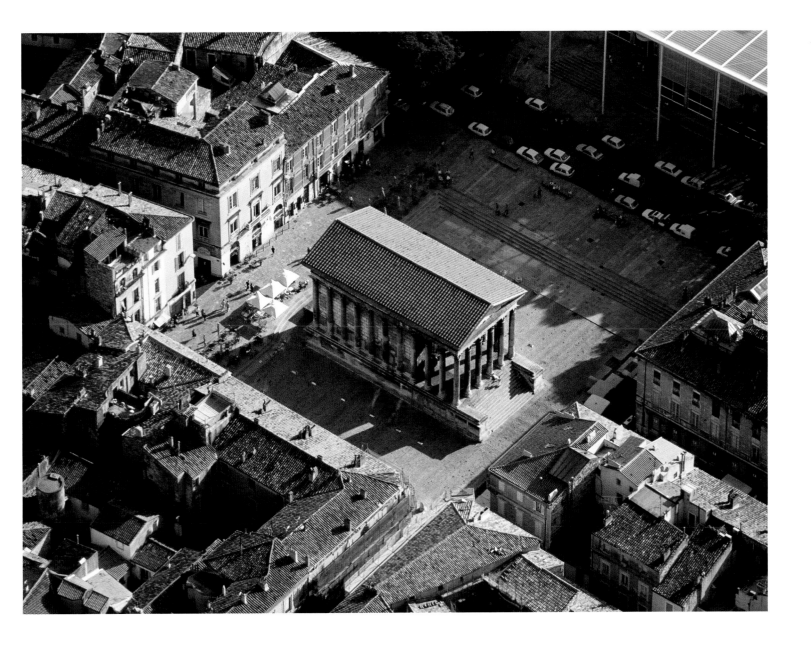

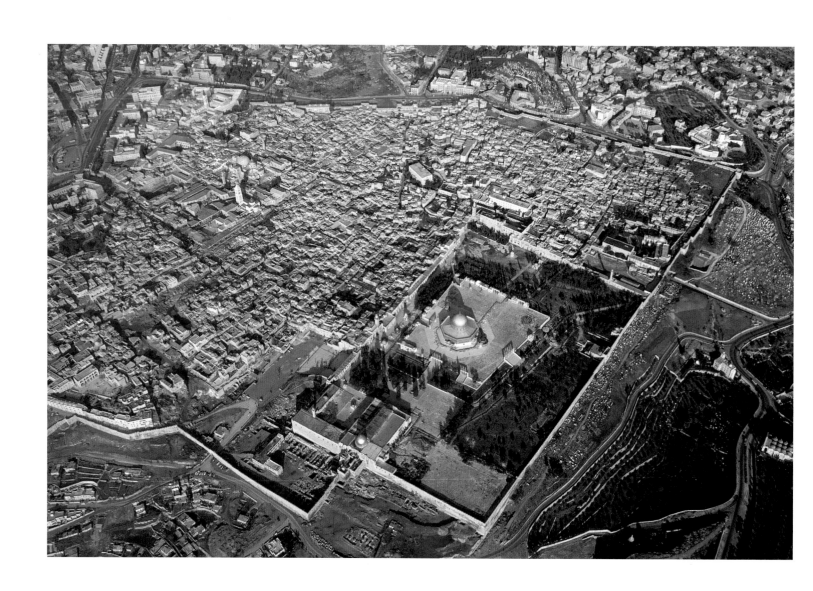

201 | **The Old City of Jerusalem/Al Khutz**, 1971. World Heritage Site

202 | **The Temple Square in Jerusalem/Al Khutz**, from the 1st century BC, 1972. World Heritage Sit

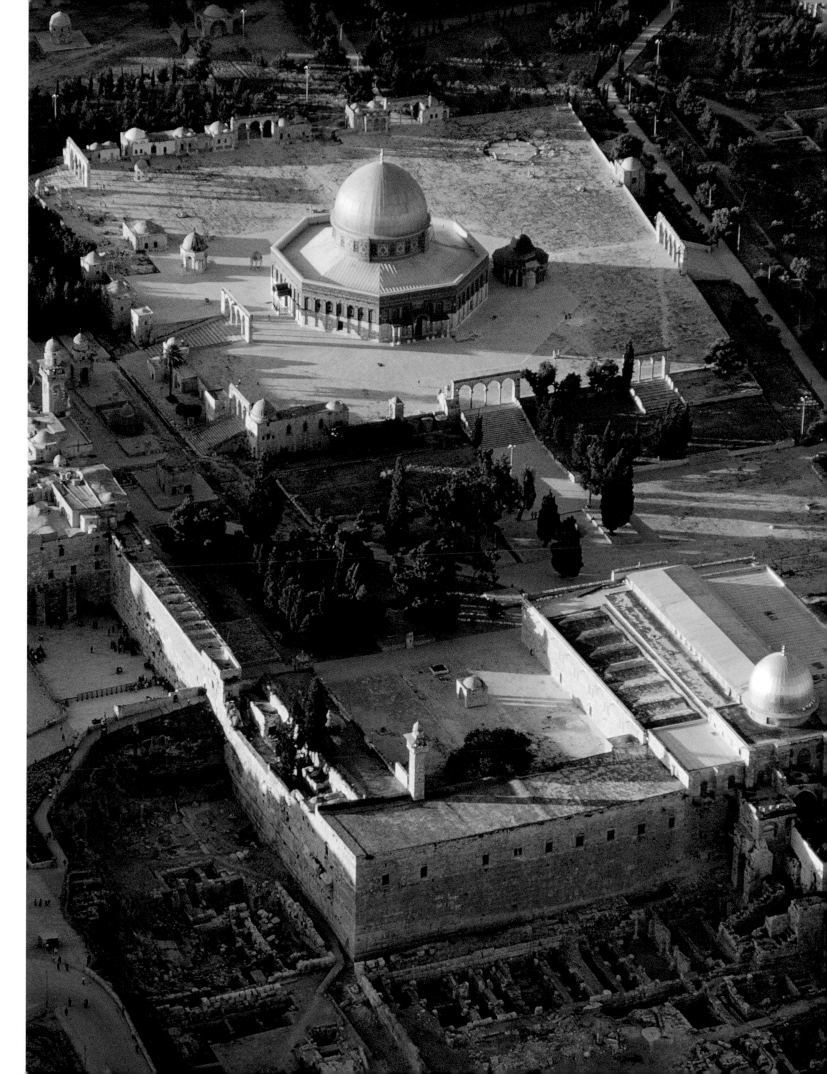

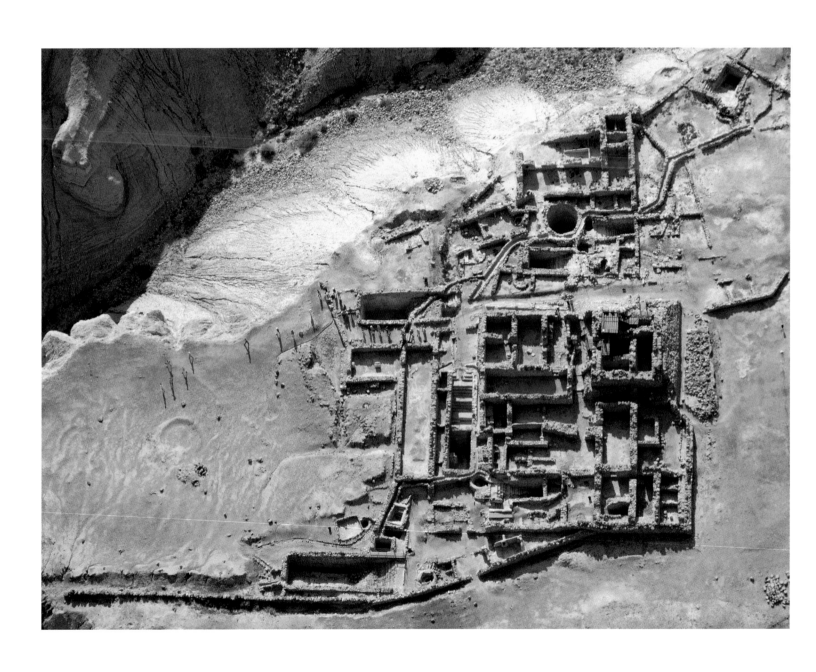

203 | **The settlement at Qumran**, from around the time of the birth of Christ, Palestine, 1972

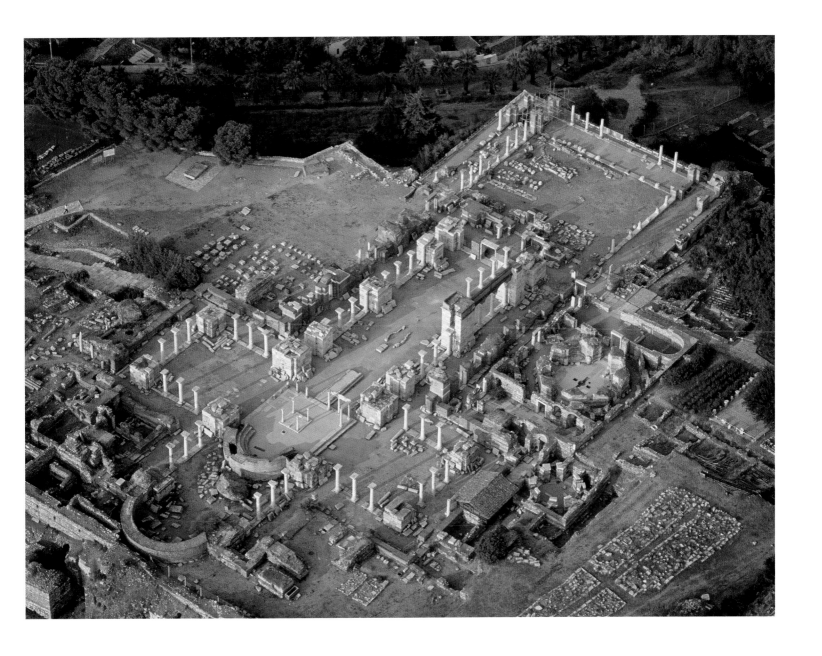

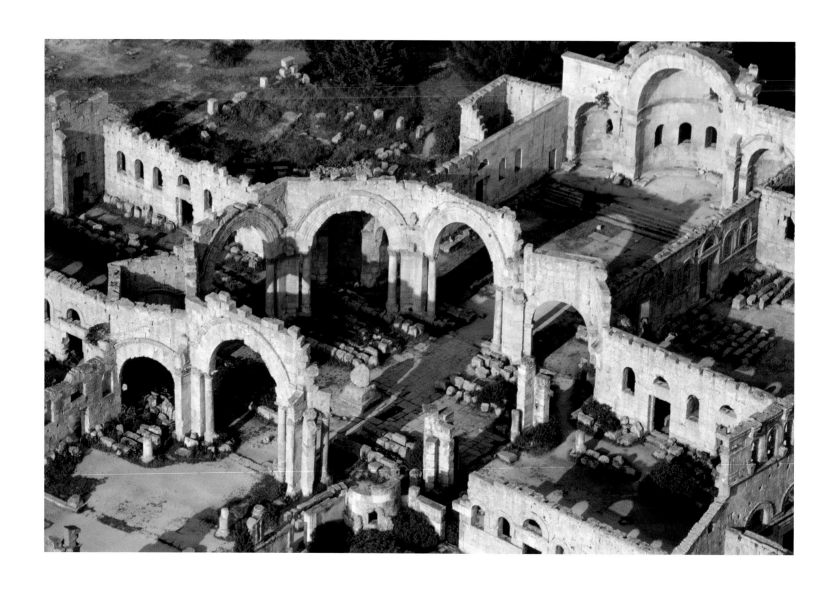

205 | **St Simeon's Monastery**, late 5th–6th century AD, Syria, 1997

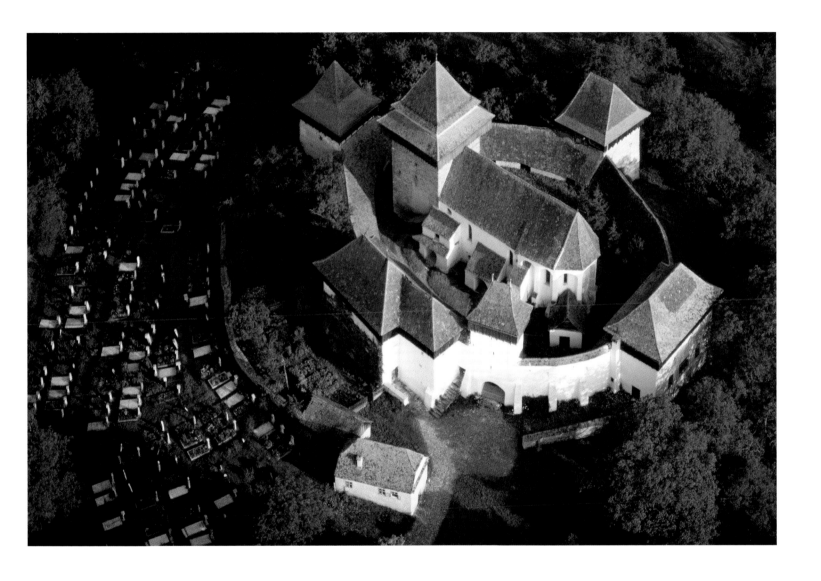

206 | **The fortified church at Viscri**, 15th century AD, Romania, 1991. World Heritage Site

153 | **Kar-Tukulti-Ninurta, Iraq**

It is said to have been at the bidding of the god
Ashur that King Tukulti-Ninurta I (1244–1208 BC)
founded a new city in the eleventh year of his reign
some 3km upstream from Ashur on the opposite
bank of the Tigris. He called it Kar-Tukulti-Ninurta,
meaning the 'Fortress of Tukulti-Ninurta'. It was
built as a symbol of imperial might following his
conquest of Babylon and victory over the Kassite
king Kashtiliash IV. A rambling palace complex lay
on the banks of the Tigris (at the top of the photo-
graph). It was brightened with cedarwood columns,
which Tukulti-Ninurta's predecessor Adadnarari I
had brought back as booty from Khanigalbat and
which had subsequently been incorporated into the
New Palace at Ashur. The palace walls were covered
in coloured plaster. To the south-east of the palace
(at the foot of the picture) is the ziggurat dedicated
to the god Ashur. It apparently had no stairs of its
own and could be entered only by free-standing
steps connected to it by a bridge. Kar-Tukulti-
Ninurta lasted only a few years, falling into neglect
following the assassination of its founder. The area
enclosed within the city wall was apparently never
completely settled. The German Orient Society
conducted excavations here in 1913, but its work
was not taken up again until 1986 and 1989, only to
be curtailed by the war with Kuwait. Kar-Tukulti-
Ninurta would have been be among the first victims
of the Maqhul Dam, which had threatened to flood
this section of the Tigris Valley (no. 12).
M. M.-K.

W. Andrae and W. Bachmann, 'Aus den Berichten über die
Grabungen in Tulul Akir (Kar Tukulti-Ninib)', *Mitteilungen
der Deutschen Orientgesellschaft*, 53 (1914), 41–57;
R. Dittmann, 'Ausgrabungen der Freien Universität Berlin
in Assur und Kar-Tukulti-Ninurta in den Jahren 1986–89',
Mitteilungen der Deutschen Orient-Gesellschaft, 122 (1990),
157–71

154 | **The megalithic temple at Hagar Qim, Malta**

Few structures are more characteristic of Malta than
the megalithic temple at Hagar Qim, which dates to
the 3rd millennium BC and towers up emblemati-
cally on a hill 1km distant from the island's
southern coastline and some 10km south-west of
its capital, Valletta. The complex is around 35m long
and is made from huge, carefully squared limestone
blocks measuring up to 20 tons each. Its curiously
irregular form is the result of modifications to its
original, standardized groundplan. Its nucleus is its
eastern half, which is seen here in the lower half of
the photograph and which was originally semicir-
cular in plan. From the southern façade to the left of
the photograph a gateway leads to a passage to
which access can also be gained from the north of
the complex. To each side of the passage are two
sets of semicircular apses partly divided off by
vertical slabs pierced by a rectangular opening. The
complex was extended in a westerly direction by
four additional oval rooms that open either to the
outside or to one of the original side rooms. Stone
slabs raised above the ground or positioned in the
apses are believed to be altars, just as the complex
as a whole is thought to be a sanctuary. To the
south lies a further, somewhat simpler structure
with circular chambers that was presumably also
part of the temple. The site is first mentioned in the
17th/18th century. It was repeatedly excavated and
restored in the 19th and 20th centuries, when
numerous obese stone statuettes of women were
found here. No doubt a part of the cult that was
practised here, they are now in the Valletta
Museum.
V. P.

J. D. Evans, *Malta* (London 1963), 103–9 (Ancient Peoples
and Places 11); J. D. Evans, *The Prehistoric Antiquities of the
Maltese Island: A Survey* (London 1971), 80–94; D. H.
Trump, *Malta: An Archaeological Guide* (London 1972),
93–7

155 | **The Tsodilo Hills, Botswana**

The Tsodilo Hills in north-west Botswana rise up to
a height of 320m over the flat, dry high plateau of
the western Kalahari. The highest points in the
massif are likened to a man, a child and a woman
by the Kung San, the ethnic group that lives in the
area and that until recently was still pursuing a
hunter-gatherer existence. Because of its plentiful
supply of water in one of the driest regions of the
earth, the Tsodilo Hills have been visited by hunter-
gatherers for over 35,000 years. The Hills are
notable not only for their prehistoric haematite
mines but also for more than 350 sites where over
4500 rock paintings have been found representing
local fauna, together with whales, penguins, human
beings and symbols. Covering an area of only 10 sq
km, the Hills thus have the densest concentration
of rock art anywhere in the world. The most recent
paintings depict cattle and were made during the
last 1500 years. Many were painted with the fingers
and show only outlines, thereby differing from the
more southerly tradition familiar from the Brand-
berg massif, a gallery of rock paintings in northern
Namibia. Although the rock paintings in the Tsodilo
Hills have been described as the 'Louvre' of
southern Africa, they have yet to be subjected to a
comprehensive and comparative analysis. As a
result, it has been possible only to observe a
general similarity with the rock paintings from the
Matopos Mountains in south-west Zimbabwe. The
local population continues to inhabit this inhos-
pitable region and to venerate the Tsodilo Hills as
the centre of the universe, a mountain of universal
and divine significance to which they undertake
regular pilgrimages.
T. St.

Laurens van der Post, *The Lost World of the Kalahari*
(London 1958); P. Lane and others (eds.), *Ditswa Mmung:
The Archaeology of Botswana* (Gaborone 1999); L. H.
Robbins and others, 'Archaeology, Palaeoenvironment and
Chronology of the Tsodilo Hills White Paintings Rock
Shelter: Northwest Kalahari Desert, Botswana', *Journal of
Archaeological Science*, 27 (2000), 1085–1113

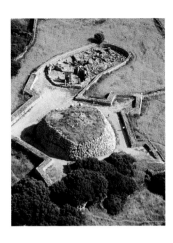

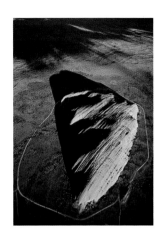

156 | Ubirr Rock, Arnhem Land, Australia

The Kakadu National Park in Arnhem Land in Australia's Northern Territory lies some 200km east of Darwin and is notable for its contrasting landscapes, with meadow-lined rivers alongside lagoons and mountain ranges. In addition to its exceptional range of fauna, the park also contains Ubirr Rock, one of the most important collections of rock art in Australia. Some 100,000 sites of rock art have been identified in Australia, and of these no fewer than 15,000 are in Arnhem Land. Their images reflect the whole history of human development in the most varied styles and techniques, including wax reliefs. After the first representatives of *Homo sapiens* reached Australia between 120,000 and 60,000 BC, they began to explore the landscape. Key geographical points such as springs and vantage points were marked, mapped and socialized by these hunter-gatherers. Man became one with his environment through myriad lines of contact. Circular depressions, often arranged in rows of several thousand, are believed to be the oldest traces of this form of communication. Dating to 75,000–50,000 BC, these were later followed by concentric circles (40,000 BC) and by lined patterns (30,000–20,000 BC). At about the same time we find the first handprints and silhouette paintings in Arnhem Land. As in the earliest examples of rock art in Europe, the first figurative motifs were animals and were incised and painted between 10,000 and 30,000 years ago. These in turn were followed by representations of human beings and, coupled with a regionalization of styles, by images of mythological beings. These rock paintings also document changes to the environment, together with social conditions and contacts with the peoples of Asia and Europe.
T. St.

E. Brandl, *Australian Aboriginal Paintings in Western and Central Arnhem Land: Temporal Sequences and Elements of Style in Caldell River and Deaf Adder Creek Art* (Canberra 1973); D. Lewis, *The Rock Paintings of Arnhem Land: Social, Ecological and Material Culture Change in the Post-Glacial Period* (Oxford 1988); J. Flood, *Rock Art of the Dreamtime* (Sydney 1997)

157 | Trepucó on Minorca, Spain

Trepucó lies in the western half of the smaller of the Balearic Islands, about 1km south of Mahon. The present photograph shows the centre of this 5 ha talayot-culture settlement as seen from the north. The talayot culture flourished in the Late Bronze Age (early 1st millennium BC). The present talayot – a dry-stone tower measuring 26m in diameter – is clearly visible in the middle of the picture and, like most talayots, presumably has a small central chamber accessible by a narrow entrance high up on the southern side. This is one of the largest talayots and is now surrounded by a star-shaped fortification dating to the 18th century. To the south, surrounded by a modern wall, lies a semicircular ceremonial building with the remains of other buildings. Measuring 15.7 x 13.1m, this sanctuary is likewise made of dry-stone walling with monolithic pilaster stones supporting the inner walls. The entrance is on the south side. Opposite it, at the centre of the temenos, stands a T-shaped taula (table) as an altar-like ritual monument. It is formed from two carefully cut stone slabs with a total height of 5m. The upper stone measures 3.8 x 1.6m. The site was already well known in the 19th century and was repeatedly excavated and restored during the 20th, notably by a team from Cambridge University in 1932. There are reckoned to be more than 1500 talayots on Minorca and Majorca. Typical of the Balearic Islands, they often stand alone but are frequently also the centre of large settlements with defensive walls. It remains unclear whether their function was as watchtowers, storage rooms, cult buildings or residential towers. They recall the Bronze Age nuraghi on Sardinia. Taulas, by contrast, are unique to the island of Minorca.
V. P.

E. Cartailhac, *Les monuments primitifs des îles Baléares* (Toulouse 1892), 38; M. A. Murray, *Cambridge Excavations in Minorca: Trapucó I* (London 1932), 13–18; L. Plantalamor Massanet, *L'arquitectura prehistórica i protohistórica de Menorca i seu marc cultural* (Maó 1991), 272–4, 362–4

158 | Uluru, the 'Great Pebble', Australia

At the heart of the continent of Australia, some 450km south-west of Alice Springs, this sandstone rock rises 350m above the Great Victoria Desert. It measures 3.1km at its maximum length and 2km at its maximum width. The first European to reach it was William Christie Gosse, who named it after Henry Ayers, five times premier of Southern Australia. It was officially renamed Uluru or 'Great Pebble' – the Aborigines' term for it – in 1980. Five years later the Australian government returned the rock to the Anangu, the Aboriginal people whose nomadic ancestors have roamed this region for centuries. Arguably Australia's most distinctive landmark, it brings together two contradictory worlds: motorized mass tourism and a hunter-gatherer society, recreational consumerism and spirituality, monotheism and natural religion. For the Anangu, Uluru is a place of spiritual energy and inhabited by ancestral beings. Its springs, collections of rock art and caves all mark particular places associated with 'dreamtime'. The term 'dreamtime' describes an all-embracing attitude to life and nature, permeating every aspect of existence and is both a rule of life and a law. Dreamtime also describes the interrelationship between the Anangu and their ancestors and ancestral beings and their creation myth. This perception of time and space is common to all Aboriginals, but the various groups differ from each other in their relations to dreamtime and to their ancestral beings, just as there are differences in the totems that are carved in wood or painted on skin, cabin walls and rocks like Ubirr Rock (no. 156).
T. St.

W. C. Gosse, *Explorations in Central Australia* (Adelaide 1874); R. Layton, *Uluru: An Aboriginal History of Ayers Rock* (Canberra 1986); S. Breden, *Uluru: Looking after Uluru-Kata Tjuta the Anangu Way* (Sydney 1994)

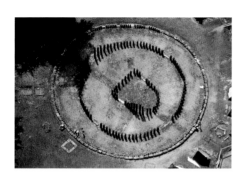 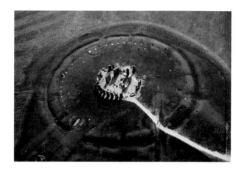 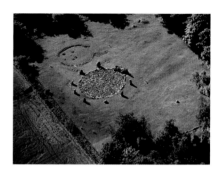

159 | The sanctuary at Sarmizegetusa Regia, Romania

Sarmizegetusa Regia lies at a height of 1000m on a high plateau in the southern Carpathian Mountains in what is now eastern Romania. When King Burebista became sole ruler of the Dacians in the middle of the 1st century BC, he founded a new capital for his empire on the Holy Mountain in south-west Transylvania. The well-organized Dacian state resisted Roman expansion until overrun by Trajan in AD 106. The ancient capital covered an area of some 3 ha, extending over 200 terraces on a southern slope of the mountain. A citadel with walls 4m thick divided the civilian settlement from the sacred site, which included seven sanctuaries scattered across three of the terraces. Here the Dacians built sacred sites that were generally rectangular but occasionally circular in design. Wood or stone columns rose up from round stone bases and were covered by shingle or tile roofs. The round sanctuary with a diameter of 29.9m consisted of stone or wooden posts arranged in a circle. The outer ring comprised 30 groups of six narrow stones and a somewhat wider square hewn stone. Inside it was a second ring of 84 wooden posts subdivided by limestone blocks into four unequal sections. All the posts were 'plastered' with mud and included iron nails on which to hang sacrificial offerings. The third ring, in the form of an apse, was made of 34 wooden posts and two square limestone blocks. The apse was aligned with the solstice and oriented to the north-west. The entrance was on the north-eastern side. The floor of the sanctuary was made of pounded clay. The sanctuary as a whole was covered with a round, conical shingle roof. The earliest finds were made here in the 16th century, but it was not until 1922 that the first systematic excavations were undertaken. The local population believed that the buildings were the work of giants.
I. G.

D. M. Teodorescu, *Cetatile* (Cluj 1923); H. Daicoviciu, *Dacia* (Cluj 1972); I. Glodariu and others, *Sarmizegetusa Regia* (Deva 1996)

160 | Stonehenge, Wiltshire, England

The standing stones at Stonehenge represent one of the most iconic archaeological sites in the world and are a focus for many visitors to England as well as those wishing to see the midsummer sunrise over the Heel Stone. This phenomenon suggests that the builders deliberately constructed the stones as an astronomical calendar, thus making the 'priests' a powerful élite capable of predicting the seasons as well as more spectacular events such as eclipses of the sun and moon. This is perhaps one of the many reasons for its construction, and although we do not know its real purpose, it is clear that henges were built as meeting places for festivals and rituals. Apart from the stones at Stonehenge there is an avenue (now only just visible on the ground) which creates an impressive walk to the henge. The first feature built at Stonehenge was the circular bank and ditch surrounding the site in the Neolithic (c2600 BC). The final stone circle, with its lintels, was completed in the Bronze Age c1800 BC. The types of stones, too, have generated a huge debate: some of the stones are made of a sarsen (a locally available hard limestone), but others, referred to as the bluestones, have only one source. This is in west Wales. So how were the stones transported? By river, by man or, much earlier, by ice movements? We do not yet know the answer. Stonehenge is part of a rich archaeological landscape on the edge of Salisbury Plain. The landscape around Stonehenge will be transformed in the next decade: the major roads will be closed or hidden in a tunnel and many of the ploughed fields returned to grass, allowing visitors to roam freely across the area.
R. B.

W. Stukeley, *Stonehenge: A Temple Restor'd to the British Druids* (London 1740); C. Chippindale, *Stonehenge Complete* (London 1983); J. Richards, *Beyond Stonehenge: A Guide to Stonehenge and its Prehistoric Landscape* (London 1985)

161 | The Loanhead of Daviot stone circle, Scotland

The Loanhead of Daviot recumbent stone circle in Aberdeenshire consists of a ring of nine stones around an inner cairn-circle and is situated on a broad shelf at 162m above sea level, near the summit of a gently sloping hill. Excavations here in 1934 produced Beaker (c2000 BC) and Middle Bronze Age (c1400 BC) artefacts as well as Iron Age burial and occupation debris (c500 BC). The central stone cairn is 3.65m in diameter and covered the original cremation pyre. The outer circle is 19.5m in diameter, and one of the stones has cup marks inscribed on it. The recumbent stone to the right of the circle was thought to be two stones, but on investigation it transpired that it was a single stone, split in two by its exposure to the elements. The less conspicuous earth circle (top left) was a Bronze Age cremation cemetery, where the incomplete remains of a 40-year-old man were discovered in a central pit.
R. B.

H. E. Kilbride-Jones, 'A Late Bronze Age Cemetery: Being an Account of the Excavations of 1935 at Loanhead of Daviot, Aberdeenshire, on behalf of H. M. Office of Works', *Proceedings of the Society of Antiquaries of Scotland*, 70 (1936), 278–310

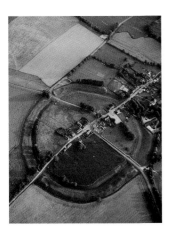

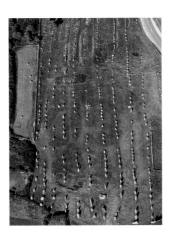

162 | **Avebury, Wiltshire, England**

The Avebury henge and stone circles in Wiltshire cover approximately 11.5 ha. The encircling ditch is one of the largest prehistoric enclosures in Europe, with an internal diameter of 347.5m and an external one of 426.7m. The ditch is over 10m deep and 11m wide. This ditch, dug from the chalk with only antler picks and bone shovels, would have been very impressive as a deep white ravine in a green landscape. It has been estimated that it took 1.5 million labour hours to construct. The stone circles were erected first in c2600 BC. Only the outer stone circle is visible now, but there are a number of smaller stone circles inside the henge. These have been removed, but in the right conditions the stone settings are visible. The ditch was begun in 2500 BC and took over a hundred years to complete. Avebury has two stone-lined avenues, one to the south-east, the West Kennet avenue, and one to the west, the Beckhampton avenue. The western avenue was recorded by the antiquarian William Stukeley in the 18th century but its existence was questioned until very recent excavations (2000–2) proved that it did indeed exist. Aerial photography in the drought summer of 1995 revealed the location of many former stone settings (as parchmarks in the grass) and a small rectilinear enclosure in the centre of the henge. The new feature may be a burial and may predate the henge. To the east (top right) are the remains of a deserted medieval village.
R. B.

W. L. Bowles, *Hermes Britannicus: A Dissertation on the Celtic Deity Teutates, the Mercurius of Cæsar, in Further Proof and Corroboration of the Origin and Designation of the Great Temple at Abury, in Wiltshire* (London 1828); J. Pollard and A. Reynolds, *Avebury: The Biography of a Landscape* (Stroud 2002); A. Burl, *Prehistoric Avebury* (London 2002)

163 | **The Le Ménec alignment at Carnac, France**

The long rows of standing stones extending over several kilometres at Carnac are a superb example of Neolithic culture in Brittany, contributing to Carnac's reputation as a high point in European prehistory. It has long been known for its particularly large, not to say monumental, menhirs and, together with similar sites at Kermario, Kerlescan and Ménec-Vihan, had generated a whole series of myths on megalithic culture well before it was properly examined: Celtic, Egyptian and extraterrestrial provenance all had their proponents. The earliest studies began with the pioneering work of James Miln (1881) and Zacharie Le Rouzic (1920), both of whom laid the foundations for archaeological research closely linked to a policy of safeguarding the national heritage. (The site passed into state hands in 1882 and was classified as a historic monument seven years later.) It is thanks to their work that these monuments are so well preserved today, for without them, they would no doubt have been torn down, like so many others. The complex dates to the Neolithic period (4th millennium BC) and has undergone numerous transformations, some of which have been highly destructive: at every period in their history, the stones have been used as a quarry, and many of them bear traces of this. The situation has now been exacerbated by the growing number of visitors, but a programme is currently in hand designed to protect, restore and evaluate these monuments from a scientific point of view.
C. B.

A. and A. S. Thom, *Megalithic Remains in Britain and Brittany* (Oxford 1978); A.-E. Riskine, *Carnac: L'armée de pierres* (Paris 1993) (Guides archéologiques de la France); G. Bailloud and others, *Carnac: Les premières architectures de pierre* (Paris 1995)

164 | **The Moose Mountain medicine wheel, Canada**

The Moose Mountain medicine wheel is a cairn with radiating lines of stones in southern Saskatchewan, some 100km north of the border with the USA. When first observed by a Canadian land surveyor in 1895, the cairn at the centre of the site was 4.3m high. It is now only 60cm, farming and souvenir hunting being seen as the main causes of its destruction. The monument, which dates to AD 300, consists of a central pile of stones from which five rows of pebbles radiate like spokes, each of them ending in a smaller pile of stones. The central pile is encircled by a further, circular line of pebbles. The siphoning off of the small piles of stones suggests looting. Some 170 medicine wheels are known to exist, all of them in the northern USA and plains of southern Canada. They are still revered as sacred sites by today's Indians. It remains unclear whether they functioned as graves, cenotaphs, ceremonial sites or the scene of sun dances or whether they are associated with 'hunt medicine' in which the wheels were regarded by the nomadic Indians as encoded 'hunt leaders'. In the 1970s it was even suggested that they served as a calendar instrument, with the central cairn and spokes aligned with the celestial markers Rigel, Aldebaran and Sirius.
T. St.

G. M. Dawson, 'Summary Report of the Operations of the Geological and Natural History Survey', *Geological and Natural History Survey of Canada 1869–1889* (Ottawa 1885); J. Eddy, 'Probing the Mystery of the Medicine Wheels', *National Geographic*, 151 (1977), 140–46; J. H. Brumley, *Medicine Wheels on the Northern Plains: A Summary and Appraisal* (Edmonton 1988)

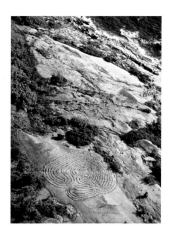

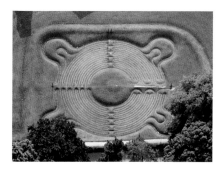

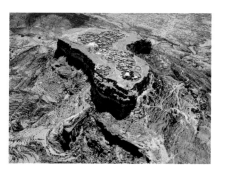

165 | **Labyrinth on Blå Jungfrun in the Kalmarsund, Sweden** The beautiful, uninhabited island of Blå Jungfrun (Blue Maiden) lies in the middle of the Kalmar Sound and consists mainly of bare rock, the absence of any harbour making access to the site difficult. Among hundreds of stone labyrinths in Sweden, the 'Trojaborg' on Blå Jungfrun is among the most famous. Labyrinths may be traced back to the Roman Trojan Games, which derive in turn from the Greek myth of Ariadne, Theseus and the Minotaur. Many of the Swedish labyrinths are called 'Trojaborg', which may be an old name and an indication of their Mediterranean origin. In Scandinavia a similar motif is also found on Bronze Age bronze shields. Stone labyrinths are found at Iron and Viking Age cemeteries and ritual sites, and the motif also recurs in murals in many medieval churches. Dating stone labyrinths is difficult. In the case of stone labyrinths along the north Swedish coast, dating by means of lichen growths (lichenometric dating) suggests that they were built between the 14th and 19th centuries. Labyrinths in southern Sweden probably belong to the same period, but it has been suggested that some may be as old as the beginning of the Christian era. They may be either pagan or Christian: in the former case, they are usually associated with fertility rites, while in the latter they are said to be connected with the idea of salvation from sin and evil. Labyrinths situated near the coast may have been built by fishermen and sailors as a means of conjuring up good weather, while others may simply have been built as a pastime by individuals waiting for a favourable wind. The labyrinth on the island of Blå Jungfrun, around which many myths have accrued, was first described by the Swedish naturalist Carl von Linné (1707–78).
U. N.

J. Kraft, *The Goddess in the Labyrinth* (Åbo 1985); H. Kern, *Labyrinthe* (Munich 2/1999)

166 | **The grass labyrinth at Saffron Walden, Essex, England** The Saffron Walden earthwork maze is 9.7m in diameter, with a central mound 3.1m in diameter, and curving lobes or ears in each corner of the surrounding rectangular low bank. The original paths were cut into the chalk but were lined with over 6000 bricks in 1911. There are 17 rings, and the paths extend for over 1500m. This is the largest publicly owned maze in England, and its original date of construction precedes 1699, when the paths were recut for 15 shillings (now about one Euro). It has been maintained ever since, with major recuts in 1828, 1841, 1859, 1911 and most recently in 1979, when the brick paths were replaced. The maze is associated with ancient fertility rites and religious penances in the 18th and 19th centuries. Courting couples played a game in which the young lady stood on the central mound awaiting her young gentleman, whose task was to complete the maze as quickly as possible and reach her. Other sources record races round the maze, with gallons of beer being waged on the outcome of the race. They do not stipulate whether the winners had to drink the beer. An ash tree used to grow on the central mound, but this was accidentally burnt down on Guy Fawkes' Night (5 November), when bonfires are traditionally lit and fireworks set off. Situated on the Common in Saffron Walden, the site is open to the public and maintained by the local council.
R. B.

W. H. Mathews, *Mazes and Labyrinths: A General Account of their History and Development* (London 1922)

167 | **The mountain monastery of Dabra Damo, Ethiopia** In the mountains of northern Ethiopia, close to the border with Eritrea, the monastery village of Dabra Damo (7th–11th century AD) looks down from a height of more than 2200m on the fertile valley below it. The sheer walls of the table mountain are up to 200m in height and can be scaled only with a rope 15m long. Groups of houses defended by round dry-stone walls dot the plateau, which is up to 600m in length. Two buildings in particular determine the lives of the monks. Both are dedicated to the monastery's Axumitic founder, Gabra Masqal (550–64). The larger of the two churches is a three-aisled basilica, its coffered wooden ceiling decorated with carved animals and other mythical beings. The other carvings in the basilica's interior have ensured that the church is a pattern book of Old Ethiopian ornamental art. On the eastern site of the site, on a ledge some 20m beneath the plateau, lies the second, smaller church with a belltower and treasury, in the vicinity of which are numerous caves and grottoes that serve as burial places for the monks. Dabra Damo is probably Ethiopia's oldest monastery. More than a thousand monks have lived here at times of high feasts, not counting the devout women who settled at the foot of the mountain and who were not allowed to enter the site. For centuries the monastery village was the centre of religious life, its cultural and political influence spreading far beyond the immediate area. In the mid-1990s a fire destroyed the monastery library, which was centuries old, an irreplaceable loss for the history and culture of Ethiopia.
T. St.

E. Littmann, *Die Deutsche Aksum Expedition*, vol. 2 (Berlin 1913); G. Gerster, *Churches in Rock: Early Christian Art in Ethiopia* (London 1970); R. Pankhurst and S. Munro-Hay, *Ethiopia* (Oxford 1995)

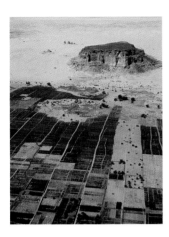

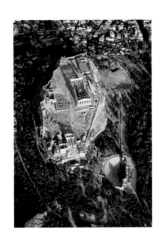

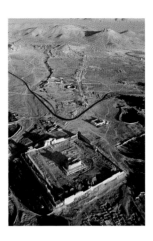

168 | **The temples and pyramids at Gebel Barkal, Sudan** Situated 20km downstream from the Fourth Nile Cataract, the Gebel Barkal towers up to a height of 91m over the surrounding area, its imposing bulk such that it was predestined to become the Nubians' 'Sacred Mountain'. The Egyptians who conquered Upper Nubia (Kush) at the time of the 18th Dynasty (c1450 BC) called it the 'Pure Mountain' and worshipped a local form of the Theban god Amun here. When the Nubians conquered Egypt around 750 BC, the city of Napata at the foot of the mountain was transformed into the magnificent capital of the Napatan kingdom (c900–250 BC). It was destined to play the role of Thebes in Nubia and was planned along correspondingly grandiose lines, with numerous temples and palaces. Its ruins may still be seen between the eastern slope of the mountain and the fertile fields that are tilled from the modern city of Karima. A royal cemetery was laid out further to the south, at what is now the village of el-Kurru, and a second one of later date was built at Nuri on the opposite bank of the Nile. In both cemeteries, rulers of the 25th Dynasty were buried beneath pyramids according to ancient Egyptian custom. The desert beyond the mountain also contains two gravefields with pyramids visible from far around. The first excavations were undertaken here by American archaeologists in 1916, but it unfortunately proved impossible to ascertain which members of the Kush royal family were buried here. Napata was destroyed by the Egyptian pharaoh Psammetich II (26th Dynasty) in 593 BC, and although it was partially rebuilt, it was finally abandoned as the capital in around 300 BC in favour of Meroe much further upstream (no. 132).
Ch. L.

D. Dunham, *The Barkal Temples* (Boston 1970); T. Kendall, 'Die Könige vom Heiligen Berg: Napata und die Kuschiten-Dynastie', *Sudan: Antike Königreiche am Nil* (Tübingen 1996), 160–71 (Munich exhibition catalogue)

169 | **The Acropolis at Athens, Greece**
The topographical and religious centre of ancient Athens was the Acropolis, a rocky plateau with many sacred buildings. There was already a palace here in Mycenaean times, and by the 6th century BC the first great temple to the local goddess Athena had been built, presumably affording protection even to the tyrants who ruled the city. But the most spectacular and best-preserved buildings date from the period of reconstruction, after the Persians had sacked the city in 480 BC. The Parthenon, in which stood Pheidias's monumental gold and ivory statue of Athena, left its mark on classical Greek architecture in general. The Erechtheion to the north incorporated several sites sacred to the Athenians, all of which illustrated the workings of the gods. Between these two buildings lie the remains of the old Temple of Athena, which housed the goddess's actual cult-image. Attributed to the architect Mnesikles, the monumental Propylaea at the entrance to the Acropolis welcomed visitors via a flight of steps leading up from the city. Above them, the small Ionic Temple of Athena Nike rose up on a bastion to the south. Other important cultic sites lie on the southern slope of the hill and include the sanctuaries of Asclepius and Aphrodite and the Theatre of Dionysus. The famous works of Attic playwrights were written for the festivals held here in the god's honour. The stone building visible today replaced a wooden structure in around 330 BC. The other theatre-like building, the Odeon, was built by the wealthy patron of the arts Herodes Atticus in the early 2nd century AD.
R. S.

U. Muss and C. Schubert, *Die Akropolis von Athen* (Graz 1988); J. M. Hurwitt, *The Athenian Akropolis* (Cambridge 1999); L. Schneider and C. Höcker, *Die Akropolis von Athen* (Darmstadt 2001)

170 | **The caravan city of Palmyra, Syria**
Palmyra lies at the heart of the Syrian Desert, some 150km from Homs and 200km from the Euphrates. The place benefited from its position as an oasis on the caravanserai trade routes between the Mediterranean and the Euphrates and between Syria and Mesopotamia. The oasis is first mentioned in cuneiform texts of the early 2nd millennium BC as a trade centre called Tadmor. The city enjoyed its period of greatest prosperity between the 1st century BC and the 3rd century AD, when it was a nodal point in international trade between China, India, Arabia and the Mediterranean. Under its apostate ruler Zenobia, it was sacked by the Emperor Aurelian in AD 273, thus ending its political and commercial significance. For centuries travellers would break their journey here, fascinated by the sight of the impressive ruins: 'The palaces of the kings have become a den of wild beasts,' wrote the Comte de Volney in 1787; 'flocks repose in the area of temples, and savage reptiles inhabit the sanctuary of the gods.' From among the city's richly ornamental and majestic ruins, the Temple of Bel stands out with its thick encircling wall. Dedicated in AD 32, the temple is among the most impressive sacred buildings in the whole of the Near East. The ruins are dominated by the great colonnaded street with its adjacent public buildings, including theatre, agora and thermae. In the distance can be seen the Western Necropolis with its grave towers (to the left) and the conical hill with the early 17th-century Arabian citadel of Qalat Ibn Maan (to the right).
R. W.

T. Wiegand and D. Krencker, *Palmyra: Ergebnisse der Expeditionen von 1902 und 1917*, vols. 1 and 2 (Berlin 1932); E. M. Ruprechtsberger (ed.), *Palmyra: Geschichte, Kunst und Kultur der syrischen Oasenstadt* (Linz 1987) (Frankfurt exhibition catalogue); A. Schmidt-Colinet (ed.), *Palmyra: Kulturbegegnung im Grenzbereich* (Mainz 1995) (special number of *Antike Welt*)

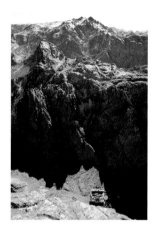

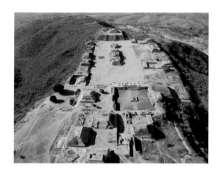

171 | The island of Skellig Michael, Ireland
Skellig Michael (in Irish Skeilg Mhichíl) is one of
two islands, the Great Skellig and the Little Skellig,
situated in the Atlantic some 8km south-west of the
mainland of County Kerry. It is the site of important
and well-preserved early monastic remains. The
island is a small rocky crag rising to a jagged peak
some 217m above sea level. The chief remains
consist of a system of walled enclosures, with six
stone huts of beehive form, a boat-shaped oratory,
a church, several raised platforms and a number of
roughly shaped slabs. The huts, which may not all
be contemporary, are dry-built and of corbel
construction, up to 5m in height. Internally they are
rectilinear, on the exterior they tend to be circular in
plan. Most have wall cupboards but they do not
have windows. The oratories are of the well-known
boat shape. The ruined church is probably the 12th-
century building known to Giraldus Cambrensis as
St Michael's. There are numerous slabs, some
roughly carved to the shape of a cross, others
incised with cross or cross-in-circle designs. At
other parts small ruined stretches of dry-stone
walling are detectable. These may have been built
to retain some small pockets of earth to enable the
monks to carry out limited cultivation. The founda-
tion of the monastery is not recorded, though local
tradition attributes it to St Finan. In the annals, at
any rate, there are notices of the deaths of various
ecclesiastics in 823, 950 and 1044. The first of
these, we are told, concerns Eitgal of Skellig, who
was carried off by Vikings and died of hunger and
thirst. The date of the monastery's abandonment is
unknown.
B. R.

L. de Paor, 'A Survey of Sceilg Mhichíl', *Journal of the Royal
Society of Antiquarians of Ireland*, 85 (1955), 174–87; L. Laing,
*The Archaeology of Late Celtic Britain and Ireland c.400–1200
AD* (London 1975), 172–4.

**172 | St Catherine's Monastery on the Sinai Peninsula,
Egypt** Egypt's highest mountain is the 2642m
Jebel Katrinahht in the central massif of the Sinai
Peninsula. At 2285m, the nearby Jebel Musa –
Mount Sinai – is somewhat smaller but is still one
of the most famous mountains in the world.
According to tradition, it was here that Moses
received the Ten Commandments for the people of
Israel. That it was this mountain that was identified
with the Horeb of the Old Testament is due to the
fact that the rocks here are marked by dendrites –
coloured markings that look like trees. From an
early date the image of a tree in the stone was
associated with the Burning Bush in which Moses
first saw God. In AD 337 Helena, the mother of the
emperor Constantine, decreed that a sanctuary be
built around what was thought to be the site of the
bush. This site remained the most sacred part of
the complex even after the emperor Justinian
ordered a new and larger basilica to be built in 562.
This basilica is still the centre of the monastery with
its high defensive walls. The link with St Catherine
was not made until the 9th century, when monks
discovered the body of the martyred saint on the
summit of the highest mountain in the region and
took it back with them to their monastery. Although
this attraction ensured that the monastery received
attention and, with it, a source of income, the
complex was repeatedly abandoned between the
14th and early 18th centuries. Not until 1872 was an
archbishop reinstated. The autocephalous
monastery is part of the Greek Orthodox Church.
Ch. L.

G. Gerster, *Sinai: Land der Offenbarung* (Frankfurt 1961);
G. H. Forsyth and K. Weitzmann, *The Monastery of Saint
Catherine at Mount Sinai: The Church and Fortress of
Justinian* (Ann Arbor 1973); J. Galey, *Sinai und das Kathari-
nenkloster* (Stuttgart 1979)

173 | Monte Albán, the Zapotec capital, Mexico
The Zapotec capital and Mexico's oldest city, Monte
Albán, lies on a hill in the Oaxaca Valley that affords
an impressive view of the extensive valley and
surrounding mountains. Oaxaca is one of the most
beautiful and fertile regions in the Mexican
highlands and can look back on a rich prehispanic
history. The principal settlement in the valley, it
seems to have been founded in the 6th century BC
and was built on a centrally situated, previously
uninhabited group of hills between the three arms
of the valley. During the period that followed, Monte
Albán extended its sphere of influence far beyond
the Oaxaca Valley. Evidence of this influence comes
from depictions of defeated enemies and subju-
gated towns on vast stone reliefs in the city centre.
This centre consists of a large, artificially flattened
area high above the valley and is fringed with
imposing pyramids, courtyards and a ball court. The
actual settlement was situated on the slopes
beneath it, some of which were terraced for agricul-
tural use. Monte Albán flourished between the 3rd
and 7th centuries AD, when the population
numbered as many as 25,000. From this period,
too, date some of the richly equipped graves of
high-ranking dignitaries that have been excavated
since the 1930s. Monte Albán was gradually
abandoned after the 8th century and only occasion-
ally used for burials. The Spanish founded the
modern city of Oaxaca at the foot of the hill during
the early colonial period.
K. L.

H. J. Prem and U. Dyckerhoff (eds.), *Das alte Mexiko:
Geschichte und Kultur der Völker Mesoamerikas* (Munich
1986); J. Marcus and K. V. Flannery, *Zapotec Civilization:
How Urban Society Evolved in Mexico's Oaxaca Valley*
(London 1996); R. Blanton and others, *Ancient Oaxaca: The
Monte Albán State* (Cambridge 1999) (Case Studies in Early
Societies)

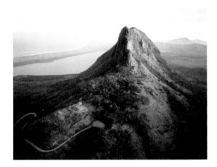

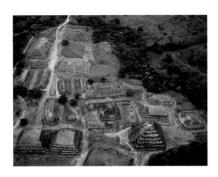

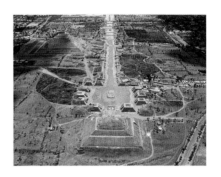

174 | **The temples at Quiahuiztlan, Mexico**

This is undoubtedly one of the most extraordinary ruined sites of ancient Mexico: tombs on a spur projecting from the side of a weathered volcanic chimney, the Cerro de los Metates, some 85km north of the modern port of Veracruz. These tombs differ from those of all other prehispanic cultures in that here and at several other burial sites in the immediate vicinity miniature temples have been erected over the graves. Rarely more than 50cm high, these temples stand in rows on low platforms with a central flight of stairs and enclose an empty rectangular plaza, thus representing a small-scale version of the larger temples. A number of these 78 small temples can be seen from the air as tiny objects at the end of the spur. Generally well preserved, they give us a good idea of what the larger temples must have looked like. Of these, mostly only ruins remain. This is certainly true of the 15th-century temples at Quiahuiztlan. Here only the foundation walls remain. The ball court, which was built on a different part of the site, is somewhat better preserved. Parts of the site, including both tombs and temples, are surrounded by a low wall that represents less of an obstacle than a symbolic boundary. The ball court and the miniature temples command a clear view of the coast and the Laguna Llana. Close to the latter (and off frame to the left of the photograph) the conquistador Hernán Cortés founded the first Spanish settlement, Villa Rica de la Vera Cruz, which was abandoned five years later and transferred further south. In Quiahuiztlan, Cortés found support for his campaign against the Aztecs with the Totonacs and their ruler, whom he called the 'Fat Cacique'.

H. J. P.

R. A. Melgarejo, *La arquitectura monumental postclásica de Quiahuiztlan: Estudio monográfico* (Xalapa 1997)

175 | **El Tajín, Veracruz, Mexico**

Tajín is the word for lightning in the language of the Totonacs, who now inhabit the flat coastland area of the Gulf of Mexico. It is uncertain whether they also inhabited the city of Tajín when it flourished between the 7th and 12th centuries AD. At that period, Tajín was one of the great cities of ancient Mexico. As the seat of government, it included large and lavish residences, and these, together with its importance as a ceremonial centre with numerous pyramids and other buildings found only here, combined to produce an architectural impression of power and wealth. The architects experimented with various building techniques and plans. From the air the 17 ritual ball courts can be identified by their narrow alley for the players framed by sloping playing surfaces and two narrow diagonal alleys at either end. Impressive stone reliefs depict scenes of sacrifice but also others of princely splendour and quotations from myth. Throughout the Tajín region a characteristic style of decoration was developed for the façades of the buildings in the form of horizontal rows of tiered niches. The central pyramid in the lower right-hand corner is of a relatively late date. Its seven steps are entirely covered in niches. The number of its niches, whether visible or concealed by steps, does not, however, correspond to the number of days in the year, in spite of claims to the contrary. We do not know why the city was finally abandoned. It was completely overgrown and forgotten by the time that a Mexican captain stumbled upon it in 1785. His published drawing of it persuaded Alexander von Humboldt and other early travellers to visit the site. Today the archaeological zone, which is located 25km south-east of the oil town of Poza Rica, is easily accessible to tourists.

H. J. P.

M. E. Kampen, *The Sculptures of El Tajín, Veracruz, Mexico* (Gainesville 1972); L. Raesfeld, *Die Ballspielplätze in El Tajín, Mexiko* (Münster 1992); J. Brüggemann, 'La ciudad de Tajín', *Arqueología Mexicana*, 5 (1994), 26–32

176 | **The pyramids at Teotihuacan, Mexico**

Covering an area of 25 sq km and with at least 100,000 inhabitants, and possibly twice that number, Teotihuacan was the largest city on the American continent prior to its conquest by the Europeans. Situated in a cove in the Basin of Mexico some 30km north-east of the centre of Mexico City, a town is known to have grown up here during the early centuries of the Christian era. Its inhabitants lived in large rectangular walled blocks, the walls of their rooms decorated with abstract or representational paintings. These residential blocks were laid out on a grid pattern constructed around the central axis of the Miccaotli, or Street of the Dead, as the Aztecs later named it. This street ends to the north of the city in a square framed by low pyramids. At the furthest end of the square lies the Pyramid of the Moon, inside which sensational sacrificial offerings from the city's early history were recently discovered. To one side of the street lies the huge Pyramid of the Sun, after which the street turns into a row of squares separated from each other by flights of steps. Towards its southern end lies the vast enclosure platform in the centre of which stands the Temple of Quetzalcoatl. For centuries the city influenced other cultures in Central America as the nub of an extensive trade network, with people from other regions housed in their own parts of the city and preserving their own customs. By the 7th century the city had fallen into decline. Almost a thousand years later the Aztecs admired the monumental remains to such an extent that they located key episodes of their creation myths here, interpreting the name – from a language unrelated to their own – as 'the city where one becomes god'.

H. J. P.

R. Millon, *Urbanization at Teotihuacan, Mexico*, vol. 1 (Austin 1973); E. Paztory, *Teotihuacan: An Experiment in Living* (Norman 1997); L. Manzanilla, 'Teotihuacan', *The Oxford Encyclopedia of Mesoamerican Cultures* (Oxford 2001), 200–8

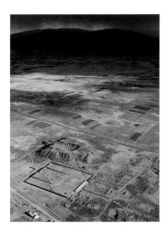

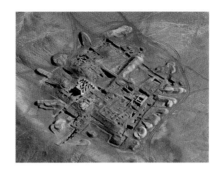

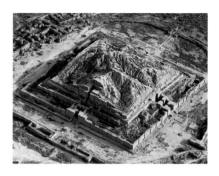

177 | **The ruins at Tiahuanaco, Bolivia**
Situated at a height of more than 3800m in the
Bolivian Andes, to the south of Lake Titicaca, the
ruins of Tiahuanaco are surrounded by the inhos-
pitable land of the altiplano. At the time when the
city flourished, between AD 300 and 900, this area
was intensively farmed. Tiahuanaco was then the
religious, cultural and, for a time, political
centre of an area of the southern Andes extending
as far as the Pacific coast. Its importance at this
period is further underlined by the fact that
centuries later the Inca rulers were still claiming to
derive their origins from Lake Titicaca. Tiahuanaco
is dominated by an impressive complex of
monumental buildings. Of these, the Akapana
Pyramid is now no more than an eroded mound
of earth, but was originally a multi-step platform
pyramid, on the topmost step of which was a
sunken courtyard. Such courtyards are a typical
feature of other buildings at the foot of the
Akapana. The Kalasasaya includes a sunken plaza
in which stand stone statues of gods and is
surrounded by a large U-shaped platform, on which
stands the famous Gate of the Sun, hewn from a
single slab and depicting the Staff Deity. On both
sides of the Kalasasaya are more courtyards, some
with rooms that no doubt served as living quarters
for the élite. The central area at Tiahuanaco was
encircled by a ditch, and this in turn was surrou-
nded by a sizeable settlement that remains largely
unexamined. By contrast, a few buildings in the
centre have been elaborately restored in recent
decades.
K. L.

A. Posnansky, *Tihuanacu: The Cradle of American Man/La
cuna del hombre americano* (New York 1945); H. Prümers,
'Die Ruinen von Tiahuanaco im Jahre 1848: Zeichnungen
und Notizen von Léonce Angrand/Las ruinas de Tiahua-
naco en el año 1848: Dibujos y notas de Léonce Angrand',
Beiträge zur Allgemeinen und Vergleichenden Archäologie, 13
(1993), 385–478; A. Kolata, *The Tiwanaku: Portrait of an
Andean Civilization* (Oxford 1993) (The Peoples of America)

178 | **The Temple of Gareus, Uruk, Iraq**
During late Parthian times, the Temple of Gareus at
Uruk in southern Iraq was surrounded by a defen-
sive wall with semicircular and engaged towers. The
temple itself was still entirely within the Babylonian
tradition, whereas the row of columns in front of it
draws on western – Graeco-Roman – models.
Dedicated to the god Gareus, it was the last major
building to be erected in Uruk. According to an
inscription found there, it was still standing in AD
111, but with it the history of one of the most impor-
tant cities in human history comes to an end.
Human beings had lived here almost without inter-
ruption for 5000 years. No town or city today can
look back on such a long settlement tradition. Uruk
was already a large town by the 4th millennium BC,
and by the early 3rd millennium at the latest, the
city wall built by King Gilgamesh enclosed an area
of 550 ha. It was 10km long. No European city of the
Middle Ages was anywhere near as big. Uruk was
repeatedly destroyed and rebuilt, but finally went
into decline in the early 4th century AD when the
Euphrates began to move westwards. Abandoned
by their lifeline, its inhabitants left, and the once
mighty city fell into decay, the home of jackals and
hyenas. The site was rediscovered in 1850 by the
British archaeologist William Kenneth Loftus. His
work was resumed by German archaeologists in
1912 and continues to the present day.
M. M.-K.

W. K. Loftus, *Travels and Researches in Chaldaea and Susiana*
(London 1857); A. Kose, *Uruk: Architektur IV. Von der
Seleukiden-bis zur Sasanidenzeit* (Mainz 1998)
(Ausgrabungen in Uruk-Warka: Endberichte 16)

179 | **The ziggurat at Choga Zanbil, Iran**
The best-preserved ziggurat in the ancient East is
not the Tower of Babel but the step pyramid of the
god of Susa, Inshushinak, at Choga Zanbil, the site
of the ancient city of Dur-Untash. The Elamite king
Untash Napirisha designed a new ceremonial and
residential centre on the plateau above the River Diz
some 40km south-east of the Elamite capital
around the middle of the 13th century BC. The inner-
most of the three ring-walls is almost entirely filled
with the step temple, which was once 52m high.
Within the second wall are temples to lesser deities,
while palaces and large underground sepulchral
vaults are located by the third, outer wall. Elam was
the little neighbour of the big kingdoms of ancient
Mesopotamia, extending from what is now
Khuzistan to the valleys of the Zagros. For
thousands of years it had its own culture, language,
cosmogony, religious beliefs and, for the most part,
political independence. As a result, the similarity of
the temple-tower at Choga Zanbil to other ziggurats
is purely superficial. French excavations that began
in 1936 have demonstrated that initially only the
lowest of the five platforms was built as a large
quadrangle of long rooms around an empty inner
courtyard. Some of the long rooms were used as
small temples. All could be entered from outside,
from above and from within. The inner terraces
were then built up within and above this base,
interlocking like boxes. Whereas the steps of other
ziggurats are on the outside, those at Choga Zanbil
are on the inside of the tower. The sanctuary was in
use as a place of pilgrimage for only a short time,
with the result that the ruins were so well preserved
that it has been possible to reconstruct the two
lower terraces.
D. H.

W. Hinz, *Das Reich Elam* (Stuttgart 1964); R. Ghirshman,
Tchoga Zanbil (Dur-Untash) I: La Ziggurat (Paris 1966); P.
Amiet, 'Die Zivilisation von Elam', *Teheran: Das Museum
Iran Bastan* (Paris 1968), 125–56 (Archaeologia Viva 1/1)

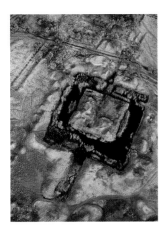

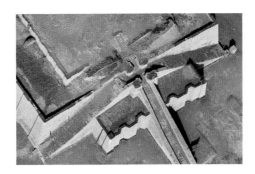

180| **The Tower of Babel, Iraq**

Little remains of the legendary tower – the ziggurat at Babylon. When Alexander the Great chose Babylon as the new capital of his world empire, he ordered the derelict tower to be razed to the ground in order to build an even more splendid monument in its place. When he died in 323 BC, the site fell into disrepair, and the remaining bricks were looted. In 1913 the foundations of the famous tower were discovered here, 90km south of Baghdad, in the water-filled ditch left by the theft of the bricks. Each side of the immense structure was 91m long. It is reckoned that the restoration alone, which was undertaken by Kings Nabupolassar (625–605 BC) and Nebuchadnezzar II (604–562 BC), required 32 million bricks and lasted more than 40 years. The Babylonians called their ziggurat 'Etemenanki', 'the house that is the foundation of heaven and earth'. The seven-step tower-temple was dedicated to the supreme god of the Babylonian pantheon, Marduk. The Babylonians believed that the world axis was here, linking the three cosmic regions of the heaven, the surface of the earth and the earth itself. The aerial photograph shows clearly the square groundplan and the position of the central stairs on the outside of the building. These stairs no longer existed by 460 BC, when Herodotus described the tower: they had been removed by the Persian king Xerxes as a way of punishing the Babylonians. The imaginative reconstructions of the tower with a spiral staircase (including Pieter Bruegel's famous painting) rest on a misunderstanding of Herodotus's description, which was of necessity limited to the steps leading up the side of the building.
M. M.-K.

R. Koldewey, *Das wiedererstehende Babylon* (Munich 5/1990); J. Oates, *Babylon* (London 1986); H. Schmid, *Der Tempelturm Etemenanki in Babylon* (Mainz 1995) (Baghdader Forschungen 17)

181| **The ziggurat at Ur, Iraq**

Dedicated to the Sumerian moon god Nanna, the temple at Ur looks down from an artificial mound on the alluvial plain of the Tigris and Euphrates in southern Mesopotamia. It was built in the 21st century BC by King Urnammu, the founder of the 3rd Dynasty of Ur, whose rule covered the whole of what is now southern Iraq, from the Gulf to north of Baghdad. The temple is the first known example of a ziggurat, a stepped tower formed from several terraces superimposed on each other, with two flights of stairs at the sides and another in the middle leading up to the temple. As such, it became the model for all the later ziggurats that were built in Mesopotamia over the next 2000 years. The most famous was the Tower of Babel (no. 180). The earliest scientific excavations were undertaken in the winter of 1853/4 by J. E. Taylor, the British Consul at Basrah, on behalf of the British Museum. Beneath a mound of rubble at this date remains of the third, uppermost terrace still existed. In 1924, an expedition led by Leonard Woolley on behalf of the British Museum and the Philadelphia University Museum, succeeded in exposing the whole of the building. Thanks to its facing of fired bricks, which protected its core of sun-dried mud bricks, and thanks, too, to the careful restoration by the Babylonian king Nabonidus (555–539 BC) 1500 years after it was built, the ziggurat at Ur remains one of the best preserved of temple-towers. The present photograph was taken soon after a further restoration another 2500 years later.
M. M.-K.

J. E. Taylor, 'Notes on the Ruins of Muqeyer', *Journal of the Royal Asiatic Society of Great Britain and Ireland*, 15 (1855), 260–76; C. L. Woolley, *The Ziggurat and its Surroundings* (London 1939) (Ur Excavations 5); E. Heinrich, *Die Tempel und Heiligtümer im alten Mesopotamien: Typologie, Morphologie und Geschichte* (Berlin 1982), 154–5

182| **The Great Mosque at Samarra, Iraq**

The Malwiya, or spiral minaret, of the Great Mosque at Samarra undoubtedly influenced early representations of the Tower of Babel, which incorrectly depict the building as a round tower with a spiral staircase leading up its outside wall. The mosque and its unusual minaret were built soon after the caliph al-Mutawakkil ascended the throne in AD 847. Only ten years previously, his predecessor, the caliph al-Mutasim Billah, had moved the Abbasid capital 125km upstream from Baghdad to Samarra, and within only a few years a magnificent city had been conjured out of nowhere on the east bank of the Tigris. It extended over more than 40km in a north-south direction, thereby overshadowing all that had gone before it. He called his city 'Surra man ra' ('He who sees it will be delighted'). Eight caliphs ruled from Samarra, until al-Mutamid transferred his court back to Baghdad in 892. Only 55 years after it had been founded, the splendid city fell into ruin. Extensive excavations were undertaken here by Ernst Herzfeld in 1911 and again in 1930. His work was resumed in 1936 by the Iraqi Department of Antiquities and continued after the Second World War. These more recent investigations have largely been carried out within the context of restoration work. Of the actual mosque, all that has survived and been restored are the outer wall and its bastions. Together they enclose an area of 240 x 156m, or almost 38,000 sq m. The roof was supported by 464 columns. The mosque is believed to be the largest in the world.
M. M.-K.

E. Herzfeld, *Geschichte der Stadt Samarra* (Hamburg 1948) (Ausgrabungen von Samarra 6); T. M. al-Amid, *The Abbasid Architecture of Samarra in the Reign of Both al-Mi'tasim and Mutawakkil* (Baghdad 1973); Th. Leisten, *Excavation of Samarra* (Mainz 2003)

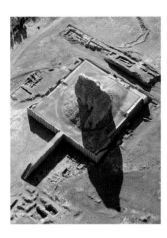

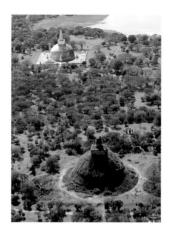

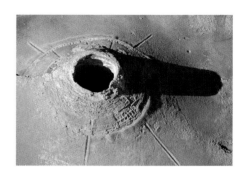

183 | **The ziggurat at Aqar Quf, Iraq**

The remains of the former ziggurat on the western edge of what is now Baghdad soar up like the pointer on a gigantic sundial. Early travellers mistakenly thought that they had discovered here the legendary Tower of Babel. Brick stamps attest to a Kassite king by the name of Kurigalzu as the builder. Kurigalzu I recognized the strategic importance of the region, where the Tigris and Euphrates are no more than a few kilometres apart, when he built his royal residence, Dur-Kurigalzu, here in *c*1390 BC. The stepped tower still rises a good 57m above the surrounding plain, owing its excellent state of preservation to the reed mats that were used as horizontal reinforcements at regular intervals throughout the mud-brick structure. The lowest terrace has been partially rebuilt by the Iraqi Department of Antiquities. With its slightly angled façade and rows of niches, it gives an idea of the former size of the building. Only the lowest steps of the central flight of stairs have been restored, but they once led up to the temple on the topmost platform and allow the observer to gain an impression of the tower's original height. The ziggurat stood in a large courtyard. Remains of the encircling temenos wall may be seen in the upper right-hand corner of the photograph. The complex was part of a sanctuary dedicated to the god Enlil.
M. M.-K.

T. Baqir, *Excavations at Aqar Quf: First Interim Report 1942–43 (Iraq Supplement)* (London 1944); T. Baqir, *Aqar Quf (Dur Kurigalzu)* (Baghdad 1959)

184 | **The Buddhist centre at Anuradhapura, Sri Lanka**

The ruins of Anuradhapura ('City of Anuradha') extend over an area of more than 30 sq km in the middle of ricefields and coconut trees some 200km to the north-east of the Sri Lankan capital, Colombo. The city was founded *c*437 BC and became the capital of the Sinhalese empire under King Pandukabhaya (437–367 BC) in 377 BC. His empire extended to the Mediterranean in the west and to Japan in the east. The city's economy rested on a complex irrigation system with channels and reservoirs that allowed rice to be grown and harvested in vast quantities. The politico-economic and architectural development of the city was closely bound up with Buddhism: thousands of international pilgrims flocked to Anuradhapura and were accommodated in their own districts. They came to venerate an offshoot of the Buddha's Tree of Enlightenment and four monumental dagobas, or stupas, Buddhist buildings designed to hold sacred relics. The Jetavana Dagoba towards the foot of the photograph is a brick-built structure dating to the 3rd century BC and originally stood 120m high on a 32,000 sq m platform up to 12m deep. In its recently restored form, the Ruvanveli Dagoba from the 2nd century BC (at the top of the photograph) extends over 287m and rises to 103m, making it one of the tallest buildings of its period. The first Buddhist chronicle, the Mahavamsa, describes the city as a model of urban planning. Following the invasion of Hindu Tamils around 993, the city was abandoned in 1017. Left to itself and overgrown by jungle, Anuradhapura was rediscovered in the early 18th century.
T. St.

B. Haris Chandra, *The Sacred City of Anuradhapura HC* (Colombo 1908); R. A. E. Coningham, *Anuradhapura: The British-Sri Lankan Excavations at Anuradhapura Salgahawatta 2*, vol. 1 (Oxford 1999)

185 | **The spring cone at Zendan-i Suleiman, Iran**

Looking virtually indistinguishable from a volcano, the crater cone at Zendan-i Suleiman ('Solomon's Dungeon') rises up from a stony calcareous sinter plateau 3km from Takht-i Suleiman ('Solomon's Throne', no. 18). These two monuments, together with two others in the area – the table mountain at Tawileh ('Solomon's Stables') and the ruined castle of Takht-i Bilqis ('Queen of Sheba's Throne', a reference to Solomon's lover) on a 3500m peak – were probably given these names not before the 15th century, after the historic tradition had been lost in the Timurid wars. Although sulphurous vapours rise from the crater, it is not volcanic in origin but a spring cone caused by calcium deposits from the highly calcinated water. As a result the cone has grown to a height of more than 100m. Now empty, the crater provides a textbook example of what the spring lake of Takht-i Suleiman, which may have come into existence after it, looks like from the inside. Archaeologically, too, the zendan is a precursor of Takht-i Suleiman. In preparing to excavate the site in 1958, Hans Henning von der Osten discovered that halfway up its side the Zendan was surrounded by a ring of box and terrace walls dating to the 8th and 7th centuries BC. This may have been the site of a sanctuary of the Mannaeans, a Churritic people that settled here in the early 1st millennium BC. Deposits show that water was still seeping from the crater at that date.
D. H.

R. Boehmer, 'Forschungen am Zendan-i Suleiman', *Archäologischer Anzeiger* (1967), 573–85; B. Damm, *Geologie des Zendan-i Suleiman und seiner Umgebung* (Wiesbaden 1968); W. Kleiss, *Zendan-i Suleiman: Die Bauwerke* (Wiesbaden 1971)

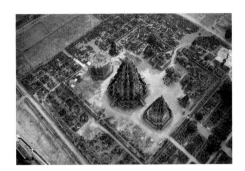

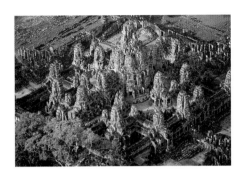

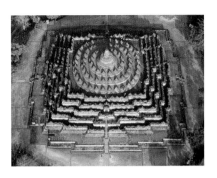

186 | **The temple complex at Prambanan on Java, Indonesia** The temple complex at Prambanan lies on a wide plain 16km north-east of the provincial capital of Yogyakarta in central Java. The Hindu Mataram dynasty (AD 732–928) drove away the Buddhist Sailendra rulers in the middle of the 9th century and under King Rakai Pikatan built the sanctuary here c856. It was intended from the outset as a Hindu-Shivaite counterpart to the temple complex at Borobudur (no. 188) only 25km away. The ceremonial site at Prambanan is divided into three areas that are separated from each other by walls. In the central inner courtyard eight temples stand on a raised terrace, the three largest of which, decorated with elaborate reliefs, are aligned on a north-south axis. The 47m high Temple of Shiva is flanked by the Temple of Brahma to the south and by the (scaffolded) Temple of Vishnu to the north. The central compound formerly contained 224 identical sanctuaries, each 14m high, while the outer compound housed the wooden buildings for pilgrims, monks and temple servants. None of these buildings has survived. The point of intersection of the diagonals of the inner temple courtyard is not in the main cella of the Shiva shrine, as one might expect, but to the side of the eastern steps. Here a rich urn burial was observed, suggesting that the complex was planned as a tomb for a Mataram ruler and served his apotheosis and deification as Shiva. By AD 929 the centre of power had shifted to eastern Java for reasons that are still unclear, with the result that the site fell into disrepair after only a few decades in use. It was rediscovered by C. A. Lons in 1733. Restoration work began in 1885.
T. St.

Moertjipto (ed.), *The Ramayana Reliefs of Prambanan* (Yogjakarta 1991); A. and E. Eggebrecht (eds.), *Versunkene Königreiche Indonesiens* (Mainz 1995) (exhibition catalogue); R. E. Jordaan (ed.), *In Praise of Prambanan: Dutch Essays on the Loro Jonggrang Temple Complex* (Leiden 1996)

187 | **The Bayon at Angkor Thom, Cambodia**
Angkor was the centre of the largely Hindu Khmer kingdom that flourished between the late 9th and mid-15th century. It lies on a fertile plain close to Siem Reap to the north-east of Lake Tonle Sap in north-western Cambodia. The various architectural complexes are scattered over an area of more than 400 sq km and form an archaeological park that is now a World Heritage Site. Overgrown by tropical jungle, Angkor was rediscovered by the French explorer Henri Mouhot in 1858. The task of examining and restoring the site was interrupted by war in 1970, when Angkor suffered serious damage. The last capital of the Khmer, it was founded by King Udayadityavarman II (1050–66) in the Baphuon period but was substantially rebuilt by Jayavarman VII (1181–1219/20) following an invasion by the Cham. The city is described in Chinese chronicles. The present photograph shows the Bayon, the last important Khmer temple in the centre of Angkor Thom, that gave its name to a stylistic period, the Bayon style (1177–1230). Primarily a Buddhist sanctuary (the 'god king' Jayavarman VII was an adherent of Mahayana Buddhism), it reflects the universe in its ground-plan and structure. The three terraces (43m in height), with their outer (160 x 140m) and inner gallery (80 x 70m), embody the sacred mountain Meru and are crowned by a round central sanctuary 23m high, around which are grouped 12 subsidiary sanctuaries in the shape of a star. Walls, pillars and lintels are richly ornamented and include representational scenes depicting war, hunting, fishing, life in the marketplace and palace, games, gods and apsaras.
S. St.

G. Coedès, *Un grand roi du Cambodge: Jayavarman VII* (Pnom Penh 1935); P. Stern, *Les monuments du style Khmer du Bayon et Jayavarman VII* (Paris 1965); C. Jacques and R. Dumont, *Angkor* (Paris 1990)

188 | **Borobudur on Java, Indonesia**
Originally a 42m high step pyramid dating from c780–930 AD, Borobudur rises above the fertile Kedu Plain some 40km north-west of Yogyakarta in central Java. By the middle of the 8th century, this plain had provided the Sailendra dynasty (778–mid-9th century) with the economic conditions necessary to complete this Buddhist sanctuary in barely 80 years. The site measures 123 x 123m and consists of eight levels – five quadrangular galleries and three circular terraces. These are surmounted by a stupa 8m high. Borobudur combines three architectural ideas basic to Buddhism: the cosmic mountain, the stupa and the mandala. It required more than 2 million square hewn stones, around 2.5km of figurative and decorative stone friezes and 504 statues of the Buddha. The settlements of central Java were abandoned c930, probably following a volcanic eruption, and Borobudur was no exception. It was rediscovered in 1814 and excavated at the instigation of the then British governor of Java, Sir Stamford Raffles. During the decades that followed many of the reliefs and statues were looted, before the Dutch archaeologist Theodor van Erp began the first systematic restorations in 1907. Meanwhile, erosion of the earthen core of the pyramid continued to worsen, and the whole site, entirely built without mortar, threatened to collapse completely. Unesco began the task of restoring the site in 1973. It was completed ten years later at a cost of $25m. Borobudur was handed back to the general public by President Suharto of Indonesia in 1983.
T. St.

T. S. Raffles, *Antiquarian, Architectural and Landscape Illustrations of the History of Java* (London 1817); A. Hoenig, *Das Formproblem des Borobudur* (Batavia 1924); L. Frédéric and J.-L. Nou, *Borobudur* (New York 1996)

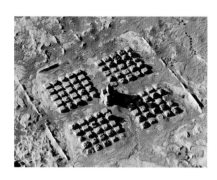

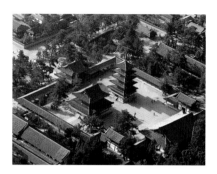

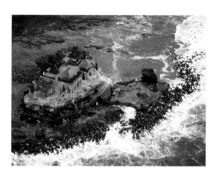

189 | **The Temple of a Hundred Stupas in Jiaohe, China**

Also known as the 'Stupa Forest', the Temple of a Hundred Stupas in the ruined city of Jiaohe 10km west of Turfan, Xinjiang, is one of the more unusual forms of early Buddhist ceremonial sites in north-west China. Relatively well preserved and surrounded by a rectangular wall, the temple is in the northern part of the city and consists of a group of stupas that Chinese archaeologists have dated to the time of the Northern and Southern Dynasty (AD 420–581). Within the walled rectangle, four groups of 25 stupas each are laid out along symmetrical lines, with a large stupa at the centre, its upper section made up of five tall towers arranged in the form of a star. The stupas are made of sun-dried mud bricks, a common building material in this part of the world. The small stupas have largely collapsed as a result of human agency and natural erosion, and only their rectangular bases, which formed their lowest step, can still be seen today. The stupa is arguably the universal symbol of Buddhism. These generally dome-shaped structures evolved from early Indian burial mounds. Following the cremation of the Buddha, his relics were divided up and preserved in stupas such as these. In this way they gradually came to symbolize his death and liberation from the cycle of rebirth. Wherever Buddhism gained a foothold, these symbolic buildings are to be found, but always influenced by local traditions. In China, for example, they evolved into pagodas. Together with the ruins at Jiaohe (no. 35), the present site has been a protected monument in China since 1961.

B. S.

Xinjiang gudai minzu wenwu (Cultural Assets of Ancient Peoples in Xinjiang) (Beijing 1985), 13

190 | **The Horyu-ji Temple at Nara, Japan**

Nara was Japan's main city from 710 to 784. Some 12km to the west lies Horyu-ji, a World Heritage Site that is undoubtedly Japan's most important temple complex from a historical, religious and artistic point of view. Covering 7 ha, the complex was begun in 607, during the Asuka period (552–645), at the time of the regency of Shotoku Taishi (593–621), one of the great cultural heroes of Japanese history, who combined Chinese thinking and culture with Japanese traditions. Horyu-ji is the headquarters of the Buddhist Shotoku sect and the most venerable of the seven great temples at Nara, constituting a unique treasury of Japanese art, with examples from every important period in the country's history. The temple precincts include the oldest wooden buildings not only in Japan but in the world. Although many of these buildings have burnt down on more than one occasion, they have always been rebuilt in the same style. The ceremonial buildings at Horyu-ji document the way in which Chinese architecture and Buddhism were taken over before spreading to the rest of Japan. The aerial photograph shows the temple courtyard of the Western Precinct (Sai-in), which numbers 31 buildings, including the Golden Hall (Kondo), five-storey pagoda (Goju-no-to), Chumon Gate and Great Lecture Hall (Daikodo). The courtyard is surrounded by roofed corridors. The Kondo functions as a prayer hall and houses valuable ancient statues, including Tori Busshi's Shaka Triad (Sakyamuni) of 623. It rests on 28 wooden pillars and is notable for its curved double roof. Dating from 607 and decorated with scenes from the life of the Buddha, the 32m pagoda is the oldest surviving pagoda in the world.

S. St.

M. Ooka, *Temples of Nara and their Art* (New York and Tokyo 1973); S. Mizuno, *Asuka Buddhist Art: Horyu-ji* (New York and Tokyo 1974); K. Suzuki, *Early Buddhist Architecture in Japan* (New York and Tokyo 1980)

191 | **The Temple at Tanah Lot on Bali, Indonesia**

The Hindu sanctuary of Tanah Lot ('Land in the Sea') stands on a rocky outcrop on the south-west coast of the Indonesian island of Bali, some 30km west of the provincial capital of Denpasar. Lapped by the sea, it can be reached on foot only at low tide. The rocky plateau is surrounded by a wall enclosing seven buildings that are accessible only by a single flight of steps. Opposite the entrance lies the main temple of the water goddess Dewi Danu, a typical example of Balinese temple architecture: on a stone base stands a wooden structure with a varying number of stepped gable roofs tapering towards the top. All the roofs are thatched with palm leaves. Many Balinese pilgrims come to Tanah Lot, which is one of nine imperial temples and protected not only against the powers of evil but also against the underworld, which is located in the sea. Their sacrificial gifts are intended to placate the demons of the sea. According to legend, the monk Nirarthu was so overwhelmed by the natural beauty of the place that he ordered a temple to be built here. It was probably built by the Megwi rulers (c1700–1891) in the 18th century as a sea temple. Following the dissolution of the Majapahit empire (c1200–1500) in the wake of the Islamic conquest, the Hindu-Buddhist religion developed a distinctive, syncretic form on Bali, namely, Hindu-Dharma, a mixture of Hinduism, Buddhism, natural religion and ancestor worship. More than 20,000 temple shrines on Bali reflect the transcendent role of this religion for the population and society in general.

T. St.

J. W. F. Herfkens, *De Expeditiën naar Bali 1846–1849* (Breda 1902); A. J. Kempers, *Monumental Bali: Introduction to Balinese Archaeology and Guide to the Monuments* (Berkeley 1991); A. and E. Eggebrecht (eds.), *Versunkene Königreiche Indonesiens* (Mainz 1995) (exhibition catalogue)

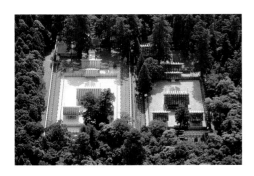

192 | The Inner Shrine at Ise on Honshu, Japan
The most important Shinto sanctuary in Japan, with the richest and most venerable tradition, the Ise Shrine lies in a fertile and rugged coastal landscape to the south-west of Nagoya on the Shima Peninsula. The whole area is now a national park. The sanctuary is divided into two parts, the Outer Shrine (Geku) and, pictured here, the Inner Shrine (Naiku). The Naiku is dedicated to the sun goddess Amaterasu Omikami, the ancestress of the Japanese imperial family and of the nation as a whole. She is represented by the eight-cornered mirror (Yata-no-kagami), one of three imperial insignia. The Naiku dates to the 4th century BC. It was originally part of the imperial palace and was not transferred to Ise until the 5th century AD. One of the rituals associated with the site is that the shrine is removed every 20 years and a new one built next to it. This Shinto tradition (Sengu-shiki) is attested from the late 7th century. By the 8th century great festivals of national importance were taking place here. The architecture eschews all use of ostentatious colour and, with its cedar and cypress, reflects the purely Japanese Shinmei-zukuri style inspired by granaries. There are no Chinese or Buddhist influences. The present photograph was taken in 1993 and is unusual in that it shows the old 1973 shrine shortly before its removal, together with the newest shrine beside it. The 61st shrine, it will remain here until 2013. As a sacred precinct, the Naiku is surrounded by several fences and comprises an outer courtyard with two halls and the large courtyard with two treasuries and the main hall (Shoden), which measures 10.9 x 5.5m. It stands out by virtue of its raised platform with surrounding verandah, wooden columns without stone bases and a grass-covered saddleback roof with crossed rafters.
S. St.

Y. Watanabe, *Shinto Art: Ise and Izumo Shrines* (New York and Tokyo 1974); T. Fukuyama, *Jinja kenchiku no kenkyu* (Research on Shrine Architecture) (Tokyo 1984)

193 | The Fushimi-Inari Shrine in Kyoto, Japan
The Fushimi-Inari Shrine is among the most famous Shinto shrines in Japan. It lies close to Momoyama in the Fushimi district of southern Kyoto. This hill was formerly surmounted by Toyotomi Hideyoshi's castle and is now the site of the mausoleums of Emperor Meiji and his wife, Empress Shoken. The shrine was dedicated to the Shinto goddess of rice and fertility, Ugoono-Mitama, in AD 711, in other words, during the early Nara period, before Kyoto became the capital of Japan. The shrine is picturesquely situated in woodland and offers striking proof of the close links between Shinto and nature. It is known above all for its thousands of generally red torii, wooden gates with a characteristically curved architrave, many of which span the path to the shrine itself, as may be seen from the air. The present shrine dates from 1499 and is built in the Momoyama style. In front of it is a covered Kagura hall for ritual dances. The sanctuary is named after the fox, 'inari', which is worshipped as a messenger of the gods and which may be found in the form of numerous stone statues.
S. St.

R. A. Ponsonby-Fane, *Kyoto: The Old Capital of Japan* (Kyoto 1956); T. Hayashiya (ed.), *Kyoto no rekishi* (History of Kyoto), 10 vols. (Kyoto 1970–76); H. Kageyama, *The Arts of Shinto* (New York and Tokyo 1973)

194 | The monolith church of Beta Giyorgis in Lalibela, Ethiopia Hidden away in the mountains at a height of 2600m, the monastery village of Lalibela lies in the province of Wollo, 640km north of Addis Ababa. Cut from solid rock around AD 1200, twelve monolithic churches have attracted Christian pilgrims for 800 years. These rock churches – even the tiniest decorative elements are carved from the same block of tuff – first entered European consciousness in the early 16th century, when they were discovered by the Portuguese priest and explorer Francisco Alvarez. This was once the site of Roha, the capital of the Zagwe Dynasty (c1140–1270), later renamed Lalibela after its traditional founder, King Lalibela (c1190–1225). Somewhat apart from the other churches, in the south-west corner of the site, lies the Beta Giyorgis, the 'House of St George', dedicated to Ethiopia's national saint. The strictly symmetrical, cruciform building, with its two axes each measuring 12.5m, lies in a depression 12m deep that covers an area of some 600 sq m. It is accessible only through a stone tunnel. The roof is decorated with three identical interlocking crosses. The church itself rests on a three-step podium that runs all around it. A flight of steps on its east side leads into the elegant, well-proportioned interior. Elements of Axumite palace architecture and early Christian basilicas provide the church's architectural foundations, but these elements have been transferred to a scene of great isolation and intensity, thus characterizing the feel of this unique building and ensuring that even today the rock churches of Lalibela retain their religious significance for Ethiopia's orthodox Christians.
T. St.

F. Alvarez, *Narrative of the Portuguese Embassy to Abyssinia During the Years 1520–1527* (London 1881); L. Bianchi Barriviera, *Le chiese monolitiche di Lalibela e altre nel Lasta-Uagh in Etiopia* (Rome 1957); G. Gerster, *Churches in Rock: Early Christian Art in Ethiopia* (London 1970)

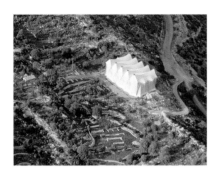

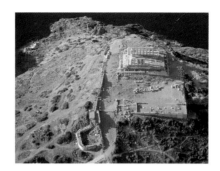

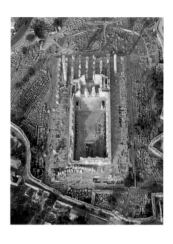

195| The Temple at Bassae in the Peloponnese, Greece The Temple of Apollo Epicurius stands alone in the fissured Arcadian uplands north-east of the ancient town of Phigalia in the Peloponnese. ('Bassae' means 'little valleys' in Greek.) Its remoteness meant that it lay undiscovered until the French architect Joachim Bocher stumbled upon it in 1765. The first excavations were undertaken by Charles Cockerell in 1812. The epithet 'Epicurius' refers to the god's attribute as a helper in time of need. Apollo was known to the *Iliad* as a sender of scourges and epidemics, but he was also revered for his healing powers. His son was Asclepius. The temple was probably dedicated at the time of a plague epidemic in *c*420 BC. In the present photograph the building is hidden beneath a restoration tent that gives an idea of its former size. It is the last of four buildings on this site. According to ancient tradition, it was designed by Ictinus, who was also responsible for the Parthenon in Athens. The temple is notable for a number of unusual details. The entrance, for example, is not on the east side, as usual, but faces north. But the east wall of the cella has a special door to allow the morning sun to strike the cult-statue. Although the cella is surrounded by the usual circle of Doric columns, the internal walls are remarkable for their engaged columns attached to the spur-walls. Only in the middle of the narrower side was there a free-standing column surmounted by a Corinthian capital, the first example of such a capital in Greek architecture. The sculptured marble frieze that runs all round the cella is also found here for the first time.
R. S.

B. C. Madigan and F. A. Cooper, *The Temple of Apollo Bassitas. 2: The Sculpture* (Princeton 1992); F. A. Cooper, *The Temple of Apollo Bassitas. 1: The Architecture* (Princeton 1996)

196| The Temple of Poseidon on Cape Sounion, Greece For the approaching sailor, the Temple of Poseidon on the steep and craggy spur on the extreme south-west tip of Attica must have seemed like a symbol of Attica as a whole. A great festival was held here every four years in honour of the god, featuring mock battles with warships. The Doric temple was built *c*440 BC, replacing an earlier building that was still incomplete when destroyed by the Persians in 480 BC. The sacred precincts lie within a solid defensive wall that encircles the whole town and that was built during the Peloponnesian War in 413/412 BC to secure a base that was important for Athens' grain supply. Sounion was a rich Attic town. The remains of the houses and public buildings extend over the ridge of the hill to the west of the town. Eleven of the temple's columns remain standing to this day. The building was a favourite destination and object of study from an early date. The English student of architecture Nicholas Revett drew it in 1765 and the Society of Dilettanti visited the ruins in 1812. Even during antiquity tourists would scratch their names on the columns. That of Lord Byron is still visible.
R. S.

W. B. Dinsmoor, *Sounion* (Athens 2/1974); U. Sinn, 'Sounion: Das befestigte Heiligtum der Athena und des Poseidon an der "Heiligen Landspitze Attikas"', *Antike Welt*, 23 (1992), 175–90; H. R. Götte, *Ho axiologos demos Sounion: Landeskundliche Studien in Südost-Attika* (Rahden 2000)

197| The Temple of Apollo at Didyma, Turkey Situated in the south of the Milesian peninsula some 20km south of the ancient trading centre of Miletus on the coast of western Asia Minor, the sanctuary of Apollo at Didyma included one of the largest temples in the classical world. The earliest investigations were carried out by English and French scholars in the 18th and 19th centuries, but it was not until 1906 that the German Archaeological Institute began to excavate the site in earnest. Here was the site of the most important oracle after Delphi and as such it was famous far beyond the immediate area. In the 6th century BC, for example, the fabulously wealthy King Croesus of Lydia and the Egyptian pharaoh Necho both presented it with valuable gifts. As with two similarly monumental temples in the area, the Heraeum on Samos and the Artemisium at Ephesus, which was even numbered among the seven wonders of the ancient world, a double row of Ionic columns rose up from the seven-stepped crepidoma. And as at Ephesus, they surrounded not a covered cella but an open courtyard whose side walls were sufficiently high as to allow the columned ambulatories to be roofed over, thereby producing the impression of a closed building. The reason why the interior of the building was open to the sky was the laurel grove and sacred fountain, beside which was a small naiskos for the cult-image. The oldest limestone building from the late 6th century BC was destroyed by the Persians when they put down the Ionian Revolt in 494 BC. Its replacement, seen here, was begun at the end of the 4th century BC, using marble, but remained incomplete. Several earthquakes have left only three of the original columns standing.
R. S.

T. Wiegand, *Didyma I: Die Baubeschreibung*, ed. H. Knackfuß, 3 vols. (Berlin 1941); G. Gruben, 'Das archaische Didymaion', *Jahrbuch des Deutschen Archäologischen Instituts*, 78 (1963), 78–177; K. Tuchelt, *Branchidai – Didyma: Geschichte, Ausgrabung und Wiederentdeckung eines antiken Heiligtums* (Mainz 1991), 1–54 (*Antike Welt*, Special Number 22)

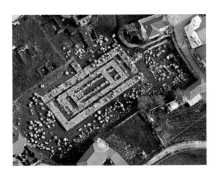

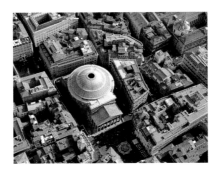

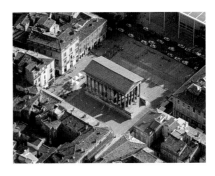

198| **The Temple of Athena at Tegea in the Peloponnese, Greece** The largest temple at Tegea – one of the oldest and most important cities in Arcadia – was dedicated to Athena Alea. The hero Aleus is said to have founded the temple, which enjoyed a famous right of sanctuary, of which such prominent refugees as the Spartan kings Leotychidas and Pausanias made use. The city was razed to the ground by the Gothic king Alaric in AD 395. The site was excavated by German and French archaeologists between 1879 and 1902. The present temple replaced an archaic predecessor that burnt down in 395 BC. The principal architect is reputed to have been Scopas of Paros, one of the most prominent artists of the late classical period, who would also have been responsible for the sculptures decorating the altar, the statues of Asclepius and Hygiea in the cella and presumably also the figures on the tympanums. This was the first temple in the Peloponnese to be built entirely of marble. The cella was surrounded by a circle of Doric columns, whereas the demi-columns on the internal walls had Corinthian capitals. The subject matter of the tympanums is drawn from local myths. On the eastern tympanum was a depiction of the Calydonian boar hunt in which the famous heroes Theseus and Meleager took part, as did the local huntress Atalante, who finally brought down the boar. Its skin was still being displayed in the temple in Roman times. The western tympanum showed the struggle between Achilles and another local hero, Telephus, who was the son of Hercules and Auge, the daughter of Aleus. Telephus went on to found both Pergamon and the Attalid dynasty.
R. S.

C. Dugas and others, *Le sanctuaire d'Aléa Athéna à Tégée au IVe siècle* (Paris 1924); F. Stewart, *Skopas of Paros* (Park Ridge 1977), 5–84; N. J. Norman, 'The Temple of Athena Alea at Tegea', *American Journal of Archaeology*, 88 (1984), 169–94

199| **The Pantheon in Rome, Italy** Situated at the heart of the old city and the Campus Martius, the Pantheon is one of the best-preserved Roman temples. Built by Agrippa in 27–25 BC, it was restored by Domitian following a fire in AD 80 and then completely rebuilt by Hadrian between AD 118 and 125. Further restoration work was carried out by Septimius Severus and Caracalla in AD 202. In 609 the Pantheon – originally a dynastic temple dedicated to all the gods of Rome – was turned into the Church of Sancta Maria ad Martyres, a circumstance to which it largely owes its excellent state of repair. Raphael and several Italian kings are buried here. From the air one can see clearly the two main elements of this masterpiece of Roman antiquity, the large three-aisled entrance portico (33.1 x 15.5m) with its granite Corinthian columns and tympanum, and the circular church proper, with the largest masonry dome ever built, its diameter of 43.3m being exactly the same as the height of the building. With its five concentric rows of cassettes, the coffered semicircular dome is built of a lighter volcanic stone, the round hole in its centre being 9m in diameter. The 6m thick outer wall is divided into three sections by string courses. The inside walls and floor are richly inlaid with opus sectile in different types of marble. The upper wall was completely redesigned in 1747. In the top right-hand corner of the photograph may be seen another of Rome's architectural masterpieces, Francesco Borromini's Baroque church of Sant'Ivo alla Sapienza (1642–62).
S. St.

L. Beltrami, *Il Pantheon* (Milan 1898); R. Vighi, *Il Pantheon* (Rome 1959); F. Coarelli, *Rom: Ein archäologischer Führer* (Mainz 2000), 280–84

200| **The Maison Carrée at Nîmes, France** The capital of the Volcae Arecomici, the city of Nîmes (Gard) can trace back its origins to prehistoric times. It was a Roman colony – Colonia Augusta Nemausus – by 42 BC at the latest. With its large number of inhabitants, extensive territories and important mint, Nîmes was quickly accounted among the leading cities of Narbonian Gaul. As a result, it enjoyed unlimited imperial attention, acquiring not only a city wall in 16/15 BC but a whole series of outstanding buildings, most notably the still visible Augusteum, into which water flowed from the sacred spring and which included a theatre and a library – the so-called 'Temple of Diana'. The famous amphitheatre was not built until the end of the 1st century AD. Caius Caesar, a grandson of Augustus, was the city's patron until his death in AD 4. The city's best-known monument, the Maison Carrée, is dedicated to him and his brother Lucius. It was built in the southern half of the forum during the last decade before the birth of Christ and, together with the Pantheon in Rome, it remains the best-preserved temple in the whole of the Roman Empire. The building stands on a stylobate measuring 31.8 x 15m and reaches a height of 17m. On a smaller scale it follows the groundplan of the Temple of Apollo in Rome, with six columns at the front and eleven along the side. Of these latter, eight are incorporated into the cella wall as demi-columns. The Corinthian capitals and architectural ornaments are influenced in the main by models in the imperial capital, above all the Temple of Mars Ultor, thus attesting to the rapid Romanization of Narbonian Gaul.
M. R.

R. Amy and P. Gros, *La Maison Carrée de Nîmes* (Paris 1979) (Gallia: Supplementary Volume 38)

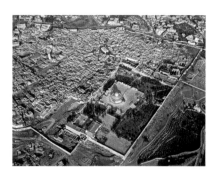

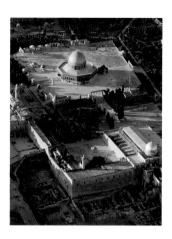

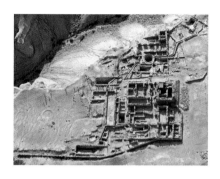

201 | The Old City of Jerusalem/Al Khutz

Visitors to the old town of Jerusalem soon become lost in its confused mass of narrow streets. Within the walls that Suleiman the Magnificent built in the 16th century, often on ancient foundations, the four parts of the city contain many sites sacred to the world's three monotheistic religions, Islam, Judaism and Christianity. The old town is dominated by the Haram es-Sharif with the Dome of the Rock and El-Aksa Mosque, the width of the platform contrasting with the narrow streets. To the north of the Haram (in the upper right-hand corner of the photograph) lies the Muslim quarter, with the Christian quarter to the west. Here we can see the 50m high bright belltower of the Church of the Redeemer built by Emperor Wilhelm II. Behind it lies the rotunda of the emperor Constantine's Church of the Holy Sepulchre. Just visible to the left of the picture are the Jaffa Gate and the citadel where the Armenian quarter begins, followed further east (towards the bottom of the picture) by the Jewish quarter. The outer wall of the Haram's esplanade still contains a few stones from the platform of Herod's Temple, which was destroyed by the Romans in AD 70. At the southern end of the West Wall of the Haram is the Wailing Wall, where the Jews pray to Yahweh. Clearly visible in the photograph, the large open space in front of the Wailing Wall was created when an old quarter of the city was torn down in the wake of the Six Days War in 1967, guaranteeing Jewish pilgrims access to the wall.
A. L.

E. Stern (ed.), *The New Encyclopedia of Archaeological Excavations in the Holy Land*, vol. 2 (Jerusalem 1993), 698–804; K. Bieberstein and H. Bloedhorn, *Jerusalem: Grundzüge der Baugeschichte vom Chalkolithikum bis zur Frühzeit der osmanischen Herrschaft*, 3 vols. (Wiesbaden 1994)

202 | The Temple Square in Jerusalem/Al Khutz

The Haram es-Sharif, with the octagonal, golden-domed Dome of the Rock and El-Aksa Mosque, is the third most holy site in Islam. The sanctuaries stand on an esplanade measuring 485 x 470 x 315 x 280m. Not only does this esplanade follow closely the dimensions of the platform of the Second Jewish Temple that was rebuilt by Herod the Great, certain parts of it even reveal masonry from Herod's Temple. The exact position of the Jewish Temple is not known. Prior to its destruction by the Romans in AD 70, it was the central reference point of the Jewish religion. Conversely, all the monuments now visible on the platform date from the period after the conquest of the city by the Arabs in AD 638. The Dome of the Rock was built in 691/2 and is one of the oldest Muslim buildings. It encircles the rock which according to tradition is Mount Moriah, the place where Isaac was bound and Mohammed later ascended to heaven. The dome was not gilded until 1963: until then it had been black lead. The El-Aksa Mosque dates to the 8th century and is the principal mosque on the hill. It has been rebuilt on several occasions, so that it retains virtually nothing of its former groundplan. The precarious religious and political situation surrounding the Haram es-Sharif has so far prevented archaeological investigations from being undertaken on the hill itself. The present photograph was taken in 1972 and shows the south-west corner of the Temple Mount in the foreground, with the excavations that Benjamin Mazar began on the Ophel and on the Herodian buildings in the vicinity of the former temple in the wake of the Six Days War. There is now an archaeological park on the site.
A. L.

K. A. C. Creswell, *A Short Account of Early Muslim Architecture* (London 1958); E. Mazar and B. Mazar, *Excavations in the South of the Temple Mount* (Jerusalem 1989); K. Bieberstein and H. Bloedhorn, *Jerusalem: Grundzüge der Baugeschichte vom Chalkolithikum bis zur Frühzeit der osmanischen Herrschaft*, vol. 3 (Wiesbaden 1994)

203 | The settlement at Qumran, Palestine

The story of the Bedouin boy who in 1947 stumbled upon the Dead Sea Scrolls in a cave at Qumran on the western side of the Dead Sea is now common lore. So dry is the climate here that these scrolls, which turned out to be part of an entire ancient library, had survived in surprisingly good condition and have proved an invaluable aid in our understanding of Judaism during the late hellenistic and early imperial periods, in other words, the very time that Jesus was alive. Whereas it is now generally believed that these scrolls were hidden in the caves, presumably during the upheavals of the Jewish War, and that they belonged to a Jewish sect known as the Essenes, it remains a matter of lively debate whether the settlement found in the area of the caves may also be linked to this group. With its central tower, the site is typical of agricultural settlements, and many parts of the buildings that were described by the Dominican archaeologists who examined the site using monastic terminology were undoubtedly misleadingly named. (One thinks, for example, of the scriptorium.) At the same time, there is something to be said for the argument that settlement and scrolls are linked, the most obvious reason being the physical closeness of the two. The site also contains numerous ritual baths of a kind unnecessary in a 'normal' agricultural settlement. And Pliny the Elder locates an Essene community in this region. The fact that the settlement is constructed along the lines of an agricultural community can be explained in part by the suggestion that it was originally such a community and in part by the hypothesis that even a religious community must necessarily have had recourse to an existing architectural type as there was no independent model for such settlements.
A. L.

R. de Vaux, *Archaeology and the Dead Sea Scrolls* (Oxford 1973); Y. Hirschfeld, 'Early Roman Manor Houses in Judea and the Site of Khirbet Qumrun', *Journal of Near Eastern Studies*, 57 (1998), 161–89; J. Magness, *The Archaeology of Qumran and the Dead Sea Scrolls* (Grand Rapids and Cambridge 2002)

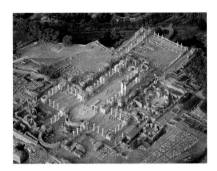

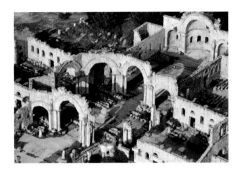

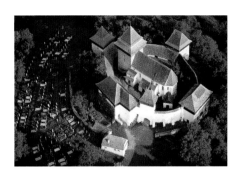

204 | St John's Basilica at Ephesus, Turkey

According to tradition, the large basilica on the Ayasoluk (no. 90) some 3km to the north-east of the centre of Ephesus lies over the grave of St John the Apostle. The excavations were begun by Georgios Soteriou in 1920/21 and continued by Keil and Hörmann between 1927 and 1933. The three-aisled cruciform domed church, now ruined, was built by Justinian between 527 and 565 on the site of its almost equally large predecessor. Its position on the slope of a hill necessitated elaborate substructures, especially for the large column-lined courtyard of the atrium in front of the narthex to the west, from which the site commanded an impressive view of the bay. The southern approach led through a wall built at the time of the Arab conquests of the 7th/8th centuries. The main entrance was in the middle of the nave. Four columns on the site of the altar beneath the central dome mark the spot where the grave of St John is said to lie in a complex system of underground chambers. All that remains of the older 5th-century building is the square, formerly domed baptistery, which can be seen on the right-hand side of the photograph, opposite the entrance and flanked by two long apsidal rooms. A smaller building constructed on similar lines lies immediately next to it. It had a square interior in which eight pillars supported the dome. It had niches in the back walls that could be locked, suggesting that it was the treasury. A modern brick roof over the small chapel next to it affords protection to the frescoes, which are still in good condition. The walls to the south of the apse may be the remains of the episcopal palace.
R. S.

J. Keil and H. Hörmann, *Die Johanneskirche* (Vienna 1951) (Forschungen in Ephesos 14/3); M. Falla Castelfranchi, 'Il complesso di San Giovanni ad Efeso', *Efeso Paleocristiana e Bizantina / Frühchristliches und byzantinisches Ephesos*, ed. R. Pillinger and others (Vienna 1991), 89–103

205 | The monastery of St Simeon, Syria

The monastery of St Simeon (Qalat Siman) lies on the southern tip of a rocky massif some 40km north-west of Aleppo and is generally regarded as one of the largest and most important early Christian pilgrimage sites in the entire Mediterranean. It owes this reputation not just to the unusual life of the saint but also and above all to the architectural unity of the 12,000 sq m site, including its excellently preserved architectural ornaments. Simeon (*c*390–459) spent the last few decades of his life living on a pillar some 20m high and no more than 2m thick. His ascetic life on this pillar led to his being dubbed Simon Stylites (Simon of the Pillar), his fame attracting pilgrims from far around, although the sanctuary was established only after his death on the initiative of the Byzantine emperor Zenon between 476 and 490. Central to the complex was the cruciform memorial church, with the pillar and its base set within an octagonal courtyard from which four three-aisled basilicas radiate. These basilicas face the direction of the four cardinal points. The eastern basilica (in the upper right-hand corner) has three apses and was the church's liturgical nub. The sanctuary also included a 6th-century monastery, a baptistery and accommodation for the pilgrims. It was abandoned by the monks in the middle of the 7th century. The flood of pilgrims dried up, and the site gradually lost its religious significance, although the monastery survived as a ruin. Restoration work began in around 1930.
R. W.

D. Krencker, *Die Wallfahrtskirche des Simeon Stylites in Kal'at Sim'aan* (Berlin 1939); G. Tchalenko, *Villages antiques de la Syrie du Nord I* (Paris 1953), 205–76; J.-P. Sodini, 'Qal'at Sem'an: Ein Wallfahrtszentrum', *Syrien: Von den Aposteln zu den Kalifen* (Linz 1993), 128–43

206 | The fortified church at Viscri, Romania

Viscri lies in a small valley to the west of Rupea in central Romania. Numerous vessel fragments have been found here, dating to the 1st–3rd century AD and pointing to the existence of a small civilian settlement. Early in the 12th century Székelys – a Magyar people – settled here. Towards the end of the century the village, which was then part of the kingdom of Hungary, was resettled by Germans, who discovered here a small chapel, a castle keep and a simple defensive wall. The present late Gothic one-aisled church and belltower date from the 15th century. A defence passage was added to the choir and west tower during a third phase of building, turning the complex into a fortified church. The double defensive walls were built in the 16th and 17th centuries. The inner ring is fortified by two bastions, three defensive towers and a gate tower. The outer ring was left without a tower. The site is both impressive and remarkable for the way in which its elements are packed together within such narrow confines.
M. Ri.

W. Horwath, *Kirchenburgen* (Hermannstadt 1940); H. and A. Fabini, *Kirchenburgen* (Vienna 1986); G. Gerster and M. Rill, *Siebenbürgen im Flug* (Munich 1997)

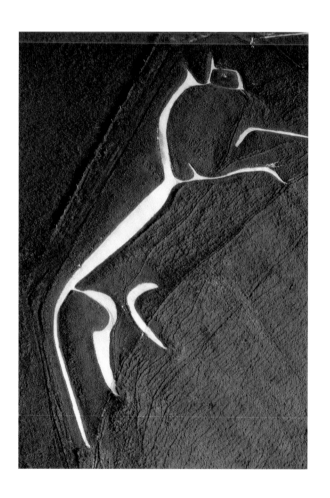

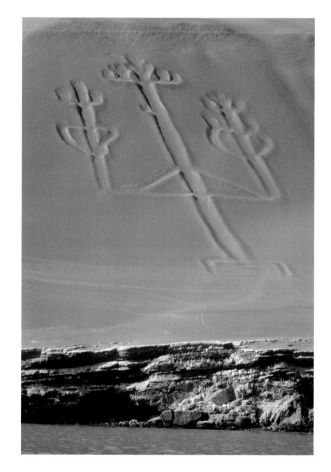

207 | **The White Horse at Uffington**, 1200 BC, England, 1977

208 | **The Candelabra at Paracas**, Peru, 1967

9. MYSTERIOUS GRANDEUR
— MONUMENTAL GEOGLYPHS

Where other explanations can't be right,
You're safe to claim it as a cultic site.

(Witticism current among archaeologists)

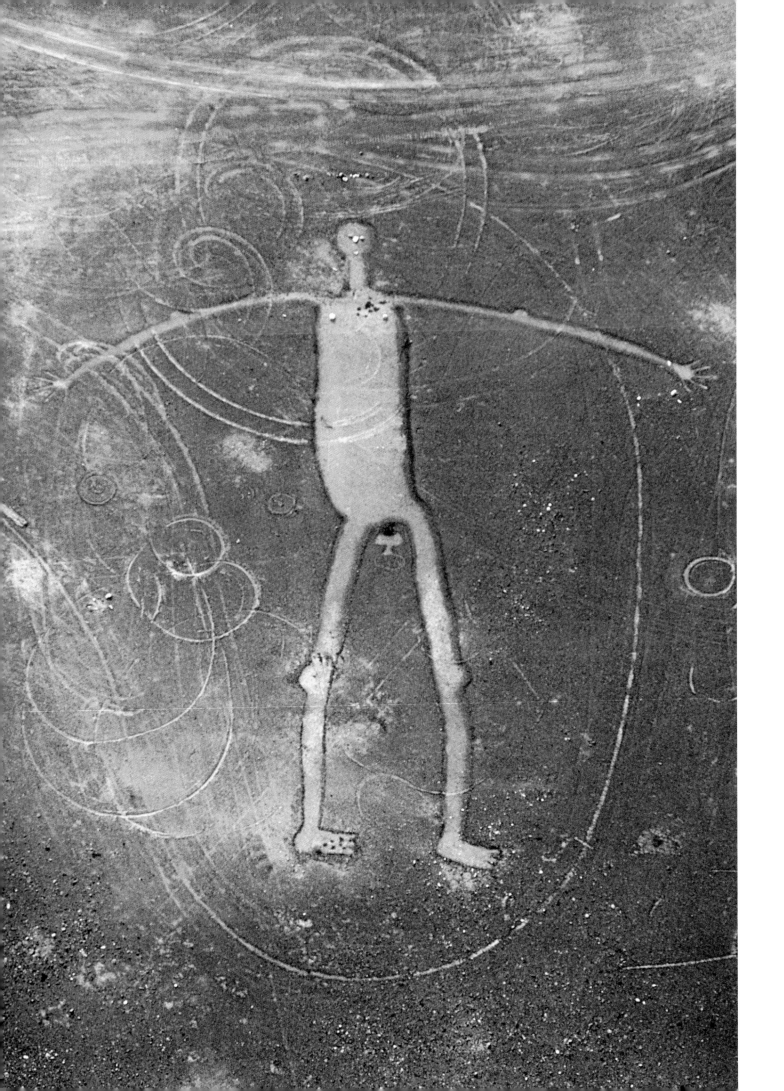

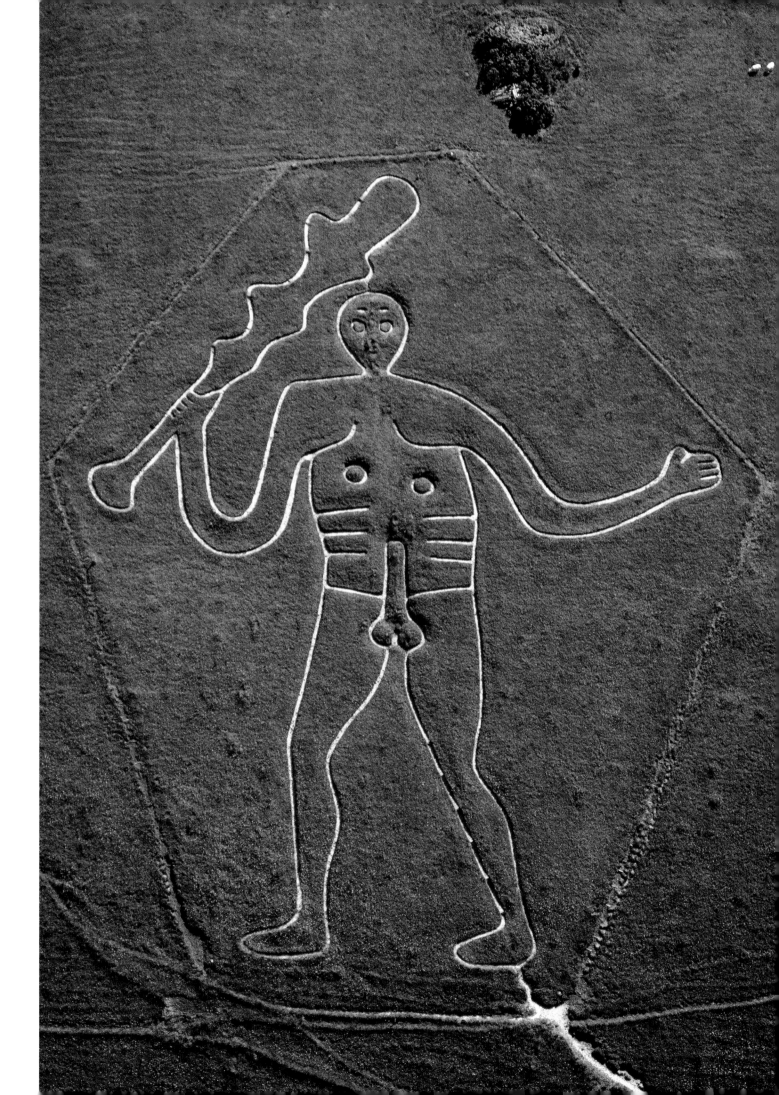

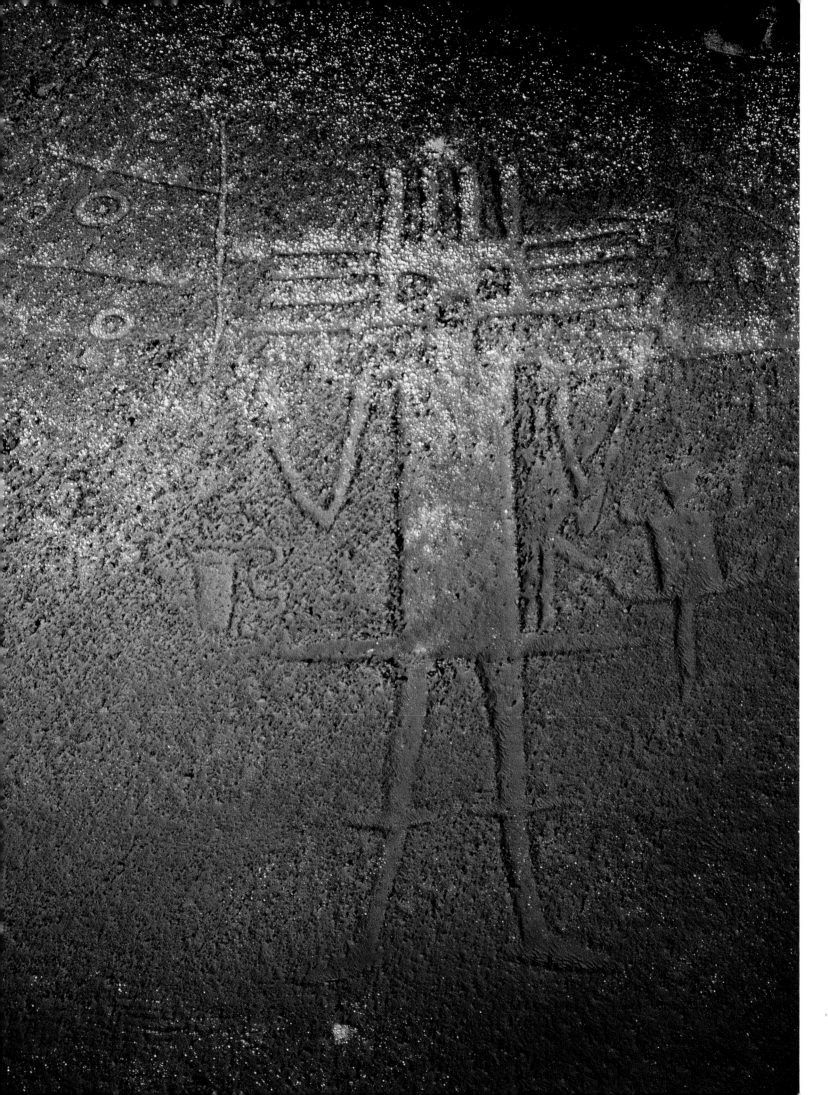

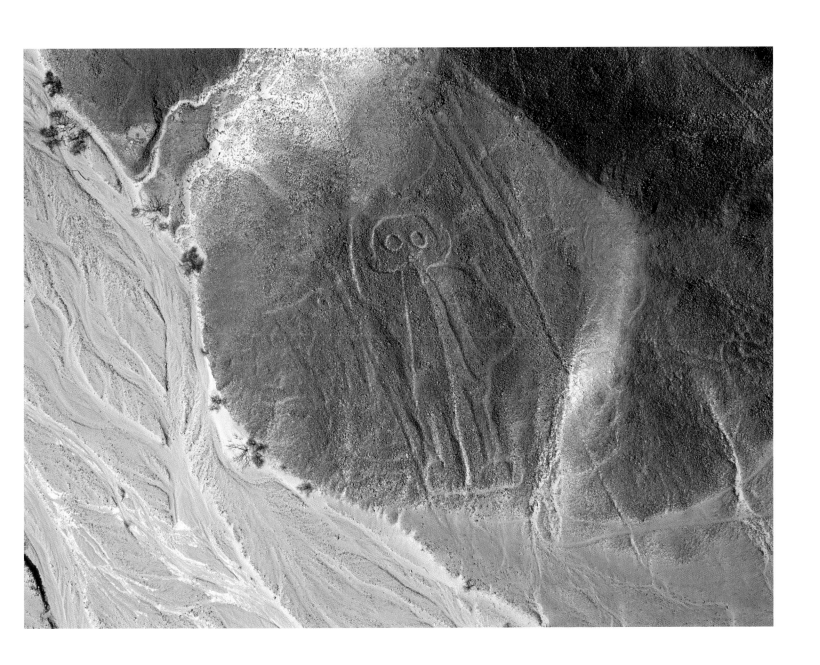

209 | *332:* **The Giant at Blythe in California**, USA, 1972

210 | *333:* **The Cerne Abbas Giant**, 2nd century AD(?), England, 1977

211 | **The figure at Cerro Unita**, Chile, 1978

212 | **The 'Owl Man' at Nasca**, 4th–1st century BC, Peru, 1976. World Heritage Site

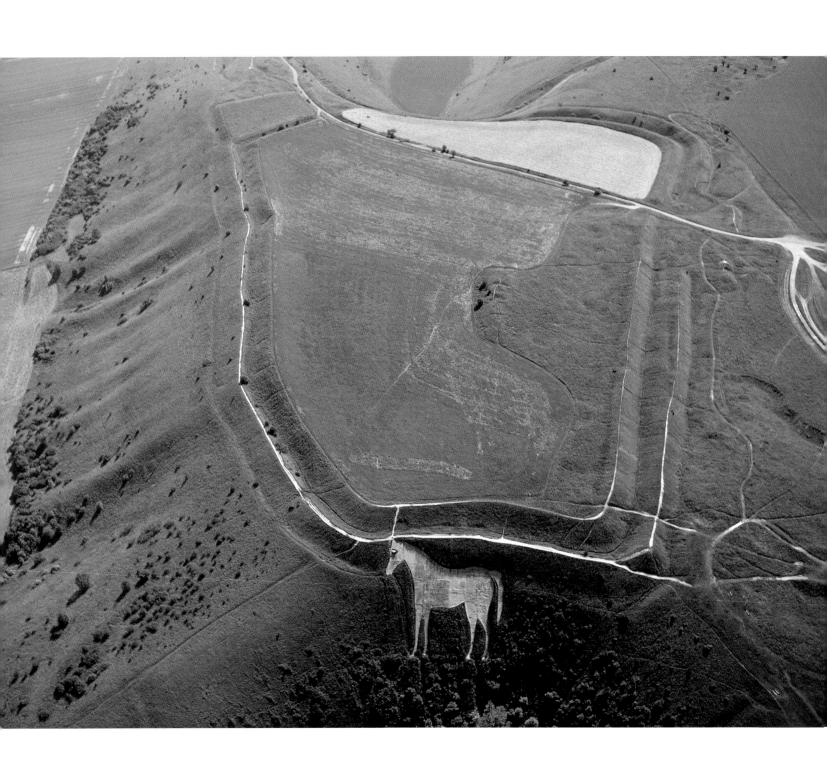

213 | *336/337:* **The Great Serpent Mound, Ohio**, USA, 1972

214 | **The White Horse at Westbury and Bratton Castle**, Wiltshire, AD 878, England, 1977

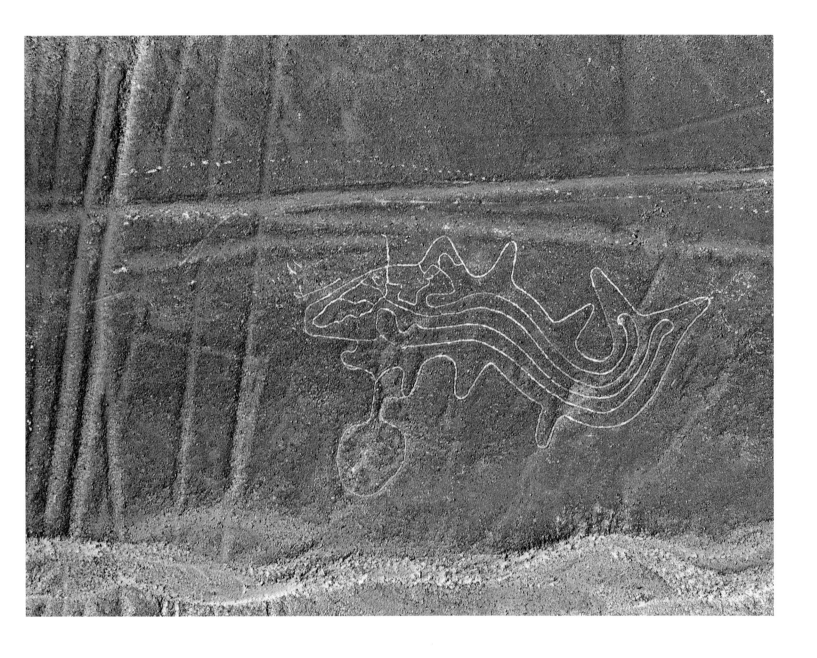

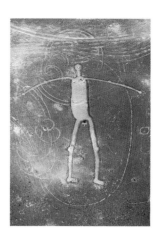

207 | The White Horse at Uffington, England

The White Horse at Uffington on the chalk scarp above the village of Uffington in Oxfordshire is the earliest chalk-cut hill figure in Britain. It is 111.3m long and has been recut and reshaped over many centuries in a very stylized fashion, but is similar to designs on Iron Age (Belgic) coins. The earliest reference to the horse dates from the 12th century AD, and a 14th-century treatise on the wonders of Britain ranks it second only to Stonehenge. Recent excavations using optical stimulated luminescence (which relies on buried soils for dating) have dated the original cutting of the horse to c1200 BC, i.e. the Late Bronze or Early Iron Age. Only 170m to the south-west there is an Iron Age hillfort, Uffington Castle, that may have been built by villagers from the Iron Age settlement in the valley below. The dramatic location of the horse means that it was clearly visible for many kilometres around. The folds in the chalk hillside change constantly when the sun highlights the horse, the only one in England to face to the right. Its purpose is not known, but it has been an important and significant landmark in the landscape for over 3000 years. Festivities and celebrations among the local community are organized on a regular basis in order to clean it. The whole hillside is open to the public and is owned by the National Trust.
R. B.

W. M. Flinders Petrie, *Hill Figures of England* (London 1926); R. Bewley, *Prehistoric Settlements* (Stroud 2003)

208 | The Candelabra at Paracas, Peru

Vistors returning from a boat trip to see the sea lions and seabirds of the Ballestas Islands off the south coast of Peru will be struck by this huge, three-armed shape on the hillside above the sheer coastline of the Paracas Peninsula. This geoglyph is now known as the 'Candelabra' or 'Tres Cruzes' ('Three Crosses') on account of its shape, although it is unclear what it actually represents. Cut into the stony desert surface to a depth of up to 3m, it reaches a length of around 190m. The three main arms of the candelabra are linked together by struts. Each ends in smaller arms that resemble cactuses. The base is formed by a rectangle with a depression in the middle. However well known the object may be, its origins and significance remain unclear. It is not mentioned in any historical sources, and the figure itself and the surrounding area have yet to be archaeologically examined. The geoglyph is often compared to the Nasca lines, but it differs so much in terms of its motif, technique and location that any link seems unlikely. Nor has it been possible to demonstrate an astronomical significance, as the representation of a constellation, for example. As the figure is properly visible only from the sea, it might rather have served as a marker for mariners and drawn their attention to local ports such as the Bay of Paracas or what is now Pisco. If this was the case, however, we still do not know whether the figure was designed to guide prehispanic balsa rafts or for the ships of the Spanish fleet. In short, its origins and significance remain a mystery.
K. L.

G. Illescas Cook, *El candelabro de Paracas y la cruz del sur* (Lima 1981); M. Bridges, *Planet Peru* (New York 1991); M. Uhle, *Pläne archäologischer Stätten im Andengebiet/Planos de sitios arqueológicos en el área andina* (Mainz 1999) (Materialien zur Allgemeinen und Vergleichenden Archäologie 56)

209 | The Giant at Blythe in California, USA

This 50m high geoglyph of a human figure lies on a terrace above the Colorado River north of the town of Blythe in south-eastern California. Apart from the Giant of Blythe, there are five other geoglyphs in the immediate area, but they can be completely seen only from the air. As a result it was not until the 1920s that they were discovered by a pilot flying over the site. The human figures, animals and symbols were made by scraping away the darker sediment on the surface and revealing the lighter stone beneath. According to one of the legends circulating among some of the Indian tribes in the Colorado region, the giant figure depicts Mastamho, the creator god. Only 100m away, a second geoglyph depicts a four-legged animal that is said to be the god's spiritual helper, the mountain lion Hatakulya. These geoglyphs were presumably created at places associated with mythical events, symbolizing both the event itself and the mythical figure bound up with it. As such, these geoglyphs may have served as ceremonial sites in the context of ritual journeys along the Colorado between the Land of the Dead in the south and the Land of Creation in the north. More than 200 of these figures have been discovered in the Colorado area, although they have yet to be comprehensively analysed from an archaeological standpoint. As a result, the age of the Giant of Blythe must remain an open question, suggested dates ranging from the 10th to the 18th centuries. A fence now protects the site.
T. St.

S. Mancini, *On the Edge of Magic: Petroglyphs and Rock Art of the Ancient Southwest* (San Francisco 1996); B. Johnson, *Quartzite Earthfigure Complex and Blythe Intaglios* (Quartzsite 1997); D. S. Whitley, *Handbook of Rock Art Research* (Walnut Creek 2001)

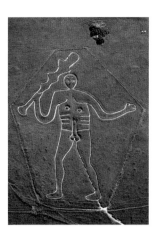

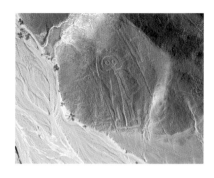

210 | **The Cerne Abbas Giant, England**

The Cerne Abbas Giant towers above and takes its name from the small quiet village of Cerne Abbas in Dorset, England. It is one of the most famous of all chalk-cut figures in England, not least because of its phallic representation and the fertility symbolism that this conveys. Its origins are shrouded in mystery and its purpose hotly debated. Is it a fertility symbol or the representation of the Romano-British god Hercules? In the 2nd century AD the Emperor Commodus attempted to revive the cult of Hercules, the god of war. A recent resistivity survey of the hillside revealed a hidden cloak over the figure's left, outstretched arm: the cloak on the left arm was a common symbol in statues of Hercules. The object in the giant's right hand must represent an offensive weapon, a threatening symbol to ward off evil spirits. The giant is 55m tall from club to foot, and it now seems as if it was created in the mid-17th century. Just beyond the giant is a small earthwork enclosure (30 x 27m), possibly an Iron Age burial mound. Is it perhaps too much to expect this to be the burial mound of the person represented as a giant cut in the chalk? Although the figure itself is now fenced off, the hillside is owned by the National Trust and is open to the public.

R. B.

H. C. March, 'The Giant and the Maypole of Cerne', *Proceedings of the Dorset Natural History and Archaeological Society*, 22 (1901), 101–18; T. Darvill, *The Cerne Giant: An Antiquity on Trial* (Oxford 1999)

211 | **The figure at Cerro Unita, Chile**

The Atacama Desert in northern Chile contains a large number of rock paintings and geoglyphs from the prehispanic period. One of the most spectacular and, indeed, the largest known geoglyph representation of a human figure is to be found on the side of the Cerro Unita, an isolated hill in the Tarapacá Desert to the north-east of Iquique. Almost 100m high, the curiously schematized figure was drawn in the stony ground by removing the larger stones and piling them up around the edges of the figure. The eyes and mouth are likewise indicated by edging them with stones. It is difficult to ascribe the figure to any particular culture or even to propose any meaningful interpretation of it as its surroundings have never been properly examined and it has so far proved impossible to date geoglyphs with any reliability. With its headgear and raised arms, the figure recalls figurative geoglyphs from the Nasca region of southern Peru, which date from the 4th to 1st centuries BC. But they are also reminiscent of reliefs of the Staff Deity from the Middle Horizon (AD 600–1000). The slopes of the Cerro Unita are covered with other geoglyphs representing human beings and animals, as well as lines and trapezoids. Until well into the 20th century the desert of northern Chile was still crossed by llama caravans passing to and fro between the coast and the Andes. Many rock paintings and geoglyphs lie along these journeys and, regardless of what they may depict, they must also have served as signposts for travellers.

K. L.

J. Reinhard, *The Nazca Lines: A New Perspective on Their Origin and Meaning* (Lima 1986); J. M. Chacama and L. E. Briones, 'Arte rupestre en el desierto tarapaqueño, norte de Chile', *Boletín de la SIARB*, 10 (1996), 41–51; P. Clarkson, 'Geoglyphen als Artefakte, Geoglyphen als Erfahrung: Bodenzeichnungen auf dem amerikanischen Kontinent', *Nasca: Geheimnisvolle Zeichen im alten Peru*, ed. J. Rickenbach (Zurich 1999), 165–75 (exhibition catalogue)

212 | **The 'Owl Man' at Nasca, Peru**

Visitors who fly over the famous Nasca lines in a light aircraft will see a large human figure on a hill at the edge of the Pampa de Nasca some 450km south of Lima. The expression of its face has led observers to describe it as the 'Owl Man'. The figure is more than 30m high and rather rudimentary in its execution. It differs from most other geoglyphs (including the lines flanking it) in that its inner surface has not been cleared of stones but was left intact, whereas the outlines of the figure were marked by clearing away the area around them. For a long time the Owl Man was thought to be unique among the Nasca lines, with the result that some observers even believed it to be modern in origin. But more recent studies at Palpa to the north point in a different direction, for entirely similar figures are found here. They presumably date to the 4th–1st century BC, in other words, to the beginning of the Nasca period or even earlier, and are thus among the oldest of all geoglyphs. Although mostly smaller in size, the figures at Palpa resemble the Owl Man in their motivic repertory and execution. They often wear a headdress or hold an object in their raised hand. The human figures were always laid out on hillsides, so that, unlike many geoglyphs on the plain, they are visible on the ground from far around. The entire Pampa de Nasca was made a World Heritage Site by Unesco in 1994. But although the Owl Man and the other geoglyphs are now protected, they remain inadequately examined and have still to be properly documented.

K. L.

M. Reiche, *Geheimnis der Wüste/Mystery of the Desert/Secreto de las pampas* (Lima 6th ed. 1976); M. Reindel and others, 'Vorspanische Siedlungen und Bodenzeichnungen in Palpa, Süd-Peru / Asentamientos prehispánicos y geoglifos en Palpa, Costa sur del Perú', *Beiträge zur Allgemeinen und Vergleichenden Archäologie*, 19 (1999), 313–81; A. Aveni, *Between the Lines: The Mystery of the Giant Ground Drawings of Ancient Nasca, Peru* (Austin 2000)

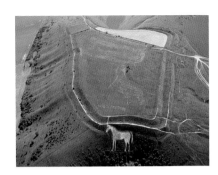

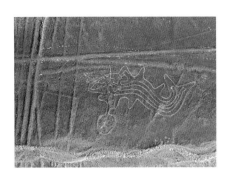

213 | The Great Serpent Mound, Ohio, USA
Dating to the period between 500 BC and AD 500, the Great Serpent Mound nestles against the gently rolling landscape above a small river in southern Ohio. More than 400m long, it can be properly seen only from the air. It is made essentially of clay and stones, over which earth has been laid to a depth of up to 1.5m. The body of the serpent thus stands out from the surrounding terrain. It was first measured and drawn in the 1840s but did not achieve popular fame until archaeological finds from it were exhibited at the 1893 Chicago World Fair. Its attribution to the Adena village culture that was supported between 500 and 100 BC by a hunter-gatherer economy and copper processing is problematical, not least because the following Hopewell culture (200 BC–AD 500) was part of this same tradition. The earthwork has been interpreted in various ways – some observers argue that the serpent is eating an egg, while others see the 'egg' as an outsized eye – with the result that the interpretation of the site as a whole remains disputed, but the absence of burials within the earthwork at least rules it out as a burial mound. Regardless of these imponderables, the huge serpent has been seen as a religious or mythological reflection of its builders inasmuch as serpents are regarded by many cultures as symbols of transformation, as the incarnation of a god or simply as an embodiment of evil in general.
T. St.

E. G. Squier and E. H. Davis, *Ancient Monuments of the Mississippi Valley* (Washington 1848, R1998) (Smithsonian Contributions to Knowledge 1); W. F. Romain, 'Symbolic Associations at the Serpent Mound', *Ohio Archaeologist*, 41/3 (1991), 29–38; R. C. Glotzhober and B. T. Lepper, *Serpent Mound: Ohio's Enigmatic Effigy Mound* (Columbus, OH, 1994)

214 | The White Horse at Westbury and Bratton Castle, England The Westbury White Horse and Bratton Castle dominate the chalk slopes above the small market town of Westbury in Wiltshire. The horse is first documented in 1742. It originally faced north and was reputedly built in AD 878 to commemorate King Alfred's victory at Ethandun. This horse was replaced in 1778 by another facing south, 51m long and 50m high. Its function is not known, but until the invention of the motor car, the major form of transport in these chalk downlands would have been the horse. Elsewhere in Wiltshire there are many other chalk-cut figures with a military flavour (regimental badges and crests). A military origin, perhaps celebrating the cavalry, is one possibility. The horse was recently (2000) completely restored. The banks and ditches of an Iron Age hillfort, Bratton Castle, are also clearly visible beyond the horse. There is some evidence for Neolithic activity on the area many centuries before the hillfort was built. The fort is situated on the summit of a chalk scarp overlooking and commanding the valley below. The interior of the fort is under cultivation, but the ramparts are protected from any agricultural activity. The thin white lines on the banks of the hillfort are the scars created by visitors. Both sites are open to the public and protected by law.
R. B.

215 | Figure of a whale on the Pampa de Nasca, Peru
A whale in the desert? The image of a whale in one of the driest regions on earth is surprising. Yet the Pampa de Nasca, some 450km south of Lima, lies close to Peru's Pacific coast. At the time of the Nasca culture (200 BC–AD 600), when this geoglyph was created, maritime creatures were important as a source of food. We know this not only from excavations in which it has been possible to identify food remains but also from beautifully painted examples of Nasca ceramics that show fishermen with their nets. In short, the sea was well known to the inhabitants of the Nasca region. Other ceramic vessels show representations of whales very similar to the one on the Pampa de Nasca. Indeed, some ceramics are entirely modelled in the shape of a whale. The 'Mythical Killer Whale' played an important role in the world of religious ideas of the Nasca period. The whale is often depicted with an arm holding a trophy head. This is presumably the significance of the round element beneath the body of the geoglyph. Taken together, the two elements – the trophy head whose lifeforce passes into its conqueror and the inhabitant of the water – form a powerful symbol of fertility and life within the desert. The geoglyph is executed as a thin line. In order to create it, it was necessary only to remove the dark stones on the surface of the desert floor and allow the lighter layer of sand beneath it to be seen. Its lines were presumably kept in good condition.
K. L.

H. Kern and M. Reiche, *Peruanische Erdzeichen/Peruvian Ground Drawings* (Munich 1974); A. Aveni (ed.), *The Lines of Nazca* (Philadelphia 1990) (*Memoirs of the American Philosophical Society* 183); H. Silverman and D. Proulx, *The Nasca* (Oxford 2002) (The Peoples of America)

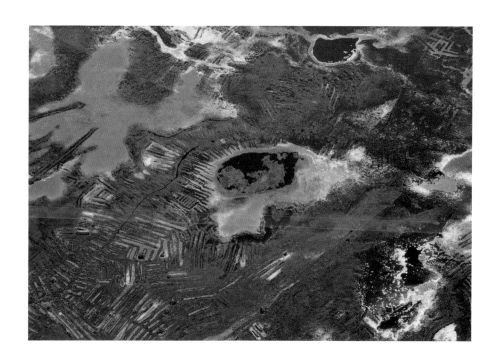

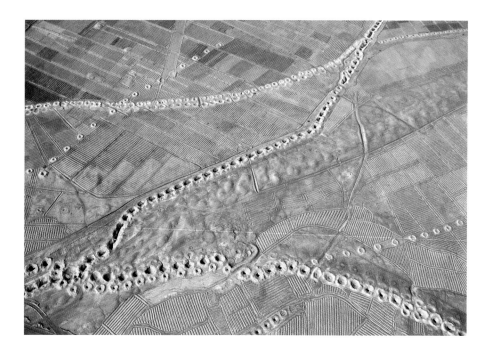

216 | **Raised fields in the Mompós Basin**, 1st–3rd century AD, Colombia, 1981

217 | **Qanats at Yazd**, from early 1st millennium BC, Iran, 1976

10. THE EARTH'S GIFTS — WATER, LAND AND MINERAL RESOURCES

Total dominion over the produce of the earth lies in our hands.
We put plains and mountains to good use; rivers and lakes belong to us;
we sow cereals and plant trees; we irrigate our lands to fertilize them.
We fortify riverbanks and straighten or divert the courses of rivers.
In short, by the work of our hands we strive to create a sort of second nature
within the world of nature.

Cicero (106–43 BC), *The Nature of the Gods* 2:152

Howl, fir tree; for the cedar is fallen; because the mighty are spoiled: howl,
O ye oaks of Ba-shan; for the forest of the vintage is come down.

Zachariah (6th century BC) 11:2

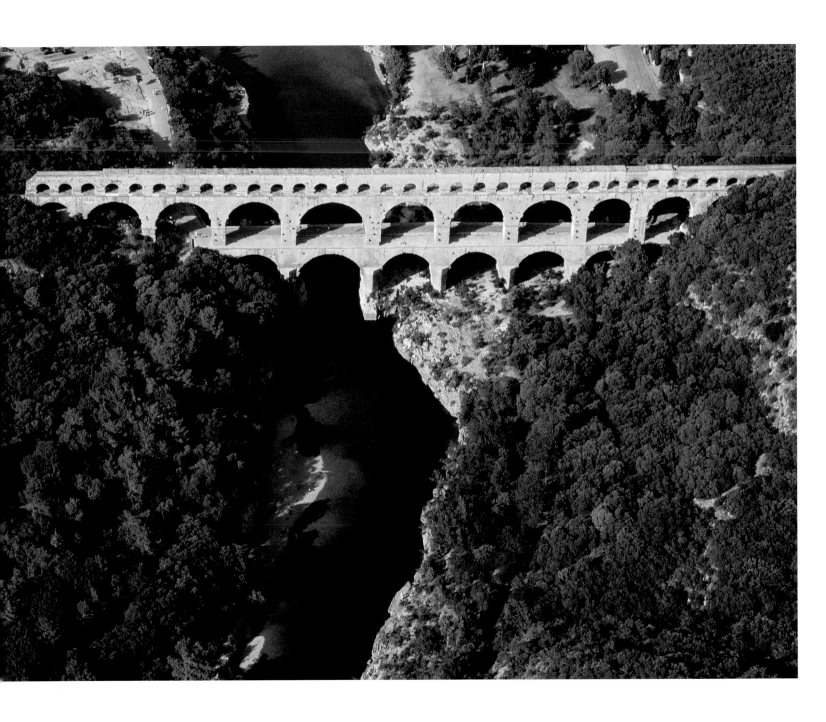

218 | **The Pont du Gard**, mid-1st century AD, France, 1998. World Heritage Site

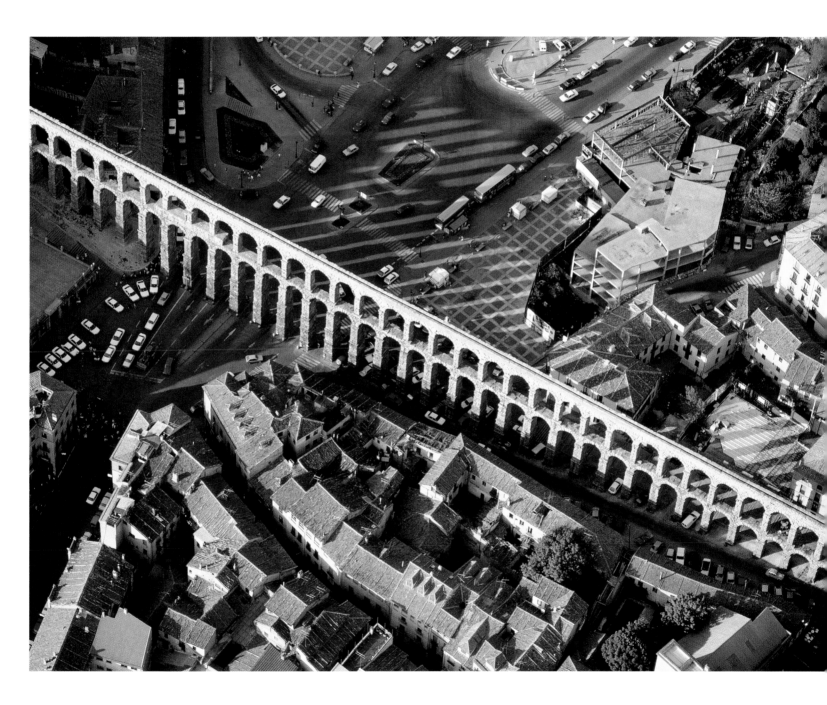

219 | **The aqueduct at Segovia**, second half of 1st century AD, Spain, 1990. World Heritage Site

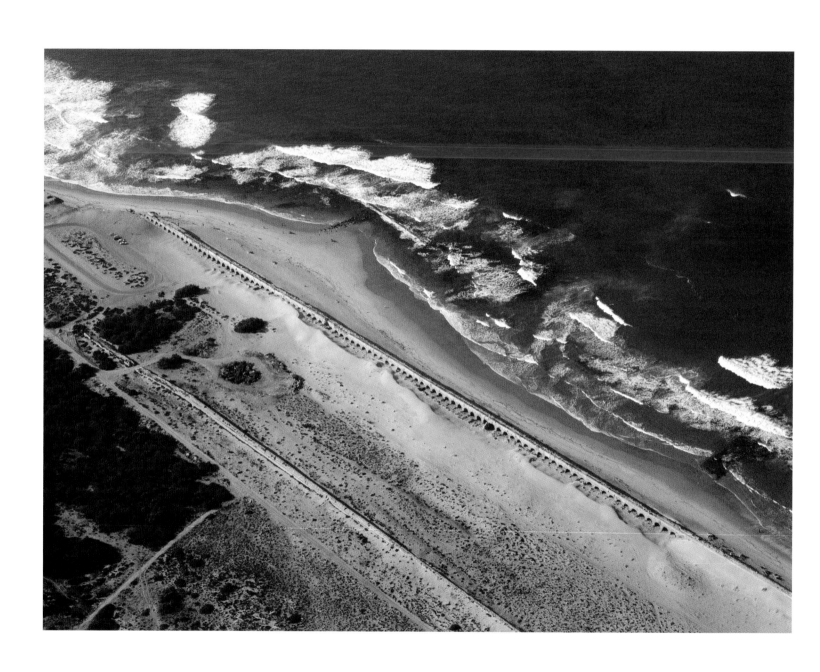

220 | **The aqueduct at Caesarea**, second half of 1st century AD, Israel, 1981

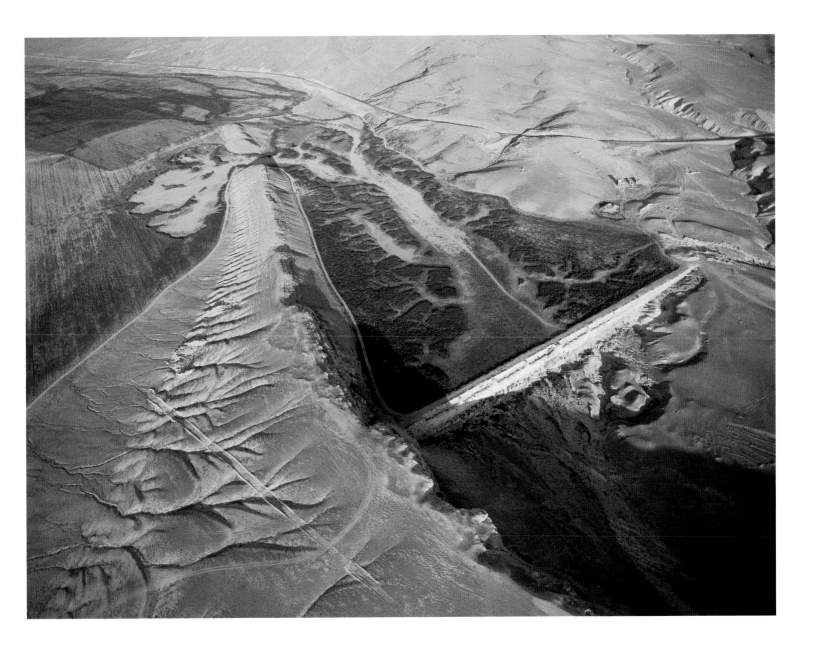

221 | **The Harbaqa Dam**, 2nd century and first half of 8th century AD, Syria, 1997

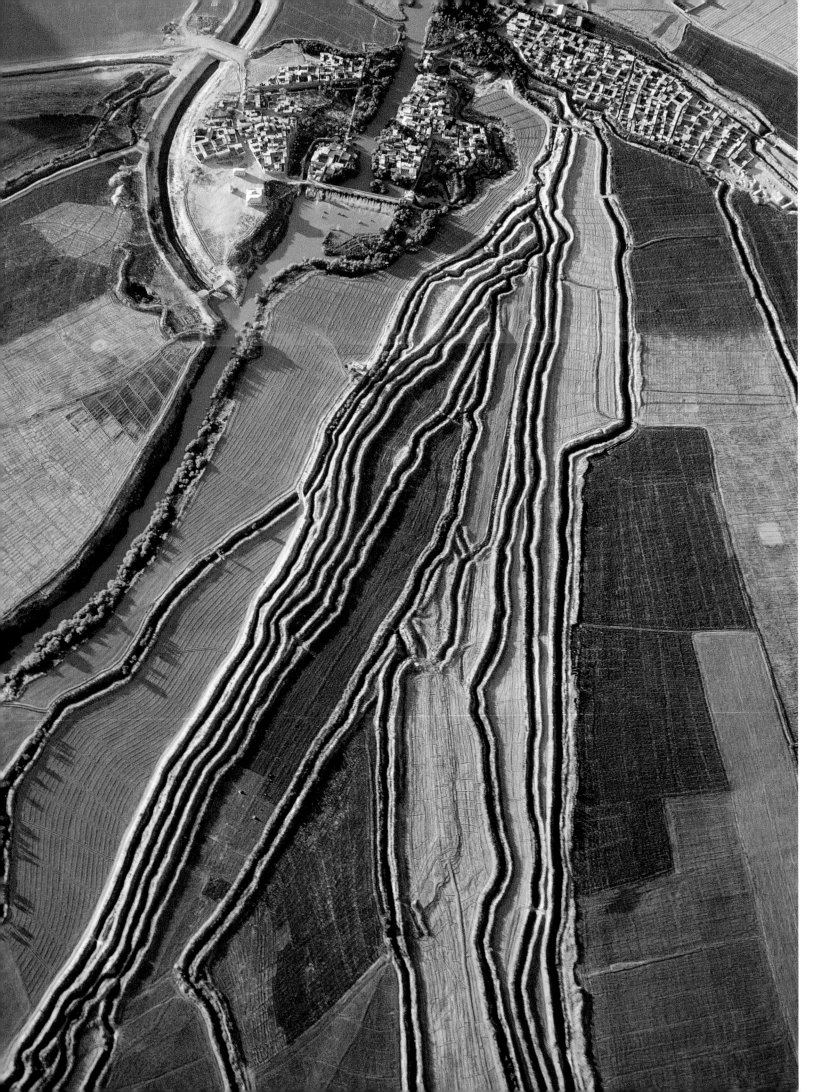

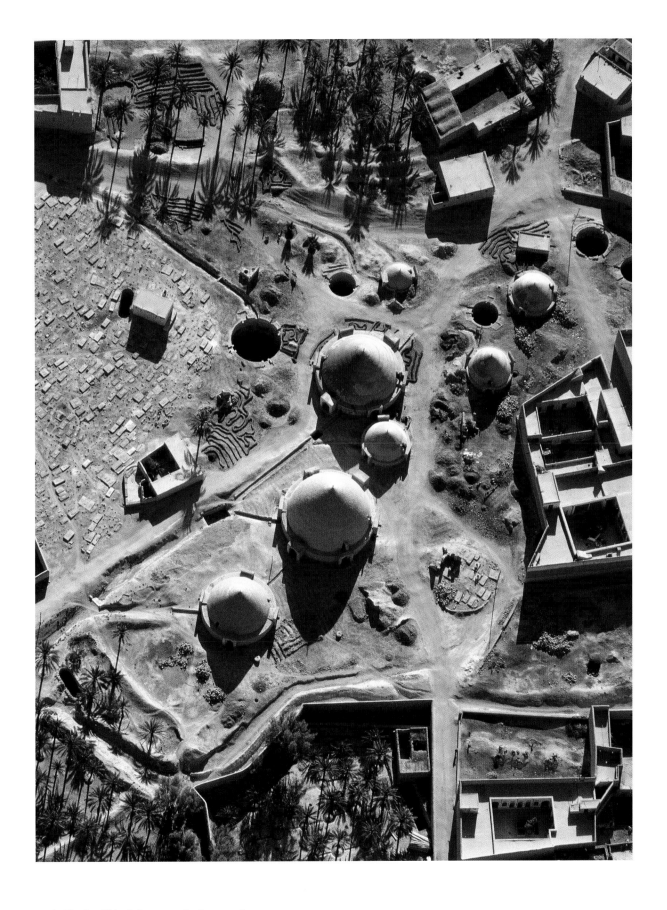

222 | **The Band-i Amir Dam**, AD 980, Iran, 1976

223 | **Cisterns at Jerash**, Iran, 1976

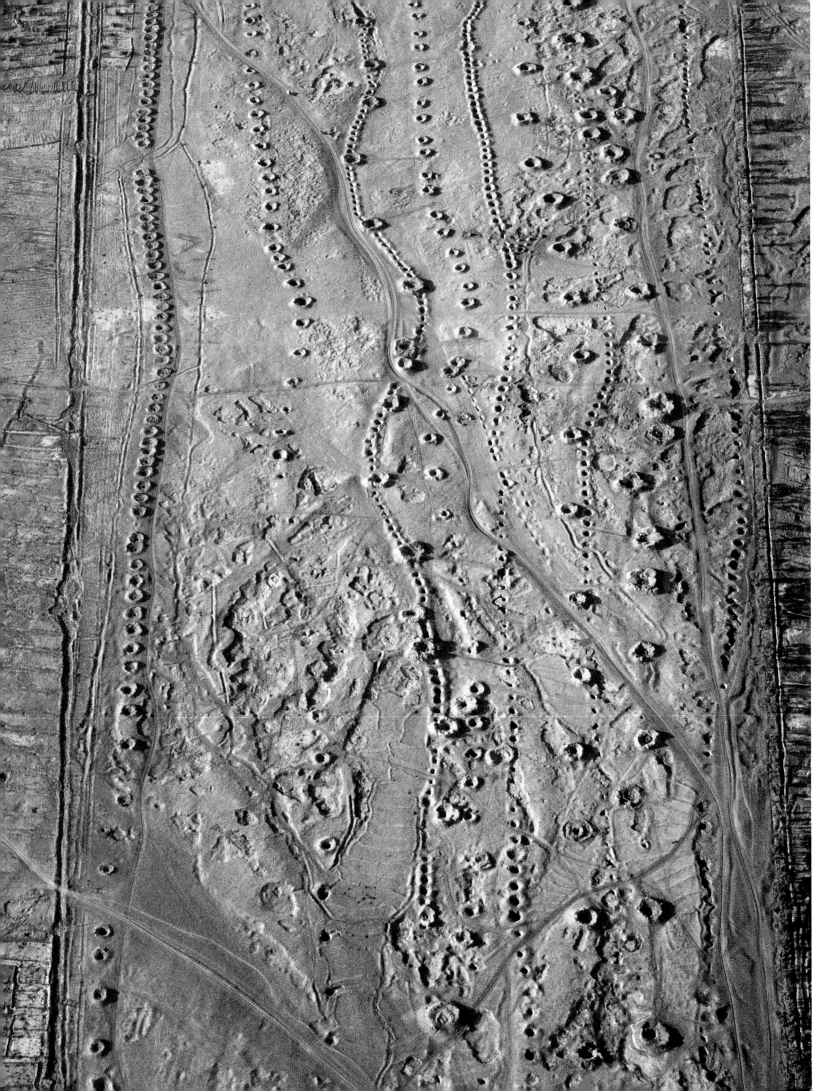

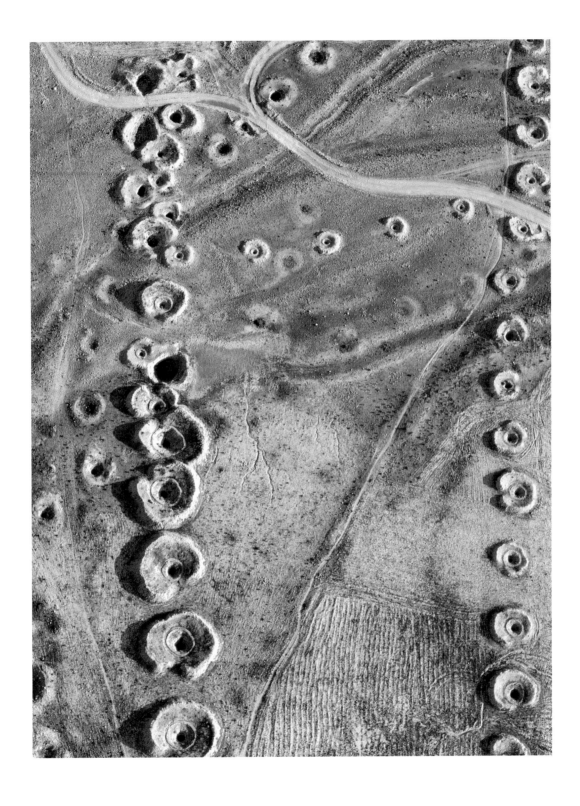

224 | **Karezes in the Turfan Depression**, from the 2nd century BC, China, 1987

225 | **Qanats at Firuzabad**, from the early 1st millennium BC, Iran, 1976

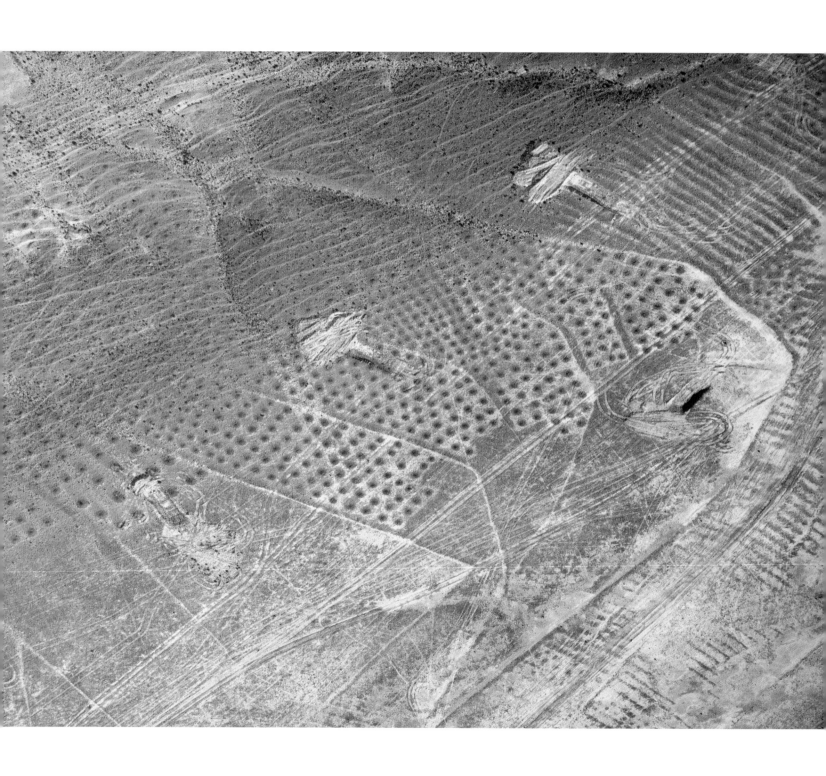

226 | **Tulelat al-Anab in the Negev Desert**, Israel, 1971

227 | **Sandfields of the Hopi Indians**, 12th century AD, USA, 1981

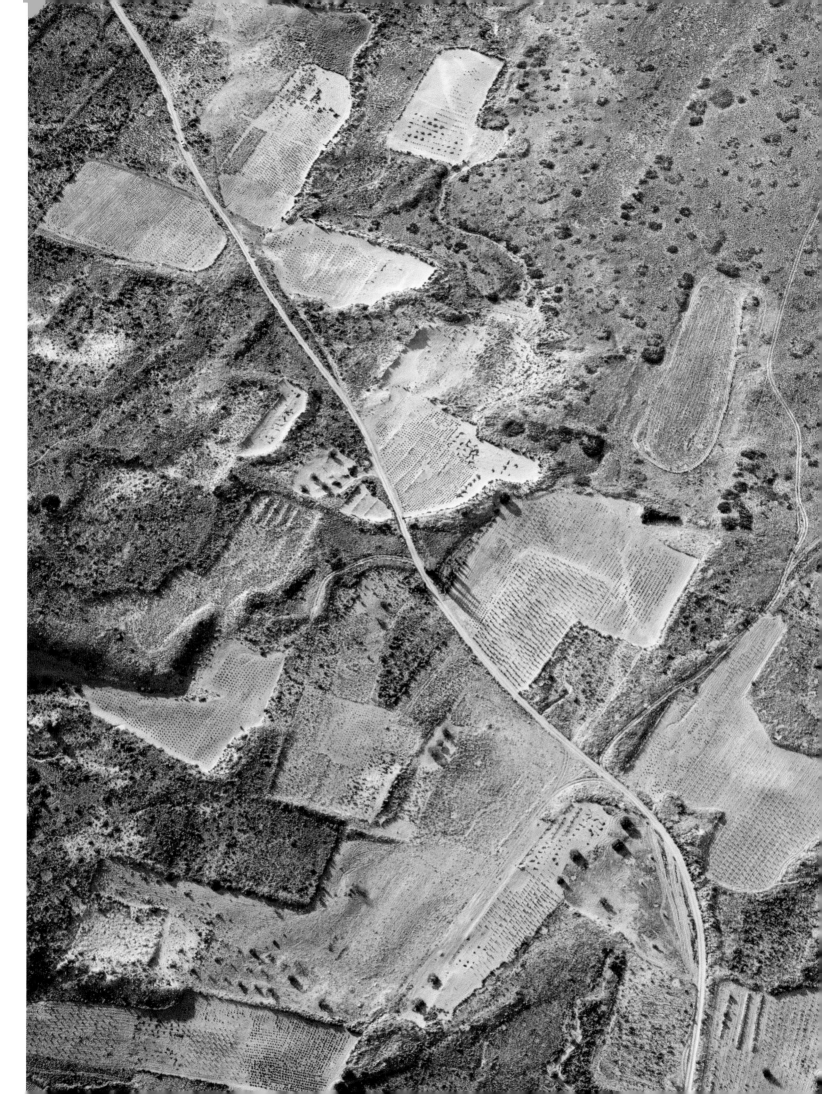

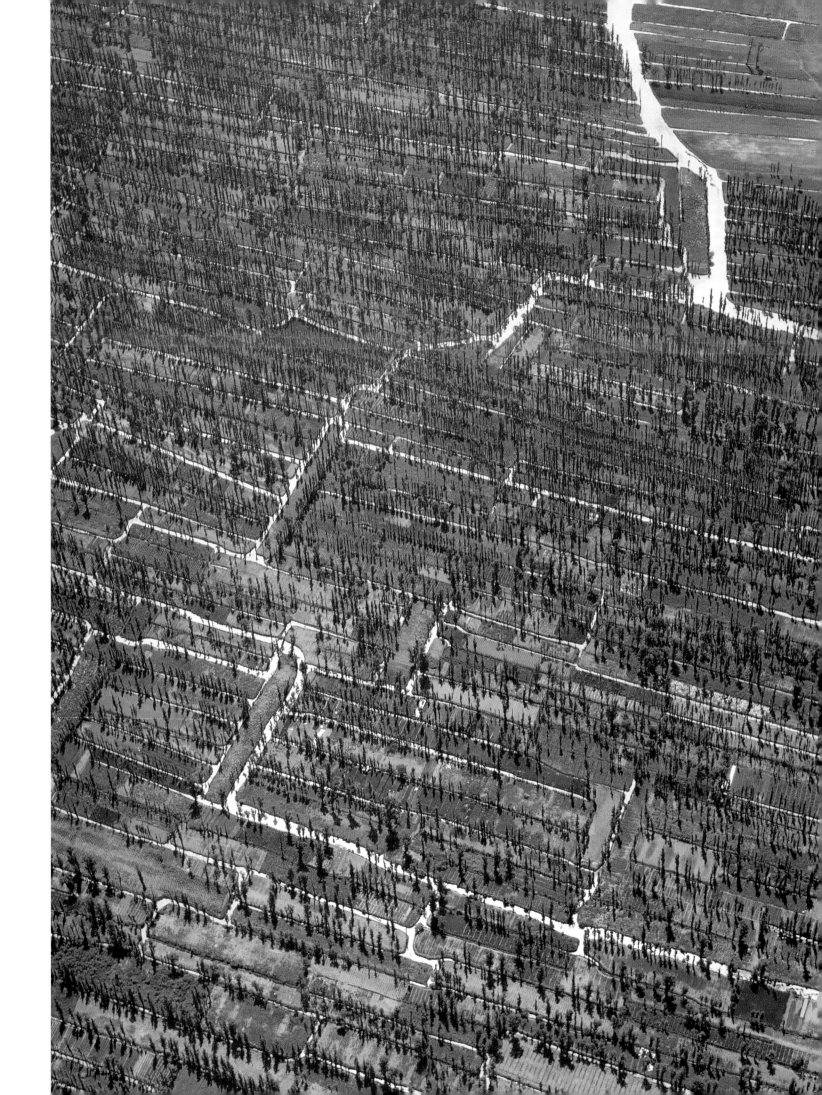

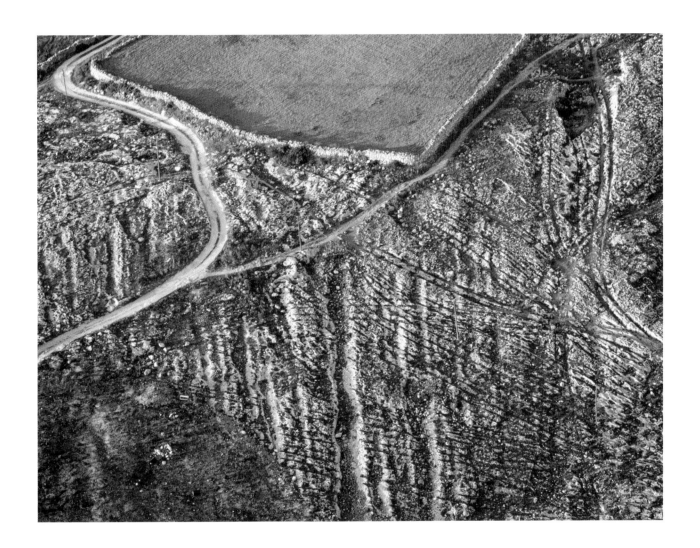

228| **Chinampas near Xochimilco**, from 2nd millennium BC, Mexico, 1971. World Heritage Site

229| **The tracks at Clapham Junction near Mdina**, Malta, 1996

230| *358–9:* **Raised fields and platforms in the Cuenca de Guayas**, 500 BC–AD 500, Ecuador, 1997

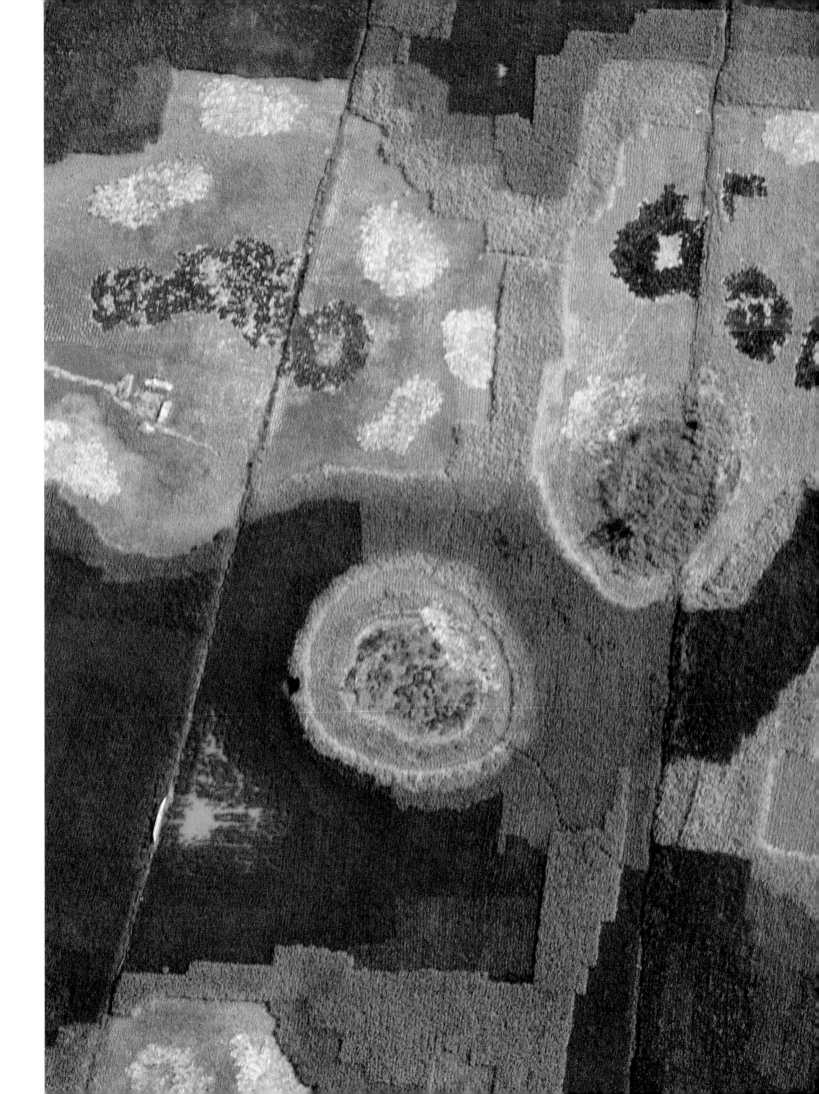

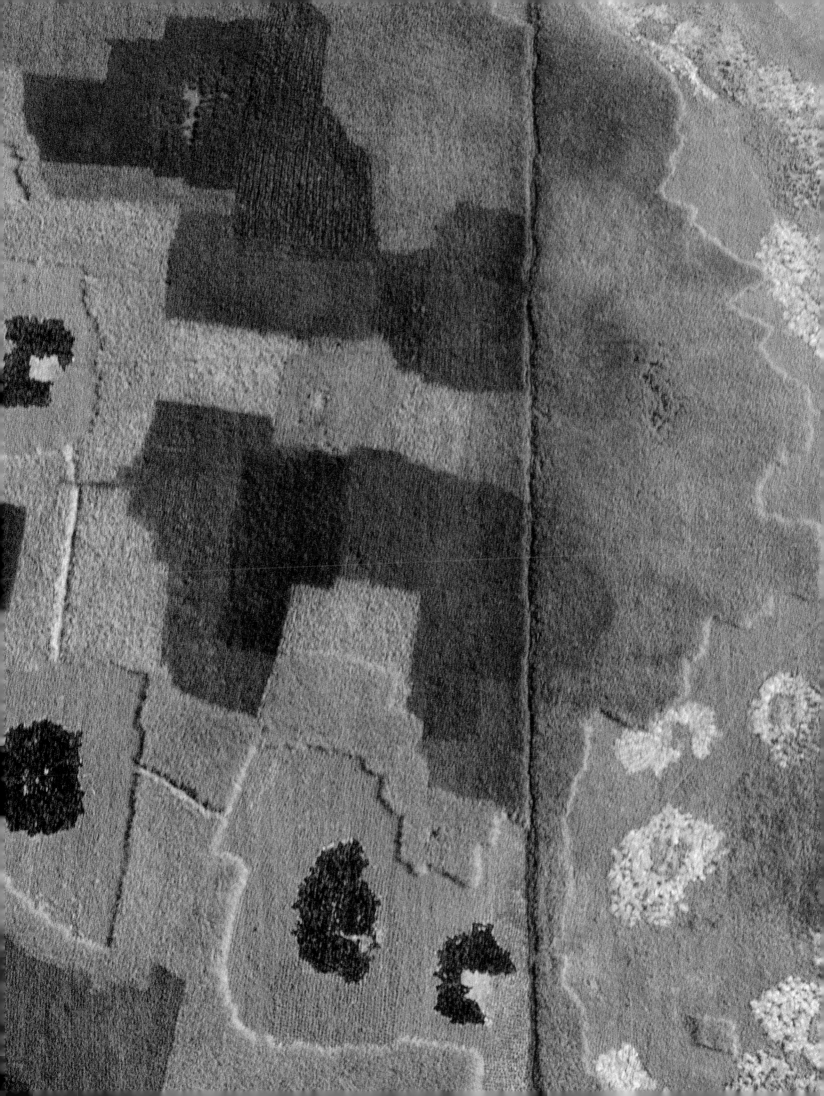

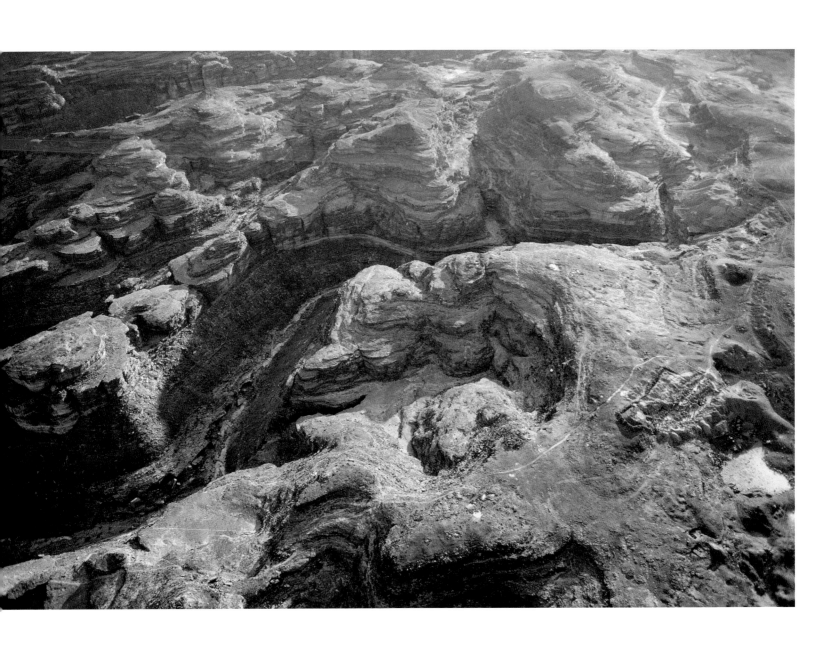

231 | **Sarabit El-Khadem on the Sinai Peninsula**, 1800–1200 BC, Egypt, 1971

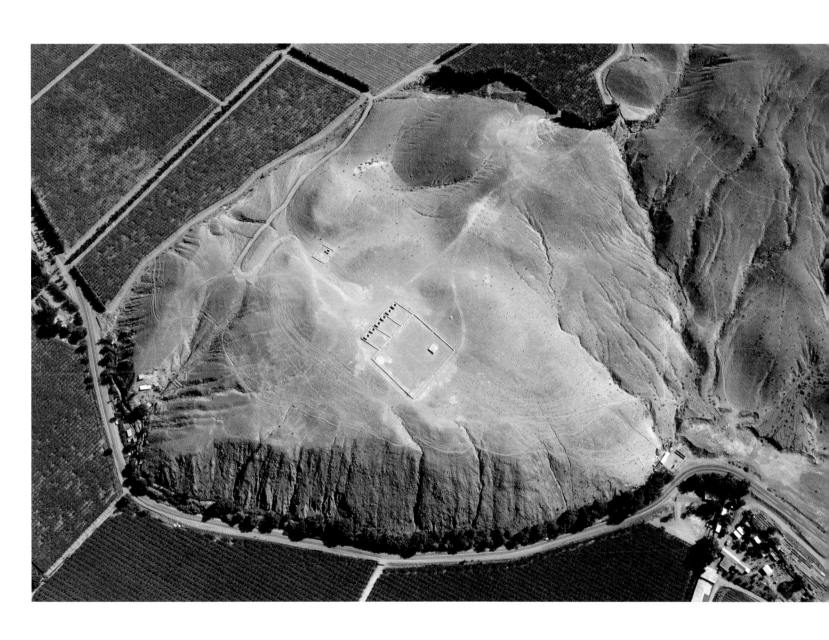

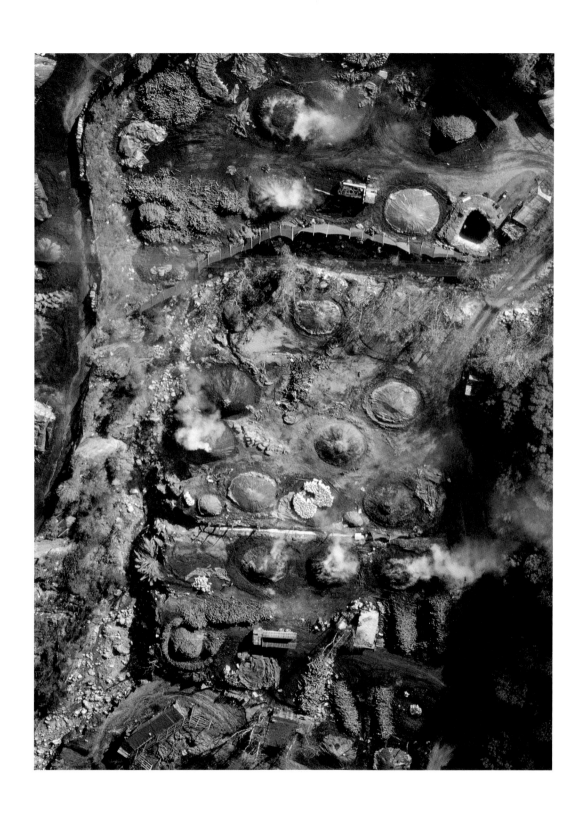

233 | **Charcoal kilns at Chalcidice**, Greece, 2000

234 | **Marble quarry near Chalki on Naxos**, Greece, 2002

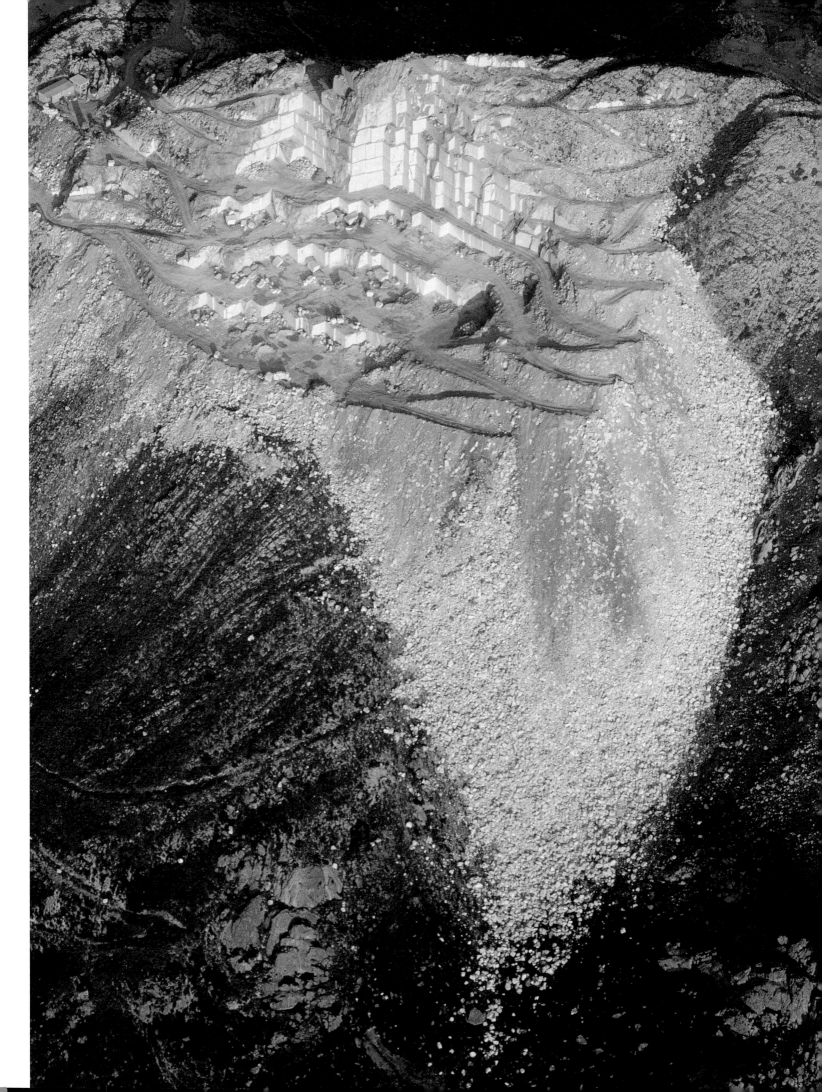

 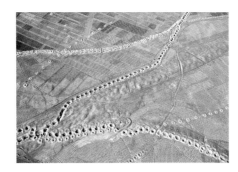 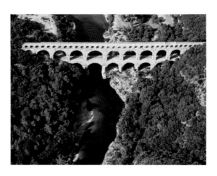

216 | Raised fields in the Mompós Basin, Colombia

As in many parts of Latin and Central America, it is impossible not to be struck by broad belts of land in flat marshlands on the lower reaches of rivers, with channels running away from them at right angles and, between them, narrow raised fields known locally as *camellones*. These are clearly artificial constructions that archaeologists have dated to the early centuries of the Christian era. Their aim seems to be to ensure that the land can be farmed safely and continuously in regions regularly affected by severe flooding. Other archaeologists, by contrast, have suggested that fish or molluscs were farmed in the channels. In fact, neither theory excludes the other. These raised fields are not linked to permanent settlements, and the ethnic, political and social attribution of whoever made them is uncertain. Equally unclear is the question whether any kind of centralized power was responsible for organizing this work, which presupposes coordinated planning. The present photograph was taken in the vicinity of Mompós, some 400km north of Bogotá.

H. J. P.

H. Wilhelmy, *Welt und Umwelt der Maya* (Munich 1981), 210–19

217 | Qanats at Yazd, Iran

Qanats are underground water channels through which water can be conducted to cultivated areas considerable distances away. They appear on the surface as ventilation shafts and inspection holes (see also no. 225). This method of irrigation must have been developed on the Iranian plateau at an early date, as it is mentioned by Assyrian kings as well as by Greek and Roman historians. From the eastern part of Iran, where the word *kariz* is used to describe these underground channels, the technique spread to Afghanistan, Pakistan and central Asia, where it is still used to water the vineyards in the oasis at Turfan (no. 224). The presence of these channels in the Roman provinces around the Mediterranean and descriptions by writers such as Vitruvius have led to the assumption that the technique was a Roman invention, but it is mentioned as a 'Persian method' by the Egyptians following their conquest by Darius I, and the Tuareg on the southern edge of the Sahara likewise referred to it as a 'Persian device'. The system found its way to Spain probably in Roman times, and certainly following the Arab invasion, and from Spain it passed to America and Mexico during the modern period. One of its main advantages is that it virtually avoids evaporation, in addition to which the water remains cool and clean. The qanat is no longer as important as it was thanks to the use of pumps that allow the aquifer to be tapped at little cost. The result is the wholesale exploitation of the groundwater streams and the drying up of natural springs that in the past were focal points for ancient monuments such as rock reliefs, temples and palaces.

D. H.

C. Troll, 'Qanat-Bewässerung in der Alten und Neuen Welt', *Mitteilungen der Österreichischen Geographischen Gesellschaft*, 105 (1963), 312–30; H. Goblot, *Les qanats: Une technique d'acquisition de l'eau* (Paris 1979)

218 | The Pont du Gard, France

The Roman Pont du Gard allowed the 50km aqueduct to cross the Gardon Valley on its way from Uzès to Nîmes. Excavations elsewhere have enabled us to date it to the middle of the 1st century AD. The bridge has been regularly restored since the 18th century. Thanks to its three superimposed rows of arches, the water channel was sufficiently elevated at 48m over the river to be able to reach the city. And thanks to its wide arches and the breakwaters at the foot of its pillars, the bridge is also able to withstand floods. Classical proportions evidently played a major role in the great rows of superimposed arches and the rhythm of the 35 arches of the uppermost tier, which is 275m long. This third tier originally had 12 more arches on the left-hand side, but these were destroyed in the Middle Ages. Everything about this bridge, which was intended to carry only water (the roadbridge behind it was not built until the 18th century), suggests a certain cost-consciousness: the protruding blocks of stone on which the lifting gear rested during the building operations were not chiselled away, for example. The bridge is made for the most part of large blocks from a quarry 600m away. Mortar was used only on the topmost tier, which was surmounted by a layer of medium-sized square ashlars. On top of these were laid the stone slabs that cover the water channel. Several decades later a similar layer was added in order to enlarge the channel.

J.-L. F.

G. Fabre and others, *The Pont du Gard: Water and the Roman Town* (Paris 2/1993), 127 (Collection Patrimoine au Présent 1992); G. Fabre and others, *L'aqueduc de Nîmes et le Pont du Gard: Archéologie, géosystème, histoire* (Paris 2000), 483; J.-L. Fiches, *Le Pont du Gard* (Paris 2001), 64 (Collection Itinéraires)

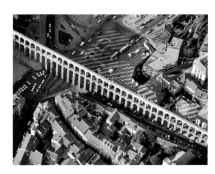 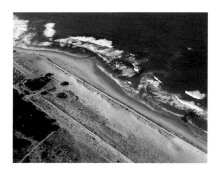 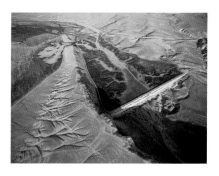

219 | **The aqueduct at Segovia, Spain**

One of the best-known monuments of the Roman occupation of Spain is the aqueduct at Segovia, some 100km to the north-west of Madrid. The city acquired its Roman civic rights under the Flavian emperors in the second half of the 1st century AD. It was during this period that the aqueduct was built as a visible sign of the city's affluence and of its investment in its infrastructure. It begins some 15km away in the Sierra de Guadarrama, but only for its final section, where a deep valley had to be bridged in the centre of the city, was it necessary to build anything as elaborate as a two-tiered structure rising to a height of almost 30m. Here, at the point where several important overland roads meet, there was originally an inscription on the large granite block above the lower tier. The large gilded bronze letters were attached by means of lead pegs, but because of their value they were forcibly removed in medieval times. The peg holes allow the inscription to be reconstructed: it says that two municipal officials restored the bridge in AD 98 on the instructions of the emperor Trajan. Presumably minor repairs were taken as an opportunity to signal the names of the ruling emperor and two local notables, since it was no longer possible to mention the name of the outlawed and murdered Domitian, under whose reign the arch had actually been built. There was undoubtedly a statue of the emperor in the small niche above the inscription, where there is now a figure of the Madonna.
R. S.

A. Ramírez Gallardo, *El acueducto de Segovia* (Valencia 1984); A. Nünnerich-Assmus, 'Segovia: Aquädukt', *Hispania Antiqua: Denkmäler der Römerzeit*, ed. H. Schubart and W. Trillmich (Mainz 1993), 318; G. Alföldi and P. Witte, *Die Bauinschriften des Aquäduktes von Segovia und des Amphitheaters von Tarraco* (Berlin 1997)

220 | **The aqueduct at Caesarea, Israel**

To the north of Caesarea (no. 26) the arches of a Roman aqueduct peer up from the sands of the eastern Mediterranean. The 9km structure ran both above and below ground to the foot of Mount Carmel, where it took in water at the springs of Shuni/Maiumas and Sabbarin in order to supply the city. Two channels ran alongside each other. The date of the aqueduct is disputed. An inscription on it reports construction work during the time of Hadrian (AD 117–38), implying that the aqueduct already existed at this date. It was presumably under Hadrian – perhaps during the Bar Kochba War – that the second channel was added. Although it has often been assumed that the older aqueduct was built when Caesarea was founded by Herod the Great in 22 BC, this is unlikely and undoubtedly stems from the wish on the part of archaeologists to associate all buildings with the name of a ruler famous for his architectural ambitions. Josephus, who reports at length on Herod's building spree in Caesarea, does not mention the aqueduct. Even more compelling than this *argumentum e silentio* are recent archaeological surveys of the site, which have provided powerful arguments, based on typology and technique, in favour of the post-Herodian period. Evidently it was only the economically prosperous post-Herodian city of the later 1st century that required an aqueduct for its water supply. The aqueduct may also have been used to provide water for the Roman troops in the First Jewish War.
A. L.

L. I. Levine, *Roman Caesarea: An Archaeological-Topographical Study* (Jerusalem 1975), 30–36 (Qedem 2); J. Ringel, *Césarée de Palestine: Étude historique et archéologique* (Paris 1975), 59–65; Y. Porath, 'The Tunnel of Caesarea Maritima's High Level Aqueduct at the Kurkar Ridge (Jisr ez-Zarqa)', *Atiqot*, 30 (1996), 126–7; 23*–43*

221 | **The Harbaqa Dam, Syria**

About 50km south-west of Qasr al-Heir al-Gharbi lies the ancient Harbaqa Dam. An earlier dam may already have been built by the Palmyrenes in the 1st century AD. The remains that are still standing today date from Roman times. The dam was restored to service during the Omayyad period, when it became a key element in the supply of water to the Qasr al-Heir al-Gharbi estates. The wall, which is made of rubble and opus caementum masonry faced with square hewn stones, dams the Wadi al-Barada and is some 345m long, rising to 20m at its maximum height. It has largely survived undamaged, as there are no settlements in the immediate area, with the result that its stones have not been taken as building material. For centuries the storage basin, which measured up to 800m wide and 1500m long with a capacity of around 5 million cubic m, collected the water from seasonal floods that was then carried to the Omayyad desert settlement 16.6km away. Today the ancient complex is no longer functional and the former artificial lake is dry land. There are few remaining signs of the old system of controlling the flow of water from the dam to the settlement to the north. Parallel to the top edge of the photograph is the stretch of railway line that runs from the phosphate deposits at Palmyra to Homs.
R. W.

D. Schlumberger, 'Les fouilles de Qasr el-Heir el-Gharbi (1936–1939). Rapport préliminaire I: L'exploitation agricole. Description. 1. Le barrage de Harbaqa', *Syria*, 20 (1939), 200–3

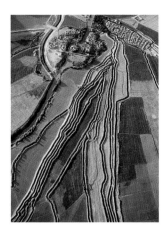

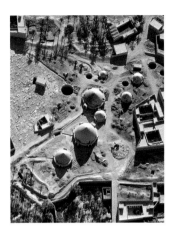

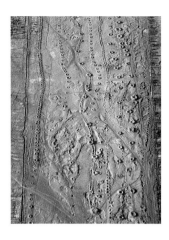

222 | The Band-i Amir Dam, Iran

The Band-i Amir Dam (the 'Emir's Dam') lies about 55km north-east of Shiraz and is the most famous medieval irrigation structure in the southern Iranian province of Fars, which was known to the ancients as Persis. Adud ad-Dawlah, the most important regent of the Buyid dynasty, who ruled over virtually the whole of Iran and Iraq, built it around AD 980 in order to irrigate the dry south-eastern part of the Marvdasht Plain. According to Al-Muqaddassi, ten large scoop-wheels were set up by the basin in order to raise water for 300 other villages, a claim that is almost certainly a well-meaning exaggera-tion. The dam is 103m long and 9m high. Its crest, which is 7.5m wide, bears 13 brick arches, making an overall height of 13.5m. The meticulous execu-tion and the paving of the riverbed were praised in medieval accounts and even today show no sign of damage or erosion. Dams can be traced back to Achaemenid times in Iran and generally combined several functions. The one at Band-i Amir also served as a river crossing for the major road from Shiraz to Isfahan and the whole of northern Iran. The head of water is also used to drive mills, some 30 of which were once operational here. The water is channelled into cylindrical shafts between 2 and 3m deep, causing a jet of water to shoot out at the bottom and to drive a horizontal turbine, on the shaft of which the millstones are mounted. Very few old watermills are still operational in Iran, although the impressive penstocks can still be observed on hillsides and at the ends of aqueduct walls.
D. H.

G. Le Strange, *The Lands of the Eastern Caliphate* (London 1905), 276–8; H. E. Wulff, *The Traditional Crafts of Persia* (Cambridge, Mass., and London 1966), 246–8, 280–83; F. Hartung and G. Kuros, 'Historische Talsperren in Iran', *Historische Talsperren*, ed. G. Garbrecht (Stuttgart 1987), 259–61

223 | Cisterns at Jerash, Iran

Garmsir, the hot region of Iran in contrast to Sartsir, the cold region, is instantly recognizable by two distinctive features: the date palms that grow properly only below 1000m and its countless cisterns. The hot climate of the coastal zone on the Persian Gulf is largely avoided because of its high level of humidity, but the Zagros valleys, being slightly higher, have a more tolerable climate and are used as a summer refuge for wealthy coastal dwellers, including those from the Arab Gulf coast. This is certainly true of the towns around Lar, Jerash and Evas. In Safavid times, when Bandar Abbas was Persia's main port, the region benefited from the trade that passed through these valleys on its way to Shiraz and Isfahan. The generally complete lack of springs or flowing surface water and the fact that the deep groundwater was almost impossible to reach compelled the inhabitants to collect all the water in cisterns during the wet season. In order to reduce the amount of water lost to evaporation, these cisterns were covered, sometimes at the time or, depending on the builders' means, at a later date. In the present case domes were used, whereas in that of another rectangular type of cistern, barrel vaults were preferred. Generally the water was channelled from the hillsides over the dried-up beds of streams and through a complex system of channels to a place close to the farms and gardens where the water was needed. Here whole colonies of cisterns arose in depressions in the ground. The present photograph shows one such colony beneath a cemetery. The manufacture of mud bricks – the most important and most traditional building material in the Orient – would also become established in the area, as water was needed in preparing the mixture of mud and chaff. The dark, winding ribbons are rows of mud bricks left out in the sun to dry.
D. H.

J.-P. Tavernier, *Voyages en Perse* (Paris 1666, R1930), 310–26; H. Gaube, 'Ein Abschnitt der safavidischen Bandar-e Abbas-Shiraz-Straße: Die Strecke von Seyyed Gemal ad-Din nach Lar', *Iran*, 17 (1979), 33–47; E. Ehlers, *Iran: Grundzüge einer geographischen Landeskunde* (Darmstadt 1980), 472–7

224 | Karezes in the Turfan Depression, China

The karez system of horizontal wells is used to collect surface and groundwater and conduct it to the user along underground channels that avoid the use of pumps by relying on gravity. A large part of the landscape in the Turfan region of Xinjiang is pockmarked by karez shafts used to ventilate and maintain the channels. They indicate the course of the underground channels that irrigate the arid fields. Far beneath the surface, the water flows along channels dug by hand and is thus protected against evaporation. In this way meltwater and spring water are conducted to the oasis from the foot of the Tian-Shan. Most of the systems date to the Qing Dynasty (1644–1911) and later. The history of the karez can be traced back to the Han Dynasty. In the *Shiji* of the historiographer Sima Qian (2nd century BC) they are described as 'well channels'. Many scholars believe, however, that similar systems were first used in ancient Persia (nos. 217 and 225) and that they passed from there to north-west China. The technique used to construct the karez wells also spread from Persia to Arabia and was later introduced to Spain by the Arabs. The conquistadors then took this complex but efficient underground irrigation system to Mexico. It is ideal for regions affected by drought, where the heat would cause any surface water to evaporate at once. In Turfan there are more than 470 such systems, with a total length of over 1600km. Together with the Great Wall and the Imperial or Grand Canal, the karezes are one of the three great building projects of ancient China. Even today they are still used to irrigate large tracts of fertile land.
B. S.

Over China (Sydney and Beijing 1988), 172–3

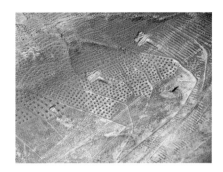

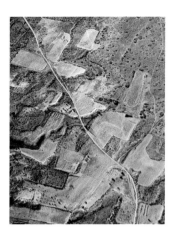

225 | Qanats at Firuzabad, Iran

As a source of water for the country's qanats, there are two possibilities: either an existing stretch of water or – and this is the more important one in Iran – the groundwater that runs downhill, underground, over layers of impermeable material from the alluvial fans at the feet of the mountains. The choice of the location of the head well demands a particularly experienced surveyor, who begins by sinking one or more trial wells with his workmen, or *muqanni*, in order to determine whether and at what depth the water table has been reached. The measured depth is projected downhill, all the time taking account of the gradient of the qanat and the position of the intermediate shafts, and on this basis the surveyor works out where the planned qanat will emerge. The qanat tunnel is then dug back to the first intermediate shaft some 30–50m away, and so on, until the aquifer around the head well is reached. Oil lamps serve to work out the direction of the tunnel and also as a warning signal if there is a lack of oxygen. The risk of the tunnel collapsing and, above all, the sudden inrush of water when the groundwater is reached mean that working at such a great depth – up to 90m – often involves risk to life. The spoil is piled up as a protective wall around the shafts in order to prevent surface mud from flooding the shafts when it rains. In spite of this, the qanat must be constantly checked and cleaned. The small inner walls around the shafts in the photograph indicate maintenance work on the qanat. (For more on the qanat and karez, see nos. 217 and 224.)

D. H.

H. Wulff, *The Traditional Crafts of Persia* (Cambridge, Mass., and London 1966), 249–56; M. Bonine, 'From Qanat to Kort: Traditional Irrigation Terminology and Practices in Central Iran', *Iran*, 20 (1982), 145–59

226 | Tulelat al-Anab in the Negev Desert, Israel

The strikingly regular fields with stone mounds produced by human hand in the vicinity of late classical settlements in the Negev Desert aroused the interest of travellers from an early date. The Bedouins called them Tulelat al-Anab (wine mounds), leading to the assumption that they were used for viniculture. But on closer investigation, this oral tradition proves untenable, for the mounds are always found on the terraced slopes of dried watercourses (wadis), and wine-growing was not possible on such slopes, with their poor soil and lack of water. Conversely, the more fertile wadis were cultivated, and experiments have shown that the mounds served to conduct the surface water into the valleys. In the spaces that were cleared between the mounds, the ground would become encrusted, allowing the water to flow into the wadis, rather than seeping away between the detritus on the surface. The result was a primitive but effective irrigation system in this arid region. With such simple agricultural installations, there are rarely any indicators as to their date, but the few finds that have been made in the vicinity of these mounds suggest that they date to the late classical period. The present photograph was taken near the ancient city of Sobata (Subeita).

A. L.

N. Glueck, *Rivers in the Desert: The Exploration of the Negev. An Adventure in Archaeology* (London 1959), 218–22; D. Hillel, *Negev: Land, Water and Life in a Desert Environment* (New York 1982), 135–44; M. Evenari and others, *The Negev: The Challenge of a Desert* (Cambridge and London 2/1982), 127–47

227 | Sandfields of the Hopi Indians, USA

The high plateau east of the Colorado in northern Arizona is notable for its desertlike vegetation, yet in spite of this, farming has become established as an economic system. Between 500 and 300 BC the cultivation of maize, beans and pumpkins slowly spread northwards from Mexico, but drought, short growing times and unpredictable periods of rain and amounts of precipitation made it difficult to cultivate the land here. Both the Anasazi culture, which flourished between AD 900 and 1130, and the Hopi Indians, who followed it, developed special farming methods designed to create enough moisture for their cultivated plants. The flooded alluvial land that arose after the snows had melted or following summer cloudbursts was planted with maize, pumpkins and melons, or artificial tiered terraces were irrigated using ditches that followed the natural slope of the land. One particular farming method that is still used by the Hopi Indians consists of fields set out on relatively small sand dunes and used mainly to grow beans. This method makes use of the high level of humidity of sandy soils that produces condensation from the fluctuations between the daytime and nighttime temperatures. Windbreaks were used to prevent erosion, although these made the farming more labour-intensive. The Anasazi culture was brought to an end by a long period of drought in the early 13th century, thus demonstrating the dependence of the inhabitants on their environment.

T. St.

S. K. and P. R. Fish (eds.), *Prehistoric Agricultural Strategies of the Southwest* (Tempe 1984) (Agricultural Research Papers 33); R. D. Hurt, *Indian Agriculture in America: Prehistory to the Present* (Lawrence 1987); R. G. Matson, *The Origins of Southwestern Agriculture* (Tucson 1991)

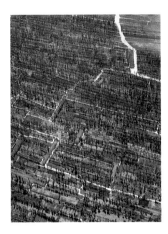

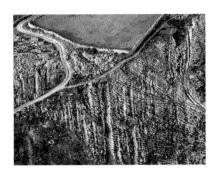

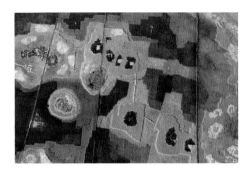

228 | **Chinampas near Xochimilco, Mexico**
Mexico City, which now numbers several million inhabitants, lies in a basin 2100m above sea level that is surrounded by volcanoes rising to more than 5000m. There was no natural outlet from the basin until the 17th century, when the Hamburg born engineer Hein Martens (Enrique Martínez) built a tunnel to carry the overflow. Until then much of the surface of the basin had been covered by a shallow lake fed by freshwater springs to the south and with a tendency to grow salty to the north, where the water evaporated. Only in the southern part had the native Indians constructed special fields known as 'chinampas', frequently, though mistakenly referred to as 'swimming gardens'. These had existed for centuries and were created by digging narrow channels in the broad, marshy area around the edges of the lake in order to draw off the excess water. The earth that was removed from the channels was used to build long beds between them. Only a few metres wide, these beds were evenly wet, producing ideal conditions that allowed several overlapping growing periods each year. It was not only useful plants that were grown here, so too were flowers, as is clear from the place's Aztec name, Xochimilco, or 'Place of Flower Fields'. (Xochimilco is now a part of Mexico City, 25km south of the city centre.) The edges of the canals have been planted with trees to stabilize them. Wider canals can be used for transport. Until the conquest of Mexico by the Spaniards in the early 16th century, the Aztec capital Tenochtitlán, together with numerous islands in the lake and the areas around the lakeside, largely consisted of chinampas that made it possible to feed the dense population. In recent decades the level of the lake has sunk dramatically, causing the beds to emerge so far that additional irrigation pumps have had to be brought in.
H. J. P.

229 | **The tracks at Clapham Junction near Mdina, Malta** The present 'cart ruts' may be seen at Clapham Junction some 4km south of Mdina on the highest point of the island of Malta (252m) and close to its southern coast. These parallel grooves are found in many parts of the islands and resemble tracks cut into the bare rock, their double lines criss-crossing the plateau in bundles several hundred metres long. They intersect and in some cases come together in the shape of a fan. They pay little heed to the terrain but pass up and down the sides of the valleys. In some cases, the lines end at cliffs overlooking the sea or peter out in very sharp curves. At Clapham Junction, which is one of the most impressive examples on the island, they partially end beneath fields covered in earth and converge towards the north on the left-hand side of the photograph. The distance between the grooves varies from 1.32 to 1.47m. They are V-shaped and up to 60cm deep. It remains unclear how, why and when they were made. At present the most likely explanation is that they are tracks designed for two-wheeled carts; sledges would not be able to navigate the curves. It is also unclear whether they were simply worn away in the rock or whether they were dug out. They were certainly moved on several occasions and used over a lengthy period of time. There are individual pointers to the fact that they existed in pre-Punic times (2nd century BC) and may even date to the Late Bronze Age, i.e., the late 2nd millennium BC.
V. P.

J. D. Evans, *The Prehistoric Antiquities of the Maltese Islands: A Survey* (London 1971), 202–4; D. H. Trump, *Malta: An Archaeological Guide* (London 1972), 31–4, 118–21

230 | **Raised fields and platforms in the Cuenca de Guayas, Ecuador** The Guayas Basin is a broad, tropically humid coastal plain extending from the foothills of the Andes to the Pacific coast in Ecuador. The basin is drained to the south by the Río Guayas and its tributaries, and it is here that the modern city of Guayaquil lies. As a result of the extreme climatic differences between the rainy season and the dry season in the equatorial Andes, the amount of water carried by the local rivers fluctuates enormously. During the rainy season large areas of the southern section of the Guayas Basin are flooded, so that the soil is repeatedly enriched with minerals. Even during the early prehispanic period, the fertile soil encouraged settlers to come here and adapt to the difficult conditions. Settlements were built on platforms or hills that are now known as *tolas*. Thousands of these *tolas* may be found throughout the Guayas Basin, often forming regular patterns. Earlier scholars believed that they were burial mounds from the late prehispanic period, but we now know that they began to be built at the time of the regional developments (500 BC – AD 500). In order to be able to use the marshy terrain for agriculture during the wet season, too, raised fields – known in Ecuador as *camellones* – were laid out, especially in the southern Guayas Basin. These *camellones* were generally long and narrow but could also be designed as platforms. Experiments in Ecuador and similar prehispanic sites in Belize and Colombia and in lowlands such as those surrounding Lake Titicaca in Bolivia have shown that this form of agriculture could be far more productive than traditional methods.
M. Re.

O. von Buchwald, 'Ecuatorianische Grabhügel', *Globus*, 96/10 (1909), 154–7; N. Guillaume-Gentil, 'Patrones de asentamiento prehispánicos en la cuenca norte del Río Guayas, Ecuador', *Beiträge zur Allgemeinen und Vergleichenden Archäologie*, 16 (1996), 263–300

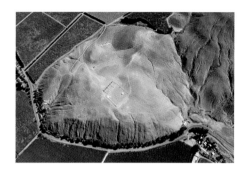

231 | **Sarabit El-Khadem on the Sinai Peninsula, Egypt** Situated on a 735m high sandstone plateau in the rugged mountain region of south-west Sinai some 29km east of the Gulf of Suez, the Temple of the Goddess Hathor was discovered in 1762 by the German explorer Karsten Niebuhr. It was first systematically examined in 1904–5 by the English Egyptologist Sir William Matthew Flinders Petrie, who shed light on the temple's complex architectural history. The Egyptians may have come to the southern Sinai as early as the 4th millennium BC in order to mine turquoise, which would explain why Hathor, the Egyptian goddess who was later worshipped here, was known as the 'Mistress of Turquoise'. But it was not until the end of the 12th Dynasty (c1800 BC) that the Temple of Sarabit El-Khadem was dedicated to her in the form of a small rock sanctuary. This was later extended by numerous courtyards built in front of it, quickly turning it into the most important Egyptian temple outside Africa. The main extensions date from the New Kingdom, when expeditions to obtain raw materials from this region became more intensive. In neighbouring Wadi Nasb, it was no longer just turquoise that was mined but also copper, some of which was smelted locally. Virtually every pharaoh of the New Kingdom left his name in the Temple of Sarabit El-Khadem, either on the parts of the building that he himself added or through votive gifts, most of them manufactured from the 'Egyptian faience' that was made to resemble turquoise. In some cases, stelas were erected in the temple courtyards. These large stone slabs are a characteristic feature of the temple and include hieroglyphic texts, some of which contain reports on expeditions, thereby making them an important source of information on the well-organized exploitation of raw materials during the 2nd millennium BC.
Ch. L.

W. M. F. Petrie, *Researches in Sinai* (London 1906); D. Valbelle and C. Bonnet, *Le sanctuaire d'Hathor, maîtresse de la turquoise: Sérabit el-Khadim au Moyen Empire* (Paris 1996)

232 | **Viña del Cerro in the valley of the Río Copiapó, Chile** The ruins of Viña del Cerro are perched on a hill that projects deep into the oasis of the Río Copiapó on the southern edge of the Atacama Desert. A group of 26 round furnaces (*huairas*) measuring 2–3m in diameter can be seen on the hilltop 50m above the valley. An exposed site 1100m above sea level, it used the keen winds to accelerate combusion of the fuel in the furnaces, which are arranged in rows of three and form the best-preserved and, as far as we know, the largest copper smelting centre in the Inca kingdom (15th/16th century). The site's importance is clear from the 56 x 50m court complex at its centre, with an *usnu* platform for ceremonial acts of state. Such platforms are found only at selected sites in the Inca kingdom. Each of the three courts on the north side of the site encloses two buildings measuring 2.3 x 3.4m, they too built in a standardized and relatively lavish style implying an official character. It was here that important officials lived and worked. To judge by the stone mills, crucibles and copper objects that have been found here, they were smelters and coppersmiths. In a separate fourth enclosure, an almost square building obviously housed some high-ranking individual, perhaps the local imperial administrator. The Inca did not use right angles in their architecture, in which respect they differred from the architects of the official buildings of the central Andean Wari empire (AD 750–1000). The ore was brought from deposits in the area, although the site reveals a surprising lack of infrastructure in the form of accommodation, storerooms and llama pens. The state-employed workmen and caravan drivers presumably lived in their own settlements some distance away or they may have camped in the open air. The modern access road cuts across older trails, among them the original Inca road.
H. B.

F. Niemeyer and others, 'Viña del Cerro: Metalurgia Inka en Copiapó, Chile', *Gaceta Arqueológica Andina*, 9 (1984), 6–7; S. Salazar and others, 'Mining and Metallurgy: From the Cosmos to Earth, From the Earth to the Inka', *In the Footsteps of the Inka in Chile*, ed. C. Aldunate and L. Cornejo (Santiago de Chile 2001), 60–71

233 | **Charcoal kilns at Chalcidice, Greece**
Wood is one of the oldest materials and sources of energy used by mankind. The benefits of charcoal over wood were discovered in prehistoric times: not only does it burn at a higher temperature but the heat is even and can be regulated. It was the discovery of charcoal that first made it possible to smelt metal from ore. Not until the beginning of the industrialized period was charcoal displaced in countries that had appreciable amounts of hard coal and brown coal deposits. But charcoal has remained an important fuel, especially in Mediterranean countries, where its production has regrettably led to the loss of entire forests, with predictable ecological consequences in the form of soil erosion. In many of these countries, including the case illustrated here, charcoal is now produced with wood from state-owned forests. Technologically speaking, nothing has changed since prehistoric times, only the transportation having been modernized. The charcoal is produced in large round kilns, in which the wood is carbonized for several weeks, with the air supply largely cut off.
R. S.

M.-L. Hillebrecht, 'Untersuchungen an Holzkohlen aus frühen Schmelzplätzen', *Archäometallurgie der Alten Welt: Der Anschnitt*, ed. A. Hauptmann and others (Bochum 1989), 203–12

234 | **Marble quarry near Chalki on Naxos, Greece**
Naxos is the largest of the Cyclades and was
famous for its marble even in antiquity. The uniform
whiteness of the marble and its regular crystalline
structure rendered it particularly suitable for
statuary and architectural elements. As such, it was
an important basis of the island's wealth in ancient
times. Among the oldest Greek sculptures are idols
that were made on Naxos during the 3rd millen-
nium BC and exported over a wide area. The use of
marble in temple architecture also originated in the
Cyclades, especially Paros and Naxos. Numerous
sculptures in Greek sanctuaries, some of them
monumental in size and including the sanctuary of
Apollo on Delos (no. 21), were made of marble from
Naxos, and many of the island's quarries still
contain unfinished classical sculptures. But all of
this is true only of quarries close to the sea that
could easily be reached by ship. Marble quarrying in
the interior of the island is a relatively recent devel-
opment, dating from a time when the quarries
could be reached by modern vehicles. This applies
to the quarry near the village of Chalki. Here the
oldest architectural monuments are the Barozzi
towers from the years around 1740: the Barozzis
were a Venetian family who were then among the
island's most influential landowners.
R. S.

E. Curtius, *Naxos* (Berlin 1846); H. Riedl and W. Kern
(eds.), *Geographische Studien auf Naxos* (Salzburg 1982)
(Salzburger Exkursionsberichte 8)

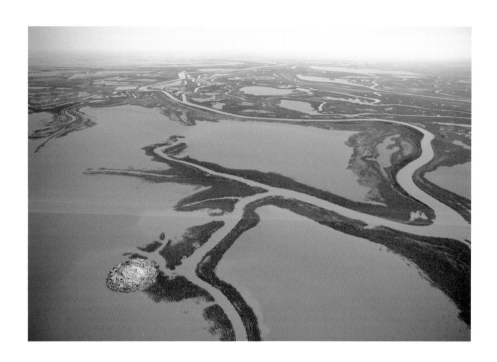

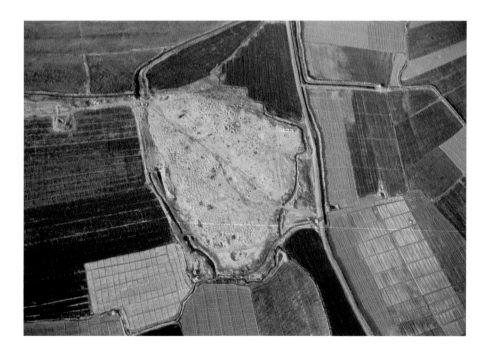

235 | **Tumulus in the inland Niger River Delta**, 12th–16th century AD, Mali, 1973

236 | **Site in the Khabur Valley**, Syria, 1997

11. THE CURSE AND FRUSTRATION OF ARCHAEOLOGISTS — LOOTING

May he who violates my site and damages my grave
Or takes my body be reviled by the Ka of Re.
He shall not bequeathe his possessions to his children,
His heart shall not be content in life,
He shall not receive water in the Kingdom of the Dead
And his Ba-soul shall be destroyed for all eternity.
This land is wide, it has no end!

Inscription on the back of the double statue of Wersu, the 'manager of Amun's goldmine', and his
wife Sat-Re (18th Dynasty, 1420 BC), Folkwang Museum, Essen

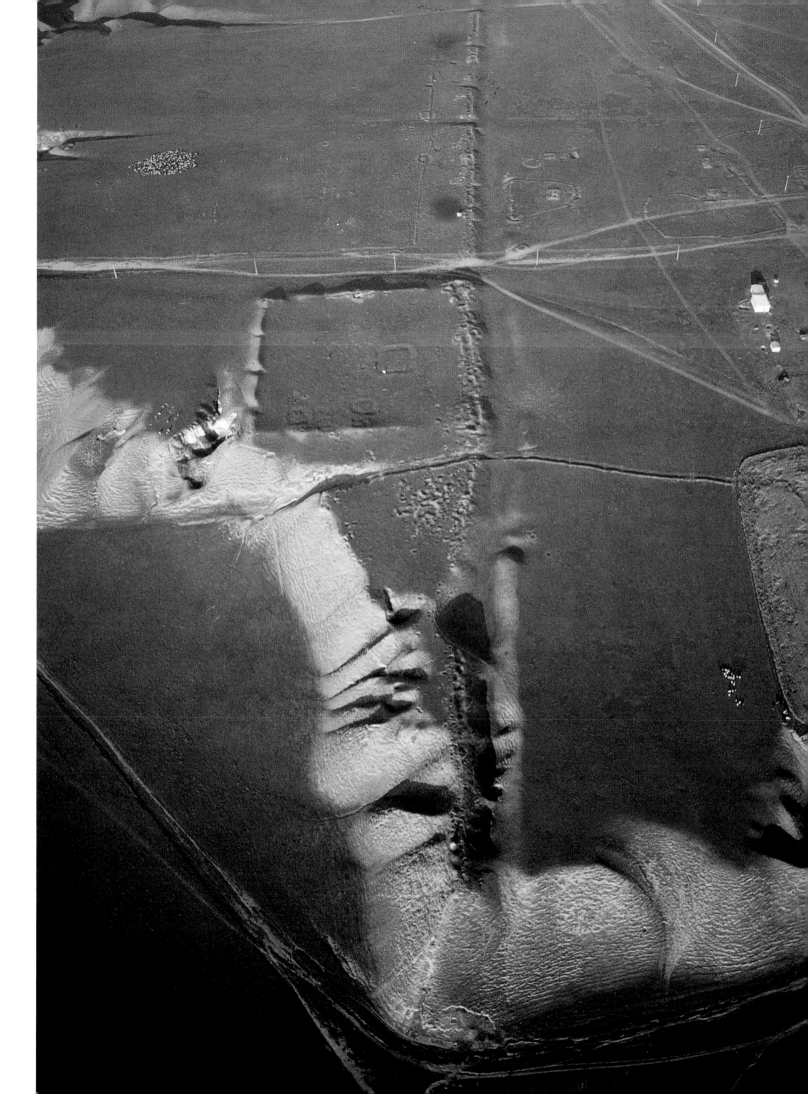

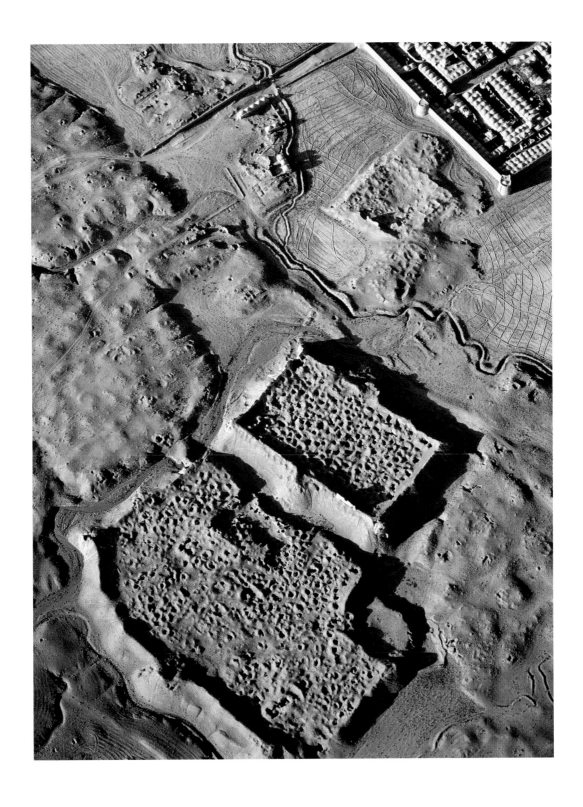

237 | **Alexander's Wall**, Iran, 1978

238 | **A citadel in Khorasan**, Middle Ages, Iran, 1977

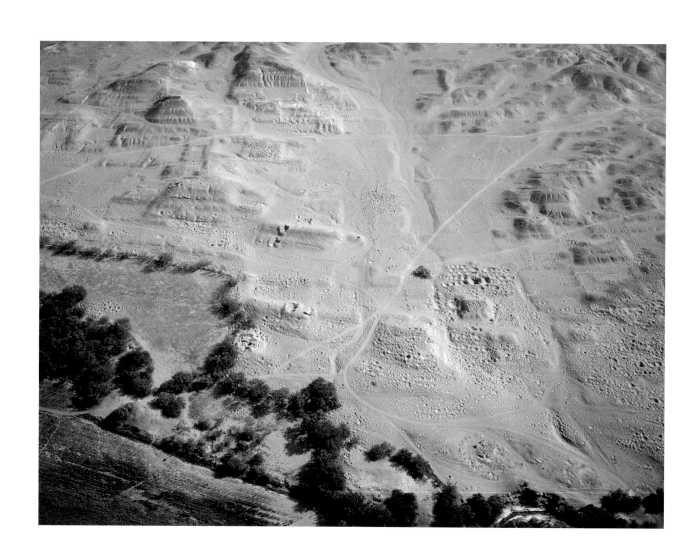

239 | **The Nasca site at Cahuachi**, 100 BC–300 AD, Peru, 1967. World Heritage Site

240 | **Site at Sipán**, 100–600 AD, Peru, 1995

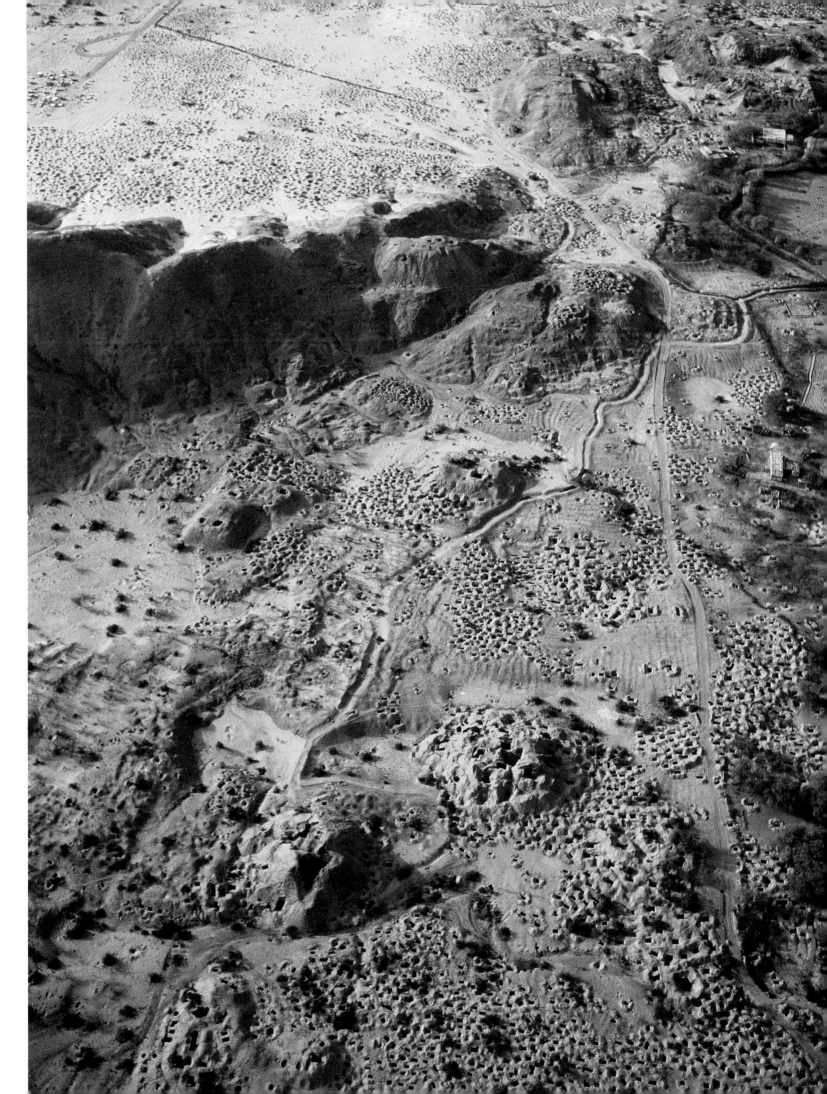

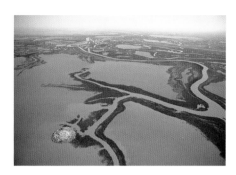

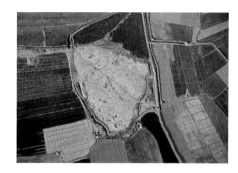

235 | **Tumulus in the inland Niger River Delta, Mali**

In the middle of the inland delta of the Niger lie hundreds of burial mounds known to the local population as *koï gurrey* ('hills of the tribal leaders'). The brown, churned-up surface of the round burial mound indicates that it has been looted. According to conservative estimates by local archaeologists, more than 60 per cent of the archaeological sites in Mali have already been looted. The ceramics and terracotta and bronze figures that have been found in these Djenne culture graves (12th–16th century AD) have come to command the highest prices at international art auctions. The Mali terracottas vary in terms of their regional styles. Human figures, either singly or in pairs, predominate. Both the quantity and quality of these figures have shed new light on the terracotta art of the African continent. Torn from their context by illegal excavations, these objects can no longer be subjected to an overall interpretation, and in many cases entire archaeolog-ical sites have been destroyed. Since 1985 Mali has tried enacting laws in an attempt to put an end to the sale of its culture, but as a result of globaliza-tion the trade in archaeological artefacts has increased dramatically. Generally looted by poorer members of the local population, these objects multiply in value on the international art market. The illegal trade in cultural artefacts is one of the leading criminal activities alongside drug dealing and the trade in arms. In spite of initiatives on the part of Unesco in 1970 and 1995, it has so far proved impossible to enact an international treaty to protect cultural assets comparable to the one designed for the protection of species.
T. St.

Unesco, *Convention on the Means of Prohibiting and Preventing the Illicit Import, Export, and Transfer of Owner-ship of Cultural Property* (New York 1970); M. Dembele and others, *Prospection des sites archéologiques dans le delta intérieur du Niger* (Paris 1993); S. Sidibé, *The Fight Against the Pillage of Mali's Cultural Heritage and Illicit Exportation: National Efforts and International Cooperation* (New York 1995)

236 | **Site in the Khabur Valley, Syria**

The Khabur Triangle and Khabur Valley are an ancient settlement area characterized by a large number of settlement mounds up to 40m high. The northern parts of the region have enough natural precipitation and have been used since records began for stable rainfield argiculture. On the lower Khabur, by contrast, the often very narrow riverside meadows have had to be artificially irrigated, chiefly with river water. This relatively flat tell is surrounded by modern irrigation channels, and the arable land extends as far as the outer edge of the ruined settlement. The old settlement site has not yet been archaeologically examined, and the stages of its development are unknown. Particularly striking is the unstructured surface of the tell, which shows few signs of erosion. A dirt track runs over it from the road to the fields. In their mixture of fallow and cultivated areas, the fields reveal a number of details of the irrigation method that is used here. Some fields are prepared for parcel irrigation. Long side channels designed to distribute the water fork off from the main channels into which the water is channelled from the Khabur – diesel pumps are now used for this operation. Each of the small rectangular parcels can be supplied with enough water by regulating the flow by hand. Apart from cereals, the Khabur Valley produces mainly cotton, which needs a lot of water, especially just before it is harvested.
R. W.

237 | **Alexander's Wall, Iran**

It is not only precious objects that are targeted by looters. Ever since late antiquity, older buildings have regularly been used as quarries for newer ones. The straight line of looting holes in the present photograph provides a negative image of the course taken by Alexander's Wall in north-eastern Iran (no. 121). Its fired bricks now form the foundations and walls of many of the buildings in the surrounding villages and towns. A similar fate befell what was originally the even more impressive Sassanian castle wall at Derbent, which ran for a distance of 40km from the opposite, west bank of the Caspian Sea to the Caucasus and which was not demolished for its stones until the 1950s. The Gurgan Plain also offered a rich booty to looters, with collectors from the late 19th century onwards taking an increasing interest in the colourful enamelled ceramics from Islamic times, for which the medieval city of Gurgan just to the south of Alexander's Wall was famous. The holes that can be seen to the right-hand side of the photograph and in the corner between the castle and the course of the Wall must have been dug by looters looking for prehistoric vessels and grave goods, for which the Gurgan Plain is also famous.
D. H.

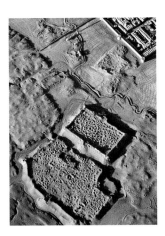

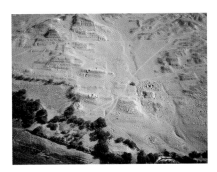

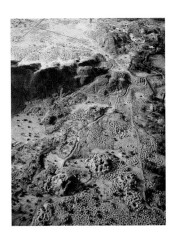

238 | **A citadel in Khorasan, Iran**

Situated in the north-east of the country, Khorasan is Iran's largest province and originally extended across Central Asia and Afghanistan as far as the Hindu Kush. It was the ancestral home of the Parthian Arsacids, whose empire in the west stretched as far as the Euphrates. Even in the High Middle Ages, cities such as Nishapur, Merv, Herat, Bukhara and Balkh were political and cultural centres of the Islam world, and Khorasan dynasties such as the Samanids and Seljuks were the real rulers of the caliphate of Baghdad. Periods of peace and prosperity were repeatedly interrupted by the incursions of Central Asian barbarians, initially Aryans, later Turks and Mongols. The Safavid kings settled bellicose Kurds on the country's north-east frontier in order to protect their new provincial capital of Mashhad, but even in the 19th century robber bands of Sunni Turkomans were still hunting down Shiite pilgrims on their way to Mashhad in order to sell them in the slave markets of Khiva and Bukhara. Until very recently the prime concern was always to ensure that settlements could be defended against attack. Here, in a large and apparently older settlement area, we see the typical arrangement of kuhendiz and shahristan, a powerfully fortified citadel and a lower town walled off from it. Both are perforated by the holes dug by modern looters. A new and well-kept fortified village lies beyond a small ruined castle and farmland crossed by an irrigation channel. It consists of practical mud houses with domed roofs. Such houses can be combined at will and are designed for every possible purpose.

D. H.

G. Le Strange, *The Lands of the Eastern Caliphate* (London 1905); E. Diez, *Churasanische Baudenkmäler*, vol. 1 (Berlin 1918); G. Gropp, *Archäologische Forschungen in Khorasan, Iran* (Wiesbaden 1995)

239 | **The Nasca site at Cahuachi, Peru**

Hole after hole: this is how Cahuachi looks from the air. Situated in the Nasca Valley some 450km south of Lima on the Peruvian coast, this was the main centre of the Nasca culture but has been ransacked by looters for over a century, leaving large craters in the ground. For the most part, they are looking for grave goods such as ceramic vessels, textiles and pieces of jewellery made from gold and shells, all of which are in great demand on the international art market. Cahuachi extends for several kilometres along the southern side of the Río Nasca, facing the Pampa de Nasca and its famous geoglyphs. The settlement lies at the edge of the desert, so that the valley itself could be used for agriculture. Cahuachi was the principal site of the Nasca culture during its early phase (100 BC–AD 300). Little has been published on the excavations here since the 1980s, so that it is unclear whether, as was suggested at that time, Cahuachi was a largely unpopulated pilgrimage site or, as originally believed, the capital of a state that encompassed the river valleys of the whole of the Nasca region. The centre of Cahuachi is dominated by large terraced open plazas between pyramids built on mounds at the edge of the desert. The buildings were made from mud bricks or had wooden posts with reed walls coated in clay. That many of these buildings had a religious function is clear not only from depositions of ceramic vessels and clay pipes but also from the burials of sacrificed llamas. Cahuachi lost its significance during the Late Nasca period but continued to be used as a burial site.

K. L.

W. D. Strong, *Paracas, Nazca, and Tiahuanacoid Cultural Relationships in South Coastal Peru* (Salt Lake City 1957) (Memoirs of the Society for American Archaeology 13); H. Silverman, *Cahuachi in the Ancient Nasca World* (Iowa City 1993); G. Orefici, 'Zeremonial- und Wohnarchitektur im Nasca-Tal', *Nasca: Geheimnisvolle Zeichen im alten Peru*, ed. J. Rickenbach (Zurich 1999), 97–108 (exhibition catalogue)

240 | **The Moche site at Sipán, Peru**

Like all the great sites along the coast of Peru, the ruins at Sipán in the Lambayeque Valley 10km east of Chiclayo are studded with craters, a sure sign that the site has been thoroughly ransacked by *huaqueros*, or looters. It is almost a miracle that the most important grave find to have come to light in Peru was discovered here in 1987: the undisturbed and richly furnished tomb of a Moche prince from the 3rd century AD. Needless to add, even this spectacular find was preceded by illicit excavations. Only after several gold objects had turned up on the market did the Peruvian authorities manage to track down the looters and place the complex of adobe pyramids and platforms at Huaca Rajada under protection, allowing archaeologists to start the process of scientifically documenting the tombs. During his lifetime, the Lord of Sipán evidently ruled over a regional Moche principality and was buried in full regalia with numerous articles of jewellery. Four women, three men and a child followed him into the tomb, which is situated on a side platform within the complex. Other intact tombs have been discovered near by, all of them occupied by dignitaries of the Moche culture. The well-preserved grave goods and the clothes of the occupants of the tombs have enabled archaeologists to compare them with the numerous scenes depicted on ceramic vessels from the Moche period and in that way to identify the social role of the individuals and the function of their grave goods. The finds at Sipán extend our picture of the Moche culture in important ways. If the tombs had been plundered, this information would have been lost for ever.

K. L.

W. Alva, 'Discovering the New World's Richest Unlooted Tomb', *National Geographic*, 174 (1988), 510–55; J. Pillsbury (ed.), *Moche Art and Archaeology in Ancient Peru* (Washington 2001) (Studies in the History of Art 63); Kunst- und Ausstellungshalle der Bundesrepublik Deutschland (ed.), *Gold aus dem alten Peru: Die Königsgräber von Sipán* (Bonn 2001)

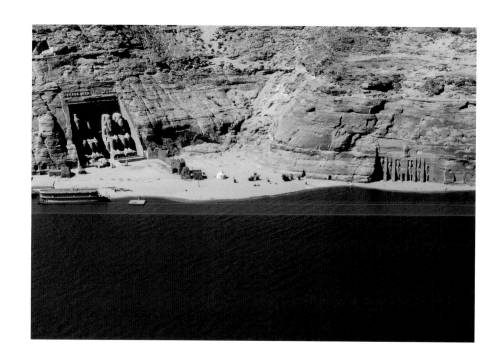

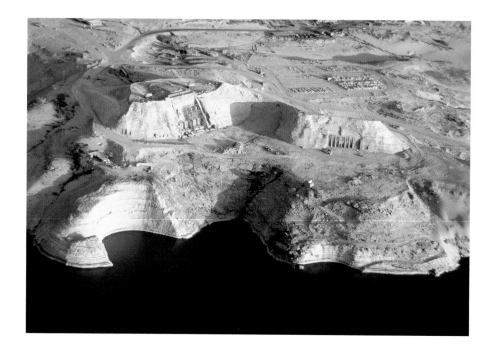

241 and 242 | **The rock-temples at Abu Simbel**, *c*1250 BC, Egypt, in their old and new position, 1964 and 1968. World Heritage Site

12. AT THE LAST MINUTE
– PLACES LOST AND SAVED

What's left but to drown the past in order to save the future?

An engineer on the site of the Aswan High Dam, 1963

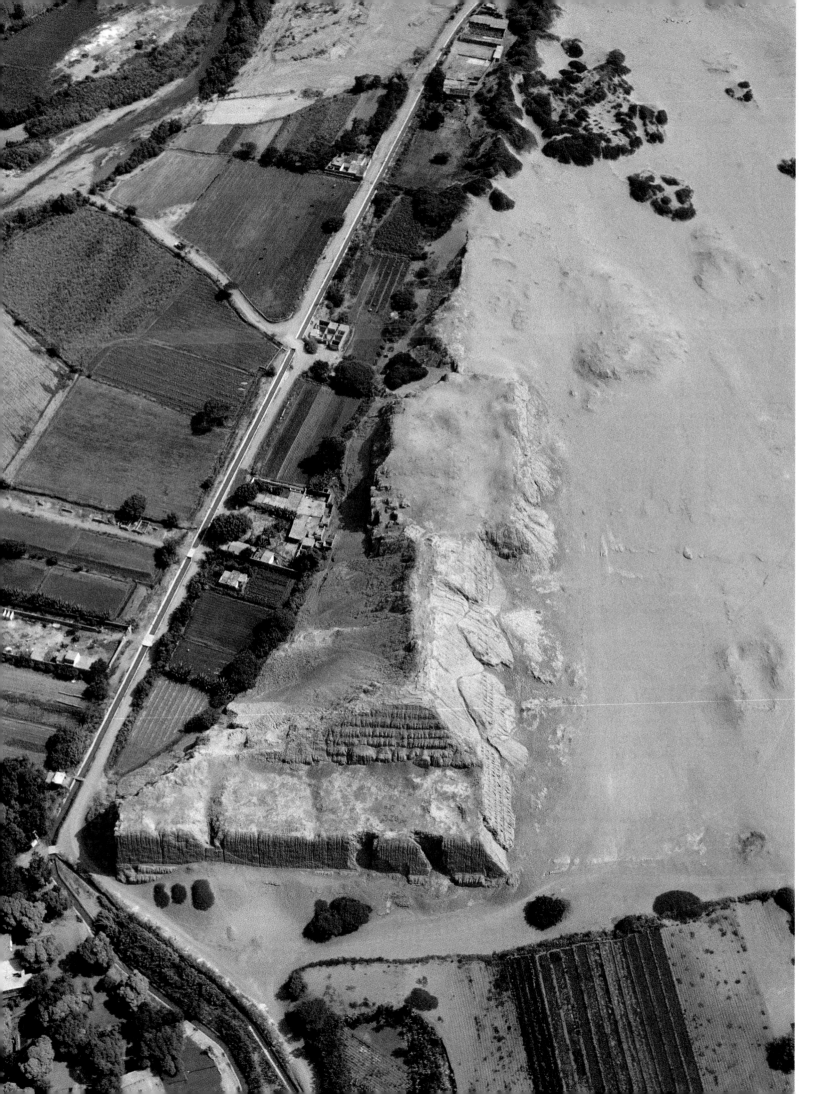

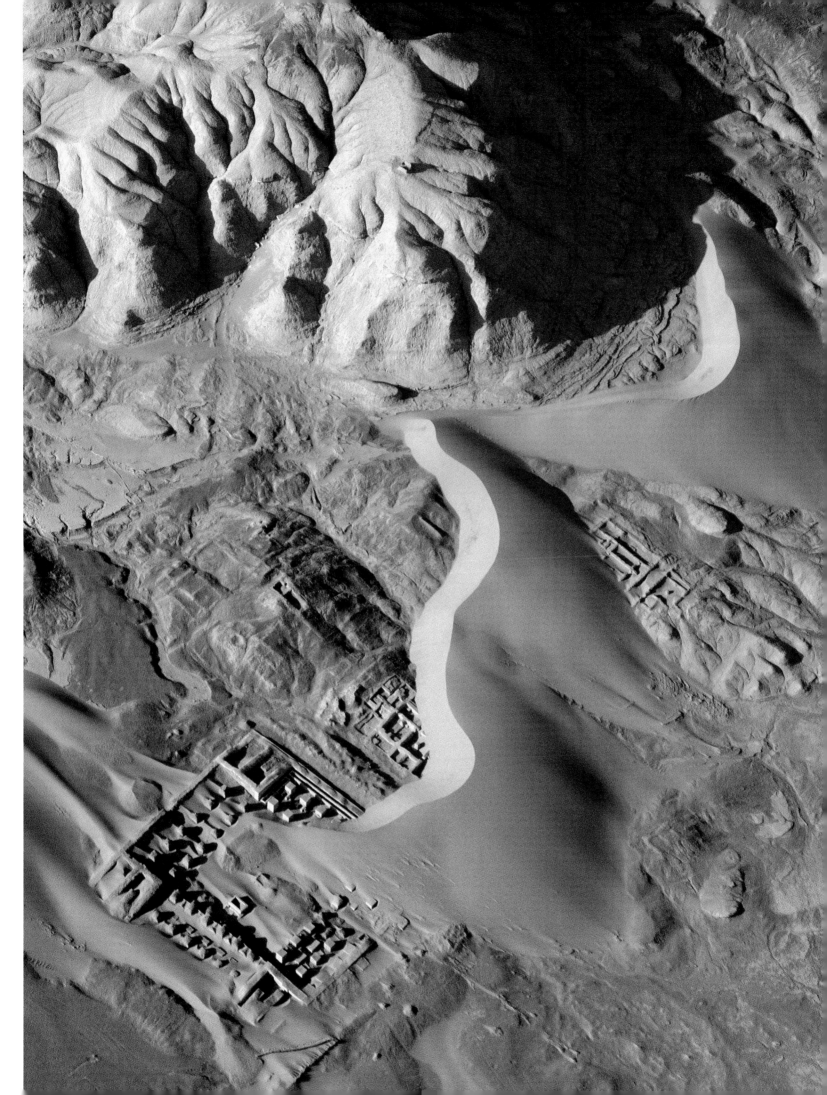

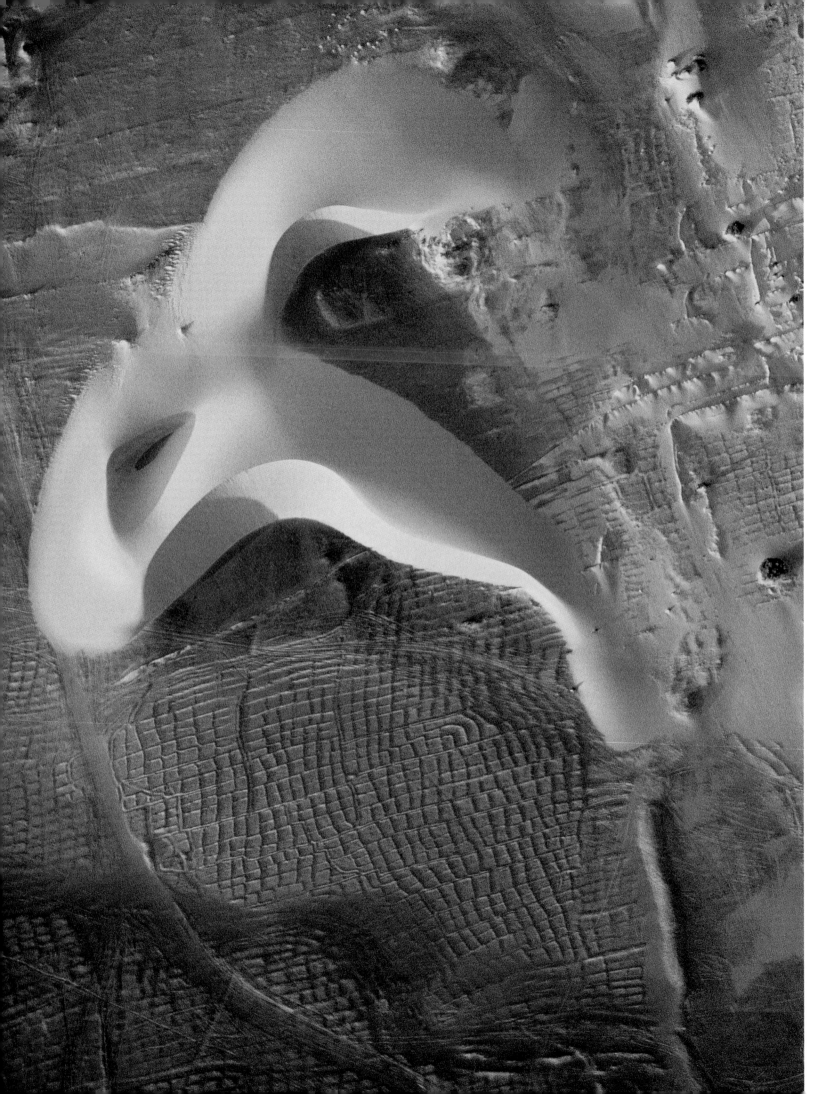

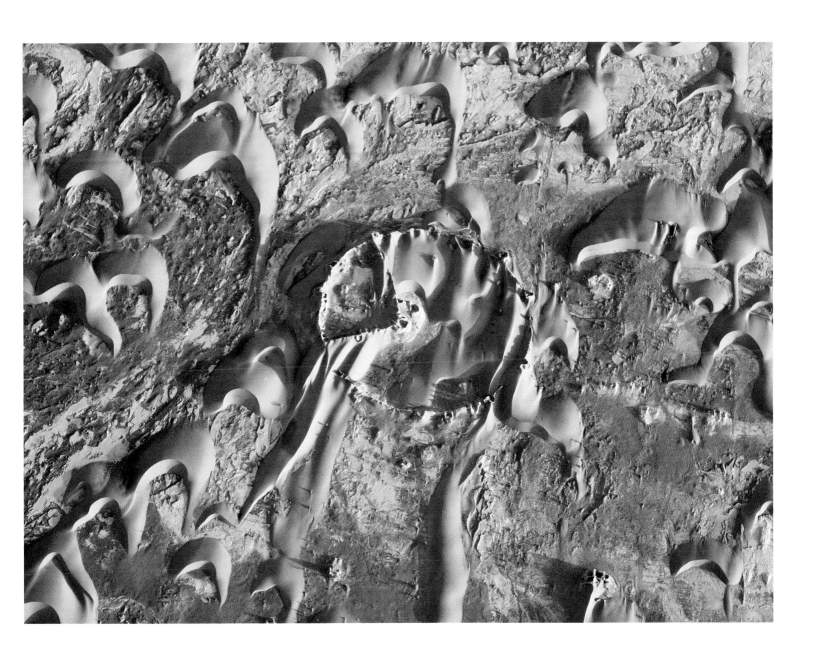

243 | *382:* **The Pyramid of the Sun at Huaca del Sol**, Moche culture, AD 1–750, Peru, 1995

244 | *383:* **Achaemenid ruins at Dahan-i Ghulaman**, 6th/5th century BC, Iran, 1977

245 | **Ancient fields and crescent dunes in the Kharga Oasis**, Egypt, 1978

246 | **The fortress at Qalat-i Gird**, 13th century AD, Iran, 1977

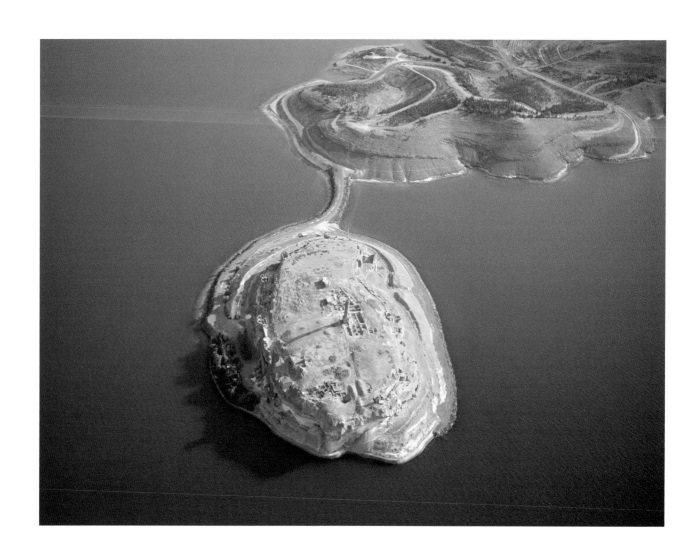

247 | **Qalat Jaber**, 10th–12th century AD, Syria, 1997

248 | **The site of Gebel Adda, Nubia**, 1st–18th century AD, Egypt, 1967

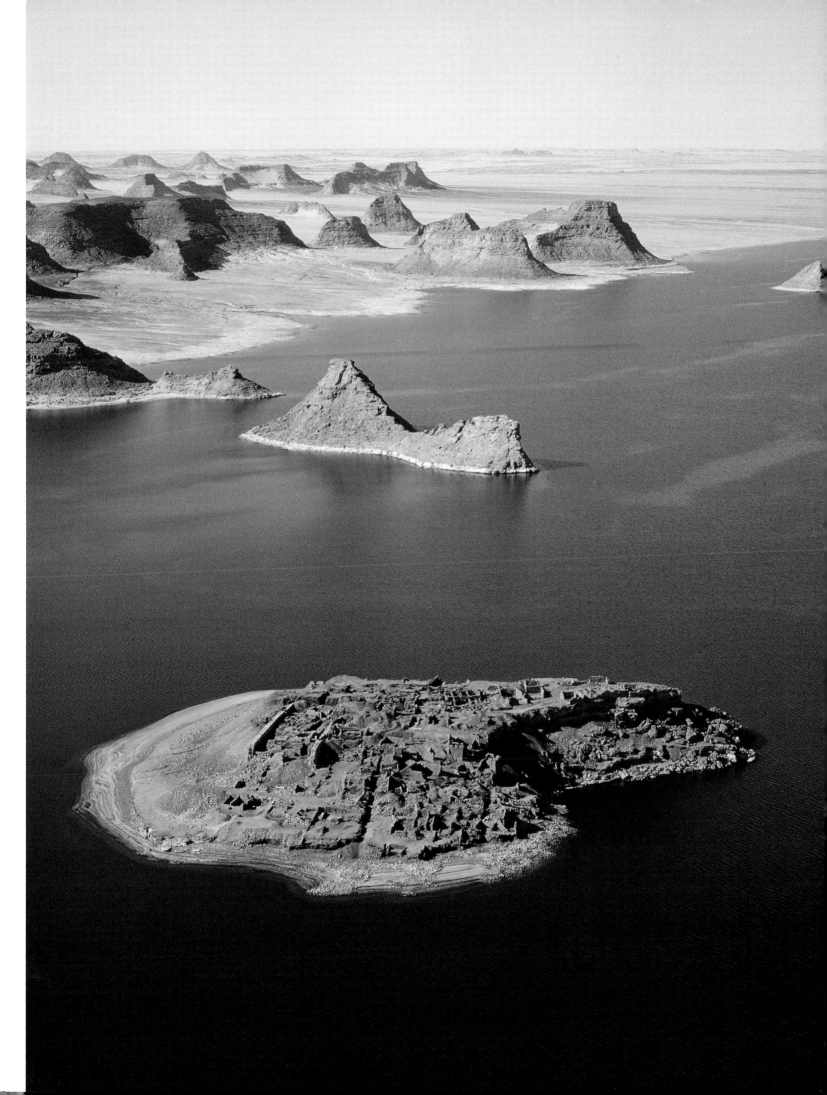

249 | **Marsh dwellers in the Hor**, from 5th millennium BC, Iraq, 1973

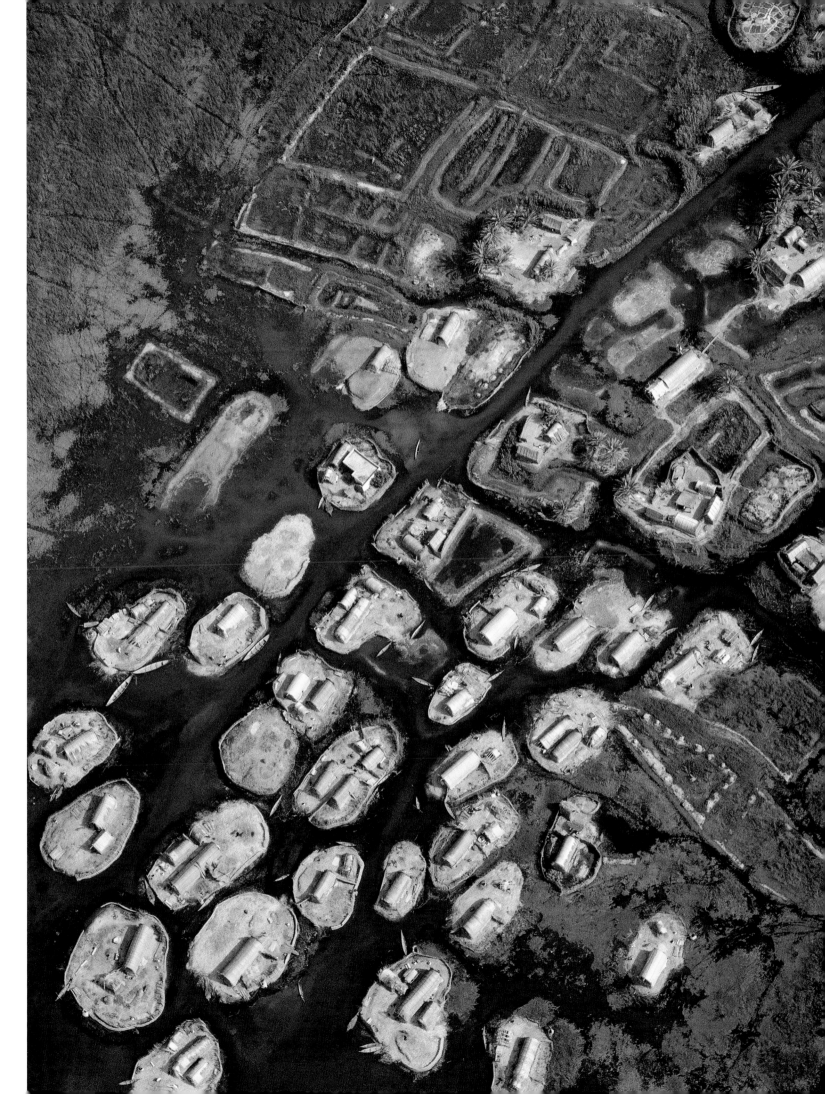

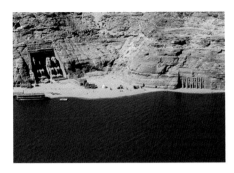

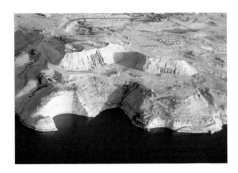

241 and 242 | The rock-temples at Abu Simbel, Egypt, in their old and new position The smaller sanctuary was dedicated by Ramesses II to his wife Nefertari and the goddess Hathor at the beginning of his reign (1279–1213 BC). Ramesses was a notorious womanizer whose megalomania extended to his harem but he seems to have had a soft spot for Nefertari ('the most beautiful of all'). Her temple creates an impression that is musical, relaxed and lovely – in a word, womanly. Several decades later Ramesses' own temple was carved out of the mountainside not far away in imitation of built architecture. The façade with its 20m high seated likenesses of the pharaoh-god replicates the pylon of a built temple. Within the hill, a hypostyle hall in place of a courtyard is followed by a second hypostyle hall, a transverse vestibule and the sanctuary itself, with seated statues of the pharaoh in the company of the kingdom's gods. Ramesses was pharaoh-god on the strength of his office and throughout the building process pursued a policy of personal deification, a policy that has given the temple the characteristics of a picture puzzle: on a relief that shows the pharaoh sacrificing to Amun and Mut he later interposed himself as a god between gods, leaving no room for Mut to remain seated, with the result that she was forced to stand. Moreover, the stonemasons had mistaken the quality of the sandstone, and even while Ramesses was still alive they had to support one of the colossi with bricks. Shortly afterwards the southernmost colossus lost its top. Nor had they reckoned with the constant exposure to the desert sand. When the Swiss explorer Johann Ludwig Burckhardt ('Sheikh Ibrahim') rediscovered Abu Simbel in 1813, he was unable to enter the great temple, and it was even unclear whether Ramesses was sitting or standing, so covered was the site with sand. Why did Ramesses go to the trouble of making this extravagant gesture on the southern edge of his kingdom? Although he depicted himself in the temple as the great fire that destroys the southern peoples, this boast was already well known: Wawat (Nubia) had

already been pacified. Christiane Desroches-Noblecourt believes that Abu Simbel was part of the celebrations associated with the annual rebirth of Egypt and its fertility by the flooding waters of the Nile. The Temple of the Sun may perhaps have been the southernmost resting place of the god's boat which sailed down the Nile on the occasion of the festival held to mark the annual Nile flood, a procession attested at least for the later period. The temple faces east, so that twice a year the rising sun would enter the sanctuary 55m within the hillside. On 22 February and 22 October (a day later than Ramesses intended, thanks to inexact calculations when the site was moved) the sun lifts Ramesses and Amun from their sacred darkness from their feathered crowns to their feet. Louis-A. Christophe has seen in the October date a reference to the 30th anniversary of Ramesses' accession. Even more speculatively, the February date may be that of the pharaoh's birthday. For more details about the relocation of the temples, see the following section. G. G.

J. L. Burckhardt, *Travels in Nubia* (London 1819); L.-A. Christophe, 'Quelques remarques sur le grand temple d'Abou-Simbel', *La revue du Caire*, 47 (Nov. 1961), 303–33; C. Desroches-Noblecourt, 'Abu Simbel: Archäologischer Teil', *Die Welt rettet Abu Simbel*, ed. C. Desroches-Noblecourt and G. Gerster (Vienna and Berlin 1968)

243 | The Pyramid of the Sun or Huaca del Sol, Peru At the edge of the fertile Moche Valley on Peru's northern coast, some 5km south of Trujillo, lie the ruins of the Huaca del Sol (Pyramid of the Sun). The size of this adobe structure – at over 340m long, it is one of the largest in Latin America – remains impressive despite the severe damage that it has suffered. It was originally a platform structure made up of several elements. During the early colonial period, however, the nearby Río Moche was rerouted along the northern façade by Spanish gold prospectors, so that the burial chambers that were thought to lie inside it would be exposed by the force of the water. The river washed away more than half of the structure, which was made only of unfired mud bricks, with the result that only the southern and eastern façades survive. It is not known whether any treasures were in fact discovered here. At the time of the Moche culture (AD c1–750), which is known chiefly for its expressive portraiture ceramics and the royal tombs at Sipán, the Huaca del Sol, together with the Huaca de la Luna (Pyramid of the Moon) at the foot of the nearby Cerro Blanco and a municipal settlement framed by both buildings, formed the political and religious centre of a well-organized state. The Huaca del Sol, which was repeatedly enlarged, presumably had an administrative and ceremonial function within this state. Several tombs were discovered on its southern platform. The Moche ruins lost their former significance centuries before the Spanish reached Peru's northern coast. K. L.

M. Uhle, 'Die Ruinen von Moche', *Journal de la Société des Américanistes de Paris* (New Series), 10 (1913), 95–117; M. Reindel, *Monumentale Lehmarchitektur an der Nordküste Perus* (Bonn 1993) (Bonner Amerikanistische Studien 22); G. Bawden, *The Moche* (Oxford 1996) (The Peoples of America)

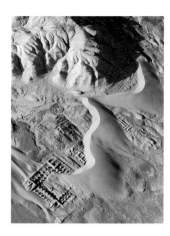

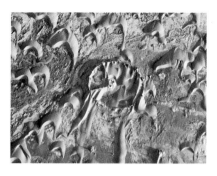

244 | Achaemenid ruins at Dahan-i Ghulaman, Iran
The shifting sand dunes of the eastern Iranian
landscape of Sistan – known to the ancients as
Drangiana – are currently in the process of
reburying the Achaemenid ruins of Dahan-i
Ghulaman 30km south-west of Zabol, which were
uncovered for the first time in 1962. In the 6th/5th
century BC this desert region was watered by a
former arm of the Helmand River, allowing it to be
farmed. A town some 1.5km long grew up along a
wide channel, with large buildings in a network of
densely packed houses that was rediscovered in
1961 by the Italian archaeologist Umberto Scerrato.
The town was once the administrative centre of the
province. Colonialization and building on this scale
could be planned and implemented only in a rigidly
organized state like that of the Achaemenid empire.
The precise purpose of the larger buildings is for
the most part unclear. Only the so-called 'Sacred
Building' was uncovered in its entirety. It is thought
to have been associated with the Zoroastrian fire
cult, although doubts have been raised about this
hypothesis on ritual grounds. The numerous box-
shaped furnaces in the hypostyle halls and court-
yard, where one of the three so-called main altars
has just been covered by the octopus-like arm of the
sand dune, can be interpreted only with difficulty as
fire altars, while the remains of animal bones in the
ashes tend to suggest a secular use rather than vast
numbers of burnt offerings. Conversely, the square
room with a central pillar in a neighbouring house
might have been used in such a cult. It appears in
the photograph above the main building in the bay
made by the dunes, awaiting its fate of being buried
in turn. A small three-step fire altar was found here.
D. H.

U. Scerrato, 'Excavations at Dahan-i Ghulaman (Seistan –
Iran): First Preliminary Report (1962–1963)', *East and West*
(New Series), 16 (1966), 9–30; U. Scerrato, 'Evidence of
Religious Life at Dahan-e Ghulaman, Sistan', *South Asian
Archaeology 1977* (Naples 1979), 709–35; M. Boyce, *A
History of Zoroastrianism II* (Leiden and Cologne 1982),
128–31

**245 | Ancient fields and crescent dunes in the Kharga
Oasis, Egypt** The only oases in Egypt are in the
Libyan Desert west of the Nile, one of the driest
regions on earth. All the more astonishing, there-
fore, is the presence of oases that seem positively
paradisiacal – Herodotus's 'Islands of the Blessed'.
They owe their existence to the north wind, which
over millions of years has produced depressions up
to 500m deep in the plateau. Only here can the
fossil water stored in the Nubian sandstone reach
the surface of the desert. The continuous settle-
ment of oases began when the inhabitants of the
eastern Sahara, who had lived there since around
350,000 BC, were forced by climate change and the
resultant drying out of the savannah-like plains to
retreat to places with access to groundwater. The
oasis dwellers soon learnt to dig wells and draw
water from great depths and to lay out large areas
of fields divided into small parcels of land, areas
still clearly identifiable in oases today, especially
when seen from the air. The present picture shows
fields from Roman times (2nd–4th century AD) in
the extreme north of the Kharga Oasis, the largest
of the five oases in Egypt's Western Desert. Here we
can also see the southern tip of the Abu Muharrik,
the 500km long sand dune field. The crescent-
shaped shifting dune that can be seen in the photo-
graph is part of the Abu Muharrik and is already
threatening to cover the ancient fields. The shifting
dunes are moving southwards at a rate of up to
10m a year and in this way preserve all that stands
in their way. As a result, archaeologists can expect
to find extremely well-preserved sites in oases,
veritable 'Pompeiis of the desert' that have only
recently been systematically excavated.
Ch. L.

P. and P. de Flers, *Das andere Ägypten: Kulturen – Mythen –
Landschaften* (Cologne 2000); J. Willeitner, *Die ägyptischen
Oasen: Städte, Tempel und Gräber in der Libyschen Wüste*
(Mainz 2003)

246 | The fortress at Qalat-i Gird, Iran
Sistan, the ancient district of Drangiana that
took its post-Achaemenid name Sakistan from the
Scythian Sakish tribes who arrived in the area in the
2nd century BC, is the home of the most famous
Iranian legendary hero, Rustam, who always
appears as the kingdom's invincible saviour in
Firdausi's *Shahnama*, the Persian Book of Kings.
A feather from the mythical simurgh, the bird that
had reared his father Zal, lent him his supernatural
strength. The love story of Zal and Rudabeh,
Rustam's mother, is one of the most dramatic
episodes in the *Shahnama*. The austere but fertile
landscape of Sistan is marked by numerous clay
castles and by the much-feared Wind of the 120
Days that blows throughout the summer and deter-
mines the angle at which the few trees grow and the
position of front doors and protective walls, while
also covering the plain with bizarrely beautiful and
distinctively shaped shifting dunes. In the areas that
have been blown free, the ruins of houses, walls and
channels appear and disappear again. Larger sites
such as the round fortress at Qalat-i Gird in turn
influence the path and shape of the dunes. Situated
some 85km to the south-west of Zabol, the fortress
was examined in 1915/16 by Aurel Stein, who estab-
lished that it dates not from the time of Rustam but
more proably from the 13th century. The three-
cornered addition dates from a later period, when
the site was reduced in size. The fortress may have
witnessed the conquest of Timur Lenk, or
Tamburlaine, who received his fatal wound
here in Sistan.
D. H.

F. Rückert, *Ferdosi's Königsbuch (Shahname)*, 3 vols. (Berlin
1890), legends 7–25; A. Stein, *Innermost Asia II* (New Delhi
1981), 948

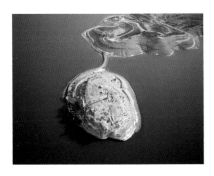

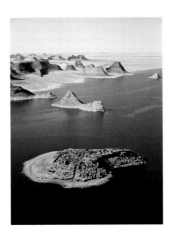

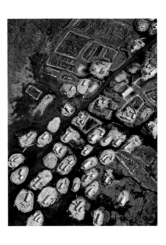

247 | Qalat Jaber, Syria

The Arab fortress at Qalat Jaber now rises up as an island from Lake Assad and is connected to the mainland only by a small dam. The origins of the fortress, which was built on a limestone cliff, date to Byzantine times (5th century AD). During the First Crusade it belonged to the Frankish principality of Balduin II of Edessa. The Franks used it as a base for their pillaging expeditions into the surrounding area. After a whole series of Arab owners, the castle was finally abandoned in 1400 at the time of the Mongol conquests under Timur. Its present appearance as a small oval island is deceptive, its strategic position controlling the Euphrates Valley no longer evident. In 657 the armies of Muawija, later the first Omayyad caliph, and the caliph Ali, the son-in-law of the prophet Mohammed, faced each other on the plain before Qalat Jaber. In 1231 one of the first Ottoman sultans, Suleiman Shah, drowned very close to the castle. Surrounded by two fortified walls, the castle covers an area measuring approximately 230 x 160m. The upper part of the walls are largely made from fired mud bricks and in this respect reflect Mesopotamian practice. In the middle of the plateau stands the brick minaret of a destroyed mosque, reaching a height even now of 28m. Archaeological investigations have shown that the site contains the ruins of a residence with a bath complex.

R. W.

A. Mahmoud, 'Rettung und Restaurierung islamischer Baudenkmäler im Euphrattal', *Land des Baal: Syrien – Forum der Völker und Kulturen* (Mainz 1982), 368 (Berlin exhibition catalogue); R. Burns, *Monuments of Syria: An Historical Guide* (London 1992), 175–6

248 | The site of Gebel Adda, Nubia, Egypt

The Nubian ruins known collectively as Gebel Adda are situated on the border between Egypt and Sudan only a few kilometres south of the famous rock-temples at Abu Simbel (nos. 241 and 242), but on the east bank of the Nile. They consist of a small rock-temple of Pharaoh Haremhab at Abu Oda, a collection of rock-chapels and stelas at Gebel el-Shams dating to the New Kingdom (c1300 BC) and a large fortified town from the Late Meroitic period (1st–5th century AD). Built high on a mountain plateau, this town dominated the exit from the Wadi el-Ur, which was an important approach for the caravan routes across the Arabian Desert. Excavations carried out here between 1963 and 1966 revealed that the town was in constant use from the Late Meroitic period until as recently as c1800. That it was an important centre from the outset is clear from a large Meroitic Temple of Amun and a cemetery with tombs in the form of pyramids evidently intended for members of the Nubian ruling family. The town also appears to have been an important administrative centre in Christian times, from the 6th/7th century to the 16th, as there is archaeological evidence here for at least seven churches. The above-mentioned monuments from the New Kingdom have been saved by cutting them out of the massif, but the town of Gebel Adda has now disappeared for good: having briefly become an island, it was the last site to defy the constantly rising waters of Lake Nasser once work started on the Aswan Dam in 1964.

Ch. L.

N. Millet, 'Gebel Adda', *Actes du IIe symposium international sur la Nubie (février 1–3, 1971) organisé par l'Institut d'Égypte,* ed. L. Habachi (Cairo 1981), 109–22; L. Török, *The Kingdom of Hindu Kush: Handbook of the Napatan-Meroitic Civilization* (Leiden 1997)

249 | Marsh dwellers in the Hor, Iraq

Time seems to have stood still here. The local people lead the sort of lives that they lived thousands of years ago, when the mud deposited by the Tigris and Euphrates had grown to a sufficient height to allow small islands to emerge from the flooded alluvial plain and enable people to build the first dwellings. As was the case then, the houses are still built from reeds, the beams from bundles of the same material, the roofs from matted reeds. Illustrations on seal cylinders from excavation layers dating to the 4th millennium BC show such reed houses, the similarities extending even to points of detail. The present photograph was taken at the Hor al-Hammar, a broad area of marshland close to the confluence of the Tigris and the Euphrates. According to legend, it was here that the Garden of Eden was located. Almost every island has a farmstead surrounded by a reed fence. Between them lies water. The only means of transport is a boat. The people here are happy. They survive by catching fish and weaving reed mats, which even today are in demand as a building material throughout the whole of Mesopotamia. Swaying in the wind, the reedbeds can be seen in the top left and lower right corners of the photograph. Stretching further than the eye can see, the impenetrable thicket of reeds has always been a retreat and refuge for the oppressed. In the wake of the bloody suppression of the popular uprising in 1991 that followed the end of the Kuwait war, Saddam diverted the course of the Euphrates. The water evaporated, unused, in a depression near Ur. The marshes dried out and became accessible to tanks. In this way we have witnessed the definitive end of a 6000-year culture. The marsh dwellers have left the stage for ever. Following the end of Saddam's reign of terror, attempts are under way to restore this former paradise by returning the Euphrates to its old course.

M. M.-K.

W. Thesiger, *The Marsh Arabs* (New York 1964)

PHARAOH IS MOVING

GEORG GERSTER

Late on the evening of 16 November 1963 the contract to save the two rock-temples at Abu Simbel was signed between the Egyptian government and a consortium of firms entrusted with the move. Calling itself the Joint Venture Abu Simbel, this group comprised the building firms of Atlas (Cairo), Grands Travaux de Marseille (Paris), Hochtief (Essen), Impregilo (Milan), Skånska (Stockholm) and Sentab (Stockholm). Hochtief was in overall control as general manager. The Swedish engineering firm of Vattenbyggnadsbyrån supervised the operation in the names of both Egypt and Unesco. That the contract was signed at so late an hour was profoundly symbolic: it was practically five minutes to twelve, leaving little time to save the two temples. The build-up of water behind the Aswan High Dam would begin in the spring of 1964, so that the engineers could expect a race against time with this man-made Flood.

The state of emergency on the Nubian Nile had become clear in 1959: the lake behind the new dam would bury Lower Nubia as far as the Second Nile Cataract 500km away. Temples, tombs, towns, churches, fortresses, inscriptions, rock drawings – the legacy of half a dozen civilizations, to say nothing of the villages of the present-day Nubians. Cries for help from both Egypt and Nubia had gone unheard, and so Unesco made itself the trustee of an international rescue operation in 1960. Emergency excavations were soon underway, although if the truth be told, the archaeologists had little choice: those who were not involved from the outset would receive no subsequent concessions. Smaller sanctuaries were dismantled and removed without further ado. But the rescue of Abu Simbel dragged on. Committee spawned committee, the final appeal was followed by yet another appeal, the very last deadline resulted in a further new extension. Instead of seeing the pharaoh's colossi as a feather in their caps, potential sponsors proved sadly tight-fisted. The Soviet Union hypocritically claimed it was building a dam to provide bread for millions of its inhabitants, while the West was wasting its money on the temples of megalomaniac kings. The West was, of course, counting the cost, with proponents of the plan comparing the cost of saving the temples to the price of bombers ('peanuts'), while opponents converted it into the cost of council flats. What was a nightmare for the accountants fired the imagination of the engineers. Why not build pontoons under both temples and wait for the water to rise? Why not build a prestressed concrete membrane in front of the two temples that would separate the dirty water of the lake from the clear water inside it. Visitors would then be able to admire Ramesses in his

aquarium from galleries inside the membrane. And so on. Ramesses bided his time, while these schemes remained on the drawing board. Only three ideas were taken any further: Unesco's idea of a protective dam, a suggestion worked out in France; the Italian proposal that the temples be cut from the rock en bloc and raised to safety by means of hydraulic jacks; and the joint Egyptian and Swedish low-cost solution (at $36 million still hardly a snip) whereby the temples would be cut up into manageable morsels and reassembled 65m higher and 180m further inland, where they would be out of reach of the water.

At the time that the contract was signed, the financing had yet to be fully secured. Nor were all the technical details of the plan's implementation clear.

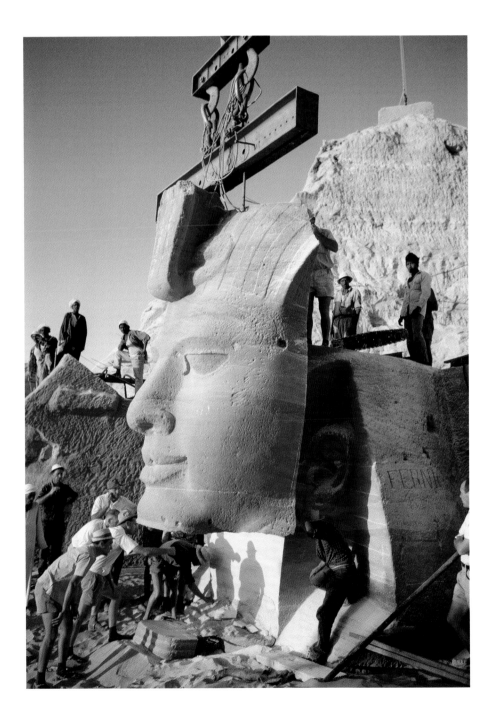

Between now and 22 September 1968, when the temples were officially unveiled on their new site, the engineers had of necessity to learn by experience, so novel was the exercise. They were dealing with moribund rock, often more sand than stone, and losses seemed unavoidable. It says much for the experience accumulated by this first-rate team and for the care and precautions that they took that the pessimists were confounded, and the rescue work, involving dismantling the temples and reassembling them, was completed with no appreciable damage to them.

The task of getting hold of all the equipment, including cranes and compressors, and setting up a building site in the desert 1500 kilometres from the nearest port at Alexandria would not have been easy even without the threat of the

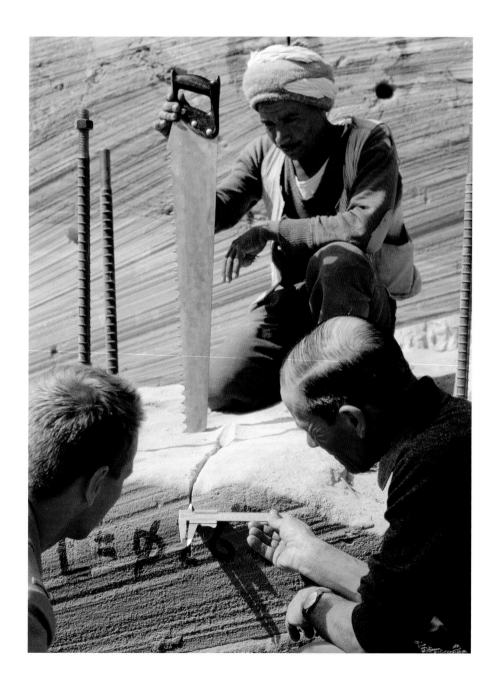

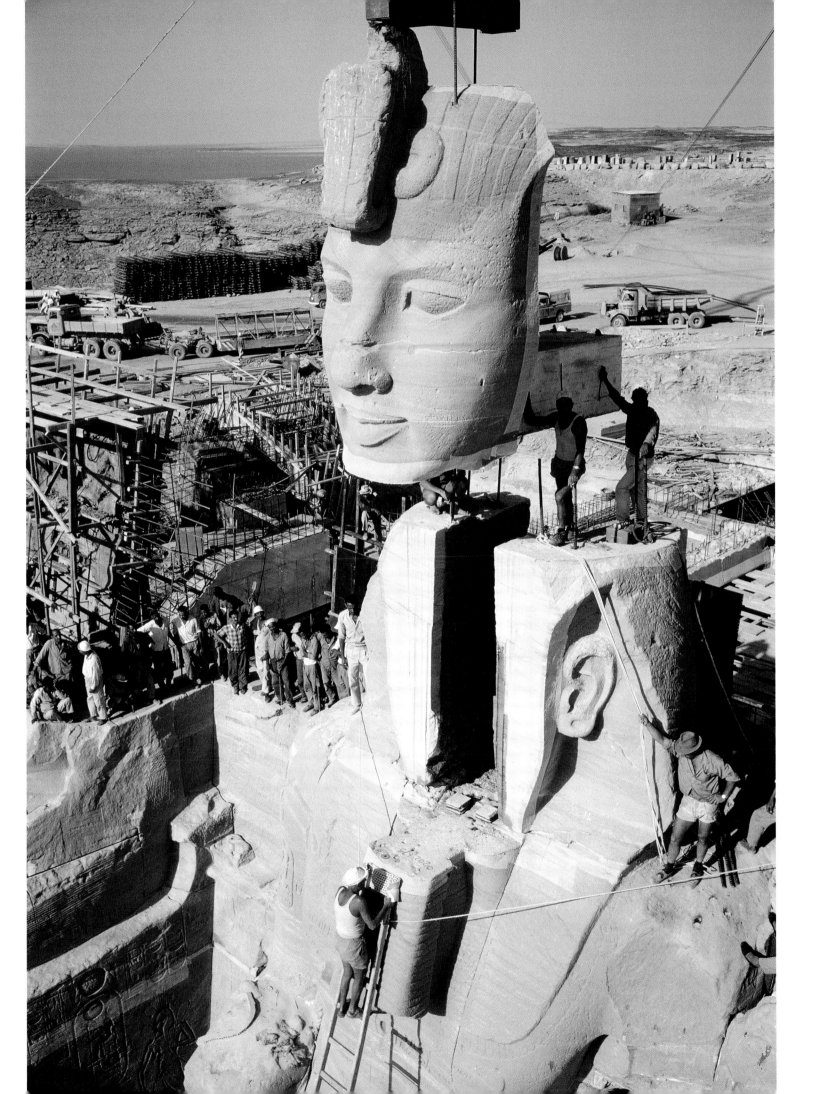

impending flood. Roads, an airstrip, a power station and the additional technical infrastructure, to say nothing of the accommodation for up to 2000 people, with all the usual facilities for taking care of them and providing for their leisure activities, had to be conjured up out of nowhere. From the outset there could be no question at Abu Simbel of the luxury of doing things in leisurely succession. At the same time that a cofferdam was being built to keep the building site dry while the temples were being dismantled, the façades of the temples were disappearing behind a sand filter and the rooms inside the complex were being supported with steel scaffolding. Engineers and archaeologists had calculated that the ceiling slabs and sections of wall should not weigh more than 20 tons, while the sections of the façade were limited to 30 tons. But how were the pharaoh-god and the cult rooms over which he presided to be cut up into transportable pieces? The chosen implement was the saw. Heavy caterpillars with rippers and hand-held pneumatic hammers groped their way from above and behind to within 80cm of the cult rooms deep inside the cliff. *Marmisti* from the marble quarries of northern Italy then marked the lines where the rock was to be cut, using hand saws and making cuts no more than 6mm wide and only a few cm deep. Motor-driven chain saws were then used to cut through the back of the blocks, which were then raised on steel bars cemented in place with epoxy resin.

In short, the temples were saved by fretwork. And it was a triumph, moreover, of the technique of sticking things back together again. It was also a triumph for me and I admit to my sin without remorse. Ramesses was to lose his face on 11 October 1965. Three days before the event a boat with a film crew aboard had

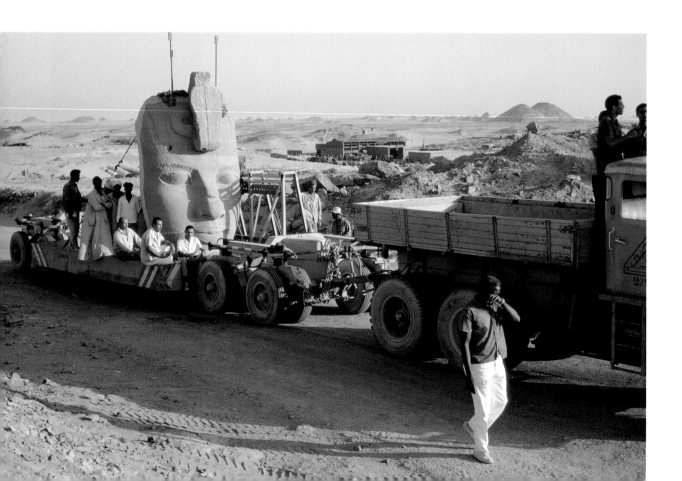

arrived, unannounced and all unsuspecting, but delighted at this bonus. I had been following the operations from the outset for the National Geographic Society in Washington and had been working towards this climax for weeks. I had no wish to forgo the exclusivity of a key image, and so I persuaded the General Manager, Carl Mäckel, to add a fast-hardening compound to the epoxy resin that was to be used to secure the lifting bars of the face. The *marmisti* organized a night shift, a crate of beer helping to keep them in a good mood – and to swear them to secrecy. And so the first colossus lost his face, unannounced, at ten past six on the morning of 10 October. The members of the film crew were still sitting in their houseboat over a mug of tea and scrambled eggs.

Storage area no. 1 was used for the blocks of sandstone from the temples – 807 blocks for the larger temple, 235 for the smaller one. The 6850 blocks of the surrounding hillside were parked in a second storage area. These areas served as a clinic. Many of the stones that arrived here were crumbly and fragile but were nursed back to health by polyester injections. They did not have long to wait here as the tasks of dismantling the site and reassembling it overlapped. The first colossus got his face back by 14 September 1966. A low loader had driven it to its new site in a procession, as if it were some miraculous icon.

Both temples were rebuilt over the same steel structures that had supported their interior while they were being dismantled, with the scaffolding that had once supported their weight now serving as a centring. More than half a million theodolite readings were meant to ensure that the blocks were precisely aligned and that the temples were within a millimetre of their same relative positions.

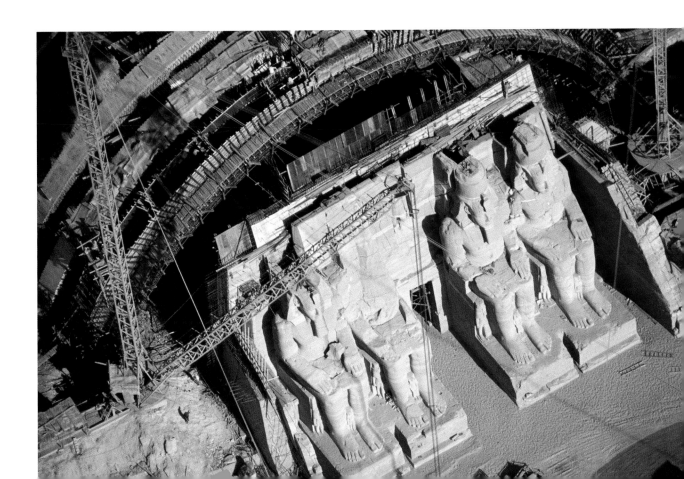

The task of reconstructing the surrounding hills required two enormous concrete domes to be built over the temples in order to carry the weight of the 320,000 cubic metres of rock fill above them and create space for their ventilation. By the middle of 1968 Abu Simbel had been reborn further inland and safe from flooding. On the old site of the two rock-temples holes now gaped as though enormous molars had just been extracted. Mention of rebirth reminds me that in the temporary village used by the workmen and engineers and their families there was also a Honeymoon Road. For good reason and to good effect. Among the children who came into the world during the rescue operation a number had Ramesses or Nefertiti as their second names.

Unesco had not minced its words when in 1960 it had declared the rescue project a test of the cultural maturity of the world's nations. Technically everything went smoothly, a bravura achievement on the part of the engineers and *marmisti*, but the fuss and bother that accompanied it was nothing to write home about. It was a rescue operation that succeeded by the skin of its teeth. But a rescue it was – and it finally established the conviction, enshrined in the 1972 Unesco World Heritage Convention, that outstanding cultural assets belong to us all, and that all of us are therefore called upon to protect them.

G. Gerster, 'Pharaoh on the Move', *The World Saves Abu Simbel*, ed. C. Desroches-Noblecourt and G. Gerster (Vienna and Berlin 1968); Vattenbyggnadsbyrån, *The Salvage of the Abu Simbel Temples: Concluding Report 1971* (Stockholm 1976)

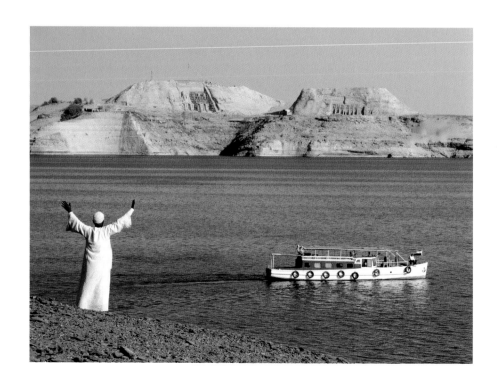

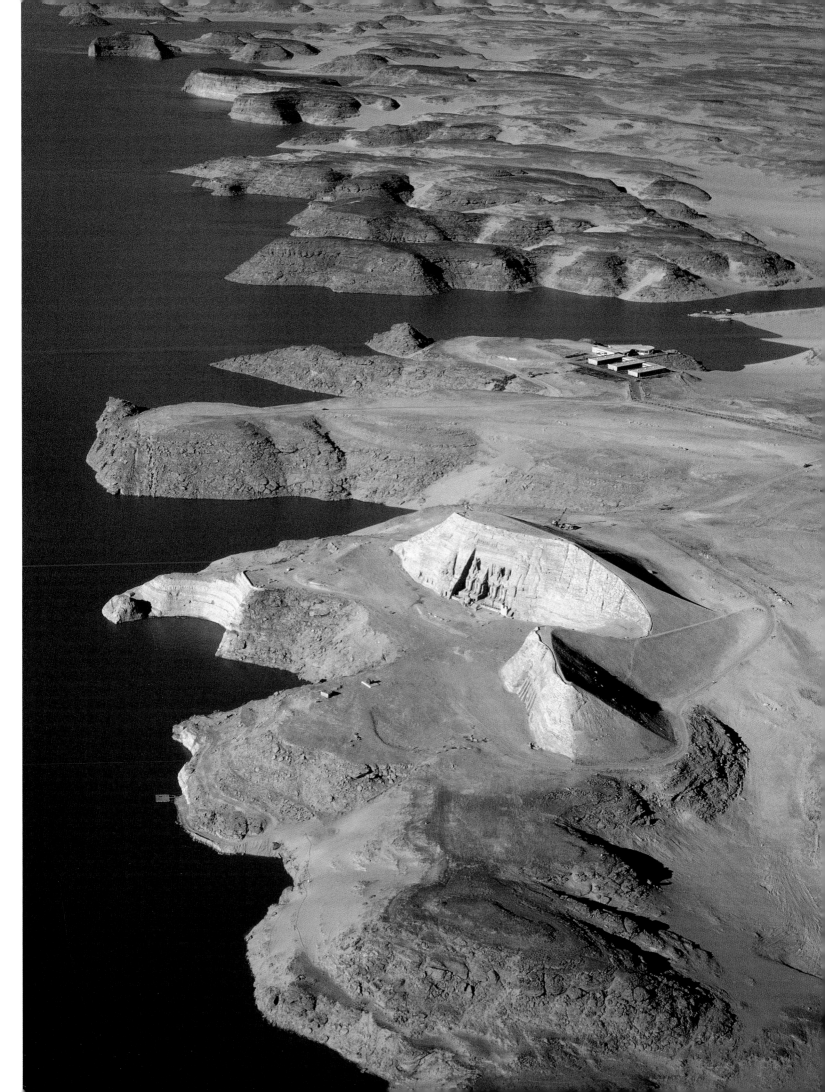

APPENDIX

THE CONTRIBUTORS

Editor Charlotte Trümpler is head of the Archaeological Collection of the Ruhrlandmuseum and Folkwang Museum in Essen. She has taken part in excavations in Switzerland and Turkey and has planned and organized many exhibitions, including the internationally acclaimed 'Agatha Christie and the Orient', which was seen in Essen (1999), Vienna, Basel, London (where it was renamed 'Agatha Christie and Archaeology') and Denmark.

S. A. Stefan Altekamp lectures at the Winckelmann Institute for Classical Archaeology at Berlin's Humboldt University. His publications include books and articles on Roman archaeology in North Africa.

R. B. Robert Bewley is Head of Survey for English Heritage.

H. B. Henning Bischof is emeritus director of the Ethnological Collections at the Reiss Museum in Mannheim. He has undertaken fieldwork in Peru, Ecuador and Colombia and published on the archaeology of these regions.

C. B. The archaeologist Christine Boujeot is director of the Service Régional d'Archéologie de Bretagne.

J.-L. F. The archaeologist Jean-Luc Fiches is head of research at the Centre National de la Recherche Scientifique in Paris. He has excavated various Gallo-Roman settlements in France.

T. F. Thomas Fischer is Professor of the Archaeology of the Roman Provinces at Cologne University and has taken part in excavations of Roman sites in Germany and Syria.

U. F.-V. Ute Franke-Vogt is on the staff of the Eurasian Department at the German Archaeological Institute in Berlin. She has undertaken fieldwork and been involved in projects in Iran, Iraq, the Arabian Peninsulas, Pakistan and Afghanistan.

D. H. Dietrich Huff is former assistant director of the Eurasian Department (Teheran) of the German Archaeological Institute in Berlin and has excavated various sites in Iran.

I. G. Ioan Glodariu is Professor of Early History at the University of Cluj-Napoca in Romania and has excavated the sites at Sarmizegetusa Regia and Blidaru in Romania.

K. L. The archaeologist Karsten Lambers is currently working on the Nasca-Palpa Research Project at the Institute for Geodesy and Photogrammetry at Zurich's Technical University.

A. L. Achim Lichtenberger is assistant professor at the Archaeological Department of Münster University and has published on archaeological sites in Israel and Palestine.

Ch. L. Christian E. Loeben is curator of the Egyptological Department at the Kestner Museum in Hanover. He has undertaken fieldwork in Egypt.

M. M.-K. The archaeologist Michael Müller-Karpe is on the staff of the Roman-Germanic Central Museum in Mainz and has helped to coordinate scientific projects with the Iraqi Department of Antiquities.

U. N. Ulf Näsman is Professor of Prehistoric Archaeology at the University of Århus, Denmark, and a specialist in prehistoric cultures in Sweden.

H. P. Hermann Parzinger is President of the German Archaeological Institute and has excavated sites in Turkey, Siberia, Uzbekistan, Tajikistan, Kazakstan and Iran.

V. P. Volker Pingel is Professor of Prehistory and Early History at the Ruhr University in Bochum. He has undertaken excavations in Spain and is director of the research project 'Aerial Archaeology in China'.

H. J. P. Hanns J. Prem is Professor of Ethnology and Ancient American Culture and Ethnology at the University of Bonn. He has undertaken fieldwork in Mexico and Argentina.

B. R. Barry Raftery is Professor of Celtic Archaeology at University College, Dublin. He has undertaken excavations in Ireland and published on the Celts and bog trackways.

M. R. Michel Reddé is director of studies at the École Pratique des Hautes Études at the Sorbonne and has excavated the site at Alesia in France.

M. Re. Markus Reindel is an archaeologist who specializes in ancient American culture and ethnology. He is on the staff of the German Archaeological Institute and the Commission for General and Comparative Archaeology in Bonn. He has undertaken fieldwork in Peru.

M. Ri. Martin Rill is on the staff of the Swabian Central Museum in Ulm and has published on aerial images of Transylvania, Romania.

E. R. Else Roesdahl is Professor of Medieval Archaeology at the University of Århus, Denmark, where she specializes in Viking culture.

P. S. Peter Scherrer works for the Austrian Archaeological Institute and has taken part in excavations in Austria and at Ephesus in Turkey.

R. S. Reinhard Senff is second director of the German Archaeological Institute in Athens. He has undertaken excavations in Turkey.

B. S. Baoquan Song is an aerial archaeologist at the Institute for Prehistory and Early History at the Ruhr University in Bochum. He is involved in the project 'Aerial Archaeology in China'.

S. St. Stephan Steingräber teaches classical archaeology at the University of Mainz and is Professor of Etruscology at the University of Padua. He has undertaken fieldwork and published on Etruscan, Pan-Greek and early Italian cultures.

T. St. Tom Stern is an archaeologist specializing in the Near East. He is on the staff of the Ruhrland Museum in Essen and has taken part in excavations in Germany and Turkey.

R. W. Ralf Wartke is a specialist in the archaeology of the Near East and deputy director of the Near Eastern Museum/Pergamon Museum, Berlin. He has conducted excavations in Iraq and Syria.

GEORG GERSTER

Biography

Georg Gerster was born in Winterthur, Switzerland, on 30 April 1928 and studied classical languages at his local grammar school, before reading German and English at Zurich University, where he also received his doctorate. From 1950 to 1956 he was science editor of the Zurich *Weltwoche*. Since 1956 he has been a freelance journalist specializing in science reporting and aerial photography. He has undertaken extensive visits to every part of the world, including Antarctica. Height provides an overview, and an overview facilitates insight, while insight may perhaps lead to greater consideration. By pursuing this line of reasoning, Georg Gerster has turned aerial photography into something more probing, something that, with luck, may prove a contemplative, philosophical instrument encouraging greater reflection. His way of viewing the world has caught on and found many imitators. Georg Gerster consoles himself with the thought that imitation is still the highest form of flattery.

For two decades Georg Gerster's aerial photographs for Swissair's posters and calendars have contributed substantially to the airline's image.

Gerster works on a regular basis for the *Neue Zürcher Zeitung* and the Washington-based *National Geographic*. Longer illustrated articles have appeared in *Geo* (Hamburg), *Stern* (Hamburg), *Bild der Wissenschaft* (Stuttgart), *The Sunday Times Magazine* (London), *Geo* (Paris), *Paris Match* (Paris), *Focus* (Milan), *Epoca* (Milan) and *Airone* (Milan). He has held one-man shows and taken part in group exhibitions in Europe, the United States of America and Japan. Portfolios of his prints are to be found all over the world in private collections, banks, hospitals, industrial enterprises and museums. He has also illustrated countless books.

Acknowledgments

The material for the present book and exhibition has taken 40 years to compile and involved more than 3500 flying hours in lightweight aircraft, helicopters and balloons in or, rather, over 107 different countries. In the final choice of 256 images of archaeologically important sites, some 50 countries and every inhabited continent are represented.

All the photographs were taken with Nikon 35mm cameras, mostly on Kodachrome film, except for a few more recent ones, for which Fuji Velvia was used.

It is unnecessary to add that the accumulated debt of gratitude is a heavy one and cannot be repaid even with a long list of names. I can do no more than express my undiscriminating thanks to all the individuals and institutions, together with an army of sponsors, wellwishers, supporters and drivers both on the ground and in the air, without whom this flight into the past would have ended prematurely in disaster.
G. G.

GEORG GERSTER
Publications (selective list)

Die leidigen Dichter (Zurich 1954) (DPhil dissertation)

Eine Stunde mit... (Frankfurt and Berlin 1956, reprinted in 1962 as *Aus der Werkstatt des Wissens*, vol. 1)

Aus der Werkstatt des Wissens, vol. 2 (Frankfurt and Berlin 1958)

Sahara: Reiche fruchtbare Wüste (Berlin and Frankfurt 1959) (also Dutch and English [as *Sahara: Desert of Destiny*])

Sinai: Land der Offenbarung (Berlin, Frankfurt and Vienna 1961) (also Dutch and French editions)

Nubien: Goldland am Nil (Zurich 1964)

Faras: Die Kathedrale aus dem Wüstensand (text by Kazimierz Michalowski) (Zurich and Cologne 1967)

Kirchen im Fels (Stuttgart 1968) (also French, Italian and English [as *Churches in Rock: Early Christian Art in Ethiopia*])

Die Welt rettet Abu Simbel (with Christiane Desroches-Noblecourt) (Berlin and Vienna 1968) (also French, Italian, Arabic and English [as *The World Saves Abu Simbel*])

The Nubians: Peaceful People (text by Robert A. Fernea) (Austin, Texas, 1973)

Äthiopien: Das Dach Afrikas (Zurich 1974) (also French)

Der Mensch auf seiner Erde: Eine Befragung in Flugbildern (Zurich 1975) (also French, Dutch, Swedish and English [as *Grand Design: The Earth from Above*]

Brot und Salz: Flugbilder (Zurich 1980) (also French)

Flugbilder: 133 aus der Luft gegriffene Fundsachen (Basel, Boston and Stuttgart 1985) (also English [as *Below from Above: Aerial Photography*])

Die Welt im Sucher: Wahrnehmungen Erkundungen Bestandaufnahmen (Zurich 1988) (texts without photographs)

Chikyu No Kao (Face of the Earth) (Tokyo 1990) (Japanese only)

The Art of the Maze (with Adrian Fisher) (London 1990) (published in the United States of America as *Labyrinth: Solving the Riddle of the Maze*)

Amber Waves of Grain: America's Farmlands from Above (New York 1990)

Siebenbürgen im Flug (text by Martin Rill) (Munich and Innsbruck 1996)

Flugbilder aus Syrien: Von der Antike bis zur Moderne (text by Ralf Wartke) (Mainz 2003)

Weltbilder. 70 Flugbilder aus den sechs Erdteilen (Munich 2004)

Mit den Augen der Götter. Flugbilder des antiken und byzantinischen Griechenland (text by Johannes Nollé and Hertha Schwarz) (Mainz 2005)

GLOSSARY

Achaemenids Old Persian royal family named after its founder Achaemenes, *c*700–330 BC

Agora Marketplace and place of assembly

Akkadians Inhabitants of the northern Babylonian kingdom of Akkad *c*2235–2094 BC

Anasazi Indian people living in what is now the south-western USA AD 200–1300

Apsaras Heavenly water nymphs in Indian mythology

Apse Semicircular area at the end of a room

Aqueduct Artificial channel for conveying water above ground

Asclepius Greek god of healing, son of Apollo

Assyria From the 13th century BC, powerful kingdom in the Near East on the middle Tigris in what is now Iraq, named after the kings of the city of Ashur

Atacama culture Pre-Columbian culture in Chile from the birth of Christ to the 13th century

Athena Greek goddess of cities, science and the arts

Australopithecus aethiopicus 'Southern ape', gracile hominid

Australopithecus boisei Robust hominid, also known as 'Nutcracker Man' on account of his well-developed masticatory apparatus

Axumites Inhabitants of the Axumite empire 1st–5th century AD, named after their capital at Axum/Aksum in what is now Ethiopia

Aztecs The most important Indian people in what is now Mexico, from AD 1215 to their conquest by Cortés in 1520

Baptistery Small building, separate from the main church, where the rite of baptism is performed

Brahma Hindu deity regarded as the creator and controller of the world

Cardo maximus Main street in a Roman town or camp laid out on a north-south axis

Cavea Semicircular tiered seating in a classical theatre

Cella Room in a classical temple, often containing the cult-statue

Chimú empire Indian princedom on the north coast of Peru, AD 1100–1450

Cistern Underground reservoir for rainwater

Citadel Fortress

Cloverleaf plan Church with an apse in the chancel and one at the end of each transept arm

Cryptoporticus Underground hall-like corridor

Curtain wall Outer wall of a castle between the projecting defence works (bastions)

Dacians Ancient people who lived in what is now Romania, from AD 106 under Roman rule as the province of Dacia

Decumanus maximus The main street in a Roman town or camp laid out on an east-west axis

Donjon Synonym for keep, a solid, fortified residential tower

Gareus Parthian deity, 247 BC–224 AD

Hominids Family of bipedal primates to which humans belong

Homo sapiens Anatomically modern man

Hurrians Ancient oriental people in northern Mesopotamia in the 3rd/2nd millennium BC, forming the Mitanni kingdom in the 15th and 14th centuries BC

Inca South American people in what is now Peru, Colombia and Chile, from around AD 1200 to 1572

Lyceum A place of higher education, named after the gardens at Athens where Aristotle taught philosophy

Manichaeans Adherents of a doctrine of redemption named after their founder, Manes (AD 216–77)

Megaron The main room in a Greek house

Meroites The inhabitants of Meroe in Nubia between the 3rd century BC and the 6th century AD

Mesopotamia The 'land between the rivers', i.e. the region between the middle and lower Euphrates and Tigris, now Iraq and Syria

Minoans The inhabitants of the area influenced by Crete in the 3rd and 2nd millennia BC, named after the legendary King Minos

Moche Pre-Columbian people on the north coast of Peru who flourished between 200 BC and AD 600

Murus gallicus Defensive wall made from wooden beams, unworked stone assembled without the use of mortar, and earth

Mycenaean period Bronze Age period from c1580 BC to 1200 BC, named after the important fortified site at Mycenae in the Peloponnese

Nabataeans Tribe that settled to the south of the Dead Sea in the 5th and 4th centuries BC

Nasca Pre-Columbian Indian people on Peru's southern coast, 200 BC–AD 600

Necropolis Cemetery, literally 'city of the dead'

Nestorians Adherents of the Christian doctrine based on the belief that Christ was human, named after Nestorius (AD c381–451)

Obelisk Narrow, rectacular stone pillar tapering towards the top and ending in a pyramid

Odeon Small theatre

Olmecs Inhabitants of what is now southern Mexico, with a highly developed culture between 1500 BC and c300 BC

Omayyads Islamic ruling dynasty, reigning from Damascus between 661 and 750 and from Córdoba between 756 and 1031

Oppidum Celtic settlement fortified by walls and ditches

Opus caementitium Roman concrete work

Opus sectile Roman construction technique using thin slabs of stone – usually rare types of marble – fitted together in segments

Orchestra Circular dance floor for the chorus in front of the stage in a classical theatre

Pagoda Tower-like temple building in eastern Asia with up to 13 successively diminishing storeys separated by emphatic roofs

Palaestra Ancient sports ground for wrestling matches

Parthians A steppe people who established a kingdom between the Euphrates and the Indus from 247 BC to AD 224

Propylon Architectonically emphasized entrance gate

Punic The Roman adjective referring to the inhabitants of Carthage and its empire between 520 and 146 BC

Pylon The monumental gateway to an ancient temple

Quadriporticus An open inner courtyard (atrium) surrounded on all four sides by hall-like porticos supported on columns

Rune-stones Stones carved with letters of the runic script, found mainly in northern Europe from the 1st century AD

Saffarid dynasty Persian dynasty founded by Yaqub as-Saffar, AD 868–1163

Sassanids Persian dynasty, AD 224–651, that succeeded the Parthians

Seleucids Hellenistic dynasty of western Asia, named after its founder Seleucus I Nicator (312–281 BC) and surviving until 64 BC

Seljuks Turkish people and ruling dynasty in Asia Minor in the 11th century, named after their leader Seljuk

Shaman A person versed in magic and religion who goes into a state of trance to make contact with supernatural forces in order to exorcize them or to use them to human advantage

Shinto shrine Sacred site in Japan dedicated to nature and ancestor worship

Siva One of the principal Hindu gods, combining destructive and beneficial characteristics

Stoa Columned hall

Stupa Buddhist monument containing sacred relics

Tell Hill that has been created over time by the stratified accumulation of debris from different settlement layers

Tepidarium A warm room in a Roman bathhouse

Toltecs Indian people in what is now Mexico, 9th century AD—AD c1160

Vishnu One of the main Hindu gods, the one who 'works everywhere', maintaining his grip on creation

Wadi A valley, ravine or channel that may fill with water in the rainy season, a type of valley in the desert

Zapotecs An Indian people in what is now Mexico, they flourished between AD 200 and 800

Ziggurat Temple-tower consisting of several super-imposed terraces with two flights of stairs at the side and one in the centre

Zinjanthopus boisei An earlier name for Australopithecus boisei (q.v.)

Zoroastrian religion Monotheistic Persian state religion with its own sacred script, founded by Zarathustra (Zoroaster) in the early 6th century BC

LIST OF COUNTRIES

Africa

Botswana (155)

Egypt (130, 131, 134, 172, 231, 241, 242, 245, 248,
　　Illus. pp.395–401)

Ethiopia (3, 29, 167, 194)

Libya (76)

Mali (6, 135, 235)

Morocco (25, 48)

Sudan (132, 168)

Tanzania (7)

Zimbabwe (9)

Asia

Afghanistan (10)

Cambodia (187)

China (35, 36, 120, 125, 133, 139, 189, 224)

Indonesia (186, 188, 191)

Iran (2, 11, 13, 17, 18, 28, 34, 52, 68, 70, 106, 107,
　　121, 136, 149, 179, 185, 217, 222, 223, 225,
　　237, 238, 244, 246)

Iraq (12, 15, 33, 153, 178, 180, 181, 182, 183, 249)

Israel (26, 61, 220, 226)

Japan (67, 140, 148, 190, 192, 193)

Jerusalem (201, 202)

Jordan (5, 43, 69)

Palestine (23, 59, 203)

Russian Federation, Altai Republic (142)

Russian Federation, Tuva Republic (110, 143)

South Korea (146)

Sri Lanka (60, 184)

Syria (14, 27, 32, 44, 45, 46, 53, 58, 63, 72, 109,
　　112,113, 119, 170, 205, 221, 236, 247)

Turkey (8, 22, 73, 80, 82, 85, 87, 90, 127, 151, 152,
　　197, 204)

Australia

156, 158

Europe

Austria (55)

Cyprus (51, 75)

Denmark (117, 129, 141, 145)

England (96, 97, 103, 122, 128, 160, 162, 166, 207,
　　210, 214)

France (16, 24, 54, 65, 71, 74, 88, 100, 111, 115, 138,
　　163, 200, 218)

Germany (56, 57, 89, 144)

Greece (21, 30, 31, 50, 66, 77, 79, 81, 86, 91, 105,
　　124, 126, 169, 195, 196, 198, 233, 234)

Iceland (4)

Ireland (93, 95, 98, 108, 147, 171)

Italy (41, 42, 49, 64, 83, 114, 150, 199)

Malta (154, 229)

Portugal (40)

Romania (102, 159, 206)

Scotland (62, 94, 104, 161)

Spain (39, 78, 123, 137, 157, 219)

Sweden (92, 165)

Switzerland (116)

Latin America

Bolivia (177)

Chile (19, 20, 37, 211, 232)

Colombia (216)

Ecuador (230)

Mexico (1, 173, 174, 175, 176, 228)

Peru (47, 99, 101, 118, 208, 212, 215, 239, 240, 243)

North America

Canada (164)

United States of America (38, 84, 209, 213, 227)

LIST OF ARCHAEOLOGICAL SITES

Abu Simbel, Egypt (241, 242, Illus. pp.395–401)

Aegosthena, Greece (91)

al-Bagawat, Egypt (134)

Aleppo, Syria (112)

Alesia, France (100)

Alexander's Wall, Iran (121, 237)

Angkor Thom, Cambodia (187)

Anuradhapura, Sri Lanka (184)

Apamea, Syria (44)

Aphrodisias, Turkey (82)

Aqar Quf, Iraq (183)

Argos, Greece (79)

Arles, France (24)

Arwad/Ruad, Syria (27)

Arzhan, Tuva Republic, Russian Federation (143)

Ashur, Iraq (12)

Astana, China (133)

Athens, Greece (169)

Aulis, Greece (126)

Avebury, England (162)

Babylon, Iraq (180)

Bampur, Iran (106)

Bandiagara, Mali (6)

Band-i Amir, Iran (222)

Barmkin Hillfort, Scotland (94)

Bassae, Greece (195)

Bastam, Iran (107)

Beijing, China (139)

Birsay, Mainland, Orkneys, Scotland (62)

Bishapur, Iran (11)

Blå Jungfrun, Sweden (165)

Blidaru, Romania (102)

Blythe, USA (209)

Borobudur, Indonesia (188)

Bosra, Syria (72)

Broch of Gurness, Scotland (104)

Caesarea (aqueduct), Israel (220)

Caesarea (port), Israel (26)

Cahuachi, Peru (239)

Cape Sounion, Greece (196)

Cappadocia, Turkey (8)

Carcassonne, France (111)

Carnac, France (163)

Carnuntum, Austria (55)

Caserones, Chile (19)

Cerne Abbas, England (210)

Cerro Unita, Chile (211)

Cerveteri, Italy (150)

Chalcidice, Greece (233)

Chan Chan, Peru (47)

Chanquillo, Peru (99)

Cheqa Narges, Iran (17)

Choga Zanbil, Iran (179)

Church Henge, England (103)

Clapham Junction, Malta (229)

Constance, Germany (57)

Crooked Wood, Ireland (95)

Cuenca de Guayas, Ecuador (230)

Dabra Damo, Ethiopia (167)

Dahan-i Ghulaman, Iran (244)

Deir el-Bahri, Egypt (130)

Delos, Greece (21)

Didyma, Turkey (197)

Dodona, Greece (77)

Dún Aengus, Ireland (108)

Dún Eochla, Ireland (93)

Ebla, Syria (14)

El Tajín, Mexico (175)

Enkomi/Alashiya, Cyprus (51)

Ensérune, France (16)

Ephesus (citadel), Turkey (90)

Ephesus (St John's Basilica), Turkey (204)

Es Tudons, Spain (137)

Flaming Mountains, China (125)

Gao, Mali (135)

Gaochang, China (36)

Gebel Adda, Egypt (248)

Gebel Barkal, Sudan (168)

Gournia, Greece (30)

Grand, France (88)

Great Serpent Mound, USA (213)

Great Wall of China, China (120)

LIST OF ARCHAEOLOGICAL SITES

Petit-Mont, Arzon, France (138)

Pompeii, Italy (49)

Pont du Gard, France (218)

Prambanan, Indonesia (186)

Priene, Turkey (22)

Pueblo Bonito, USA (38)

Pukara de Turi, Chile (20)

Qadmus, Syria (58)

Qalat-i Gird, Iran (246)

Qalat Jaber, Syria (247)

Quiahuiztlan, Mexico (174)

Qumran, Palestine (203)

Ramesseum, Egypt (131)

Rome (Castel Sant'Angelo), Italy (114)

Rome (Imperial Forums), Italy (41)

Rome (Pantheon), Italy (199)

Rome (Piazza Navona), Italy (83)

Saffron Walden, England (166)

St Catherine's Monastery, Egypt (172)

St Simeon's Monastery, Syria (205)

Sakai, Japan (140)

Salamis, Cyprus (75)

Samarra, Iraq (182)

Santa, Peru (118)

Santa Luzia, Portugal (40)

Santa Tecla, Spain (39)

Sanxay, France (74)

Sarabit El-Khadem, Egypt (231)

Sarmizegetusa Regia, Romania (159)

Schleswig-Holstein burial mound, Germany (144)

Se Girdan, Iran (149)

Segovia, Spain (219)

Serjilla, Syria (45)

Sigiriya, Sri Lanka (60)

Sipán, Peru (240)

Siraf/Bandar Taheri, Iran (28)

Skellig Michael, Ireland (171)

Sooru Valley, Altai Republic, Russian Federation (142)

Stonehenge, England (160)

Takht-i Suleiman, Iran (18)

Tanah Lot, Bali, Indonesia (191)

Tara, Ireland (98)

Tegea, Greece (198)

Tell Brak, Syria (32)

Tell Knedig, Syria (53)

Teotihuacan, Mexico (176)

Tepe Yahya, Iran (52)

Tere-Khol, Lake, Tuva Republic, Russian Federation (110)

Thingvellir, Iceland (4)

Tiahuanaco, Bolivia (177)

Tivoli, Italy (64)

Trelleborg, Denmark (117)

Trepucó, Spain (157)

Trier, Germany (89)

Troy/Ilium, Turkey (127)

Tsodilo Hills, Botswana (155)

Tulelat al-Anab, Negev Desert, Israel (226)

Turfan Depression, China (224)

Ubirr Rock, Australia (156)

Ugarit, Syria (46)

Uluru, Australia (158)

Unteruhldingen, Germany (56)

Ur, Iraq (181)

Uruk, Iraq (178)

Via Domitia near Montpellier, France (54)

Viña del Cerro, Chile (232)

Viscri, Romania (206)

Volubilis, Morocco (48)

White Horse of Uffington, England (207)

White Horse of Westbury, England (214)

Wiltshire (round barrow), England (128)

Wupatki Pueblo, USA (84)

Xochimilco, Mexico (228)

Yazd, Iran (217)

Yoshinogari, Japan (148)

Zendan-i Suleiman, Iran (185)

Zenobia on the Euphrates, Syria (109)